FORT BEND COUNTY LIBRARIES

PRESENTED BY

FORT BEND
TELEPHONE COMPANY

Caravaggio: A LIFE

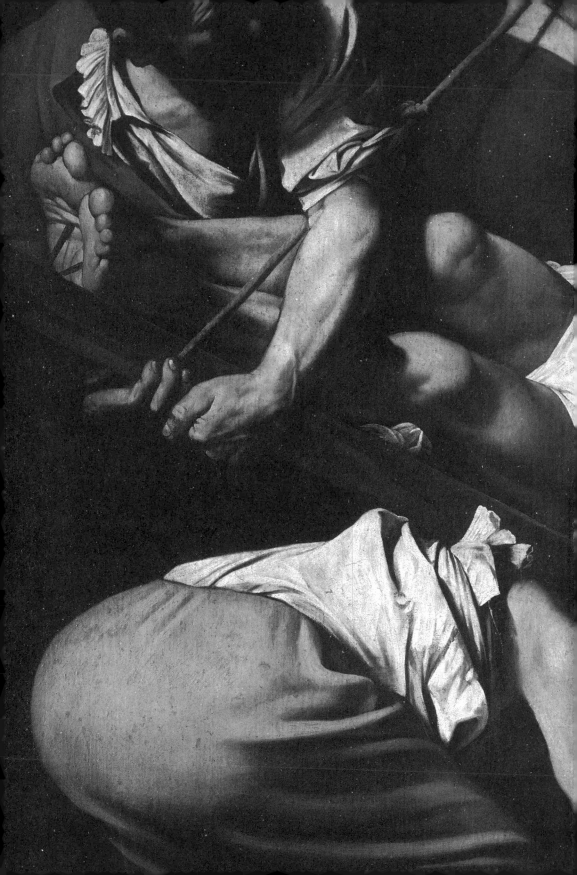

Caravaggio: A LIFE

Helen Langdon

Farrar, Straus and Giroux
NEW YORK

By the same author
Claude Lorrain

For Anthony, John and Esther
forsan et haec olim meminisse iuvabit

Farrar, Straus and Giroux
19 Union Square West, New York 10003

Copyright © 1998 by Helen Langdon
All rights reserved
Printed in the United States of America
First published in 1998 by Chatto & Windus, London
First Farrar, Straus and Giroux edition, 1999

Library of Congress Cataloging-in-Publication Data
Langdon, Helen.
 Caravaggio : a life / Helen Langdon. — 1st Farrar, Straus and Giroux ed.
 p. cm.
 First published in 1998 by Chatto & Windus, London.
 ISBN 0-374-11894-9 (alk. paper)
 1. Caravaggio, Michelangelo Merisi da, 1573–1610. 2. Painters—Italy—Biography.
I. Title.
ND623.C26L36 1999

 98-51195

Contents

ILLUSTRATIONS vii

INTRODUCTION 1

ONE Milan 9

TWO Rome 1592 33

THREE Flowers and Fruit 51

FOUR A Gypsy, Cardsharps and a Cardinal 77

FIVE In the Household of Del Monte 96

SIX The World of Street and Brothel 131

SEVEN Conversion and Martyrdom:
the Jubilee of 1600 154

EIGHT *Ut Pictura Poesis* 191

NINE The Shock of Humility: the Imitation
of Christ 222

TEN Rivals 252

ELEVEN Rome 1603–1606 275

TWELVE Naples 319

THIRTEEN Caravaggio in Malta 340

FOURTEEN Sicily 364

FIFTEEN Naples and Death 381

NOTES 393

LOCATIONS OF PAINTINGS 421

ACKNOWLEDGMENTS 425

INDEX 427

Illustrations

ILLUSTRATIONS APPEARING WITHIN THE TEXT

Title page: Caravaggio, *The Crucifixion of St Peter*, detail (Rome, S Maria del Popolo) ii

1. Ottavio Leoni, *Portrait of Caravaggio*, (drawing) (Florence, Biblioteca Marucelliana) xii
2. The Town of Caravaggio; detail from 18th-century map 11
3. Giuseppe Rados, *View of the Corso dei Servi, Milan* (print, c. 1820, Milan, Civica Raccolta Stampe Achille Bertarelli) 13
4. Cesare Bonino, *Carlo helps and brings aid to the poor* (print) 17
5. Nunzio Galiti, *Milan in the Plague*, 1578, (print) 31
6. Tommaso Laureti, *The Triumph of Religion* (Rome, Vatican Palace, Sala di Costantino) 33
7. Antonio Tempesta, *Map of Rome*, 1593 (print) 36
8. Ludovico Ciamberlano 'He saw the faces of St Carlo and St Ignatius Glow'; scene from the Life of S. Fillippo Neri (print) 45
9. Scipione Pulzone, *Holy Family* (Rome, Galleria Borghese) 53
10. Caravaggio, *Boy Peeling a Fruit* (London, Phillips) 58
11. Portrait of Mario Minniti (print, from G. Grosso Cacopardo, ed. *Memorie de' Pittori Messinesi*, Messina 1821) 60
12. Federico Zuccaro, *Self Portrait* (Florence Cathedral, dome fresco) 63
13. Ottavio Leoni, *Portait of the Cavaliere d'Arpino* (print) 64
14. The Master of Hartford, *Fruits and Flowers in two Carafes* (Hartford, Wadsworth Atheneum) 73
15. Claude Mellan, *Portrait of Vincenzo Giustiniani* (print, from the Galleria Giustiniani) 99
16. Michael Natalis, *Portrait of Cardinal Benedetto Giustiniani* (print, from the Galleria Giustiniani) 100

17. Theodor Dirck Matham, *Portrait of Gerolama Giustiniani* (print, from the Galleria Giustiniani) 101
18. Jan Breughel, *Vase of Flowers* (Milan, Pinacoteca Ambrosiana) 117
19. Caravaggio, *The Conversion of the Magdalen* (Detroit, Detroit Institute of Arts) 122
20. G. B. Falda, *Casino Ludovisi* (print) 128
21. Caravaggio, *Jupiter, Neptune and Pluto* (Rome, Casino Ludovisi) 129
22. Caravaggio, *Portrait of Fillide* (destroyed; formerly Berlin, Kaiser-Friedrich Museum) 147
23. Antonio Tempesta, *Scene of Martyrdom* (print) 155
24. Caravaggio, *St Catherine of Alexandria* (Madrid, Museo Thyssen-Bornemisza) 164
25. Caravaggio, *David and Goliath* (Madrid, Prado) 169
26. Caravaggio, *The Conversion of St Paul* (Rome, Odescalchi collection) 183
27. Caravaggio? (attrib. to) *Portrait of Giovan Battista Marino* (Private collection) 198
28. Giovanni Volpato, *The Farnese Gallery, Rome* (print) 206
29. Annibale Carracci, *Self Portrait* (Parma, Galleria Nazionale) 208
30. Bartolomeo Manfredi, *Mars chastising Cupid* (Chicago, Art Institute of Chicago) 212
31. *Cupid with his Bow* (print after antique sculpture, from the Galleria Giustiniani) 214
32. G. B. Falda, *The Palazzo Mattei* (print) 227
33. Caravaggio, *Christ on the Mount of Olives* (destroyed; formerly Berlin, Kaiser-Friedrich Museum) 236
34. Caravaggio, *St Matthew and the Angel* (destroyed; formerly Berlin, Kaiser-Friedrich Museum) 238
35. Giovanni Baglione, *Divine Love Overcoming the World, the Flesh and the Devil* (Staatliche Museen zu Berlin – Preußischer Kulturbesitz Gemäldegalerie) 260
36. Giovanni Baglione, *Divine Love Overcoming the World, the Flesh and the Devil* (Rome, Galleria Nazionale d'Arte Antica, Palazzo Barberini) 261
37. Ottavio Leoni, *Portrait of Giovanni Baglione* (print) 262

38. Ottavio Leoni, *Group Portrait of Artists, including Sigismondo Laer and Ottavio Leoni* (print) 268

39. Guido Reni, *David contemplating the Head of Goliath* (Paris, Louvre) 283

40. Antoine Lafréry, *The Seven Churches of Rome* (print) 288

41. Gian Lorenzo Bernini, *Bust of Scipione Borghese* (Rome, Galleria Borghese) 291

42. Caravaggio, *St Jerome in his Study* (Rome, Galleria Borghese) 293

43. Caravaggio, *St Francis in Meditation* (Rome, Galleria Nazionale d'Arte Antica, Palazzo Barberini) 294

44. Caravaggio, *St John the Baptist* (Rome, Galleria Nazionale d'Arte Antica, Palazzo Corsini) 295

45. *The Conclave of 1605* (Columbia University, New York) 297

46. Caravaggio, *Mary Magdalene* (Private collection) 315

47. View of Naples (print) 320

48. Matteo Perez d'Aleccio, *The Investment of Fort St Michael* (Valletta, Grand Master's Palace) 341

49. Francesco dell'Antella, *Valletta* (from G. Bosio, *Dell'Istoria della Sacra religione et Ill ma Militia di San Gio.Gierosol.no di Iacomo Bosio*, Rome, 1630) 343

59. Caravaggio, *Portrait of Alof de Wignacourt* (Paris, Louvre) 350

51. *Castel Sant'Angelo, Malta* (photo: Marquis Anthony Cassar de Sayn) 360

52. C. von Osterhausen, *The Oratory of St John* (Valletta, Malta) 362

53. View of Messina (print) 370

54. Caravaggio, *The Adoration of the Shepherds* (Messina, Museo Regionale) 374

55. Caravaggio, *The Adoration of the Shepherds with Saints Lawrence and Francis* (formerly Palermo, Oratorio di San Lorenzo) 378

56. Caravaggio, *The Crucifixion of St Andrew* (Cleveland Museum of Art) 387

COLOUR PLATES APPEARING BETWEEN PAGES 116 AND 117

1. Caravaggio, *The Sick Bacchus* (Rome, Galleria Borghese)
2. Caravaggio, *Boy with a Basket of Fruit* (Rome, Galleria Borghese)
3. Caravaggio, *The Gypsy Fortune Teller* (Rome, Pinacoteca Capitolina)
4. Caravaggio, *The Musicians* (New York, Metropolitan Museum of Art)
5. Caravaggio, *The Cardsharps* (Fort Worth, Kimbell Art Museum)
6. Caravaggio, *The Lute Player* (St Petersburg, State Hermitage)
7. Caravaggio, *Mary Magdalene* (Rome, Galleria Doria Pamphili)
8. Caravaggio, *The Rest on the Flight into Egypt* (Rome, Galleria Doria Pamphili)
9. Caravaggio, *The Ecstasy of St Francis* (Hartford, Wadsworth Atheneum)
10. Caravaggio, *Bacchus* (Florence, Uffizi)
11. Caravaggio, *Boy Bitten by a Lizard* (London, National Gallery)
12. Caravaggio, *Basket of Fruit* (Milan, Pinacoteca Ambrosiana)
13. Caravaggio, *Judith and Holofernes* (Rome, Galleria Nazionale d'Arte Antica, Palazzo Barberini)
14. Caravaggio, *Medusa* (Florence, Uffizi)

COLOUR PLATES APPEARING BETWEEN PAGES 212 AND 213

15. Caravaggio, *St John the Baptist* (Rome, Pinacoteca Capitolina)
16. Caravaggio, *Victorious Cupid* (Berlin, Gemäldegalerie Staatliche Museen Preussischer Kulturbesitz)
17. Caravaggio, *Narcissus* (Rome, Galleria Nazionale d'Arte Antica, Palazzo Barberini)
18. Caravaggio, *The Calling of St Matthew* (Rome, San Luigi dei Francesi, Contarelli chapel)
19. Caravaggio, *The Martyrdom of St Matthew* (Rome, San Luigi dei Francesi, Contarelli chapel)
20. Caravaggio, *The Crucifixion of St Peter* (Rome, Sta Maria del Popolo, Cerasi chapel)
21. Caravaggio, *The Conversion of St Paul* (Rome, Sta Maria del Popolo, Cerasi chapel)
22. Caravaggio, *The Supper at Emmaus* (London, National Gallery)

23. Caravaggio, *Doubting Thomas* (Potsdam, Sanssouci-Bildergalerie)

24. Caravaggio, *The Taking of Christ* (Dublin, National Gallery of Ireland)

25. Caravaggio, *St Matthew and the Angel* (Rome, San Luigi dei Francesi)

26. Caravaggio, *The Entombment of Christ* (Rome, Vatican Palace, Pinacoteca)

COLOUR PLATES APPEARING BETWEEN PAGES 308 AND 309

27. Caravaggio, *The Death of the Virgin* (Paris, Louvre)

28. Caravaggio, *St John the Baptist* (Kansas City, Nelson-Atkins Museum of Art)

29. Caravaggio, *The Madonna and Child with Saint Anne* (Madonna dei Palafrenieri) (Rome, Galleria Borghese)

30. Caravaggio, *The Supper at Emmaus* (Milan, Brera)

31. Caravaggio, *The Madonna of Loreto* (Rome, San Agostino)

32. Caravaggio, *The Seven Acts of Mercy* (Madonna della Misericordia) (Naples, Pio Monte della Misericordia)

33. Caravaggio, *The Madonna of the Rosary* (Vienna, Künsthistorisches Museum)

34. Caravaggio, *The Flagellation of Christ* (Naples, Capodimonte)

35. Caravaggio, *Portrait of a Knight of Malta; Fra Antonio Martelli* (Florence, Palazzo Pitti)

36. Caravaggio, *St Jerome Writing* (Valletta, Co-Cathedral of St John)

37. Caravaggio, *The Beheading of St John the Baptist* (Valletta, Oratory of the Co-Cathedral of St John)

38. Caravaggio, *The Burial of St Lucy* (Syracuse, Museo Regionale di Palazzo Bellomo)

39. Caravaggio, *The Resurrection of Lazarus* (Messina, Museo Regionale)

40. Caravaggio, *Salome with the Head of St John the Baptist* (Madrid, Palacio Real)

41. Caravaggio, *David with the Head of Goliath* (Rome, Galleria Borghese)

42. Caravaggio, *The Martyrdom of St Ursula* (Naples, Banca Commerciale Italiana)

1. Ottavio Leoni, *Portrait of Caravaggio,*
 (drawing) (Florence, Biblioteca Marucelliana).

Introduction

THE NAME OF CARAVAGGIO has always been associated with a bold and revolutionary naturalism. To his contemporaries his art, rooted in the senses, dependent on the live model, had an almost magical power, and created wonder and enchantment. He began his career as a painter of lyrical and courtly genre, with pictures of gypsies, musicians, and card players, which ravish with the beauty and precision of their naturalistic detail. But he developed into the most powerful religious artist of his age, creating a new Catholic art deeply rooted in the contemporary spirituality of the Counter-Reformation. The most famous painter in Italy, and celebrated throughout Europe, he was also feared as a difficult and strange personality. He flaunted his originality, and mocked authority; he was fearless and belligerent, and in 1606 he killed a man, and spent his last years in exile. His greatest gift was for empathy, for making religious narrative new and vivid, and it is through this, and through his compelling personality, that he speaks so directly to the modern age. But although Caravaggio's religious art sometimes shocked his contemporaries, at its deepest level it is in harmony with sixteenth-century spirituality. It reflects the passions of a restored Catholicism, yet its brooding darkness suggests both individual terror and the fears of an age of spiritual crisis and the collapse of a universal faith.

Caravaggio was born in 1571, and in the next decades Italy, and above all Rome, the city of the Popes, rose to new eminence, and won back the power that it had enjoyed in the most splendid years of the Renaissance. The early years of the sixteenth century had been years of continual warfare. France and Spain fought for dominance in Italy, turning northern Italy into a vast battlefield. The Medici Pope, Clement VII, attempted to maintain the balance of power, but so incompetent was his diplomacy that in 1527 an unruly army of Spaniards, German *landsknechte*, and Italians, employed by Charles V, German Emperor and King of Spain, had sacked Rome. The troops behaved with appalling brutality, the Pope

was humiliated, and there was outrage throughout the peninsula. Spain was left dominant in Italy, in possession of Milan, Naples and Sicily, and in 1559 this was confirmed at the Peace of Cateau Cambrésis, a settlement between France and Spain. In Naples and in Sicily the King of Spain was represented by a viceroy. But with Spanish power there coexisted a variety of independent states, duchies and republics, among them the Papal States; the republic of Venice, with extensive territories; the republic of Genoa; and Tuscany, under the Medici Grand Dukes. Parma and Piacenza were ruled by the Farnese Dukes, while Mantua was in the power of the Gonzagas, and Ferrara and Modena of the Estes.

In 1556 Philip II of Spain succeeded his father, Charles V, and in the 1560s and 1570s he was often in conflict with the Popes. Rome dreamed of a revival of the power of France to curb that of Spain, and when the last of the Valois Kings was assassinated in 1589, Sixtus V began to make overtures to his heir, the Huguenot Henry IV of Navarre. In France and Spain the succession of a Protestant king was resisted, and in the ninth French War of Religion (1589–98) Spain joined the fight against Henry IV. France was devastated by civil war, and Paris was in a state of siege. But in 1593 Henry IV dramatically converted to Catholicism, reuniting his country, and entering Paris in triumph. Pope Clement VIII recognised Henry as King of France, and reduced Spanish influence in the college of Cardinals. Over the next years Spain and France were constantly at war, but in 1598, in the greatest political triumph of his reign, Clement VIII arranged the Treaty of Vervins, by which Spain recognised Henry as King. Clement, having brought peace between Spain and France, in that same year annexed Ferrara for the Papal States. Rome was renewing her power, and a newly confident Catholicism dreamed of crusade. After 1593, right up until 1606, there were periodic campaigns against the Turk in eastern Europe and in Hungary.

Rome's renewal was based on a passionate upsurge of Catholicism, which, earlier in the century, had been shocked by the onslaughts of Martin Luther and by the spread of dissent in northern Europe. The desire to reform and reorganise the Catholic Church antedates Protestantism, but it was the challenge of Protestantism that led Pope Paul III to summon a Council at the tiny city of Trent (Latin Tridentum)

in 1545, where matters of doctrine were reformulated over the next eighteen years. The Council of Trent renewed confidence in the Sacraments and in the priesthood; it declared that Purgatory exists and that the saints in heaven intercede with God on man's behalf; it gave fresh emphasis to the ideology of the bishop as pastor, and in its final hours it recognised the primacy of the Pope. The Council condemned much Lutheran teaching, perhaps most importantly Luther's belief that man is saved by faith alone. For the Catholic, faith without works was dead, and it was through good works, and the sacraments, that man could, gradually, be transformed and saved. A revived Catholicism led to the foundation of new and reformed religious orders, the Theatines, the Capuchins, the Oratorians, the Jesuits, while the concern with good works led to the elaboration of the confraternities, secular organisations committed to charity and welfare, and to tending the soul as well as the body. The movement sought to revive the direct and popular appeal of medieval Christianity, of the colourful world of the thirteenth-century *Golden Legend*, a collection of much loved stories about biblical figures and saints, though there was concern to eliminate all that was apocryphal. Very many meditative tracts were published, and such devotional works as the fifteenth-century *Imitation of Christ* were a constant source of inspiration.

In the earliest years of the sixteenth century two great art patrons, Julius II (Pope 1503–13) and Leo X (Pope 1513–21), had turned Rome into a grandiose Renaissance capital, the centre of Renaissance art, and a magnet to artists and scholars from throughout Europe. Between 1508 and 1512 Michelangelo had painted the ceiling of the Sistine Chapel in the Vatican, creating a series of Old Testament scenes and a display of the beauty of the male nude; in the same years Raphael was painting the Vatican Stanze, with scenes that creatively fused the Christian and ancient worlds, and epitomised the classical balance and monumentality of Renaissance art. But at the Sack of Rome many artists fled, and Michelangelo's fresco of the *Last Judgement* (1542; Vatican, Sistine Chapel) conveys the terror and spiritual crisis of these years. Art languished, and artists suffered from the burden of Michelangelo's influence. Italian artists were primarily concerned with the figure, and believed in an art

rooted in nature, yet nature corrected and idealised; Michelangelo expressed his contempt for the interest of north European artists in natural phenomena, in landscape and still life, and in the surface and texture of nature. But at the turn of the sixteenth century new life was brought to Roman art by an influx of artists from northern Europe, and from northern Italy, where, in Venice and Lombardy, there had long been a tradition of more naturalistic art.

Rome, and the other great Italian cities, offered plenty of work to artists, for the popes at the end of the century were patronising vast decorative projects, and the many new churches had chapels whose decoration was supervised by wealthy individuals. But the search for a protector, or patron, was crucial, and only young and unknown artists put their works in the hands of dealers. Patrons tended to favour artists from their native towns, and such loyalties ran deep. Throughout his life Caravaggio was watched over by one of the most illustrious Italian families, the Colonna, whose feudal subject he was. Other many-branched and complex noble families, whose influence spread throughout Italy and Europe — the Medici, the Borghese, the Doria, the Gonzaga, the Este — all longed for a work from his hand, for he became Italy's most famous painter.

Caravaggio's works create a strong sense of a compelling personality, but little other evidence remains; he wrote nothing, and very few of his words are recorded. His biography was, however, written by two of his contemporaries who knew him well. One was the Sienese doctor, Giulio Mancini, writer on art and connoisseur, collector and dealer. He was a vivid and eccentric personality who looked after Caravaggio when he was ill and knew him well, particularly during the period in which Caravaggio was in the palace of Cardinal Del Monte in the later 1590s.[1] His is the first biography of Caravaggio and he later made a series of additions to his manuscripts which show that he tried to keep his information up to date. Next came the life by Giovanni Baglione, published in his *Lives of the Artists* in 1642. Baglione was a respectable painter and writer, who worked in Rome when Caravaggio was there, and knew him well. His biography is short but accurate, and given that Caravaggio was his enemy, and openly derided him, it has a remarkable objectivity. A

further biographer, Giovan Pietro Bellori, who wrote a little later in the century, based his *Life* of 1672 on that of Baglione, but it was well researched and added some new information; he annotated his copy of Baglione's *Lives*. All these early biographies, including Mancini's additions and Bellori's marginal notes, have been published in translation by Howard Hibbard in his *Caravaggio*.[2]

His contemporaries marvelled at Caravaggio's naturalism, but by the next generation he was already seen as an anarchic force, who threatened the art of painting. To Poussin it seemed that he had come into the world to destroy painting, while to Bellori the darkness of his art was due to his physiognomy: 'Caravaggio's style corresponded to his physiognomy and appearance: he had a dark complexion and dark eyes, and his eyebrows and hair were black; this coloring was naturally reflected in his paintings.'[3] In the eighteenth and nineteenth centuries his reputation continued to fall, and little interest was taken in him. But in the twentieth century, and particularly since the 1951 exhibition in Milan, 'Mostra del Caravaggio e dei Caravaggeschi', organised by the great Italian scholar of Caravaggio, Roberto Longhi, he has risen to new and unparalleled fame, celebrated initially as the first popular artist, a rebel who cast aside academic convention and ideal beauty. In the 1950s, with Walter Friedlaender's *Caravaggio Studies* (1955), new emphasis was laid on Caravaggio as a storyteller, as an artist brilliantly gifted in rethinking the iconography of scriptural scenes. The 1960s and 1970s saw metaphysical-existentialist interpretations, and a growing interest in a psychoanalytic approach, and in Caravaggio's sexuality. Thom Gunn's 'In Santa Maria del Popolo' is the most poetic rendering of the homosexual and existential Caravaggio of the 1960s and 1970s; he describes Caravaggio's *Conversion of St Paul*, adding

> No Ananias croons a mystery yet,
> Causing the pain out under name of sin.
> The painter saw what was, an alternate
> Candour and secrecy inside the skin.
> He painted, elsewhere, that firm insolent
> Young whore in Venus' clothes, those pudgy cheats,

Those sharpers: and was strangled, as things went,
For money, by such one picked off the streets.

. . . For the large gesture of solitary man,
Resisting, by embracing, nothingness.

Caravaggio became known as a homosexual painter, whose lyrical paintings of young boys were painted to entice viewers of similar sexual tastes. The German scholar Herwarth Röttgen in his *Il Caravaggio: Ricerche e Interpretazione* (1974), followed by Hibbard, presented Caravaggio as a narcissistic and insecure homosexual. This reading, a cliché in England, has never been current in Italy, and in recent years many powerful voices have been raised against it, culminating in Creighton Gilbert's *Caravaggio and His Two Cardinals* (1995), which demonstrates, with true forensic power, that the historical evidence for Caravaggio's homosexuality is extremely flimsy. Other readings have been offered for the early paintings; Franca Trinchieri Camiz has related the paintings of musicians to contemporary musical practice, while Stephen Bann, in *The True Vine*, has discussed the boys with still life as 'essays in the art of presentation'.[4] And in recent years a vast amount of archival research in Italy has opened up new areas of interest, providing us with new knowledge about Caravaggio's friends and patrons, and a new awareness of his world; Maurizio Calvesi has brilliantly re-created the network of patronage in which Caravaggio operated.

A new Caravaggio has been created by this wealth of research and approaches. He was a violent man, but he lived in an extraordinarily violent time, and his behaviour was governed by complex codes of honour. He was, however, often described as strange and odd by his contemporaries; he lacked strong relationships, though he moved in the world of the Roman courtesans, and had lovers. He was a highly intellectual painter, admired and fêted by poets and literary men, and many of his paintings are a sophisticated play on the nature of artistic illusion. He was also a great religious artist who created a new and passionate Catholic art, with an extraordinary ability to re-imagine the scriptures, and to relate them to his own times; but more than this,

Caravaggio had an unusual sensitivity to place and to the needs of his patrons. In executing a commission, he thought very deeply about what was needed by that church, and that patron, at that particular moment in time, and his works weave together the ideal and the real, artistic tradition and the most topical references. He had, too, an uncanny empathy with place, and as he moved around the southern Mediterranean, his art responded to the new atmospheres of Naples, Malta and Sicily. But Caravaggio's art transcends the pietistic art of the Counter-Reformation, and makes a powerful and immediate appeal across the centuries. For his works also convey a highly individual response to the Christian mysteries; they suggest an extraordinarily direct and tragic sense of the human condition and the fate of man. Often Caravaggio included a self-portrait, reflecting the new self-consciousness of the seventeenth century, and his art seems bound up with the stormy events of his life. It was predominantly a public art, but none the less Caravaggio transformed his own world; over the years his models changed, and as Caravaggio himself grew older, the young men and women of the early pictures yield to an older and frailer cast of characters.

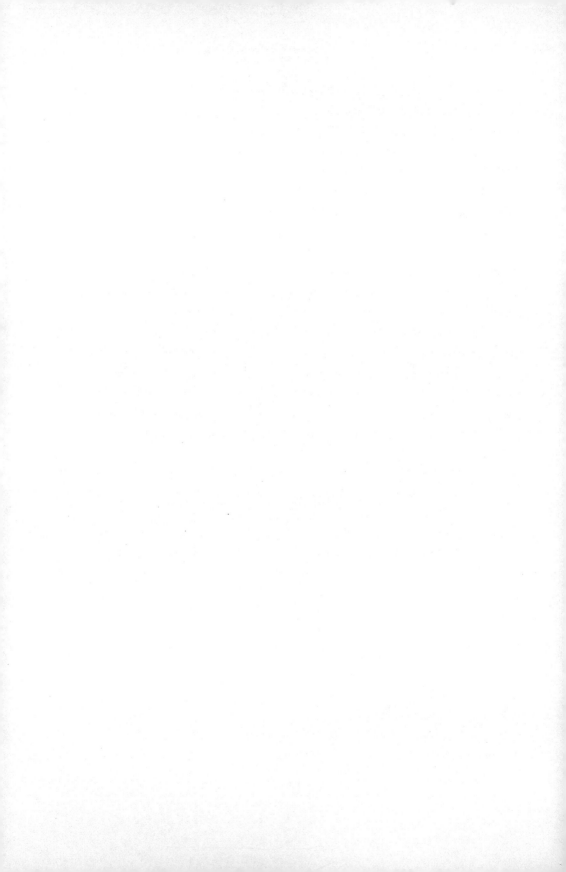

Milan

O N 4 DECEMBER 1571 an enormous theatrical triumph was staged in Rome. Its hero was Marcantonio Colonna, scion of one of the most illustrious of all Roman families, and commander of the papal galleys in the triumph of the Holy League over the Turks at Lepanto. He progressed from the church of San Sebastiano, on the Appian Way, passing the Baths of Caracalla, and under the triumphal arches of Constantine and Titus, to the monastery of Santa Maria in Aracoeli, built on the holiest site of the Capitol, at the very centre of the old Roman Empire.

Colonna rode, unarmed, on a white horse. He was escorted by a glittering cortège of five thousand people, and 170 liveried and chained Turkish prisoners were driven before him. Before them the standard of the sultan was trailed in the dust. The procession pressed forward through tumultuous applause. 'Here from every part', wrote an observer, 'his name rang out. Everyone rushed to the street, clapping their hands. Crowds of people thronged together, crying out, while trumpets serenaded him. He was greeted from far and near, by people gesturing, shouting, waving caps and banner.'[1] Ringed by twenty-five Cardinals, Colonna crossed the Tiber at the Ponte Sant' Angelo, and then rode to St Peter's and the Vatican Palace, where Pope Pius V received him in the Sala Regia.

His progress was modelled on the triumphs that were granted to generals in ancient Rome and it drew on the splendour of ancient myth. Yet it was also an intensely Christian event. The façade of the church of Santa Maria in Aracoeli was decorated with captured Turkish flags. It bore the proud inscription: 'The gratitude which, in their pagan folly, the Ancients offered to their idols, the Christian conqueror, who ascends the Aracoeli, now gives, with pious devotion, to the true God, to Christ the Redeemer, and to His most glorious Mother'.[2] Colonna seemed to bring the new promise of a more joyful Christian era.

LEPANTO had been a spectacular feat of courage and arms where the Catholic powers had united against the Turk and broken their supremacy for ever. It had been a terrible victory, with the seas running red with blood, and 8000 Christians killed. However, for the Catholic people of southern Europe who were threatened by Protesant heresy in the north and the Turkish infidel in the East, Lepanto was an ecstatic release. The visionary Pius V had long dreamed of a mighty war to reunite Christendom. A shepherd boy risen to Pope, he was an ascetic, nothing but skin and bone, and far removed from the princely popes of the Renaissance. To him the next world alone was real, and he yearned to re-create the sublime spirit of the medieval crusades. He had prayed and fasted for victory, and, with his ravaged, austere face and deep-set eyes, his flowing hair and beard of an extraordinary whiteness, he seemed to embody the charisma of a medieval saint. And so Lepanto soon became legend; a mood of exalted fervour spread and poets everywhere sang the praises of its heroes. Success had been won on the day the Confraternities of the Rosary held their processions in Rome, and thanks were offered to the Madonna of the Rosary, while in the next years very many churches and chapels were built to Santa Maria della Vittoria, Our Lady of Victory. *The Madonna of the Rosary* became the banner of the Counter-Reformation.

In late September, when all Italy was waiting for news of the Holy League's Armada, the painter, Michelangelo Merisi, was born, in the small Lombard town of Caravaggio, to the east of Milan, which was then under Spanish rule. His family waited for news of the Christian fleet with particular eagerness. His father, Fermo Merisi, was in the service of the Sforza da Caravaggio, a noble family who lived in Milan. The young Marchesa di Caravaggio, Costanza Colonna, was the daughter of Marcantonio, who was soon to ride in triumph as the Roman hero of Lepanto. Five years earlier, in 1567, she had married Francesco I Sforza da Caravaggio, but the marriage between the seventeen-year-old Francesco and the twelve-year-old Costanza had opened with great unhappiness. Costanza had threatened suicide, writing to her father: 'If you do not free me from this house and husband I shall kill myself, and I care little if I lose my soul with my life.'[3] Marcantonio, distraught,

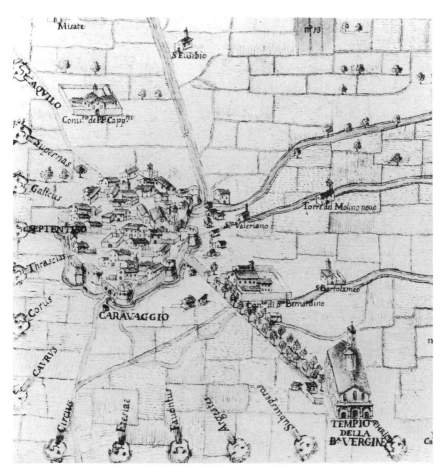

2. The Town of Caravaggio;
detail from an 18th-century map

begged Cardinal Carlo Borromeo, Archbishop of Milan, to intercede, and arrange for his daughter to enter a convent. Their two families were closely united, for Anna Borromeo, the Cardinal's sister, had married Costanza's brother, Fabrizio Colonna. Yet somehow, to general amazement, given the apparent unremitting hostilities, and Costanza's youth, a child, Muzio Sforza, the first of six sons, was born in 1569, and the couple were reconciled.

Now, as Costanza awaited news of her father, and the Christian armada sailed to Corfu, Michelangelo, the son of her household steward, was born. His date of birth is unrecorded, but it has been brilliantly suggested that it may have been 29 September, the feast day of the Archangel St Michael, Caravaggio's namesaint, the symbol of victory over evil. It was a name resonant with the fears and aspirations of these days.

The Colonna claimed descent from Aeneas, the legendary founder of Italy. They were warlike and vain of their prowess at arms, and in the sixteenth century were famed as fighters against heresy. United as they were by marriage to the noblest Italian families, their power extended throughout Italy. Two of Costanza's sons, Muzio and Fabrizio, were, like Caravaggio, stormy characters. Their father, Francesco Sforza, died in 1580, but Costanza and her family were to watch over Caravaggio, their feudal subject, with touching loyalty. Perhaps his birth at the tense moment of Lepanto particularly endeared him to them. Their shadowy presence, running through a vast network of feudal relationships, will often be sensed in the background of his life.

MICHELANGELO came from a middle-class provincial family in Caravaggio (although his mother's side, the Aratoris, may have had some claim to nobility), not rich, but with some money and land, and with some of its members in the Church. His grandfather, Bernardino Merisi, had a modest house, on two floors, near the Porta Seriola, in the north-east of Caravaggio, and a small piece of land. He married twice, and the sons of his first marriage were Fermo, Michelangelo's father, and Pietro, while from his second were born Ludovico, who became a priest, and Francesco, Giacomo and Caterina. Bernardino lived and worked in Caravaggio, but his eldest son, Fermo, moved to Milan. There, in 1563, he married Maddalena Vacchi, the daughter of either a builder or a swordmaker from Caravaggio. But only two years later, having borne two daughters, Caterina and Margarita, Maddalena died. In 1571 Fermo, who had probably continued to live with his wife's family in Milan, married Lucia Aratori. Her family also came

3. Giuseppe Rados, *View of the Corso dei Servi, Milan*
(on the right is the household of the Merisi family)
(Print, c. 1820, Milan, Civica Raccolta Stampe Achille Bertarelli)

from Caravaggio, and the wedding took place in the small country church of Santi Pietro e Paolo, just beyond the Porta Seriola. Francesco Sforza paid them the honour of acting as a witness at their wedding, which suggests that Fermo's position in the Sforza household was of some importance. The Sforza lived mainly in Milan, in a splendid palace near the church of San Giovanni in Conca, in the Piazza Missori; Fermo's role there seems to have been as builder or site architect, though he remains a shadowy figure. Mancini tells us that he was 'majordomo and architect to the Marchese of Caravaggio'[4] and Baglione that he was 'a mason, quite well off'.[5]

After his marriage in 1571 Fermo first rented two rooms with an attic from Gabriele Varola, which he seems to have kept as a workshop after he moved to a larger apartment, with one Giacomo Rossi, in the Corso dei Servi (now the Corso Vittorio Emanuele), opposite the Servite monastery (since replaced by the church of San Carlo). This was the

centre of medieval Milan, and in this parish the births of two of his children are recorded in the parish registers, Giovan Battista in 1572, and Caterina in 1574.[6] (The first Caterina had died in 1567.) There is no record of Caravaggio's birth, either in Milan or Caravaggio, but he took the name of his native town, and it seems likely that his mother was sent to Caravaggio for his birth, and perhaps the family travelled frequently between Milan and Caravaggio.[7] Regional loyalties were strong, and Michelangelo's name is strikingly unusual in this family context, since the other children were called after local saints. Bernardino and Fermo, in particular, were names closely associated with the town, where Fermo was the local saint, and where there was an Oratory of San Bernardino. As Bellori was later to write, Michelangelo doubled the fame of the small town, which had earlier boasted only of the celebrated Renaissance painter Polidoro da Caravaggio, who was murdered in Sicily.

Milan, where Caravaggio passed his infant years, was a Spanish dominion, subject to Philip II, King of Spain, who appointed a Spanish governor. At its centre stood the potent symbol of Spanish power, the vast brick Castello Sforzesco, facing it, in the still Gothic centre, the immense cathedral, the square cluttered with the shops of artisans, and, close by, the Archbishop's dour palace, and the elegant medieval tower of San Gottardo. A city renowned for the beauty of its setting in the abundantly fertile plains of Lombardy, where canals and gardens glittered between the walls, its circular plan seemed a symbol of perfection. It was a city of businessmen and artisans, famed for its luxury trades, and noble Milan indulged in sumptuous displays of wealth; Paolo Morigi, celebrating the city in 1595, delighted in 'the numerous rich bankers, merchants and artists, who bring fame and glory to a city . . .'; and the 'very great number of priceless horses, the opulent and wealthy cavalcades of our gentlemen through the city, and the lavish decoration of rooms, of beds, the silverware for tables, and the very great opulence in all things . . .'[8] The Milanese had long been famous for their armour and for their prowess in arms; they were, wrote Morigi, 'most valorous in swordsmanship and in the art of the dagger, and attained the highest celebrity through their great skill as armourers, competing with the most famous armourers of Europe'.[9] But such

luxury contrasted brutally with harsh poverty, for Milan had for many years been torn apart by war, while plague and famine had desolated the countryside. In the winter of 1570 snow had driven many from the outlying regions into the city, crowding the streets with destitutes, and in the following winter, just after Michelangelo's birth, many died of hunger. The diarist Giovan Ambrogio Popolano recalled 'that in the year 1570 there was a great famine, with no food to be found . . . after the famine the death rate soared, and more died among those who did not have food than among those who did, and suffered hunger; and this was the year 1571'.[10]

Dominating this ravaged city was its Archbishop, Cardinal Carlo Borromeo, Cardinal Papal Legate of all Italy, whose austere features and sombre presence permeated Milanese life. He came from a noble Milanese family, and in 1560, then only twenty-two, had been summoned to Rome by his uncle, elected Pope Pius IV in 1559. There he had lived in the magnificent style of the great cardinals of the Renaissance, with a large household of 150 members, dressed in black velvet. But in 1562 his elder brother, Federico, had died, and Carlo underwent a religious crisis. He renounced all the worldly splendour of a Roman cardinal, and lived simply and with increasing austerity. On 29 November 1560 Pius IV had recalled the Council of Trent, formed in the early years of the century to rally the forces of a Catholicism shocked by the dissent in northern Europe. Carlo, at the side of his uncle, laboured tirelessly to ensure its success. Its last sessions were held in 1563, and it closed, in unexpectedly victorious mood, on 4 December. Trent claimed to restore a Catholic faith, for so long polluted and obscured, in all its purity and splendour. It recovered a sense of the Fall and redemption, reaffirming a sacramental confidence, and the belief that through good works and through a devotion to Christ's sufferings in the Passion man might re-create his lost union with God. The Protestant belief that the Fall was total, and that salvation was attainable through faith alone, was utterly rejected. Steeped in the atmosphere of Trent, the Cardinal, already famed for his asceticism, returned to Milan in 1565. His entry was triumphal, and to the Milanese it symbolised a new era. Carlo proceeded, for the first time, and with tireless passion, to put into practice the reformed ideal of the episcopate.

The Archbishop sought to breathe new life into a dull faith and to create a new mood of popular devotion that should bring all Milan together in a passionate search for salvation. Within the Archbishop's palace he and his household lived with utmost simplicity, Carlo himself inhabiting, amid sumptuous surroundings, only two little rooms, very sparsely furnished, with on the walls pictures of scenes from the Passion of Christ – 'In his Archbishop's palace,' wrote Padre Negrone later, 'you did not see carriages, or horses, or carpets, tapestries, or canopies, or curtains for the beds; but unfurnished rooms, bare walls, the bedsteads bare . . .'[11] The most fervent of the new Orders, the Jesuits, Theatines, Barnabites, dedicated to recovering a life of prayer, and of strict poverty, were called to the city, where the Capuchins, devoted to the absolute poverty of St Francis, were already established.

Carlo sought an ardent devotion to the passion of Christ, encouraging meditation on His life, and on the lives of the saints, and drawing on such richly imaginative spiritual works as the Dominican Luis de Granada's popular *Brief Memorial and Guide to the Duties of a Christian* (1561), which made the Christian mysteries visible and moving. The Christian, wrote Granada, should every day meditate on the life of Christ; 'he should represent each mystery as present to him here and now. The representation of these mysteries is a function of the imagination, which knows how a painter would portray them.'[12] An intense charitable concern, a desire to restore dignity to the poor in Christ, and to revive the Christian virtue of humility, lay at the centre of his faith. This concern was rooted in the writings of the Fathers of the early Church, from whom the Catholic Church claimed a glorious and unbroken tradition. Such moving passages as St Jerome's 'He whom we look down upon, whom we cannot bear to see, the very sight of whom causes us to vomit, is the same as we, formed with us from the selfsame clay, compacted of the same elements. Whatever he suffers, we also can suffer'[13] echo through the homilies of Carlo and many Tridentine preachers, although they sometimes sit uneasily with the growing fear of poverty and crime. Gregory of Nazianus, in 'On the Love for the Poor', held that the main part of charity is 'the love for the poor and mercy and compassion for our fellow brethren'. The poor were the earthly image of

Multitudinem peregrinorum Mediolanum iubilæi caufa undiq: confluentium benigné recipit, eorumq. pedes humilli me lauat

Al tempo che publica il Giubileo in Milano ui concorrono molti pellegrini, gli riceue con ogni carità et anco gli laua humilmente li piedi

4. Cesare Bonino, *Carlo helps and brings aid to the poor*

(print)

Christ, and the Lord 'asks for mercy rather than sacrifice, large entrails of compassion rather than thousands of lambs. Offer them to him, then, through the poor and those who are spread throughout the earth, so that, when we leave this world, we will be welcomed by them into the eternal dwelling with the same Christ, our Lord . . .'[14] In imitation of Christ, in an evocative ritual of abasement, Carlo himself washed the feet of the pilgrims who flocked to Milan for the Jubilee in 1576.

IN THIS YEAR, when Caravaggio was about five, and the city was crowded with pilgrims, the Milanese prepared to enjoy the lavish celebrations welcoming Don John of Austria, half-brother of Philip II, and the hero of Lepanto, to their city. But as he entered in triumph, ominous signs of the plague began to spread. Don John fled, and with him the Spanish governor of the city, and many of the Milanese nobles. There remained the Archbishop, Carlo, who over the next months, with unwavering courage, laboured tirelessly to bring comfort to the sick, to both their bodies and souls, winning the devotion of the poorest and most miserable. He visited those who were incarcerated in the leper house, whose terrible cries could be heard in the street: 'As people walked outside, those within screamed, and beat against the windows, lamenting their calamities . . . Carlo consoled those sick people with great humanity, as far as he was able . . .'[15] Bringing food and kindness, the Archbishop travelled tirelessly in the surrounding villages and hamlets, where the sick suffered, yet more horrifically, in makeshift straw shelters. His biographer, San Carlo Bascapé, describes the strange and pathetic sight of the poor, draped in garments improvised from the tapestries and curtains of the Archbishop's palace to protect them in winter — 'so that crowd of poor people . . . offered a sight both grotesque and moving, with those garments of purple, violet, green and black . . .'[16] Above all, Carlo, with immense rhetorical skill, transformed the city into a vast and highly orchestrated display of penitence and of ceaseless prayer. The Milanese, whom the quarantine laws forbade to go to church, worshipped at their doors and windows. Tabernacles and devotional images embellished the roadsides, while at the crossroads, and through the

squares of the city, Carlo erected altars, where Mass was celebrated, and those confined to their houses could listen at the windows. And at the centre of this intense display of devotion Carlo himself, bearing aloft the relic of the Holy Nail from the cathedral, shoeless and oblivious to his bleeding feet, walked amid a dolorous procession of penitents. Bascapé later described how he wore 'the purple mantle with the hood on his head, dragging the train on the ground. He had bare feet, a rope around his neck, like a condemned man . . . The Canons were dressed in the same way . . .'[17] Carlo had become an emblem of Catholic charity, engraving in his own flesh the sufferings of Christ and re-creating the glories of the early Church, seeking a heroic martyrdom in the streets of Milan.

As the terror of the plague began, Caravaggio's father and mother, Fermo and Lucia, and their children, Margarita and Giovan Battista, are recorded in the rooms they rented from Giacomo Rossi, but neither Michelangelo, nor Caterina, nor a fifth child, Giovanni Pietro, whose name first appears in 1578, are mentioned, and they had perhaps already been sent to Caravaggio to live in greater safety with their grandparents. But they must shortly have been followed by the rest of the family, for on 20 October 1577, within a few hours of each other, Caravaggio's grandfather, Bernardino, and his father, Fermo, died at Caravaggio, presumably of the plague. Fermo died in the night, after his father, which was to have implications for the division of the property; Fermo's brother, Pietro, had died earlier in the year. The plague was already on the wane in Milan itself, but continued to flourish in Caravaggio, doubtless because those fleeing there, as the Merisi family had done, brought it with them. Michelangelo's mother, Lucia Aratori, was thus left a young widow, with a stepdaughter, Margarita, and four small children. In 1578 she assumed the guardianship of her own children, and over the next two years, apparently supported by her father, Giovan Giacomo, in whose spacious house at Porta Folceria, in the south-east of the town, the negotiations took place, she attempted to reach a just settlement over the property of her husband and his mother. In the end her debts were settled and she received some small pieces of land, while Caravaggio's uncles retained the house at Porta Seriola, and Francesco Merisi, Caravaggio's uncle, agreed to care for Margarita, his half-sister.[18]

It was thus in the small and provincial town of Caravaggio, which had a warlike history (the celebrated *condottiere* Bartolomeo Colleoni had fought there, and it had been sacked by the Medici warrior Giovanni delle Bande Nere in 1524), that Caravaggio was brought up. The town itself, whose Roman origins may still be sensed in its straight and narrow medieval streets, is architecturally dour and undistinguished. At its centre is the market place, bounded by the heavy portico of the fifteenth-century Palazzo del Comune; beyond lies the bleak brick church of S. Fermo e Rustico, with an unadorned Gothic façade and portico. In the early years of the century little of artistic interest had taken place at Caravaggio, and the local painters were entirely provincial, but in the later years Counter-Reformation fervour had encouraged a new interest in art. The Mannerist artist Bernardino Campi had decorated the sophisticated Renaissance chapel of Corpus Domini in the church of SS Fermo and Rustico with frescoes which introduced to Caravaggio the elegance of Late Mannerist painting. Of yet greater impact, and conveying a sense of the grandeur of Rome, were works designed by Carlo Borromeo's favourite architect, Pellegrino Tibaldi. The church of San Giovanni Battista, next to what was then a monastery, is attributed to him, and he designed the vast sanctuary of the Madonna of Caravaggio. Beyond the town gates of Caravaggio, preceded by a magnificent avenue of lime trees, this sanctuary is a grandiose building, and its splendid dome may be seen for many miles around across the Lombard plains. Here Bartolomeo Merisio, Caravaggio's uncle, who also went to Spain with Tibaldi, worked as site architect.[19]

The church was commissioned by Carlo Borromeo to commemorate the appearance of the Madonna to a peasant girl in 1432, and the work on it, which began in 1575, must have lasted through Michelangelo's childhood in Caravaggio. A vast undertaking, it created a constant sense of the intensity of Counter-Reformation spirituality, with its belief in miracles, and in the comfort of the Virgin's mediation on behalf of humankind. The church is still a centre of pilgrimage, an oddly rural sight with its surrounding fields and poplars, among the supermarkets and garages that spread from Milan.

Michelangelo probably went to school in Caravaggio, for by this date

there were grammar schools throughout the duchy of Milan. The Counter-Reformation had recognised the pressing need for elementary and secondary education, and the Jesuits had fervently addressed these needs. Small children went to the infant school, the Scuola di Leggere e Scrivere, and this was followed by the grammar school, which was essentially free, and was attended by boys from the professional classes, and by the sons of tradesmen and artisans. It seems highly likely that Caravaggio, whose family had been associated with a noble household, would have gone to a grammar school, at least briefly, and gained there a reasonable knowledge of classical and Italian literature. His brother, Giovan Battista, was clearly both ambitious and academically gifted, for he later attended the Jesuit Collegio Romano in Rome, a school with a high reputation, whose numbers were growing at this period, and whose prestige was challenging that of the University of Rome, the Sapienza. It seems likely that he and Michelangelo, so close in age, would have studied together, and would have acquired some knowledge of classical literature, of Ovid, Virgil, Sallust, Juvenal, Seneca, Terence, and have studied rhetoric in Quintilian and in Cicero's *De Oratore* and *De Inventione*.[20] By 1583 Giovan Battista had settled on a career in the Church.

Caravaggio, however, had decided to become a painter, and in the early 1580s he was looking around for a teacher, and was perhaps already in contact with Simone Peterzano in Milan, to whom he was to become apprenticed. Caravaggio's family may have moved freely between Milan and their home town. The choice was limited; the minor and very distant followers of Leonardo still working in Milan were unexciting; there were widespread laments over the provinciality of Milanese patrons, who were lambasted both for their meanness and, paradoxically, for their uneducated extravagance. In *Rabisch*, the dialect poem of Gian Paolo Lomazzo, the voraciously intellectual Milanese painter and theorist, the poet looks back to the golden days of the Renaissance, when painting was revered, and laments the meanness and lack of vision of collectors:

O wretched, hapless painting, . . .

you are become foul, shabby, withered, in a sorry
plight . . .
Alas what has become of the ancients?
Oh for the good old days, when you were loved, and
revered, and
held as a goddess more beautiful than gold . . .[21]

To Giovanni Battista Armenini, theorist and mediocre painter, the fault
lay rather in vulgar and spendthrift Philistinism; he wrote despairingly of
a visit to Milan – 'I associated with some of the young Milanese whom
I found much more inclined to adorn themselves with all sorts of
clothes, and with beautiful shining arms, than to handle pens and brush-
es with any sort of application: there, also, I saw many palaces painted
by those Milanese in a vulgar fashion at great expense of money and
time.' He was particularly horrified by the task of one young painter
who, 'like the others, was more partial to the sword than to the pen', and
was busy applying, at great and pointless expense, a lot of old-fashioned
and tasteless gold to his ceiling decoration. His patron, on being asked
what subject he would prefer for the frescoed decoration, answered
cheerily, without much thought, 'Make it like a pair of those trousers
that are now so fashionable, with many colours.'[22]

In such a context Peterzano had many virtues, and on 6 April 1584,
Caravaggio, now thirteen, who was already living in his house, signed an
apprenticeship contract with him. Peterzano lived, with his wife
Angelica, and other relatives, at the Porta Orientale, in the parish of
Santa Babila, and the contract bound him to keep Caravaggio with him
in his house, for a period of four years, and to instruct him in every
aspect of his art, so that he would be able to establish himself as an inde-
pendent artist.[23] Caravaggio was to pay twenty-four gold scudi. Peterzano
came from Bergamo, close to Caravaggio, and local pride may have
played some part in Michelangelo's choice, but he also brought with him
a sense of wider horizons. He had apparently come into contact with
Titian in Venice, of which he was intensely proud, and in the art world
of Milan this added lustre to his name. Documents refer to him as 'pupil
of Titian'; he himself signed a painting 'Simon Petrazanus Titiani

Alunnus'. His wide culture was admired; a contract of 1580 refers to him as 'a not unlearned painter'; on his arrival in Milan he was immediately celebrated by Lomazzo, who wrote poems in praise of his earliest Milanese works, and later singled him out, in truly hyperbolic vein, as one of the Venetian artists most worthy of imitation. In 1590 he awarded him the glowing accolade of inclusion in an array of great painters most distinguished for their perfection as colourists and in the portrayal of expression – 'To Titian, and Giorgione, and Antonio da Correggio, have succeeded Paolo Cagliari [Veronese], Tintoretto, the Palmas, Pordenone, the Bassani, Federico Barocci and Simone Peterzano . . .'[24] His name today sits somewhat oddly in this list, yet to Lomazzo Peterzano clearly brought to the limited art world of Milan, where he was established by 1572, an exhilarating sense of the more painterly and splendid traditions of Venice. Peterzano's first Milanese works are indeed deeply indebted to these Venetian traditions.

But in the early 1580s, Peterzano, who had worked at the cathedral, and was well known in Milan, was drawn into the orbit of Carlo Borromeo. In Lombardy there had long been a tradition of naturalistic religious art that resisted the idealisations of central Italy, and from the late 1570s and early 1580s this was given new vigour by the Counter-Reformation need for a devout art that should inspire intense piety. Carlo Borromeo had himself written a short chapter on 'Sacred Images and Paintings' in his massively detailed architectural treatise, *Instructiones fabricae et Supellectilis Ecclesiasticae* (1577), which echoes the demands made by the Council of Trent – that religious art should be decorous and avoid false teaching; that it should, above all, incite to piety and avoid novelty, shunning 'whatever is profane, base or obscene, dishonest or provocative'.[25] All artistic licence is forbidden, and an array of punishments, fines and penalties is set for painters and sculptors and for pastors who fail to observe these requirements. There developed an ideal of art that was stark and intensely concentrated, stripped of a Renaissance delight in details – of landscape, still life, or genre – that give purely visual pleasure. Above all Carlo was moved by a dark night scene of *The Agony in the Garden* by Antonio Campi, which comforted him on his deathbed. Turbulent and passionate, it shows Christ kneeling in anguished prayer,

before him the Cross, and invites meditation on his Passion. To Carlo this was the purpose of religious art, and he closed a sermon in 1584 with the prayer, 'O Lord, let us have always before our eyes your most tragic Passion, and let us keep the crucified Christ always before the eyes of the body and of the spirit.'[26]

It was with such ideals that Peterzano had painted, just before Caravaggio's arrival in his studio, an extensive fresco cycle at the charter-house at Garegnano, where Carlo sometimes went to practise the spiritual exercises. Peterzano's contract stressed that the work should avoid indecency, and that it should encourage devotion: 'All the human figures, and above all the Saints, should be executed with the greatest honesty and gravity, and there should not appear torsoes, nor other limbs or parts of the body, and every action, gesture, clothes, attitude, and drapery of the saints should be most honest, modest and full of divine gravity and majesty . . .' None the less the work should be beauti-ful; it should be executed 'with every care and skill, and the greatest and most exquisite perfection that is possible'. Peterzano was to rectify every error of art, and the Prior to examine its religious correctness.[27]

These frescoes are bewilderingly eclectic, but they contain many passages which Caravaggio later recalled. There is an *Adoration of the Shepherds*, rendered with an archaising simplicity and rustic humility, where an old man and woman, with wrinkled brows, join the shepherds in their broad-brimmed country hats. Grander, and more Roman, are the muscular Evangelists, which nevertheless, with their heavily veined hands and feet, remain intensely naturalistic, while an altarpiece of the *Resurrection* is lit by dramatic contrasts of light and dark. Over the next few years, when Caravaggio was in his studio, Peterzano's style became increasingly devotional, and is characterised either by extreme composi-tional simplicity, or by the concentrated expression of dramatic emotion as in the richly coloured *Deposition* painted for the church of San Fedele. At around the same date, and for the same classically severe church, Ambrogio Figino, a Milanese painter much admired by Carlo, painted his *Madonna of the Serpent,* and echoes of both these works occur many years later in the art of Caravaggio.

In Peterzano's studio Caravaggio received the thorough training of a

Renaissance artist, learning how to prepare colours, presumably how to draw and to paint in fresco (though he was never to do either), and studying anatomy and perspective. There, are, however, very few clues as to what he actually painted while there. Bellori gives a romantic account of Caravaggio's training as an artist: 'Since Michele was employed in Milan with his father, a mason, it happened that he prepared glue for some painters who were painting frescoes and, led on by the desire to paint, he remained with them, applying himself totally to painting. He continued in this activity for four or five years, making portraits . . .'[28] In the light of later developments this emphasis on portraiture seems convincing, and among Caravaggio's first Roman works were pictures which were painted from posed models. In some of Peterzano's paintings there are naturalistic still-life details of fruits and flowers, while amongst the drawings from his studio are oil sketches of fruits and vegetables, all of which suggests that a study from nature was part of his studio practice.[29] It is likely that the main emphasis of Caravaggio's training was in the lowly genres of portrait and still life. An intense and passionate observation of nature was to become the very foundation of his art, which remained deeply rooted in Lombardy.

In the Renaissance the central artistic theory was that art was an imitation of human nature, rooted in reality, yet perfected and idealised. But in northern Italy, where the naturalism of Titian was idolised – indeed, the art of Titian had been equated with nature itself – and where Tintoretto and the Bassani were powerful exemplars, treatise writers laid greater emphasis on painting's power to re-create, through light and colour, the manifold beauties of the external world. And in the Milanese workshops there remained the shadowy but intense presence of Leonardo da Vinci. To Leonardo the powerful illusionism of Renaissance painting, its heightening of three-dimensionality through effects of light and shade, seemed a source of almost magical power. To him painting was the greatest of the arts, for through it the artist could summon up new worlds -'rivers of greater or lesser transparency, in which can be seen fishes playing between the surface of the water and the bed; also the polished pebbles of various hues, deposited on the washed sand of the river's bed . . .'[30] and penetrate the secrets of nature. Milanese artists

studied his *Virgin of the Rocks*, in San Francesco Grande (now in London), in which the draperies gleam amid dark shadows whose soft play creates a unified and murky atmosphere; they studied, too, his *Last Supper*, not only for the naturalness of the expressions, the poignancy of figures frowning, or with passionately interlaced fingers, but for the lovely effects of light and reflected light on the carafes and table cloth.

In the studios of Milan Leonardo's ideas were much discussed, and the varied writings of Lomazzo vividly convey the ongoing debates which flourished in the literary and artistic circles where Caravaggio made his début, and where painting and poetry were unusually close. These writings suggest another world, partly secret, and far removed from the penitent saints and martyrs of Borromean Milan, for Lomazzo was the Abbot of the Accademia della Valle di Blenio, an eccentric academy dedicated to the cult of Bacchus. Here painters gathered, and, dressed in the rough clothes of wine porters, created a provocatively low art, of caricature and genre pictures, which mocked the Counter-Reformation severity of Borromean Milan, and echoes of which underlie Caravaggio's early Bacchic pictures.

At the centre of Lomazzo's concerns were expression and light; he recalled Leonardo's advice to painters to study the gestures of men condemned to death, and recommended the study of 'the eies of privie murtherers, the courage of wrastlers, the actions of stage-plaiers, and the inticing allurements of Curtisanes, to the end he bee not to seeke in any particular wherein the very life and soule of painting consisteth'.[31] He wrote in disapproval of the modish use of an oblique light (he was probably referring to the tenebrist pictures of the Campi), which was 'the manner of some of our contemporaries whose works were unpleasant for this reason and, by intercepting the rays of light, appear mad rather than just confused'[32] – a debate to be continued in the studios of Caravaggio's Rome. In his *Trattato* there appeared, too, the first commentary on Giuseppe Arcimboldo, who in 1587 returned from the court of Rudolf II in Prague to Milan, where he embarked on a ruthless self-advertising campaign; he was the creator of strange heads, made up of fruits, flowers, fish and utensils, whose fantasy charmed the Milanese.

Another enthusiastic Arcimboldo admirer was the Lateran canon Gregorio Comanini, a man of deep learning, yet witty and eccentric, who admired both the fantasy and the sharp observation of Arcimboldo's works, writing of his brush:

> . . . that far surpasses
> That of Zeuxis or of those
> Who created veiled deceptions,
> Delicately beautiful,
> In their contest for great fame?

and of his choice to paint:

> A thousand flowers, thousand fruits,
> Set to weave this cheerful mixture,
> This great product of creation
> Into an artistic garland
> Of his own . . .'[33]

Comanini mixed with painters, and was a friend of the painter Ambrogio Figino. In 1591 he published his *Il Figino*, an imaginary dialogue set in Figino's house in Milan. Here he draws a distinction between fantastic and icastic representation. Icastic is the imitation of 'things as they are in nature', fantastic of 'things which exist only in the mind of the imitator'.[34] Icastic art is essential for religious painting, which, as 'the book of idiots', had to be comprehensible; but it also gave greater pleasure than fantasy, because it involved conquest of a greater difficulty – 'it is more difficult to imitate something real, for instance in painting the portrait of a living man . . .'[35] In the late sixteenth century the power of art to deceive the senses, to astonish the spectator by the creation of another reality, was a recurrent theme, and gave new life to those trite stories in Pliny about the miraculous illusionism of ancient artists. Lomazzo writes: 'The story of Zeuxis is well knowne, who painted clusters of grapes on a table so lively in the Theater, that the birdes flying by pecked at them: though he were after beguiled himself, by a curtaine which Parrhasius painted in emulation of his grapes . . .'[36]

The Colonna household, too, was a cultured one which encouraged an interest in literature and philosophy, for after Caravaggio's departure Costanza Colonna's son, Muzio Sforza Colonna, who returned from his education in Spain in 1592, opened an academy called Gli Inquieti, where, Paolo Morigi tells us – 'as he was noble and generous in soul and thought, and the instigator, it was agreed by all the Academicians that he should be the first to be created Principal . . .' Here there gathered 'the most distinguished literary gentlemen, and other toga-clad people . . .'[37] Muzio Sforza and Caravaggio's paths may have crossed for only a brief time in Milan at this point, but Muzio was to appear in Rome, where, if only as an indifferent poet, he cut a minor figure in the literary world; Comanini addressed a poem to Figino's untraced portrait of Muzio. Caravaggio must have absorbed much of the lively literary artistic culture in Milan before he moved to Rome, and Figino may have already painted his astonishing *Still Life with Peaches*, a fresh and naturalistic rendering of peaches on a plate, and amongst the very first Italian still lifes.[38]

At the end of his apprenticeship in 1588 Michelangelo may have stayed in Milan for a period, perhaps hoping to win commissions through the contacts of his uncle Ludovico, but he seems then to have returned to Caravaggio, where, as 'habitans Caravaggio', he is mentioned in a series of legal documents over the years 1589–92 which record the sale of bits of land, though it seems likely that he continued to move between Caravaggio and Milan. He probably now lived in his mother's house at Porta Folceria. It is extremely unclear what he was doing through this period, and no paintings remain, though he was now twenty-one, and, for a painter, no longer young. It may be that he was adding to his apprenticeship in Milan a deeper knowledge of the art of the towns near Caravaggio – Bergamo, Brescia, Cremona, Lodi, and perhaps Venice. In later years there are often echoes of the grave art of Moretto, with its darkly shadowed interiors, and humble figures, and of the more lyrical work of Giovanni Girolamo Savoldo, with its glamorous effects of artificial light and glimmering expanses of pure colour; sometimes his later works seem to recall the roughly naturalistic terracotta sculptures of religious subjects that were popular in Lombardy.

These seem to have been restless years for the family, involving moves and sales, as though they had fallen badly into debt, or were suddenly urgently in need of money, or were preparing for major change. Michelangelo's uncle, the priest Ludovico, moved to Milan, often changing his residence, though in 1591 he was established in the Archbishop's palace in the service of Carlo Borromeo. In September 1589 Michelangelo, declaring himself to be about eighteen, sold his share of a piece of land that he owned jointly with Giovan Battista, and from this moment both he and his brother seem to have been intent on divesting themselves of their small inheritance. Their mother fell ill, and died on 29 November. Ludovico became the guardian of the surviving children, with Francesco Merisi and Giovanni Aratori; he helped Michelangelo and Giovan Battista with further sales of property in 1591. On 11 May 1592 there took place the final division of the estate, between the two brothers and their sister, Caterina. By this date Ludovico had moved to Rome. On the same day Michelangelo sold the small piece of land that remained to him, receiving, for his so rapidly vanished estate, the relatively small sum of 393 imperial lire, and a little later left Caravaggio for Rome. He never returned to his native town.

It is not clear why Caravaggio ran through his inheritance so rapidly. It may simply have been that he was already a turbulent, extravagant character; Mancini tells us, generously, that 'at a young age he studied diligently in Milan, though now and again he would do some outrageous thing because of his hot nature and high spirits'.[39] Milan was a violent city, where order was disrupted by the unemployed, and by the swaggering *bravi* (immortalised in Manzoni's *I Promessi Sposi*), without home and without occupation, who were swift to reach for arms. There were very many street crimes and homicides, often for vengeance and theft; many were accused of rape, incest and sodomy, and many were executed (in 1585 six together) for street murder. There are, in the early sources, mysterious hints that Caravaggio may already have been involved in this street violence and on the wrong side of the law; he was undoubtedly, in true Milanese tradition, an expert swordsman. Bellori states plainly that Caravaggio 'ground colours in Milan, and having learned to colour, and having killed a companion, he fled from his country'.[40] But a series of

random jottings in Mancini's manuscript, which is almost indecipherable, may suggest a different sequence of events. These jottings perhaps read: 'They committed a crime. Whore/police spy/and gentleman. Police spy daggers gentleman and the whore slashed. They wanted to know who the accomplices were. Then a year in prison, and he wanted to see his property sold. He goes to Milan. Prison he does not confess comes to Rome.'[41] Perhaps Caravaggio was involved in a street brawl over courtesans or whores, but refused to say who was involved, and as a result suffered a year in prison. This would explain his need for money, and at least to some degree his strange lack of activity at this time. The criminal archives in Milan have so far yielded nothing, but they too are hard to read, and often damaged. In any event Michelangelo's rapid sale of his property does suggest some kind of crisis, or major decision, and he left Caravaggio in a hurry. He may first have travelled to Venice, to admire the naturalistic art of Giorgione,[42] and he may also have paused in Bologna, where the Carracci family were exploring a new kind of naturalism, based on intense drawing from life.

Michelangelo left for Rome after a childhood spent in the shadow of plague, famine and desolation, and he took with him something of the darkness of Carlo Borromeo's Milan. Uncle, grandfather and father had died in quick and terrifying succession, and his mother before he was twenty; he was later to shun close ties, to be feared for his proud and satirical nature. Carlo died in 1585, and Caravaggio (who may have known him, so closely were the Colonna and Borromeo households connected) was perhaps present at the drama of his funeral, when the celebrated Franciscan preacher Francesco Panigarola delivered a moving oration which evoked with intense passion the charisma of Carlo's physical presence. 'Behold, O Milanese,' he implored, 'that your and my Cardinal is dead, behold our crown is fallen, our sun has set; our light is spent, and I am left in misery and grief . . .' Carlo's hands had been always cold, his brow fevered: '. . . there could be no body more afflicted by penitence, more weakened, more pallid, more bloodless . . . it is a miracle that he lived for so many years, for in life he was dead . . .'[43]

In Caravaggio's art there is a deep sense of abandonment, and he may have absorbed, at the deepest level, the terrors that ring through Carlo

5. Nunzio Galiti, *Milan in the Plague*, 1578,
(print)

Borromeo's *Memoriale* (1579), a passionate plea to the Milanese to
contemplate the horrors through which they had passed, and to remain
united in their search for salvation; he may, too, have absorbed some-
thing of Carlo's austere grandeur, his sense of the dignity of the poor
and humble. To Carlo the plague had been sent by God, a terrible
punishment for sin, and for worldly vanity. He evoked a city abandoned
and solitary, from which 'there fled the great, there fled the low, all
abandoned you, both nobles and people';[44] it is the city of Nunzio
Galiti's moving votive image of 1578, in which a single gilded carriage
moves along the road, past appalling scenes of desolation, while the
spires of the great churches yearn for the heavens. But only death
remains, 'in a terrifying desert, full of poison, full of death, full of
graves',[45] where gold and velvets glitter vainly, and merchants and
jewellers weep. Milan, once so lovely, whose grandeur reached the
heavens, and whose riches spread to the very limits of this world, is

another Babylon, or Nineveh, and in Carlo's stark prose there echo the rhythms of the Old Testament prophets and of the penitential psalms. The *Memoriale* is a harsh reminder of mortality, a sonorous denunciation of vanity, and its darkness is to beat through seventeenth-century lyric poetry, and to touch the art of Caravaggio, so deeply pervaded by a sense of death, and of man as a pilgrim in this harsh world.

But all this was to come. As Caravaggio left Milan it was, above all, to bring to Rome, whose ancient art had long attracted artists from throughout Europe, the newer pleasures of a freshly naturalistic north-ern art. A madrigal by Comanini addressed to Figino's *Still Life with Peaches* at about this time evokes Figino's astonishing naturalism, his colours so skilled and so lovely that his peaches seem fragrant, in words that look forward to the magical illusionism of Caravaggio's first fruits:

'ON THE PAINTING OF CERTAIN VERY
NATURALISTIC PEACHES'

Nature was mother to us
On the second bough
Now we are sons to Painting
Fruits in unfruiting wood behold us here.
Not only will you be persuaded by the colour,
But scent too emanates from what you see.
Sweet, soft and mellow,
Your eye devours us all,
What gentle skill
Guided the hand that immortalised this fragile
beauty.[46]

CHAPTER TWO

Rome 1592

'The city is all court and all nobility:
every man shares in the ecclesiastical idleness.'
MONTAIGNE[1]

L ATE SIXTEENTH-CENTURY ROME, where Caravaggio arrived in
1592, at the age of twenty-one, was a city rising from a long
period of decline and desolation to a new and unsurpassed
beauty. In the middle years of the century, after the Sack of Rome in
1527, its population had dwindled. The hills of Rome had been aban-
doned, and the majestic antiquities, covered by vegetation and mounds
of earth, were reminders of past grandeur. The forbidding Tarpeian rock
was now the Monte Caprino – the Hill of the Goats – and the Forum,
renamed the Campo Vaccino, was the site of a cattle market, with many
of its monuments engulfed by risen earth. A medieval tower crowned the
Arch of Septimus Severus, while small shops and shacks clustered
against the walls of the great Arch of Constantine, itself deeply sunk in

6. Tommaso Laureti, *The Triumph of Religion*
(Rome, Vatican Palace, Sala di Costantino)

the earth. In these years visitors seeking the splendours of classical antiquity grieved over Rome as over a dead city; Montaigne, in 1581, was moved by the tracts of desolate wilderness within the walls to declare that nothing of Rome remained. Yet by the end of the century all this had changed. A wealth of new buildings, palaces, churches, confraternities, was creating a modern city. Domes were beginning to replace the old medieval towers, and the narrow, twisting streets of medieval Rome were giving way to straighter and grander arteries.

This new Rome, *Roma Sancta*, was above all a celebration of a renewed Christianity. It was the creation of Pope Sixtus V, an energetic pope possessed by the powerful vision of a city whose beauty should draw pilgrims from throughout Europe to the capital of a restored Catholicism, where they could be reconciled with God, and their sins forgiven. Sixtus's secretary, Antonio Maria Graziano, commented that Rome, the centre of Christian power, made holy by the blood of the Apostles themselves, should be, as far as was humanly possible, 'a most grandiose temple, embellished with the utmost splendour'.[2] All the emphasis fell on the beauty of the Christian sites of Rome, its ancient churches, its catacombs, the tombs and relics of the martyrs. In 1588–90 the cupola of St Peter's had been finished, and on 18 November 1593 an enormous metal sphere, surmounted by a golden cross, was put over the lantern. The church still lacked a façade, but its dome became one of the wonders of Europe. The great basilica of Santa Maria Maggiore, where Sixtus was buried, was to provide a second dramatic focus, and the Pope created a series of long straight avenues radiating out from this church and linking the seven great basilicas visited by pilgrims in search of indulgences. All the vistas culminated in an ancient obelisk, whose pagan splendour both upheld and was conquered by the Christian symbols which crowned them. The most celebrated and imposing of Sixtus's avenues, the Strada Felice (now via Sistina and Quattro Fontane), thrust from the heights of the Pincio, across the Esquiline Hill, to Santa Maria Maggiore, where a dramatically placed obelisk drew the eye. Beyond, the avenue swept on again to Santa Croce in Gerusalemme. The Antonine and Trajan columns were crowned with statues of St Paul and St Peter, both martyred in Rome.

Thus physically linked, these, the most holy places of Christianity, were then embellished with frescoes which encouraged the pilgrim to meditate both on the power of the Church and on the mysteries of the Christian faith. At St John Lateran a covered portico led the pilgrim from the grandeur of the Piazza San Giovanni towards the Scala Santa (the staircase of Pilate's house, which Christ had walked down), which the pilgrim ascended on his knees and where a cycle of frescoes on themes of the Passion of Christ stimulated meditation on the events of Holy Week. In the Vatican Library a vast team of fresco painters covered the walls with scenes celebrating Sixtus's creation of new Rome and the serried ranks of high churchmen convey the absolute and authoritarian ambitions of the Church. Tommaso Laureti's *Triumph of Religion* (Plate 6) is a powerful rendering of Sixtus's vision. This contrasts sharply with Raphael's decoration of the Vatican Stanza della Segnatura, where his *Disputa*, with the Fathers of the Church encircling an altar displaying the Eucharist, faces the *School of Athens*, an ideal gathering of the philosophers of Antiquity, and pagan past and Christian present fuse. Here, in a severely composed architectural setting of richly coloured marbles, an isolated pagan sculpture lies in fragments before a Crucifix, and beyond this, at the end of a long perspectival vista, stands a circular temple, symbol of the Catholic Church.

The physical city of Rome was transformed. It was the city of Peter, to whom Christ had handed the keys, and of the Apostles; it was the one holy centre of the Church, and preachers and orators elaborated ideas of peace and glory, of continuities with the Church's early days. It no longer aroused nostalgia for the classical past, but glory in its downfall; as the Jesuit priest Gregory Martin exulted in *Roma Sancta* of 1581: '. . . finally where all the beautie was upon the seven hilles, what is there now but desolation and solitarinesse? no dwelling, no house, but onely here and there manie goodly and godly Churches of great Devotion? And here, gentle Reader, see and consider with me . . . how in Rome Christianitie hath succeeded Paganisme, the kingedom of Christ, overthrown the Empire of Satan . . .'[3]

Within the resonant symbolic patterning of streets and monuments created by Sistine Rome, new areas were being rapidly urbanised. The

traveller arriving from the north, as Caravaggio did, entered Rome through the Porta del Popolo, from which the Piazza del Popolo was flanked on the north by the church and monastic buildings of Santa Maria del Popolo, and on the south by houses of modest size. In the

7. Antonio Tempesta, *Map of Rome*, 1593
(detail from print)

centre stood an obelisk, erected in 1587, and beyond it a fountain. Despite these attempts to create a grander entry to the city, the Piazza retained a remarkably rural air, with animals wandering about, carters resting, and just beyond the gate fields and hills and shepherds grazing their flocks. Beyond the Piazza lay the city's most densely populated area, the *rione*, or district, of Campo Marzio, the heart of medieval and Renaissance Rome. Here lay the Platea Trinitatis (now the Piazza di Spagna), from which a grassy bank led to the newly completed façade of Santa Trinità dei Monti, whose twin towers crested the hill. The Platea was circled by modest two-storey houses, many of them the homes of artisans and artists, and was already famed for its taverns and eating houses; near by, the via Margutta, surrounded by gardens, with a splendid view of the Pincio, and tax-free to foreigners, was already, as it has remained, the site of a lively colony of artists, many of them from northern Europe. South lay an ancient quarter of small streets and squares, of alleyways such as the Vicolo del Divino Amore, where Caravaggio was later to live, which runs alongside the Palazzo Firenze, the home of the Medici ambassadors. Another densely populated area, where high narrow streets still retain a medieval atmosphere, lay at the foot of the Capitol and included the Jewish ghetto. Grander and more spacious, and increasingly sought after by the wealthy (the French pastry-makers lived here), was the area around the two great squares, the Piazza Navona and the Campo de' Fiori. The Piazza Navona, built over the ancient Stadium of Domitian, was then circled by relatively modest houses, and was already the site of festivities and spectacle, while the Campo de' Fiori, then as now, was a marketplace. Near by stood the churches of the Spanish and German nations, San Giacomo degli Spagnoli, and Santa Maria dell'Anima, and to the east of the Piazza Navona rose the church of the French nation, San Luigi dei Francesi.

A constant flow of pilgrims passed to the Vatican across the Ponte Sant'Angelo, where once the heads of executed prisoners had been displayed; here the luxurious Ostaria dell' Orso welcomed visitors (among them Montaigne) and in the Piazza Sant'Angelo a lively throng of street vendors and acrobats entertained the traveller. Close by, at the prison housed in the medieval Tor di Nona, public executions offered a more

gruesome diversion. The spacious via Giulia, which had been home to the Florentine colony in early sixteenth-century Rome, and where artisans, craftsmen and jewellers still lived, ran parallel to the river, culminating in the church of San Giovanni dei Fiorentini and the vast Ospizio Sistina (now destroyed), which the Pope had intended to house two thousand beggars. This remains one of the loveliest streets in Europe, a sequence of the most subtly elegant Renaissance palazzi, mostly opening into courtyards, and externally embellished with chiaroscuro decorations by such artists as Polidoro da Caravaggio, Federico Zuccaro and Raffaellino da Reggio. Near by, the *rioni* of Ponte and Parione were a busy section of the city, where the Oratorian church of Santa Maria in Vallicella was being rebuilt, close to the houses of businessmen, lawyers, scholars, and nobles and great cardinals.

In these years Rome was still a small city, although the population was growing (in 1600 it was to number 109,729 persons). Nevertheless it was a major European capital, subject to the temporal and spiritual power of the Popes, and dominated by the Cardinals, with the cardinal nephews of the reigning Pope at their head. In the early 1590s, beneath the triumphalism of the new Rome, lay fears and tensions. On 5 January 1591 a newspaper reported: 'Every day we hear that someone has died of hunger';[4] famine, and consequent fear of bandits, constantly threatened. The stormy conclaves and rapid succession of four popes in 1590–91 had fostered chaos and insecurity, and a sense of desolation was exacerbated by the Protestant menace throughout Europe and by the continuing fear of the Turk. In 1591 Cardinal Agostino Valier, the Bishop of Verona, wrote: 'Our own time is one of the greatest suffering, with the desolation of the great kingdom of France, the baneful progress of the heretics in Germany, in England and elsewhere, the growing horrors of the cruel Turkish tyrannicide, and the peace shattered by the hideous doings of unscrupulous hired assassins, subversive of peace, and famine, of a seriousness unrivalled in the chronicles . . .'[5] Street fights between the supporters of France and those of Spain were common, for these rival powers were engaged in a bitter struggle for political domination over the Papacy. Henry IV, the French king, had, in 1593, announced his decision to return to the Catholic Church, and in 1595 had declared war on Spain;

in Rome the Spanish king, Philip II, ambitious to defeat Protestantism by dominating western Europe, exerted such pressure on the Pope to reject Henry's conversion that the independence of the Papacy itself seemed at risk.

With the election of Ippolito Aldobrandini as Clement VIII on 30 January 1592 a measure of security and stability was restored; Clement was not anti-Spanish, but he was free of undue influence, and the possibility opened up of his receiving the emissaries of Henry IV. Of majestic presence and grave manner, Clement came from an ancient but undistinguished Florentine family. Guido Bentivoglio, whose *Memorie* give a lively picture of his court, described him as 'of average height, with a constitution between the sanguine and the phlegmatic, of grave and noble aspect, with a body which is heavy rather than otherwise'.[6] He was an infinitely conscientious administrator, cautious and diplomatic by temperament, perhaps to the point of indecisiveness, and neurotically suspicious of advice. An anonymous chronicler described how he revealed 'prudence, forbearance and skill in waiting for the moment, secrecy and silence where it was necessary, circumspection and maturity in speech'.[7] A man of outstanding piety, who fasted rigorously, performed harsh penances, and, famed for his copious tears, participated in all religious ceremonies with displays of abundant emotion, Clement, heir to the austere popes of the mid-century, presided over a court from which he demanded simplicity and moral virtue. He waged war on the prostitutes of Rome, and, only four months after his election, distressed by nudity in art, he arranged a pastoral visit to the churches of Rome, with the aim of removing all unsuitable and disturbingly profane images from their altars (the objects of greatest dislike tended to be images of St Lawrence, and, above all, St Mary Magdalene) and of drawing up rules for the production of religious art. The resulting Edict of Cardinal Rusticucci created an intimidating array of penalties and fines for painters and builders, and demanded that painters should show cartoons or drawings to the authorities for approval.[8]

At Clement's side there reigned his nephews, Pietro Aldobrandini, and Cinzio Passeri. Both were made cardinals in 1593, when Cinzio became generally known as the Cardinal di San Giorgio. Initially it

seemed that the Pope favoured Cinzio, but Pietro was a tougher charac-
ter, endowed with greater gifts for diplomacy, and he was to play a
larger political role, while the splendours of the Villa Aldobrandini at
Frascati bear witness to his magnificence as patron of the arts.
Bentivoglio gives an extremely unflattering description of Pietro. He
was not, he writes, favoured by nature, who had made him very small,
and of little nobility; he was pock-marked and his chest was attacked by
asthma, which made his speech almost incomprehensible; he suffered
from 'fits of coughing so that his face reddened, and his breathing
became laboured'. He desired to be a zealous ecclesiastic, but it was
commonly held that 'there prevailed in him by a long way temporal
desires, and . . . he was desirous above all of satisfying the senses'.[9] Pietro,
far from averse to nudity in art (he was to commission one of the most
erotic of all seventeenth-century paintings), played a lively role in
Rome's night life, displaying a weakness for married women, but being
also attracted by courtesans.[10] Cinzio's palace became an academy where
those branches of knowledge fitting to a prince of the church were
studied – cosmography, mathematics, ethics, politics, and literature.

The most celebrated poet of the age, Torquato Tasso, was invited by
Clement to Rome, where he was to be honoured by a coronation on the
Capitol; Tasso, on the edge of death, was too ill to profit long from his
new prosperity, but he spent his final days admired and protected by
Cinzio Aldobrandini. Tasso' s return to Rome had a symbolic value, and
seemed to herald a new era of courtly patronage. The Pope himself
invited Francesco Patrizi to take up the chair in Platonic Philosophy at
the Sapienza, where his teaching concentrated on the subject of light. In
this favourable climate Giordano Bruno returned optimistically to Italy,
and mathematicians, medical men, and natural scientists were drawn to
Rome, among them the German Johann Faber, Francesco Stelluti, and
Giulio Mancini, a Sienese doctor who had studied medicine, astrology
and philosophy, and was to become Caravaggio's first biographer. Sadly,
their fine hopes were to be dashed, for in time Clement's reign was to
become repressive; Patrizi was humiliated, and Bruno burned.

Around the papal court there clustered the smaller courts, of the
cardinals, of the great Roman aristocracy, of the ambassadors of the

major states, each with their swarm of retainers, each the source of patronage. Many patrons lived in great splendour, preserving the luxurious lifestyle with which the Cardinalate had been synonymous in the Renaissance, for it was incumbent on the great cardinals to uphold the prestige of the papal court, and to devote their wealth to maintaining the churches of Rome. The cardinals from great dynastic families enhanced the Cardinalate with the lustre of their names and splendid lifestyle which involved a generous patronage of the arts; Cardinal Ferdinando de' Medici arrived in Rome in 1569 with a following of 'more than three hundred mouths' and 180 horses, a display that caused Cardinal Alessandro Farnese, one of the wealthiest and most glittering of Renaissance patrons, dubbed the 'great Cardinal' to fear looking like a beggar.

Such cardinals and princes lived in sumptuous palaces, and summered in the villas in cool parts of Rome, or in the green of the Alban Hills. The map of the engraver Antonio Tempesta – later a friend of Caravaggio – a perfect memorial to the Rome of 1593 (Plate 7), vividly conveys, with its suggestions of light and shade, how these great villa gardens, and the large tracts of uncultivated land, invaded Rome, creating a veritable *rus in urbe*. And here the classical world was not banished, but the ancient, Virgilian harmony between man and nature was re-created. The façades of the Villa Celimontana, and the Villa Medici on the Pincio, were encrusted with a dazzling array of classical sarcophagi, urns, and busts, and their gardens repopulated with antique sculptures, which together created a kind of open-air museum. Travellers in Rome were overwhelmed by their beauty; to the writer Jacob Spon, 'the beautiful gardens and pleasure grounds of Rome have everything that is wondrous and curious; they are truly earthly Paradises, and enchanted places, such as the Villas of the Borghese, Pamfili, Montalto, Ludovisi, Mattei . . .'[11]

But by the end of the century other, more austere virtues, of simplicity and frugality, and particularly charitable activities, were attracting praise; Bentivoglio particularly admired Anton Maria Salviati, a man 'most upright in life and mind, great lover and benefactor of the poor, as demonstrated by the [institutions he] founded, greatly enlarged, or

entirely erected anew with much splendour of charity and expenditure'.[12]
Salviati's art collection was small, and consisted entirely of landscape,
portraits and very many paintings of saints, with no mythological or
profane pictures. In 1591, when the young Odoardo Farnese was made
a cardinal, Fabio Albergati dedicated a treatise, *Il Cardinale*, to him, and
celebrated the patronage of art as amongst the duties of the cardinal.
The ideal cardinal, wrote Albergati, should avoid vulgar and lascivious
art, but could fittingly enjoy music and paintings that offered repose and
delight, in which 'no ugly action is portrayed. Pictures of this kind might
represent trees, fish, birds and other singular animals, whose appearance
and nature, while seemly, have something of the rare and marvellous
about them. The same might be said of medals and statues.' He should
enjoy those works which confirmed him in the habit of his own virtue,
seeking pictures which showed examples of 'strength, liberality, temper-
ance, and above all of piety, and devotion, of such a kind as were those
which induced Gregory of Nyssa sweetly to weep'.[13] Although his advice
was to be boldly ignored by Odoardo Farnese, for the most part the
sensuous mythological decorations that had graced so many Renaissance
palaces yielded to landscape friezes and personifications of the Virtues.
The Farnese, a family of great wealth and power, were ancient enemies
of the lowlier Aldobrandini, and conflicts between them were to trouble
Clement's reign.

But while simplicity was admired, in the world beyond, the world of
the Roman nobles, of bankers, lawyers, and financiers, a love of osten-
tation and luxury flourished unbridled. In 1595 the Venetian ambassador,
Paolo Paruta, described the city's richness at length:

> The city and court of Rome are presently at the
> height of their greatness and prosperity, as anyone
> living there may see through clamorous examples of
> such pomp and splendour; and since, in this age,
> every province and court, even in the most far-flung
> and barbarous nations, is steeped in luxury and
> pleasure; so, in the city, and court of Rome, such
> manifestations are especially prevalent, and

proliferate, since here, among the greater part of
the most distinguished persons, the desire to live in
great magnificence, with every convenience, is
conjoined to the excessive wealth required to do so.
Whence there is now the most excessive spending:
and that lavish living which in other ages was the
prerogative of a few of the foremost cardinals, now
leaves its mark upon the magnificence of the
buildings and the rich and noble decoration of the
Palazzi, with truly regal pomp. Indeed, in these
latter years as many public and private buildings,
churches and palaces, streets and fountains have been
made, that they alone would suffice to adorn a
noble city.[14]

Paruta's description of Rome's increasing luxury contrasts sharply with
Agostino Valier's sense of the harshness of the times, and the city's pros-
perity was indeed based on slender foundations, while its ceremonial
splendours were increasingly threatened by the ever more turbulent and
threatening world of the poor and dispossessed. Rome acted as a mag-
net to a vast itinerant population. It was a city where men outnumbered
women, and, dominated by celibate churchmen, it attracted courtesans
from all over Italy, who formed a colony in the *rione* of Campo Marzio.
The number of pilgrims and beggars, attracted by indulgences, and by
the charitable institutions, was huge, and in the Jubilee years outweighed
the permanent population. Ruthlessly suppressed by Sixtus V, bandits
none the less remained a constant fear beyond the city walls. And the
poor, whose humility had, in the Middle Ages, been exalted as a spiritu-
al value, were growing in numbers, in Rome as throughout Europe.
Camillo Fanucci, the chronicler of the good deeds of Gregory XIII and
Sixtus V, described how, 'At Rome you see nothing but beggars, and they
are so numerous that it is impossible to walk down the street without
their thronging around you.'[15] They became increasingly hated and feared
as a danger to stability and to the very fabric of society, and stern mea-
sures were taken against them. Sixtus V had delivered a startlingly harsh

8. Ludovico Ciamberlano
'He saw the faces of St Carlo and St Ignatius Glow':
scene from the Life of S. Filippo Neri
(print)

tirade against beggars in a papal bull of 1587, *Quamvis Infirma*. The poor,
he railed, roamed the streets like wild beasts, intent only on filling their
bellies; their wailing and lamenting disturbed the faithful as they prayed

in the churches.[16] He had built a new hospital near the Ponte Sisto where over a thousand beggars were confined. Their numbers grew in the famines of the early 1590s, and the streets were plastered with notices expelling beggars and gypsies. In the taverns, inns, and brothels, courtiers, rowdy followers of different noble houses, and of opposing political factions, and the private armies of foreign ambassadors, brawled and fought, delighting in their prowess as swordsmen. The Roman police force, the *sbirri*, universally despised, struggled to control them, and the Roman prisons were crowded with Jews, gypsies, slaves and vagrants.

The world of the poor was newly threatening, but their suffering had, for many centuries, seemed Christ-like, and the poor were the earthly image of the suffering Christ. In the streets of Rome the new orders — the Jesuits, the Theatines, the Capuchins, the Oratorians — laboured amongst them, exalting humility and mortification, harshly reminding the world of the court that it was through the attainment of virtue, through alms-giving and good works, that the Catholic hoped for salvation. The Jesuits were the most powerful of the new Orders; they believed in an active, heroic Christianity, and for them Christian martyrdom, often sought in far-flung quarters of the world, was the most glorious of goals. Their language was militant, and they saw the Christian life as a combat, a battle against heretics, and a struggle against the world, the flesh and the devil. But Rome itself was a city of saints, and martyrdom was to be sought amongst the poor and dispossessed that thronged its streets; its saints became symbolic figures, incarnations of suffering, constant reminders of the conflicting Christian ethos of humility in a world obsessed by honour and luxury. St Camillo de Lellis, who carried in his pocket the best-selling guide to a Christian life, Lorenzo Scupoli's *A Spiritual Conflict*, tended the sick in the most ravaged quarters of Rome; the Capuchin Fra Felice da Cantalice offered, in the street, a constant reminder of an ideal of simplicity.

But perhaps most revered was Filippo Neri. With his 'high forehead, his aquiline nose, his small eyes of a celestial blue, a little sunken, but full of life, his short black beard',[17] Filippo, who drew men to him as though to a magnet, had long been famous. Now ill and tired, his beard

white, he lived in retirement in three small rooms at the Vallicella. Nevertheless his presence was felt throughout Rome, and the Congregation of the Oratory – a brotherhood of secular priests, committed to a communal life, and devoted to charity, to discourse and to prayer – which he had founded in 1564, remained a powerful spiritual force. A charismatic and eccentric character, witty and ironic, yet gentle and tender, averse to mysticism and extravagant asceticisms, yet troubled by palpitations, violent trembling and fits of fainting ('his heart glows and emits flames and sparks, so that the passages of his throat are burned as though by a real fire'),[18] Neri was a scourge of intellectual pride and of showy displays of piety, which he attacked with barbed practical jokes. At the Oratory, he strove to create a community which should unite high and low, and revive the simple faith and love of the Apostolic Church; he wished his teaching to be accessible and familiar, concerned with concrete subjects such as the lives of the saints, and conveyed in language that was full of tenderness. There was a widespread reaction against arid learning and the dullness of scholastic teaching; many turned for spiritual solace to the medieval *Imitation of Christ* and to the great thirteenth-century Franciscan tract, the *Meditations on the Life of Christ*, with their emphasis on passionate feeling and on an individual piety.

At the centre of the Oratory's charitable concern was the confraternity of the Trinità de' Pellegrini, founded in 1548 to assist poor pilgrims who arrived in the Holy City from every part of Europe, and which became increasingly important in the struggle against pauperism. In comforting the poor and sick, eating with them, and tending them with their own hands, the Oratorians stressed that they were seeking Christ; they sought, not the material poverty of the Capuchins, nor the extreme asceticism of the Theatines, but meekness of spirit, and it was through absorbing the spirit of poverty, of mortifying pride and moving close to the poor and lowly of the Roman streets, that they hoped to address the values of the secular world. And rich and powerful Romans, fearing damnation, tempered the pleasures of courtly life and displays of worldly splendour with tears, ecstasies, self-mortification, and resonant rituals of abasement. In imitation of Christ they washed and kissed the feet of beggars and pilgrims, and Clement VIII invited twelve poor men, for the

twelve Apostles, to dine, and served them with his own hands. Through Christ, and through the sacraments, they were taught, man might be saved, and an intense devotion to the Eucharist was revived in Rome.

In the 1590s, Filippo Neri's three small rooms at the Vallicella, which remained open to everyone, saw a revival of the informal discussions on sacred topics, and at this date he enjoyed immense fame and celebrity; Cardinal Cusano commented that, during the last twenty years of Neri's life, 'to his knowledge no ecclesiastic, whether religious or secular, had been held in greater veneration by people of all classes, common folk as well as nobles, courtiers, prelates, bishops, cardinals and popes'.[19] Members of the most illustrious noble families, the Colonna, Massimi, Salviati, Altieri, Farnese, remained devoted to the Oratory; and Federico Borromeo continued an intimacy that had its roots in the days of Carlo and Anna Borromeo. Clement VIII was particularly close to the Oratorians and this made them fashionable; Bentivoglio recalls how, on his way to Rome, Grand Duke Ferdinando I de' Medici strongly advised him to visit the Vallicella, for Clement entertained a high opinion of those who associated with the Oratorians, and this was the way to get on in the world. Ferdinando piously advised Bentivoglio to follow the path of virtue, but concluded that Rome, 'all in all, proves but the stepmother of virtue, though sometimes she has also shown herself to be a most partial mother of fortune'.[20]

Most influential in Neri's innermost circle was the historian Cesare Baronio. Baronio, now in his fifties, had come to Rome from southern Italy, and had been close to Neri for many years; he was a religious zealot, tormented by the rise of Protestantism, and was often chided by Neri for his too great severity. In the 1580s he had been the dominant figure in a revision of the *Roman Martyrology*, weeding out error and superstition, and critically examining ancient sources for the lives of saints and martyrs. At this date Baronio was beginning to reap rich rewards for his long and arduous labours on the *Annales Ecclesiastici*, which had been written at Neri's request; Neri encouraged him to model himself on the great biblical scholar St Jerome. This immense work was a history of the Roman Catholic Church intended to refute the heresies of the *Magdeburg Centuries*, written three decades earlier by a committee of Lutheran his-

torians, who believed that the Church had plotted to corrupt the Christian faith, and portrayed the papacy as the instrument of the devil. In the *Annales* Baronio set out to demonstrate the authenticity of the Catholic Church. He wrote simply, without rhetoric, in the belief that the straightforward narrative of events from the earliest days of the Church to the present would ineluctably establish an unbroken tradition. The *Annales* revives the Church's history, and presents memories of the purity and simplicity of its first days for meditation. Baronio laboured for thirty years before publishing the first volume in 1588; the fourth volume, published in 1593, was dedicated to Clement VIII. The *Annales* were greeted with relief and immense enthusiasm throughout the learned world of Europe – it seemed as though a dark menace had been miraculously averted; Baronio became a celebrity in Protestant as well as Catholic countries. The popular preacher Francesco Panigarola, Bishop of Asti, who was later to make the first volume more widely available in Italian, wrote, 'I have never seen such a rich work; it is to me like seeing an ocean of beautiful things; it is like reading not just one book but four complete books, all of them classics; a competent history of the Church, a most learned commentary on the New Testament, a brave disputation amongst the modern heretics, and a most minute collection of all the ancient customs.'[21]

Baronio's passionate historical research had deep implications for painting, and new standards of historical accuracy were demanded from religious painters. It was no longer acceptable to incorporate motifs from the thirteenth-century *Golden Legend*, that collection of picturesque anecdotes and legends about the lives of Christ and the lives of the saints which had been so loved by the Middle Ages, and had provided so rich a source for artists. In 1590 the Bishop of Bologna, Cardinal Gabriele Paleotti, had moved to Rome, where he too frequented the Oratory, and became, with Cardinal Federico Borromeo, director of the Accademia di San Luca, the artists' guild. Paleotti had written a treatise on religious art, *Discorso intorno alle immagini sacre e profane* (1582),[22] which was already well known in Rome. He believed that sacred painting should be easily accessible to everyone. It should imitate visible reality, and create figures that seemed real and tangible; it should convey the his-

torical reality of biblical scenes, clearly defining time and place, and the age and physical build of the figures. He condemned allegory, for painters should show everything as it appears to human eyes. He believed that an art addressed to a wide public should be traditional and conservative; he opposed novelty, and unusual motifs; he wanted art to reassure by its adherence to tradition, and by showing the expected. Art should not idealise, but none the less naturalism should be tempered by classicism and should not shock or disrupt. To him the artist was the bearer of a sacred mission, and at the Accademia di San Luca in these years there was much emphasis on Christian doctrine and piety. The labours of Baronio and Paleotti were backed up by scholars and Christian archaeologists who attempted, through immense scholarly efforts, to establish the history of the early Church, and to shore up with solid evidence the much-loved stories of the lives of the saints.

This then was Rome in the early 1590s, when Caravaggio, young and unknown, arrived from Milan. It was a cosmopolitan city, of intellectuals, scientists, artists, businessmen, ambassadors and diplomats; it was a city of extreme splendour and luxury, and of miserable poverty and extraordinary violence; the centre of Catholicism, it displayed its renewed confidence with a rich ceremonial life. But even so Rome of the 1590s remained troubled and tense. As the century drew to a close, apocalyptic fears spread, and in the poetry of the period, alongside the celebration of courtly pleasures, there is a sense of fear and desolation, of terror at the prospect of damnation.

Flowers and Fruit

I N THE AUTUMN OF 1592, Caravaggio, now twenty, a Lombard artist with no reputation, arrived in Rome. The Marchesa Costanza Colonna was there in September, and maybe Caravaggio travelled some of the way in her entourage.[1]

Rome, the centre of an ancient civilisation of unparalleled splend our and authority, and made glorious, in the early years of the sixteenth century, by the works of Michelangelo and Raphael, had long been a magnet to artists from northern Europe and from all over Italy. A jour-ney there was an essential part of an ambitious young painter's education, and Caravaggio 'went to Rome with the desire of learning this admirable discipline with diligence'.[2] Above all, artists were drawn by the fame of the ancient sculptures, and the Mannerist painters of the mid-century spent long hours drawing, not only from the posed model, but from the antique and from admired modern painters. Federico Zuccaro, thirty years older than Caravaggio, captured the dreams and sufferings of the provincial artist in a series of drawings that he made of the youth of his elder brother Taddeo in Rome. Taddeo, born in 1529, went to Rome when he was fourteen, and suffered the romantic hardships of rejection and of menial and unworthy work; but Federico shows Taddeo's imagination teeming with images and ideas of the antique; he draws the ancient sculp-tures, the Laokoön, the Apollo Belvedere, the paintings of Michelangelo and Raphael, and the classical friezes of Polidoro da Caravaggio, which fill his fevered brain as he sleeps on the banks of the Tiber.

In the middle years of the century, however, art was dull, and many painters limped haltingly along in the shadow of the divine Michelangelo. There flourished the *maniera statuina* (statuette manner),[3] an idealising art, in which the figures, in complex, unnatural poses, resemble statues, their stony flesh pallid, as if whitewashed, and bled of life and passion. In the early years of the sixteenth century the godlike creativity of Michelangelo had been idolised, but after the unveiling of

the *Last Judgement* in 1542 in the Sistine Chapel voices were raised against him – 'Who would dare to maintain', railed Lodovico Dolce in 1557, 'that in the Church of Saint Peter, chief of the Apostles, in a Rome where the whole world assembles, and in the Chapel of the Pope . . . it was proper that one should see depicted such a quantity of nudes, who display their fronts and backs in an immodest way . . .'⁴ and a little later, in 1564, Gilio da Fabriano, an ecclesiastic concerned with the errors and abuses of contemporary religious art, accused Michelangelo of wishing to leave a memorial to his 'marvellous talent, while laying aside devotion, reverence and historical truth'.⁵

By the 1580s new ideas had begun to challenge the excessive idealism of the academic Mannerism of the mid-century, for in Rome, the centre of the Counter-Reformation, high churchmen and writers were redefining the ideals of the Christian painter, laying fresh emphasis on qualities of simplicity, clarity, and emotional stimulus to piety, and emphasising that painters should adhere strictly to religious texts. Scipione Pulzone's *Holy Family* (*c.* 1590) (Plate 9), represents a new kind of naturalistic religious painting, unthreatening, and devotionally idealised, that fulfilled such demands. The composition, reassuringly traditional, looks back to Raphael, but the mood is humbler, more rustic, and suggesting a sweeter piety. The setting is unadorned, the cradle rough-hewn, and homely woven draperies muffle the figures, revealing only a hint of flesh, while the suitably tender faces of the Virgin and St Anne are brought close to the spectator, appealing to his emotion. In the Vatican the colossal undertakings of Pope Sixtus V, the decorations of the Sistine Library in the Vatican Palace, and of the Scala Santa at St John Lateran, provided work for huge teams of fresco painters, and quick and simple results were much in demand. Painters were organised in large studios, and merged their individuality in teams who laboured together more humbly for the glory of God, aiming to produce works which brought religious truths to a wider public in a straightforward and easily reproduced style.

The presence of the papal court, the many diplomats and cardinals, and the rise of the religious orders, all meant that there was a great deal of work for artists. An artist freshly arrived in the city might seek

9. Scipione Pulzone, *Holy Family*
(Rome, Galleria Borghese)

employment in one of the great studios. These were dominated by the
leading figure painters, but still provided jobs for a host of specialists in
such minor genres as architectural perspectives, landscape and still life.

Yet more desirable was the position called *servitù particolare*, whereby the painter lived in the palace and in the service of a prince or cardinal, through whom his name might become known. In such a position he would have the pleasure of working for a courtly élite, interested in art as well as religion, and through such a patron his fame would spread and he might aspire to fashionable public commissions.

To the connoisseur avid for the lustre of a glorious collection, however, there were very many artists but few great talents. Laments over the poverty of art were commonplace in the 1580s and early 1590s: in 1582 Francesco Maria Del Monte, who would become Caravaggio's most enthusiastic protector, commented that the only distinguished artist then in Rome was Scipione Pulzone, a naturalistic portrait painter as well as religious artist.[6] Much later, Bellori crystallised this mood in a memorable sentence – 'I have more to say that will seem fantastic: neither within nor without Italy could a painter be found, although not much time had gone by since Peter Paul Rubens first carried colors out of Italy. Federico Barocci, who might have been able to restore and give aid to art, languished in Urbino . . .'[7]

Outside the official art world, and the courts of the great princes, innumerable jobbing painters survived without protection, dependent on dealers who sold their wares in small shops, amongst the booksellers and lute-makers of Parione and Campo Marzio, or in stalls in the Piazza Navona and Trastevere. Some pictures were even sold by street vendors, and Annibale Carracci's series of drawings of tradesmen included a *Picture Seller*, who sports a Madonna and Child like a billboard. Many traders specialised in small devotional works, rosaries, *ex votos*, and other religious goods. Such works were churned out in large numbers by long-forgotten Roman artists. But to paint for the open market lacked all prestige, and an ambitious Italian artist would only turn to dealers when he was young and desperate. The Accademia di San Luca, the artists' guild, forbade its members to engage in such undignified activities, lamenting that 'it is serious, lamentable, indeed intolerable to everybody to see works destined for the decoration of Sacred Temples, or the splendour of noble palaces, exhibited in shops or in the streets like cheap goods for sale'.[8]

Rome was full of immigrants and each group tended to carve out its own district, so that the Flemish gathered in the Via Margutta and in streets around the Trinità dei Monti, while Lombards lived in an area called Pantani, near the church of Santa Maria della Consolazione. Many artists lived in the parishes of San Lorenzo in Lucina and San Andrea delle Fratte, sharing houses and drinking and gambling in the local taverns. A colony of shopkeepers, craftsmen, and swordmakers from Caravaggio's own home town was established in the *rione* of Campo Marzio, where Caravaggio too was later to establish his studio.

To Caravaggio, who was by no means a prodigy, and who came to Rome with no reputation and 'without lodgings and without provisions',[9] the search for a wealthy protector was crucial. The accounts in the early sources of his first Roman years are inconsistent and confusing, and it is not possible to establish a chronology for the events which they relate, some of which may be apocryphal. Yet all emphasise the harshness and poverty of those years; from each emerges the picture of a restless artist, moving from one hack job to another – as copyist, as creator of cheap devotional images, as lowly painter of fruits and flowers – in Roman studios of varying reputations. He changed lodgings constantly (at least ten times in these first years), sometimes granted a room in the *palazzo* of a high churchman or noble family, sometimes with painter friends, once at least at an inn. There are suggestions that he was often at odds with his surroundings, chafing at a lack of dignity, but full of energy, ambitiously planning and working for advancement.

Yet this poverty, perhaps romanticised for dramatic effect by the early writers, may have been to some extent self-inflicted, for Caravaggio was not entirely lacking in influential connections, and he had not left Milan without money – though perhaps, already a stormy character, he had run through his inheritance very quickly. His uncle, Ludovico Merisi, who had played a large role in his youth, had moved to Rome in 1591 or 1592, and the Marchesa Costanza Colonna may have introduced him to other members of her powerful and prestigious family, so dominant in the Roman world of affairs. Her brother, Cardinal Ascanio Colonna, was distinguished by his wide-ranging literary culture and celebrated library; the family enjoyed, too, a close relationship with the Milanese Borromeo

family, and Federico Borromeo, Carlo's cousin, was not only in Rome in this period but was principal of the painters' guild, the Accademia di San Luca.

It seems likely that Caravaggio, fresh from Milan, stayed first with an otherwise unidentified Tarquinio, perhaps a compatriot, maybe a painter, or perhaps an innkeeper. But his next residence, with Monsignor Pandolfo Pucci, a beneficed priest of St Peter's, strongly suggests the influence of the Colonna, perhaps encouraged by Caravaggio's priestly uncle, Ludovico.[10] For Pandolfo Pucci was steward, or Maestro di Casa, to Camilla Peretti, the sister of Pope Sixtus V Peretti, and the Peretti family had close ties with the Colonna. Camilla's great niece, Orsina Damasceni Peretti, was later to marry Costanza's son, Muzio Sforza, and herself to become the young Marchesa di Caravaggio. On the death of Sixtus V Camilla Peretti had retired to a wing of the Palazzo Colonna, where it would have been customary for her steward to live with her, so it may well have been in this palace that Caravaggio commenced his Roman career. The medieval *palazzo* lay between the church of Santi Apostoli, whose portico fronts the elongated Piazza, and the dark and narrow via della Pilotta, today criss-crossed by bridges that link it to the formal gardens laid out in the seventeenth century. In the 1590s, though, above this road, on the western slope of the Quirinal and linked to the palace by three arches, rose a tract of garden and wilderness, crowned by great ilexes and adorned by the colossal fragments of a great fallen temple, from where, Suetonius tells us, Nero watched Rome burn. A fortified medieval tower rose against classical ruins, and the romantic blend of buildings, much sketched by Renaissance artists, conveyed the long-established power and colourful history of the Colonna. In this palace, in the mid-1540s, the poetess Vittoria Colonna had gathered around her men of letters and artists, among them Michelangelo.

It was thus in the home of a celebrated Roman family, distinguished patrons of art and literature, that Caravaggio's career began, but his stay was brief and unsatisfactory. He was asked to do unpleasant work, and there is a suggestion that he found it unfitting to his status; moreover, he complained bitterly that he was only given salad to eat in the evening, 'which served as appetizer, entrée and dessert – as the corporal says, as

accompaniment and toothpick'. After a few months of such treatment Caravaggio, having profited little, left, sarcastically dubbing his host 'Monsignor Insalata'. Yet the artistic tasks he was given must have annoyed him as much as the food; Mancini tells us that here he painted 'copies of devotional images that are now in Recanati'. Monsignor Pucci returned to Recanati in 1600, where he died around 1614: presumably he took some of Caravaggio's pictures back with him, but none have come to light. In this period Caravaggio was reduced to painting pictures for sale, of humble subjects beneath the dignity of the great Roman figure painters, and often the speciality of artists from northern Europe. Mancini tells us that he painted for the open market 'a boy who cries out because he has been bitten by a lizard that he holds in his hand, and then he painted another boy who is peeling a pear with a knife, and a portrait of an innkeeper who had given him lodgings . . .'[11] It seems that he was then invited to return to Tarquinio[12] (who, just possibly, *was* the innkeeper whose portrait he painted), but the chronology is impossibly confusing. Mancini's description suggests typically Lombard works, of unassuming genre motifs, and many copies are known of the *Boy Peeling a Fruit* (Plate 10).[13]

After this dispiriting experience, Caravaggio hawked his talents around a series of Roman studios, whose sequence cannot be established, and for which there are only the palest hints of a possible chronology. Perhaps he rose from working for the most minor artists to the more elevated, which would suggest that his first spell in an artist's studio was with an otherwise unidentified Lorenzo Siciliano, a studio probably in the Pantani, south of the Forum, in the area colonised by Lombard artists. Baglione places this event at the very beginning of Caravaggio's Roman period, saying that Caravaggio 'settled down with a Sicilian painter, who had a shop full of crude works of art'; here, Bellori adds, 'as he was in extreme need and naked, he painted heads for a groat apiece, and he did three a day'.[14] It is not clear what kinds of heads these were, but portraits of famous men had long been a fashionable form of decoration, bought both by noble patrons and by men of letters; Ferdinando de' Medici had a famous collection at the Villa Medici on the Pinciana. It may be that this was the speciality of Lorenzo Siciliano, and one to which Caravaggio, with his Lombard background in portrai-

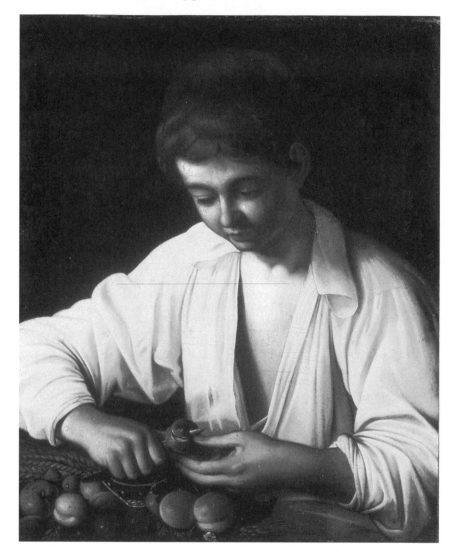

10. Caravaggio, *Boy Peeling a Fruit*
(London, Phillips)

ture, was well suited. It was demeaning work, but perhaps his gift for
investing such heads with fresh life already attracted attention, and won
him a place in the studio of Antiveduto Grammatica, a Sienese artist
who had a studio in the Borgo.[15]

Antiveduto was a much more considerable figure than Lorenzo Siciliano. He had been inconveniently born on the road between Siena and Rome, a problem which his father had foreseen and which thus gave him his quirky name (Antiveduto means 'foreseen', almost 'I told you so'). He was the same age as Caravaggio, but already ran a successful business. At this period Antiveduto was known as a specialist in painting heads, and Baglione tells us that he copied the celebrated series of famous men in the Villa Medici. 'No one was better than he at shaping and colouring heads, and he made excellent likenesses . . . and no Prince, or other illustrious Personage, came to Rome, but called by to see Antiveduto, to have him portray their head; and this exercise made him a wealthy man; and indeed his heads were so fine, and well executed, that he earned the nickname the "great head painter".'[16] Antiveduto was a man of wide culture, who delighted in poetry, and his studio must have provided Caravaggio with intellectual stimulus; painting and poetry were close allies, and many of Caravaggio's painter friends were highly cultivated, with aspirations as poets and as musicians. Antiveduto was moreover an ambitious man, of strong opinions, albeit 'of courteous manners, Christian and civil, and most zealous in his profession',[17] who, despite his financial success and busy trade, was anxious to prove himself as a figure painter, the pinnacle of painting for the Italian artist. What he wished for from Caravaggio was those half-length figures and portraits which Caravaggio's north Italian training had equipped him to provide; these paintings, done in Antiveduto's studio, were more ambitious than the heads Caravaggio painted for Lorenzo Siciliano. All are lost, although it has been suggested that a portrait of Cardinal Baronio, distinguished by its sharp lighting and intense naturalism, may be such an early work, and it is surely close to the kind of picture he was producing at this time.[18]

It may have been in Antiveduto's studio that Caravaggio formed a friendship with Cherubino Alberti; Cherubino, from a well-known family of artists, was at the centre of the official Roman art world, receiving prestigious commissions from the Pope, and developing an eclectic style deeply indebted to the antique and to Raphael. He remained a loyal friend and supporter of Caravaggio who stayed close to him, perhaps

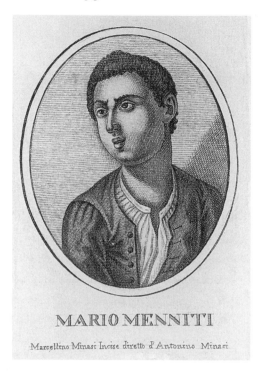

MARIO MENNITI

Marcellino Minasi Incise diretto d'Antonino Minasi

11. Portrait of Mario Minniti
(print, from G. Grosso Cacopardo, ed.
Memorie de' Pittori Messinesi, Messina 1821)

partly because his art presented no threat. More surprisingly, Caravaggio seems to have remained friendly with Antiveduto, despite the fact that Antiveduto later fell under his spell and imitated his style, a practice which usually enraged him.

In the studio of Lorenzo Siciliano (although the dates remain puzzling), Caravaggio had also struck up a friendship with a young Sicilian painter, which was to last throughout his career. This was Mario Minniti, whose journey to Rome, as it is given by his eighteenth-century biographer, Susinno, reads like a romance – Minniti, we are told, fled Syracuse, through Malta, to cast off some (unspecified) local embroilments. Once in Rome, he took up lodgings with a Sicilian painter, who sold pictures by the dozen, and in that studio he formed a friend-

ship with Caravaggio, when both were working as 'labourers for that coarse artisan'.[19] Allies in hardship, both dissatisfied, spurred on by the spirit of emulation, they determined to win their independence and to aim higher, and for some time (though it is not at all clear exactly when) they lived together. It may be that Minniti made some of the earliest copies of Caravaggio's paintings, and he may also have served as a model.

All these references create the picture of a group of young artists, outsiders, often in poverty, on the fringes of the official art world, yet resenting their humble role and striving for grander employment. The mood is touchingly re-created in the account of a young Spanish artist, Cristofero Orlandi, who, in evidence he gave to a magistrate, described his early days in Rome, when, young and penniless, he was seeking employment and moving in much the same circles as Caravaggio. Orlandi arrived in Rome with only twenty scudi and looked for a room with his compatriots on the Via del Corso. One of these introduced him to a painter called Vittorio who lived in Campo Marzio, and he stayed there for a year. Here he managed to earn enough to live without asking for money to be sent from Spain, and came to know many painters. Next he went to work with Antiveduto Grammatica, who then lived near San Giacomo degli Incurabili, opposite the new palace which the painter Giuseppe Cesari (later known as the Cavaliere d'Arpino) was building, 'with whom I stayed for more than a year, and having learned to paint better, he gave me 25 baiocchi a day'. After two years, 'I worked in my own room for the third and fourth gentleman, such as that mirror maker at the Magine di Ponte, who sent me here, and to Signor Vincenzo Giustiniani, and many others whom I can now no longer remember, from whom I earned eight scudi a day, and with whom I lodged. After the said two years I came to an arrangement with Signor Cardinal Piatto, with whom I am today.'[20] Orlandi's was to be a humble career, but his account captures the atmosphere of the Roman art world, where impoverished artists struggled to gain a foothold. Like Caravaggio, he moved from rented rooms to the studio of a successful artist, Antiveduto Grammatica; he worked for a famous collector, and admirer of Caravaggio, Vincenzo Giustiniani, and finally entered the service of Cardinal Flaminio Piatto.

With his work for Antiveduto behind him, following the pattern that Orlandi suggests, Caravaggio was well placed to look for advancement in a grander Roman studio. The most celebrated artist in Rome was the widely travelled and learned Federico Zuccaro, a majestic and handsome man, who had just returned from Spain laden with money and gifts. He was now fifty-two, and thirty years older than Caravaggio. Zuccaro had been a member of various artists' academies, and was passionately committed to upholding the prestige of his profession, presenting an image of the noble artist, living in worldly splendour, and enjoying the gentlemanly academic pursuits of learned discourse and philosophical endeavour. In Florence, with overweening ambition, he had completed Giorgio Vasari's dome frescoes in the cathedral. Here he shows himself (boldly signed on the collar, and dated on the chest) towering over his companions, with square jaw and curly beard, his stature accented by his striking headgear, and thrusting his palette, symbol of his pre-eminence, before him (Plate 12). But Zuccaro was mediocre, combative, and vain. He was a tireless self-advertiser, and avid for glory and fame, but although Baglione tells us that no artist had ever been more richly rewarded, nor more loved and honoured by Princes, by the early 1590s his idealising and intellectual art was out of tune with the times, and he withdrew to decorate his house, the Palazzo Zuccaro, on the Pincian hill, with frescoes glorifying his own art and family. His endeavours caused a stir in Rome, and the ambassador of Urbino reported to his master: 'Federico Zuccari, as your Highness may perhaps have heard from others, has embarked on the realisation of a poetical caprice which may well prove the ruin of his children. He has started building a small palace without rhyme or reason on a most extravagant site, which might have made a beautiful painting but will easily engulf whatever capital he has accumulated.'[21]

With Zuccaro withdrawn, another possibility for Caravaggio was the studio of Cristofero Roncalli, a fashionable religious fresco painter, universally respected (even, later, by Caravaggio), who had trained in Florence and Siena, worked in an eclectic Mannerist style, and became the favourite artist of the Oratorians. Roncalli was a learned artist, whose company was sought by wealthy virtuosi, amongst them Vincenzo

12. Federico Zuccaro, *Self Portrait*
(Florence Cathedral, dome fresco, detail)

Giustiniani. He taught drawing to various members of the noble
Crescenzi family, and was 'very virtuous, honoured and God-fearing, and
always behaved with decorum. He loved his profession, and its practi-
tioners.'[22]

The rising star of the Roman art world, however, whose youthful
celebrity humiliated the elder Zuccaro, and whose busy studio was
attracting many young artists, from both northern Europe and Italy, was
Giuseppe Cesari d'Arpino. His studio was then 'alla Torretta', in Campo
Marzio; there still exists here, between the Corso and the piazza
Fontanella Borghese, a piazza della Torretta. Cesari was only a little older
than Caravaggio (he had been born in Arpino in 1568), but his career had
been startlingly different. The son of an inferior painter of *ex-votos*,
Muzio Cesari, he had come as a young boy to Rome with his mother, in
a state of extreme poverty, but almost immediately joined the team of
fresco painters working in the Vatican Logge, where he was swiftly
acclaimed as a prodigy and was lucky enough to attract the admiration

13. Ottavio Leoni, *Portait of the Cavaliere d'Arpino*
 (print)

of Pope Gregory XIII, who granted him eight scudi a month. Cesari
rapidly established himself as a fashionable fresco painter, working in
a graceful, elegant style, in pale, clear colours, and was much sought
after too as a painter of small, highly finished cabinet paintings of
erotic mythological subjects, in which he explored the Mannerist themes
of a variety of difficult and complex poses, dramatic effects of light
and an expression of a sweet, poetic sentiment. By 1593 he had already
completed a series of enviable commissions, in both Rome and Naples,
and had won the protection of powerful cardinals, among them
Cardinals Giulio Santori, Paolo Emilio Sfondrato, and Alessandro
Montalto; he was to become a favourite painter of Clement VIII. An
early biographer cites a tiny but apparently telling incident as evidence
of their familiar footing; on one occasion, after a meal, the Pope offered
Cesari a large glass of Dutch beer, which Cesari began, out of curiosity,
to drink; the Pope swiftly realised that it was distasteful to him, took the
glass and emptied it.

With aristocratic good looks (a self-portrait shows a lean face, aquiline nose, a mass of black, curly hair, carefully groomed moustache and small pointed beard), 'of a good complexion, and fiery energy . . . rarely ill . . . witty, and of wide-ranging ideas',[23] Cesari was not only a cultivated artist but also a member of the distinguished literary academy, the Accademia degli Insensati, and later established a theatre in the grander *palazzo* that he bought in the Corso. He cherished immense social ambitions, and took great pleasure in bearing arms, which he did until his last illness, keeping a fine arms collection in his studio. He was, however, of a fiery temperament, difficult, always dissatisfied, and given to melancholy. Success crowned all his ventures, and yet, writes Baglione, somewhat tartly, although few have been more blessed than he, on whom fortune had smiled since his earliest years and although he had been loved by princes, and by the most noble families, he 'set little value on their favours . . . he would far rather have worked for men of lowly status, than for eminent patrons . . . he was very little satisfied with his condition, and continuously brooded on the disasters that fate had meted out, lamenting from one hour to the next against the blows of fortune'.[24]

Cesari's brother, Bernardino, was his principal assistant. Bernardino, a second-rate artist, was best known as a draughtsman (said to equal Giuseppe in this medium), and also as a skilled copyist of some of Michelangelo's famous presentation drawings for Tommaso de' Cavalieri. In character, however, he was unlike his brother, delighting in the conversation of princes and nobles, commenting that one has nothing to lose by mixing with those of rank more elevated than one's own. Bernardino was good-natured, loving, loyal to his friends, but he was rash and impetuous, and on 9 November 1592 he was condemned to death, and his goods sequestered, for consorting too freely with bandits, particularly with one 'signore Antonio Griettano, "leader of the bandits"'. He fled to Naples, only returning to Rome in 1593, when he was pardoned on 13 May, on the intervention of Cardinal Sfondrato. It may be at this moment that Caravaggio entered the studio, for he seems to have been befriended particularly by Bernardino, whose portrait he painted, and this suggests a date in the second half of 1593. A position

in so flourishing a studio also suggests that Caravaggio had already won some recognition in the Roman art world.

In these prosperous times commissions were pouring into Cesari's busy studio, and he directed a large team of artists. Self-consciously the heir to Raphael, he employed, as his great predecessor had done, specialists in the minor genres of landscape and still life. He also dealt in pictures, and, with an acute business sense, was alive to the growing interest of Roman collectors in small Dutch and Flemish cabinet pictures – landscapes, or alpine scenes, or city scenes with small figures, which, with their vivid evocation of the beauties of nature, bright with colour and light, and alive with picturesque detail, offered a sensuous but innocent pleasure in sharp contrast to Roman posturing. Both still life and landscape were then novel forms of art which had begun to spread in both northern and southern Europe in the later years of the sixteenth century, and in Cesari's studio north and south mingled in a highly creative interchange. The Dutch Floris van Dyck, who later became a successful still-life painter in Haarlem, worked there around 1600, and must have known Caravaggio; other kinds of novel still life flourished, and Francesco Zucchi (brother of the more famous Jacopo) painted fanciful heads in the style of the Milanese Arcimboldi, works whose pleasure lies in the tension between naturalism and artifice, in the play on the pleasure of recognition and the extreme fantasy of the composition. Baglione tells us that, 'Francesco it was who, in his canvases, devised a way of arranging and colouring the heads of the Four Seasons, with their fruits, flowers and other things which are customarily produced during the said season: and so cleverly did he plan them that he caused all the parts to appear outwardly just as we see in human heads . . .'[25] It may well be that Caravaggio, fresh from Milan where Arcimboldi was famous, told him of these strange and unusual subjects, which then became fashionable in Rome. And Zucchi, 'an excellent painter of fruit and flowers',[26] also framed Cesari's stately frescoes in St John Lateran with bright garlands of fruit and flowers, of overripe pomegranates and transparent grapes, brilliantly coloured and naturalistic. Such garlands were a characteristic product of Cesari's studio, and continued a Raphaelesque tradition, one indebted to the legendary illusionism of

ancient decorative art, fragments of which could still be glimpsed in Rome.

Most importantly, it was probably here that Caravaggio met Prospero Orsi, who remained his closest friend for several years, and in these early Roman days was constantly at his side. Prospero, a little older than Caravaggio, came from Stabio, a small town in the outskirts of Rome. A small man (hence his nickname, Prosperino) with a short and wispy black beard, he had already won some fame as a fresco painter and had contributed to the decorations of the Scala Santa at St John Lateran; now he specialised in painting grotesques, so skilfully that he was known as 'Prosperino delle grottesche', a decorative speciality that endeared him to Cesari. He was indeed a great friend of Cesari's, admiring the grace of his art, and striving to imitate it, and singing its praises throughout Rome.[27] It was a lively studio where old and new met, and doubtless Caravaggio took part in debates between rival aesthetics, between traditional idealising artists, and newer forms of naturalism. Lombard artists were typecast as simple and unlearned, and Caravaggio set out to defend his skills; but he also absorbed something of the great traditions of Roman history painting, of Raphael, Michelangelo, and the Antique; he may have taken part, too, in discussions of poetry and literature, perhaps of Cesare Ripa's recently published *Iconologia*, to become so popular with artists.

Caravaggio spent about eight months in the studio of Cesari. Later writers romanticised their relationship, suggesting enmity and jealousy between them, although in fact Caravaggio (perhaps out of self-interest) continued to express admiration for Cesari. Yet there are hints that their relationship was stormy; Mancini tells us that Caravaggio was made to sleep on a straw mattress, and in a further, very confusing passage, which is almost impossible to decipher, hints that he and the two Cesari brothers were together involved in some crime; he mentions Giuseppe's fear, and his reluctance that Caravaggio should be seen while working on a painting, the *Death of St Joseph*. It is impossible to tell what crimes had been committed, or who had committed them. Their relationship finally collapsed when Caravaggio became so ill that he had to be taken to the Hospital of Santa Maria della Consolazione (a hospital for those

suffering from fever, or for the victims of street fights), where he was looked after by the Prior, for whom, during a long convalescence, he painted many pictures, which were later taken to Sicily, or Seville.[28] Mancini's account of this incident is full of convincing detail: Caravaggio was wounded by a kick from a horse, and suffered from a swollen leg, but the Cesari brothers, suffering from some obscure fear, would not let him be seen, and he was taken to the hospital by a Sicilian friend (this perhaps was Lorenzo, or Mario Minniti). The brothers never visited him there, and Caravaggio, once recovered, did not return to the studio. For the time being he endeavoured to live by himself, and to paint, as Bellori says, according to his own inclination.

The role performed by Caravaggio in Cesari's studio remains unclear. There are hints that he collaborated with Cesari, and he perhaps worked as his assistant on the vault frescoes of the Contarelli chapel, in the church of San Luigi dei Francesi, on which Cesari was working in 1592–3 and where he himself was later to make a dramatic début. Or he may have contributed to the rich and glowing swags which surround Cesari's frescoes in the Olgiati chapel in Santa Prassede, which introduced a decorative opulence into Roman art. But only Bellori offers clear information; he says that Cesari 'had him paint flowers and fruit, which he imitated so well that from then on they began to attain that greater beauty that we love today. He painted a vase of flowers with the transparencies of the water and glass and the reflections of a window of the room, rendering flowers sprinkled with the freshest of dewdrops; and he painted other excellent pictures of similar imitations.'[29]

It would have seemed natural to Cesari to entrust a young and untried Lombard painter with this kind of specialised task, for which northern artists were famed, and yet Caravaggio chafed at such restrictions, worked reluctantly, and longed to compete in the nobler Roman arena of figure painting. No pure still lifes from this early period survive (though they may well have existed, and certainly Caravaggio painted still life at a later date). But pictures which were almost certainly painted in Cesari's studio, or immediately afterwards, and which were still in his stock in 1607, include the *The Sick Bacchus* (Col. Plate 1) and the *Boy with a Basket of Fruit* (Col. Plate 2), and these do include prominent still lifes.[30]

These works intensely suggest Caravaggio's presence. The *Sick Bacchus* is a self-portrait, showing, for the first time, the dark Lombard, with deeply sunk eyes, whose black and sinister appearance later seemed an emblem of his dark art. Both are theatrical works, in which Caravaggio, with some flamboyance, presents himself and his art to a Roman public; they are the response of a northern artist, trained in a more naturalistic tradition, to the classical art of Rome, and both are in a sense provocative. They throw out a challenge to an idealising tradition, pitting against it the resources of a new naturalism, and yet at the same time bringing fresh life to the illusionism of ancient Roman art, re-creating the sense of wonder which the most celebrated painters of classical antiquity had aroused, their very virtuosity a reproof to the crude frescoes of the Sistine painters.

The insecure pose, and the subtly sad smile, of the *Sick Bacchus* convey both longing and withdrawal; it shows the young artist, pallid, melancholy, perhaps suffering from the illness which had put him in the hospital, and, semi-naked, an outsider, offering his Lombard skills, in portraiture and still life, to the Roman art world. And before him, like a symbol of his art, against the grey stone of the simple table, is placed an astonishing still life, of deep black grapes, luminous, transparent, flecked with highlights, and sharp yellow peaches against yellowing leaves. The still life seems somehow touchingly small and isolated, a plea for naturalism amid the stony rhetoric of Rome. But the naturalism of the semi-nude figure, so clearly studied from life, so astonishing in a Roman context, threw out a challenge of another kind; Bacchus, the ancient god of wine, of poetic inspiration, of conviviality, has become a sick Roman boy, with coarse, dirty fingernails, and only lightly disguised by his vaguely classicising shirt (secured by the black bow that Caravaggio was to use many times) and the trailing ivy leaves casually twisted in his dark curly hair.

The painting is a rethinking of ancient myth, an attempt to restore to it both fresh reality and mystery; it perhaps, too, conveys the artist's sense of his own power which none the less involves suffering. The figure's startling pallor – the greyish lips subtly related to the bloom on the grapes – suggests the deep shadows of melancholy, and perhaps

allude to the Renaissance belief that melancholy is associated with the privileges and dangers of creative genius. In a similarly self-dramatising spirit, laden with suffering and despair, the poet Giambattista Marino, who was later to become a friend of Caravaggio's, demanded of a portrait painter –

> Take the extremes of ice and heat,
> the horrors of a brown and shadowy night,
> and the pallor of death, and from this strange mixture
> make my true portrait[31]

Through suffering the artist ascends to immortality. On the brow of Bacchus the traditional ivy crown conveys the artist's confidence in his eternal fame, in the self-glorifying spirit in which the ancient Roman poet Horace had written:

> But me the ivy guerdon on learned brows
> Ranks with the Gods above . . .
> And should you list me among the lyric bards
> I shall nudge the stars with my lifted head.[32]

The other painting, of the glowing boy, with rosy skin, offering the spectator a basket of fruits, stands in sharp contrast to this pallid Bacchus, but this picture also courts the viewer, offering the sensuous delights of a newly naturalistic art. It creates a more convincing sense of illusionistic presence, catching the figure in the subtle play of light against the plain ground, and introducing, for the first time, the diagonal shaft of light which was to become a leitmotif of Caravaggio's art. The basket is of woven reeds, and the leaves, just cut, still bright, yet curling at the edges, delicately suggest the freshness of the fruits, of shining cherries, firm pears, and transparent grapes. The basket, curiously unrelated to the figure, seems suspended before us, as though inserted into the picture, and the highly detailed rendering of the varied surfaces and textures contrasts with the broader brushwork which sweeps in the face and drapery of the boy. The boy himself, his hair windswept,

his lips parted, is immediate, caught in a transitory moment, but his white shirt falls from his shoulder in a way that loosely evokes classical sculpture, and his shadowed eyes have something of the dreamy grace of Giorgione. The humble and rustic motifs — the windfall apples, marked and blemished — look back to Lombardy, and yet there is something of the richness and abundance of ancient Roman art, perhaps an echo of an old mosaic, or fragment of fresco.

Caravaggio would have been well aware of Pliny's trite stories about the fabled skills of ancient artists, of Zeuxis' grapes, rendered with such astonishing illusionism that the birds themselves swept from the air to peck at them; he may well also have known the then fashionable Philostratus' sensuous descriptions of ancient still life:

> See, too, the pears on pears, apples on apples, both
> heaps of them and piles of ten, all fragrant and
> golden. You will say that their redness has not been
> put on from the outside, but has bloomed from
> within. Here are gifts of the cherry tree, here is fruit
> in clusters heaped in a basket, and the basket is
> woven, not from alien twigs, but from branches of
> the plant itself. And if you look at the vine sprays
> woven together and at the clusters hanging from
> them and how the grapes stand out one by one you
> will certainly hymn Dionysus.[33]

Philostratus is describing a *xenia*, a painting of a gift offered to guests, and conveys a sense of a bounteous nature which delights the senses. In Caravaggio's picture, too, the boy offers brilliantly coloured fruits, there to be gathered, and the motif has a Golden Age note, a pleasure in simple nature such as that celebrated by the Horace, who, in the tranquillity of his Sabine farm, enjoyed 'a fruitful abundance of rustic glories [poured out] from a lavish horn'.[34] In a similar spirit, contemporary courtiers enjoyed the pleasures of the marketplace; Giovanni Battista del Tufo, languishing in exile (perhaps himself indebted to Philostratus), wrote nostalgically of such beauties in Naples, where the

gardener's boys, and the courteous street vendors, at break of day, tempt-
ed with their fruits:

> That mannerly fruit seller
> Who lays before you, choice and perfect, a thousand
> baskets . . .
> With all their sweet and mellow fruits,
> Seeing them thus exquisitely laid out
> Atop the tender verdant fronds:
> And you, thrice blessed,
> Are destined to sample these fruits, nay, tempting bait,
> Such as would make a serving maid a queen . . .

Theirs were fruits picked at dawn and most beautifully arranged on fresh
green leaves, the most perfect fruits placed at the summit. Their baskets,
of woven reeds, 'making a pattern graceful to behold', delighted the
eye, and he compared them to small paintings.[35] Caravaggio's picture is
insistently real and modern, a boy selling fruit in the Piazza Navona
– yet it is theatrical, set in an unreal space, and touched with echoes
of these poetic evocations of a Golden Age. And it is also a display of
artistic skill, designed to attract a patron through an attempt to rival
nature herself, reminiscent of Comanini's wonder over the miraculous
naturalism of Figino's peaches.

A group of works, once in the stock of Giuseppe Cesari, suggest the
immediate impact of Caravaggio's startling naturalism. These works,
whose enigmatic creator is now known as the Master of Hartford, include
a picture of *Fruits and Flowers in two Carafes* (Plate 14) and two large paint-
ings, a *Still Life with Fruit, Flowers and Vegetables*, and a *Still Life with Game Birds*,
both now in the Borghese Gallery in Rome. It has been suggested that
these works are apprentice pieces by the young Caravaggio, or that they
are composite studio works in which he may have collaborated. They do
indeed explore motifs familiar from Caravaggio's pictures. The *Fruits and
Flowers* shows a carafe of wild flowers, casting a shadow, lit in the centre,
on the white cloth, and a basket of fruit projecting over the edge of the
table, as in Caravaggio's London *Supper at Emmaus* (Col. Plate 22). The

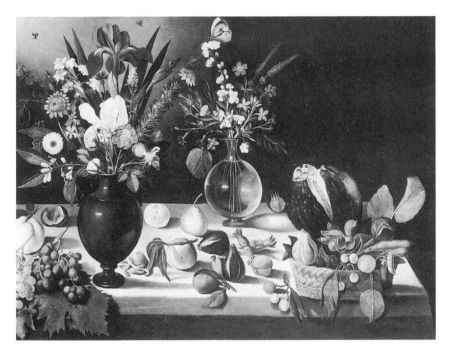

14. The Master of Hartford, *Fruits and Flowers in two Carafes*
(Hartford, Wadsworth Atheneum)

bright, crisp clarity of the light, and the patterning of objects along the
perspective lines, recall the same picture. But the painting does not
suggest an early phase from which the richness of Caravaggio's later still
lifes might develop; it has, rather, a simplified, archaic air, as if a more
naïve artist has become enthralled by the power of Caravaggio's vision,
has idealised and tidied up his fruit and flowers, and touched the picture
with a Flemish charm by adding the butterflies and other insects of
an older tradition. It seems likely that these works are by a precocious
follower, perhaps more than one artist (the game birds are surely by a
more pedestrian, cataloguing painter), who united a northern passion for
descriptive realism with an Italian interest in light and space, and they
may date from after the turn of the century.

Caravaggio's pictures, the heirs to Giorgione's half-length paintings of
young boys from the early years of the sixteenth century, yet with Roman
overtones, provocatively suggest a new kind of art, and one sharply at

odds with the metaphysical theories of art elaborated by Zuccaro at the newly reorganised Accademia di San Luca. Zuccaro, passionate to renew the dignity of the artist as intellectual and as creator, and to restore the noble traditions of Michelangelo and Raphael, was a key figure in reorganising the academy. He presided over the first meeting, on 14 November 1593, incongruously held in a hayloft – and was elected president. The account of the secretary, Romano Alberti, vividly conveys Zuccaro's pompous and ceremonial behaviour: Zuccaro, he wrote, rose slowly to his feet, bearing aloft his palette, and academic sceptre. Surrounded by his advisers, and brother painters, and many noble dilettantes, waiting for silence to fall, and looking with dignity around the room, he began slowly to speak. He opened with a lengthy and pious exhortation to unity and virtue, which alone could make man happy, and railed against dissolution, and the unbridled and extravagant behaviour which brought artists into disrepute. He proposed that, after Mass each Sunday and holy day, the members should enjoy theoretical debates, and discuss such subjects as the *paragone* (whether painting or sculpture was the superior art form), decorum, and theories of gesture and expression. The statutes later elaborated were extremely severe; 'No one in the Academy', reads one prohibition, 'shall dare to act otherwise than in a virtuous and modest way; one shall be quiet and peaceful, and shall in no manner provoke by griping and grousing.' He who defies the Principe shall be imprisoned on the Capitol, 'on simple order of Signor Principe'.[36]

A series of lectures at the Academy was planned for 1593–4, to be opened by Giuseppe Cesari, whom Romano Alberti described as 'a spirited young man', whose theme was 'figures, and what may be understood from movement, gesture and attitude . . .' Longhi was to speak on *grazia*, and the devoutly Christian, and cultured artist, Durante Alberti, a relative of Cherubino, was to speak on 'what is the true imitation of reality, and what is the real essence of the art of painting well'.[37] In the event Cesari lost his nerve and did not turn up for his lecture, but Cherubino Alberti gave a lively talk on decorum, and what it meant in regard to figures, expression and dress. The meetings of the Accademia were also attended by interested amateurs or virtuosi, such as Asdrubale Mattei, who in these years began to take an interest in purely

aesthetic debate. The lectures, however, fell very quickly by the wayside, as did the planned education of young artists, and already by 1595 the secretary was lamenting that the academy had been abandoned, and that nothing was happening there. But in Zuccaro's book on art, *Idea*, he elaborated his theories. Here, in sharp contrast to the writers who had dominated Caravaggio's Milan, he declares his belief that drawing, or *disegno (segno di Dio in noi)*, was supreme, and the grace and beauty which should be the goal of the artist pre-existed in the mind, and could not be taught. In the frescoes of his house, which itself suggested an ideal artistic life, he painted Disegno as a god enthroned, supported by three daughters, Painting, Sculpture and Architecture. To Zuccaro the purpose of Christian art was to make visible the invisible, and through the intellect to rise to the contemplation of the divine. Zuccaro's theorising, arrogance, and difficult language seem oddly out of date in the remark-ably theory-free 1590s, when so many new forms of art were taking root, and when both Annibale Carracci and Caravaggio were to express them-selves briefly and pungently. Caravaggio himself expressed admiration for Zuccaro, but the older artist held him in contempt.

In the early 1590s, Caravaggio was part of the ceremonial artistic life of Rome, and in the autumn of 1594 was one of 105 artists who took part in the liturgical devotion, the Forty Hours, performed as part of the celebrations in honour of St Luke, the patron saint of artists (St Luke painted the Virgin herself) which took place on the first Sunday of October. These artists, who belonged to the Accademia or the Compagnia di San Luca, are listed in pairs: Caravaggio, partnered by Prospero Orsi, performed his devotions between two and three on the Sunday afternoon. The Forty Hours was a Eucharistic devotion, com-memorating the Forty Hours that Christ spent in the tomb; the Blessed Sacrament, placed in a monstrance over the altar, was continuously exposed, and adored throughout the city, an adoration accompanied by passionate preaching. Caravaggio had not yet painted a work for a public place in Rome, the fundamental requirement for an artist's admission to the Accademia, but he may have been associated with it as a virtuoso, and he almost certainly became a full member later in his career.[38] Another pair of artists who, fascinatingly, took place in these

devotions together were Orazio Gentileschi and Caravaggio's biographer Baglione. They were an ill-matched pair: Gentileschi, a Tuscan artist, was a difficult, troublesome character; the Roman Baglione was a pillar of respectable artistic society, passionate to rise to the knighthood. They were to be the first artists to fall under Caravaggio's powerful spell, and Gentileschi became his best and most poetic follower. But in time Gentileschi and Baglione became bitter enemies, and their lives remained stormily intertwined.

In this procession and in these studios, we see Caravaggio at the centre of Catholic Rome, and at the heart of the official and academic art world. His early works, his glowing fruits, so rooted in the senses, became in a sense an emblem of his art, and Caravaggio later told Vincenzo Giustiniani that 'to make a fine painting of flowers was as much work for him as to make one of figures',[39] provocatively stressing his Lombard skills of hand and eye. But nonetheless much of the power of his mature art depends on his union of the natural and the ideal, and, though he professed to scorn the antique, he remained on good terms with artists from the official world, and the compositions of Raphael and Michelangelo later influenced his work. He perhaps absorbed poses and compositions through the engravings of his friend Cherubino Alberti, a skilled professional engraver of the most celebrated Renaissance and Mannerist artists.

Floris van Dyck sent back to Carel van Mander, the Dutch biographer, in Holland an account of his days in the studio of Cesari d'Arpino, and something of their atmosphere is caught in van Mander's description of Caravaggio, the first to appear in print:

> . . . he has climbed up from poverty through hard work and by taking on everything with foresight and courage, as some do who will not be held back by faint-heartedness or lack of courage, but who push themselves forward boldly and fearlessly and who everywhere seek their advantage boldly . . . for Lady Luck will rarely come to those who do not help themselves . . .[40]

A Gypsy, Cardsharps
and a Cardinal

CARAVAGGIO LEFT THE STUDIO of Giuseppe Cesari dramatically, in a situation clouded with suggestions of violence and enmity. Illness and ambition spurred him on; he was tired of his role as Lombard still-life painter, his genius rebuked by the immense acclaim of Cesari. At his side, egging him on, was Prospero Orsi. When the two artists met, wrote Bellori, 'Caravaggio took the opportunity to leave Giuseppe in order to compete with him for the glory of painting . . . despising the superb statuary of antiquity and the famous paintings of Raphael.'[1] Prospero, once so enraptured with Cesari, had turned violently against him. Baglione puzzled over Prospero's rebellion, commenting, 'I don't know for what reason, but, after a little time, he grew less friendly towards Cesari, and became a henchman of Caravaggio, doing his best in every way to oppose the Cavaliere',[2] concluding brusquely that Prospero's inconstancy made him generally disliked. But Mancini spoke more warmly of him, saying that there was no artistic project in Rome in which he was not involved, and that he was well known for helping young artists establish a foothold in court circles. He was, moreover, particularly well placed to do this, as his brother, Aurelio Orsi, was a distinguished poet, and secretary to the powerful Farnese.[3] Perhaps the freshness of Caravaggio's naturalism had been a revelation, and Prospero had in a sense undergone conversion. He had become so convinced of the power of this startling new art, so unlike anything else in Rome, that he encouraged Caravaggio to kick over the traces, to reject old-fashioned authority, and to risk independence. A powerful advocate, in touch with many noble families, he set out to launch his friend's career, singing his praises throughout Rome, as once he had Cesari's; he was so effective that his efforts were resented by other artists.

But independence was risky, and initially hardship followed for

Caravaggio. Mancini tells us that he stayed first with a certain Asdrubale[4] (just possibly a later patron, Asdrubale Mattei, who at this time was involved with the Accademia di San Luca) and then with a churchman, Monsignor Fantin Petrignani, who 'gave him the comfort of a room in which to live',[5] in his palace in the Piazza di San Salvatore in Campo, close to where Prospero Orsi lived with his mother, Carlotta. It was in a poor part of Rome, described in an earlier census as consisting of two hundred houses with 'low and dishonest people, very many prostitutes, and some Jews'[6] and close to Sixtus's vast refuge for the poor, and the Trinità dei Pellegrini. As Petrignani was away from Rome in 1594, it is likely that Caravaggio's stay with him was early in 1595.[7] On the other hand, Baglione tells us that he tried to live by himself, painting many works for which he could find no buyers, and suffering harsh poverty; too poor to afford a model, he painted his own face in a mirror and was forced to accept humiliatingly low prices. For help Caravaggio and Orsi turned to a dealer, Costantino Spata. Costantino had been a dealer since 1593. He lived over his shop in the Piazza San Luigi dei Francesi with his wife, Caterina Gori, and his four children, and he worked alone, closing the shop when he went out. Spata was a friend of the two painters, spending his evenings with them in the neighbourhood taverns. He had a good eye for new talent, and through him Caravaggio was to attract the attention of Cardinal Del Monte, a collector on the look-out for new artists, and for works that were not too highly priced.

Caravaggio's introduction to the circle of Cardinal Francesco Maria Del Monte was most important, for it was through Del Monte that he was to win a wider fame and to obtain the most prestigious Roman commissions. Del Monte was the most significant figure in Caravaggio's Roman years, and his tastes and interests were important to Caravaggio's art. A voracious intellectual, with a dazzlingly wide range of skills and knowledge, in music, theatre, literature, art and archaeology, history and the natural sciences, he was also a protector of young artists, in whose education he took the most detailed interest. No origins could have been more auspicious for such a career than those of Del Monte. Born in 1549 in the Fondaco dei Turchi in Venice, his baptismal ceremony was graced by the greatest luminaries of the Venetian literary and artistic world: the

poet, letter writer and dramatist Pietro Aretino; the painter Titian, and the sculptor and architect Jacopo Sansovino. His father, Ranieri Del Monte, a friend of Aretino, was in the service of the Della Rovere family, and he himself, and his brother, Guidobaldo, who later became a mathematician and distinguished writer on perspective, were educated at the Della Rovere courts in Pesaro and Urbino, with Torquato Tasso and the prince, Francesco Maria Della Rovere. The two Del Monte brothers spent a period in Padua, from 1564 to 1570, where the prestigious Studio Padovano attracted scholars from throughout Europe.

At the court of Urbino Del Monte enjoyed a youth distinguished by refined and subtle worldly pleasures, for which the place was famous. Guidobaldo da Montefeltro's Renaissance court at Urbino had been the setting of Baldassare Castiglione's *Book of the Courtier*, which defined the courtly ideals of *sprezzatura* (seemingly effortless accomplishment and physical prowess), and of delight in sophisticated pastimes, and Del Monte flourished in that atmosphere. Castiglione gives a vivid picture of this early Renaissance court; 'to the opinion of many men, the fairest that was to bee found in all Italie; and so furnished it with all necessary implements belonging thereto, that it appeared not a Palace, but a Citie in forme of a palace, and that not onelye with ordinarye matters . . . but also for sightlines; and to decke it out withall, placed there a wondrous number of auncient Images, of Marble and Mettall, very excellent paintings and Instruments of Musicke of all sorts . . .'[8]

Here Del Monte enjoyed a charmed youth, and there are hints of its pleasures in his letters. In his later years he wrote nostalgically to a friend, 'One remembers when we played ball, and all the sweetnesses [*melerie*] with the Artemisias and the Cleopatras, yet all passes . . .'[9] A particularly touching vignette of the cultured life at Urbino is given by Agostini, who described an outing on the lake, where there drifted past him another boat, bearing 'the celebrated political thinker and moralist Fabio Albergati and the mathematician and musician Guidobaldo Del Monte, who invited us all to sing some motets from Willaert'.[10] Music remained a lasting passion, and it was also at Urbino, the home of Titian's *Venus of Urbino*, that Del Monte became attracted to Venetian art, to its brilliant colour and warm naturalism, and to its richness of surface

and texture. To such beginnings Padua added the stimulus of the scientific interests of the Studio Padovano, and an interest in the naturalistic art of Flanders, long popular in northern Italy. Here, in 1566, Del Monte commissioned his first work of art, a medal (now in the British museum in London), which shows on one side an elegant profile portrait, with high collar and curly hair, of the seventeen-year-old Francesco Maria, and on the verso his *impresa*, which consisted of a flaming mountain, and the words *Sidera lambit*, an invocation suggesting courage and boundless ambition. The medallist was Ludovico Leoni, whose son Ottavio was to become a protégé of Del Monte, and, as a famous portrait draughtsman, was to draw Caravaggio.

Steeped in the cultural interests of northern Italy, of Venice and Padua, Francesco Maria Del Monte moved to Rome, probably around 1572. He swiftly became involved in the Roman art world, encouraging young artists from Urbino, in whose artistic education he took the most detailed interest, and expressing his admiration for the naturalistic art of Scipione Pulzone. His rise to eminence was ensured by his winning the patronage of Cardinal Ferdinando de' Medici, whose closest and most valued adviser he became.

Cardinal Ferdinando de' Medici was the second surviving son of Grand Duke Cosimo I, and, destined for the church from his earliest years, he had been made a cardinal at the age of fourteen and had taken up residence in Rome. Here he lived in great princely splendour, winning a reputation as a patron of music and of art. In 1587 he bought the Villa Medici on the Pincio, and created there a sculpture garden, enriched with some of the most celebrated ancient sculptures; but he was active too in religious Rome, and served as protector of the hospital of the Trinità dei Pellegrini, founded by Filippo Neri in 1548. He was well liked by his contemporaries, admired for his quick intellect, his skill and caution in diplomacy, his wide learning, and his pleasure in mixing with scholars, scientists and men of letters. He drew men to him, for he delighted in *conversazione*, and mixed gravity with sweetness. His secretary, Usimbardi, wrote his biography, his tribute warmly evoking Ferdinando's charm of manner: 'He was of a generous spirit, drawn to great undertakings . . . he was sincere, free and open in his behaviour . . . And with this manner,

accompanied by a certain natural cheerfulness, enhanced by the majesty of his bearing, he attracted everyone, drawing them to him . . . He did not lack an inclination to licentiousness, but did not so abandon himself that he won disfavour . . .'[11]

Del Monte had been politically involved with Ferdinando in the 1570s, and had many times travelled to Florence with him. By 1586 he had become indispensable to the Cardinal; there were rumours that he was also his secretary in affairs of the heart. But in 1587 all this was to change dramatically, when Ferdinando's elder brother, Grand Duke Francesco I, and his wife, Bianca Capello, died of fever within a day of each other. There were rumours of poison, and Ferdinando, renouncing his vows, hastily returned to Florence to become Grand Duke, taking Del Monte with him. In 1588 Tommaso Contarini, the Venetian ambassador to Florence, described the Medici court at the moment of Ferdinando's accession to the throne. The Grand Duke, he wrote, ate alone, admitting no one to his table, with the exception of Del Monte, who 'took part in all his most secret thoughts . . . he was so tireless in his service, that neither in the country, nor in the city, nor for any reason, while he was in Rome, did he leave his person . . . [Del Monte] is well versed in letters and other learning . . . and the Duke loves him and takes pleasure in his being praised and esteemed.'[12]

Francesco I had been deeply unpopular, and by contrast Ferdinando, a subtle diplomat after his years at the Roman court, was well liked in Florence. Almost at once he reversed the pro-Spanish policies of his father and brother, deciding to marry a princess of Valois France, Christine of Lorraine. Their wedding, in May 1589, was accompanied by extravagant theatrical entertainments, planned to honour the Medici dynasty. There were triumphal entries, naval battles, comedies, and, above all, musical interludes or *intermedi*, in spectacularly complex settings, the most lavish ever created. The Grand Duke had brought the Roman composer Emilio de' Cavalieri (the son of Tommaso Cavalieri, the beloved of Michelangelo) to Florence, where he administered the wedding festivities, and was also made overseer of his artistic workshops.

As the wedding preparations took place, Del Monte was in Rome, for on 14 December 1588, through the offices of the Grand Duke, he rose to

the purple, thus ensuring the continuation of a Medici supporter in the affairs of the Curia. Thrown off balance by this sudden turn of events, he wrote to Ferdinando on 9 January 1589, '. . . and withal, although I am a Cardinal, Rome without you seems no longer Rome, nor can I stay longer without coming to render you service . . .'[13] He returned for the wedding, but in the autumn of 1589 he took up residence at the Palazzo Madama, the Medici palace in Rome, and over the next years he worked as Ferdinando's political agent and artistic adviser in Rome.

A link between the artistic worlds of Rome and Florence, Del Monte was deeply involved in the most brilliant and lavish entertainments of the Medici court, both musical and theatrical, and in building up the Grand Duke's collections of art and science. Ferdinando was, moreover, interested in science, and in enriching the Medici collections of naturalia; he corresponded with the Bolognese scientist Ulisse Aldrovandi, and artists of such distinction as Jacopo Ligozzi were employed to make drawings of plants and animals. Del Monte moved easily in such a context, and in Rome, in his own collections of art and science, he was to echo the Medici interests. He may have met Galileo in Rome in 1587, and Galileo was also supported by his brother, Guidobaldo. They failed, however, to win for him a much desired chair in Florence, but negotiated a similar post at the University of Pisa.

Del Monte's life in the Palazzo Madama is touchingly described by Emilio de' Cavalieri in a letter of 19 November 1593, addressed to Marcello Accolti, the secretary of Ferdinando de' Medici:

> Del Monte amazes me in regard to spending that
> he can live on what he has and do it so honourably.
> It is true that for his clothing he doesn't spend a
> *giulio*: he has had only one livery made; his coach is
> also the first he has had; he makes the best of what
> he has; he has bought himself a carriage and with
> this he keeps himself; the mouths [he feeds] in all
> don't amount to fifty; he doesn't keep horses or
> gentlemen but his servants are treated well and given
> good meals — all that is seen through your highness's

favour of a beautiful home, which is now finished; as
a cardinal of Rome, he formally receives in the
morning with his silverware; and he is courted by
more Romans than cardinals for his great trafficking,
which is all honest, with his metalworkers; and his
antechamber is always filled with people; there are no
high-ranking clergy. The reason for this is that he is
not involved in important transactions and those that
come do so only to visit.[14]

Del Monte was not a rich cardinal (in 1605 he had an income of 12,000
scudi, comfortable but very far from lavish)[15] and the simplicity and
modesty of his life is a recurrent theme in contemporary descriptions, as
is his charm of manner. In Cavalieri's letter Del Monte's simplicity seems
attractive, and is conveyed with freshness and directness by someone who
knew him well, capturing the atmosphere of his court on the eve of
Caravaggio's move to the Palazzo. But he was also well known for
his pleasure in the world, in the elegant refinements of courtly life, a
quality caught vividly in an anonymous description of 1603 – 'Monti is
a gentleman, a fine musician, a ready joker: he takes the world as it
comes, has a thirst for life, and has friends in the world of letters.'[16] His
theology was beyond question, but to some his delight in life seemed a
little extreme; it was only in his old age that he took up devotion, and
then, as the Venetian ambassador wryly remarked in 1623, to compensate
for the pleasures of his 'more lively youth'.[17]

The contemporary descriptions are often bewilderingly contra-
dictory, but perhaps the subtlest is that by an anonymous writer of 1621,
which sums up all these traits, and yet also conveys the sharpness of his
intellect, and his skill in negotiating the world, in treading warily
amongst the great and powerful, with an appearance of modesty and
charm:

No one was ever a greater lover of recreation and of
leisure, and none more skilful at negotiations. He
drew all hearts unto himself. His quickwittedness,

adroitness, charm and wit: his interest in all things curious, and his knowledge of sounds and songs; his intellectual nimbleness and other aspects yet, in keeping with the sweetness of his temperament: all these, and his modest and unassuming ways, earned him the goodwill of Ferdinando de Medici, whence came his fortune. People say that this jesting and love of leisure conceal a certain ability to set great things in motion, should occasion arise. It is said of him that he is never carried away by any partisan feeling in gatherings or councils, and that he is a man of singular rectitude and integrity: he dresses in the fashion of the ancient Spartans, is open-handed in public and sparing at home, in works of piety commensurate with his fortunes: he is second to none in his quiet, modest courtesy, and lives in unostentatious, uncalculating simplicity.[18]

In Del Monte's own letters he reveals a sharp wit, a dry turn of phrase, and a mocking, ironic acceptance of the structures of worldly power which accord well with this letter.

In the early months of 1595, Caravaggio stayed with Fantin Petrignani, who seems to have had little interest in art,[19] although Anton Maria Panico, a Bolognese pupil of Annibale Carracci, had decorated his palace with frescoes that were much admired for their colour and skill.[20]

Caravaggio however turned to his friend, Costantino Spata, and, with two colourful and Venetian genre pictures, *The Gypsy Fortune Teller* (Col. Plate 3) and *The Cardsharps* (Col. Plate 5), redolent of the popular theatre which Del Monte so admired, Caravaggio and his dealer tempted the Cardinal.[21] Del Monte bought the *Cardsharps*, and perhaps the earlier *Gypsy Fortune Teller*, from Costantino, the latter a work which Caravaggio, now without protection, was forced to sell for the humiliatingly low price of eight scudi. It is possible that Caravaggio brought this picture, painted over a used canvas, with him from Cesari's studio, or finished it after taking lodgings with Petrignani.[22]

These two works, whose brilliant colour was quite unlike anything in Roman art, and which are so humorous and direct in their portrayal of human character, and so strong in the sense of a moment seen, were deliberately provocative. In an art world dominated by large-scale frescoes, often crudely painted, and by the *maniera statuina* of so many sixteenth-century painters, they assert the power of a new and naturalistic art, and the pleasure of a startlingly novel subject, the tavern and street life that Caravaggio knew so well. The theme of both paintings is the same – deception and the snares that beset innocent youth.

In *The Gypsy Fortune Teller* the young man falls sweetly in love as the gypsy steals the ring from his finger, and in *The Cardsharps* he falls into the hands of cheats. Women and cards appear as two great perils in much Renaissance literature; Aretino had described cards as the prostitute's greatest enemy, for only they could arouse as great a passion. Bellori (who is writing of the second version of the painting, now in the Louvre, Paris) makes it very clear that Caravaggio intended *The Gypsy Fortune Teller* as a manifesto of naturalism. He tells us that when Caravaggio left the studio of the Cavaliere he began to 'paint according to his own inclinations'. With challenging bravado, he professed his scorn for those idols of the Roman art world, the famous paintings of Raphael, and the superb statuary of antiquity. Instead he considered nature to be the only fit subject for his brush. To demonstrate this:

> . . . when he was shown the most famous statues of
> Phidias and Glykon in order that he might use them
> as models, his only answer was to point towards a
> crowd of people, saying that nature had given him
> an abundance of masters. And to give authority to
> his words, he called a Gypsy who happened to pass
> by in the street and, taking her to his lodgings, he
> portrayed her in the act of predicting the future, as
> is the custom of those Egyptian women. He painted
> a young man who places his gloved hand on his
> sword and offers the other hand bare to her, which
> she holds and examines; and in these two half

figures Michele captured the truth so purely as to confirm his beliefs.[23]

However, the relationship of Caravaggio's painting to nature is complex and indirect. Gypsies had first been chronicled in Italy in the early fifteenth century, when they had been welcomed as pilgrims. Very quickly this welcome had turned to fear and contempt, and by mid-century they were universally described as beggars and robbers. There are many descriptions of their skill and deftness as thieves, and Anton Maria Cospi's *Il Giudice Criminalista*, a magistrates' handbook, provides a collection of gypsy stereotypes. 'They are robbers by nature, the descendants of Cos, the son of Cam, cursed by Noah';[24] and 'the women steal hens, and while they pretend to predict the future from the palms of the hand, they steal from the peasants'.[25] Condemned to eternal wandering and poverty, gypsies led a miserable life, and in Ripa's *Iconologia* the gypsy was an emblem of poverty. A newspaper of 14 June 1570 tells us that many remained in Rome, and that Filippo Neri had protested at the Pope's desire to round them up and send the men to the galleys. But the gypsies were also objects of curiosity. Their exotic dress, their air of mystery, the aura that they brought with them of strange and mysterious worlds, of erotic promise, of arcane, perhaps dangerous knowledge of magic and prophecy, exerted a considerable fascination. It was perhaps this that made them so popular in the theatre, and they became the subject of popular songs, called *zingaresche*, which flourished particularly in Rome, and were performed in the streets. In one such song the gypsy sings

> From distant countries and strange places,
> Weary, are we come, little by little,
> Only to give to you delight, and festival . . .[26]

They also figured frequently in the *Commedia dell'Arte*, a type of popular drama, often performed out of doors, which employed stock characters and depended on spontaneity and improvisation. Many of these comedies are intrigues of disguise and of recognition, which spin out vast webs of trickery and lying; and show innocence and virtue snared

by wily and corrupt opponents. They bear such titles as *The Deceived, The Theft, The Furious Lover, The Gypsy Thief.* One anonymous comedy opens with the declaration 'Here shall you see the tricks of a cunning gypsy', and another pastoral eclogue promises —

> Here shall you see an innocent gull
> Fooled by a crafty gypsy and a peasant . . .'[27]

In 1589, at the sumptuous wedding celebrations for Ferdinando de' Medici and Christine of Lorraine, the Gelosi, a long-established and distinguished company of actors, had performed Gigio Artemio Giancarli's 1545 comedy, *The Gypsy,* in which the gypsy plays a central role as kidnapper, temptress and subtle thief. These actors brought a popular touch to the celebrations, but they were court entertainers and were almost certainly invited by Del Monte, who was himself present. The star performance of Vittoria Piisimi was much admired, and described by a spectator with delight and wonder — 'but whoever has not heard Vittoria perform the Gypsy (that is imitate the language and customs of gypsies) has neither seen nor heard something rare and marvellous'.[28] It became her *pièce de résistance,* for which she was famed, and the court was amused by her rivalry with the other leading actress of the Gelosi, Isabella Andreini, who performed *La Pazzia* (Madness). The costumes became known through a series of French engravings, which Caravaggio may have known.[29]

It may be that Caravaggio was already trying to attract the attention of the Cardinal, and his treatment of a popular theme (like the work of the Gelosi themselves) is highly sophisticated and subtle, intended to appeal to the most élite audience. The gypsy, far from bringing with her the dirt and tatters of the street, as Bellori's anecdote might imply, is beautifully dressed and carefully posed, while the young man flaunts a rich and elaborate costume, with plumed hat and short cloak. The gypsy's dress, lovingly described, with the chemise gathered up and trimmed round the neck with a band of embroidery (that Caravaggio often used), conforms to descriptions in contemporary costume books. Cesare Vecellio, for example, in a costume book of 1590, describes the

cloak of long woollen cloth (*panno*) that gypsies wore, 'over the shoulder, passing it under the other arm; and it is long enough to reach down to their feet'.[30] Her face is caught in the play of light in the corner of Caravaggio's studio, suggesting that Caravaggio has re-created a fleeting moment in the life of the street. But it is also a painting of a moment in the theatre, an imitation of an art that creates a different kind of illusion, and it evokes that atmosphere of deceit and enchantment that is so central to the *Commedia dell'Arte*. The picture seems a plea for the magical deception of painting itself, for an art that is warm, instinctive, that enraptures and beguiles the spectator in a way far removed from the tired pedantry of Roman classicists.

Caravaggio's theme was unprecedented in Rome, and has only shadowy forerunners in north Italian and north European art. Such comic subjects were permissible in a Cardinal's collection because they ridiculed vice,[31] and Ripa described the Gypsy as an emblem of comedy, because she was low in society, as comedy was low in the hierarchy of the arts; her dress was to be of various colours, their variety signifying the diverse actions dealt with by comedy, which delight the eye of the mind. The frontispiece of an early seventeenth-century edition of Ariosto's *Comedies* shows a gypsy very similar to Caravaggio's, with a turban, and a mantle draped over the left shoulder.[32] It may be that Caravaggio intended his picture as the emblem of a new kind of popular subject, transformed by the magic of his art. But it was the beauty of the gypsy, and her power to deceive, that enchanted his contemporaries, as Gaspare Murtola's madrigal of 1603 makes clear:

> I don't know which is the greater sorceress:
> The woman, who dissembles,
> Or you, who painted her . . .[33]

The picture continued to be read in this way – the poet Ottavio Tronserelli, in his *L'Apollo* of 1634, addressed three poems to Caravaggio's *Gypsy Fortune Teller* (although he was writing about the Louvre version, then in the collection of his friend Alessandro Vittrice) and in each played on the theme of illusion and reality. One such concludes –

> Even when painted, woman ever lies:
> Hence, never shorn of tricks,
> To one she may seem lifelike,
> And to you, alive . . .[34]

— forcefully suggesting that the painting was seen as a kind of manifesto.

The theatrical figures of *The Cardsharps* are companions of *The Gypsy Fortune Teller* and like her they draw both on the life of street and tavern and on literary and iconographic prototypes. In the Renaissance, skill at cards had been amongst the accomplishments of the courtier; on the frescoed walls of the Casa Borromeo in Milan (which Caravaggio would certainly have known during his youth), elegant courtiers play cards, and in Renaissance art and literature games of chess and cards subtly convey allegories of love and power. In the early sixteenth century Francesco Berni, in his *Capitolo del Gioco*, had sung the praises of Primiera, a game not unlike the modern poker, playing on the sexual connotations of the word:

> A man's whole three score years and ten
> Even Tithonus' lengthier span
> Would not suffice to tell of primiera.[35]

His *Commento alla Primiera* is a light-hearted formal play on the same low theme, which, as Caravaggio's art was to do, inverts hierarchies and attacks stylistic decorum.

But beyond the court, preachers thundered against the evils of gaming, cards and dice; in northern Europe, in a harshly satirical print by Hans Holbein, *The Gamblers*, from a series of *The Dance of Death*, death and the devil fall upon a brawling card player. In Italy gambling, which often led to bloodshed and to duelling, was seen as so great a social evil that Sixtus V issued an edict against it in 1588. So desperate for money was he, however, that he separated dice from cards, banning the former utterly, but levying a useful tax on card players. But writers continued to inveigh against both. In 1617 A. Rocca, in his *Treatise for the health of the soul and for the preservation of property and goods against card and dice players*, wrote of

'the many sins and horrendous disaster which are born from these abominable games'.[36]

Despite such tirades, gaming was a true passion in every sector of Roman society. Ferdinando de' Medici was a great gamester, reproved by the Pope himself for leaving thousands of scudi on the gaming table, and Del Monte enjoyed playing with Cardinal Pietro Aldobrandini. In a letter of 22 August 1597 he described a dinner with Ottavio Farnese and Pietro Aldobrandini, where they had gambled – 'there was a great battle, and Aldobrandini and I lost, however I more than he'.[37] The saintly Camillo de Lellis suffered over his youthful love of cards, and instructed his followers to urge gamesters to penitence; the angelic Guido Reni was addicted to the table. And in the squares, taverns and guardhouses, in the stables and gardens of the great palaces of princes and cardinals, soldiers and servants played cards and dice. In 1595, a police captain, Valerio Baroncelli, while patrolling the Strada delli Greci, entered the Tavern of the Blackamoor, where Caravaggio and his friends often ate and drank, and there arrested a group of three dice players, whom, 'he had often been told, had reputations as cheats'. One of these friends, Dionysio, lived, like Caravaggio, in a rented room near San Salvatore, and had lost a great deal of money that summer, particularly in the game at the Piazza del Duca; another, Bartolommeo, was well known as a cheat, and had been thrown out of his lodgings for this. Their evidence gives a vivid picture of cheating, of the sudden appearance of jewels and of gold chains, and of where they played, on holidays, and on other days 'when there was nothing to do' – in the gardens of Cardinal Montalto, with the grooms of the house of the Contestabile Colonna, at the Piazza del Duca, in the palace of the Marchese del Riario and of Don Verginio Orsini.[38] The craze continued, and in 1611 a newspaper announced: 'On Wednesday in the Piazza Borghese some card players were seized . . . and on the following day 30 vagabonds and idlers were taken, who had played cards there all through the day without any respect for Lent.'[39]

Caravaggio's picture is, then, vividly topical, a warning against the dangers that beset the gullibility of youth. It was a scene of cheating which he may well have seen in the Tavern of the Blackamoor, yet its immediacy is enriched by its allusion to the conventions of the theatre.

Bellori described it in detail: 'He showed a simple young man holding the cards, his head portrayed well from life and wearing dark clothes, and on the opposite side there is a dishonest youth in profile, who leans on the card table with one hand while with the other behind him he slips a false card from his belt; a third man close to the young one looks at his cards and with three fingers reveals them to his companion.'[40]

Its main characters, the cheat and his accomplice, are two *bravi*, or soldiers of fortune, a type thrown up by the disastrous upheavals of the sixteenth century, without trade or home, hangers-on at the small courts of the nobility, fomenting civil strife. Such men had been banned from Milan in 1583, where the edict embraces 'all vagabonds, rascals, cheats, idlers and others who wander round the squares, taverns and brothels, calling on God, under the pretext of being poor soldiers just returned from the wars'.[41] They were, however, absorbed into Renaissance comedy, the heir to the Latin *miles*, the rough footsoldier. Poor, bedraggled, in torn clothes, but sporting odd bits of finery, often brandishing weapons, they swagger across the Renaissance stage, snaring innocent youth in their toils. They are forced to live by their wits, and act as pandars, pimps, hangmen's helpers; through gaming and cheating they struggle to keep body and soul together. Such is Spampana, who features in Venturino da Pesaro's *La Farsa satyra Moral* (1521) and tempts the godly youth, Asuero, with dicing, cards and other idleness; or Passamonte, the loathsome braggart of *Il Parto Supposito*. cursed with ill luck at gambling.[42] Most famous was Capitano Spavento, a remarkable amalgam of complex literary sources, adept at dicing and cards. He was made famous by Francesco Andreini, leader of the Gelosi, who played him for many years, and who in 1607 collected together his dialogues as *Le Bravure del Capitano Spavento* (*The Brags of Captain Frightall of Hell Valley*). Francesco was the husband of Isabella, star of Ferdinando's wedding celebrations, and Del Monte may well have known him.

Caravaggio's cheats, predatory in gaudy blacks and yellows, wear raffish finery, brilliantly coloured damask doublets patterned with bold applied stripes of black, torn gloves and ill-matching sleeves, the elder sporting a tattered doublet patterned with small sprigs. In their midst sits the young and wealthy boy, his features delicate, his plumed hat neat,

his sober black sleeves rich and voluminous, and trimmed with delicate Italian embroidery. He is the innocent gull, but he is also the mirror image of the young cheat, and it seems that Caravaggio used the same model, reversing the pose. The elder man is more comically sinister, his grimace and swirling moustache adding a touch of the stage villain, and his finger, its tip revealed by the torn gloves at the very centre of the composition, the apex of the triangle. This finger is perhaps the polished, oversensitive finger of the cardsharper, one of the many tricks against which contemporary writers warned. A catalogue of such tricks became a literary genre, and Cospi, in *Il Giudice Criminalista*, devoted a chapter to them. He described how some 'use cards thick with colour, so thick indeed that they have a noticeable bulk, and are held by the middle finger of the right hand at the top, which is very smooth, so smooth in fact that they have what amounts to a thin skin, and for this reason they give out a very precise message in that area, so that in running said finger over the card it senses those colours, and knows which card is underneath; particularly the chalices, and the court cards, where the most solid colour has been applied . . .'[43] He continues: 'and if an outsider should take it into his head to play with other cards, this does not in the least deter such cardsharps: quite simply, one of them stands behind the person playing with them during the game, and lets his companion know which cards the player has in his hands by means of nods and winks'.[44] Most interesting is Pietro Aretino's *Le Carte Parlanti*. This is a defence of cards, but it also embraces a warning against cheats, with a dazzling array of the evil practices of low-class card cheats, who catch the reflections of cards in the polished hilts of their swords, whose fingers, the hands of clever cheats, are highly polished, and whose touch 'is dextrous like those of gypsies',[45] and illustrated with small vignettes from the everyday world. Nevertheless, Aretino also saw in the card player something robust, happy, and full of life, which he opposes to academic pedantry.

This, too, is the theme of Caravaggio's picture; he startled the classical art world with a story from the everyday world; the morality is lightly worn, and its subject is warmly human, glowing with lifelike colour, and vivid in gesture. Caravaggio began with something that he had seen, a moment rooted in reality, but turned it into a story, a

painted novella. He knew the inns of Rome, the Tavern of the Turk, and the Tavern of the Blackamoor, where he dined with Prospero Orsi and other artists, and where gamblers played; they were famous, and wittily characterised in a contemporary comedy, *The Inn at Velletri*, in which Monello, an old waiter who had worked in Rome, describes what he has learned in the famous hostelries of Rome: 'At the Moon to put water in the bottles at night. At the Star to rob fodder from the horses in the stables. At the Eagle to live as a predator. At the Turk and the Blackamoor [where Caravaggio drank] to be bad at paying.'[46] Cavaraggio's picture, like *The Gypsy Fortune Teller*, shows the life of the tavern, but rendered as comedy, and brilliantly displayed for the delight of the court; he rejected the world of the ancients, those celebrated sculptures of Antiquity which Taddeo Zuccaro had so feverishly drawn. Instead he painted the life of the streets, and with these paintings about trickery, tempted the world of the courts, where all was illusion; and with their strong overtones of Venetian art, he perhaps particularly courted Del Monte. *The Cardsharps* won him immense success, startling Rome above all with the brilliance of its colour, and many collectors sought copies of it. And it was after buying this picture, Bellori tells us, that Del Monte rescued Caravaggio, and gave him an honoured place in his household.

It is significant that the earliest picture by Caravaggio that Del Monte owned was *The Gypsy Fortune Teller*, symbolic of the lures of woman, for Del Monte, after his death, was to be maliciously described as a lover of boys, and Caravaggio's later paintings for him have often been seen as homoerotic works for a patron of similar tastes. In a group biography of Cardinals, the Flemish writer Amayden suggested first that Del Monte acted as a pandar for Ferdinando de' Medici, and then mercilessly mocked the simplicity of his way of life – 'In his house he was frugal and saving, so that he used cheap and ragged clothing, and though he sometimes carefully covered his throat with silk underpants, he wore worn-out shoes in public.' Worse sins follow:

> He was of unusual sweetness of behaviour, and
> loved to be familiar with youths, not, however, for

a criminal reason, but from natural sociability.
This is presumably connected with the fact that he
prudently hid it before Urban was elected. When
Urban was made Pope he threw off all restriction;
in the longed-for reign he indulged his inclination
openly, and, though aged and almost blind, more a
trunk than a man and thus incapable of allure, a
young man of short stature got a benefice from
him.[47]

Amayden adds, for good measure, the startling remark that Del
Monte was 'stoked up in mediocre learning' ('*litteris erat imbutus medioc-
ribus*').[48] In the early 1590s, however, the young Cardinal was struggling
against criticism that he was too easy a prey to the sweetnesses of
Artemesia and Cleopatra. In a passionate letter of 9 July 1593, written to
Belisario Vinta, the Medici Secretary, Del Monte goes to great lengths to
dispel rumours that he was too dedicated to pleasure, and careless of
Florentine political interests. He answers the Grand Duke's criticisms
one by one, beginning with the frivolity of his way of life:

> As for my life, so given to pleasure, I submit that I
> stay all day at home, receiving no one if the time is
> inconvenient; I go out either to fulfil my duties, or
> towards the evening, around half past ten, and by
> midnight I am back home. It is over ten months
> since I have gone out at night . . . Women have never
> entered my house, or at least rarely, and all this I
> shall show to be the simple truth; and if you wish
> to send a witness, I shall not only provide for him,
> but have him sleep in my room.[49]

In the rest of the letter he declares his loyalty to the Grand Duke's
interests, whose reputation he defends, and whose views he conveys,
with freedom and liberality, in the papal congregations. He would, he
concludes, throw himself down a well should the Grand Duke so wish.

The rift seems to have healed, for there are no further suggestions of it in the letters. Amayden was politically opposed to Del Monte, an unreliable historian and extremely hostile witness, whose report carries little weight. Caravaggio, it seems, felt no such hostility. It is likely that he moved into the Palazzo Madama in the autumn of 1595, and he was to enjoy the protection of the Cardinal for several years, and through him to win an introduction to élite circles of Roman patronage.

CHAPTER FIVE

In the Household
of Del Monte

IN THE AUTUMN OF 1595 Caravaggio entered the service of Cardinal Francesco Maria Del Monte, taking up residence in the Palazzo Madama. Filippo Neri had died in May, and, on the eve of his coronation as poet laureate that year on the Capitoline Hill, Torquato Tasso died, in the monastery of Sant' Onofrio where, protected by Cinzio Aldobrandini, he had spent his final days. Cardinal Federico Borromeo, on being created Archbishop, returned to Milan; his place as the director of the Accademia di San Luca was taken by Cardinal Del Monte, and shared with Cardinal Gabriele Paleotti, the great reforming Bishop from Bologna (a Latin version of whose treatise on religious art had come out in 1594).

With this new residence Caravaggio was placed at the centre of artistic Rome. The Palazzo Madama, now vast and imposing, was then more modest and the comparatively austere fifteenth-century façade bore only a grandiose rendering of the Medici arms, proudly proclaiming Medici power at the heart of Rome. Even so, the palace was a sizeable building in Caravaggio's time, measuring almost ninety by sixty metres. Apart from the main state rooms there were rooms for courtiers on various floors, and some of these had been divided up by wooden partitions to make monks' cells. Additonally, there was the usual complement of servants' quarters, cellars, coach house and stabling.[1] The palace was made splendid with tapestries and paintings sent to Del Monte by Ferdinando, and, in 1589, as soon as he took up residence, the Cardinal had been concerned to create a *salone* for music. Here there was the nucleus of his distinguished collections of books, science, musical instruments, oriental carpets and art. His art collection was eventually to comprise 599 pictures and 56 sculptures in marble, as well as many medals, gems, cameos and small bronzes. It is not clear what works were

already there when Caravaggio moved in, but, characteristically for this period, his collection concentrated entirely on works of the sixteenth century, and on antiquity, and he may well already have had a traditional array of Old Masters paintings from central Italy, among them works (presumably copies) by Michelangelo, Andrea del Sarto, Raphael, and Leonardo da Vinci. Del Monte particularly liked Venetian painting, and perhaps already owned a picture ascribed to Giorgione himself, of a soldier in armour accompanied by a woman carrying a flute, while his *Mary Magdalene*, a copy of a celebrated Titian then in the collection at Urbino, attracted admiration. His collection had five Titians, all optimistically claimed as originals, and pictures by the Venetian artists Palma Vecchio, Bernardino Licinio, and Jacopo Bassano. Amongst a comparatively small collection of ancient art, a strikingly naturalistic sculpture of a *Cupid with a Bow* stood out, and one extraordinary acquisition, the celebrated *Portland Vase*, was already admired by the most distinguished European connoisseurs. And he presumably had too the beginnings of what was to be an overwhelming collection of portraits of famous men, many of them copied from Ferdinando's celebrated collection in the Villa Medici. His portraits honour the great names of history, and were built up in sets. In a much later inventory one entry reads: '277 pictures without frames, d4 palmi each, of various popes, emperors, cardinals and dukes and other illustrious men and some women', yet another: 'eight portraits of women'.

The Palazzo offered Caravaggio not only the splendour of rich collections of art and science, but also an environment rich in intellectual interest and a stimulating meeting place. Del Monte was in touch with poets and men of letters, with musicians and singers, such as Emilio de' Cavalieri and Girolamo Mei, with connoisseurs and men of letters, among them Battista Guarini, whom Del Monte had known in Florence, and who was to make a brief visit to Rome in 1600, and the writer on emblems, Cesare Ripa, who was to dedicate the second Roman edition of his *Iconologia* to Del Monte in 1603, and the doctor, biographer and connoisseur, Giulio Mancini; he knew scientists such as Johann Faber and Federico Cesi and his distinguished brother Guidobaldo; he corresponded with Galileo; he was in touch with such celebrated

antiquarians and bibliophiles as Fulvio Orsini, then in the service of the Farnese.

Caravaggio probably lived in one of the small rooms on the upper floors of the palace, at first eating with the servants, and possibly sharing these lodgings with Mario Minniti, with whom he remained closely involved in these years. Singers, musicians, as well as other artists, were also quartered there: the French sculptor Nicolas Cordier lived there in the 1590s; it may well have been there that Caravaggio met Ottavio Leoni – who (probably for Del Monte) executed the famous portrait drawing of him – and the printmaker Antonio Tempesta, creator of the map of 1593, who was also associated with the Cardinal. Ottavio Leoni was the son of the Paduan medallist Ludovico Leoni, whom Del Monte had known in his student days in Padua; Ludovico had moved to Rome, where he lived near the Piazza del Popolo, and entered the service of Gregory XIII. His son, whom Del Monte in 1599 described as 'a young pupil of mine',[2] was protected by the Cardinal and may have lived in the Palazzo Madama. He became a famous draughtsman, and his many portrait drawings bring vividly to life the Roman world of Caravaggio and Del Monte, of its popes, and cardinals, but above all of those artists and men of letters with whom they were most closely involved (particularly in the early years of the seventeenth century), and it seems extremely likely that these were undertaken for Del Monte himself, whose collection so strongly suggests his passion for portraits of famous men.

At the Palazzo Madama Caravaggio was also well placed to attract the attention of other wealthy and influential Roman collectors. In a very small area of Rome, which is little changed today, lived a group of distinguished and wealthy collectors and connoisseurs, high churchmen and men prominent in the Roman world of affairs, who were to play an influential role in Caravaggio's life, and all of whom were associated with Cardinal Del Monte. Del Monte's closest friend was the powerful Cardinal Alessandro Montalto, the nephew of Sixtus V, who retained his power through the reign of Clement VIII. Witty, brilliantly intelligent, worldly, and immensely rich, Montalto lived only a step away, at the elegant Renaissance Palazzo della Cancelleria, cultivating his pleasure in

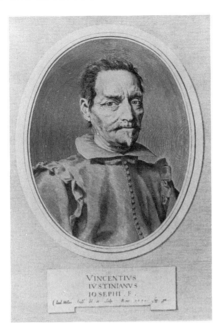

15. Claude Mellan, *Portrait of Vincenzo Giustiniani*
(print, from the Galleria Giustiniani)

music, and passionately addicted to the chase. With the Cardinal Pietro
Aldobrandini, Montalto and Del Monte formed a trio, dominating
much of the ceremonial life of Rome, and their banquets were vividly
described in the newspapers.

Almost directly across the road from the Palazzo Madama was the
vast and severe Palazzo Giustiniani, home to the rising Giustiniani fam-
ily. Vincenzo, born in 1564, and his much older brother, Benedetto, born
a decade earlier, were the sons of Giuseppe and Gerolama Giustiniani.
Giuseppe, a Genoese nobleman, had ruled the island of Chios, but, on
its occupation by the Turks, had moved his family to Rome in 1566. He
had been attracted to Rome by the presence there of powerful relatives,
above all of his brother, Cardinal Vincenzo Giustiniani, an influential
Dominican, although it was probably in the palace of another brother,
Giorgio, the Palazzo Giustiniani alle Coppelle (now destroyed), that the
family first lived. In 1586 Benedetto became Treasurer of the Apostolic
Camera, and was made a Cardinal; the younger Vincenzo meanwhile

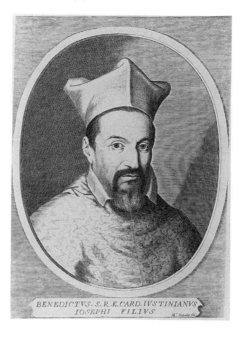

16. Michael Natalis, *Portrait of Cardinal Benedetto Giustiniani* (print, from the Galleria Giustiniani)

flourished as a highly successful banker, amassing fabulous wealth, and at the same time built up a knowledge of the arts of immense breadth and sophistication. The family are vividly recorded in the gallery of portraits that forms part of *La Galleria Giustiniani*, Vincenzo's lavish publication of a volume of engravings intended to immortalise his collection, and the impression that together they convey is one of immense power and assertive energy; Cardinal Vincenzo, imposing with massive head and flowing beard; Benedetto (Plate 16), dark-haired, with neater beard, the face of a subtle administrator (though he had a stormy and impetuous character) and strikingly like his father, Giuseppe (though an English visitor to Rome, Robert Tofte, in 1589 left an extremely unflattering description of Benedetto. In a letter to the Bishop of London he commented on Benedetto's wealth – 'His living that he holds from the church is but 8000 yet he has more which he has purchased by his own industry', adding 'of visage he is somewhat hard

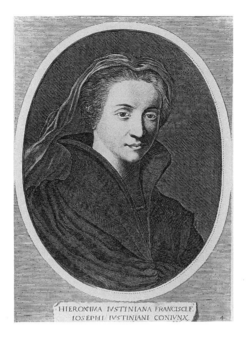

HIERONIMA IVSTINIANA FRANCISCE
IOSEPHI IVSTINIANI CONIVNX

17. Theodor Dirck Matham,
Portrait of Gerolama Giustiniani
(print, from the Galleria Giustiniani)

favoured and black, his beard being of the same colour. Of sight he
is spur blind and is low in stature, having a kind of odd fashion that
when he talks with any he turns his head and looks as it were over his
shoulder.')[3]

Gerolama (Plate 17), Giuseppe's wife, was a beautiful woman, full-
lipped with a slightly heavy, sensual face, and it may be that she was the
model for some of Caravaggio's paintings of the late 1590s. Vincenzo
himself, immortalised in the fine engraving by Claude Mellan (Plate 15),
has, in contrast, a strikingly modern look, and one that asserts a strong
individuality, suggesting an aristocratic and penetrating intelligence,
while the taut features convey a controlled passion.

But these portraits record the family at a later date. In the 1590s the
Giustiniani were concerned to win for themselves a secure place in the
aristocratic life of Rome, buttressed by wealth, possessions and prestige
in Church and State. The immense Palazzo Giustiniani dominated the

fashionable centre of Rome by its sheer scale and magnificence and had already been sumptuously decorated. Many of the rooms had rich wooden ceilings with frescoed friezes, ideal for the display of paintings and rich wall hangings. The Palazzo stands opposite the church of San Luigi dei Francesi, and one vast façade, little changed today, leads down the via Crescenzi, where six bays on either side flank a grand main door-way: in this wing Giuseppe, Benedetto and Vincenzo occupied separate apartments.

Closely associated with Giustiniani was another wealthy Genoese banker, Ottavio Costa. Costa was a member of the minor nobility from Albenga, a small city near Genoa; he was related to the most influential Genoese families, for his wife was a Spinola, and her mother a Doria. Costa came to Rome as a young man, where, living in the area around Sant' Andrea della Valle, he pursued a highly successful career in the financial world, amassing great wealth and becoming the most important papal banker in the city. He was passionately concerned to maintain the status and the splendour of his family and name, and he enriched his palace at Albenga with ancient sculpture, and a spacious garden. In Rome his main interest seems to have been his pictures, and his taste was close to that of Giustiniani; he had works by Caravaggio, Lanfranco and Guido Reni.

Another old and distinguished Roman family, long involved in the cultural life of Rome, lived in the Palazzo Crescenzi, which stood beyond the Palazzo Giustiniani, facing the Pantheon, and overlooking the Piazza del Pantheon. The family was closely involved with the Oratory, and shared Del Monte's interest in the natural sciences. On the ground floor of the Palazzo Giovanni Battista Crescenzi ran one of the many private academies then fashionable in Rome for the practice of virtu, for the cultivation of an understanding of the arts and sciences. Cardinal Federico Borromeo, before his departure for Milan, had lived near by, and on his return to Rome in 1597 he was to live for a period in the Palazzo Giustiniani alle Coppelle, which belonged to Giorgio Giustiniani, the brother of Cardinal Vincenzo.

These men were at the centre of Roman intellectual life, sharing inter-ests in music, science, art, and antiquities. As a collector of painting Del

Monte was perhaps closest to Cardinal Federico Borromeo. The two men were friends, and corresponded for many years. In his letters to the Medici court Del Monte was proud to describe him as 'my very great friend' and in 1595 told the Grand Duke, with considerable pleasure, that 'Borromeo offers me his friendship and includes me in all his projects'.⁴ The two cardinals exchanged works of art, sending each other pictures, clocks, glasses, all of the most sophisticated workmanship. Del Monte protected his friend's artistic interests after Borromeo's return to Milan, writing in 1596 to let him know that the clockmaker 'has put aside the work which he was doing for Cardinal Farnese, and is now concentrating entirely on yours. Scipione Pulzone has sketched [*sbozzato*] the head of the Madonna.'⁵ Cardinal Federico was particularly attracted by Flemish art, and it was probably at the Accademia di San Luca, over whose opening he presided, that he made the acquantance of Paul Brill, at this date an extremely fashionable fresco painter, and one of the *professori accademici* at the Accademia. In the same year he met Jan Breughel, (son of the famous Pieter Bruegel), who had been in Rome since 1591 (in 1593 he had scrawled his signature in the catacombs) and who specialised in small paintings on copper, executed in a highly detailed, miniature-like technique. His paintings were to delight the Cardinal for very many years, and their friendship opened dramatically. Federico rescued Jan from prison, where he had been detained for an unknown crime – probably the result of one of the many street brawls in which northern artists were very frequently involved – and gave him lodgings in his *palazzo*, the Palazzo Vercelli. On Federico's return to Milan the painter accompanied him

Del Monte, like Borromeo, came from northern Italy, where both had developed a love for naturalistic painting, both for the naturalism of Venetian art, and for Flemish landscapes, popular there since the sixteenth century, and Del Monte was to own two pictures by Brill, and ten by Jan Breughel. In some of Caravaggio's early paintings there are flowers, fruits, and virtuoso effects of light reflected in glass, which are strongly reminiscent of Flemish pictures, and it may well be that he met Jan Breughel in the Palazzo Madama in these years. The closeness of this group is touchingly conveyed in 1606, when Vincenzo Giustiniani, with

the painter Cristofero Roncalli, and with Bernardo Bizoni, who record-
ed their adventures, made a five-month trip around Europe, studying
churches, works of art and famous men. During a lavish banquet at
Nuremberg the travellers remembered their Roman friends, and drank a
toast to the Republic of Genoa, to Cardinal Del Monte, to the Medici
and to Benedetto Giustiniani. And, concludes Bizoni, 'after making the
toasts and speeches with copious wine in generous glasses, all fell asleep
and vomited, from the signor Marchese onwards . . .'[6]

Baglione's account suggests Caravaggio's relief on winning the securi-
ty of the Palazzo Madama, and the pleasure with which he painted for
the Cardinal 'a Concert of Youths, from nature, very well',[7] a work far
removed from the bravura of *The Cardsharps* and which suggests
Caravaggio's pleasure in a refined and courtly ambience. It is the first of
his works painted expressly for the Cardinal, and the first of a group of
works which show Caravaggio's close involvement with the rich musical
environment in Rome in the 1590s.

In this period Italy, above all Rome, was a centre of musical culture,
attracting musicians from throughout Europe, where churches, colleges
and seminaries offered employment, and visitors to the city were aston-
ished by the many opportunities it offered to hear music. The Jesuit
priest Gregory Martin delighted in the variety of sacred music:

> It is the most blessed varietie in the world, where a
> man may go to so many churches in one day, chose
> where he wil, so heavenly served, with such musike,
> such voices, such instrumentes, al ful of gravitie and
> majestie, al moving to devotion and ravishing a mans
> hart to the meditation of melodie of Angels and
> Saintes in heaven. With the Organs a childes voice
> shriller and louder than the instrument, tuneable
> with every pipe; Among the quyre, Cornet or
> Sagbut, or such like above al other voices.[8]

The Oratorians, too, saw the power of music, and at their meetings
spiritual *laudi* were performed, and enjoyed by noble Rome; in 1593 a

newspaper reported that Cardinal Aldobrandini had given dinner in the home of the fathers of the Chiesa Nuova to Cardinals Del Monte and Montalto, 'after certain spiritual recreations'.⁹ Neri had renewed the ancient pilgrimage to the seven basilicas of Rome, a pilgrimage that passed through grasslands and fields fringed with catacombs, offering distant views that stretched to the Alban Hills and the horizon of the sea. Throughout it was accompanied by music, by the chant of litanies and *laudi* in the vernacular, and it ended in a picnic breakfast in one of the Roman villas – the Villa Mattei, from where great Roman arches frame views of the distant Colosseum, or the nearby *Vigna* of the Crescenzi, close to the pyramid of Cestius. Here, beneath tall pines, with majestic ruins all around, pilgrims, bare-headed, and seated on the ground, ate a simple meal to the accompaniment of singing, horns and lutes, the music blending with the beauties of nature.

In aristocratic circles musical skills had long been valued, and small and intimate groups delighted in the skills of the gentleman amateur who sang of the power of love; Castiglione, in language that has the most delicate erotic undertone, thought music should be played 'at all times when a man is in familiar and loving company, having nothing else adoe. But especially they are meete to be practised in the presence of women, because those sighes sweeten the mindes of the hearers, and make them the more apt to be pierced with the pleasantnesse of musicke, and also they quicken the spirits of the very doers.'¹⁰ The madrigal had flourished in the earlier years of the century, when the Flemish composers Jacques Arcadelt and Adrian Willaert had been popular, but the 1590s witnessed a new and lovely flowering, of madrigal settings for the richly coloured verse of Tasso, for the delicate pastoral of Guarini, and the sensual, erotic poems of Marino. The emphasis was now on emotional intensity, and on an increasing virtuosity, and the nobleman amateur yielded to the professional performer. Music played a role, too, in the then popular pastoral play, in which courtiers themselves took part, seeking relief from the intrigues and sophistication of worldly life in the feigned simplicity of a rural Arcadia, where shepherds and shepherdesses sang, with great poignancy, of the passing of a Golden Age and the pain of lost love.

In this culture Cardinal Del Monte, an enthusiast for 'curious things and the knowledge of sounds and songs',[11] played a leading role; both he and Ferdinando de' Medici were passionate lovers of music, in touch with leading composers and performers of the day, and eager to encourage in Rome the new styles, above all of singing, which had developed in Florence in the 1580s. Here, on his many visits to the city, Del Monte absorbed the new aesthetic of the Florentine Camerata, an informal association of noblemen and musicians who gathered at the house of the patron of music, Giovanni de Bardi. The Camerata sought in music a new simplicity and power to convey human passion, condemning the artful relationships and abstract beauty of recent polyphony. Their spokesman was Vincenzo Galilei, father of the astronomer, and a humanist writer, steeped in knowledge of Greek and Latin authors' descriptions of the enchantment wrought by Greek musicians, by Orpheus, who moved inanimate things, and by Arion, who charmed the dolphins in the sea. His *Dialogue on Ancient and Modern Music* (1581) is a passionate plea that modern composers should again unite music and poetry, and restore classical music's fabled emotional power. He believed that this lay in the purity and simplicity of ancient monody, commenting: 'Today the singing in harmony of many voices is considered the summit of perfection; among the ancients solo singing had this reputation. And if the singing of many together was also esteemed, it was the singing of one melody and not of so many . . .'[12] Galilei's ideals were taken up by the composer and singer Giullo Caccini, whose singing enraptured Clement VIII, and who created a new style of song for the solo voice; he published a collection of solo songs with basso continuo as *Le Nuove Musiche* (1601) and in the preface described how he had taken this style to Rome in the 1590s, where it was rapturously received in the house of Signor Nero Neri ' . . . and everyone can testify how I was urged to continue as I had begun, and was told that never before had anyone heard music for a solo voice, to a simple stringed instrument, with such power to move the affect of the soul as these madrigals . . . they did not think a soprano part sung by itself alone could have any affect whatsoever, without the artful interrelationships of all the parts.'[13] Caccini contributed to the sumptuous musical *intermedi* for the wedding of

Ferdinando and Christine of Lorraine in 1589, where again the theme was the wondrous power of music. Arion is carried by dolphins; an enchantress, on a golden chariot, sings of her power to charm the very moon from the skies. In the 1590s Cavalieri encouraged the development of pastoral themes; Tasso was in Florence in 1590, and for the Carnival of that year Cavalieri staged Tasso's lyrical pastoral *Aminta*, where nymphs and shepherds, lightly draped *all'antica*, lament the transience of love and life, and look back with longing to the sensual freedom of a lost Golden Age.

Del Monte moved easily between musical circles in Rome and Florence. Emilio de' Cavalieri often visited him in Rome, where he shared such interests with the papal nephew, Cardinal Pietro Aldobrandini, Cardinal Alessandro Montalto and Vincenzo Giustiniani. As soon as he had moved into the Palazzo Madama, he had hastened to create a small room for concerts, informing the Grand Duke: 'Today Montalto was here for a time in this house, where I have set aside a room for harpsichords, Guitars, a Chitarrone and other instruments, and he has taken such a liking to it, that he says that he will be good enough to favour me with frequent visits, and come and dine with me.'[14] The three cardinals enjoyed many lavish entertainments together, in both Florence and Rome; Del Monte and Montalto, with the Grand Duke, were present in Florence at the performance of Cavalieri's *Blind Man's Bluff* (*Il Gioco della Cieca*), from Battista Guarini's *Il Pastor Fido*, in 1595, and again on its revival in 1599. Del Monte gives tantalisingly brief glimpses of their entertainments in Rome; on 9 June 1595, he described a banquet held by Aldobrandini 'where there was music all the day';[15] later that month Montalto was the host, and Aldobrandini and Del Monte guests at a banquet 'at which the usual music was performed'.[16] A month later it was Del Monte's turn, and so it continued, with increasingly lavish parties as the Jubilee year approached. On 29 August 1600 Del Monte told the Grand Duke that he had entertained Cardinal Aldobrandini and Cardinal Deti 'with a little music', and afterwards they had enjoyed a walk in Rome. He added, as an afterthought, that Baronio had just sent him another volume of the *Annales*.[17]

A lively picture of the opulent and abundant musical life of Rome is

given by Vincenzo Giustiniani, who, in 1628, in his *Discorso sopra la Musica*, written in the form of a letter to a young nobleman, looked back with some nostalgia to the musical world of the 1580s and 1590s, a world of cultured and noble dilettantes. The *Discorso* is written with a light touch, forswearing theory and philosophy, and it conjures up, with pleasure and affection, the world of noble amateurs, of intimate musical performances in rooms designed for that purpose, perhaps decorated with paintings of musical subjects. He bases his thoughts on 'the little experience I have acquired while I was conversing in houses where there was no gambling, but rather delightful occupations, particularly music, performed without the assistance of paid performers by divers gentlemen who took pleasure and delight in it through natural inclination . . .'; it is knowledge acquired through 'conversations engaged in by many lords and gentlemen in my house where, among other honourable practices, making music was the custom . . .'[18] The main protagonists are vividly sketched in: the then Cardinal Ferdinando de' Medici, who hastened to acquire excellent musicians, spurred on by rivalry with the Dukes of Ferrara and Mantua, who had noble ladies and gentlemen singing 'entire days in some rooms designed especially for this purpose, and beautifully decorated with paintings'; Giulio Caccini, who sang 'with extraordinary feeling and a particular talent to make the words clearly heard', and Cardinal Montalto, who 'played and sang with much grace and feeling, even though his appearance was more martial than apollonian, and who had a scratchy voice . . .' Del Monte, too, sang, accompanying himself on the Spanish guitar.

These men were also collectors of musical instruments and scores. Later Del Monte had a remarkable room, displaying thirty-seven musical instruments, and a 'chest where the viols are'.[19] These instruments, beautifully crafted, were themselves works of art, and commanded extremely high prices. The men competed, too, for the possession of the most celebrated and virtuoso singers, whose excellence cast lustre on the patron: Montalto supported singers and musicians in his house, and often begged the Grand Duke for the loan of the celebrated castrato Onofrio Gualfreducci. His success spurred on Del Monte, who provided for the Spanish castrato Pedro Montoya, a singer at the Sistine

Chapel since 1592; in 1597 Emilio de' Cavalieri described how the Cardinal 'was amazed because he can sing on a level with Onofrio, and if he doesn't create problems, within a month he will surpass Onofrio'.[20] In the summer months the Cardinals dined in the lovely gardens of the Grand Duke's Villa Medici, on the Pincian Hill, 'which truly is an earthly Paradise';[21] Montalto summered at Bagnaia, where the Grand Duke lent him the services of Onofrio. It was fashionable, too, to enjoy the small towns of the Alban Hills, Tivoli, or Frascati, where the ancient Romans too had sought relief from the heat of a Roman summer. At Frascati Pietro Aldobrandini was building the spectacular Villa Aldobrandini, which recalled the villas of classical antiquity, and which was the centre of elaborate gardens and rich collections of art. Here too the three Cardinals enjoyed music, and pastoral plays, with their evocations of the classical past, and in 1599 Del Monte described the delights of a summer at Frascati to the Grand Duke. The Pope and Baronio, he wrote, had been staying nearby and the Pope had ridden with him, and honoured him with his conversation. Later 'Montalto and Aldobrandini passed the time with warm displays of friendship, and Aldobrandini held a most perfect concert'[22] in the splendid setting of his Villa, causing Montalto to think longingly of Gualfreducci's performances in the past.

Caravaggio's first painting for Del Monte, *The Musicians* (*c.* 1595) (Col. Plate 4), suggests his pleasure in this refined and courtly world.[23] It is rooted in Venetian art, in the concert pictures of Giorgione and Titian, and yet it is disconcertingly novel. Baglione's emphasis was on Caravaggio's having painted from life,[24] and it is clear that Caravaggio has pieced his composition together from studies of only two models, painted from different points of view. He paints a group of young musicians, clad in loose-fitting shirts, preparing for a concert in one of the small chambers in the Palazzo Madama. The lutanist is tuning his instrument; the singer studies his part book, and behind them the cornetto player (perhaps a self-portrait) turns to look at the viewer. The picture is haunting and sensual, its theme the power of music to arouse erotic desire and to convey human passion, a theme long familiar in Renaissance art and literature. The lutanist's eyes glisten with tears, and

the red of his lips is taken up in the full and voluptuous red of the heavy brocaded mantle. Painted from nature, it yet evokes an unreal world, the illusory world of the theatre, creating a vaguely mythological and pastoral aura, and evoking the atmosphere of contemporary pastoral plays, where gods, courtiers and shepherds mingle, and, with exquisite melancholy, lament lost love. Tasso's celebrated *Aminta*, itself so musical, and so often set to music, opens with Love, in pastoral guise, wandering amongst the shepherds; in Caravaggio's picture a winged Cupid, with a quiverful of arrows, unheeded by the rapt musicians, plucks a grape, reminding us that music and wine both lighten the spirits and prepare for love. The music is indecipherable, but it is surely a pastoral lament, such a plea as that made by Aminta to his cruel lover:

> Rocks and waves I have seen moved to pity by my
> complaints
> I have heard the trees accompany my tears with sighs,
> But I have never found, nor hope to find, compassion
> in this cruel fair . . .[25]

The cornetto, a gently curved wood instrument, has the feigned rustic simplicity of pastoral, and carries with it the erotic charge associated with many types of wind instrument. Giustiniani delighted in the skills of cornetto players, mentioning the celebrated Cavaliere Luigi del Cornetto from Ancona, who, Giustiniani recalls with intense pleasure, 'played many times in one of my little rooms to the accompaniment of a cembalo which was closed up and could scarcely be heard; and he played the Cornett with such moderation and exactitude that it astonished many gentlemen present who liked music, because the Cornett did not overshadow the sound of the Cembalo'.[26]

Such a painting surely delighted Del Monte, who took such pleasure in the pastoral *intermedi* performed at many Roman palaces, and it perhaps adorned his musical Camerata. The picture's naturalism and directness evoke the expressive simplicity of the new music, while the lutanist's tear-filled eyes, a virtuoso passage of naturalistic painting, suggest the new emphasis on passionate emotion. Del Monte's copy of

Titian's *Magdalene* was admired for this quality, and the beauty of her weeping eyes was deeply admired by Mancini, who described them as 'overlaid with tears, with the light reflected and refracted in both eyes and tears, so that this light takes on the shape of a great diamond, with some small sprinkling of ruby around great pearls, a most lovely thing to behold'.[27] Tears were the theme of many madrigals, and Gaspare Murtola subtitled his *Rime* of 1604 'eyes, tears, pallor, beauty spots, loves . . .', describing how:

> Yours is the face of April,
> Which gathers roses, and lilies,
> And the eye is the fount, which opens
> Crystalline humours,
> To make more lovely the flowers.[28]

Seeing this picture in the house of his friend may have inspired the noble and wealthy amateur, Vincenzo Giustiniani, to commission a similar musical theme, *The Lute Player* (Col. Plate 6).[29] one of the loveliest and most poetic of Caravaggio's works. Here, caught in a bright shaft of light, a solo singer accompanies himself on the lute. He is clad in a loose shirt, his thick black curls tied by a white fillet; before him, on a marble slab, lies an open part book, turned towards the viewer, and a violin and bow. The youth is framed by a carafe of simple flowers, more freely painted than the instruments, and a cluster of fruits, pears, an overripe fig, a cucumber, on which drops of water glisten. The picture has an extraordinary freshness and directness, and yet at the same time it is highly refined, exquisite, rendering the varied beauties of texture and surface with virtuoso skill, and creating an intensely erotic mood of melancholy and longing. In the part book are portions of four madrigals by Jacques Arcadelt, all passionate (if somewhat trite) love songs. Most emphasis is given to the line 'Voi sapete ch'io vi amo' ('You know that I love you') with which the singer regales the viewer. The fruits themselves carry an erotic charge, and yet here it is veiled, courtly, far removed from the bawdy humour of North Italian concert scenes. The evanescent beauty of fruit and flowers — and here they are so fresh that they shine

with dew, and the leaves seem to curl before our eyes – suggests the transience of youth and beauty, which is evoked, too, by the delicate, fleeting strains of the lute, which is a fragile instrument, its surface here slightly worn and its ribbed cage split. Long associated with love, the lute was the most noble and refined of instruments, and Galilei had described with passion its ability to 'express the affections of harmonies, such as hardness, softness, harshness and sweetness, and consequently shrieks, laments, complaints and weeping, with such grace and wonder'.[30] But it was becoming less popular, yielding to the easier theorbo and Spanish guitar, as were the songs of the Flemish composer Jacques Arcadelt, which at this date would have had an archaic flavour; Arcadelt had been most famous in the decade before 1550, but his four-voice *Primo Libro* had been many times reprinted and is the best-known single book of madrigals ever published. Giustiniani recalls that he had, as a boy, studied the compositions of Arcadelt, and in a sense the picture looks back with nostalgia to Giustiniani's youth, and laments the passing of youth itself. It seems to evoke a lost age, that 'lovely Golden Age' which Tasso had invoked in the *Aminta*; it perhaps looks back too to the classical world, the power of whose fabled musicians, of Orpheus and Amphion, the new music sought to re-create.

The picture does not show an amateur musician, one of those noblemen with scratchy voices, such as Cardinal Montalto, but one of the professional musicians who began to replace them. It may even perhaps portray the Spanish castrato singer Pedro de Montoya, who lived in the household of Del Monte, and the fleshy, effeminate beauty of the sitter (whom Bellori described as a girl) supports this identification.[31] It celebrates the mystique of the solo singer, to whom many contemporary poems are addressed.

Caravaggio's picture was clearly successful, for a little later, perhaps in 1597–8, he created another *Lute Player*, for Cardinal Del Monte, a more prosaic painting perhaps not entirely from Caravaggio's hand, and which replaces the still life of fruit and flowers with an increased emphasis on musical instruments – a tenor recorder, a violin and bow, a spinettina – of which Del Monte had a large collection. Del Monte was to collect other paintings of musical subjects – among them concert scenes by

Gerrit van Honthorst and Antiveduto Grammatica, which later in his life were to hang together in a small room, with the map of Jacopo de' Barbari — but perhaps in this period his *Lute Player* and *The Musicans* decorated the musical *camerino* in the Palazzo Madama, where the Cardinal entertained Montalto.

Del Monte was as passionately interested in geography and science — botany, medicine, pharmacology, physics — as in music, and his attraction towards alchemy and alchemical experiments existed side by side with an interest in a new culture founded on observation. This too he shared with the Grand Duke, who continued a long-established Medici tradition; his brother, Francesco de' Medici, had created the Studiolo in the Palazzo Vecchio at the centre of Florence, and decorated it with paintings of alchemy and of the elements, and Ferdinando corresponded enthusiastically with the celebrated Bolognese natural scientist Ulisse Aldrovandi, who was building up a vast encyclopaedic collection of drawings of natural history. In the garden house of the Palazzo Avogardo, which Del Monte later acquired, he was to have a distillery, and a collection of scientific instruments and utensils; it was decorated with portraits of scientists, of such famed figures as Paracelsus and Hermes Trismegistus. Del Monte liked, as did the Grand Duke, drawings of plants and animals, and acquired such works from the famous scientific illustrator Jacopo Ligozzi, who worked for Ferdinando. Such drawings were enthusiastically welcomed in Rome, and in 1599 Del Monte assured Ferdinando, 'The painting of the red bird is of exceptional beauty, and has pleased everyone . . .'[32] Del Monte was fascinated by pharmacology, and enjoyed providing his friends with cures for a variety of ailments, creating an atmosphere of pleasurable secrecy around his experiments. In 1607 he wrote wryly to Belisario Vinta, 'I lack only the remedy to put time back for forty years, and if you will send me this prescription, I promise you all the rest.'[33] His patronage of scientists was often brilliant; he supported Galileo, and spotted the talent of Fabio Colonna, who became one of the most celebrated botanists of the age, and whom Del Monte recommended to the Grand Duke in 1606. Guidobaldo Del Monte dedicated his treatise, *Perspectivae* — which became a seminal work of reference on perspectival projection — to Francesco

Maria. It is likely that in his household Caravaggio was present at the most modern and stimulating discussions on perspective and on the projection of cast shadows, and his own works became more spatially sophisticated, and more subtle in their use of light and shade.

Such interests, and the growing passion for an exact observation of nature created by the new science, Del Monte shared with his circle of scientists and collectors. The German doctor Johann Faber, who kept a small museum of animals at his house near the Pantheon and Santa Maria sopra Minerva, also enjoyed mixing with artists – Rubens and Adam Elsheimer frequented his house, and Rubens was later to look back with deep nostalgia on the good conversation he had enjoyed in these circles in Rome. In 1603 he was to use an antidote mixed by Del Monte to cure a reaper of a viper bite. In a room on the ground floor of his palace near the Pantheon, Giovanni Battista Crescenzi, himself a painter, ran one of the many private academies then fashionable in Rome for the practice of virtu; Cristofero Roncalli, a painter closely associated with the Oratorians, instructed the family in the art of painting, and, wrote Baglione:

> Signor Giovanni Battista was eager that virtu should always be exercised in his house, and continually had various young men studying there who were inclined to painting: and his academy was active there both by day and by night, so that they might all have greater occasion to learn the subtleties of their art; and he sometimes also liked to have them draw from life, and he would go around Rome seeking out beautiful and curious fruits, animals and other oddities, which he would hand over to these young men in order that they might draw them, in the pure hope that they would become skilled masters, as indeed they did. His palazzo was a school of virtu, and fine artists issued from it . . .[34]

Cardinal Federico Borromeo shared this passion for the small and curious things of nature, and it was these that he loved in the tiny landscapes that Brill and Jan Breughel were painting in the 1590s. Paleotti, in his treatise on religious art, had sanctioned the pleasure a churchman might take in landscape and genre painting, for 'the Holy Scriptures, in many places, speak of the sun, the stars, winds, animals, fishes, pearls, doctors, soldiers, merchants: it would be unsuitable if a Christian could not learn of all these things, so often named in holy books, and particularly in the writings of the Fathers of the church . . .'[35] For Cardinal Borromeo the power of Breughel's paintings lay in their evocation of the wondrous variety and infinite beauties of the created world, through contemplation of which the mind may ascend joyfully to God. These works gave spiritual delight and solace, and it was a delight nourished by the achievements of the new science. He took intense pleasure in the newly visible worlds revealed by the telescope and microscope, and in experimenting with the prism, mirror, and camera obscura. The telescope, he later wrote, has discovered for us new worlds, while the microscope has shown 'that little animals that are much smaller than the eye of a needle are of the very same species — even if they do not appear to be, they truly can be! — as the larger animals that are visible with the naked eye. All of which demonstrates the supreme Workmanship of nature . . .'[36] On 17 August 1603 Federico Cesi founded the first scientific society, the Accademia dei Lincei, which took as its emblem the sharp-sighted lynx.

Such an environment was rich in interest for Caravaggio, who had already mixed with northern artists in the studio of the Giuseppe Cesari, and who had already painted natural objects with sharp intensity. Now he developed this interest in paintings of flowers and fruit, exploring the complex effects of light in glass carafes, in transparent water, and reflected by mirrors. Del Monte owned a painting of a carafe by Caravaggio, which is described in his inventory simply as 'a carafe from the hand of Caravaggio' ('una caraffa di mano del Caravaggio')[37] and which is now lost. It seems likely that this was the work described by Baglione, whose description somewhat confusingly describes the still life as a detail within the Hermitage painting of *The Lute Player*, yet who probably meant to

describe two paintings — *The Lute Player* and an independent flower paint-
ing. His description suggests his delight in Caravaggio's virtuoso effects
of refraction and reflection: '. . . everything seemed lively and real, such
as the carafe of flowers filled with water, in which we see clearly the
reflection of a window and other objects in the room, while on the
petals of the flowers there are dewdrops imitated most exquisitely. And
this picture (he said) was the best he had ever done';[38] Caravaggio devel-
oped these interests in other works, in the *Boy Bitten by a Lizard* (Col. Plate
11) and the Uffizi *Bacchus* (Col. Plate 10). Such effects had long interest-
ed Netherlandish painters, and it is possible that Caravaggio was
responding to the art of Jan Breughel, who may have painted a small
Carafe of Flowers, now in the Borghese Gallery, Rome, strikingly similar to
the flowers in the Hermitage *Lute Player* (where the choice of flowers,
particularly the iris, seems to look back to an older Netherlandish
tradition) in Rome in the early 1590s, although the first certain flower
paintings by him date from 1606.[39] These works delighted their public,
and perhaps Vincenzo Giustiniani wanted a copy of Del Monte's still
life, as much as he desired a musical painting.

Yet Caravaggio's only surviving pure still life, the *Basket of Fruit* (Col.
Plate 12), contrasts very sharply with the minutely detailed and joyous
paintings of Jan Breughel. Breughel went with the Cardinal to Milan in
1595, but only two years later Federico was back in Rome, where he
remained until 1601, and it seems likely that he commissioned the *Basket
of Fruit* directly from Caravaggio, perhaps shortly after his return in 1597.
Borromeo's later devotional tracts, *Le Piaceri* (1625) and *Le Laudi* (1632),
convey his belief that the seasons, the elements, and all created things
reveal the glory of God, and through praising them the mind ascends to
the divine. The grander vases of flowers that Breughel began to paint
from 1606, showing a rich abundance of exquisite blooms encircled by
gleaming shells and fragile butterflies, are full of a sense of the wonder-
ful variety of nature, of the rarity and beauty of the specimens, whose
fragile perfection inspired contemplation on the brevity of life and
earthly things. In sharp contrast Caravaggio's basket holds everyday
fruits, windfall apples and bruised pears, and yet they too perhaps
conveyed to Borromeo a spiritual significance. In *Le Laudi* and *Le Piaceri*

PLATE 1:
The Sick Bacchus

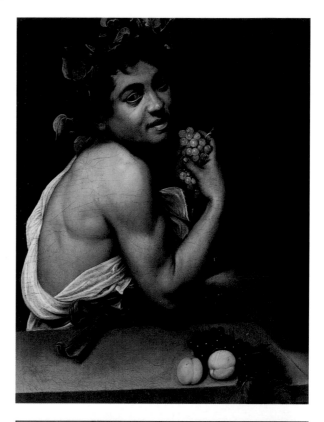

PLATE 2: *Boy with a*
Basket of Fruit

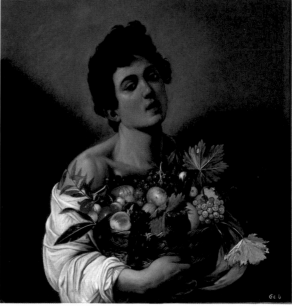

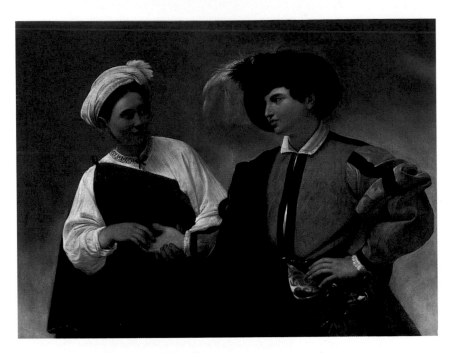

PLATE 3: *The Gypsy Fortune Teller*

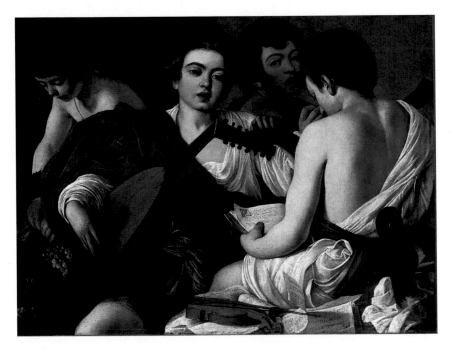

PLATE 4: *The Musicians*

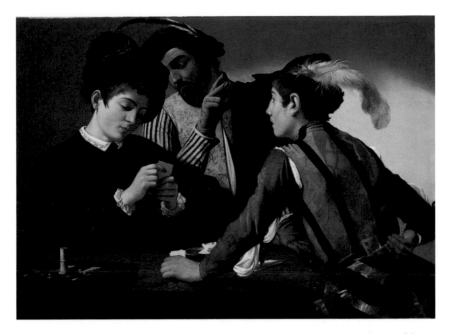

PLATE 5: *The Cardsharps*

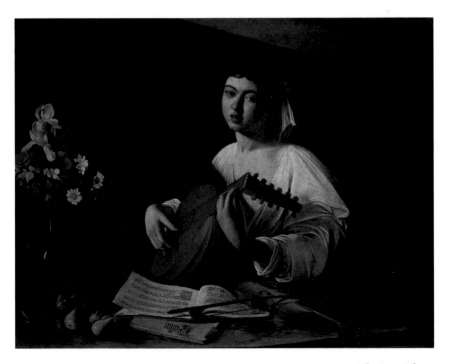

PLATE 6: *The Lute Player*

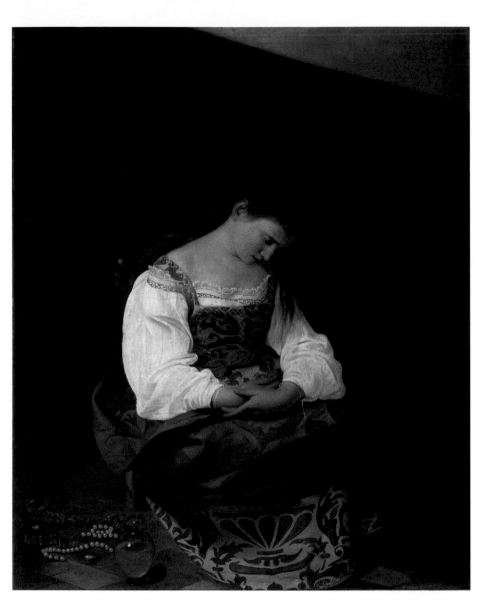

PLATE 7: *Mary Magdalene*

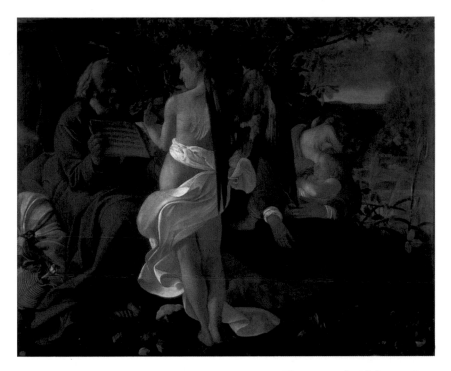

PLATE 8: *The Rest on the Flight into Egypt*

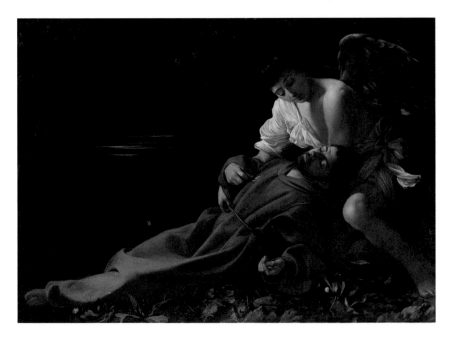

PLATE 9: *The Ecstasy of St Francis*

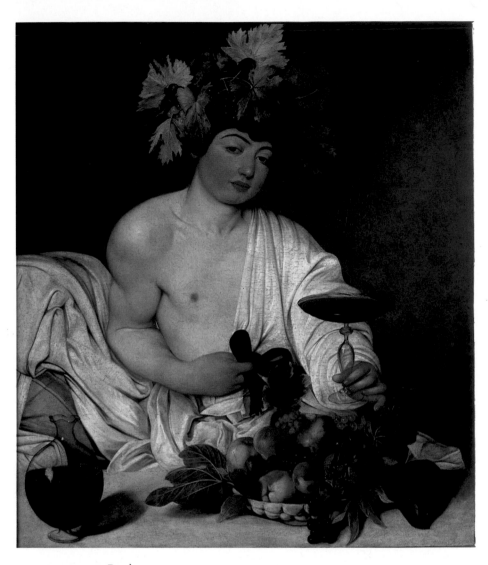

PLATE 10: *Bacchus*

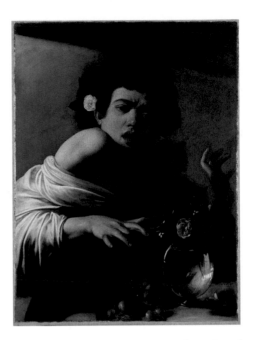

PLATE 11: *Boy Bitten by a Lizard*

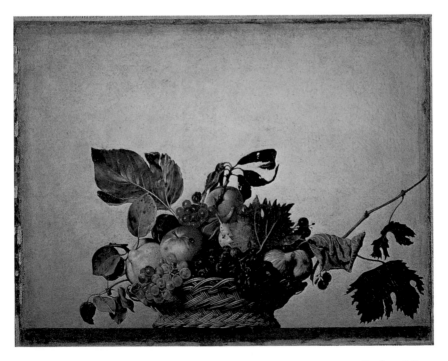

PLATE 12: *Basket of Fruit*

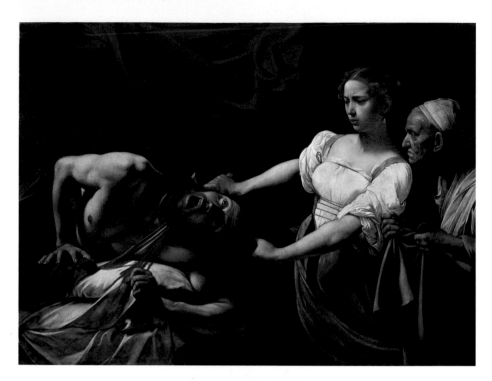

PLATE 13: *Judith and Holofernes*

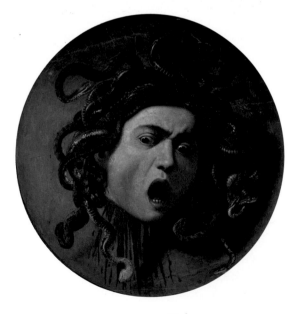

PLATE 14: *Medusa*

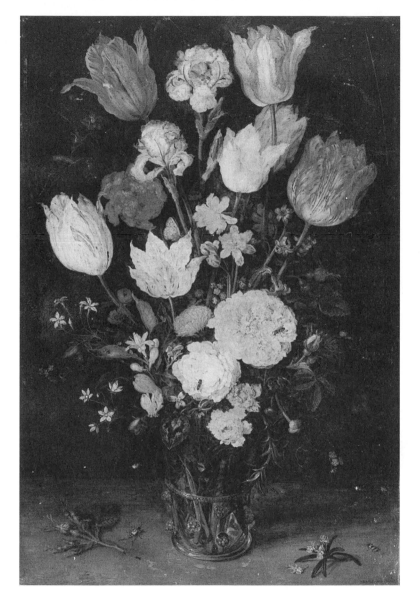

18. Jan Breughel, *Vase of Flowers*
(Milan, Pinacoteca Ambrosiana)

he stresses, as St John Chrysostom had done, the beauty of the small and humble products of nature, as in the latter, where he mentions the attention that should be paid to creatures 'which are not outlandish and

notable as curiosities, but utterly ordinary and everyday', such as the fruits and leaves of the chestnut tree (subjects which were to attract other Lombard painters of rustic still life). We should contemplate these lowly things 'without seeking out Indian herbs and flowers from the Orient, but remaining always within our own woods'.[40] And Caravaggio's painting, so isolated from any context, so startling in the way that it projects, shadowless against the brilliance of the background, with its evocation of the gold backgrounds of religious works, seems offered to the spectator as an object of contemplation, or prayer.

To Caravaggio himself the picture was also highly personal, a *tour de force* of illusionistic skill, which plays on realism and illusion in a way that became almost an emblem of his art. For the immediate appearance of realism is comprehensively interpenetrated by ambiguities, which have the effect of checking and blocking many ways of responding to the painting before, as it were, they have had time to gather momentum. Nothing is quite what it seems.

The fruit is massive and palpable, and its weight is emphasised by the depression and slight unravelling of the basket's left-hand edge, but this weight and centrality is neutralised by the vine stem on the right which goes floating airily out of the picture frame. This stem does not even 'belong' to the grapes in the basket and it must originate from some outside source about which the viewer is told nothing at all. Within the still life there is a carefully painted system of light and shade, but the only shadow that the composition throws outside its boundaries is the one cast by the foot of the basket where it overhangs the shelf, and even that is insufficient to tell us whether the basket is round or oval. While most of the lighting is consistent with a light source from the left and in front, the uppermost leaves and the ones at the right are, quite arbitrarily, painted as silhouettes, as though they were lit from behind. Most of all, Caravaggio makes it impossible for us to be confident about the way in which the objects he has created are related to their surrounding space. The vertical edge of the supporting shelf is reduced to a teasing token strip, and the horizontal plane merges into the background so cunningly that the viewer is constantly forced to ask himself where he is actually viewing the painting from, and whether the fruit is

in the picture's space or his own. Perhaps the most subtle of all these devices is the astonishing virtuoso rendition of water drops that rest on the fruit and leaves and yet simultaneously appear to have been scattered on the surface of the painting.[41]

The mimetic skill in capturing textures and masses is just one component in what is essentially a statement about the nature of art itself, and the entire project is controlled by extreme intellectual rigour. The sense of the passing of time, delicate in Breughel's flowers, is here more dramatically confronted. The picture must have created an aura of melancholy in a collection dominated by the radiant and miniature beauties of Breughel. In his *Musaeum*, a description of his collection, Borromeo later wrote: 'Of not little value is a basket . . . with flowers in lively tints. It was made by Michelangelo da Caravaggio, who acquired a great name in Rome. I would have liked to place another similar basket nearby, but no other having attained the beauty and the incomparable excellence of this, it remained alone.'[42] Yet his praise for Breughel is warmer – in his *Vase of Flowers* (Plate 18) (which is still, like Caravaggio's *Basket of Fruit*, in the Ambrosiana in Milan, where Federico's collection is preserved), Breughel 'painted at the bottom of the vase a diamond, whose view makes us understand that which we would have thought just the same, namely, the work is as valuable as a gem, and we payed for it as such. Around the flowers there were flitting butterflies, green grass and shells scattered on the ground, for which any other painting would be sold at an expensive price.'[43] The astonishing description of Caravaggio's painting as a basket of flowers suggests that perhaps the Cardinal was more deeply involved with the aristocratic and costly vision of Breughel.

Borromeo, Ferdinando and Del Monte shared many scientific interests, and, before the spring of 1598, Caravaggio had painted an astounding image of the *Medusa* (Col. Plate 14), which is a product of the close interests that united them, and which was either sent or taken to Florence by Del Monte, probably to spread Caravaggio's fame, and to let the Grand Duke see the works of Del Monte's new protégé. It is paint-ed on canvas mounted on a convex poplar shield, and was exhibited as a prop in the Grand Duke's armoury, amongst an exotic display of

armoured knights. In classical literature the snake-haired Gorgon, Medusa, was killed by the Greek hero Perseus and her head adorned the aegis of Zeus and of Athena. Her eyes turned men to stone, but Perseus tricked her by showing her her own reflection in a mirror, so that he could decapitate her. Caravaggio shows the precise moment in which Medusa catches sight of herself, and with a shriek of appalled terror senses her harsh fate, as her blood, already hardening, falls like stalactites against the concave surface. Her decapitated head seems to project from the surface of the shield, and to cast shadows against it, as it would have done when embedded in the aegis of Athena. Caravaggio has painted the true shield of Athena, and images of the Medusa, bringing terror to the enemy, had been traditional on shields and armour since Antiquity.

Although the shield is convex, Caravaggio has created the illusion of a concave surface, and then used the physical shape to project the image forcefully towards the spectator, so that the Gorgon seems to look down upon us from a startlingly close viewpoint. We, the spectator, feel ourselves caught up in her horror and are mesmerised by the picture's power; it is an unreal, necromantic subject, yet it has a haunting presence. It fascinated poets: and Giovanni Battista Murtola, perhaps soon after the work was painted, wrote:

> Is this the Medusa, her poisoned hair armed with a
> thousand snakes?
> Yes, yes; do you not see, how the eyes roll and dart?
> Flee, flee her anger, flee her scorn,
> For should she catch your gaze,
> She'll change you too to stone.[44]

His poem creates a powerful sense of looking at the picture, which seems to spring to life as we do so. It conveys Murtola's sense that art has increased the Medusa's petrifying power, and that wonder and astonishment will enthral the spectator, will truly turn him to stone. The subject had traditionally been a display of skill, and Murtola's poem is a continuation of such a common Renaissance conceit as that by Andrea Navagero, on the power of a sculpted Medusa:

Verior est ipsa quae ficta ex arte Medusa
Spectantum magis hac obstupuere animi.

('The Medusa crafted by art is more real than the creature herself; the minds of viewers have been even more stunned by it'.)[45]

It was a theme which had strong links with Florence and the Medici, for the Medusa had a long and rich history in Florentine art and literature. In the Piazza della Signoria stood Benevenuto Cellini's *Perseus with the head of Medusa*, a work which seemed to symbolise the power of art so to astound the spectator with its living beauty that the spectator himself becomes marble before it – a conceit which informed the lavish tributes of many Florentine poets. It had, too, a political reading, and could be seen as a tribute to Duke Cosimo, an allegory of his power to bring peace and to triumph over vice. Duke Cosimo, moreover, owned another celebrated rendering of the theme, a *Medusa* painted by Leonardo da Vinci, which the Florentine biographer of Renaissance artists Giorgio Vasari described very briefly: 'There came into his mind the idea of painting in oil the head of a Medusa, with an array of serpents on the head, the strangest and most extravagant invention that one could ever imagine . . . This was amongst the most excellent works of Duke Cosimo.' Del Monte would surely have known this work in the Grand Ducal collection, to which he had easy access, and the work was part of Leonardo's myth. But a little before this description – and Del Monte would surely have known this passage too – Vasari wrote, far more memorably, and with a wealth of astonishing detail, of an image that Leonardo created for a peasant who had brought him a small shield to decorate. Leonardo wished to create, as he had done with the *Medusa*, an image that would inspire terror. He gathered together, wrote Vasari, in a small room, where no one else entered, 'Lizards, crickets, snakes, butterflies, locusts, bats, and other strange examples of similar creatures' and from these he made a horrific whole, a monster whose breath was poisonous and which breathed fire, and whose illusionistic power truly terrified the peasant when he came to collect his shield. The story suggests Leonardo the necromancer, and it may well be that Del Monte, himself so fascinated by alchemy, wished Caravaggio to pit himself

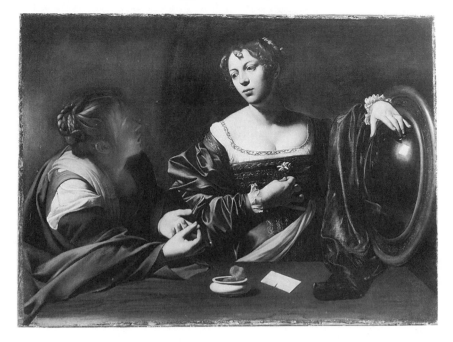

19. Caravaggio, *The Conversion of the Magdalene*
(Detroit, Detroit Institute of Arts)

against his great Lombard predecessor, and by his close observation of
natural phenomena, create an imaginary monster yet more astounding
than that of Leonardo. He shared these interests with the Grand Duke,
and the gift of a Medusa also carried with it a courtly compliment, for
the Medusa, who turned men to stone, armed them against worldly
temptation, and became a symbol of the triumph of virtue. The vipers
that encircle the Gorgon's head derive directly from a drawing by Jacopo
Ligozzi now in the Uffizi and presumably the Grand Duke sent Del
Monte a copy of this work.[46]

Caravaggio's painting also suggests the contemporary interest in the
mysterious effects that could be created by mirrors, for it seems that he
studied either his own face (which he then considerably altered) or the
face of a model lit by a lamp in a darkened convex mirror, and it is this
that creates the distortions and gives the painting its strange power.
Baglione said that Caravaggio, after leaving the studio of Giuseppe

Cesari, 'painted some portraits of himself in the mirror',[47] but suggestions that he used mirrors and other optical devices in other works tend to be over complex. But a large convex Venetian mirror, with a darkened surface – a highly expensive and courtly object that Caravaggio would have access to in the household of Del Monte – appears in a painting of the late 1590s, *The Conversion of the Magdalene* (Plate 19), and it may be this mirror that Caravaggio used to study the Medusa. He probably knew the writings of the eccentric and fascinating scientist Giovanni Battista della Porta, whose *Natural Magic* (1558) was many times reprinted and immensely popular. He devotes a chapter to concave mirrors, entitled 'Of Strange Glasses', and suggests the wondrous ways in which they may be used. The word 'mirror' itself suggests wonder, for it is closely related to the word 'miracle', and Caravaggio's picture was truly an object of wonder, a *meraviglia* that shocked the spectator. And it is deeply disturbing, for as the silent yet lifelike disembodied head replaces our own image, it creates a deep sense of psychological shock. Such effects fascinated contemporary poets, for in this period mirrors, though very expensive, created clear images, and they became symbols of the ambiguities of life and death. The poet Baldassare Pisani created a similar effect, when he imagined a young boy looking in a mirror, there to be dramatically confronted with a death's-head:

> With dying rays, innocent glass,
> Hesperus presages your splendours,
> Now that a death's-head, with its blazing gaze,
> Inveils tragedies, and shows forth horror.[48]

In more tender vein is *The Rest on the Flight into Egypt* (Col. Plate 8), one of Caravaggio's first religious works, yet it is a work of such intellectual sophistication that, although the patron is unknown, it must surely be connected with the circle of courtly collectors around Del Monte, and may date from the mid- to late 1590s. Although Mancini implies an earlier date, it is tempting to imagine that it was commissioned by Del Monte himself. It shares a lyrical, intensely erotic quality with *The Ecstasy of St Francis* (Col. Plate 9), which may, too, have been painted for Del

Monte. The story of *The Rest on the Flight into Egypt* is told briefly in the Gospel of St Matthew (2: 13–14): 'The angel of the Lord appeareth to Joseph in a dream, saying, Arise, and take the young child and his mother, and flee into Egypt, and be thou there until I bring thee word; for Herod will seek the young child to destroy him. When he arose, he took the young child and his mother by night, and departed into Egypt.' In the Middle Ages the story was enriched by a cluster of picturesque anecdotes: a field of corn sprang up to shelter the fugitives; a date palm bowed down to offer them fruit; angels accompanied them across perilous rivers. Artists delighted in such charming incident, but in the late sixteenth century it was rendered with more dignity. The Holy Family now often walk before the humble donkey, and St Joseph became increasingly heroic and youthful. Much of the appeal of Caravaggio's picture depends on his return to a medieval humility, a humility deeply reminiscent of north European art, and clearly conveying Caravaggio's own Lombard roots, in the rustic poetry of such artists as Lorenzo Lotto and Savoldo. The popular thirteenth-century Franciscan tract, the *Meditations on the Life of Christ*, stressed the defencelessness of the Holy Family, alone in a strange land: 'It was also grievous that they had to go to a distant country of which they knew nothing, by rugged roads which were difficult for Our Lady on account of her youth and for Joseph because of his age, and also because of the sweet Infant, not yet two months old, whom they had to carry.'[49]

Federico Borromeo later wrote that it was sometimes acceptable to keep the much-loved and comforting medieval traditions, such as that which prescribed an aged Joseph, and Caravaggio's Joseph is an old man, slow, ponderous, tiredly rubbing his feet; he and the donkey, whose huge eye is so close to Joseph's face, seem somehow touchingly united in their tender watchfulness for the Virgin, freeing her from the heavy burdens of this world. They crowd one half of the painting with their block-like forms, and the angel, like a *genius loci*, lulling them to sleep with the music of the violin, sharply divides the picture into two halves. At the angel's feet the earth is barren, dry, cracking, and beneath Joseph's feet are sharp stones and withered, frail leaves, laid out with resonant precision. On the other side the Virgin and Child, warm and naturalistic, sleep, encircled

by brambles, protected from danger, in a luxuriant twilight landscape, where the blades of corn perhaps reflect the old legend. It suggests a movement from the harsh and stony path that leads through this vale of tears to the radiance of the everlasting life promised by the birth of Christ. And at the painting's very centre, Joseph holds up to the angel a large oblong part book, thrust towards the spectator in a way that insistently claims his attention. It shows the cantus part of a motet by the Flemish composer Noel Baulduin, first published in 1519. The text, of which Caravaggio shows only the letter Q, reads *Quam pulchra est et quam decorum*, words taken from the Song of Songs. The passionate eroticism of this biblical book, a lyrical dialogue between the Bridegroom and the Bride, underlies the picture's mood. In the Christian centuries this ancient poem, perfumed and sultry, had become virginal, and its most ardent words became the language of the soul. To the Roman Church the bride and bridegroom of the Song of Songs represented the mutual love of Christ and his Church, and Mary was herself the symbolic bride of Christ. Caravaggio's angel is sweetly erotic, and the lush landscape beyond the Virgin suggests the bucolic imagery of the biblical text, with its apples, grapes, lilies and green bed, while the Virgin's unusual mass of red hair perhaps recalls that of the bride, whose 'head upon thee is like Carmel, and the hair of thine head like purple' (Song of Soloman, 7:5). Yet Baulduin's music itself is sombre and Caravaggio's lyrical, autumnal landscape is touched by melancholy and transience. The strains of the music evoke the passing of time, time that leads to Christ's death, but also to his Resurrection. And woven into the naturalistic landscape are symbols of his passion, for the donkey's back is marked by the sign of the cross, the thorns evoke the crown of thorns, and the blades of corn the Eucharist. Federico Borromeo, in *Le Piaceri*, was to exalt the beauties of the descriptions of nature in the *Song of Songs*, and to recommend it to those practising the contemplative life, although adding that the work was not suitable for everyone, and that it should be recommended with caution.

Caravaggio's picture has none of the Egyptian palms favoured by Italian artists, but shows, as northern artists did (there is a very similar print by Abraham Bloemart), a real stretch of countryside, beside the

banks of the Tiber. It has something of Borromeo's feeling for the humble things of nature, for the 'trees of our woods', lowly plants and stones, an oak tree bearing fungi. The sense of the simple beauties of nature and music together praising God is perhaps Oratorian in feeling, and Del Monte's circle of friends enjoyed the musical world of the Oratorians; the picture perhaps conveys the atmosphere of the pilgrimage to the seven churches, when the beauties of nature were enriched by music and sermons. Caravaggio built up this poetic vision from intense observation. The solid still life of sack and carafe, its neck closed with a twist of paper, is a passage of forceful realism; so too are the angel's wings, which, rendered feather by feather, were probably painted from the wings of a pigeon. The angel needs a score to play, and Joseph holds up the part book to this ethereal visitor, the strings of whose lovingly executed violin curl profusely, in a wonderfully naturalistic passage, around the pegs. We may perhaps sense, in Joseph's uncomfortable, awkward pose, something of the tiredness of the studio model.

The Ecstasy of St Francis,[50] perhaps close in date, shares this sense of the beauties of nature; St Francis, dedicated to poverty, devoted to Christ's passion, was one of the most popular Counter-Reformation saints, and Carlo Borromeo had made a pilgrimage to Mount La Verna in Tuscany, where Francis, passionate in his desire to be mystically united with Christ, had received the stigmata. In earlier periods artists showed St Francis kneeling, but in Caravaggio's painting he lies on the ground, tenderly supported by an angel, in a state of ecstasy. His hand draws attention to the stigmata on his breast (there are no wounds on his hands). An early account, rich in echoes of the birth of Christ, records how 'the whole mount of La Verna seemed to flame forth with dazzling splendour, that shone and illumined all the mountains and valleys round about, as were the sun shining on the earth. Wherefore, when the shepherds that were watching in that country saw the mountain aflame and so much brightness round about, they were sore afraid . . .'[51]

Caravaggio's sky is streaked with light, and fires flicker in the distance, but the light that falls softly across the foreground has a supernatural radiance. Francis's was a passion undergone through love, and ecstatic love was a metaphor for death. The mystic language of sixteenth-

century poets is intensely erotic; Tasso, in a sonnet to St Francis's wounds, 'the sweet wounds of love', sings of the stigmata as though in a vision, and blends, as does Caravaggio, the light of the stars and flames with the mystic light of God:

> And far-flung stars you see, bright
> With the light of Him who sprinkled them in you . . .[52]

and Maffeo Barberini, later to patronise Caravaggio, wrote of the stigmata: 'although they seem like wounds, yet they are not, but openings whence the heart breathes out its flames . . .'[53] At the Oratory Filippo Neri read the poems of the thirteenth-century Franciscan Jacopone da Todi (a copy of his verses bearing Neri's name survives), who wrote of the cross as a sweet death, where pain is changed to sweetness. Crucifixion is the joy of love:

> Then let death come
> To the bride
> In the bridegroom's embrace
> Such is the joy of love . . .[54]

And through the devotional writing of the sixteenth century, as in these early pictures of Caravaggio, echo the rhythms of the *Song of Songs*. Luis de Granada wrote: 'Now the soul understands all the loving language that is spoken in the Song of Songs, and sings all those sweet canticles in its own fashion, saying, "His left hand is under my head, and His right hand doth embrace me" (Cant. ii.6). And in the verse before, "Stay me with flagons, comfort me with apples; for I am sick of love." Now does the soul, burning with this divine flame, long with earnest desire to escape out of this prison; and while her departure is deferred, her tears are her food day and night.'[55] Caravaggio's is perhaps the first picture to convey this thread of sixteenth-century spirituality.

At the end of the decade Cardinal Del Monte had the good fortune to acquire a garden villa and casino, now called the Villa Ludovisi, at the Porta Pinciana, in a beautiful part of Rome, where he created a distillery,

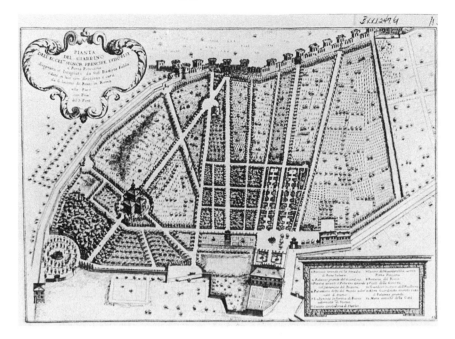

20. G. B. Falda, *Casino Ludovisi*

 (print)

21. *Opposite:* Caravaggio, *Jupiter, Neptune and Pluto*

 (Rome, Casino Ludovisi)

and, in a small room next to it, which strikingly recalls the Studiolo of Francesco de' Medici in the Palazzo Vecchio in Florence, had the ceiling painted by Caravaggio (Plate 21). Here Caravaggio painted, around a crystal sphere representing the globe of the world, Jupiter, Neptune and Pluto, personifying the elements of air, water and earth. Del Monte had bought the villa in 1596, but in the following year had been obliged, reluctantly, to cede it to the powerful papal nephew Cardinal Pietro Aldobrandini. However, in 1599 it was returned to him, and it was probably at this time that Caravaggio painted the ceiling. Here Del Monte enjoyed his alchemical experiments, and entertained his guests with music. A letter of 1602 from Emilio de' Cavalieri describes one such impromptu concert – Cardinals Altieri, Paravicino and Acquaviva 'in most beautiful weather'

had visited the Villa of Del Monte. By chance the famous singer Vittoria Archilei arrived there, sightseeing with her husband. The Cardinals begged her to sing, and sent for instruments, and 'I certainly have never heard her in more beautiful voice . . . so that Acquaviva has said, I for shame have not wept . . .'[56] It is the power of music, and the intensity of natural objects, that characterise Caravaggio's paintings executed for the circle of Del Monte.

The World of Street and Brothel

'Set honour in one eye and death i' the other
And I will look on both indifferently.'
SHAKESPEARE, *Julius Caesar*

'HE WAS A LARGE YOUNG MAN, around twenty or twenty-five years, with a thin black beard, black eyes with bushy eyebrows, dressed in black, in a state of disarray, with threadbare black hose, and a mass of black hair, long over his forehead.'[1] In these vivid words Luca, a barber, described Caravaggio, a stocky dark Lombard, and a familiar figure in his neighbourhood. This is the first account of Caravaggio in Rome, part of Luca's evidence given to the notary of the Tribunal of the Governor of Rome on 11 July 1597 for a criminal case that was later dropped. Luca's apprentice, Pietropaolo, had been assaulted in the street, and was in prison for refusing to name his assailant; the investigator was angling to find out who had returned to the barber a black cloth cloak found near the scene of the crime. The cloak, Pietropaolo had told him, had been returned by a painter, but, Luca added, 'he told me the name but I don't remember it . . . I know this painter by sight because he once came to have his hair done in my shop, and another time he came to be treated for a wound . . . which he had suffered in a fight with a groom of the Giustiniani or Pinelli household.' (Barbers commonly served a dual role as surgeon.)

The next witness, called later the same day, was Caravaggio's friend the dealer Costantino Spata, who described how, as he was closing his shop at sunset, two painters had passed – 'one is Michelangelo da Caravaggio who is the painter of Cardinal Del Monte, and lives in the house of that Cardinal, and the other a painter called Prospero, from I

don't know where, but he lives there near Monsignor Barberini . . . he is small with a straggly beard and about 25 or 28 . . . They asked me if I had eaten, and I said yes, but they had not, and wanted to go to the Tavern of the Wolf, so we all three set off together . . .' After eating, continued Spata, he left the two painters to go home, when he heard cries in the distance and was passed by a fleeing man – 'I don't know who was running and screaming, because I withdrew, and anyway I see very badly without my glasses . . .'

On the following day Prospero Orsi appeared before the court. He too described the cries coming from San Luigi and the running man: 'I could not see his face, nor his clothes, he passed like a shadow . . .' A little further on they found the black cloak, which Caravaggio picked up and delivered to Luca's shop, perhaps because he had recognised the running man as the apprentice Pietropaolo. Neither Costantino nor Prospero was armed, 'but Michelangelo wore a sword . . . Michelangelo usually wears a sword, because he is in the service of Cardinal Del Monte, and I have seen him carry one often enough.' And, Prospero concludes, 'he used to carry one by day, but does so no longer, except when he is going out by night'. Caravaggio was never called, and the case petered out. The two painters seem to have been merely bystanders, and Caravaggio was perhaps protected from questioning by his role in the household of Del Monte.

Within the palace and the paradisaical gardens of the Villa Medici, Del Monte's household enjoyed the most refined and aristocratic pleasures, and Caravaggio's pictures of these years have an exquisite quality, a sense of the beauty of precious and fragile objects. But beyond the palace walls, in the streets, shops and taverns – the Tavern of the Wolf, the Tavern of the Blackamoor, the Tavern of the Tower, close to d'Arpino's studio, or the Tavern of the Turk, below the Trinità dei Monte – and in the many brothels, clustered around the Mausoleum of Augustus, incidents like the skirmish near San Luigi were common. A wave of extraordinary brutality and violence, with constant brawling with swords, daggers and stones, swept the streets of Rome. It was an overwhelmingly male city, of celibate churchmen, diplomats and ambassadors, each with a crowd of servants, retainers, and soldiers, quick

to take arms on behalf of their patron. Violence was endemic, and it exploded in the 1590s, when many soldiers lost their occupation. Mercenaries, *bravi* and soldiers from throughout Italy mingled with the vast number of vagabonds who were moving into Rome from the poverty-stricken *campagna*, together creating an atmosphere of extreme public unrest and idleness.

Caravaggio was in the thick of this bellicose street life. He roamed from tavern to tavern with a band of 'mainly lusty young fellows, painters and swordsmen, who had as their motto *'nec spe, nec metu'* – 'without hope or fear'.[2] This was a celebrated Renaissance motto, associated with Isabella d'Este, Philip II and others, and it implied a search for moral equilibrium. For Caravaggio's friends it implied rather a bold independence, for they were aggressive, quick to respond to insult, passionate in defence of their honour and reputation, and swift to draw their swords, 'as a cat arches its back'.[3]

The rowdy architect Onorio Longhi dominated this small group. A passionate ball-player and swordsman, Longhi had a fiery temperament; he was immensely litigious, always in and out of prison, constantly involved in duels and fights and in brawling in the many brothels, and frequently being summoned before the magistrates for breaches of the peace. Caravaggio was particularly closely associated with Longhi in the years around 1600, but he may have met him in the early 1590s. Longhi was a member of a distinguished family of architects who, like Caravaggio, came from Milan. His father, Martino Longhi, had worked in Rome, where he had been papal architect, and the two eldest sons, Onorio and Decio (who later became a priest), had studied law at the Sapienza, the University of Rome, receiving a literary and classical education. As a family they were notoriously difficult, contemptuous of their teachers and colleagues, often involved in disputes, their works a strange mixture of the new and the ultra-conservative. They were on the rise, and Onorio, well-travelled and far more cultured than his father, also nurtured ambitions as a poet. By 1589 he had already published a volume of occasional verse, uninspired and mediocre but none the less displaying a great deal of scholarly classical learning. Martino Longhi had died in 1591, when Onorio was away in Portugal; he returned to take

charge of his affairs, starting a long-running battle with his brothers' guardian over his inheritance, and taking over many of his father's important architectural projects. He had already begun to practise as an architect, creating 'the gateway of the vineyard of the Duke of Altemps . . . richly detailed, and very lovely . . .'[4] He became involved with the Crescenzi family, and in 1592 designed the tomb of Virgilio Crescenzi in San Gregorio. The family had acquired considerable prestige, and in 1596 Onorio, then twenty-eight, lived with his mother, his two brothers, Decio and Antonio, and two servants, in their own house near the Piazza dei Santissimi Apostoli, where there was a colony of Lombards. Longhi aspired to worldly elegance and to the display of an aristocratic taste. Sporting a small blond beard, and dressed in rich black velvet, he did not carry his own sword – 'I do not carry arms of any sort, neither by day nor by night, but the servant who accompanies me carries it'[5]: an arrangement that flattered his rank and wealth.

Throughout the 1590s one noisy adventure followed another. In 1593, for example, a young married woman, Leonora Palelli, who lived near the Piazza dei Santissimi Apostoli, denounced Decio and Onorio for making a disturbance in the streets, beneath her windows – 'singing with lutes and guitars abusive songs in the manner of famous insults' (libelli famosi), and making such a racket that all the neighbours had come out.[6] In 1596–8 Longhi was away from Rome, but in 1598 he returned, and with his friends and their pages stormed round to the house of 'Maria the innkeeper' to root out his brothers' guardian, yelling at him, 'You cuckolded thief, I want you to die by these hands.' Longhi and his troop were, the guardian complained, 'armed with cudgels and had forced the door of the room wherein I found myself'.[7] The following year a widow, Felice Sillana, who lived in the house of Lorenzo Argentini, added her grievances: Longhi had appeared at her house, hammering at her door and yelling, 'Whore, tart, open up, and having left once then returned, wanting to kick down the door, and shouting filthy words. He said that if I spoke he would beat my head with his sword . . .'[8]

Such incidents were common in Clement's Rome, but even so Longhi's behaviour startled his contemporaries. In the eighteenth century Lione Pascoli wrote of him, 'He was eccentric by nature, and

his head smoked, adding that he had been 'generossimo' (exceptionally generous), and on his death had not left the great wealth that had been expected.⁹ Baglione, who had many reasons to detest Longhi, gave a remarkably objective picture of him, suggesting a young man who was highly gifted and well educated, but difficult, vain, and jealous of his competitors – 'he had had a university education, and from this became a virtuoso, and dedicated himself to the study of architecture, and profited from this, and the labours of his father were of some help to him, but all the same he had always so strange a brain, that it was difficult to get along with him, and he spoke ill of all his mentors, so that he was much hated by the others . . .'¹⁰ Baglione suggests that the excesses of Longhi's life hastened his death, commenting: 'he was so disordered, that when he caught a fever, even though his constitution was robust he died at the age of 50 . . .'¹¹

Onorio was not the only troublemaker among Caravaggio's friends; Orazio Gentileschi, too, so lyrical and tender a painter, was a prickly character, whose reputation suffered from his frequent feuding. His satirical tongue was feared, and Baglione, later a tormented target, wrote: 'had he been of a more practical temperament, he would have advanced in *virtù*, but he conducted himself more like a beast than a human'. He had no respect for rank, holding stubbornly to his own opinions on everything, and assaulting the world with his satirical tongue. Baglione concluded piously . . . 'Let us hope that God in his goodness will pardon all his faults.'¹² His perhaps biased view was confirmed by the Roman agent of Cosimo II of Tuscany, who warned the Grand Duke against him in 1617, saying that he was 'deficient in draughtsmanship and composition' so that he failed to delight 'even people of mediocre understanding . . . On top of that he is a person of such strange manners and way of life and such temper that one can neither get on nor deal with him.'¹³

Indeed, many artists seemed strange to those around them. Even Cherubino Alberti, an establishment painter and member of an ancient and admired family of artists, who rose to the coveted rank of *cavaliere* under Clement VIII, was deeply eccentric. Rich and successful, with a wife and children, he none the less 'fell into a melancholic humour',

wrote Baglione with deep disapproval, and spent his time constructing 'diverse catapults, such as were used in olden times, before the introduction of artillery . . . In this caprice he passed all his time, and he had so many of these weapons that his house was full of them, and now he experimented with one, and now with another . . . It was ridiculous that he should try to work catapults in times when one uses big muskets and formidable cannon. He wanted all his friends to have a try and he himself lost the time which he could have better employed towards improving himself.'[14] The Pope's favourite, the elegant Giuseppe Cesari, was reported by his neighbours for consorting with prostitutes,[15] and Minniti, too, was involved in brawls.

Among such eccentric and violent friends Caravaggio displayed his swordsmanship, and his prowess at tennis. Like Onorio Longhi, he dressed elegantly – 'he wore only the finest materials and princely velvets; but once he put on a suit of clothes he changed only when it had fallen into rags'.[16] Van Mander, in the earliest published description of the artist, mentioned his lack of perseverance – 'he does not study his art constantly, so that after two weeks of work he will sally forth for two months together with his rapier at his side and his servant-boy after him, going from one tennis court to another, always ready to argue or fight, so that he is impossible to get along with'.[17] All his early biographers comment on his quarrelsomeness. To Baglione, who suffered so much from him, he seemed 'proud and satirical'; he noted his excessively fearless nature, and his desire to look for a chance to break his neck, in the company of other men, who 'like himself were also belligerent'.[18]

At the centre of this life of street and brothel, their stories fatally interwoven with those of Longhi and Caravaggio, were the young swordsman Ranuccio Tomassoni and the rising *cortigiana*, or whore, Fillide Melandroni.[19] As the wars in eastern Europe came to an end, and there was peace between France and Spain, soldiers flooded back from the campaigns in Flanders and in Hungary, Croatia and Slovenia, where the army had suffered badly from disease as well as war. The streets were crowded with aggressive young men armed for adventure and with little to do, adding to the Roman idleness on which Montaigne had commented some years earlier. Among them were members of the Tomassoni

family, who boasted a long tradition of military service, and had won many honours in the long wars of religion. Lucantonio Tomassoni, Ranuccio's father, had taken part in the French wars, and had been present at the massacre of the Huguenots on the night of St Bartholomew; his great uncle, Lodovico Tomassoni, had participated in an expedition against the bandit Curbiello. The family had for many years been in the service of the illustrious Farnese household, and Lucantonio expressed his loyalty by embellishing his sons with names long favoured by the Farnese – Alessandro, Ottavio, Giovan Francesco (born in 1573 and godson of the Duke of Parma, Octavio Farnese), Mario, and, the youngest, Ranuccio. In 1591 Captain Lucantonio Tomassoni became the castellan of the Castel Sant' Angelo, but by 1592 he was dead. The patrimony was not divided until 1600, and perhaps this was when Ranuccio, whose date of birth is unknown, came of age.[20] His two elder brothers had served in the wars, Alessandro in Flanders (where he had been lamed), and Giovan Francesco first in Flanders and then, under the command of the papal nephew Giovan Francesco Aldobrandini, in Hungary, where 'conducting himself not as a young man, but as a skilled Captain, he won great praise'.[21] Giovan Francesco was the dominant figure amongst the brothers, with the most distinguished military career. They kept company with other soldiers, and Giovan Francesco was friendly with Ignazio Giugoli, who had fought in the Hungarian wars and whose sister was later to marry Ranuccio. The Tomassoni were protected not only by the Farnese, but by other noble families such as that of Melchiorre Crescenzi (who was also a patron of Caravaggio), and Ranuccio and Mario were for some time in the service of the papal nephew, Cinzio Passeri Aldobrandini, the Cardinal of St George.

Over the next few years the Tomassoni names appear constantly in the criminal records, at the centre of brawls and riots, disputes over gaming, bearing arms, fighting over women. Against their urban thuggery, underpinned by such powerful patrons, the *sbirri*, or police, were powerless. The *sbirri*, who were universally despised and mocked by the Romans as cowardly spies, were organised at stations throughout the city. They made nightly rounds to preserve the peace, bursting into inns and houses looking for the companions of bandits and arresting men for

gambling, or for carrying arms. In the margins of their depositions is sketched in an extraordinary array of arquebuses, short daggers and other forbidden weapons, together with articles like compasses and dice. But Caravaggio, in the household of Del Monte, and the Tomassoni, supported by great nobles who often barred their doors against the police, encouraging private wars and vendettas, were to some degree protected against them. The Tomassoni lived in the Piazza di San Lorenzo in Lucina, a long narrow square, overlooked by the Early Christian campanile of San Lorenzo; they played a prominent role in the affairs of the neighbourhood, where Giovan Francesco was later to be *caporione*, or chief lay official. In the centre of the *rione* of Campo Marzio, the Piazza lies opposite the Via Frattina, where many artists lived, and only a step away from the Vicolo del Divino Amore, where Caravaggio later had a house. In this small area, the heart of the most densely populated part of medieval and Renaissance Rome, the drama of the next few years was to be played out.

In 1598 Caravaggio was arrested, between the Piazza Navona and the Piazza Madama, for carrying weapons without licence — a sword and a pair of compasses. He replied to questioning: 'I wear a sword because I am the painter of Cardinal Del Monte because I have the Cardinal's support for myself and my servant, and lodgings in his house, where I am engaged as one of his employees.'[22] It was an arrogant response, and suggests that Caravaggio, now attended by a servant, had moved out of the servants' hall and was rising in status. He was certainly privileged, for all sorts of licences were required to carry arms in the city, varying by time, place and occupation. Permission to wear a sword at night, as Caravaggio was doing the previous year, was particularly restricted, since brawls were far more likely to break out after dark.

Two years later, in 1600, Ranuccio makes a first shadowy entrance in the life of Onorio Longhi, when his name recurs in testimony that Longhi, accused of a variety of breaches of the peace, gave to the police. By this date Caravaggio and Longhi were certainly street-fighting together, and it is likely that Caravaggio also knew Ranuccio. Longhi's description of a July afternoon in 1600 is a particularly vivid evocation of Roman pastimes. He recalls that he had been at a ball game near

Santa Lucia della Tinta, where a duel had taken place. He had then wandered on to the Piazza Navona, where there was a game of football. Here he met a group of men who had been involved in the duel, and a dispute erupted over the prowess of the competitors. The row flared into violence, when Longhi, 'for my honour and for my defence, I too thrust my hand on my sword, delivering I know not what blows . . .' The men were parted, but Longhi later learned that he had wounded his opponent a little in the hand. This man was from Terni, and it may be that he was a henchman of Ranuccio, for the interrogator then pressed Longhi about his acquaintance with Ranuccio; Longhi, however, claimed that he was Ranuccio's friend, emphasising that he had only recently dined with him – 'Ranuccio is my friend, and it is not many days ago that I dined with him, and I have not rowed with him, nor attacked him.' His friend-ship with Ranuccio also emerges from the testimony of Lorenzo Capellario, a hatmaker, summoned by Felice Sillani, who lodged in his house, to support her grievances against Longhi. Longhi, protesting unconvincingly, 'it is not my custom to knock on the doors of others nor to threaten women', boldly insisted on interrogating the witness himself, and displayed considerable forensic skills. Above all he attacked Lorenzo's identification, asking how he knew him, and how, at night, he could have recognised him by his voice. To this Lorenzo replied, 'I recog-nised you by your voice, because I have heard you talking at the Pantheon with Signor Ranuccio, and I have seen you there at the ball game at the Vicolo de' Pantani . . .'[23] Another document, from the Act Book of the court of the Governor of Rome, further suggests that Longhi had threatened Ranuccio. The sculptor Hippolito Butio of Milan, who lived by the church of San Spirito, pledged that Longhi would neither assault, nor cause others to assault, an extremely odd array of people, among them the tormented Felice Sillani, Flavio Canonici of Scandriglia, and Ranuccio Tomassoni of Terni.[24]

Disputes over women were often at the root of these violent incidents. Prostitutes from all over Italy flocked to serve this city of celibates, of clerics, diplomats, pilgrims and businessmen. They were confined to a kind of ghetto, a quarter called Ortaccio (the evil garden, or anti-Eden), near the Mausoleum of Augustus by the Tiber. Here they often

occupied entire streets, and Gregory Martin vividly suggests the squalor of their quarter of Rome: 'Their dwellings are together as it were pent up into one place of the citie in corners and bylanes and small outhouses, for this very purpose, that the place should be notoriously infamous . . .'[25] They had lost something of their elevated status since the Renaissance, but nevertheless Montaigne commented on their apparent beauty. He described the Roman passion for going from street to street, without having any place in mind, mainly to see the courtesans, 'who show themselves at their Venetian blinds with such treacherous artfulness that I have often marvelled how they tantalise our eyes as they do . . . I wondered at how much more beautiful they appeared to be than they really were . . . All the men are there taking off their hats and making deep bows, and receiving an ogling glance or two as they pass.'[26]

Among the most famous courtesans of these years was Fillide Melandroni, who came from a modest Sienese family, but rose to enjoy considerable wealth and status. Fillide, who was born on 8 January 1581, was the daughter of Enea de' Melandroni, and on his death she moved to Rome with her mother, Cinzia, and her brother, Silvio. Here she is first mentioned in April 1594, when, with Anna Bianchini, also to become a prostitute, she was arrested and taken to prison for being out in the streets after dark, near the walls of San Silvestro.[27] Fillide's mother had been ill, and Anna Bianchini had come to prepare a meal for her, and the two girls, both in their early teens, had walked back together. By 1597 Fillide's career was launched; she had won a protector in Ulisse Masetti, in the service of Cardinal Benedetto Giustiniani, and friend of Ranuccio Tomassoni, with whom she had, in her own words, 'carnal knowledge' and who gave her a 'a flame-coloured taffeta dress' which cost him five or six scudi.[28] Ulisse Masetti, in evidence given to the courts in 1601, claimed that their sexual relationship had been over for two years, but that four months earlier he had dined with her and with Ranuccio Tomassoni.[29]

Ranuccio's name often appears in the lives of the Roman courtesans, and perhaps, well connected as he was, and moving easily amongst the noble families of Rome, he offered some kind of protection against the forces of law and order. Certainly he enraged the notary of the Corte

Savelli, Gaspare Albertini, by taking the part of two courtesans, Prudenzia and Caterina Zacchia, who had viciously attacked the notary in the street, throwing bricks from their window, and wounding him on the leg. He marvelled that Ranuccio, 'a man of your own station, should be on speaking terms with a common whore, this well-fucked cozener who has so viciously attacked me', a remark to which Ranuccio responded with a well-worn list of syphilitic insults, about boils and sores.[30] A witness, Pietro, the process server of the governor, vividly evoked the confusion of such night-time scuffles. He said that the whores had thrown only half a brick, and that the moon had been shining (important for the law, as he, a policeman, knew): 'There was light and the moon shone, and I saw an arm, but I don't know to which of the two it belonged, and Gaspare said to me "Be my witness"' (this call to witness was standard form).

But only three weeks later Prudenzia Zacchia was herself ferociously attacked. Fillide caught up with her in Ranuccio's house near the Pantheon, waving a knife at her, pummelling her with her fists, pulling her hair. Back in the peace of her own house, which lay behind the Convertite (a house for reformed whores), 'with no hint of suspicion' Prudenzia had been the victim of a second sudden onslaught. Fillide and her friend Prudenzia Brunori had burst through the door, roughly pushing aside Prudenzia's mother; Fillide had gone for her face with a knife, and all three had struggled violently, leaving Prudenzia wounded on the wrist, and, touched by the point of the knife, near her mouth. All this – the ritual assaults on the door, the attempt to leave a facial scar (*sfregio*) – was standard street-battle behaviour, a very common occurrence.

The description of the attack at Ranuccio's house was embellished by Antonio Mattei, who had been present, and who described how 'Ranuccio was in bed with a woman, Prudenzia Zacchia, while I was standing there close to the fire, and there came a woman, Fillide . . .' As soon as she saw Prudenzia with Ranuccio, she had yelled, 'Ah, whore, strumpet, here you are!' and, seizing a knife from the table, had attacked her viciously. Later another witness heard Fillide shouting at Prudenzia, who was standing in the doorway of her house, nursing her wounded

hand — 'You scum, you strumpet, I wounded you in the hand, but I wanted to get you in the kisser. Don't worry, I'll be back.'

Clearly Ranuccio's favours, whether sexual or administrative, aroused violent passions, and Fillide's connections with the Tomassoni family were to remain strong. Meanwhile her career flourished. She amassed considerable wealth, living from 1603 in the prestigious via Paolina, in the parish of Santa Maria del Popolo, a district for which she would have had to buy a certificate of exemption. She now lived with her aunt, Petra, and her brother, Silvio. In 1598 a Florentine noble, Giulio Strozzi, arrived in Rome. He became passionately enamoured of Fillide, and his admiration, so intense that he wished to marry her, suggests that she had become a courtesan of the highest rank.

The unruly behaviour of these painters and swordsmen, the sense of a constant concern with rank and status, and the ritualised responses to slight and insult, are reflections of a rigidly stratified society. Their world was governed by a complex culture of honour, an inspiration and ideal that succeeded the Renaissance ideal of courtly love, and which shaped the behaviour of very many Romans. Honour was the badge of the élite, displayed through power, wealth, knowledge, and arms; it crystallised a man's value and status in the eyes of the world. Skill at swordsmanship was central to the culture of honour, and Rome was the centre of a flourishing school of famous swordsmen, where the rapier, a light weapon worn by the courtier, was becoming increasingly popular. As Castiglione had written, 'I judge the principal and true profession of a courtier ought to be in feates of arms . . . There happen oftentimes variances between one gentleman and another, whereupon ensueth a combat. And many times it shall stand him in stead to use the weapon that he hath at that instant by his side...'[31] Duelling had been outlawed at the Council of Trent, but this meant that the man-to-man fight, once hedged about with complex rituals, now became more informal and rapid, more a vehicle for the aggressive individual. Many artists, obsessed by social status, dreamed of rising to glittering social ranks, of becoming a Knight of Christ, or — the ultimate accolade — Knight of Malta, and in the last two decades of the century, such dreams were fed by a vast spate of treatises and handbooks on the subject of knighthood

and on the life of the gentleman. In 1583 Francesco Sansovino's *Origine de cavalieri . . . con la descrittione dell'isole di Malta et dell'Elba* was republished, but its idyllic tone contrasts sharply with the more brutal treatises of the 1590s. For example, in *Il Cavaliere*, written in 1589 by the Bolognese colonel Domenico Mora, it is recommended that the knight should offend fearlessly, for this, as Aristotle had claimed, is the mark of true distinction. Mora echoes Aristotle's sentiment, 'The source of the pleasure found in an insolent action is the feeling that in injuring others we are claiming an exceptional superiority to them. This is the reason of the insolence of the young and the wealthy; they look upon it as a mark of superiority.'[32]

The most violent of these handbooks is a dialogue by Tommaso d'Alessandri, entitled *Il Cavaliere Compito* (*A Knight's Duties*), dedicated to the Cavaliere d'Arpino, which sings the praise of swordsmen and describes with gory relish all the cruel blows needed to confer honour upon a *bravo* – 'Attack him with your dagger, and plunge it into that ill-borne breast . . . thrust at him your knife, and colour it in the biggest vein of his hot red blood . . . make him fall to the earth like a sack of straw.'[33] To d'Alessandri the duel (though he dared not use the word, writing of *il D*) had been introduced to punish vice, and to maintain and conserve honour. In the weighty technical literature, different grades of insults – through fierce looks, words, words plus blows – are minutely analysed, as are methods of retraction and arbitration; assaults on different parts of the body, and on property, all formed part of elaborate rituals of affront.

Such rituals, so deeply at odds with the Christian ethic of humility, underlay the constant Roman jockeying for position. Women, too, had a role in the culture of honour. The austere Popes of the mid-century had waged war on the prostitutes, but none the less their numbers had depressed Clement on his accession. Cardinal Rusticucci gloomily estimated that there were 13,000 prostitutes in the city, and there probably were eighteen prostitutes for every 1000 women, including the old and babies. They were hemmed in by penalties and prohibitions, forbidden from going out at night, and from riding in carriages, and their constant brawling with the police added to the urban warfare. In the most

dangerous parts of Rome, on guard at their windows, whores hurled abuse at the passers-by in the busy streets. Often their houses were attacked by raucous young men whose sexual designs had been thwarted, and attacks on doors and shutters, with stones and fire, or with excrement and scurrilous lampoons and verses, were so common that the crime had its own name, *deturpatio*.[34] Aristocratic and bourgeois women were kept apart and led circumscribed lives, while the whores, enjoying their freedom, were pugnacious and vituperative, and fought rowdy battles with male audacity. In this sphere of life alone could they aspire to equality with men. As a Paduan courtesan declared in Francesco Pona's *La Lucerna*, 'Freedom is the most precious gem a courtesan possesses and contains within itself everything she desires. Given this privilege, even infamy seems honourable to her. Since she is not subject to the tyranny of husband or parents, she can deliver herself to her lovers without fear of being killed for questions of honour. In this way she is free to express natural appetites and feminine lasciviousness.'[35]

Many penalties were meted out to whores and their customers, preachers railed against them, and Gregory Martin describes how 'wise matrons of Rome' strove to convert them, matching themselves with 'the notorious sinful wemen of the citie, such as sometime Mary Magdalene was, and so by their wordes and behaviour and promises and liberality towards them, they win them to honest life . . .'[36] Far stronger measures were taken against homosexuals, however, and the penalty for sodomy was death. Sodomy, the sport of Renaissance aristocrats, now carried with it real danger, and there were many condemnations of this practice in the reigns of Sixtus V and Clement VIII. Many offenders, both lay and ecclesiastic, were hanged or burned throughout Clement's reign.[37]

From his small group of friends – painters, soldiers and whores – Caravaggio drew the models for his early pictures, and in a sense these paintings are aesthetic transformations of an intensely private world. For example, a young man, with a plump, round face, elegant, richly dressed, and ageing slightly as the years pass, appears in several of these early works. He is the lute player in *The Musicians*, a work pieced together from studies of two models juxtaposed on a spaceless surface. He appears again – apparently aged about twenty – in the second version of *The*

Gypsy Fortune Teller. He is idealised in the Uffizi *Bacchus*, and – jauntily posed, leaning on the table, and a little older – in *The Calling of St Matthew* in the church of San Luigi dei Francesi, in Rome. It was perhaps Minniti who modelled for this group of works. Until around 1600, he remained one of Caravaggio's closest friends, and he may have executed some of the copies which were spreading Caravaggio's fame; in particular, the *Boy Peeling Fruit* and *The Cardsharps* were very much copied at this time. In a nineteenth-century edition of Susinno's life of Mario Minniti there appears an engraving of the artist (Plate 11), perhaps made from a lost portrait by Caravaggio, and showing a dark, curly-haired youth, with a full face, close in type to the youth in Caravaggio's pictures.[38] The model for the young Cupid in *The Musicians* also reappears, as the angel in the *Ecstasy of St Francis*. Throughout these works the light catches the blades of swords and daggers. In the second version of *The Gypsy Fortune Teller* Minniti's fashionably gloved hand rests on an elaborate hilt; before *St Catherine* (Plate 24), tinged with red, there glints what was probably Caravaggio's own duelling rapier, long and deadly. In later works the swords became simpler in form, the brutal, heavy swords of executioners.

Fillide, too, acted as a model, and Caravaggio painted her portrait (Plate 22) for her lover Giulio Strozzi The picture was later owned by Vincenzo Giustiniani, in whose collection it was described as a 'courtesan called Fillide'. (Vincenzo also owned another 'portrait of a famous courtesan' (untraced) by Caravaggio, and the artist's works in his collection are distinguished by their courtly and highly sophisticated sensuality. Strozzi lent the portrait to Fillide, who provided in her will that it should be returned to him.[39] The portrait showed her richly dressed, with elegant simplicity, her brown curls piled high, her full face set off by clustered pearl earrings. She had a distinctive, classy name, with strong literary overtones, which distinguishes her from the very many Maddalenas, Domenicas, Angelicas and Prudenzias of the streets. Although she participated violently in street fights, she had some culture, and she may have reminded her contemporaries of the golden days of the Renaissance, when the great 'honest courtesans' – cultivated, witty, elegant, and living grandly in sumptuous palaces in the most

patrician areas of Rome – had been one of the city's splendours. The beauty of her portrait was celebrated by poets in terms which suggest nostalgia for those golden days, when Raphael had painted Imperia. An anonymous poet, perhaps Marzio Milesi, playing on Caravaggio's name (Michelangelo), wrote:

> Only an Angel could portray you, the lovely Phyllis,
> Creating your lovely face, because you are an angel
> from Paradise,

thereby setting up a most unlikely apotheosis for both painter and sitter.[40]

In her portrait Fillide remains insistently real, with none of the lovely flesh of Titian's Floras. It is the richness of her clothes, her clustered earrings, her embroidered bodice shot through with gold thread, her massed curls, that create the glamour of the courtesan. She delighted in luxury, and owned many splendid dresses and jewels – dresses of scarlet and green taffeta, amber-coloured gloves, sleeves of embroidered silk, Spanish-style gowns of peacock-blue taffeta, a skirt decorated with thread-of-gold embroidery, a pair of enamelled earrings decorated with two large and one smaller pearl, a coral bracelet mounted in gold, and so on. Fillide was also the model for *St Catherine*. Another woman, of a more sensual, heavy beauty, who may perhaps be identified with Geronima Giustiniani,[41] modelled for the *Judith and Holofernes* and perhaps for the *Conversion of the Magdalene*.

As he moved from genre into religious subjects, Caravaggio's transformation of a personal world became subtler. His lyrical *Mary Magdalene* (Col. Plate 7), so close to the mood and warm naturalism of his early genre and musical pictures, was painted for an unknown patron, but one presumably in the circle of Del Monte; it has always been with the *Flight into Egypt* and shows the same model. In an era passionately concerned with salvation, Mary Magdalene became the most popular of the female saints, a heroine whose role in the Gospels is second only to that of the Virgin. *The Golden Legend* tells us that she anoints Christ's feet in the house of Simon the Pharisee; shunning the activity of her industrious sister,

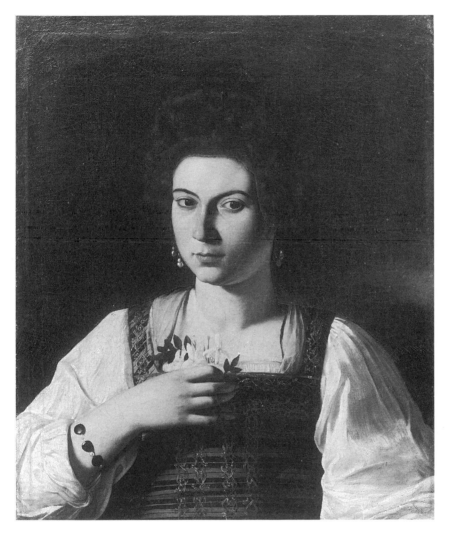

22. Caravaggio, *Portrait of Fillide*
(destroyed; formerly Berlin, Kaiser-Friedrich Museum)

Martha, she chooses instead contemplation, the 'one thing needful'. Christ's dead body is tended by her, and it is to her that the resurrected Christ is first revealed. Rich, beautiful, sensual, she had delighted in the pleasures of the flesh (for, as *The Golden Legend* comments, 'sensuous pleasure keeps company with great wealth')[42] but she heroically renounced the vanities of this world to lead a solitary and spiritual life. In some

accounts she is a beautiful prostitute, suddenly converted to Christianity, and she became the patron saint of sinners and penitents, a consolation to suffering women.

In Cardinal Del Monte's collection there hung a copy of Titian's *Mary Magdalene* (now in the Palazzo Pitti in Florence), then the most famous rendering of this theme. Titian's is an overtly voluptuous image. The saint is three-quarter-length, nude, and her breasts and arms, revealed by rich and dazzling waves of wonderfully erotic red-gold hair, are brought startlingly close to the spectator; she stands in a dark grotto, penitent, her tear-filled eyes turned heavenward. But by the more austere 1590s, churchmen and theorists railed against images that could be seen as lascivious or worldly; they disliked both nudity and those images of the Magdalene decked in the rich and worldly finery of the courtesan. In his rendering Caravaggio complies with the demand for decency. His Magdalene wears the elaborate dress of the contemporary courtesan, but she has cast off her rich jewels, which lie beside her, and her red hair is tied back, only hinting at voluptuousness. Her pose is one of melancholy, dejection, a figure helpless and weighed down by guilt and grief, brooding upon the vanities of this world, her hands empty, and a tear on her cheek. She is almost without attributes; what seems to be a small flask of wine stands beside her, while in the pattern of her damasked gown, a hidden symbol, appears the shape of the usual alabaster vase of ointment.[43]

The image is so naturalistic, and the symbolism so understated, that Bellori believed the picture to have been conceived as a genre painting, and then given the title of Mary Magdalene. His description of its conception is fascinating; he writes . . . 'when he came upon someone in town who pleased him he made no attempt to improve upon the creations of nature. He painted a girl drying her hair, seated on a little chair with her hands in her lap. He portrayed her in a room, adding a small ointment jar, jewels, and gems on the floor, pretending that she is the Magdalene . . .'[44] But this account perhaps belies the picture's extraordinary originality. Indeed, Caravaggio does not show the lovely and archetypal penitent in the desert, familiar from so many images; he shows an individual and melancholy young girl in a room, at the very

moment when she sees that the pleasures of this world are a temptation. He puts the religious scene back into a real context, into the context of the everyday, renewing its immediacy, re-creating its meaning. It has been suggested that the model may be identified with Anna Bianchini, Fillide's friend in her early Roman years. The evidence for this is not watertight, but it may be right, and it is extremely likely that the model was from the same circle as Fillide.[45]

It may be that Caravaggio truly saw a girl drying her hair, and liked the image; but the image reminded him that the Magdalene was once such a girl, who had delighted in the world, and he thought back to the beginning of the story, painting her realisation of guilt with new tenderness and poignancy. This ability to rethink religious imagery and to endow the intensely real with profound resonance remained characteristic of Caravaggio's religious art. The painting's sense of immediacy may also be indebted to the contemporary conception of the Magdalene as a model for penitent prostitutes; Fillide herself owned a painting of the Magdalene.[46]

In 1541 the celebrated preacher Cornelio Musso, in the church of San Lorenzo in Damaso, had railed against prostitutes, urging upon them the penitence of the Magdalene, 'My dear ladies, courtesans, if there are any of you here, do not wait until you are getting old, when your lust is satiated, when your lovers turn their backs on you: now, right now, as I am speaking, you should decide to go to the Convertite and spend your whole life in that holy prison to do penance for your sins'.[47] The convertites, or converted women, Gregory Martin tells us 'so called bycause they are converted from their naughty life, and of common whoores and harlots made good Christian wemen', were sheltered at the Casa Pia, and 'if they choose with Marie Magdalene the best part, to sit at Christes feete in quiet contemplation, and by penance to wash his feete with their teares of true repentance . . . much is forgeven them . . .'[48]

The Golden Legend describes how Mary 'is called enlightener, because in contemplation she drew draughts of light so deep that in turn she poured out light in abundance: in contemplation she received the light with which she afterwards enlightened others. As she chose the best part of heavenly glory, she is called illuminated, because she now is enlight-

ened by the light of perfect knowledge in her mind and will be illumined by the light of glory in her body.'[49] Perhaps the shaft of light, which penetrates the darkness of the room in which Caravaggio's *Magdalene* sits, is symbolic, as it is to be in other paintings, of spiritual enlightenment. Her name, Mary, is interpreted as *amarum mare* (bitter sea), or illuminator, and Caravaggio unites the ideas of penitence and illumination. In another work, the *Conversion of the Magdalene* (Plate 19), Caravaggio shows the ray of light entering the sinner, as she casts off worldly vanities. The picture was perhaps painted for a woman patron, Olimpia Aldobrandini, and suggests the 'wise matrons' of Rome converting the Roman whores. Many noble Roman women gathered around Filippo Neri, engaging in active charity and conversion, and modelling themselves on those early Christian women who had been inspired by St Jerome.

The *Bacchus* (Col. Plate 10) is also a painting about transformation, but it is one of a very different kind, for here Caravaggio exalts the transforming power of art.[50] The god, reclining on a Roman *triclinium*, his mass of abundant black curls wonderfully crowned with vines, offers an elegant Venetian glass of wine to the spectator. In classical literature Bacchus, the god of vegetation and the creator of the vine, presided over feasts; he was also the god of poetic inspiration, through whose gifts man might reach union with the divine and penetrate the mysteries of nature. In Roman literature he tends to be jollier, less awesome than the Greek Dionysus, offering peace, happiness, and freedom from care. As Horace had written:

> Give the sacred vine preference, Varus, when you plant
> your trees . . .
> For the god has cursed abstainers – nothing in their life
> goes right;
> He alone provides the means to put man-eating cares
> to right . . .[51]

Bacchus was also the autumnal god, associated with abundance, with the lovely richness and fertility of nature, and hence with the freedom and creativity of the artist. The Bacchus myth was deeply ambiguous; his

birth was both human and divine; he was both savage and civilising, noble and corrupt, and Caravaggio's strange figure, so oddly dressed up, so fleshy, and yet exotically beautiful, idealised by the unusual tautness of line, and the abstract patterning of the drapery, conveys this ambiguity. His sexual ambiguity is rooted in classical texts, while his oriental features suggest the myth of his Eastern upbringing. We remain intensely aware of the studio, of the brawny model (perhaps Minniti, considerably idealised), his hands red, his fingernails dirty, toying with his velvety black bow, and yet, as we look, he becomes Bacchus, and we sense the presence of the divine, of the god amongst us. It was perhaps this sense of a sudden revelation that artists sought in their Bacchic ceremonies, and Caravaggio may have remembered the Academy, dedicated to Bacchus, over which Lomazzo presided in Milan. Northern artists in Rome were later to band together in a boisterous cult of Bacchus.[52] And Caravaggio, as if to stress the nature of the illusion, of his astounding sensory realism, and the marvellous power of naturalistic painting so brilliantly displayed in the still life, included, as many northern artists had done, a hidden self-portrait, reflected in the carafe, its bubbles moving on the surface as though it had been just set down.[53]

The *Bacchus* perhaps crowns the youthful paintings of the 1590s, before the models, like Caravaggio himself, begin to age. At this period these lightly disguised paintings of his friends suggest the delicate transience of youth and beauty, and the snares (especially of love) that threaten innocence. His works suggest invitations to love, or warn against its perils. The beauty of a voluptuous youth, caught in a fleeting moment, is set against frail roses, a reflection shimmering in the glass carafe. Another curly-haired boy, a rose behind his ear, his bared shoulder thrust provocatively forward, reacts with extreme and exaggerated horror at the bite of a lizard concealed among the fruits and flowers before him. The rose will fade, and pain and death lie concealed among the pleasures of the senses. The rose, so often used by lyric poets, is a symbol of the courtly world of the late sixteenth century, a flower luxuriant and splendid, yet quick to perish, its highly wrought beauty soon passing.

Bacchus himself is touched with melancholy, as in the increasingly elegiac odes of Tibullus and Propertius. He offers the riches of autumn,

of cultivation, of wine, but the leaves are already curling, and the still life, so voluptuous, so opulent, is already blemished. Autumn yields to winter, and the desire to drink with Bacchus veils a fear of ageing and of death, conveying a passionate desire to seize the day. This group of pictures transforms Caravaggio's world, creating a lyrical, courtly ideal of the beauty of young men and women, but one given tension by the subtly underlying sense of a more violent reality. Young women — the red-haired Magdalene, the sensual Catherine — play as dominant a role as the young boys; and these boys suggest a lyrical ideal of male beauty, sensuous and soft, that is courtly but not necessarily homoerotic. It is a luxuriant beauty, languid and adolescent, that is evoked by contemporary lyrics, the beauty of Narcissus, or of Hyacinth, their throats like ivory, and their lips ruby-red; it culminates in Marino's description of Adone, the hero of his epic of love:

> But who could draw the two lucent and serene stars of
> one and the other brow?
> Who the lovely ruby of his sweet lips, rich and full in
> glowing treasure?
> Or what whiteness of ivory or of lily can compare with
> the throat,
> Which raises and upholds a heaven of marvels gathered
> in that face?[54]

Caravaggio was at the centre of a coterie of swordsmen, painters and whores, playing tennis and fighting with Longhi and the Tomassoni, using the famous courtesan Fillide as a model, and perhaps exchanging studio props with Gentileschi. But he remained an oddly isolated figure. He was aggressive and insecure, and intensely jealous of his honour. Sandrart's story of how Caravaggio came to cherish the dream of being a Knight of Malta, albeit inaccurate in detail, may well be true in essence. 'Soon afterwards,' wrote Sandrart,

> . . . it happened that Giuseppe d'Arpino, riding to
> court on horseback, met Michelangelo da

Caravaggio, who accosted him and said, 'This is the
time to settle our quarrel, since we are both armed,'
and told him to get off his horse and prepare to
fight. Giuseppe, however, answered that as a papal
knight he could not deign to fight with one who
was not of that rank. This courtly answer wounded
Caravaggio more deeply than a sword thrust might
have, and it so upset and maddened him that he
immediately (because he had no intention of
delaying) sold all his possessions to Jews for cash
and set out for Malta to have the Grand Master
make him a knight and *cavaliere*.[55]

Caravaggio was never without protectors, but he lacked close ties.
Mancini tells a chilling little story. Caravaggio's brother, a priest, had
arrived in Rome to see Caravaggio, having heard of his growing fame. He
was received by the Cardinal, who sent for Michelangelo, who, 'At the
sight of his brother . . . declared that he did not know him and that he
was not his brother.' The poor priest made a tender reply, but was forced
to leave without even a goodbye. There are difficulties with this story –
Giovan Battista Caravaggio seems to have lived in Rome, certainly from
1599 where he studied moral theology with the Jesuits, and was probably
ordained there on 27 May 1600. Perhaps this interview took place on his
arrival. Mancini knew Caravaggio well, and the story is told so vividly
that it is probably true; it suggests Caravaggio's isolation, and Mancini
pithily concludes: 'Thus one cannot deny that Caravaggio was a very odd
person . . .'[56] So odd, perhaps, that some of his friends deserted him.
Mario Minniti, himself violent, became tired of Caravaggio's eccentric-
ities, and 'settled down and took a wife, because he found the stormy
escapades of his friend distasteful . . .'[57]

Conversion
and Martyrdom:
the Jubilee of 1600

IN THE LATER 1590s the energies of Church and Pope were concentrated, with increasing confidence and passion, on the preparations for the celebrations of the Jubilee Year of 1600. The Anno Santo, or Holy Year, was proclaimed every twenty-five years, and in these years the penitential pilgrim could receive exceptional indulgence for all his sins, and thus gain a place in heaven; he could be cleansed from sin, as though baptised anew, and the Jubilee of 1600 was a call to the faithful to flock in their hundreds to the Eternal City. The Protestants abhorred external acts of penitence, believing penitence to be inward; but Rome shone with tears, and the tears of the Magdalene, of Peter, of the psalmist David, filled the hearts of the devout. In this year, wrote Ottavio Panciroli, more than in any other, 'pilgrims come to the Holy city of Rome . . . heretics are inspired to convert, the faith of the Roman church burgeons, and the authority of the Apostolic Seat grows to a marvellous extent . . . enemies are reconciled . . . almsgiving multiplied, hospitals filled, the churches restored and adorned more than usual . . . saints are honoured, and sinners are inspired to repent . . .'[1]

An atmosphere of unrelieved gloom had marked the early years of the reign of Clement VIII; Del Monte's letters constantly suggest Clement's anguished fears for the Holy Church, menaced by 'the devastation of France, the discords in Poland, the terrors in Germany, the threats of the Turks, and the disunity amongst the Catholic princes of Europe . . .'[2] Greatest amongst his concerns was the apostasy of Henry IV, who, excommunicated by Sixtus V, now saw the advantages of returning to the Church. Spain vigorously opposed him, but a long period of delicate negotiation led to Clement's accepting the King, once 'the prince of all

23. Antonio Tempesta, *Scene of Martyrdom*
(print)

heretics, and anti-Pope',[3] back into the Church. Cardinal Baronio, now Clement VIII's confessor, argued that it was the Pope's duty to absolve all penitent heretics, and by February of 1595 Del Monte, who had always preached the folly of sending an army against a 'warlike and victorious King',[4] was laying a bet on his absolution with Cardinal Paravicino – 'I have made a bet of 100 scudi with Cardinal Paravacino that for all August Navarre will be reconciled: and I certainly believe that I shall win . . .'[5]

The ceremony of absolution took place on 17 September 1595; St Peter's Square, the courtyards, and staircases of the Vatican were crowded with onlookers. In the atrium of the great basilica, before the enthroned Pope, Henry's representatives abjured the heresies of Calvin, and received absolution. There was general rejoicing, but, as Del Monte wryly remarked, 'The people's rejoicing was great, and the children deafened the air, but they could not speak well of France, without speaking ill of Spain . . .'[6]

There followed, in 1598, the second great political triumph of

Clement's reign, the acquisition of Ferrara for the Papal States, without recourse to arms. For this Clement orchestrated a spectacular triumphal entry to Ferrara, a celebration which displayed the renewed power and authority of the papacy, and created a symbolic end to the wars of religion, and to the Franco-Spanish war. The papal court, preceded by the Holy Sacrament, progressed through many lavishly decorated Italian cities, where the Pope was acclaimed as having brought peace to the world. The journey took eight months, and with Clement there travelled twenty-seven cardinals, and very many priests, musicians, architects and painters. In his entourage was Cardinal Pietro Aldobrandini, with his painter Cesari d'Arpino. Del Monte, too, was amongst the first to be invited by the Pope, and wrote to Ferdinando de' Medici in January 1598: 'His Holiness let me know that I could take with me an entourage of fifteen men and twelve horses, and he bore the expenses for me . . .'[7] His painter, Caravaggio, clearly did not accompany him, as during Del Monte's absence he was arrested for carrying arms in the Piazza Navona. Many of the prelates took the opportunity to visit Venice, among them Aldobrandini, Del Monte, Benedetto Giustiniani and Baronio, and they were to bring back to Rome a renewed passion for Venetian art. It is possible that the Venetian painter Carlo Saraceni, who was to become a supporter of Caravaggio, came to Rome in the train of Del Monte.

Clement constantly exhorted his cardinals to set a good example for the Anno Santo ('He has urged us', wrote Del Monte in May 1599, 'to say many things piously, and with respect'[8]) and also encouraged them to restore the ruined churches of Rome, to re-create the beauty of a city which had triumphed over paganism and which had now once more gloriously defeated the forces of darkness; Baronio had earlier exclaimed, 'What are the heretics to say about the dilapidation of these churches, they who daily come to the city and slander us all over? You know, Lord, what I would do if I had the power.'[9] There was particular emphasis on the Early Christian churches, – mosaics were restored, and the little squares before them embellished – for they symbolised the origins of the Roman Church, suggesting an unbroken tradition and the simple and pure faith which the new orders sought to re-create. Scholars and Christian archaeologists explored the legends that clustered around the

lives of the early saints, and new critical editions of the lives of the saints were published, eliminating all that was apocryphal. Particularly popular were the early Virgin martyrs: St Cecilia, St Pudenziana, St Lucia, St Felicità, whose very names were so poetic, so evocative of innocence and frailty confronting the power of the Roman Empire, but who were now ridiculed and despised by sceptical northerners.

In 1578 all Rome had marvelled at the dramatic discovery of the Catacomb of Priscilla, which seemd so vivid and timely a proof of the many stories of the vast number of Early Christian martyrs whose blood had sanctified Rome. Only a few months after its discovery a contemporary wrote:

> The place is so venerable by reason of its antiquity, its religion and sanctity, as to excite emotion, even to tears, in all who go there and contemplate it on the spot. There men can picture to themselves the persecutions, the sufferings and the piety of the saintly members of the primitive church, and it is obviously a further confirmation of our Catholic religion. One can see with one's own eyes how, in the days of the pagan idolaters, those holy and pious friends of Our Lord, when they were forbidden public assemblies, painted and worshipped their sacred images in these caves and subterranean places, those images which blinded Christians today seek, with sacrilegious zeal, to remove from their churches.[10]

In one of the most impressive Early Christian churches in Rome, the circular San Stefano Rotondo, the Jesuits had commissioned thirty scenes of martyrdom, showing the early history of the Church. They are truly horrific works, crude, and oddly passionless, and seem an illustrated textbook of atrocities, complete with captions, inspired by a desire to instruct, to assert the objective truth of many grisly legends by a use of precise details. They invited reverence for the past, and inspired

emulation in the future; they seemed to link the present with a heroic past. In the dark atmosphere of the 1590s such torture cycles spread through the churches of Rome. Cardinal Baronio commissioned a series of crude and coarsely didactic frescoes for the small and neglected church of Santi Nereo ed Achilleo, on the Via Appia near the Baths of Caracalla, an Early Christian church to which he was drawn because here 'St Gregory addressed a homily to the people, and [here] in ancient times our forebears had erected the titulus, formerly called *fasciolae*'.[11]

On the walls of Santa Susanna Cardinal Rusticucci commissioned colossal scenes of martyrdom (rendered in 1596–8) which, set against magnificent backdrops of classical architecture, suggested the might of that ancient world which bowed before Christianity. Festive, dazzling, they are painted on feigned tapestries evoking the richness of the Jubilee decorations. Clement himself commissioned a team of painters, headed by Cesari d'Arpino, to decorate the transept of St John Lateran, a church venerated for its association with the early days of Christianity, with frescoes whose themes celebrated the glorious omnipotence of the papacy, and whose Raphaelesque style itself suggested continuity and tradition.

A penitential ardour, a longing to be called to Christ, and through the imitation of Christ to win salvation, filled Catholic Rome. Martyrdom was the supreme act of the *Imitatio Christi*, and news of the deeds of Jesuit missionaries in the New World, and the East (many Jesuits and Franciscans were famously crucified at Nagasaki), and the immensely successful letters of St Francis Xavier from India, excited admiration, and inspired emulation. It seemed that the early days of the Church, when Christians had been united by a willingness to die for their faith, had been gloriously reborn. Missionary activities were aimed at others; but equally passionate was the desire to convert the self, to turn to a more spiritual life in the hope of salvation. The great sixteenth-century saints, St Ignatius, St Theresa, had themselves experienced conversion. Baronio had felt a personal call to God, as had the early Apostles, and meditative texts promoted conversion as a call to the devout life, which involved prayer and active charity, and was now a goal not only for contemplatives, but for ordinary Catholics.[12] Such ardour was nourished

and stimulated by painting. Cardinal Gabriele Paleotti, in his influential *Discorso intorno alle immagini sacre e profane* (1582), wrote that painting's power to move was far greater than that of literature, and through it the viewer is led to penitence, suffering, charity, and contempt for worldly pleasures.[13] How much more compelling it is, wrote Paleotti, to *see* the martyrdom of a saint, the zeal of a tortured Virgin, the Crucified Christ, before our very eyes, rendered with lifelike colours – 'All this increases devotion, and moves us viscerally, and he who does not recognise this is made of wood, or marble.'[14]

Yet despite Clement's sense that his reign had inaugurated a new age of piety, despite the rhetoric of the second triumph of the Church, the city remained deeply troubled and harshly repressive, with a constant fear, only just below the surface, of the devilish machinations of English and German heretics. In the stillness of San Stefano Rotondo, Sixtus V had wept over the sufferings of the Early Christian martyrs; but in the prisons of Rome men and women were submitted to identical tortures, on the rack and the *veglia*, and throughout Rome, in the prisons of the Tor di Nona and the Tor Savella, in the Piazza Salviati, the Piazza del Popolo, the Campidoglio, the Campo de' Fiori, more and more victims were hanged, strangled, quartered, beheaded, mutilated, and burned, their numbers increasing as the Jubilee approached.[15] Many of these executions, demonstrations of the awful power of the state, were splendidly orchestrated so that executioner and victim were bound together in a terrible drama that enthralled the public. The lay brothers of the Archconfraternity of St John the Beheaded, dressed and masked in linen, with black cassocks and hoods, comforted the victim, and held before his eyes small panels (*tavolette*) showing scenes of saintly torture and martyrdom, encouraging him to repent and to endure, and through conversion to transform his death into a kind of martyrdom. In the chapel of their oratory a dramatic altarpiece, Giorgio Vasari's *Beheading of St John the Baptist*, drew the eye, and may well have been remembered by Caravaggio, in his later years in Malta.

At the end of the century the Roman atmosphere, already tense, a hectic mixture of triumph and apocalyptic fear, of rejoicing and penitential fervour, was heightened by a bloody trial that enflamed passions

and in whose drama nature herself seemed to take part. In 1598 the long criminal saga of the ill-famed Cenci family, which was to end in scenes of extreme cruelty, was slowly unfolding. On 11 September, the tyrannical Francesco Cenci, who had imprisoned his second wife and daughter, Lucrezia and Beatrice, in the fortress of Petrella Salto, in the brigand-infested mountains of the Cicolano, was murdered by Beatrice, with the help of her brother Giacomo, and Olimpio Calvetti, the chatelain of Petrella. The family then moved to Rome, where, at the Palazzo Cenci on 5 November, Beatrice apparently responded satisfactorily to the interrogation of the notary Mariano Pasqualoni (who was later to fall foul of Caravaggio).

The Pope was closely involved in this drama, but as he returned from Ferrara to enjoy a magnificent procession through the streets of Rome, its houses hung with rugs, tapestries and paintings to welcome him, his attention was diverted from the Cenci by the most overwhelming natural disaster that has ever threatened Rome. On the day of his return the skies were grey and the weather threatened. Torrents of rain fell in the night, and on the following day the Tiber swelled. At first little heed was paid, but by Christmas Eve widespread flooding was causing chaos. The devastation was so great, and the wind and rain so relentless, that the city was numbed with fear and fell appallingly silent. As the danger grew, church bells rang, and there was wailing and lamentation. Finally, only moments after Pietro Aldobrandini had crossed over, a great wave destroyed the Ponte di Santa Maria, which ever since has been called the Ponte Rotto, or Broken Bridge.

Christmas was shrouded in gloom, with neither masses nor vespers sung in the churches; but on the following day, St Stephen's day, the waters began to recede, and the long process of cleaning the city, littered with timbers, fallen beams, and buttresses, began. Against this apocalyptic background the Cenci tragedy resumed its momentum. In January 1599 Giacomo, Beatrice and Olimpio were arrested, and in the next months were tortured and tried. Sympathy was with the Cenci (the Pope was suspected of wanting to get his hands on Cenci wealth), and the agent of the Medici Grand Duke, Francesco Maria Vialardi, himself liberated from the prisons of the Inquisition, described the affair to

Ferdinando always with compassion for the courage and beauty of Beatrice. The trial dragged on, and Prospero Farinacci, Beatrice's lawyer, claimed that her father's many cruelties included sexual abuse. Nobles, ambassadors, and the Roman people prayed for mercy but the Pope remained inflexible, and the sentence of death was pronounced on 10 September, and carried out on 11 September 1599.

The execution was a horrendous spectacle; soldiers and the executioner, the Brothers of Mercy and the Brothers of St John the Baptist, with other companies and confraternities, accompanied the condemned, along many of the longest and most beautiful streets of Rome, the via di Monserrato, the via dei Banchi and via di San Celso, to the Piazza di Ponte Sant'Angelo. Here a vast crowd of spectators waited in the sweltering sun (several were to die from the heat) to witness their deaths. Lomazzo tells us that Leonardo advised the painter to 'see the reactions of those condemned to death when they are led to their execution, in order to study those archings of the eyebrows and those movements of the eyes'.[16] Surely Caravaggio, remembering this advice, was there, perhaps with Orazio Gentileschi, and his young daughter, Artemesia. Annibale Carracci's painful drawing of a hanging, with the victim awkwardly propped up on the ladder, and the comforter holding up a small image, suggests that artists followed his advice. The sacristan, Luigi Vendenghini, wrote to his mother: 'This morning a terrible spectacle. They publicly beheaded a mother and a daughter of singular beauty, while a son had his flesh torn from his living body for murdering his father, with the help of the said mother and daughter. A younger son was present on the scaffold, and watched the deaths of his mother, sister and brother.'[17] The newspaper described how 'the corpses were left until the 23rd hour to the public view, that is, the ladies each on a bier with lit torches round about, and Giacomo hanging in quarters'.

Unusually, however, the crowd was moved to pity. There was pity for all the Cenci, and admiration for Giacomo's dignity and courage, but Beatrice, young and lovely, who displayed great dignity as she walked through the crowd, touched the heart. Paolucci write to the Cardinal d'Este, 'The death of a young girl, who was of very beautiful presence and of most beautiful life, has moved all Rome to compassion', and

Vialardi, reporting to Grand Duke Ferdinand, said that she had died 'in most saintly fashion'. Beatrice seemed to have attained sanctity through suffering, and her story began to merge with those of the Roman virgin martyrs. Her severed head was crowned with flowers as it lay on the bier, and at her funeral, when her bier was laid down in the centre of San Pietro in Montorio, Vialardi described how 'All the populace ran to weep over the body until midnight, and to put lighted candles around it.'

A little later in the year, in a way that seemed miraculous, the earth yielded up the body of a Roman virgin martyr, that of St Cecilia, who had also touched the heart of the executioners. She was discovered, on 20 October 1599, under the main altar of Santa Cecilia in Trastevere, by Cardinal Sfondrato. Here, in a cypress coffin, he had found her body 'entire and uncorrupt . . . more than one thousand three hundred and seven years after her death . . .'[18] Baronio later described how 'At her feet were still veils imbued with blood . . . the very chaste virgin was lying on her side, as on a bed, the knees tucked in with modesty . . . no one dared lift the vestments in order to discover the virginal body . . .'[19] All Rome flocked to Trastevere, especially the most noble Roman women, and so dense were the crowds, filling the bridges and narrow streets, that the Pope sent the Swiss Guards to control them. Stefano Maderno's statue of the saint, believed to show her body as it had been discovered, was placed under the high altar in 1600 (where it still is), and its naturalism, the moving twist of the head to reveal the wound, St Cecilia's blend of elegance and frailty, inspired intense pity. Later, in Sicily, Caravaggio was to remember this statue as he painted a Sicilian Virgin Martyr.

It seemed as though Rome was revealing its most secret early Christian soul, and that the present was blessed by a heroic past, and was returning to the purity of its origins. But darkness followed. In the worst stain on Clement's reign, the impenitent heretic Giordano Bruno was taken, on the night of 16 February 1600, from the prison of the Tor di Nona and burned, naked, and in darkness, in the Campo de' Fiori. His death was the shameful and muffled end of a long process begun in 1593, and he died cursing his persecutors. The machinations of heretics were a constant fear, and in 1595 Del Monte told the Grand Duke that thirteen people had abjured their errors at the Minerva – amongst them

a German priest, an impenitent Lutheran, who was burned, a Jew converted to Christianity who had returned to Judaism, and other necromancers, one a hermit who had consorted with the devil.[20]

The Cenci trial, the burning of Bruno, the terrors of the flood, added a sinister quality to the Jubilee, but none the less the Pope's anxious care was well rewarded. The Hospice of the Trinità de' Pellegrini, founded by Filippo Neri, alone sheltered 500,000 people, and very many infidels — Protestants, Jews and Turks, and amongst them Stephen Calvin, related to the arch-heretic — converted. Clement wept during the ceremony of the opening of the Holy Door at St. Peter's, on 31 December, when, accompanied by three penitents, he struck three times on the Holy Door with a silver hammer, symbolising the start of a year of plenary indulgence. Confraternities from outside Rome made spectacular entrances. Everyone ran to see those from Foligno, who, on 9 May, entered in darkness with 300 flaming torches, with floats on which they showed boys dressed as angels with the instruments of the Passion, followed by floats on which they performed tableaux vivants of the mysteries of the Passion of Christ. Those from Aquila carried a splendid standard and the silver busts of six saints. Through the 1590s the brooding darkness and barbarous cruelty of Senecan tragedy dominated the Roman theatre, and the plays of the most celebrated Jesuit dramatist, Stefano Tuccio — *Crispus*, performed in 1597, and *Flavia*, in 1600 — are spectacular works, showing the conflict between good and evil, martyr and oppressor, creating a crescendo of horror as the Holy Year drew close. On Tuccio's death in 1597 the Pope had torn his clothes to acquire a relic, and many were converted after seeing his dramas.

Among those who came to Rome for the Jubilee was Costanza Colonna, and her son, Muzio Sforza, who addressed a laudatory poem to the frescoes that Baronio had commissioned in Santi Nereo ed Achilleo. Muzio had, in 1597, married the Principessa Colonna, Orsina Peretti Damasceni, and was engaged in disputes with Cardinal Farnese. The Marchesa Costanza came to Rome in the autumn, pausing at Genoa to meet her brother, Cardinal Ascanio Colonna, who was leaving Italy for Spain. He left her in control of his affairs, and for the next few years, from 1600 to 1605, the Marchesa was in Rome, where she lived at the

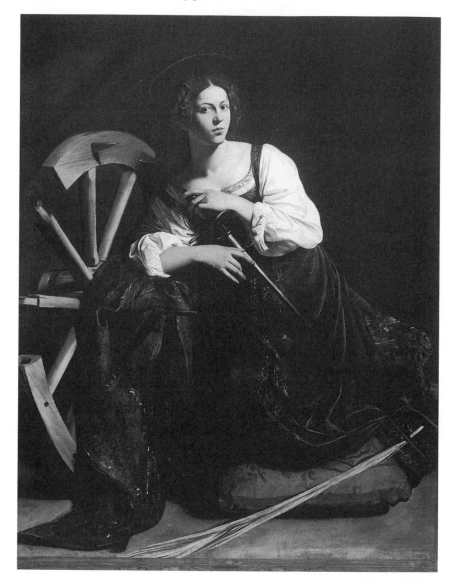

24. Caravaggio, *St Catherine of Alexandria*
(Madrid, Museo Thyssen-Bornemisza)

Palazzo Colonna at Santi Apostoli, and doubtless renewed her contact with Caravaggio. Later he was to use the connections of her powerful family with Genoa.[21]

In Caravaggio's work the themes of martyrdom and violent death appeared, and a savage mood began to alternate with the lyrical, Giorgionesque charm of his early works. He painted, probably around 1598–9, Del Monte, a full-length *St Catherine of Alexandria* (Plate 24), which marks the beginning of a move towards a more Roman figure style. St Catherine of Alexandria was one of the most popular of the female saints, but the colourful legends of her life, so richly embroidered in *The Golden Legend*, were an easy target for Protestant scorn. None the less Italians remained devoted to the story of her immense erudition and wisdom, of her inspired defence of her faith against the wily arguments of as many as fifty philosophers sent by the Emperor Maxentius, of her torture on a wheel, studded with iron spikes, which was dramatically destroyed by a thunderbolt, and her eventual beheading. So persistent, so loved, was this story that it survived despite all the passionate historical research of the 1590s.

Caravaggio's *St Catherine* was one of Del Monte's prized possessions, and he owned four other images of the saint, by distinguished artists, perhaps attracted by a saint whose beauty was made respectable by her status as patron of learning. In his will he expressed his devotion to the saint, praying for her intercession.[22] St Catherine was of royal birth, and Caravaggio conveys this through the richness and beauty of the draperies, of purple-blacks and blues shot through with golds and silvers, of the boldly patterned red damask cushion on which she kneels. He created the glow and texture of the fabric by using the butt end of the brush, allowing a red pigment beneath to shine through the purples and blues. This suggestion of courtly wealth is brutally juxtaposed with the coarse wooden wheel, rendered not as a symbol, but full-size, with concrete reality, its primitive structure and rough textures meticulously detailed, and with the sword, so deadly and so elegant, tipped with red reflected from the cushion, yet evocative of blood.

Within this dazzling array of objects a young Roman woman, rendered with intense naturalism, looks at the spectator with a direct yet watchful gaze. We remain strongly aware of the studio, in which the artist has carefully arranged the heavy drapery over the spike of the wheel, perhaps adding with a final flourish the martyr's palm spread out

over the silk cushion. But the setting remains abstract, and in this space, dark and shadowy, and pierced by a beam of light which falls, unusually, from the right, the objects attain an almost hallucinatory quality, as though summoned up by intense meditation, while the sword, caressed by the saint, who points at the stained tip with a gesture that is almost sensual, seems to hover before her. She is far removed from the very many contemporary renderings of the Virgin martyr, which tend to stress a sweet virginity, and show Catherine, gently beautiful, jewelled and crowned, her eyes turned heavenwards in supplication. Caravaggio has tried to imagine her in his own violent times; the sword is his duelling rapier, and the model is the courtesan Fillide Melandroni. His St Catherine is a disturbingly modern and real woman, surrounded by darkness; she suggests that sense of despair and melancholy that lies beneath the surface of so much late sixteenth-century splendour.

There followed, maybe late in 1599, the painting of *Judith and Holofernes* (Col. Plate 13), which became one of the most treasured possessions of Ottavio Costa, who, in his will of 1632, was to specify that his heirs should not, under any circumstances, part with 'any of the paintings of Caravaggio, and particularly not the Judith'.[23] Judith's story is told in her book in the *Apocrypha*, a book rejected by the Protestants, but included in the Sixto-Clementine Bible of 1592. This tells how the Jewish heroine Judith, a rich and beautiful widow, heroically saved her people from destruction at the hands of Holofernes, the Assyrian general. She dressed in her richest clothes, 'so as to catch the eye of any man who might see her' (10: 5), and with her maid, Abra, entered the enemy camp. Holofernes was beguiled into excessive indulgence, and while he lies in a drunken stupor, she 'approached to his bed, and took hold of the hair of his head, and said, Strengthen me, O lord God of Israel, this day. And she smote twice upon his neck with all her might, and she took away his head from him' (13: 7–8). Abra, keeping watch outside the tent, quickly bundled their gory trophy into a sack.

Judith was immensely popular throughout the sixteenth century; she came to be seen as prefiguring the Virgin Mary, and as symbolising the Church. In these hectic years, aflame with missionary zeal, when the churches of Rome displayed the tortures meted out to early martyrs, she

suggests the response of a militant Church, wreaking terror on heretics and sinners. In the theatre of the *Sacra Rappresentazione* (a very popular play, entitled *La Rappresentazione di Judith Hebrea* of 1518, was reprinted many times through the century, and again in the Jubilee Year) her story was presented on stage, with gory violence. In *Judith*, a Latin drama by Tuccio, Judith is a type of Mary, whose cold killing of Holofernes is the fulfilment of a sacred duty, and she prays for strength from God. The execution, on stage, is like a rite. 'Do you wish to see', comments the chorus, 'with what force, with what protection, [Mary] conquers the enemy? This will Judith teach you . . .'[24]

In his interpretation Caravaggio, for the first time confronting the problems of dramatic narrative, created an image of horrifying violence. Holofernes is shown, as Medusa had been, at the very moment of death, his head at the meeting point of strong diagonals. He shrieks, and blood jets from the gash. The space is enclosed, and the dark red of the tent the colour of blood. There is no space between the half-length figures, brought close to the picture plane, so that the viewer, thrust up against the actors, becomes intensely involved in the drama.

Although a widow, Judith, partly in white, has an icy, virginal quality, her polished face a cold and formal beauty (the model was not Fillide, though she has a similar style of beauty; she may have been Geronima Giustiniani). Her expression is appalled yet intent, and her heavy gesture has a ritual quality. She is very much a Judith of the 1590s, close to that of Tuccio, the chaste and strong instrument of God, her implacable mission to destroy the devil, as Mary, in a later painting, is to tread on the serpent. (Judith's chastity had been celebrated by the Church Fathers, and it had been emphasised by St Jerome, who added his own phrase to the Latin Vulgate 'And chastity was joined to her virtue'.)[25] Holofernes, animal-like, is an incarnation of evil, suggesting the damned souls in many renderings of the Last Judgement. The ritual quality, the frozen expressions and gestures, are also the product of Caravaggio's method of painting from posed models. Incised lines are visible in the picture's surface — around Judith's left arm and shoulder, around the neck of the elderly maid, and around Holofernes' head — and it seems that Caravaggio, working from models, used them, here and elsewhere, to fix

the crucial elements of his composition. But he could not cut off his model's head, and X-rays have revealed that he must have asked the model to take a different pose as he developed the composition. His working method, after nature, gave his picture the immediacy of a tableau vivant, perhaps like those that were performed for the Jubilee.[26]

Caravaggio nevertheless gave to these symbolic figures a new and bloody reality, and shows Holofernes awake, aware at the moment of death rather than, as earlier artists had done, in a comatose slumber.[27] It is extremely likely that the Cenci execution, which enthralled all Rome, had a deep impact upon his imagination (as it may also have done on that of the young Artemisia Gentileschi), and it is this that accounts for the picture's immediacy.[28] This immediacy creates a disturbing ambiguity, transforming the scene into a sado-erotic drama, suggesting a Senecan fascination with horror, blood and sex, personified by Abra, who recalls the procuress in other, less *virtuous* scenes. It was a fascination shared by writers and poets, and Federico della Valle, whose tragedy, *Judith*, written at the turn of the century, is set in the dark and enclosed places of prison or encampment, returned to the image as though to an appalling and compulsive obsession. In *The Queen of Scotland* he lingers erotically on the decapitation of the Catholic martyr Mary Queen of Scots, whose body seems still to tremble after her death:

> . . . the blade, death-dealing,
> Which, as it struck, sank deep
> Into the snowy flesh, into that lovely neck,
> And thus, her limbs stretched to one side,
> Her head to the other, she remained
> A trembling corpse, whence blood gushed forth
> From her soft throat:
> Her so sweet mouth,
> Drawing its final breath,
> Was seen to open one more time,
> And then to close for ever,
> Graceful, even in the pangs
> Of her horrendous death . . .[29]

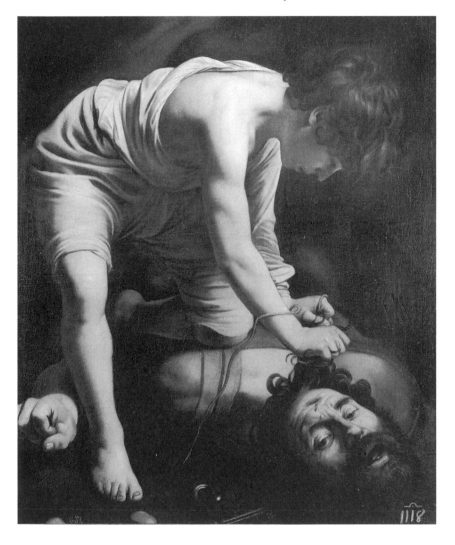

25. Caravaggio, *David and Goliath*
(Madrid, Prado)

Caravaggio's *David and Goliath* (Plate 25), from the same time, is sharply contrasting in mood, and David seems touched with compassion for Goliath. Beneath the head of Goliath, whose gaze seems to appeal to the spectator, is a first, much more horribly realistic rendering of a decapitated head, which again suggests that Caravaggio perhaps heeded

Leonardo's instructions. The head recalls a fearsomely satirical passage in Della Porta's comedy *La Turca* (1606), where the hangman attempts to wheedle money from his victim, with the promise that 'If after death you remain with your eyes open, twisted and squinting, if your tongue hangs out and one eye looks at the earth and the other at the sky, I shall close your eyes and rearrange your mouth . . . I will make you the loveliest hanged man ever . . .'[30] These were the terrors of a society to which such sights were common, and, as Caravaggio came in later years to fear his own execution, his portrayal of the relationship between victim and persecutor would become ever more complex.

THE *Judith* and the *St Catherine* were relatively small works, for private collectors, but suddenly, in 1599, Jubilee fervour brought Caravaggio to a wider Roman stage. On 1 May a chapel in the church of San Luigi dei Francesi, which belonged to the heirs of a French Cardinal, Matthieu Cointrel (or Matteo Contarelli), opened for the celebration of Mass, a dramatic moment in its troubled history. San Luigi, which is just across the road from the Palazzo Madama and the Palazzo Giustiniani, was the national church of the French, and important to Rome's large French population. It was run by a council of leading citizens, and had a secular clergy. Contarelli, twenty years before his death in 1585, bought the chapel, which was to be dedicated to his name saint, Matthew, and planned its decoration, suggesting subjects from Matthew's life for the frescoes, amongst them the saint's calling and martyrdom. Contarelli had clear ideas on how the scenes should be shown. In *The Calling* he wished the saint to be shown in the tax collector's office, busily counting money, or, 'what would be better, rising in the desire to come to Christ, as Christ, passing in the street with his disciples, called him to the Apostolate. And in the action of St Matthew, as in the rest, the painter should show his skill.'[31]

For *The Marytrdom*, he envisaged a grandiose architectural setting. like a temple, with an altar raised up above steps. St Matthew should be killed while celebrating Mass, and 'it would be more artistic to show him . . . in the act of falling but not yet dead' and surrounded by a crowd of

men and women, youths, the aged, of all kinds and ranks, praying, and displaying their grief and disgust. The church had naturally been at the centre of the ceremonies for the conversion of the French king, Henry IV (a descendant of San Luigi), and the papal Bull of Absolution had opened with these dramatic words:

> When We consider the superabundance of the
> divine grace shown in your conversion, and carefully
> ponder in Our mind how you have been brought
> into the light of Catholic truth from the deepest
> obscurity of error and heresy, as though from an
> abyss of evil, by a mighty act of the hand of the
> Lord, We feel ourselves constrained in Our wonder
> and admiration to exclaim with the Apostle; O the
> depth of the riches of the wisdom and of the
> knowledge of God! How incomprehensible are his
> judgements, and how unsearchable his ways![32]

The church of San Luigi was actively involved in conversion, and Clement himself remained passionately committed to the reconversion of France. After the conclusion of peace between France and Spain in 1598, he addressed a pastoral letter to the French episcopate on 20 August 1599, shortly after Caravaggio began work on the chapel. In this he encouraged his bishops to 'labour unweariedly in expectation of the eternal crown which is awaiting them . . . France . . . is not yet sufficiently cleansed from the thorns and cockle of heresy and corruption . . . help your country, drive away heresy, preach and convert those who have gone astray . . .'[33]

The subjects of the frescoes, conversion and martyrdom, had thus become increasingly topical, and the coming of the Jubilee encouraged the church authorities to bring to an end a disastrous series of delays in its decoration. Several artists had been involved: Girolamo Muziano, contracted by the Cardinal himself to paint the chapel, but who achieved nothing; the Flemish sculptor Jacques Cobaert, tormented for very many years by his commission, granted in 1587, and renewed in 1596, for a

marble altarpiece, and Cesari d'Arpino, who, commissioned to decorate the chapel in 1591, fulfilled at least part of his contract, completing the vault frescoes in 1593, perhaps when Caravaggio was in his studio. The congregation became increasingly querulous, and in 1594 they complained bitterly to Clement VIII about the malpractice of Abate Giacomo Crescenzi, who had succeeded his father, Virgilio, as executor of Contarelli's will, and who, they believed, had deliberately prolonged the work on the chapel, so that his family might continue to enjoy the interest on the money which Contarelli had left for it. The Crescenzi, the priests complained, had blamed first one thing, and then another, first the sculptor, then the painter, 'and in this way the soul of the deceased is cheated of the masses which are its due, and the church of San Luigi cheated out of the endowment assigned to that chapel'.[34]

Their complaints grew in the succeeding years, and finally, in 1597, the Pope removed the responsibility from the Crescenzi family and assigned it to the governing body of the Works of St Peter's (Fabbrica di San Pietro). They again, in 1597, tried to attract Giuseppe Cesari, the most sought-after painter in Rome. But Cesari was now overwhelmed with major commissions from the Pope himself, and it was this, along with Del Monte's association with the Works, which opened the way for Caravaggio. Del Monte was, moreover, a friend of the Crescenzi family, and had been the executor of Virgilio Crescenzi's will in 1592. Baglione, resenting the luck of the inexperienced Caravaggio, tells us, with a touch of sharp envy, that it was ' with the support of his Cardinal'[35] that he won the contract for the Contarelli chapel. On 23 July 1599 Caravaggio's name appeared for the first time in the proceedings, when the two rectors, or head priests, signed a contract with him for the two side paintings, to be completed by the end of the year, and to follow the programme laid down by Virgilio Crescenzi for Cesari d'Arpino in his contract of 1591. Contarelli's instructions were attached to this contract, and Caravaggio would certainly have known them.[36] On 5 January 1600, Cobaert received 120 scudi for the statue of St Matthew on which he was working.

To Caravaggio, hitherto largely a painter of elegant and lyrical scenes, of fragile and delicate objects and figures which captured the courtly

ambience of a small circle of patrons, the task was immensely challeng-
ing. In these large works, which demanded many, possibly life-sized,
figures, he had to pit his skills against the Renaissance tradition of
history painting. History paintings showed noble scenes from the Bible
or classical literature, and in them the artist, having mastered human
anatomy after long study of the live model and of antique sculpture and
Renaissance painting, displayed his skill in complex poses, and in a
rhetorical language of expression, gesture and motions. They show the
nobility of man's actions, and create a sense of moral worth by the
grandeur of setting and the universality of the figures, who meditate on
the scene depicted, drawing out its eternal significance, and mediating
between painting and viewer. Such works were the supreme achievement
for the painter, and it was this kind of painting that Contarelli's instruc-
tions suggest. Such expectations must have weighed heavily upon
Caravaggio, a Lombard painter of half-length Giorgionesque figures,
whose early style had depended on his novel method of working direct-
ly from life, and creating a startling naturalistic intensity. The weight of
a Renaissance tradition, which demanded that the artist build up com-
plex compositions through a series of quick sketches, of studies of
individual figures, of details of gestures and drapery, followed by more
highly finished compositional drawings, must have seemed intimidating,
and he must too have been aware of the grandiose scale of contempo-
rary fresco cycles, such as those by Giuseppe Cesari in the transept of St
John Lateran, pageant scenes which revived the classical naturalism of
Raphael. An artist was judged by his powers of *invenzione*, invention, of
mastering difficult and complex poses, and by the sophistication of his
treatment of space – and Caravaggio, who painted from the model, and
tended to set his figures within a simple foreground plane, was well
aware of this.

With such inhibitions, with Contarelli's instructions, and the weight
of tradition and expectation, Caravaggio began *The Martyrdom of St
Matthew* (Col. Plate 19), a composition which was to cause him immense
difficulties. Matthew, who preached in Ethiopia, there converted to
Christianity a young virgin, Iphigenia, the betrothed of Hirtacus, the
King of Ethiopia. On hearing that she had become the bride of Christ,

the King was consumed with rage, and *The Golden Legend* tells us, after Mass, he 'sent a swordsman, who found Matthew standing before the altar with his hands raised to Heaven in prayer. He stabbed the apostle in the back, killing him and making him a martyr.'[37] X-ray photographs have revealed that Caravaggio began with a composition in which the figures are comparatively small, occupying the foreground plane in the lower part of the canvas, and in which the action takes place in a grandiose setting of elaborate Renaissance architecture. At first the exe-cutioner stood in the centre, sword raised, before an upright St Matthew; to the right stood a nude recording angel, holding the Gospel, and point-ing to heaven; in the foreground a soldier, seen from the back, divided the composition in two with the sharpness of a pilaster. The whole must have had a static, hieratic quality, and represented the symbolic confrontation of the forces of good and evil. In a second composition, or in a modifi-cation of these first ideas, he drew closer to a traditional iconography, basing his composition on Raphael, and adding a crowd of onlookers displaying fear and pity, amongst them a woman who may be Iphigenia, and drawing close to Contarelli's description of setting and crowd. But he remained dissatisfied. The composition and the movements of the figures troubled him, and it seems likely that at this moment he turned to the painting for the left-hand wall, *The Calling of St Matthew* (Col. Plate 18), with the aim of finding a radical solution for the problem of painting from life a large and complex multi-figured composition.

Here, and we may sense his relief, and his renewed certainty, Caravaggio, so ill at ease with the traditions of contemporary idealising history painting, turned back to the subjects of his youth, with which he had won such success and with which he must have hoped again to captivate a Roman audience.[38] With a boldness that cut through all convention, he transformed his popular and novel early works, *The Cardsharps* and *The Gypsy Fortune Teller*, into the material for a large religious painting. In *The Calling of St Matthew* Caravaggio again drew inspiration from his own world, daringly setting the biblical scene in contemporary reality. The splendid architecture of *The Martyrdom* yielded to the evocation of a dark Roman street, or perhaps the courtyard of a Roman palace, where the round-faced boy in feathered hat, leaning so

nonchalantly against the saint, is again the duped youth from *The Gypsy Fortune Teller*, probably modelled on Minniti, while Malvasia identified the youth with his back to us as Lionello Spada. Although this is unlikely, the figures have an immediacy that suggests that Caravaggio persuaded his friends to model for him. The setting is Matthew's tax office, but the scene conjures up the shady atmosphere of long evenings spent gambling or looking, armed, for adventure, in the streets and taverns of Rome. Indeed so concentrated and intent is the atmosphere that Sandrart thought that it showed a gambling scene set in a dark room, where Matthew is shown 'seated with a bunch of rogues playing cards and throwing dice and drinking'.[39]

The subject is taken from a short passage in the gospel of Matthew (9: 9): 'Jesus saw a man called Matthew at his seat in the custom house, and said to him, "Follow me," and Matthew rose and followed him.' In Caravaggio's painting Matthew, rich and fashionably dressed, as befitted his status as toll-gatherer and publican, a coin tucked in the brim of his hat, sits at his work table with his louche companions. He looks up in astonishment at the appearance of Christ, and points to himself in wonder and humility at his call.[40] Caravaggio sets a world of brilliant colour, of bold contrasts of reds, greens, and golds, of the varied textures of velvets, rakish feathers, and soft fur, against the timeless and austere simplicity of Christ and Peter, roughly toga-clad and barefoot. He contrasts lightness of gesture and expression with ritual solemnity, and the hand of Christ is modelled on Michelangelo's hand of Adam on the Sistine ceiling. These are the contrasts of the Roman streets, where priests and friars, seeking Christ in the poor, preached penitence and conversion. The clarity of Caravaggio's contrasts of shapes and forms, his creation of a taut rectangle of figures, parallel to the plane, and built up around a careful balance of horizontals and verticals, seems to embody the simplicity of Christ's words. The play of light and shade creates intense drama. The figures are wrapped in shadow, and the large area of dark wall over their heads seems to weigh upon them, prison-like, suggesting man's brief stay in this gloomy world. The darkness is pierced by the shaft of light which falls diagonally across the wall, following Christ's hand, and brightens the face of St Matthew, who turns towards

it. It is a moving symbol of divine illumination; Matthew was widely thought of as a sinner, whose call redeemed him from the dark abyss of sin. As St John Chrysostom wrote, 'Matthew . . . was a publican, living in continual rapine. But he . . . all at once stripped himself of the mischief, and quenched his thirst, and followed after spiritual gain'.[41] The light falls on Matthew alone, while the other figures remain nonchalant. Their expressions are fleeting, conveying a psychological unease and inward complexity that seems strikingly modern, and very different from both the rhetoric of the Renaissance, and from the caricatured treatments of similar themes, with the ludicrously bespectacled, morally blind usurers and misers, that were popular in northern Europe.

The youth at the end of the table, his head in shadow, his fingers lingering on the coins, suggests unredeemed humanity, dwelling in darkness, and perhaps carries overtones of the story of the rich young man who could not forsake all and follow Christ. In the Oratorian church of the Chiesa Nuova, on 6 January 1600, Emilio de' Cavalieri's *Rappresentazione di Anima e di Corpo* was performed, with young men symbolising Pleasure, the World, the Body, and the Soul, and in which the Body stripped itself of worldly finery, such as a gold chain and feathered hat ; Caravaggio's figures, clad in the finery of pages, seem also to be participants in a moral drama. In an era passionately concerned with personal salvation, and with the individual's call to God, the picture, so rooted in contemporary reality, had immense power. It addressed the needs and interests of a national Church, whose King had been responsible for many Catholic deaths, and yet it is intensely personal. It symbolises the end of Caravaggio's own youth, and the little cluster of gaudy figures, whose colours glitter so vainly in the darkness, are the lyrical boys of his early works, who conveyed with melancholy the transience of love and beauty. Now they warn against the snares of worldly pleasure, and provoke meditation on salvation and redemption. After these paintings they appear only rarely, and their place is taken by heavy peasants, and by a cast of humble and proletarian characters.

When Caravaggio completed this work, and turned back to *The Martyrdom*, he would have immediately appreciated that the figures in his first version of this work were, in comparison, disproportionately

small, and he began an entirely new composition. He rejected the idea of
figures in a foreground plane, against an architectural background. His
figures now emerge from blackness, and the composition is centrifugal.
It seems to radiate, like the spokes of a wheel, from the central figure of
the executioner, and an irrational play of light and shade picks out
points of emphasis and creates a threatening mood. He has returned to
some aspects of Contarelli's original instructions. The martyrdom now
takes place before a free-standing altar, with steps leading up to it, at
which Matthew has been celebrating Mass. The cross on the altar frontal
is just visible behind the angel's cloud, and above the executioner's dark
curls two altar candles flicker in the darkness. In the corners of the
canvas he has added three large male figures, naked apart from loincloths,
who are probably intended to be neophytes, awaiting baptism beside a
lustral pool.[42] These figures concentrate the composition, and form
the basis of a triangle whose apex is the head of the executioner, set
with such powerful drama at the picture's formal centre. But, above
all, Caravaggio has turned back to his own world, as he had just so
triumphantly done in *The Calling of St Matthew*; he has stripped his com-
position of its earlier idealising, celebratory note, and tried to imagine
such a martyrdom in the here-and-now, and to create a vivid sense of
reality. It becomes the murder of a contemporary priest, dressed in a
black, short-sleeved chasuble, who has just been taking Mass in a dark
Roman church, and we may sense, in the gesture of his arms on the
ground, the gesture of the priest elevating the host.

The chilling horror of such a murder fascinated and appalled the
Romans. Protestants scoffed at the Eucharist, the very centre of the
Catholic faith, and an attack on it aroused deep, obsessive fears; in the
heightened emotional fervour of these years sinister tales of the devilish
attacks of northern heretics on Roman priests circulated around Rome.
In 1581, for example, the Venetian ambassador reported that 'on Sunday,
in St Peter's, an English heretic, just as the priest, having consecrated the
host, was about to elevate it, attacked him in order to knock it from
his hands . . . he was kicked and beaten by the people, and taken to the
prisons of the Inquisition' and later executed.[43] Caravaggio's painting
conveys this sense of immanent terror, but he also, in small details, such

as Matthew's bare feet, evokes a distant and heroic past. Past and present blend, too, in the language of gesture and expression, for underlying the immediacy and reality of the figures is an older, traditional language, with a powerful symbolic resonance. Caravaggio incorporates figures from the most celebrated paintings of the Italian Renaissance, and his central group, of executioner, Matthew and the fleeing boy, has its origins in the most famous Renaissance rendering of a martyrdom, Titian's *Death of St Peter Martyr* (since destroyed). The scream of the fleeing choirboy seems to reverberate through the picture, and it suggests that Caravaggio had also studied Raphael's *Transfiguration*. It is an extraordinary face, a real boy in a moment of terror, and yet caught and held with such intensity and pared-down geometric economy that it has the symbolic power of an ancient Roman mask of despair. The executioner himself is a handsome Roman youth, his mass of dark curls bound with a fillet; but his pagan nudity, and Leonardesque savagery, dominate the picture. His nudity links him to the foreground figures awaiting baptism, and the suggestion that he has risen from amongst them, thus killing the instrument of his salvation, intensifies the terror of the scene.[44]

The Contarelli chapel celebrates conversion and martyrdom, through which man rises from the dark abyss of sin, and through which he wins eternal life. But the painting is not triumphal, and Matthew is humiliated and alone. The crowd of figures, who in Contarelli's original instructions were conceived as acting as a chorus, bringing out the scene's universal significance, and creating from it a sublime drama, flee from him in terror. There are no women, but a crowd of raffishly dressed, mainly young men, the light glinting on their modish dress. The young men from Matthew's toll-house have become the onlookers at a street fight, ready to abandon the victim to his fate. And among them, smartly dressed, with a little goatee beard, his dark cloak pulled around him, his hose tight, his shoe slipping off as he flees with the crowd, is Caravaggio himself, who looks backward over his shoulder, with a complex expression of shame and pride. He draws the eye of the spectator, for, when viewed at an angle from the aisle, his portrait stops the long diagonal that runs upward from the foreground nudes at the bottom right along the arm of the executioner. The inclusion of a participant

self-portrait within a large public painting was an established tradition (Michelangelo, in *The Last Judgement* in the Sistine Chapel, Vatican, had given his own features to the flayed skin of St Bartholomew) and in this, Caravaggio's first such work, it acted as a signature, and conveyed his sense of achievement. It also heightens the viewer's sense of emotional involvement, for he seems, like Caravaggio himself, to be part of the crowd, looking at the murder from the side facing the artist himself.

The clergy of San Luigi dei Francesi had wanted Caravaggio's pictures to be ready for the Jubilee, and his contract demanded that the paintings should be finished by the end of 1599. The chapel had been opened for the celebration of Mass in May 1599. But Caravaggio had had considerable difficulties with this commission; he had had to paint the *Martyrdom* scene twice, and the pictures were not ready until the summer. On 4 July 1600 he received 50 scudi of the money still owing to him, and it seems that by this date the pictures were already in place. The installation of the pictures at this moment was, however, perhaps only temporary, for the carpenter, Gregorio Cervini da Pietra Santa, was not paid until December 1600, when the pictures must have been finally in their place.

The pictures may have been first exhibited to the public in the Palazzo Madama, and they brought Caravaggio immense attention. His fame had begun to spread before their installation, and in April he had signed a contract with a Sienese patron, Fabio de' Sartis, for a painting whose large size (it was to be almost three metres high) suggests that it was an altarpiece. The guarantor of the delivery of the picture was Onorio Longhi. Caravaggio had submitted a sketch to win this contract, and he was paid for the painting on 20 November, at the Palazzo Madama, where he still lived, the payment witnessed by Vittorio Travagni, a little-known Florentine painter. The painting is lost, and there is no record of its subject, but its size and value suggests an important commission. Then, in September, only two months after the installation of the Contarelli pictures, Caravaggio was awarded another, yet more glittering commission, this time for two lateral pictures in a chapel in Santa Maria del Popolo, from a distinguished and eminent patron, Tiberio Cerasi, the Treasurer-General under Pope Clement VIII. In the contract for this painting he is flatteringly described as 'egregius in Urbe pictor'.[45]

Tiberio Cerasi, who lived in the *rione* Parione, was immensely wealthy; his father had been an eminent physician at the Ospedale della Consolazione, and Tiberio retained close links with the charitable activities of this institution. Cerasi had had an academic and legal career, but in 1596 became Treasurer-General under Clement VIII, a job which brought him into contact with the Roman art world. The narrow chapel, in the transept immediately to the left of the high altar in Santa Maria del Popolo, had been acquired from the Augustinian friars of the Congregation of Lombardy, and Cerasi had been given a free hand, encouraged to decorate it how and when he wished. He was anxious to proceed, and, with great boldness, chose the two most advanced artists in Rome, Annibale Carracci and the young Caravaggio, to decorate his chapel, creating the stage for a contest between two opposing views of art, between Annibale's revival of High Renaissance grandeur, and the aggressive naturalism of Caravaggio, whose Contarelli paintings had so amazed the Roman art world. Annibale, the celebrated fresco artist, was commissioned to paint the high altar, with an *Assumption of the Virgin*, and to design the frescoes of the vault, showing further scenes from the lives of Saints Peter and Paul; Annibale had probably completed his commission by May 1601, when Tiberio Cerasi died. No contract or record of payment with Annibale survives, but Caravaggio signed his contract for two lateral paintings on 24 September 1600. This specifies that he should paint scenes of the Martyrdom of St Peter and the Conversion of St Paul. They were to be painted on two cypress panels, measuring 10 8 *palmi* (over two metres high), and within eight months. He would be paid 400 scudi, of which 50 scudi would be advanced. Cerasi also demanded that Caravaggio should first show his patron *bozzetti* (sketches) and drawings for the work, showing how 'ex sui inventione et ingenio' he intended to present these subjects. Caravaggio received the 50 scudi in the presence of witnesses, in the form of an order drawn on Vincenzo Giustiniani who acted as banker. This is the first mention of a professional relationship between Vincenzo Giustiniani and Caravaggio.

The Jubilee year was now drawing to its close, but the subjects that Cerasi chose remained redolent of its spirit. Saints Peter and Paul, linked

by a centuries-old tradition, were above all the two great Apostles of Rome, to whom Romans felt a special devotion. They had, it was believed, been martyred on the same day, and together laid the foundation of the Roman Church, sealing it with their blood. In these years of the city's rebirth as Holy Rome, the Princes of the Apostles were passionately revered. Atop the most splendid of pagan monuments, the towering columns of Trajan and Marcus Aurelius, triumphant statues of Peter and Paul, who together had routed the pagan cults of antiquity, dominated the city's new splendour. Sixtus V had set them there so that he and all Rome might see 'the most holy testimonies of our redemption and the images of the founders of the Apostolic See' and prayed that they might bring to life 'the sacred images that he carried within his heart'.[46]

St Peter was revered as the founder of the Church, and the first Bishop of Rome, to whom Jesus had said: 'Thou art Peter, and upon this rock I will build my Church; and the gates of hell shall not prevail against it' (Matthew 16: 18), and from him was derived the authority of the Pope and all true Christianity. St Paul was a complementary figure; his rich learning and erudition provided a weapon against Protestantism, and he became a powerful exemplar of conversion, whose evangelical mission had ended with glorious martyrdom in Rome. In such terms had they been contrasted for many centuries, and throughout Rome the saints' residence and martyrdom seemed vividly present. They were recalled by the Mamertine prison, from which Peter's attempt to flee martyrdom was halted by a vision of Christ carrying the cross, to whom he addressed the famous words *Domine Quo Vadis?* – Whither goest thou? – in the small and humble church of Santa Prisca, built over the house of Aquila and Prisca, where Peter had stayed, and which was restored for the Jubilee by Cardinal Benedetto Giustiniani, who shared with Baronio a special veneration for St Peter, and in the church of Santa Pudenziana, built over the house of the senator Pudens and his daughters, Praxedis and Pudenziana, both virgin martyrs, and restored by Cardinal Alessandro de Medici. Filippo Neri had often prayed through the night in the catacombs where their bodies had been discovered. Relics of their heads were encased in the high altar of St John Lateran, and their bodies entombed before the high altar of St Peter's.

The church of Santa Maria del Popolo stands at the edge of the Piazza del Popolo, which welcomed the pilgrim journeying from the north to Rome and formed a prelude to these pilgrim sites of Holy Rome. Caravaggio's paintings were intended to suggest the city's reawakening to a new life, to the rebirth of a Christianity rooted in the blood of Peter and Paul, an invocation of that Apostolic age in which the humble had brought low the proud. Tiberio Cerasi nourished a deep devotion to the Princes of the Apostles, and his will opens with an invocation to their name, with those of God and the Virgin Mary.

Caravaggio probably began to work on the paintings shortly after he signed the contract in September 1600, and it is not clear whether he made the drawings and sketches which this demanded. However, his fulfilment of this commission was to cause considerable difficulties. Baglione, who was close to Caravaggio in this period, tells us that Caravaggio's first paintings were rejected, and were acquired by Cardinal Giacomo Sannesio.[47] He states, very precisely, that the pictures were executed in 'a different style',[48] and did not please the patron. But Mancini's account does not tally with this. He says that the pictures which Sannesio owned were retouched copies. The first version of *The Crucifixion of St Peter* has been lost, but Caravaggio's first *Conversion of St Paul* (Plate 26) has been identified as a painting now in the Odescalchi collection in Rome, which is painted on cypress panel. It is one of Caravaggio's most puzzling works, whose attribution is now almost universally accepted.

The story of Saul's conversion is told three times in the Book of the Acts of the Apostles; Saul, a feared and terrible persecutor of the Christians, was travelling to Damascus with the chief priests from Jerusalem, when, he wrote,

> . . . it came to pass, that, as I made my journey,
> and was come nigh unto Damascus about noon,
> suddenly there shone from heaven a great light
> round about me. And I fell unto the ground, and
> heard a voice saying, Saul, Saul, why persecutest
> thou me? And I answered, who art thou Lord? And

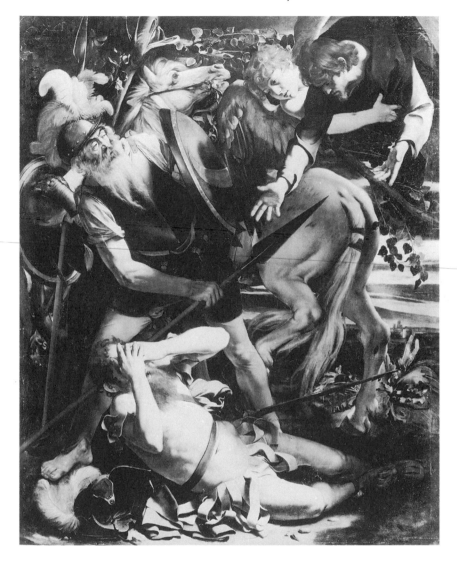

26. Caravaggio, *The Conversion of St Paul*
(Rome, Odescalchi collection)

he said unto me, I am Jesus of Nazareth, whom
thou persecutest. And they that were with me saw
indeed the light, and were afraid; but they heard not
the voice of him that spake to me. And I said, What

shall I do Lord? And the Lord said unto me, Arise,
and go into Damascus; and there it shall be told
thee of all the things which are appointed for thee
to do. And when I could not see for the glory of
that light, being led by the hand of them that were
with me, I came into Damascus (Acts 22: 6–11).

The author of Acts refers here only to a bright light, but a later account in Acts perhaps suggests a vision of Christ – 'But rise, and stand upon thy feet: for *I have appeared unto* thee for this purpose' (Acts 26: 16) – and Paul himself said that God 'called me by his grace, To reveal his Son in me' (Gal. 1: 15–16). Elsewhere he claimed to have seen the Risen Lord, 'Am I not an apostle? am I not free? have I not seen Jesus Christ our Lord?' (I Cor. 9: 1). Thus Paul himself believed that this was a resurrection appearance, which bestowed upon him the authority of the first apostles, who had themselves known Christ, and his words were so interpreted by the Church.

In the most celebrated precursors of Caravaggio's rendering – a design by Raphael for a tapestry (*c.* 1514–17), now in the Vatican Pinacoteca, and Michelangelo's great fresco in the Pauline chapel in the Vatican – Christ, ringed by angels, appears in the sky. In Raphael's cartoon Christ is encircled by light; in Michelangelo's fresco the light is directed by Christ's hand. Caravaggio, uneasy with multi-figured compositions, turned back, as he had done in *The Martyrdom of St Matthew*, to the most celebrated Renaissance artists, above all to Raphael, the main outlines of whose composition he adapted. But where Raphael creates a moment of stillness at the centre, with the emphasis on Saul's recognition of Christ, Caravaggio's composition is turbulent. It is built up around the clash of two great diagonals, and Christ seems to erupt from the heavens, overpoweringly physical, and brought startlingly close to the reeling Paul, who shields his eyes as the light blinds him. Where in Raphael and Michelangelo Christ speaks from the distant empyrean, here heaven and earth are brought close. The space is shallow, and figures and forms press against the frontal plane, creating a dense and jagged surface pattern of thrusting shapes, with the strong lines of spears and swords playing

against the sharp angles of limbs and bodies. An irrational light picks out details – a spear head, a plumed helmet, a shield with pagan crescent moon, dark leaves against a glimmering sky – presented with an extraordinary intensity. They seem to jostle together, and to create a sense of crisis and dislocation. Christ disrupts the mundane world; his eloquent hands both condemn and invite Paul to arise; the old and bewhiskered soldier sees the light, and is afraid; the brilliant midday sun has been darkened by divine light, which shone 'above the brightness of the sun' (Acts 26: 13). It is in darkness that the mystic becomes one with God; his hands prevent his seeing Christ, and his conversion is within his soul. The landscape has the fresh beauty of Savoldo, or maybe Caravaggio remembered Titian's *Resurrection* that he had seen in Brescia and, as Titian had done, used the glimmering rays of light in the sky as a poetic promise of rebirth.

Caravaggio's deadline for these paintings was the end of May 1601. But before this date two things had happened. First, Annibale Carracci had almost certainly completed the chapel's altarpiece, *The Assumption of the Virgin*. Well aware of the challenge that the young Caravaggio would present, Annibale created a dramatic work. The holy figures, massive, and physically powerful, are brought close to the spectator. The surface is patterned with a *virtùoso* display of gesture and expression, of sharply turned heads and eloquent hands, all of which convey wonder. Annibale's figures are idealised, and carry with them the solemnity of a revered tradition. It is one of his most classical works, and the cool and clear colours, hard outlines and boldly simplified forms all reject the murky darkness and dependence on the live model which Caravaggio favoured.

The second significant event was the death of Tiberio Cerasi on 3 May, at Frascati. On 5 May a newspaper reported this, and described the chapel in Santa Maria del Popolo, where he was to be buried, as 'his most beautiful chapel, which he had made in the Madonna della Consolazione, by the most celebrated painter, Michelangelo da Caravaggio'. The report goes on to say that Cerasi had made the fathers of the Madonna della Consolazione his heirs, and left to them the task of completing the decoration.

This is a puzzling account, for Caravaggio's deadline was not until the end of May. The writer got the name of the church wrong, and perhaps he mistook the name of the artist too, and actually referred to Annibale Carracci, whose altarpiece was finished. Or possibly Caravaggio *had* completed his paintings, and temporarily exhibited them in the church, in place of the sketches which the contract had demanded, and they were rejected by Tiberio Cerasi.

It is, however, more likely that Cerasi never saw the pictures at all, and that they were completed after his death, and rejected not by him, but by the new patron, the Fathers of the Madonna della Consolazione, who took over the commission. Doctrinally the surviving work is beyond reproach, though the body of Christ may have seemed vulgarly close to earth. The explanation may be simple, for perhaps Cerasi, or the Ospedale, simply did not like them, and asked for pictures in another style, or decided that paintings on canvas would better suit the lighting in the chapel. (Baglione's phrase, 'in a different style' – *in un altra maniera* – may refer to a different technique or medium rather than style.) For the *Conversion* is an old-fashioned, Brescian work, an odd blend of Raphael and clumsy rustic realism, and perhaps disappointed a patron who had appreciated the contemporary immediacy and psychological depth of the Contarelli pictures. Or perhaps Caravaggio *had* submitted a sketch, and then disappointed his patron with a very different product.

Whatever the reason, in his second versions Caravaggio pondered the text more deeply, and abandoned a traditional iconography, setting the sacred events boldly in the everyday world, and yet creating a profound poetry from the symbolic treatment of light and dark. His figures are, for the first time, aggressively plebeian, the dirty feet of St Peter's executioners jabbed towards the spectator, and St Paul's horse turning its large rump towards the *Assumption of the Virgin*, as if in protest at Annibale's idealising art.

The most striking quality of these second paintings is their starkness and stillness. Caravaggio has pared his stories down to their essence, and stripped them of any context. Powerful, sculptural figures, naturalistic and yet simplified, are arranged along bold diagonals. In *The Conversion of St Paul* (Col. Plate 21) he rejected the confused panic of his earlier

treatment. A delicate ray now strikes Paul, who has been flung violently from his horse towards the spectator, his arms flung wide in welcome, as if drawing the viewer into the mystery. And yet the painting is still, and what we witness is a mystic communion with God, an inward conversion. Paul, eyes closed, is no longer old and bearded, but, as the story demanded, a young and common soldier, in antique armour. The horse has become a heavy carthorse, unsaddled, raising a hoof to avoid trampling Paul, and the old man, no longer a soldier or priest, has become a groom. Horse and groom, who wait, uncomprehending, in darkness, belong to a different reality. They seem a group observed in the dusty streets of contemporary Rome, and it is almost as if Paul exists within the old man's imagination. Paul's conversion was the classic exemplar of sudden and total transformation, and most artists painted a scene of sound and fury; Caravaggio's new emphasis on an inward process evokes the heightened emphasis on the conversion of self through meditation on the mysteries of Christ.

The young Paul seems touchingly vulnerable, his body open, unprotected on the bare earth. It stresses his humility, and in this is deeply at one with the spirit of Paul's writings. In Ephesians 3: 8, Paul wrote, 'Unto me, who am less than the least of all saints, is this grace given, that I should preach among the gentiles the unsearchable riches of Christ,' and, although he had seen the Risen Christ, he also wrote, throughout the letters, of conversion as an inward revelation of the spirit of Christ. Thus in 2 Corinthians 4: 6, he declared: 'For God, who commanded the light to shine out of darkness, hath shined in our hearts, to give the light of the knowledge of the glory of God in the face of Jesus Christ.' The supernatural light suggests a Nativity painting, and Paul, through God's grace, is born again; on the wall opposite, St Peter (Col. Plate 20), crucified upside down, out of humility, descends to the earth, from which he too shall be born again. St Peter, weak and impetuous, was the most attractive, the most intensely human, of the Apostles, and here he is very much the simple fisherman from Bethsaida, stoically suffering an unheroic and brutal end in unrelieved darkness. Caravaggio again draws on the great prototype in Michelangelo's fresco in the Pauline chapel, although his executioners become contemporary Roman workmen,

frozen against a dark background, their faces hidden, and their muscles straining, their veins swelling, as they toil to complete a job of work. The diagonal line of figures draws the viewer into the composition, and the powerful forms, so harshly modelled, seem to move into his space, asserting their physical presence, inviting involvement in the religious drama. The spectator remains aware of the elements of reality – an old man, a spade, the great spike of the nail, a plank of wood – out of which Caravaggio has built up his painting, and yet somehow the simplicity of these elements, and their compelling material presence, conveys the primitive grandeur of the early Church. On 10 November, 1601 Caravaggio received his final payment of 50 scudi. He may have been late for his deadline because he had had to do a second pair of paintings; or perhaps illness had delayed him, for in October Onorio Longhi, involved in a street fight, told the magistrate that Caravaggio had been so frail that a servant had carried his sword.

In the Contarelli and the Cerasi chapels Caravaggio composed like a stage designer, arranging his figures in carefully directed light. Bellori tells us that he set them in 'the darkness of a closed room, placing a lamp high so that the light would fall straight down, revealing the principal part of the body, and leaving the rest in shadow so as to produce a powerful contrast of light and dark'.[49] Caravaggio's dramatic chiaroscuro enhances the figures' sculptural force and powerful illusionism, so that the scenes of calling and martyrdom seem to take place in the real space of the chapel before us. To Bellori Caravaggio's method was limited, and his paintings lacked the action of traditional history painting, which, rather than stressing an instant of reality, meditated on past and future; Mancini too commented on its shortcomings: 'it is impossible to put in one room a multitude of people acting out the story, with that light coming in from a single window ...'[50]

But neither men comment on the poetic power of Caravaggio's light and dark, whose charged symbolism belongs to a long Christian tradition. In the Old Testament, the birth of the Messiah is symbolised by light – 'The people that walked in darkness have seen a great light; they that dwell in the land of the shadow of death, upon them hath the light shined' (Isaiah, 9: 2). At the moment of Christ's death, a mantle of

darkness enfolded the earth – 'And the sun was darkened, and the veil of the temple was rent in the midst' (Luke, 23: 45). Above all St John's gospel is pervaded by the great conflict between light and dark, and the world which man inhabits is a realm of spiritual darkness and death, brought about by evil and sin; but it is a world loved by God to which Christ brought light: 'I am the light of the world; he that followeth me shall not walk in darkness, but shall have the light of life' (John, I: 8–12).

This theology of light, elaborated by the Fathers of the Church, is deeply part of sixteenth-century spirituality; Baronio opened the *Annales* with a passionate statement that the Catholic Church must be reunited with its ancient prototype, and that the splendour of this pristine beauty will throw apart the shadows and dispel the gloom. Trent had renewed a sacramental confidence in the Catholic Church, but still the voices of Luther and Calvin, the fear of darkness, Hell and damnation, were powerful in the Catholic world. The great Catholic saints knew the anguish of separation from God, and the Jesuit saint Ignatius Loyola had undergone spiritual conversion when he was thirty, and, after meditating on his sinful past, had renounced his life as courtier and soldier. He had developed meditative techniques as instruments of conversion, and the exercitant of Loyola's *Spiritual Exercises* closes the door and windows to exclude the light, and, in darkness, practises penance, concentrating on such topics as death and judgement. In the first week, Loyola recommends, the exercitant should 'Suppose yourself in the presence of God, as a culprit guilty of grievous crimes, who presents himself to the judge loaded from head to foot with the heaviest chains', for the Christian remains guilty; he 'does not cease with fresh blows to renew His passion and death, and scourge Him again by his dishonesty . . .'[51] Caravaggio shows himself complicit in the murder of St Matthew, and this autobiographical suggestion, this personal sense of a universal darkness and guilt, recurs in his religious works and gives them their extraordinary power and tension. The apocalyptic darkness that shrouds St Matthew, the blackness into which St Peter stares, are so dark, St Peter so isolated, so stripped of comfort, that they convey an undercurrent of tormented questioning of grace and salvation, a deep fear that the sun may not rise again, that suggest an anguished fear of death and personal need

of grace. At the end of Webster's play *The Duchess of Malfi*, the dying murderer Bosola broods on darkness:

> Oh this gloomy world,
> In what a shadow or deep pit of darkness
> Doth, womanish, and fearful, mankind live?[52]

– and to Tommaso Campanella the times were out of joint: 'The century is dark, it cannot see the sky; the stars are cloaked by clouds, there is no glow, the sun has disappeared in darkness, and the moon is blood.'[53]

Ut Pictura Poesis

The end of the poet is to arouse wonder
(I speak of the excellent, not the foolish);
Let him who cannot arouse wonder go work
 in the stables!

 MARINO, 'MURTOLEIDE' [1]

IN THE CHURCHES OF ROME exemplars of martyrdom and conversion encouraged the faithful, and stern measures were taken against anything indecent or lascivious. In the palaces of great princes and cardinals another ethos reigned, and there was a sharp distinction between the public world and what could be enjoyed in private. Here courtiers took pleasure in light-hearted intellectual pursuits, in aesthetic debate, and in literary *conversazione*. In the increasingly popular long galleries that began to enrich many Roman *palazzi* the noble dilettante displayed his wealth and taste, walking with his courtiers amongst works of art which provoked pleasurable discussion, and inspired dazzling displays of wit and fancy. The lively and charming essays of Vincenzo Giustiniani — on hunting and etiquette, music, sculpture, architecture and games — express curiosity and interest in all gentlemanly pursuits. His essay on architecture, for example, is addressed to 'any gentleman or other person who, for his own gain or delight, might embark on some building enterprise'. Giustiniani enjoyed hunting, in the company of Cardinal Montalto and Ciriaco Mattei (another patron of Caravaggio), delighted in recounting the exploits of the great Roman nobles and of Grand Duke Ferdinando de' Medici, and was a tireless traveller and sightseer. In one essay he expresses his preference for croquet over the more violent tennis — 'it is more fitting to gentlemen,' he writes, 'for it requires but moderate exercise and does not oblige the player always to remain in one place, but affords great freedom, not only for discussion and negotiation, but also for jest . . .': a sentence

that vividly conveys a gentlemanly ideal of ease and spirited conversation.[2]

Giustiniani had an unrivalled breadth of knowledge, and enjoyed exercising the newly fashionable skills and tastes of the connoisseur; he was interested in how paintings were made, and in the tools of art, and visited artists in their workshops. His many portraits of artists – among them Caravaggio's portrait of Sigismondo Laer, and portraits of Orazio Borgianni, Gerrit van Honthorst, Jacques Stella, Andrea Schiavone, and Federico Zuccaro – suggest a curiosity about the artistic personality. He discussed painting with Caravaggio, whose views he introduced into his 'Letter on Painting' with a reverential flourish, and perhaps they paused together in his gallery before the dark paintings of Luca Cambiaso and the Bassani.

In the seclusion of galleries and private chambers more voluptuous works could be displayed. Giulio Mancini, in his advice to connoisseurs on displaying their collections, wrote piously that it was wise to control pictures on public show. In the house of a private gentleman, however, he recommended that landscapes should be put on general view, while erotic paintings, and paintings of Venus, Mars, and nude women, should be displayed in garden rooms and in the most secluded rooms of the ground floor. The most lascivious should be hidden away and covered, and visited only by the head of the family, with his wife, or with a trustworthy and unshockable friend. In this way, he added, such pictures encourage the procreation of beautiful children.[3] For Caravaggio's pictures, which were so dark, Mancini advised gilt frames. In a similar vein the poet Marino wrote to Ludovico Carracci on behalf of a Genoese collector asking him to paint an ancient myth, 'perhaps that of Salmacis and Hermaphrodite, showing them nude and in each other's arms in the fountain'.[4] He need not, Marino reassured him, nurse scruples about painting obscene and lascivious fantasies, for the picture will be kept in the study, and will be shown only to intimates; moreover Federico Barocci and Jacopo Palma, extremely pious artists, had not refused a similar request

In the many literary academies of Rome, too, there flourished a lively interest in the visual arts and in aesthetic debate, and in the 1590s there was a remarkable flurry of poems about paintings. In 1593 Cesare

Ripa had dedicated to Del Monte his *Iconologia*, a collection of emblems which, immensely popular with both painters and poets, encouraged sophisticated conceits and displays of learning. In the same years the epigrams on statues and paintings in the Greek *Palatine Anthology*, redis-covered in the early sixteenth century, and long imitated, became newly popular. Such an epigram as this on Medea – 'The inspired hand infused into the marble both pity and fury, and made the stone Medea, under the empire of his art, remember all her griefs'[5] – with its emphasis on the miraculous power of art to bring dead stone to life, inspired many imitations, and poets took intense pleasure in works of art as starting points for the display of ingenious wit. To the theme of art's rivalry with nature they added the rivalry of painting with sculpture, a tired Renaissance debate (the *paragone*), to which the painters and sculptors of the turn of the century, passionately interested in illusionism, brought fresh life. The Renaissance artist had challenged nature (*vinta sarà natura*) with a world more perfect and more exquisite than that of reality; now the emphasis was on wonder, on the truly marvellous power of art to deceive the senses.

The most brilliant and celebrated poet of his age was Giambattista Marino, who came to Rome in 1600, where, in the years immediately after the unveiling of the Contarelli chapel, he was painted by Caravaggio (Plate 27), and became a friend of the painter. At this moment the astonishing naturalism of Caravaggio's art was the talk of Rome. It seemed magical, and Scanelli later wrote '[he painted] narra-tives with such truth, vigour and relief that quite often nature, if not actually equalled and conquered, would nevertheless bring confusion to the viewer through his astonishing deceptions, which attracted and rav-ished human sight'.[6] Caravaggio fascinated Marino, who addressed a sonnet to his portrait, praising Caravaggio's god-like power to bestow immortality on his friend. The two men were together fêted by the Roman literary world; Bellori tells us that 'Caravaggio painted the por-trait of Cavalier Marino, with the reward of praise from literary men; the names of both painter and poet were sung in the Academies . . . Because of his kindness and his delight in Caravaggio's style, Marino introduced the artist into the house of Monsignor Melchiorre Crescenzi, clerk of

the papal chamber . . . Michele painted the portrait of this most learned prelate.'[7] A papal chamberlain and himself a poet, Mechiorre Crescenzi was a member of a cadet branch of the old and illustrious Crescenzi family who had been involved with the Contarelli chapel. He was the centre of a brilliant literary circle, whose brother Crescenzio Crescenzi, whom Caravaggio also painted (untraced), was renowned for wit and learning, and a gifted singer: in his will Crescenzio left both his own portrait and that of Marino to his nephew, Francesco. Ranuccio Tomassoni was for some time in their service.

Around the Crescenzi and around Marino there clustered other poets, who fell under Caravaggio's powerful spell. The circle included the private and retiring Marzio Milesi, scholar and man of letters and poet (albeit remarkably pedestrian), who was drawn to Caravaggio as to his opposite, claiming his friendship and seeking to bask in his reflected glory. Milesi was a Lombard, and his grandfather had been a patron of Polidoro da Caravaggio. Marzio passed his youth in the Casa Milesi in Rome, its façade splendidly decorated by Polidoro's elegant grisaille frieze, a re-creation of the style of an ancient Roman relief. It was a celebrated work, a tribute to the refined culture of the Milesi, and the house became a meeting place for intellectuals and artists, above all those from Lombardy. It was perhaps this Lombard connection which initially drew him to Caravaggio, whom he may have met well before 1600 – one of his verses is addressed to Caravaggio 'still young'. Marzio, the heir to this refined humanist culture, was concerned to spread the fame of the Casa Milesi through engravings by Caravaggio's friend Cherubino Alberti. Both devout and scholarly, an enthusiastic student of classical antiquity and Christian archaeology, he was a collector of inscriptions, reliefs, tombs, busts and medals, and had a small museum and rich library.[8] He was later to contribute a sonnet, 'La Pittura', to the 1613 edition of Ripa's *Iconologia*. Another member of the circle was Milesi's friend the Genoese Gaspare Murtola, who addressed several elegant madrigals to Caravaggio, whom he must certainly have known, and who like him enjoyed the patronage of the Crescenzi. Also in the circle was Milesi's friend Francesco Gualdo, who also had a small museum, of antiques and natural curiosities, gems, cameos, coins, and inscriptions.

In addition to these circles several of Caravaggio's contacts — among them Giuseppe Cesari, Gaspare Murtola, Aurelio Orsi, the brother of Prospero, and Maffeo Barberini — were members of a Perugian literary academy, the Accademia degli Insensati (or Non-Sensual Academy), and the director of the Academy, Cesare Crispolti, may have been the first owner of Caravaggio's *Boy Peeling a Fruit* (Plate 10). Crispolti wrote that 'they wished with that name to show to the world that they were non-sensual, that is that they did not apply themselves to sensual things, but, fleeing those, they were intent only on the contemplation of the celestial and divine'.[9] Within this group Aurelio Orsi was celebrated for the purity and elegance of his Latin epigrams, a genre in which he was unrivalled, and he enlivened banquets and feasts with his brilliant improvisations; Maffeo Barberini, the future Pope Urban VIII, intensely vain of his own gifts as a poet, would have no other teacher. At the same time Barberini, an elegant Florentine prelate a few years older than Caravaggio, was laying the foundations of his brilliant career and the fortunes of his family at the papal Curia, writing elegant verse in both Italian and Latin; he strove to retain a classical simplicity, rejecting the contemporary and modish delight in elaborate conceits. Barberini lived in the Casa Grande in the via dei Giubonnari, where he was building up a rich art collection; he was also a patron of scholars and literary men. 'And what was most noteworthy', wrote his biographer, Andrea Nicoletto, 'was that his palace became like an Academy of the most refined literary men who then shone in Rome. There gathered learned men, and there flourished the arts of refined and noble conversation, and finally his courtiers were the most successful, not only in the most beautiful and cultivated literary arts, but in every learned discipline and branch of knowledge.' With his courtier scholars, versed in Latin and Greek letters, Barberini enjoyed the pleasures of *conversazione*, 'in the gardens of the Belvedere at the Vatican, or in the villa of the Borghese on the Pincian hill, or in other places far from disturbance . . .'[10]

In 1603 an academy more glittering than the Insensati, the Accademia degli Umoristi, was founded, at the Palazzo Mancini in the Corso, at the centre of fashionable Rome, where the aristocracy enjoyed their evening *passeggiata*. Many contacts of Caravaggio were members, among them a

small group of friends which included Giovanni Milesi and Giovanni Zaratini Castellini, scholar and archaeologist Andrea Ruffetti, a jurist who later offered help to Caravaggio in a moment of need, Francesco Gualdo, and Giovanni Vittorio Rossi, alias Giano Nicio Eritreo. Eritreo was later to become famous as a collector of anecdotes and gossip about papal Rome, and for his *Pinacotheca imaginum illustrium*, a sharp and ironic collection of elegantly written Latin biographies of famous Roman personalities. But at this point, after a youth indulging in elegant and worldly pastimes, frequenting the courtesans, he was in extreme financial need, and just beginning his literary career.

Also among the Accademia's members were Onorio and Decio Longhi, Caravaggio's biographer Giulio Mancini, and Fillide's lover, the poet Giulio Strozzi. Mancini was an eccentric character, who had come to Rome from Siena in 1592. He was a doctor, collector and art dealer, as well as a writer on art, and he got to know Caravaggio in his years in the Palazzo Madama, looking after him when he was ill. Mancini liked to be paid in kind for his medical services, and Eritreo gave an amusing description of him, as he visited his patients. 'In the first place he darted his eyes around the room, and if they lit on a fine painting, he fell passionately in love with it; he was very learned in such things, and put his mind to getting the picture. Nor was it difficult for him to get paintings from those who had entrusted their safety and life to him. He bought these pictures as cheaply as possible so that he could sell them as dearly as possible.'[11] In later years Eritreo mixed with the French *libertins* in Rome, and he also gives a very lively description of Mancini's self-confessed atheism and scandalous affair with a married woman.

But at this point both were circumspect, and the emphasis at the Accademia was on the *spiritosa*, on light and exuberant displays of wit and fancy. It opened with a discourse on the beard by Castellini, and there followed a deluge of epigrams and *cicalata* – talk – of ostentatious displays of vast erudition on modest subjects that delight in paradox and in unexpected and far-flung comparisons. In an age of religious passion and gravity, when the pagan gods were outlawed, such wit and ingenuity offered delight and diversion. Painters and poets were close; Giuseppe Cesari and Longhi were highly cultivated artists with literary ambitions;

Antiveduto Grammatica delighted in poetry; Baglione was a littérateur; and Antonio Tempesta, wrote Baglione, was 'a virtuoso in many kinds of music, and sounds, and at languages he had no rival; he was witty, pleasing and full of wise sayings.'[12] Mancini adds a vivid sketch of Tempesta in the tavern where he went, not out of greed but to save trouble, and where he gathered around him a group of admirers, attracted by the charm and wit of his conversation. According to Malvasia, Caravaggio took to the Bolognese painter Spada, saying that he had found a man after his own heart, because Spada was a lively character, who enjoyed writing playful and satirical poetry. It is in fact unlikely that Caravaggio knew Spada, but the story does suggest that he had a reputation for enjoying the company of poets.[13]

His fame spread beyond Rome; Paolo Gualdo, scientist, antiquarian and littérateur, who had a celebrated private museum in Vicenza (who may have come from another branch of the same family as Francesco Gualdo), had been in Rome in 1602–3, and had bought an expensive picture from Caravaggio. But it remained important to tread cautiously, and in 1603, Cardinal Paravicino, closely associated with Cardinal Baronio, wrote a veiled letter to Gualdo in Vicenza, warning him of Caravaggio's liking for pictures that were between the sacred and profane, 'tra il devoto e il profano'. [14]

A T THE CENTRE OF THIS WORLD, its true impresario, was Giambattista Marino, who had fled imprisonment in his native Naples, to seek his fortune in Rome in 1600. His early life had been colourful; the son of a lawyer, he had struggled to avoid following in his father's footsteps; and from 1596 he had been in the service of the wealthy Matteo di Capua, Prince of Conca, and later Grand Admiral of the Neapolitan realm, who in 1592 had been host to Tasso. The prince lived in fabled splendour, and here Marino first enjoyed a courtly atmosphere of refined pleasures and wealth; here he developed a love of painting, and appreciated the lustre that art could bestow upon its owner. His own ambition, to rise to the highest summits of both prestige and wealth, took root. But his ascent was to prove perilous, and in

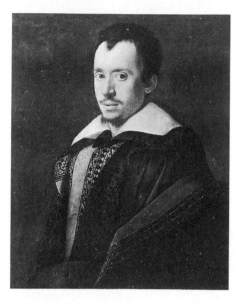

27. Caravaggio? (attrib. to) *Portrait of Giovan Battista Marino*
(Private collection)

May 1598 he was suddenly imprisoned. The cause is not clear; hostile
sources said that it was for sodomy, a charge often brought against
Marino; others claimed that he had seduced a young girl, Antonella
Testa, who had been made pregnant by him, miscarried and died, and
whose father had brought charges against him. It seems likely that
Marino at least did not believe the cause to be too serious (sodomy car-
ried with it a possible death penalty), for he addressed a burlesque poem
on his imprisonment to the Prince of Conca. The prince intervened, and
Marino, enjoying his freedom, went to Rome for the Jubilee of Clement
VIII, and wrote a famous sonnet on the flooding of the Tiber (later put
on the index for its over-voluptuous wit).

Yet later in that year he was again imprisoned, and this time in real
fear of his life. He had forged documents to save a young friend of his
from execution, but all was discovered, the friend was executed, and his
hand lopped off; Marino, again in prison, feared the same fate. This time
his pleas from prison to the Prince of Conca are no longer facetious, but
suggest real terror:

This Stygian hell, sunk in oblivion deep,
Shrouded in gloom, horror and in tears,
Harbours distressed Marino in its bowels . . .[15]

In the end, with the aid of powerful friends, Marino was allowed to flee to Rome. Here he soon found a protector in Melchiorre Crescenzi, and was given a room in the Palazzo Crescenzi. He undertook the duties of the court poet, addressing two pious canzoni to Crescenzi's sister, a nun, and producing very many lyrics celebrating the worldly pleasures of aristocratic Rome. In 1601 Marino decided to journey to Venice to publish his poems; he lingered for some time in Florence, where he may have seen Caravaggio's *Medusa*, arriving in Venice early in 1602. The first volume of Marino's *Rime*, published in that year, is dedicated to Melchiorre, whom he honours for having comforted him in distress 'for bringing to life the flowers of his hopes, which then were deadened and languishing'.[16] The *Rime* brought fame to Marino, hailed as the heir to Tasso, and fêted by the Crescenzi on his return to Rome.

So great was his fame that he attracted the attention of Pietro Aldobrandini, the most powerful man in Rome, and left the Crescenzi to enter the yet more glittering household of the Aldobrandini. Here Marino enjoyed the life of the courtier-poet, flourishing in an atmosphere of hedonistic splendour, enjoying adulation, skilled in polemic, and cunning in his self-advancement. From his pen there flowed epithalamia, sonnets, and madrigals, evoking the sensuous, aristocratic pleasures of Rome and the beauties of the Cardinal's great villa at Frascati; his poetry is richly ornamental, seeking to surprise and delight with its novelty, and creating paradoxical or extravagant illusions that appeared to him like *meraviglia*, or wonders. Around the costly adornments of the courtesan – her fans, beauty spots, mirrors, earrings – and around the trifling *passatempi* of the courtier – music, games of dice and cards, tennis and ball gamer – Marino spun a dazzling web of metaphor, and the ingenuity of his word play seems itself to evoke the artifice of the courtier's life. Caravaggio's *Cardsharps* may well have suggested this novel motif to Marino, and it was with this painting of a trick that Caravaggio had himself gained entrée to the court.[17] In his search for

novelty, and new forms, Marino was aware not only of the sister art of music, whose emotional power he praises in many poems addressed to singers, but also of the possibilities offered by the new imagery of painting. He planned a collection of poems addressed to paintings and painters, later published as *La Galeria*, a concept self-consciously modelled on Philostratus' *Imagines*; Philostratus had described a picture gallery in Naples (perhaps imaginary), using the pictures as stimuli for showy ingenuity, and attempting, through rich and ornamental description, to convey their visual and emotional power. In the *Galeria* Marino was free, as great princes were free, to indulge his taste for the luxurious and the marvellous. His imaginary gallery of history paintings evokes a Senecan thrill in blood and horror; around the spectator he conjures up a glittering array of the most celebrated sado-erotic paintings of severed heads, among them Cristofano Allori's darkly sensual *Judith with the Head of Holofernes*, the Cavaliere d'Arpino's *Jael and Sisera* and *David killing Goliath*, pictures of *Samson and Delilah*, and *Herodias with the Head of John the Baptist* by Annibale Carracci and Lavinia Fontana, and, at their centre, Caravaggio's *Medusa*, its shocking power the epitome of a *meraviglia*.

Throughout, Marino exalts the stupefying power of art to rival or conquer Nature herself, he writes of images so alive that reality pales before them; of gestures and actions so powerfully presented that we wait to hear their sounds; (and it was perhaps the effect of sound that Caravaggio strove for in the *Judith and Holofernes* and in the shrieking acolyte in the *Martyrdom of St Matthew*), of a painted figure so lifelike that it enchants the spectator, and reality and illusion seem to change place. He caught in verse, as perhaps Caravaggio did in paint, that precise moment at which life hardens into art, writing of a sculpture of Niobe,

> See how he hardens now her stiffened limbs:
> Motionless and bloodless: how she now becomes
> Body, and sepulchre, at one fell touch . . .[18]

and in a series of poems on a marble Cupid asleep in a fountain, he played on the ambiguities of different kinds of illusion, of sleep and death, dreams and desire, cold heart and cold marble. These are both

ancient and contemporary themes, but Marino's virtuosity is unparalleled. In the poetry of his rival, Gaspare Murtola, there is a pallid echo of Marino's ingenuity; Murtola describes the rich and precious beauty of curious and intricate works of art, of snaky earrings, gold-bordered gloves, a bee enclosed in amber. Through images caught in tears, or reflected in rock crystal (and at the bottom of his lady's glass goblet Murtola shockingly glimpses the head of Medusa) or in convex and concave mirrors, he evokes the strange and dreamlike beauty of courtly life. He wrote many poems on the classical sculpture of the *Niobe* (then in the Villa Medici, but now in the Uffizi), to which Barberini also addressed an epigram, and by 1603 Murtola had written six madrigals to Caravaggio. He moved in the same circle, dedicating a poem of perfumed sensuality, 'La Bella Bocca', to Crescenzio Crescenzi, and others to 'Sig. Muzio Sforza, Poeta Eccellente' and to Onorio Longhi, poet and mathematician. Caravaggio's early works, *The Lute Player*, *The Boy Bitten by a Lizard*, the *Medusa*, so exquisite, so rich in coloured reflection, seem made for this poetic ambience, stimulating poets to weave conceits around them. It is unlikely that Caravaggio himself intended precise emblematic readings, but he knew that his paintings would be read in this way: *The Boy Bitten by a Lizard* (whose modern title sounds so like a sixteenth-century madrigal) looks like a painting conceived as a study of expression, around which the artist then set a fashionable froth of accessories which indulged a contemporary delight in symbol and emblem. A member of the Insensati, Giovanni Battista Lauri, wrote a poem of very similar theme, 'Of the Boy and the Scorpion':

> While the child was playing by the damp reefs,
> Disturbing the cold stones with his childish hand,
> A tenacious and ferocious scorpion gripped his fingers,
> Slowly drawing up foul poison from the depths of its
> breast.
> In pain the child lifted his hand to his mouth, and with
> it the wild beast
> That despatched miserable ruin to the bottom of his
> heart.

Alas, wretched boy; while you hope for comfort from
 your warm mouth,
From that very place you drink in certain death.[19]

About this time, when Caravaggio was most closely in contact with
Marino, in the years around the Contarelli chapel, he painted one of his
most haunting works, the *Narcissus* (Col. Plate 17), a mythological sub-
ject almost alone in Caravaggio's oeuvre. In Ovid's *Metamorphoses* the poet
describes how the handsome boy Narcissus, who had spurned the love
of his companions, was condemned to fall in love with his own reflec-
tion, and to perish from this unrequited love. Weary from the hunt,
Narcissus stooped to drink at a 'clear pool, with shining silvery waters,
where shepherds had never made their way; no goats that pasture on the
mountains, no cattle had ever come there. Its peace was undisturbed by
bird or beast or falling branches . . . encircling woods sheltered the spot
from the fierce sun, and made it always cool'. Here Narcissus, as he
drank, 'was enchanted by the beautiful reflection that he saw. He fell in
love with an insubstantial hope, mistaking a mere shadow for a real body.
Spellbound by his own self, he remained there motionless, with fixed
gaze, like a statue carved from Parian marble.'[20] In Caravaggio's painting
there is no reference to the ancient world; Narcissus is a young Roman
boy, in a sleeveless damask doublet, looking into a pool; Caravaggio has
pared down Ovid's narrative, rendering its stark essence. The composi-
tion is based on a circle, and within it, circle within a circle, is Narcissus'
knee, startlingly foreshortened.[21] The drawing is distorted, with the curve
of the back unnaturally long, as though the whole figure has been
pulled out sideways, and thus locked into the demands of this circular
composition. It creates a sense of intense concentration, and the picture's
meaning lies in this circle of self-love.

Yet it may also be read as a tribute to the illusionistic power of paint-
ing, to the power of the artist to create a duplicate world. Figure and
reflection have almost equal weight, and reality and illusion are divided
by touches of white water. The play on reality and illusion is given
prominence in Philostratus' *Imagines*, which contains a long description
of a painting of Narcissus. 'The pool', writes Philostratus, 'paints

Narcissus, and the painting represents both the pool and the whole story of Narcissus. A youth just returned from the hunt stands over the pool, drawing from within himself a kind of yearning, and falling in love with his own beauty . . . The painting has such regard for realism that it even shows drops of dew dripping from the flowers . . . As for you, however, Narcissus, it is no painting that has deceived you, nor are you engrossed in a thing of pigments or wax; but you do not realise that the water represents you exactly as you are when you gaze upon it . . .'[22] No other painting by Caravaggio is inspired by the *Metamorphoses*, but he was a common source for Marino, and in the *Galeria* he devoted a sequence of four poems to paintings of Narcissus. Marino's poems play on the relationship of art to nature, and of reality to illusion. He writes of Narcissus' face, wondering whether canvas or water bestows a more vivid reality; he writes, as Philostratus had written, of layered deceptions, of Narcissus deceived by the fountain, and the spectator by paint and canvas; of an image so real that nature herself, a tiger glimpsing its mirror image, pauses in wonderment. In a sonnet to Bernardo Castello's *Narcissus* Marino praises the artist's illusionism:

> No imitation fountain this:
> for what is seen in it is real and living;
> living is the wave . . .[23]

and then elaborates the theme in Philostratus, of Narcissus' rapt silence before his reflection:

> The boy keeps silent, utterly absorbed
> In fixed contemplation of that face that so delighted
> him . . .[24]

The virtuoso power of the artist is a constant theme in Marino, and perhaps both he and Caravaggio knew the puzzling reference in the treatise *On Painting*, by the Renaissance theorist Leon Battista Alberti, to the myth of Narcissus as symbolising the origins of painting – 'the inventor of painting, according to the poets, was Narcissus . . . What is

painting but the act of embracing, by means of art, the surface of the pool?'[25] And in Caravaggio's picture the illusion is heightened by the sense that it is caught and held only for an instant, and that as Narcissus' hand disturbs the surface of the pool, it will vanish.

Narcissus' fate was tragic, Marino writes of the 'lethal fountain',[26] and Caravaggio conveys a dark melancholy. Narcissus' eyes are deeply shadowed, his full lips voluptuous, and his yearning gaze is fixed on black water. This water was frequently associated by ancient writers with the waters of the Styx, and the narcissus into which the boy was transformed was associated with death, with Demeter and Persephone, with dank pools and funereal flowers. Here no flowering narcissus blooms by the pool, nor does the nymph Echo, who languished with love for him, accompany the lovely youth; his story is unrelieved by the promise of redemption or metamorphosis. In this association of love with death Caravaggio is again close to Marino, whose lyric verse evokes a dark and fated sensuality. In a series of poems to a young boy, Ligurino, Marino warns of the passing of youth and beauty:

> Yet time, O Ligurino, will at last
> Shrivel the Graces' garden, making it
> One horrid desert: and will cast the bloom
> Of all angelic beauty to the dust . . .

Caravaggio's *Narcissus*, like his *Boy Bitten* and his *Lute Player*, is perhaps also a *vanitas*, a warning against the darkness and horror that follow the beauties and vain pleasures of love and youth.

There is no contemporary reference to Caravaggio's *Narcissus* and we do not know for whom it was painted, but it seems likely that it may be connected to these Roman literary circles, so dominated by Marino, and was perhaps painted under the encouragement of Marino and the highly refined Vincenzo Giustiniani. They interested other artists in such themes: Castello, to whose *Narcissus* Marino paid poetic tribute, was a learned artist, who illustrated Tasso's *Gerusalemme Liberata*. He came from Genoa, and was portrait painter to the Giustiniani family,[27] but he was in Rome in the 1590s, and moved in the same circles as Caravaggio. In

1605 the Giustiniani brothers commissioned him to fresco their country villa at Bassano da Sutri with the story of Cupid and Psyche, again a favourite theme with Marino, and providing a sensuous and erotic pleasure which could be enjoyed in the seclusion and privacy of a country residence. Marino may, too, have interested Caravaggio in erotic themes, for, in a letter of 1620, addressed to Paolino Berti, he referred to a painting of *Susanna* by Caravaggio which he owned. The picture is lost, but presumably did show, unusually in Caravaggio's work, a female nude. The poet asked Berti to send him a version of the darkly sensual *Judith and Holofernes* by Cristofano Allori, which he described in *La Galeria*, to accompany Caravaggio's *Susanna*.[28]

In the succeeding years Caravaggio was to be overwhelmed with commissions for important and lucrative altarpieces, but at this moment, at the beginning of his success, he was much in demand for gallery pictures, and for portraits. Of the fifteen works ultimately in the Palazzo Giustiniani six were portraits, among them portraits of the celebrated advocate Prospero Farinacci (lawyer for Beatrice Cenci), of Cardinal Benedetto Giustiniani, of the artist Sigismondo Laer, and an unknown woman, Marsilia Sicca. His portrait of *Maffeo Barberini* in a vivid baroque pose, gesturing towards the spectator, survives, and his portrait of Marino has recently, perhaps, been identified; but most of his portrait production has been lost.

On 2 June 1601 a Roman newspaper announced:

> In the past days there has been unveiled the beautiful gallery of Cardinal Farnese, painted by the Bolognese Carracci family. Its success has been so great that Cardinal Pietro Aldobrandini has asked the painter for a *Domine Quo Vadis?* and has given him a golden chain worth 200 scudi with a large medallion of Our Lord . . . Now one finds that painting flourishes in Rome, no less than it has done in times past. The completion of the Cavaliere d'Arpino's decorations in the Palazzo del Campidoglio is expected, and the two paintings which Caravaggio is

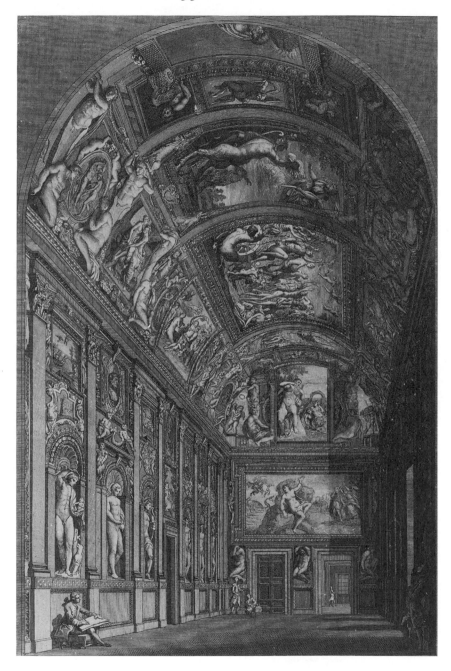

28. Giovanni Volpato, *The Farnese Gallery, Rome*
(print)

doing for the chapel which belonged to the
treasurer, Monsignor Cerasi, the main altarpiece in
that chapel by the already mentioned Carracci, and
all these three paintings of the greatest excellence
and beauty . . .[29]

Painting, no longer languishing, seemed gloriously reborn, and Annibale
Carracci, Caravaggio and the Cavaliere d'Arpino together hailed as its
three greatest exponents. Annibale and Caravaggio competed in the
Cerasi chapel in the autumn of 1601, where Caravaggio's proletarian
figures were a provocative response to Annibale's idealising style. But the
frescoes of the Farnese Gallery, a lovely and overwhelmingly sensuous
tribute to physical beauty, and at the same time a magnificent display
of the power of art itself, were a yet greater challenge to Caravaggio's
naturalism.

Their creator, Annibale Carracci, had left Bologna with his brother
Agostino in 1594, when he had been invited by the young Cardinal
Odoardo Farnese to decorate the Palazzo Farnese. This was the most
celebrated and grandest of all the Roman palaces, completed by
Michelangelo, and a property envied and perhaps coveted by the lowlier
Aldobrandini. Annibale was in his mid-thirties, eleven years older than
the twenty-three-year-old Caravaggio, and though his works were little
known in Rome, he was a famous painter, at the height of his powers,
who had already decorated Bolognese palaces and created a series of
impressive altarpieces for Bolognese churches and for other centres in
Emilia Romagna. His art, like Caravaggio's, is rooted in nature, but to
him this meant constantly underpinning his work by drawing from life,
and his first works had had an almost aggressive rough naturalism. But
increasingly he turned to more idealising traditions, uniting a passionate
study of nature with an interest in both ancient art and in the
Renaissance, and combining a naturalistic play of light and shade, and
figures whose flesh seems warm and alive, with the formal power and
idealising beauty of a classical tradition. He and his brother were given
rooms in the top floor of the Farnese palace, and the grandeur of its
art, and the splendour of ancient and Renaissance Rome around

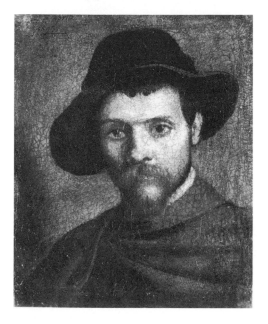

29. Annibale Carracci, *Self Portrait*
(Parma, Galleria Nazionale)

him, encouraged Annibale to create a more classical and monumental style.

The frescoes in the Farnese Gallery were the most sumptuous palace decoration since Raphael, but the creator of all this courtly splendour was a strangely uncourtly, solitary character, dirty and unkempt, and uncomfortable in the world of power and wealth. Annibale's father was a tailor, and Annibale remained faithful to his lowly origins, preferring the company of craftsmen to courtiers, and it is as a modest artisan that he appears in a small *Self Portrait* of 1593 (Plate 29). Malvasia, his Bolognese biographer, describes his disdain for splendour and luxury, saying that Annibale cared little for himself, he was not very clean, badly dressed, 'with his hat thrust on anyhow, his coat badly arranged, his beard disordered . . . he was always abstracted, always alone, so that he seemed a philosopher from antiquity . . . and for this reason he was not always esteemed as he should have been . . .'[30] Malvasia draws a touching picture of Annibale's attempts to avoid his patrons, blushing

with confusion when he ran into Cardinal Farnese in Rome, and avoid-
ing a visit from Cardinal Borghese by slipping out through the back
door. At the same time Annibale resented the miserly way in which the
Cardinal treated him. A letter sent from Rome in August 1599 evokes his
penurious life: 'M. Annibale Carracci receives from his [patron] no more
than ten scudi per month, and portions for himself and a servant, and a
little room under the roof. And for this he toils and pulls a cart the
whole day like a horse, and does loggias, rooms and salons, pictures and
altarpieces, and works that are worth a thousand scudi. He is worn out
with hard work and has little taste for such servitude.'[31]

Agostino, Annibale's brother, who worked with him in Rome until the
two fell out, nursed quite different social pretensions, and, richly dressed
and clean, enjoyed cultivating the company of men of letters; he was
'loving in conversation, learned and erudite in planning, shrewd and
watchful in negotiating'.[32] Agostino's pretensions irritated his brother,
who was inclined somewhat savagely to remind him of his lowly birth,
and on one occasion, tired of Agostino's erudite discourse to a group of
courtiers on the antique sculpture, the Laokoön, he drew the sculpture
on the walls of the Palazzo Farnese, stunning his audience, and remark-
ing tartly to Agostino: 'Poets paint with words; painters speak with
works.'[33] Annibale was loved by his pupils, but he had a sharp tongue, was
violently jealous of other artists, and developed a pungent and epigram-
matic manner of speech; unlike Caravaggio, he revealed his contempt for
Giuseppe Cesari and his followers openly, turning from d'Arpino's
Triumph of Constantine in St John Lateran to remark to his pupils: 'Who
would have ever believed that a clumsy and wretched fellow could
triumph?' and, asked who was the greatest poet, Ariosto or Tasso, he
replied: 'Raphael.' On one occasion d'Arpino responded to his criticism
with a challenge to a duel, and, Annibale, laughing, 'seized his brush and
said "I challenge you."'[34] His sayings include only one remark on
Caravaggio: 'Asked to give his opinion on a *Judith* of Caravaggio, he
replied: "I don't know how to say otherwise, it is too natural."'[35]
Caravaggio, so different in his violence and aggression, none the less
shared with him a taste for emphasising the craft of painting, and punc-
turing intellectual pretension.

Annibale's reputation had surely preceded him to Rome in 1594, but it seems likely that few of his works were known there, and his first painting for a Roman church, Santa Caterina dei Funari, was an altarpiece, *St Margaret*, which was installed in 1599. This painting has the bright colour and light, the warm and tender humanity, of Venetian art, lacking entirely the cloying eroticism or iconic purity and simplicity of paintings of saints by contemporary Roman painters. Caravaggio, then still a comparatively unknown Lombard painter of genre and still life, welcomed this picture with an unusual enthusiasm, 'I am happy that during my time I see a real painter,' meaning, Bellori explains, a painter with the good realistic manner which in Rome and other parts was still completely missing.[36] As late as 1658 Annibale's pupil, Francesco Albani, was to remember Caravaggio's admiration, writing to a friend that Caravaggio had 'died on beholding this work'.[37] Perhaps Caravaggio saw Annibale as a worthy competitor, and he was later to speak of him as a friend.

Annibale's most intense activity, during these years, was concentrated on the decoration of the Farnese palace (Plate 28). In the Gallery Annibale created a radiant, sensual decoration, with scenes from classical mythology showing the power of love. They are witty and playful, and show the most splendid of the ancient gods humbled by love. The scenes are presented as simulated easel paintings, that seem to hang against an illusionistic architectural framework which continues the real architecture of the room, and the room itself seems to open into an intensely imagined and radiant world of the gods, a celebration of ideally beautiful figures, lit by bright daylight. The gallery was intended to display marble classical sculptures, and over these Annibale created an imaginary gallery of pictures, each in an ornate frame, as though in a princely gallery. His figures are deeply indebted to classical sculpture, and it seems as though, in his paintings, he brought the sculptures below to warm life, in a conscious display of the power of the rival art of painting. At the same time he borrowed many of the nude youths from Michelangelo's Sistine ceiling, yet created a warmer sensuality.

At either end of the long gallery are paintings telling the story of Polyphemus and Galatea. The body of the cyclops, Polyphemus, has a

truly massive grandeur and muscular power, and suggests Annibale's response to the most celebrated and monumental classical sculptures, the Vatican *Belvedere Torso* and the *Farnese Hercules*, which then stood in the courtyard of the Palazzo Farnese. Annibale thus unites a tribute to the splendour of his patron's princely collection, with a proclamation of the power of painting to rival sculpture. The illusionistic architectural framework plays on different layers of illusion, creating a dazzling array of feigned bronze roundels and simulated stucco sculptures, playful satyrs and putti, and nude youths holding garlands, all of which re-create, in a lighter vein, the decorative accessories of Michelangelo's Sistine ceiling. Such an extraordinary display of pagan nudity was truly startling in Clement's Rome, when palace decoration for the most part consisted of dull biblical scenes and personifications of the *Virtùes*. It was perhaps only possible for so powerful a family, and one so hostile to the Aldobrandini.

The theme of Annibale's ceiling, love conquers all – recalling a celebrated line in Virgil: *Omnia vincit amor; et nos cedamus amori* (Love conquers all, let us, too, yield to love) (*Eclogues* X,69) – became immediately fashionable. The nature of Love was a popular subject with poets and painters throughout the sixteenth century. In the wake of Marsilio Ficino's Latin commentary on Plato's *Symposium*, 1469, dozens of treatises and dialogues on love, amongst them works by such celebrated authors as Pietro Bembo and Mario Equicola, Tullio d'Aragona and Pico della Mirandola, had been written. Writers and poets endlessly analysed the distinctions between earthly love and heavenly love, which Plato had seen as a metaphysical principle, transcending the material universe. Bellori, with probably mistaken emphasis, was to describe the Carracci ceiling as 'the strife and the harmony between Heavenly and Common Love, a Platonic division'.[38] The theme was taken up by Caravaggio, and Mancini, writing to his brother in 1613, recalled how Caravaggio had promised him a painting of the wrath of Mars, trampling beneath his feet Cupid and all his arms. He had attended Caravaggio during an illness, and this was to be his reward. But Cardinal Del Monte had seen the picture, and taken it for himself, and in 1613 it was still in the Palazzo Madama.[39] Del Monte also owned a *Divine Love triumphing over Earthly*

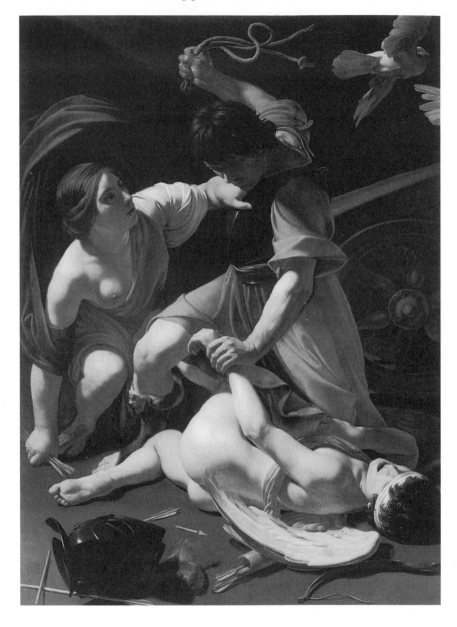

30. Bartolomeo Manfredi, *Mars chastising Cupid*
(Chicago, Art Institute of Chicago)

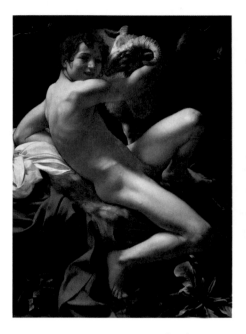

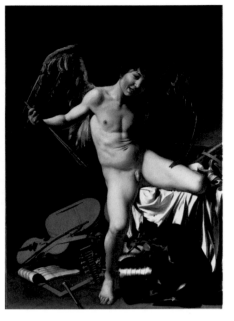

PLATE 15: *St John the Baptist* PLATE 16: *Victorious Cupid*

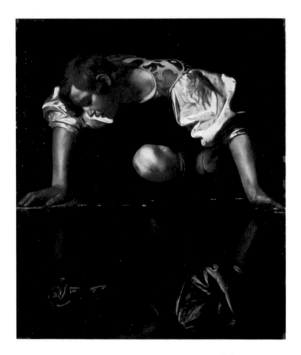

PLATE 17: *Narcissus*

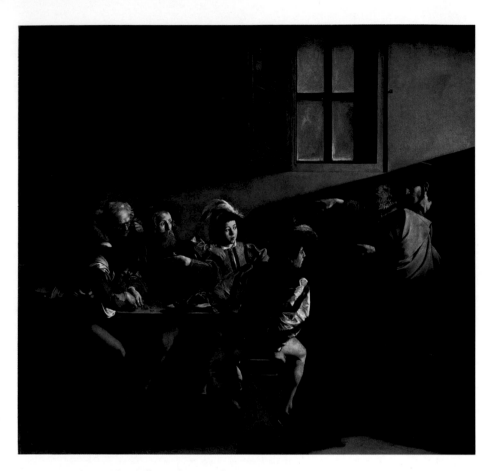

PLATE 18: *The Calling of St Matthew*

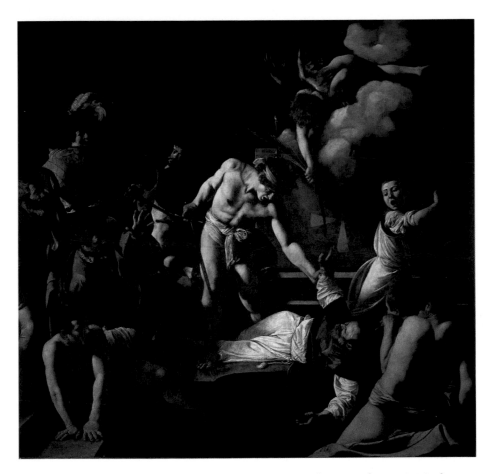

PLATE 19: *The Martyrdom of St Matthew*

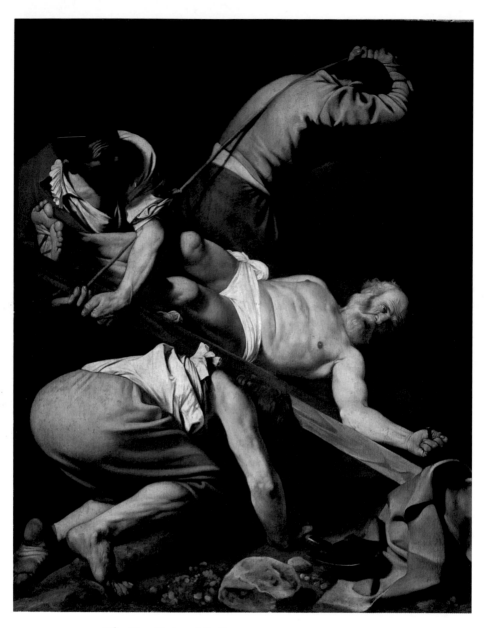

PLATE 20: *The Crucifixion of St Peter*

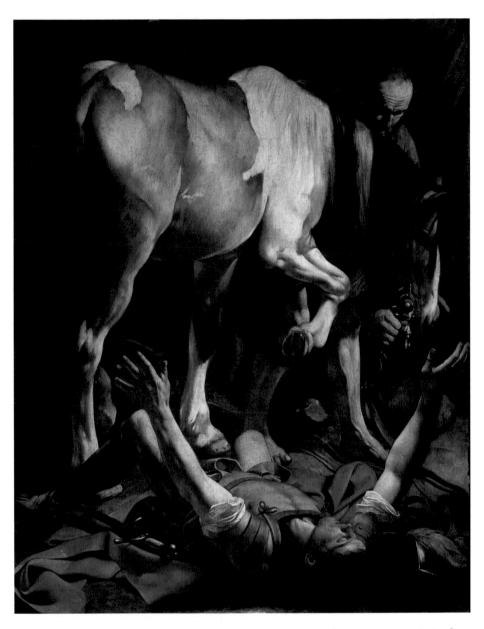

PLATE 21: *The Conversion of St Paul*

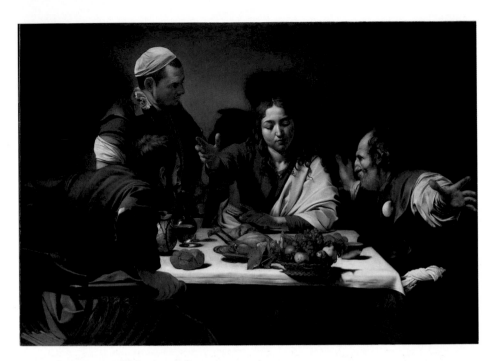

PLATE 22: *The Supper at Emmaus*

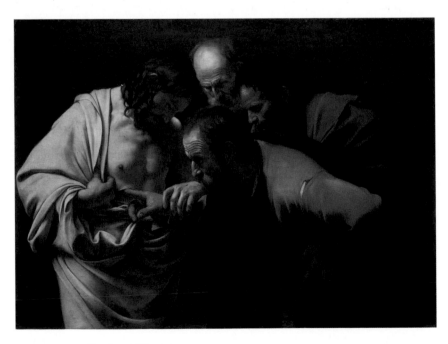

PLATE 23: *Doubting Thomas*

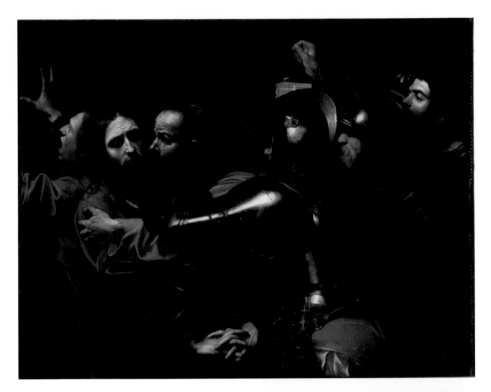

PLATE 24: *The Taking of Christ*

PLATE 25: *St Matthew and the Angel*

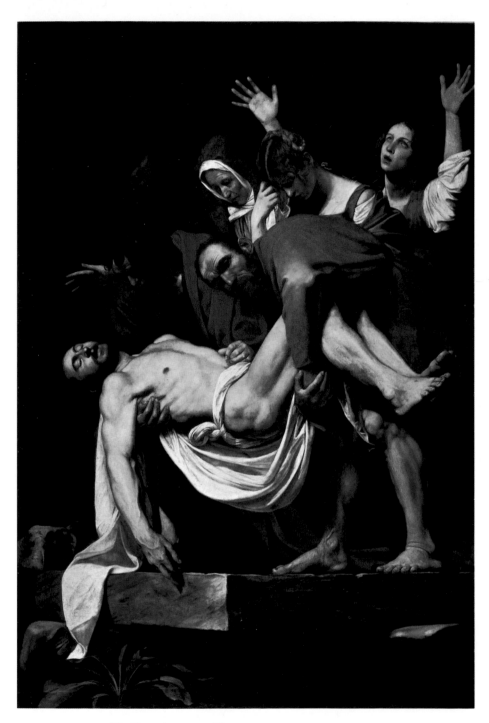

PLATE 26: *The Entombment of Christ*

Love (untraced), mentioned by Baglione (though possibly this was the picture promised to Mancini), and Caravaggio also painted, around this date, a *Sleeping Cupid* (untraced).[40] Mancini, unable to get a copy of the Caravaggio, commissioned instead a *Mars chastising Cupid* (Plate 30) from Bartolomeo Manfredi, and thought it Manfredi's best work. It is a mock heroic, sexy picture, which may well echo aspects of Caravaggio's lost pictures.

Sophisticated collectors enjoyed setting one painter against another; Tiberio Cerasi (perhaps encouraged by Vincenzo Giustiniani) had paired Annibale with Caravaggio, and in a similar spirit Onorio Longhi, who in 1601 married the young Florentine Caterina Campani, commissioned portraits of himself from both Caravaggio and Annibale (both are untraced).[41] (Caravaggio also painted Caterina Campani.) Later, in 1608, Mancini asked his brother to arrange a contest between two paintings of St John, one by Caravaggio, one by Annibale, which he had sent to Siena (the outcome is unknown).[42]

On the unveiling of the Farnese Gallery, Giustiniani perhaps saw a new opportunity for competition and urged Caravaggio to pit his naturalistic art against that of Annibale, an artist whom Vincenzo also admired. For in the period immediately after the completion of the Farnese Gallery and the Cerasi chapel Caravaggio painted his only full-length male nudes, the *Victorious Cupid* (Col. Plate 16), probably in the first half of 1602, for the collection of Giustiniani himself, while the Capitoline *St John the Baptist* (Col. Plate 15) was painted for Giustiniani's friend Ciriaco Mattei in 1602. With these works, both smiling, disturbingly provocative figures, Caravaggio answered Annibale's celebration of the power of art with equally ambitious claims for his own heightened illusionism; again like Annibale, he suggested that painting may rival the power of sculpture; and against the radiance of Annibale's heavenly lovers, he set an earthier, bitterer concept of the dangerous power of love.

The *Victorious Cupid* shows a young boy, of about twelve, transformed into Cupid by shaggy eagle's wings, perching, as though he has suddenly alighted there, on a white sheet draped over a stone bench, with behind a starry globe, and at his feet symbols of intellectual life, of worldly

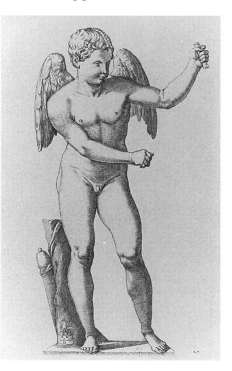

31. *Cupid with his Bow*
(print after antique sculpture,
from the Galleria Giustiniani)

power, of military glory and fame. The *St John the Baptist* shows the same model, languorously posed against a fur, embracing a ram. The paintings are linked above all by their naturalism. The Cupid has an extraordinary intensity of presence, of vivid sharpness and clarity; with the *St John* the light, gathering in curves and hollows, suggesting the play of muscles beneath the surface of the skin, brings the flesh to warm life. It was this quality that attracted Caravaggio's contemporaries. Baglione stressed that the *Cupid* had been painted from nature, while Scanelli wrote of the *St John* that it could not 'reveal truer flesh if he had been alive, like the Amoretto'.[43] Both have their roots in Michelangelo, in the *ignudi* of the Sistine ceiling, but they are still more deeply indebted to Annibale Carracci. It is as if Caravaggio, having studied the very many quotations

from Michelangelo and classical sculpture on the Farnese ceiling, decided to test his naturalistic style against this exemplar, to redo these poses by a direct reference to nature. He saw, in his patron's collection, a Hellenistic sculpture of *Cupid with his Bow* (Plate 31), and, as Annibale had done, rivalled the intensely naturalistic effect of ancient sculpture in the sturdy torso of his Cupid.[44] (The *paragone* debate lived on, and in 1600 Guidobaldo Del Monte, in the introduction to his treatise on perspective, had praised painting as superior to sculpture.) The *St John* is another variation on the theme of Michelangelo's *ignudi*, which had themselves inspired Annibale's display of male beauty, the flesh-coloured youths whom Bellori described as 'nude youths painted in lifelike colours'.[45] But where Annibale had drawn from life, and then idealised his poses, Caravaggio's works are demonstrations of the power of painting directly from the model. Caravaggio's triumphant Cupid is the triumph of painting itself, over the other arts, and over all rivals. Marzio Milesi praises it as such –

> Love conquers all things, and you painter conquer all
> > things
> He indeed conquers souls, but you bodies and souls.[46]

And the painting plays, too, on the theme of Annibale's ceiling, love conquers all, or *Omnia vincit amor*. Where Annibale opens up over the viewer's head a sunlit world of heavenly lovers, Caravaggio's Cupid has emphatically descended to earth. He displays himself on the rumpled sheets of the bedroom, and both pose and expression are provocative, enticing; Cupid seems a dark force, ruling over the planets, and mocking man's highest and most civilised aspirations. With one hand behind his back, he points suggestively to his buttocks, while displaying the softness of his thighs, and the V between his legs, to the spectator.

In this conception of Cupid Caravaggio drew on classical and Renaissance literature and art. Ovid, in the *Metamorphoses*, describes him as carrying two arrows, as does Caravaggio's Cupid, one golden, to kindle love, and the other tipped with lead, to put love to flight and generally create chaos. His clearest ancestor is Parmigianino's *Amor*

(Cupid carving his bow), in which Cupid, an androgynous young boy displaying his buttocks, conspires with the spectator as he maliciously sharpens his bow. Glimpsed between his sensual thighs are two putti, one of whom cries out in pain as he touches Cupid; Cupid parades his triumph, his elegant foot poised over two books, the fruits of the intellect.

Caravaggio's Cupid, too, is dangerous, and Murtola addressed three madrigals to Caravaggio's picture, warning against love's dangerous power. Look not on love, he implores, for he will make ashes of your heart, and these fresh and living colours bring death. And the perils associated with love run through Marino's *Adone*, his epic of love, where the light and playful tone of Ovid is darkened. Marino addressed a large part of his sixth canto to Amor. His Amor is no longer the inspirational force of the Petrarchan tradition, but has become a darker power, associated with death. He describes a love which, while laughing, sucks away life; it is a Medusa, a basilisk, a bird of prey which gnaws at the mind and destroys reason (and so naturalistic are Caravaggio's dark eagle's wings that they invoke the sinister power of a bird of prey); it is a voluntary madness, a pleasing evil. At the end of this canto, love and death change places; they exchange their arms of torch and bow, and Amor, with his wolf's eyes, laughs while weeping as he destroys youth and reason.[47] Love and death are close, too, in Caravaggio's painting. Its composition reminds us of the traditional *vanitas* still life, in which symbols of intellectual and worldly power, beautiful, and piled high, are dominated by a skull, a chilling reminder of their insubstantiality. But here Caravaggio, as Marino also does, has replaced the skull with the mocking and malign Cupid.

The picture was one of Vincenzo Giustiniani's most treasured possessions. It flattered and displayed his knowledge, and the objects over which Cupid triumphs suggest the range of his learning, that of the true Renaissance courtier, skilled in the arts of warfare and of peace. They include music, one of Giustiniani's greatest passions, and the lute, becoming, at this date, a nostalgic reminiscence of a past era, is juxtaposed with a modern violin, while the musical score starts with a prominent V for Vincenzo. A touching tribute to the breadth of his

interests is given by his close friend Theodore Amayden, a Flemish lawyer, who lived in Rome, and wrote of him: 'Marchese Vincenzo, Cavaliere di Bassano, a man of incomparable virtue and merit, known to all but particularly to me, since I have known him very well for upwards of twenty years, and not a day has gone by but that we saw each other. The world never saw a greater intellect. He would discourse on all things, even the most recondite sciences: and, with his affability, he had drawn to his house a gathering of gentlemen and practitioners of every profession whose like had never been seen in Europe'.[48] Vincenzo, delighting in the stylistic debate between Annibale and Caravaggio, also enjoyed literary *conversazione*, and in the erudite literary gatherings at the country villa of Bassano, where the ceilings were decorated with light mythological scenes, the subject of love may well have stimulated learned discourses, reminiscent of those described in Castiglione's *Courtier*. He may have seen his picture, a sardonic joke about all ideal love, as a playful rejoinder to his friend Del Monte's picture of *Divine Love*.

Baglione tells us that Vincenzo admired the *Cupid* beyond reason, and it hung in the great room of the *quadri antichi* in the Palazzo Giustiniani (though it is not clear when the paintings were arranged in this way; there may have been a different hang when Caravaggio was himself in Rome). In this room were the most celebrated of Old Masters, but it also included the works of two modern painters, Caravaggio and Annibale Carracci. The *Cupid*, far from being hidden away in the kind of private chamber where Marino intended to put his *Salmacis and Hermaphrodite*, formed the triumphant finale to a tour of the gallery; Sandrart, who later curated the collection, tells us that 'at my suggestion it was given a dark green silk covering and only when all the others had been seen properly was it finally exhibited'[49] – a device probably suggested, not from prudery, but from a desire to increase the startling immediacy with which Cupid seems to have alighted on the bed and to emphasise, in a way then customary, the painting's fame.

Vincenzo's gallery demonstrates his sense that Annibale and Caravaggio had together brought about a rebirth of the great traditions of Italian painting, and in his later *Letter on Painting* he makes this brilliantly and unexpectedly clear.[50] He lists twelve categories of painting,

leading up to a final group of three. First of these are artists (among them Roncalli and the Cavaliere d'Arpino) who work *di maniera*, that is, without a model, but drawing on knowledge acquired through long study; second are those (among them Ribera and Rubens) who paint directly from the object, with the emphasis on light and shade, colour and chiaroscuro. But final, and most perfect, was the twelfth category, which united painting *di maniera* with painting from the object. And in this category, the most excellent, he placed Caravaggio, Annibale and Guido Reni. In this passage Giustiniani separated himself from classicist critics, who saw only Caravaggio's dependence on the model; he was aware that Caravaggio had much in common with Annibale and that, far from simply copying nature, he had a complex relationship with the art of the past and united an extraordinary immediacy of vision with gestures and compositions rooted in the eloquence of ancient and Renaissance art. His most famous Caravaggios, *The Lute Player* and the *Victorious Cupid*, are refined works, commissioned by a cultured connoisseur who delighted in all the arts.

Vincenzo may well have discussed the iconography of the *Cupid* with Caravaggio, but the picture, with its provocative sense of triumph, undoubtedly had a strong personal meaning for the artist. It retains, and very powerfully, a sense of the studio and of the model. The musical instruments are still-life accessories (both lute and violin lack strings), and it seems as though Caravaggio has been arranging, in a corner of his studio, an elaborate still life, and that this has been suddenly disrupted by the flaunting behaviour of the model, who has so strong, so intense, a presence. In its mocking mood it forcefully suggests that of Ovid's *Amores*, when Cupid (*saeve puer*) grins and calmly puts an end to Ovid's epic aspirations;

> My epic was under construction — wars and armed
> violence
> in the grand manner, with metre matching theme.
> I had written the second hexameter when Cupid
> grinned
> and calmly removed one of its feet.

> 'You young savage,' I protested, 'poetry's none of your
> business
> We poets are committed to the Muses. (ll 1–6)
> . . .
> You've a large empire, my boy – too much power
> already.
> Why so eager for extra work?
> Or is the whole world yours – the glens of Helicon
> included?
> Can't Phoebus call his lyre his own these days? (ll
> 14–17)[51]

This smiling boy appears in other paintings, and replaced Minniti as Caravaggio's principal model; he is certainly St John the Baptist in the Capitoline *St John*, the angel in the Odelscalchi *Conversion of Saul*, and perhaps Isaac in the *Sacrifice of Isaac*, painted for Maffeo Barberini at around the same date. It has also been suggested, but less convincingly, that he is the angel in the first version of *St Matthew and the Angel*, and Christ in the *Supper at Emmaus*. He disappears from the paintings around 1604. Murtola also addressed a poem to Caravaggio's *Amore*, a lost picture of a sleeping Cupid –

> Should you wish to depict Love,
> skilled painter,
> you might paint that beautiful little Giulietto;
> both are pretty, both are fond.
> You might wish to portray him blind:
> look at him there,
> his tender little limbs,
> languid in sleep . . .[52]

This is one of a group of madrigals, a sequence addressed to a baby, Giulietto, sucking at his mother's breast. It neatly suggests how Caravaggio moved from something real and seen, and then created a story around it, and in the same way Caravaggio's *Cupid* began in the lif

of the studio, and moved into myth; he flattered a real boy by giving him the wings of Cupid, and the beauty of a Hellenistic sculpture, creating that ambiguous relationship between symbol and reality, art and life, so loved by the Marinisti.

In 1649–50 the English traveller Richard Symonds visited the Palazzo Giustiniani, and before the Victorious Cupid jotted down in his note-book:

> 'Cupido di Caravaggio / Card. di Savoya profe. / 2 milia duboli p[er] / il Cupido di Caravaggio /Costo 3 cento scudi. / Checco del Caravaggio tis /calld among the painters / twas his boy- / haire darke, two winges / rare, compasses lute / violin & armes & laurel / Monsr Crechy vuolle dare / 2 milia dubole / Twas the body & face / of his owne boy or servant / that laid with him.'[53]

But this passage, at first sight seeming evidence of Caravaggio's homo-sexuality, disintegrates on closer examination. Caravaggio did have servants or studio assistants, and Milesi, in 1606, addressed a poem to 'a young painter, pupil of Caravaggio'.[54] In 1605 a boy, Francesco, perhaps a studio assistant or simply a servant, lived with Caravaggio in his house in the Vicolo del Divino Amore. It is possible that he was a relative, from Caravaggio, and that Caravaggio used him as a model; Cecco may be short for Francesco. The model for the Cupid disappears from the paintings when Caravaggio moved from the house, and perhaps, if he was Francesco, he had had to seek other lodgings. Mancini writes of a painter, Cecco del Caravaggio, whom he describes as a follower of Caravaggio, but what we know of this artist's works does not suggest that he was in Caravaggio's studio when he was twelve. Nor is there anything to suggest that Caravaggio lay with his assistant. Like Longhi and Minniti, both undoubtedly heterosexual, he mixed with the Roman whores. Symonds' garbled jottings, far from settling the issue of Caravaggio's sexual orientation, have the feel of a colourful anecdote enjoyed by tourists – particularly English tourists, so convinced that

sodomy was a favourite Italian practice — and he also spun fantasies over the picture's fabulous value. Nor is it likely that Vincenzo, a pious and married man, and brother of an eminent Cardinal, would have flaunted a painting of so celebrated a painter's homosexual lover at the centre of papal Rome.

The Shock of Humility: the Imitation of Christ

'Humility is the cornerstone of the Christian virtues
. . . it is the inclination of the mind towards God'

AGOSTINO VALIER

IN THE YEARS 1600–1601 Caravaggio, now aged thirty, was at the height of his public success, and in the next few years he was to continue to paint public works, and to be very much in demand with private collectors. He painted fast, and there are a remarkable number of works from the years 1601–3.

Towards the end of 1601 he finished his *Crucifixion of St Peter* for the Cerasi chapel in Santa Maria del Popolo, and with this painting, in which the saint, old and heavy, is very much the poor fisherman from Bethsaida, and the executioners, their hands heavily veined and reddened, their feet dusty, are toiling workmen, he initiated a new phase of his art. In the next years he painted scenes from the Passion of Christ, and from the Apostolic age, which are meditations on the mysteries of the Christian faith, and convey the passionate contemporary concern with salvation; they explore the Christian ethos of humility, an ethos so deeply at odds with the code of honour that ruled the Roman streets. For the Protestants the Fall of Man was total and irredeemable, and it was through faith alone that humankind could be saved; but Catholics believed that man could re-create his ancient union with God through good works and the attainment of virtue, and through the sacramental church. The Christian should cherish the ardent ideal of imitating Christ, for in Him lay all the virtues, and at the Passion He had become the exemplar of 'Patience, and humility, and exalted charity,

and meekness, and obedience, and unshaken firmness of soul not only in suffering for justice sake, but also in meeting death'.[1] Through a meditation on the Passion the worshipper could participate in Christ's intensely human suffering. Preachers, wrote Gregory Martin, depicted this tragic drama so powerfully that 'the hardest hart melteth into dropping teares, and craveth mercie for his sinnes by the merites of that bitter passion.'[2] The thirteenth-century Franciscan treatise the *Meditations on the Life of Christ*, which dramatised every detail of Christ's life, enjoyed a new popularity, saturating the imagination of the devout individual. It recommended the worshipper to 'Heed all these things as though you were present, and watch Him attentively',[3] and it was written in a rough and familiar manner, for 'the rough sermon reaches the heart while the polished one feeds the ear'.[4] A plethora of treatises on meditation, throughout the sixteenth century, encouraged the development of techniques for making the Christian mysteries as tangible and visible as possible, so renewing the affective piety and richly imaginative spiritual life of the Middle Ages, and at their centre is the paradox of God made man. They encouraged empathy, and the creation of vivid interior images.[5] And the Christian painter, too, was implored to move the heart; his duty, wrote Cardinal Gabriele Paleotti in his *Discorso intorno alle immagini sacre e profane* (1582), was to imitate visible reality, to create figures that seemed real and tangible, and through this naturalistic and human art to move the viewer. The Passion and miracles of Christ had not been a major artistic subject in the early years of the century, but soon after 1550 Christ became dominant in painting.

At the centre of the Christian virtues was humility, and through ministering in humility to the poor and sick the Roman Church was united through the bonds of charity. To Luther poverty was the curse of God, and in Rome the vast numbers of beggars, making it difficult to walk in the streets, angered the people. But devout Catholics saw Christ himself in the suffering poor, and through an ardent charity aspired to perfect virtue; Camillo de Lellis, who laboured in the most derelict streets, commented: 'The sick and the poor reveal to us the face of God.'[6] And at the Jubilee the great Roman aristocrats, as Marcantonio Colonna had done at the Jubilee of 1575, abased themselves, as Christ had done before

Peter, to wash the feet of the pilgrims. The austere ideals of the poor Orders – the Barefoot Carmelites, founded in 1597, and the rigorous Capuchins, who revived a pure Franciscan ethos, with its emphasis on charity – radiated through Rome. Filippo Neri shocked and mortified a courtly world with insistent reminders of the religion of the streets; he strove to revive a pure sense of the poor in spirit, and a spirituality that should reunite the literate and sophisticated with the lowly and simple. In the early days of the Oratory, when its members had together read sacred texts, they had favoured the *Laudi* of the medieval Franciscan Jacopone da Todi, whose harsh and rugged poems convey emotion with a passionate simplicity. His *Pianto della Madonna* has the primitive voice which Filippo sought:

> Help! Lady full of woe
> For see, they strip Him now
> And on the Cross bestow,
> With nails, that Body blest . . .[7]

The stark, pared-down style of Baronio's *Annales* too sought to re-create an Apostolic simplicity, and Baronio himself recalled how, in the early days of the Oratory, its meetings had resembled those of the first apostles. The Oratorian emphasis on a low style, on the *sermo humilis*, on a Christian sublimity that rejects pagan subtleties and the blandishments of the fine style, perhaps contributed something to the harsh vernacular of Caravaggio. Around the ministry of the Orders there sprang up a vast charitable world, of confraternities, seeking eternal life through good works, and devoted to such acts as burying the dead and comforting those condemned to death, of caring for pilgrims, of administering hospitals, and institutions for converting and protecting women, and it was from this enlightened world of active charity that Caravaggio drew his patrons.

Earlier artists of the Catholic Reform, such as Scipione Pulzone, had painted religious pictures with humble figures, but they tend to be dull and timorous works, where the poor, devotionally idealised, are the clean and grateful recipients of charity. But in Caravaggio's art the poor are

included in a way strikingly new in art. The viewer is thrust relentlessly against the rough and soiled clothes of the executioners of St Peter, so close to the frontal plane: grave, insistently proletarian figures from the contemporary working world – the groom in *The Conversion of St Paul*, the innkeeper in the *Supper at Emmaus* – are set against the holy figures; a ragged Roman street boy, roughened by work, models for *St John the Baptist*; the first lines of the gospel appear from the massive labourer's hands of a doltish St Matthew. The Apostles are poor travellers, weather-beaten and old, with torn and rustic clothing. Their ordinary humanity is stressed by the simplicity of their expressions and gestures, and by the extreme surface realism with which Caravaggio renders worn and frail flesh; his feeling for old age itself, for wrinkled brows and heavily veined limbs, so distant from the springtime world of the Renaissance, suggests an ancient church.

In a sense Caravaggio, like Filippo Neri, is creating a shock of humility, pushing the world of the poor before an élite audience, and using a language that seems rough and vernacular, and available to everyone. Yet his figures are also grand and his massive, sculptural style conveys the power of a primitive, heroic era. Christ had come for the poor, for 'Hath not God chosen the poor of this world, rich in faith?' (James, 2: 5). Among high churchmen, and particularly among the Oratorians, the days of the early Church seemed vividly real, days when, it was believed, a poor fisherman had reigned, and the Apostles, simple and unlettered men, had shared their meals and worldly goods. Theirs was a vision nourished by the writings of the Fathers of the Church; Tertullian had written '*Deus semper pauperes justificavit, divites praedamnat*' and St John Chrysostom that Christ had come to subjugate human pride and arrogance, 'for this he made himself not only a man, but a poor man; for this he chose a poor mother and a most modest dwelling . . .'[8] To St Jerome was attributed the saying 'Follow naked the naked Christ'. The reformers sought to re-create this ancient purity and to renew the glorious days of the early Church. To make this past vividly present, and to re-enact, in the mind, the moving drama of Christ's suffering, was the aim of many meditative techniques; but Caravaggio creates an intensely personal vision of the early Church through figures and scenes from

the contemporary secular world. This too is a meditative technique –
for, as Lorenzo Scupoli's popular handbook to the devout life, the
Spiritual Conflict (1589) says, everything may be a reminder of Christ's life
and death: 'Poor inns may bring back to the mind the stable and the
manger of the Lord . . . When you hear the shouts and the cries of the
people, remember those abominable words: "Crucifige, crucifige" . . .
Every time the clock strikes . . . you may seem to hear those hard blows
with which He was nailed to the Cross.'[9] Caravaggio's was a new and
profoundly Catholic art which rejects the ideal beauty of Raphael
and Michelangelo, and whose brooding and tragic darkness conveys the
terror of broken humanity at man's alienation from God. His earth-
bound figures are travellers or pilgrims, mired in the prison of this
world, and unconsoled by any vision of Paradise. Only the light suggests
the soul, and the grace without which man cannot attain union with
God.

Painters were swift to follow his lead, and some great and distin-
guished collectors, too, were enthralled by the power of a new religious
art which broke with the dull conformity of such artists as Scipione
Pulzone and which regained the affective power of the art of the Middle
Ages. A small circle of patrons was anxious to acquire works by
Caravaggio. It included members of the old Roman aristocracy, such as
the Mattei and Massimi families, high churchmen, such as Cardinal
Benedetto Giustiniani, and also self-made men, lawyers and wealthy
bankers, who were anxious to play a prominent role in the affairs of the
Curia, and to display their wealth by the patronage of chapels in major
Roman churches.

Prominent amongst these in the years of 1601–2 was the Mattei
family, a Roman family of venerated antiquity, and for this contact
Caravaggio was again indebted to the tireless campaigning of Prospero
Orsi, his 'torchbearer', who was already in their service. In the summer
of 1601 Caravaggio left the Palazzo Madama, and took up residence in
the Palazzo Mattei, the splendid home of Cardinal Girolamo Mattei,
whose two brothers, Ciriaco (the elder), and Asdrubale, lived in an
adjacent *palazzo*. Here, on 14 June 1601, Caravaggio signed a contract with
the distinguished lawyer Laerzio Cherubini to paint, within a year, a

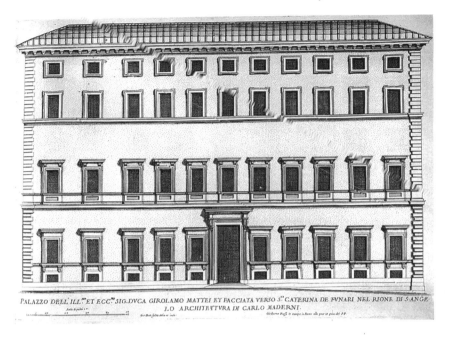

PALAZZO DELL.ILL.^{mo} ET ECC.^{mo} SIG.DVCA GIROLAMO MATTEI ET FACCIATA VERSO S.^{ta} CATERINA DE FVNARI NEL RIONE DI S.ANGE
LO ARCHITETTVRA DI CARLO MADERNI.

32. G. B. Falda, *The Palazzo Mattei*
(print)

Death of the Virgin for the Roman church of Santa Maria della Scala in
Trastevere. In the contract he states that he is living 'in the palace of the
illustrious and reverend lord cardinal Mattei'.[10] The Palazzo Mattei (now
Caetani) overlooks the Via delle Botteghe Oscure, in what is now a quiet,
even rundown, area of Rome. It is part of a vast block of adjacent
palaces, known as the Isola dei Mattei, in the Sant'Angelo district of
Rome. The Mattei had moved there from Trastevere, and in the first half
of the sixteenth century had amassed riches and power, presiding over a
court vaster than any save that of the Pope himself. The façade of the
Mattei palace, enriched by chiaroscuro frescoes by Taddeo Zuccaro,
looked out over the Piazza Mattei, at the centre of which is the elegant
Fountain of the Tortoises by Tommaso Landini. Close by were the small
churches of San Sebastiano, and Santa Caterina dei Funari, with
Annibale's much-admired St Margaret altarpiece.

Within the palace where Caravaggio stayed, the *salone*, and the private

chapel which opens from it, perfectly convey the spiritual atmosphere of these years. The *salone* is a grand room, with a sumptuously carved wooden ceiling, glittering with reds, blues and golds, and decorated with the Cardinal's arms, but the frescoed decoration is very far removed from the sensuous mythological decoration which graced so many Renaissance palaces. It had been decorated in 1599 by the fashionable landscape painter Paul Brill, whose frescoes show the peaceful charms of the world of nature, and unfold the landscape, with all its power to refresh the spirit, before the viewer. They show forest scenes, with horsemen and hunters (Ciriaco Mattei had hunted with Vincenzo Giustiniani); mountainous views, with monastic buildings or Roman ruins; estuaries and harbours, full of incident, where mill wheels turn, and donkeys and pedlars journey across bridges. And framing each scene, with easily recognisable attributes drawn from the *Iconologia* of Cesare Ripa, are female figures, well draped, personifying the Virtues, such as Charity, Prudence, Truth.

The Mattei were close friends with both the Giustiniani family and with Del Monte, and, while Cardinal Girolamo had only a modest interest in painting, Ciriaco and Asdrubale were avid collectors, aware of aesthetic debate, keen to practise the skills of the connoisseur, and, like Vincenzo Giustiniani, interested in young artists.[11] Asdrubale played an active role in the Roman art world, and in 1598 his name headed the list of gentlemen amateurs under whose protection Federico Zuccaro placed the Accademia di San Luca. Both Asdrubale and Ciriaco were celebrated as collectors of ancient art, and Ciriaco was an enthusiastic collector of the most advanced contemporary painters, and was always on the lookout for new talent. They were on close terms with Roman artists, and both were attracted by the naturalism of Caravaggio, and by fashionable northern artists, while at the same time appreciating the classical art of the Bolognese. These men were connoisseurs who doubtless enjoyed discussing the finer points of painting with such an expert as Vincenzo Giustiniani.

In the same circle was the noble Roman Massimo Massimi, who commissioned from Caravaggio a *Crowning with Thorns* (probably the picture now at Prato) and an *Ecce Homo*. Massimo Massimi was the

richest and most famous member of his illustrious family, who lived in the celebrated Palazzo Massimo alle Colonne, made splendid by the remarkable pagan decoration of Perin del Vaga, and the centre of his family's activity, He, too, was a virtùoso, who played an active part in the new decoration of the Palazzo, and he may have frequented the Accademia dei Crescenzi, since he was in close contact with Cristofero Roncalli.

Caravaggio stayed in the Palazzo Mattei during 1601 and probably until 1602–3 but he was still in the service of Del Monte; in October he was arrested in the Piazza Navona for bearing arms, and when challenged, although he had no licence, he claimed this privilege." It is possible that Del Monte had initially lent him to the Mattei for only a few months, and perhaps he moved between the two households.

Caravaggio was now in an enviable position. He had access to splendid Roman collections, of Del Monte, the Giustiniani brothers, Ciriaco Mattei: Prospero Orsi was a tireless agent, and Vincenzo Giustiniani was equally effective, and played a key role in the contract for *The Death of the Virgin* (as perhaps he had in the Cerasi chapel), securing an unusually high price for Caravaggio. Laerzio Cherubini, the patron of this work, lived in the region of Sant' Eustachio, where the Giustiniani and Crescenzi lived, and in 1603 he bought another house, near Del Monte's Palazzo Madama.

Caravaggio had a close relationship with his patrons; he aroused intense loyalty, and the rich and powerful never failed to offer money and protection in times of distress, and to step in when he ran into difficulties with some of his bolder projects. Asdrubale was to remain faithful to his art long after his death, and to create an extraordinary gallery of Caravaggesque paintings.

The immense privileges that Caravaggio enjoyed, cherished by such wealthy and powerful protectors, enraged his rivals, and many years later Malvasia's account suggests their malice and envy: 'This authoritative support (of a Marchese Giustiniani, a Ciriaco Mattei, but above all others of Cardinal Del Monte) brought such immense fame to his works, that . . . where at first they had gone begging at the public exhibitions, now there was no gallery, no museum, that did not acquire a piece, through his henchman Prosperino . . .'[13]

During his stay in the Palazzo Mattei Caravaggio, perhaps while completing the Cerasi chapel canvases late in 1601, painted an outstanding group of gallery paintings, assertions, for discerning connoisseurs, of the marvellous power of his new naturalistic art. They were assured and confident works by an artist at the height of his fame, lacking the stiffness of some of his earlier figure paintings and without the brooding melancholy of later works. The first was the *Supper at Emmaus* (Col. Plate 22), for which Ciriaco paid 150 scudi on 7 January 1602, and which was presumably painted in 1601. There followed two payments, in June and December 1602, probably for the Capitoline *St John the Baptist*, a picture of his name saint which Ciriaco commissioned as a gift to his son, Giovanni Battista, and which shows the same model, and flaunts a similar provocative naturalism, as Giustiniani's *Victorious Cupid*. Finally, Ciriaco paid 125 scudi for *The Taking of Christ* in January 1603. Asdrubale was less fortunate, but by 1603 he owned a now untraced painting of St Sebastian,[14] which he does not seem to have kept for very long, as it is not mentioned in his inventories after this year. At this time, too, probably late in 1602, he almost certainly painted the *Doubting Thomas*. These were high prices (in 1602 the Trinità dei Pellegrini offered him only 40 scudi for an altarpiece), and Baglione, who believed that Ciriaco had been duped by Prospero Orsi, spitefully remarked, 'Thus Caravaggio pocketed many hundred scudi from this gentleman.'[15] They were prices almost certainly out of the reach of Del Monte, who bought no works in these years.

The story of the supper at Emmaus is told in the Gospel of St Luke (24: 13–32), which tells how the disciples could not believe the women who told them that Christ had risen from the dead: 'And their words seemed to them as idle tales, and they believed them not' (Luke 24: 11). Then two of the disciples, Cleophas and an unnamed companion, set off, downcast and dejected, to journey to Emmaus, and as they travelled Jesus, unrecognised, drew near, and went with them. As they ate, 'he took bread, and blessed it, and brake, and gave to them. And their eyes were opened, and they knew him; and he vanished out of their sight (Luke 24: 30–31).

This is a story of muted despair, and slow recognition. But Caravaggio's rendering is explosive, full of movement and dramatic

effects of light. The disciples recognise Christ's gesture, and it is the sacramental gesture of blessing the host that Caravaggio shows. Cleophas thrusts back his chair, while the other flings out his arms, reaching towards the spectator. The tight perspective, the chair cut off by the frame, very close to the viewer, and the foreshortened gesture that explodes through the picture plane, seem to destroy the barriers between the world of art and the world of the viewer, and draw him into the drama. At the same time the picture interweaves different kinds of reality. Our sense that Christ is a vision is heightened by the brilliant light upon his face, and his face itself, youthful, sensual, beardless, and framed by flowing hair, contrasts sharply with the earthy humanity of the disciples, with their heavy fishermen's hands, and torn working dress. Both are distinguished from the stocky innkeeper, standing in dark shadow, his hands, in a brilliant gesture of blunt incomprehension, thrust in his belt, and his head covered in the presence of the divine. He is a contemporary figure, from the ordinary, working world, and the moment seems conjured up by his imagination. As we observe this scene set in a Roman tavern, with its rough wooden chair and majolica jug, Caravaggio subtly suggests a world in which the acts of every day are steeped in echoes of biblical reality. The innkeeper's shadow becomes a dark halo behind Christ's head, and the fruit bowl casts a shadow against the cloth which suggests that much-loved early Christian symbol, the fish. The great gesture of the apostle, arms outstretched, is a poignant reminder of Christ on the cross, where the apostles last had seen him, and as he blesses the bread and wine, the disciples are reminded of the Eucharist. The body of Christ was present throughout the created world, and the richness of the fruits suggests the beauty of this world, through contemplation of which the mind ascends to God. Emmaus, the first communion, had a Eucharistic significance, and the Jesuit priest Richêome finished a meditation on the Eucharist with a prayer:

> Shall I admire thy infinit bounty, in making us
> this present of thy Body, a present that surpasseth
> the price of all things created, a present of thyne
> own selfe, of infinit valew . . . and therefore in

this holy Table, we haue a lively figure, and a
pledge of the future felicity, which shall be to liue
in heauen of thy selfe, and to enjoy the immortall
food of thy selfe . . . Do me, sweet Iesus, this
favour, thus to eate and receaue thee, and to see
my selfe alwayes drowned in the depth of thy
infinite charity.[16]

After the years of the great public commissions, the Contarelli and
Cerasi chapels, this picture, a collector's piece, has a *virtùoso* quality, a
sense of renewed delight in the skills on which Caravaggio's early fame
had rested. It is brightly coloured, exuberantly naturalistic, the paint laid
on smoothly in flat areas of unmodulated colour, and lacks the tragic
darkness of recent works. In the home of a new and sophisticated
family of art patrons, Caravaggio set out to create a flamboyant
showcase of illusionistic skill. It is a throwback to his earlier works,
and to those Lombard and Venetian themes of the varied effects of light
on surface and texture, with which he had challenged the idealising
traditions of Rome. It also retains a strong sense of the studio, of the
artist selecting a majolica jug, a twist of startlingly white cloth, a fine
oriental rug, such as he might have seen in the collection of Del Monte
or Ottavio Costa.

Bellori complained that the fruits that Caravaggio showed were not
in season at Easter time (they are autumnal fruits, ripe when the picture
was painted) and he perhaps sensed, in this extraordinary bowl, which
perches so precariously on the table edge, and which seems so lush and
decorative in this grave context, Caravaggio's insistent claim for attention.
The fruit seems like an insertion, a quotation from another painting; it
links the painting to his earlier *Basket of Fruit* (Col. Plate 12) and to the
Uffizi *Bacchus* (Col. Plate 10), with the force of a trademark, a reminder
of the presence of the Lombard artist who had said so provocatively to
Vincenzo Giustiniani that there is as much crafstmanship in a good
painting of flowers as in the human figure. Prominent, and distracting,
the still life seems laid out to entice the spectator, to encourage him to
reach forward, and push the bowl back on the table, where it will reveal

itself as a display of astonishing skill, a *meraviglia* such as Marino would have admired, a work of art that rivals or surpasses nature herself.

The Taking of Christ (Col. Plate 24), which probably hung with this work, is a more sombre, tragic vision, and the two pictures would have presented a dramatic contrast, setting deep space against a crowded frieze of figures that press against the frontal plane. The story of Christ's betrayal is told in both John and Mark. John tells how men and officers went to seek Christ with 'lanterns and torches and weapons' (John 18: 3) and Mark that Judas revealed him with a kiss – 'Whomsoever I shall kiss, that same is he; take him, and lead him away safely. And as soon as he was come, he goeth straightway to him, and saith, Master, master; and kissed him. And they laid their hands on him, and took him' (Mark 14: 44–46). Mark adds a detail about a young man, draped only in a linen cloth, whom the soldiers tried to hold – 'And he left the linen cloth, and fled from them naked' (Mark 14: 52). Caravaggio has taken elements from both accounts, and has re-thought the biblical story in intensely human terms. Everything heightens the scene's dramatic intensity: Christ, aware that he has been betrayed, suffers with humility. In the brutal face of Judas, who has kissed him, there is a nascent horror. It was Christ's humilty on which devotional writers laid emphasis – in a moving passage, Luis de Granada wrote: 'Consider our saviour well, how he goeth in this dolefull waie, abandoned of his owne disciples; accompanied with his enemies . . . his colour changed . . . And yet in all this evil entreatinge of his person, beholde the modest behaviour of his countenance, the comelye gravitie of his eies, and that divine resemblance . . .'[17]

The picture is an elaborately orchestrated tableau vivant, in which every aspect of the composition is concentrated on creating the unprecedented immediacy and reality of the figures. Almost three-quarter-length, they are ingeniously arranged in a semicircle that suggests movement from left to right, while the subsidiary figures are seen in profile, thus focusing attention on Christ and Judas. Christ's hands, so poignantly interlaced, are at the apex of a huge inverted triangle that is woven into, and gives variety to, this semicircular movement. The close viewing point creates an overwhelming sense of physical presence, and

involves the spectator in the drama; the gleaming highlight on the soldier's armour seems to burst through the picture plane, so that we become involved in his guilt. The main source of light is not the lantern, but an unseen source of light high on the left, and the dramatic chiaroscuro both enhances the three-dimensionality of the figures and accents the drama, creating an abstract pattern that draws the composition together. The picture glows with brilliant colour, and is rich in passages that proclaim the artist's naturalistic skills – the decorated helmet of the foreground soldier, the delicate wire by which the lantern is carried.

Much of Caravaggio's power lies in his union of naturalism with idealism, and perhaps Ciriaco appreciated this, as did Vincenzo Giustiniani, when he classed Caravaggio amongst those painters who paint from memory and from nature. Thus he blends heavy and ponderous figures, taken from life, with those which have the authority of tradition. The old, bearded soldier reappears from the *Supper at Emmaus*, while the fleeing figure on the left, whose billowing cloak frames the heads of Judas and Christ, was based on a classical Maenad, such as Caravaggio may have seen in the Mattei collection. His anguished cry, so redolent of ancient art, was a favourite motif, which Caravaggio had earlier used in his *Martyrdom of St Matthew*, and through it he adds a sense of the sounds of terror to the jostling drama of his picture. This figure may be intended as the young man who left his cloak in the soldier's hands, although Bellori believed that he was John the Evangelist, as his red and green drapery suggests. The three heads at the left seem part of one figure and, Janus-like, draw together past and future. As Judas approaches, St John, whom Christ so loved, flees, and his grief anticipates the Crucifixion.

At the right of the painting appears the shadowy figure of the artist himself, holding the lantern. Caravaggio had already painted himself, looking over his shoulder at the violence he had created, in the *Martyrdom of St Matthew*. Here again he includes himself as witness, present, as he had indeed often been present, at the sudden flaring up of violence and panic in the dark streets. His presence heightens the picture's reality and drama, and suggests the influence of sixteenth-century meditative techniques, which encourage the participant to visualise the

Passion of Christ, with an emphasis on what it was like to be there and then, to suffer with Christ; as Antonio de Molina wrote: 'Thus when we see our Saviour taken prisoner, and used so ill . . . we must consider that we be there present amongst those villaines and that our sinnes be they who so abuse him . . .'[18] At the same time it exalts the power of naturalistic art. The composition is derived from a print by Dürer, but in Dürer's print – and this was a traditional motif -- the lantern lies in the foreground, dropped in the confusion. Caravaggio, however, holds the lantern, emphasising that he, the painter, has brought light to the scene. The light from the lantern falls most brightly on the painter's hand and eye, and the position of Caravaggio's hand, at the painter's angle, as though holding a brush, emphasises this point. This is the divine hand of the artist which brings light to nature, and the painting is a celebration of an art rooted in nature. It is a polemical work, a defence of hand and eye, a response to the idealising doctrines of Federico Zuccaro, and one which Caravaggio was to make less subtly in the trial of 1603. His holding of the light was an evangelical call to younger artists, a revelation of the true path to follow, a symbol of the rebirth of painting.

In the Palazzo Mattei, too, Caravaggio almost certainly painted the *Doubting Thomas* (Col. Plate 23), a picture perhaps ordered by Cardinal Benedetto Giustiniani, or given to him by Ciriaco Mattei.[19] Caravaggio had almost certainly painted a portrait of the Cardinal (untraced) in 1602, and it was probably in these years that Benedetto Giustiniani built up a remarkable group of works by Caravaggio, among them *Christ on the Mount of Olives* (Plate 33), a *Crowning with Thorns*, now in Vienna, and paintings of *St Jerome*, *St Augustine* and *Mary Magdalene* (untraced). The *DoubtingThomas* became a treasured possession, and later Benedetto took it with him to Bologna. After the crucifixion, Jesus appeared to the doubter, Thomas, saying to him, 'Reach hither thy hand, and thrust it into my side; and be not faithless, but believing' (John 20: 27). Caravaggio creates a tautly constructed semicircular arch of figures, with the four heads patterned in a diamond around the central axis, and the light falling on Thomas's wrinkled brow. Christ guides Thomas's hand to the wound in his side, which he explores with a shocking intensity. It stresses the humanity of Christ, and reawakens a medieval sense of

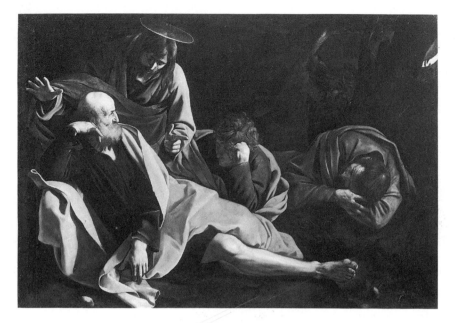

33. Caravaggio, *Christ on the Mount of Olives*
(destroyed; formerly Berlin, Kaiser-Friedrich Museum)

encountering divinity through His wounds. It suggests the prayer of the
Anima Christi:

> Soul of Christ, sanctify me.
> Body of Christ, save me.
> Water from the side of Christ, wash me.
> Hide me within your wounds . . .

The disciples are travellers, old and bewildered, earthbound in the dark-
ness of this world, but gradually touched by the redeeming light of
Christ. The shocking realism of Thomas's probing hand heightens the
mystery of a man-God who alone could conquer death, and no painting
more movingly conveys the era's renewed sacramental confidence, and
passionate belief in the Real Presence of Christ, 'true God and man', in
the Sacrament of the Eucharist. For the Catholics it was a story that
refuted Protestant heresy, and suggested the certainty of resurrection,

and faith in the life to come. Less showy than the Mattei pictures, and painted for a cardinal who liked night scenes and appreciated harsh naturalism, the picture has a Borromean humility and sober intensity, conveying the kind of stark vision, unrelieved by distracting ornament, which Borromeo had himself demanded from painters. At almost the same date Caravaggio was painting the *Victorious Cupid* for his brother Vincenzo, and the collections of the Cardinal and the connoiseur Vincenzo contrasted sharply.

His relationship with the Mattei did not prevent his working for other patrons, and throughout 1602 the troubled history of the Contarelli chapel in San Luigi dei Francesi continued. The Flemish sculptor Jacques Cobaert struggled with his statue of *St Matthew and the Angel*, and was paid for the St Matthew alone in 1600; Baglione tells us that 'He spent his life on it, never letting anyone see it, and not knowing how to carve the hands since he had no experience in sculpting marble, but would not get advice or help of any kind. He worked on it until he was almost eighty, and when old could not finish it.'[20] In January the St Matthew, still lacking an angel, was installed on the altar, but disaster followed. It was a dull work, and the long wait had been in vain. Baglione, somewhat maliciously, wrote: 'The Contarelli, when they saw it, expecting something divine, or miraculous, and finding something dry, did not want it in their chapel; in exchange they commissioned a St Matthew from Michelangelo da Caravaggio.'[21]

Above all the statue disappointed Francesco Contarelli, the illegiti-mate son of Cardinal Matteo Contarelli, who had been brought up by the Crescenzi, and made Rector of the congregation in 1602.[22] Only eight days after the rejection of the sculpture, on 7 February 1602, Giacomo Crescenzi, on behalf of Contarelli and the priests of the church, signed a contract with Caravaggio for a painted altarpiece. It was to show St Matthew in the act of writing the Gospel, with an angel on his right-hand side, and both figures were to be full-length. Caravaggio's deadline was Pentecost, 23 May 1602, his fee 150 scudi, and, if he did not fulfil this contract, the Crescenzi were free to find another painter. Yet the problems of the chapel were by no means over. Caravaggio painted a *St Matthew and the Angel*, sticking very closely to the demands of the

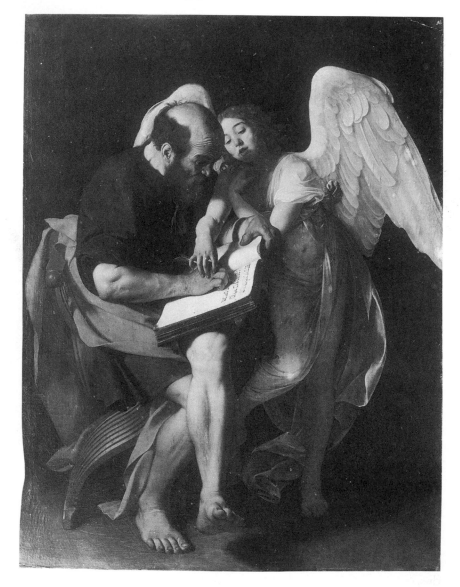

34. Caravaggio, *St Matthew and the Angel*
(destroyed; formerly Berlin, Kaiser-Friedrich Museum)

contract, but this too was rejected, and within a very short space of time he replaced it with a second version, which remains in the church. He may well have kept the original deadline for the first version, for he

was paid for the second *St Matthew* on 22 September 1602, and in the succeeding months the carpenter Gregorio Cervini received various payments for frames.

Caravaggio's first *St Matthew* (Plate 34) showed an old man, bearded and bald, dressed in a simple tunic, and seated in a Savonarola chair. He is a plebeian figure, with a tough, weather-beaten appearance, and his sturdy legs are thrust towards the spectator, his foot apparently bursting through the picture plane (just above where the priest would have held the elevated Host). He holds a heavy book on his knees, and leans forward, to look with amazement at the Hebrew characters that appear with such startling precision on the page before him. These form the first verse of Matthew's Gospel, describing Christ's descent from Abraham; they read: 'The book of the generation of Jesus Christ, the son of David, the son of Abraham, Abraham begat . . .' Matthew's was the first of the Gospels, and it was believed that, inspired by God, Matthew had written it in Hebrew, in his own hand.

Caravaggio portrays Matthew as simple and unlettered. His pose is uncomfortable, and he grasps the book as one unaccustomed, his heavy, workman's hand resting on the page; his wrinkled brow and bulging eyes convey astonishment. The angel touches his hand, and seems to breathe across the page, his wing framing the saint's head, as the words appear miraculously, with little help from the quill pen (there is no ink-well). The crosss-legged pose and chair had been traditional in Renaissance evangelist portraiture; but Caravaggio rethought the story's meaning, and tried to unite an old and revered tradition with a bold novelty. His humble Matthew recalls the Apostles as they were described by St John Chrysostom, who emphasised their proletarian qualities – '. . . it was a divine power that pervaded all, and made [the Gospels] to prosper with all men. For if it had not been so, how could the publican, and the fisherman, and the unlearned, have attained to such philosophy?'[24] Caravaggio thrusts the coarse and very physical presence of St Matthew in the face of the spectator, and his startling image perhaps recalls Filippo Neri's shock tactics, his desire to humble a polished élite, to push the religion of the poor before them, and to value rough and vernacular modes of expression.

Caravaggio's picture was apparently, however, rejected. Baglione, who in these years was growing increasingly hostile to the artist, said that the painting pleased nobody, and later Bellori elaborated this incident. 'After he had finished the central picture of St Matthew and installed it on the altar,' he wrote, 'the priests took it down, saying that the figure with its legs crossed and its feet rudely exposed to the public had neither the decorum nor the appearance of a saint.'[25] One factor may have been that this burly St Matthew is a completely different figure type from the elegant tax collector of the *Calling*, and this is corrected in the second version. But most likely Bellori's explanation was right, for although Caravaggio's composition is based on a print by Raphael, his lowly St Matthew must have had a shocking strangeness, an ironic inversion of values, unacceptable to the conventions of public art. The group, intended to replace a sculpture, is massively plastic, and its power perhaps seemed threatening. The plebeian hero is brought uncomfortably close to the spectator, challenging hierarchical views of sanctity, and too radical for a clergy possessing a French admiration for the intellect. The second version of *St Matthew* (Col. Plate 25) supports this interpretation. It moves away from the description in the contract, and shows the angel, with no erotic undertow, above the saint, who has hastened to his desk to write down his words. He remains an austere figure, with bare chest and feet, but, transformed into an intellectual, has attained a greater dignity, with halo and toga-like cloak. The stool seems about to tumble into the viewer's space, but compared with the way in which he had thrust the bare feet of the earlier St Matthew outwards, this seems a gimmicky device, and the picture is less sculptural, displaying a greater emphasis on surface pattern, and exploiting to the full the tall format. St Matthew is now reconcilable with the saint as he appears in the lateral paintings, and the picture provides a far less startling focal point to the entire chapel.

Caravaggio, Bellori tells us, was in despair after the rejection of his altarpiece, but Vincenzo Giustiniani, so closely involved in furthering Caravaggio's career over these years, stepped in and bought the painting for his gallery. Meanwhile on 25 June 1602 the Archconfraternity of Santa Trinità dei Pellegrini, so closely associated with the spirituality of Filippo Neri, approached Caravaggio to paint an altarpiece of the

Trinity, 'con qualche bel capriccio', for the modest sum of 40 scudi. The altarpiece was destined for a Mexican confraternity newly admitted to the Roman institution. It may well be that Caravaggio was suggested by Ciriaco Mattei, who, with other members of the Mattei family, participated in the assemblies of the Archconfraternity, Francesco Contarelli, too, was associated with them. In 1603, however, the commission was handed over to the Cavaliere d'Arpino. It is not clear what happened; it seems likely that Caravaggio did execute the painting, as a painting of the Trinity is recorded in the Borghese inventory of 1634, and later described in language that strikingly recalls the contract as 'a caprice of Caravaggio's through which he has wished to convey the Trinity'.[26] It is possible that this work, like the St Matthew, was rejected, or that the Archconfraternity lost its nerve when this happened, and moved to the safer artist, the Cavaliere d'Arpino. At his notorious trial in 1603 Caravaggio commented that the Cavaliere d'Arpino 'did not talk to him' and d'Arpino, resenting his former pupil's success, was becoming increasingly jealous.

IN THE FOLLOWING YEARS Caravaggio was to be very much less in demand in the public arena, and these rejections marked a turning point. But in the later part of 1602, he was busy with the altarpiece of *The Entombment of Christ* (Col. Plate 26) for the Oratorian church of Santa Maria in Vallicella which was to win universal admiration. This was a prestigious commission and in 1606, when Rubens won the contract for the high altar of this church, he wrote in some jubilation of the 'new church of the Priests of the Oratory, called Santa Maria in Vallicella — without doubt the most celebrated and frequented church in Rome today, situated right in the centre of the city, and to be adorned by the combined efforts of all the most able painters in Italy'.[27] The church, known as the Chiesa Nuova (new church), stood in one of the most flourishing areas of Rome, amid the great houses of the aristocracy, and at the heart of Rome's business centre. It had been enlarged towards the end of the century, and Caravaggio's altarpiece was intended for a new chapel, replacing a chapel in the earlier church, and originally under the

patronage of Pietro Vittrici. Pietro died in 1600, and it was his nephew and heir, Gerolamo, who commissioned the work from Caravaggio.[28] Pietro may, however, have interested Girolamo in Caravaggio, for he was almost certainly the first owner of the Paris *Gypsy Fortune Teller*, which passed to Gerolamo and then to his son Alessandro Vittrice.[29] Pietro moved in the same circles as other early supporters and patrons. He had been Gregory XIII's Master of the Wardrobe, and much loved by that austere Pope; he had also been a close follower of Filippo Neri, and instrumental in introducing Neri to the papal court. The few hints that we have as to his personality suggest that he aspired to the simplicity and humility that characterised the early stages of the Oratory's history; he spoke simply and clearly; and on one occasion he was miraculously saved from death by Filippo Neri himself. In 1584 he had made a pilgrimage with Fabrizio de' Massimi, whose family was also deeply involved with the Oratory.

It seems likely, too, that Pietro Vittrice shared the Oratorians' ideal of art, prizing works that were direct and simple, and touched the heart, just as their discourses were intended to do. Such ideals were articulated by Cardinal Baronio, who, as early as 1564, had written of a wooden figure of the crucified Christ, which he had commissioned, that it was suited 'to make those weep who contemplate it attentively' and recommended that a simple wooden cross of chestnut should be made for it, 'for the nearer it draws to nature, the more it arouses devotion'.[30] It is clear that the priests of the church shared his vision, and, although dependent on rich patrons to decorate the chapels, none the less played an active role in the choice of artists and in iconography, asking for preliminary drawings or *bozzetti*, and making refined aesthetic decisions. In the 1570s and 1580s the church had received altarpieces which, although stylistically disparate, do nevertheless share qualities of naturalism and tenderness. Durante Alberti's *Nativity* (*c.* 1580) shows humble, gentle figures, conveying a spiritual ideal of poverty that was later to characterise Caravaggio's Sicilian works. The chapel of the Pietà, for which Caravaggio's work was destined, was between the chapel of the Crucifixion, with an altarpiece by Scipione Pulzone, and a chapel with an altarpiece of the *Ascension* by Girolamo Muziano. Scipione Pulzone's

Crucifixion (1586), a harsh, realistic work, sharply lit, with a concentrated composition and dark background, won wide acclaim, and, an observer commented, it 'gave great satisfaction, and everyone, even painters, canonised it as the most beautiful in the church. Only Padre Agnolo [Velli] . . . said that a drop of blood, which fell on the face of the Crucifix, did not please him . . .'[31] Filippo himself had most deeply loved Federico Barocci's *Visitation* (1586), a work which shows the meeting of St Elizabeth and the pregnant Virgin in a domestic and tender context, laying emphasis on the human and everyday, on lovingly rendered passages of naturalistic still life, animals and birds, rather than on the miraculous. He is said to have been rapt for many hours before this painting.

Caravaggio's painting unites the direct appeal of popular art with the stability and grandeur of the most classic Roman traditions. It far surpasses these pietistic works, but none the less it shares with them an interest in naturalism and in strong emotion, and its ideals are entirely in harmony with the Oratorians. (It seems likely that an Oratorian scholar, perhaps Baronio himself, created the chapel's programmes). Its subject is the entombment of Christ, and the figures are standing within a sepulchre, lowering the body of Christ into a tomb, with, on the left, an opening that was originally much clearer (the stone slab is the door to the tomb).

The story of Christ's entombment is told in all the Gospels. A rich man, a disciple of Christ, called Joseph of Arimethea, is said to have begged the body of Jesus from Pilate and 'wrapped it in a clean linen cloth. And laid it in his own new tomb, which he had hewn out in the rock; and he rolled a great stone to the door of the sepulchre, and departed. And there was Mary Magdalene, and the other Mary, sitting over against the sepulchre' (Matthew 27: 59–61). Although the Virgin did not assist at the burial, Mark adds: 'And Mary Magdalene and Mary the mother of Jesus beheld where he was laid' (Mark 15: 47). John adds another character, Nicodemus, who anointed Jesus' body with spices. In Caravaggio's rendering of the scene he has brought together different moments in the biblical story. The unusual presence of St John, who more often lowers the body in paintings of the *Descent from the Cross*, recalls this earlier scene, and Bellori refers to the picture as the *Deposition*

of Christ. Bellori also describes the burly figure on the right as Nicodemus, which means that Joseph of Arimethea, the key actor, is omitted; Caravaggio was concerned above all to fill his painting with simple, humble figures. The three Marys, moved from onlookers to participants in the drama, anticipate the later discovery of the empty tomb by the Holy Women (Mark 16: 1–8). The chapel was dedicated to the Pietà, and the picture was intended to inspire meditation on the death of Christ.

The spectator before the altar would have looked up at the altarpiece, which was lit by a comparatively dim light from the right, identified with the painted light within the painting. The body of Christ is lowered towards him; the sharp edge of the stone juts forward, into his space; Nicodemus' highlit elbow breaks through the plane, and his gaze, and deeply shadowed eyes, draw the spectator into the drama, as does the great diagonal sweep of the composition, which leads upwards from Christ's trailing hand to Mary Cleophas' outflung arms, so subtly reminiscent of the Cross. Bellori commented on how 'Nicodemus holds [the body] under the knees; in lowering the hips the legs jut out'[32] and throughout there is an emphasis on physical reality, on the cruel reopening of Christ's wound in his side; on the awkwardness and difficulty of lowering the heavy body; on the muscles and veins in Nicodemus' legs and feet, brought so close to the very edge of the stone; and on the confusion of legs, arms and draperies in the lower part of the canvas. The grieving figures are grouped in pairs, young and old, and Caravaggio explores different responses to grief, setting the darkly shadowed face and passionate gesture of St John, who seems to embrace Christ's body, against the more stoical Nicodemus, and the inward-turned grief of Mary Magdalene, sensuous, with bare shoulders, against the ageing Virgin, in heavy nun's garb, whose wide-flung arms brings stability to the group, and seem to recall the universally protective gesture of the Madonna della Misericordia. It may be that Caravaggio added St John, the disciple whom Christ so loved, to heighten the emotional impact, and to create continuity with Scipione Pulzone's *Crucifixion* chapel, where a strikingly similar St John stands at the foot of the Cross. The picture has a static, iconic quality. It inspires passion, and invites the

viewer to empathise with each of the holy figures, appealing to the emotions with the directness of Luis de Granada's evocation of grief at the death of Christ: 'Al those that were present, wept with [the Virgin]. Those holie matrones wept. Those noble gentlemen wept. Heaven and earth wept, and al creatures accompanied the teares of the virgin. The holie Evangelist also wept, and embracing the body of his maister said: O my good lord and maister, who shal be my teacher from this time forwards? . . . Likewise that holie sinner Marie Magdalene wept . . .'[33]

The picture is very large (the body of Christ is over seven feet long) and monumental, and Caravaggio unites his Lombard realism with the grandeur of Rome. The stupendous physical power of the figures has a strikingly sculptural character, and is reminiscent of the veristic groups of terracotta sculptures that Caravaggio would have seen in the Sacri Monti of Lombardy, but underlying this realism is the eloquence of ancient and Renaissance art. The composition has echoes of Greco-Roman reliefs showing a hero carried from the battlefield, and of famous compositions by Raphael and Titian. But he rejects ideal beauty, and, in the true spirit of the Catholic Reformation, shows the pain of Christ's suffering. And Caravaggio brings the biblical world of the poor and humble – the worn Madonna, the burly Nicodemus, with his coarse tunic, and weathered face – into the contemporary world. They attain a tragic grandeur, and movingly suggest that Christ, both now and in the past, brought a message of hope and salvation to the poor in spirit. The suffering of the holy figures heightens their humanity, deepening the mystery of God-made man. As the priest at the altar raised the consecrated host to the worshippers, the body of Christ represented the reality which the Mass symbolised. The painting's tightly woven composition, its poise and careful balancing of expression and gesture, create the sense of community which the Mass itself conveyed, and it would have deepened the worshipper's sense of mystery. With this union of real and ideal Caravaggio creates a new and popular Catholic art, direct and yet retaining a classical emotional power.

In the stucco decoration over the chapel's archway is a representation of the Holy Shroud of Turin, a celebrated relic which had been moved from France to Turin in 1578.[34] It is a long, narrow cloth, which bears on

the front and back the coloured and realistic imprint of a crucified body, and was believed to have been the winding sheet in which Christ's body had been wrapped as it lay in the tomb. This shroud deepened the sense of mystery in Christ's burial and resurrection, and at the same time exalted the emotional power of naturalistic painting. In Turin Marino later wrote a discourse on painting, called 'Painting, or the Holy Shroud', and he plays on the theme of God as a naturalistic painter, and the power that the shroud has, like poetry, to move the emotions. Naturalistic painting, he writes, has the power to deceive the devil, to please God, and to ravish man's senses, and its greatest example is the shroud, which surpasses even the illusionism of Zeuxis' grapes. He imagines the Virgin, after her son's death, visiting the tomb, and finding there the shroud, and shedding tears upon it, for whoever sees it sees a damaged painting, coloured with blood, and varnished with tears.[35]

Caravaggio's altarpiece was, Baglione tells us, 'said to be his best',[36] but at the same time Caravaggio was busy with *The Death of the Virgin* (Col. Plate 27), a commission which was to end in bitter failure, for which he had signed the contract in the summer of 1601, just before the delivery of the lateral paintings for the Cerasi chapel. The patron was Laerzio Cherubini, who lived very close to San Luigi dei Francesi, and must have been impressed by the two remarkable histories of St Matthew, installed only six months earlier. He was doubtless encouraged by the Giustiniani brothers, friends and business associates, and close neighbours – their palace was just across the road. The contract demands that Caravaggio, then living at the Palazzo Mattei, should paint, for a newly constructed altar in the church of Santa Maria della Scala, an altarpiece showing the death or transit of the Virgin (*mortem sive transitum*). The work should be finished within the year, and Vincenzo Giustiniani was to be the picture's judge, and decide its monetary value.[37] Caravaggio was given an advance of 50 scudi.

Laerzio Cherubini, who came from Norcia, in Umbria, was a distinguished criminal lawyer, and legal historian, whose greatest claim to fame was the publication of a collection of papal bulls from Leo I to Sixtus V. He was a prominent figure in the Roman legal world, the holder of many offices, and in 1601 he was a Conservator of Rome. He was also a

successful businessman with extensive property in Rome and in the country. Newly rich and ambitious, Cherubini was also devout (four of his six sons became monks) and public-spirited; he was closely associated with Cardinal Benedetto Giustiniani, whose interest in social welfare he shared, and whom he appointed guardian of his children in his will of 1602.[38] He was also involved in the work of charitable organisations, such as the Archconfraternity of Santa Maria dell' Orazione e Morte (whose principal task was burying the dead), to which he left money, and of which he may have been a member. Self-made, professionally on the rise, connected with the most enlightened sections of the Catholic reform, Cherubini was characteristic of a new type of patron who was then seeking the honour of the decoration of an important chapel in a Roman church.

The church of Santa Maria della Scala stands in Trastevere a little set back from the road. This was Rome's poorest working-class area, an area of narrow streets and many churches, lacking the grand *palazzi* of other parts of Rome. The new church of Santa Maria della Scala had been begun in 1593, under the protection of Cardinal Tolomeo Gallio, to celebrate a miracle-working image of the Virgin, which was finally incorporated into the high altar. It was closely associated with the monastery of the Casa Pia, a charitable institution founded by Carlo Borromeo, and currently under the protection of Cardinals Benedetto Giustiniani and Tolomeo Gallio. The monastery ran a kind of battered-wives refuge, whose aim was the protection of women in danger of falling into prostitution and other social ills. It gave protection to *malmaritate* (ill married) women who had been abused or left in poverty by their husbands, although in 1599 the emphasis was changed, and the Casa Pia began instead to concentrate on the education of young unmarried women, hoping to make them fit for a role in society or in religious communities. In 1597 Laerzio Cherubini had been appointed one of three official custodians of the church, and in the same year Clement VIII ordered Gallio to allocate his newly constructed church to the order of the Discalced Carmelites. The ties with the Casa Pia remained strong until 1609. The Discalced Carmelites were a new order in Italy, granted independence by Clement VIII in 1597, and dedicated to veneration of the

Madonna and to charitable works. Cherubini played a leading role in the affairs of the church and was present at the ceremonies when the church was allocated to the Carmelite order; he was deeply involved in the activities of the Casa Pia, a member of the governing board of the institution, and in 1597 appointed supervisor of admissions to the monastery and house of the Casa Pia.

For this church and patron Caravaggio painted his *Death, or Dormition of the Virgin*. In the contract it is called 'death, or transit', and the word transit means passage, and suggests the Christian belief that death is not an end, but a passage from one state of being to another. After the death of the Virgin, it was believed, her soul, and then her body, ascended to heaven. Around her last days and death many picturesque legends had clustered, but in the later sixteenth century, with the new emphasis on historical accuracy, some of these legends had been stripped away. At the same time, in answer to the Protestant attacks on the cult of the Virgin, there was a new emphasis on her humanity, and on her sufferings as an earthly woman. Baronio himself declared that the Virgin had died a mortal death – 'The Catholic Church admits no doubt concerning the death of the mother of God, because it knows that she shared human nature; it affirms that she experienced equally the human necessity of death'.[39]

Despite the ecclesiastical passion for historical accuracy, however, Caravaggio drew on the old account given in *The Golden Legend*. This tells how, at the death of the Virgin, the Apostles, then scattered around the world, were miraculously transported to her deathbed in Jerusalem, where they officiated at her death and burial. In earlier Italian renderings Christ is shown miraculously appearing at the Virgin's deathbed or her bier, ready to convey her soul to Paradise, while northern artists show the dying Madonna lovingly tended in a comfortable domestic setting. But Caravaggio has rethought the story; he strips it of all its fanciful and picturesque anecdotes, and removes any hint of bourgeois northern warmth. Most strikingly, he excludes any reference to the divine; no flights of angels choir her to her rest; no upward-turned eye looks to a world beyond; no hint of divine succour lightens the atmosphere of heavy grief. Caravaggio shows the eleven disciples gathering around the Madonna's corpse. St Peter is at the feet of the Madonna, John at her

head, while the central Apostle, one hand raised, is St Paul. It seems that she has just died, and that Mary Magdalene (whose presence is highly unusual) has been washing the body, before wrapping it in the brown mantle flung across it. The Apostles have been allowed into the room, and the wake is about to begin. It may be that Caravaggio intended to show the moment after Christ, with a multitude of angels, has taken her soul to heaven. After the burial, the body too ascended to heaven.

Caravaggio shows the scene in a setting of bleak poverty, with cross-beamed ceiling, bare walls, and rough wooden chair, whose simplicity is relieved only by the vast red curtain looped over a beam. The Virgin herself, still young, with the startling pallor of death, and clad, as is the Magdalene, in the contemporary dress of a working woman from Trastevere, lies stiffly stretched out on a simple wooden cot. She has not yet been decorously arranged in death, and the immediacy touches the heart. The emphasis is throughout on human grief, inward-turned, restrained, yet compelling; there is a complex patterning of gesture and expression, of heavily veined hands suggesting revelation, melancholy brooding, or deep contemplation, and of the dark play of shadow on the face. The sheer weightiness of the Apostles, simple, rough figures, and heavily robed, contributes to the sense of a stifling and grief-filled interior. Above all the colour suggests passion, and the unconventional and daring red of the Virgin's dress is taken up in the vast red curtain, whose deep folds continue the flowing shapes of the brown mantle over the corpse, and suggest a soaring upward movement, filling the spectator with awe.

The painting is immediate and contemporary. The Magdalene, a model for female sinners and penitents, recalls those endangered women to whose cause the church of Santa Maria della Scala, and the associated Casa Pia, were devoted, while the working-class poverty, with its overtones of paupers' funerals, suggests the surrounding squalor of Trastevere. It is about the starkness and bleakness and utter finality of death. And yet it has a grandeur that lifts it out of contemporary life, that makes it a profoundly moving religious work. The painful humanity of the Virgin, whose hand on her swollen belly seems so movingly to recall the protective gesture of a pregnant woman, does not negate

redemption, but inspires a passionate contemplation on the mystery of the divine made human. She is the poor mother of Christ, of whom St John Chrysostom had written: 'He chose a poor mother, and a most modest dwelling, embracing from the very beginning and from his birth itself the extremes of poverty.'[40]

The Apostles themselves, toga-clad, from another era, their bare feet ancient symbols of holiness, carry with them the weight of the apostolic age, and their touching, sometimes childlike gestures, are drawn from classical art, and fill the painting with the resonance of ancient gestures of grief and mourning. The light seems to flood through an unseen window on the left, shining on the Virgin's body, above all on her face and head, so frailly encircled by the thinnest of haloes, and it is the extraordinary intensity of this light that creates a sense of divine mystery. The Virgin's dead body, above the altar where the Mass for the Dead was celebrated, had held the body of Christ, and reminds us of the Eucharist; the brown cloak across her belly is the scapular, a garment given by the Virgin to St Simon Stock, venerated by the Carmelites, and which promised mercy in the hour of death.[41]

But disaster followed. The Discalced fathers did not see a moving meditation on grief and death, but 'some dirty whore from the Ortaccio', shockingly displayed on their altar, with offensively bare feet and swollen belly. Yet worse, the picture showed a whore known to be the lover of Caravaggio.[42] They were shocked by the picture's lasciviousness, its lack of decorum, and its rendering of harsh poverty. They were uninterested and perhaps irritated by the immense interest it aroused in the art world, removed it from their altar, and hastened to commission a tame replacement from Carlo Saraceni. In 1606, when the picture was on the market, Mancini wrote to his brother reminding him of it, and telling him that it had been removed because it was 'lascivious and lacked decorum . . . it was well done, but without decorum or *invenzione* or cleanness . . .'[43]

The common humanity and poverty of Caravaggio's Virgin, and his unprecedented empathy with the sacred figures, albeit rooted in contemporary spirituality, must have shocked all artistic preconceptions. To the Carmelites the Virgin was the Queen of Heaven, and Federico

Borromeo, in his *De Pictura Sacra*, said that the Virgin should be shown with the greatest majesty while preserving decorum, and in painting her death the artist should carefully avoid apocryphal sources. Caravaggio had not only painted a whore, but his own lover, and Paleotti had earlier warned against the use of prostitutes for models in sacred paintings. It is not, however, clear when the painting was removed, or indeed when it was painted. It may well be that Caravaggio, a fast painter and good deadline keeper, kept his deadline, and finished the painting in 1602. It is possible, however, that pressure of work caused him to delay. and that the painting was delivered later, although this is unlikely to have been as late as 1606, when Caravaggio fled Rome, after which the picture was sold. Certainly Vincenzo Giustiniani, whom the contract appointed as the judge of its monetary worth, admired it, for the price was high, and when Cherubini later sold it he was anxious to recoup his purchase price of 280 scudi;[44] Mancini, too, deeply admired the painting, and tried to buy it when it appeared on the art market.

Rivals

'He stuns the world, and all its greatest men
Do pay him tribute, in this age of ours . . .'

<div align="right">MARZIO MILESI [1]</div>

THE CONTARELLI PAINTINGS enthralled all Rome. Never before had an artist presented religious drama as contemporary life, apparently taking place in the chapel before the viewer; nor had any earlier painter dared to break so dramatically with long-established studio traditions, painting his figures from nature, directly on to the canvas, with complex effects of studio lighting. It was the figures having been painted from life that most fascinated his contemporaries; Bellori, generally unsympathetic to Caravaggio, admired the power of his story-telling in *The Calling of St Matthew*, commenting that he painted 'several heads from life, among them the saint's, who, stopping to count the coins, with one hand on his chest turns toward the Lord'.[2] The miraculous ability of Christ to draw St Matthew to him is paralleled in Caravaggio's evangelical call to young painters, to follow him in a new art whose compelling power was a revelation. Older painters and mentors, whom Caravaggio had long known, such as Antiveduto Grammatica and Orazio Gentileschi, were drawn to his art. Artists from very different traditions, such as Giovanni Baglione, Tommaso Salini and Guido Reni, were early converts, while among young artists not yet established, such as Orazio Borgianni and Carlo Saraceni, were sown the seeds of a passionate partisanship. In 1602 Borgianni was living in the Via della Croce, while the Venetian Saraceni had come to Rome in 1598, perhaps in the entourage of Del Monte. Artists arriving in Rome from northern Europe, bringing with them new forms of naturalism, found the art world alive with passionate debate over the new style of Caravaggio. The melancholy and introverted German Adam Elsheimer arrived around 1600 and over the next few years painted tiny landscapes

on copper, of a magical intensity, with lyrical effects of light and dark. In the summer of 1601 Peter Paul Rubens, after a period at the Gonzaga court in Mantua, arrived in Rome with an introduction from Vincenzo Gonzaga to Del Monte's friend Cardinal Montalto; he stayed until the following spring, and later made a longer stay. Rubens studied the antiquities in the collection of Ciriaco Mattei, and may well have frequented the Del Monte household. He later wrote with nostalgia of the 'good conversation' he had enjoyed in Rome, with Elsheimer and other artists; he admired Caravaggio, and copied his works, drawing the seated youth with his back to the spectator in *The Calling of St Matthew.*

In 1601 Guido Reni arrived from Bologna, followed by Domenichino, who joined the Carracci studio, in 1602. Reni possessed a marvellous ease of manner and grace and painted, initially, works of refined simplicity and charm. But he, too, fell under Caravaggio's spell, collected his works, and modified his elegantly pre-Raphaelite style with a darker naturalism. From southern Lombardy came Bartolomeo Manfredi, to study with Roncalli, but later to become the closest of Caravaggio's followers. Distinguished collectors – such as Vincenzo Giustiniani and Ciriaco Mattei hastened to support the new art, their wealth and power deeply resented by less glittering artists; Malvasia later wrote spitefully: 'It was this influential support that gave Caravaggio's works so much renown . . . There was no gallery, no museum, that did not acquire a work by him . . .'[3] There is still, in Franceso Scanelli's *Il Microcosmo della Pittura* (1657), a sense of this excitement. *The Calling of St Matthew*, he writes, 'the first, and also the best' of his Roman works, '. . . is truly one of the most luminous, sculptural, and natural works, which serves to demonstrate the artifice of painting when it imitates mere reality'.[4]

It was a new situation, for no earlier artist, in an era dominated by vast studios, had created so individual a cause drawing to it such passionate partisans. But Caravaggio, having won sudden stardom, with a place in the world, responded badly. He became vain and proud, increasingly involved in street violence, and so famed for his belligerence that news of it circulated through Europe. In 1604 the Dutch artist Carel Van Mander published his *Lives of the Painters*, basing his information on letters written from Italy around 1600; Van Mander describes Caravaggio

as working for two weeks, and then sallying forth 'for two months together with his rapier at his side and his servant boy after him, going from one tennis court to another, always ready to argue or fight, so that he is impossible to get along with'.[5] Often his accomplice was Onorio Longhi, and Longhi's many brushes with the law confirm van Mander's account, even of the tennis courts, and yield a vivid picture of the sudden bursts of violence, of the volleys of vulgar abuse and taunts that provoked brawling and duelling among those whom Sandrart described as Caravaggio's 'young friends, mainly lusty fellows, painters and swords-men',[6] and which characterised Roman street life. (In 1598, after a period abroad, Longhi had returned to Rome, and in 1599 was already once more in trouble with the police.) Caravaggio attracted not only voluble and quarrelsome supporters, but also bitter rivals. He taunted more traditional artists with provocative and boastful remarks, but at the same time was jealous of his followers, and bitterly resented any artist who came too close to his style or who seemed to challenge his leadership. Other painters trod warily, and came to fear him.

The unveiling of the Contarelli pictures in the summer of 1600 split Rome into opposing artistic camps. Caravaggio, wrote van Mander, 'is one who thinks little of the works of other masters, but will not openly praise his own. His belief is that all art is nothing but a bagatelle or children's work, whatever it is and whoever it is done by, unless it is done after life, and that we can do no better than to follow Nature.'[7] To artists trained in a classical tradition this seemed a facile call to anarchy, a dangerously attractive liberation of young painters from the rigours of a long studio training in drawing and composition. To many critics Caravaggio's style spelled the death of history painting, for artists who worked in this way could not put two figures together, nor create narratives which held together past and future. Bellori, after a description of Caravaggio's cellar lighting, gave a lively account of the debates in the art world which his pictures stimulated – the painters in Rome, he wrote, particularly the young ones, were greatly taken by his lighting, and

> looked on his work as miracles . . . Without
> devoting themselves to study and instruction, each

one easily found in the piazza and in the street
their masters and the models for imitating nature.
With this easy style attracting the others, only the
older painters already set in their styles were
dismayed by this new study of nature: they never
stopped attacking Caravaggio and his style, saying
that he did not know how to come out of the cellar
and that, lacking *invenzione* and *disegno*, without
decorum or art, he painted all his figures with a
single source of light and on one plane without any
diminution; but such accusations did not stop the
flight of his fame . . .[8]

First to take up arms, an 'older painter already set in [his] style', and himself increasingly out of favour, was Federico Zuccaro, who attempted to stop the flight of Caravaggio's fame by a shrug and a dismissive comment. Baglione believed that Caravaggio's paintings, done after life, became famous because they were in a chapel already decorated by the revered Cavaliere d'Arpino, whose fame cast lustre on the younger, little-known artist. He saw their admirers as conspirators, plotting to destroy the great traditions of Roman figure painting, and he recalled Zuccaro's reaction: 'While I was there, he exclaimed: What is all the fuss about? and after having studied the entire work carefully, added: I do not see anything here other than the style of Giorgione . . . and, sneering, astonished by such commotion, he turned his back and left.'[9] It is not entirely clear what Zuccaro meant by the style of Giorgione; Giorgione, Vasari tells us, 'loved beautiful things and did not want to paint anything that he did not paint from life'[10] and probably Zuccaro saw Giorgione as epitomising the naturalism and colour of Venetian art, to which his own Roman concept of *disegno* as the foundation of all the arts and as something divinely inspired was opposed. Many Venetian paintings had arrived in Rome with members of the Pope's entourage on his return from Ferrara in 1598, and the new and modish enthusiasm for Venetian art must have irritated the increasingly unfashionable Zuccaro.

In the same camp as Zuccaro was his pupil, Marco Tullio, and in July

1600, a little after the installaton of the Contarelli pictures, in the Via della Scrofa, very close to the church of San Luigi dei Francesi, Tullio became the target of an attack by Caravaggio and Longhi, perhaps provoked by his association with Zuccaro.[11] Longhi gave a lively account of the incident to the magistrate. He and a group of friends had been walking along, idly muttering scurrilous insults, which a passer-by, accompanied by 'a certain painter', took as meant for himself, although, Longhi protested, he did not know him at all. Insults ('Let us fry the balls of such scum as you')[12] turned to fisticuffs and stone-throwing, until they were separated. The painter, added Longhi, was Marco Tullio, while he himself was accompanied by Caravaggio. But throughout Longhi loyally insisted that Caravaggio had not fought; Caravaggio, he claimed, had been seriously ill, almost too weak to walk; he had been reduced to having his sword carried by a boy, who had been with him during the incident; it was Longhi's opponent who unsheathed his sword and Caravaggio who separated them. Caravaggio had indeed been seriously ill, but it is possible, even likely, that Longhi was lying during this evidence. For in the following year, on 7 February 1601, Caravaggio made a judicial peace with Flavio Canonici, a former sergeant of the guards at the Castel Sant' Angelo. He, Longhi and Caravaggio had been involved in a brawl, and Caravaggio had wounded Canonici on the hand, leaving a scar. It may be that Flavio Canonici was Marco Tullio's companion in the fight that took place in July of the previous year, and that this was the brawl over which he later made peace.[13]

Longhi's desire to protect his friend is characteristic, and Caravaggio was rarely short of friends and protectors, anxious to guard him from the results of his 'excessively fearless nature', and of his thirst for adventure. More shameful attacks were to follow. In November Girolamo Spampa, a young pupil at the Accademia di San Luca, made a formal complaint to a notary that Caravaggio had attacked him as he came home, with the French painter Horace Le Blanc, from a late evening's dutiful study at the Accademia.[14] It was eight o'clock, and while he knocked at the door of the candlemaker for candles, he was suddenly attacked by Caravaggio, who rained cudgel blows upon his shoulders. Some butchers with lanterns approached, and at that point Caravaggio

drew his sword, tearing the heavy cloak with which Spampa attempted to parry the thrust, and which he produced as evidence. Caravaggio then fled, and at this point, Spampa, who had been attacked from behind, and in the dark, recognised his assailant. The cause of this attack is not clear, but it evokes the hazards of sinister Roman streets, whose atmosphere Caravaggio re-created in his *Martyrdom of St Matthew*, and his *Taking of Christ*. Caravaggio was socially on the rise, parading his servant, as Longhi did, through the Roman streets, but insecure, and responding to success with illness and violence.

In the spirited world of the Roman academies writers, too, became partisan, adherents to Caravaggio's cause. In verses written about 1600 or 1601 the Lombard Marzio Milesi threw out a deliberate challenge to Caravaggio's detractors. A verse which opens 'Ammirate l'altissimo Pittore' celebrates the artist in superlative terms, demanding homage to his genius, to a painter in whom has been reborn the fabled skills of the painters of antiquity. A longer poem, in blank verse, praised the Contarelli paintings themselves, and these verses are the first written descriptions of them. Here, in language which echoes Marino, Milesi reveals his wonder before the powerful illusionism of Caravaggio's work:

> Let others simulate, illume, outline:
> You bring us things that are alive, and real . . .[15]

and a touching desire that his own Muse, so pallid beside them, may be touched by their glory. At the end he suggests that Caravaggio towers above the hatred and envy of his detractors, and although a somewhat feeble and stumbling conclusion, it does seem that Milesi saw himself as a partisan, as defending Caravaggio against the fury that he aroused in the camp of Zuccaro and Baglione, more classicising and infinitely less gifted artists. Milesi later contributed a sonnet, 'Pittura', to the 1613 edition of Ripa's *Iconologia*, where he clarifies his Lombard standpoint. He defined painting as an imitation of reality, which, conveying human passion through colour, is an act of creation that rivals nature itself; it is the greatest of the arts, which both ravishes the eye and suggests the god-like power of the human intellect. His is a view opposed to that of the

Roman Zuccaro, who believed that the basis of art is *disegno*, and that the beauty of a work of art lay, not in its representation of the outside world, but in the *idea* in the artist's mind, which derived from the mind of God.[16]

To Baglione, Caravaggio's proselytisers were 'evil people', and he bitterly resented Prospero Orsi's advertising prowess.[17] But, ironically, Baglione was one of the first painters to dare to emulate Caravaggio, and Mancini describes how he followed 'for a time the manner of the Cavaliere Giuseppe . . . afterwards it seems that he turned to that of Caravaggio'.[18] He had, too, his own supporters, most prominent Tommaso Salini (nicknamed Mao), with a pudgy, dapper face, neat, perky hat, and small double chin. Salini, a pedestrian painter, was an unattractive character, and little liked. He was notorious for speaking ill of other artists; in 1601 he was sued by Adriano Monteleone for calumny,[19] and even Baglione wrote of his satirical and biting tongue. Antiveduto Grammatica detested him. His art limps along behind that of Caravaggio, and it may well have been to him that a flower painting by Caravaggio in the collection of Del Monte was wrongly attributed; Malvasia tells us that Caravaggio was shocked to see this false attribution, and gave proof of his hand by painting others, 'yet more beautiful'.[20] Baglione, however, showered praise on Salini as a flower painter, writing that he was 'the first who painted, and arranged flowers with leaves in vases, playing on this theme in varied and original ways'.[21] Baglione's claims are probably exaggerated, and suggest a desire to belittle Caravaggio, to whom such praise was due.

Baglione followed his first imitations of Caravaggio's style with a *Divine Love Overcoming the World, the Flesh and the Devil* (Plate 35), in which he attempted to surpass Caravaggio's already celebrated *Victorious Cupid* (Col. Plate 16), the picture that had thrown out such a provocative challenge to idealising artists.[22] With this work he also threw down the gauntlet to Orazio Gentileschi, who, at the art exhibition held annually in San Giovanni Fiorentini, on 29 August 1602, had exhibited a picture of *St Michael the Archangel* (untraced), and Baglione hung his work, in the spirit of rivalry, opposite this. All three artists were experimenting with the theme, which has its roots in ancient art and in the art of Michelangelo,

of full-length, conquering figures, astride their vanquished opponents, but Baglione's subject, Divine Love, threw out a specific challenge to Caravaggio's emphatically earthly love. Baglione dedicated the painting to Cardinal Benedetto Giustiniani, whose brother Vincenzo owned Caravaggio's work, which hung in their family palace, and the Cardinal rewarded him with the compliment, so coveted by all artists, of a gold chain.

The picture, however, which shows the somewhat stiff figure of Divine Love awkwardly encased in armour, subduing a languorous Cupid, was mocked by other painters, and did not, according to Gentileschi, 'please as much' as Caravaggio's. Gentileschi, moreover, told Baglione plainly that it had many imperfections, among them his depiction of 'a grown-up, armoured man, who should have been young and nude, and he therefore did another, which was entirely nude'.[23] In a second rendering of the theme (Plate 36) Baglione does not show a nude figure, but he has bared Divine Love's leg, and the figure stands astride a fallen Cupid, while behind him the devil has turned a macabre face towards the spectator. In his autobiography Baglione lists these two commissions as 'two Divine Loves done for Cardinal Giustiniani, which have Profane Love, the World, the Devil, and the Flesh beneath their feet'.[24] Baglione was proud of these paintings, and described them as studied from nature; but in fact his *Divine Love*, with its elaborate jewellery and drapery, is a pompous and chilly attempt at idealisation, a response to the earthiness of Caravaggio's *Victorious Cupid*; moreover, it seems to interrupt the dalliance between Cupid and the Devil, who seems to bear the features of Caravaggio himself.[25] His intense dislike of Caravaggio, and his desire to demonise him, had been further stimulated by the abuse heaped by his rivals on Baglione's most ambitious work of these years, a vast altarpiece (it measured 8 by 4½ metres) of the *Resurrection* for the Gesù, one of the most prominent of Roman churches. He had been awarded this coveted commission in 1602, and had presumably been working on it in this atmosphere of envy and rivalry, fired by the desire to wrest the leadership of Roman painting away from Caravaggio. The painting has vanished, but a *bozzetto*, or sketch, remains, and, although it suggests a visionary, bombastic work, far removed from Caravaggio's naturalism,

35. Giovanni Baglione, *Divine Love Overcoming the World, the Flesh and the Devil* (Staatliche Museen zu Berlin – Preußischer Kulturbesitz Gemäldegalerie)

36. Giovanni Baglione, *Divine Love Overcoming the World,*
the Flesh and the Devil
(Rome, Galleria Nazionale d'Arte Antica)

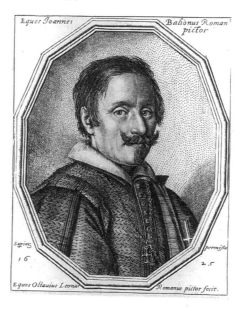

37. Ottavio Leoni, *Portrait of Giovanni Baglione* (print)

the lighting is stormy and dramatic, and the figures in the lower half, crowded and turbulent, suggest that perhaps Baglione was aping the drama of Caravaggio's *Martyrdom of St Matthew*. It is an unsuccessful work, although Baglione describes it as having been done 'with love and with learning',[26] and it is not clear why the General of the Jesuits, Claudio Acquaviva, awarded the commission to Baglione, though it may be that he appreciated the sense of spiritual chivalry Baglione had attempted in the *Divine Love*, which had been painted for a Jesuit cardinal. The picture was unveiled on Easter Sunday, 1603, and Roman painters flocked to see it, but to Baglione's rage it was greeted with scorn and contempt, above all by Caravaggio.

Shortly after the unveiling of the painting, scurrilous verses began to circulate around Rome. These attacked Baglione and his henchman and proselytiser, Tommaso Salini, in the most obscene and filthy language. The first poem runs:

Giovan Bagaglia, you are a know-nothing;
Your pictures are mere daubs. . . .
I'll warrant that you will not earn
So much as a brass farthing from them.
Not even enough cloth
To make yourself a pair of breeches,
So you'll have to go round with your arse in the air.
So take your drawings and cartoons
Round to Andrea Pizzicarolo [the grocer],
Or maybe wipe your bum with them,
Or stuff them up Mao's wife's cunt,
So that he can't fuck her any more with his great mule's
 prick.
I'm sorry I can't join in all this mindless praise,
But you are quite unworthy of the chain you're wearing
And a disgrace to painting.
Because, having seen the fathers,
You now appear to practise with the sons.

The award of a gold chain had infuriated Baglione's rivals, as had Salini's completely unquestioning and indiscriminate praise of his idol's achievements. The gold chain was a coveted symbol of status: it was a reward for intellectual achievement, that honoured painting itself; it brought lustre to the painter, for it was an attribute of honour, and suggested nobility and exalted rank. The great painters of the seventeenth century – Rubens, the elegant Anthony van Dyck, Rembrandt, with a variety of self-awarded decorations, parade before us bedecked with golden chains, and Federico Zuccaro, in a frescoed self-portrait in the Palazzo Zuccaro, toys idly with a golden chain as he looks down at the viewer. Baglione's attainment of such distinction was an intolerable provocation, and in the second poem scorn is heaped on him for his mediocrity as a painter. He is derided for his malevolent remarks about the works of other artists, and for his hypocrisy, for in his own house he kept works which it would be shame to exhibit.

The phrase prize prick might certainly describe
One who undertakes to find fault with another
Who could be his master for a hundred years,
With my words I am referring to painting,
Since this man [Baglione] claims to be called a painter,
Though he could never rank with that man
 [Caravaggio].
I am not mealy-mouthed,
Nor do I lavish undeserved praise,
As [he] does [upon] his idol . . .
Were I to undertake to discourse
About this man's exploits,
An entire month or two would not be enough.
Come hither, please, you who presume to find fault
With other men's paintings, and yet know that your
 own
Are still nailed up in your house
Because you are ashamed to show them in public.
Indeed I will abandon my undertaking
Because I feel that I have too great an abundance of
 subject matter,
Especially if I were to enter upon the chain,
The gift which he wears around his neck unworthily,
For I certainly think that — if I am not mistaken —
An iron one on his feet would be more fitting.[27]

Angered by these outrageous verses, and sure whose his attackers were, Baglione, supported by Salini (who had gone to considerable trouble to obtain written copies of both poems), brought a suit for libel against Onorio Longhi, Caravaggio, Orazio Gentileschi, whom he identified as the writers of the verses, adding, as an afterthought, the Roman painter Filippo Trisegni, who had supplied Salini with the copies. The evidence that followed suggests an acrimonious art world, where painters borrowed each other's props, envied each other's skills, lied, quarrelled and deceived one another, and where petty resentments could suddenly flare

into violence and real danger.[28] Above all they gossiped, and jockeyed for position, and the defamatory verses had spread rapidly through Rome, amusing and scandalising their audience. There is a sense of settling old scores, of Baglione and Salini pushed to the limits by repeated insults and blows; of Caravaggio, anxious to defend his position as leader of the naturalism, defensive of his style, disingenuously disarming and distracting the enemy by giving generous praise to the artists of the establishment, whose enmity would have been unwelcome, and who presented no competition.

In his deposition, made on 28 August 1603, Baglione says that Caravaggio and his friends had been motivated by envy over the commission for the *Resurrection* in the Gesù, and by their fear that Baglione's pictures were more highly esteemed than their own; he says that he 'had painted a picture of Our Lord's Resurrection for the Father General of the Society of Jesus. Since the unveiling of the said picture on Easter Sunday of this year, Onorio Longo, Michelangelo Merisi [Caravaggio], and Orazio Gentileschi, who had aspired to do it themselves – I mean Michelangelo . . . have been attacking my reputation by speaking evil of me and finding fault with my works.'[29] He then adds, tellingly, 'They have always been persecuting me . . . seeing that my works are held in higher esteem than theirs.' On the same day Salini, whom the first verse had so scurrilously mocked, added his supporting testimony,[30] describing how he had questioned Filippo Trisegni about what the world was saying about Baglione's *Resurrection*, and how he had extracted from him, over a period of months, copies of verses made against Baglione and against him 'for being his companion'. It was Trisegni himself, so Salini claims, who, presenting him with one copy 'with fine words' (a phrase which subtly suggests that Trisegni may have taken some sly pleasure in his friend's discomfiture), revealed the authorship of the poems. Trisegni said that one set of poems was made by Gentileschi and Ottavio Leoni, and the other by Caravaggio and Longhi, and he elaborated the story, adding that one set of verses had sped around Rome, distributed by a painter, Ludovico Bresciano, to many artists, among them Mario 'who lives in the Corso', while Trisegni had got his copies of Caravaggio's poem from a young boy, 'a *bardassa* of Onorio and Michelangelo, called

Giovanni Battista, who lived behind the Banchi'. (The word *bardassa* raises difficulties. It is of Persian origin, but where some authorities claim that it means catamite, others insist that it means simply a servant.) According to Salini, Caravaggio had been made anxious by the swift spread of scandal, because his servant, Bartolomeo, had distributed these and others, to anyone who wanted them. Accordingly he had warned Trisegni to be careful to keep the poems from falling into the hands of Baglione and Salini. At the end of his evidence he recognised the two poems presented as evidence.

After Baglione's deposition, nothing happened for a week or two, until, in early September, the accused people were arrested. On 11 September Filippo Trisegni was seized at his house, 'at dinnertime at home', and imprisoned, while Caravaggio was picked up in the Piazza Navona. On the following day Gentileschi was imprisoned, and from his house various poems and letters were removed, among them a playful letter to the monks of St Paul, for whom he was working on a commission, and various sonnets sent to him several years earlier by the engraver and painter Giovanni Maggi. Longhi was away, but sonnets, love poems and accounts were taken from his house.

The first to give evidence, on 12 September, was Trisegni. He confirmed that he had given copies of the two poems to Salini, but had refused emphatically to say who had written them, thus throwing Salini's testimony into considerable doubt. He described how he knew Salini well, and lived close to him on the Via della Croce. The two artists went to look at each other's paintings, and Trisegni had once or twice borrowed an iron helmet from his friend. On hearing another painter, Gregorio Rotolanti, recite the verses, he acquired copies of them, out of friendship for Salini. He showed them to Salini, but he refused to tell him who had written them, and described how he had provoked Salini with hints and prevarications. For Salini made many suggestions, putting forward the names of Caravaggio, Bartolomeo, Gentileschi, Ludovico Parmigianino, Francesco Scarpellino, to all of which Trisegni maddeningly answered. 'Perhaps.' He explained his irritating behaviour by saying that he was angry with Salini, because he was waiting for him to teach him how to do figures in cast shadows, and had offered to tell Salini who wrote the

poems when he received this guidance, but Salini never offered it. Trisegni then acquired, again from Rotolanti, a written copy of the second poem, beginning 'Giovan Baglione'; Rotolanti claimed that these were written by 'a youth studying logic or physical science, he was a *valent'huomo* and a friend of his'; adding that this versatile young man would gladly turn his hand to love poems should Trisegni so wish.[31] Trisegni identified the written copies of the poems, and added that Salini spoke ill of all painters except Baglione, so that an attack on Baglione was also an attack on him.

Gentileschi's testimony, on 12 September, was largely concerned with trying to establish his handwriting, from the material confiscated from his house; Gentileschi, on being asked whether he knew how to write, replied: 'I know how to write but not very correctly.'[32] On the following day, 13 September, two events took place. The magistrate brought Trisegni and Salini together, to confront them with their opposing testimonies, and Caravaggio himself gave evidence. Trisegni stuck to his guns, and firmly denied that he had ever told Salini who wrote the poems. He agreed that Salini had put forward several suggestions, but denied that he had confirmed them, and stressed that he did not want to involve Rotolanti, who had wished no one any ill. But Salini, too, confirmed his evidence, repeating, with particular emphasis, that Filippo had told him the name of the boy, their *bardassa*. (But oddly, at this point, Salini had forgotten this name.)

There followed the evidence of Caravaggio himself, who gave his profession as painter.[33] His evidence is confusing; he is rude, and contradicts himself; he protects his interests, trying to see where the advantage lies. But none the less, beneath the prevarications, and the shifting evidence of a court trial, a strong statement about his belief in painting does emerge. As the magistrate tried to establish his relationships with other Roman painters he parried the questions, adding asides, contradictions, attempting, deceitfully, to distance himself from Gentileschi. Naturally, he said, he knew all the painters working in Rome, and proceeded to list them, beginning with the *valent'huomini*, or good artists, almost all of whom, he claimed, were his friends. His list includes the Cavaliere d'Arpino, Carracci, Federico Zuccaro, Roncalli, Gentileschi, Prospero Orsi, Gio. Andrea, Baglione, Gismondo, Giorgio Todesco, and Antonio

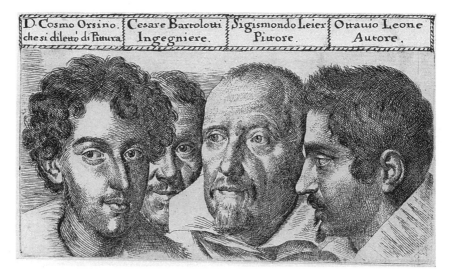

| D. Cosmo Orsino. | Cesare Bartolotti | Sigismondo Leier | Ottauio Leone |
| che si diletto' di Pittura | Ingegniere. | Pittore. | Autore. |

38. Ottavio Leoni, *Group Portrait of Artists,*
 including Sigismondo Laer and Ottavio Leoni
 (print)

Tempesta. He then says, puzzlingly, that all these painters are his friends, but not all are *valent'huomini*. He defined a *valent'huomo*: 'By the term *valent'huomo* I mean he knows how to do well, that is, he who knows how to do well by his craft. Thus in painting a *valent'huomo* is he who knows how to paint well and to imitate natural objects well.'[34] This is a provocatively brief, down-to-earth definition of a realist agenda with overtones of Lombard truisms that Caravaggio would have picked up years earlier in Peterzano's studio. But it also stresses technical ability, 'doing well', the skills of hand and eye, which, as Caravaggio had earlier said, were as important in painting a fine picture of flowers as in painting the human figure. He now adds that some of the artists mentioned earlier, d'Arpino, Baglione, Gentileschi and Giorgio Todesco, are not his friends – 'because they do not talk to me, all the others talk to me and converse with me'. And as he brooded on the question of what made a *valent'huomo*, he shortened his list dramatically, leaving only four – d'Arpino, Zuccaro, Roncalli, Annibale Carracci and, a little later, and as an odd afterthought, a fifth, Antonio Tempesta.

Those whom he had dropped from this second list are artists outside the mainstream of Italian figure painting, some from northern Europe, some highly individual, specialist artists, and artists experimenting with new kinds of scientific naturalism. Gio. Andrea may perhaps be identified as Giovanni Andrea Donducci, known as il Mastelletta,[35] a Bolognese painter, whose fanciful landscapes, crowded with whimsical, spirited figures, were enlivened by intensely naturalistic effects of light, suggestive of Elsheimer. Mastelletta had worked at the Carracci academy in Bologna, but, impatient with long study from the nude, had come to work in Rome. He was a prickly, independent character, only comfortable with vulgar and low-bred people, and rejected the praise of rich patrons. Malvasia gives a vivid picture of his later life in Bologna: 'He was such an enemy of company and praise that when patrons came to see him paint he hid behind the canvases . . . If they considered themselves satisfied and praised him, he answered gruffly that he was ignorant, and did not know how to do things, and that when anything turned out well it had happened thus by chance and luck.'[36] Giorgio Todesco remains an unidentified German artist, and Sigismondo Laer, another German, was a specialist in small pictures on copper, and tiny paintings on jewels, which sometimes showed several figures in a space only the size of a fingernail. Although he never competed in the public arena, his works caused such wonder that his name was famous throughout Rome. (Giustiniani owned a portrait of him, attributed to Caravaggio.)

Asked again what made a good artist, Caravaggio replied that a good artist is one who understands painting, and agrees with Caravaggio about everything, for ignorant and bad painters esteem those who are bad like themselves. Caravaggio's redefinition of a good artist suggests a surge of bad temper, a desire to give an insultingly simple and egocentric answer to an irritating question. His final list of valent'huomini is somewhat surprising, for the experimental artists have been excluded, and these are the most conservative and classicising artists in Rome, popular with the Church and with great patrons. But his redefinition also suggests a traditionally Italian belief in the supremacy of history painting, and in the human figure as the subject of the artist. Perhaps,

like Vincenzo Giustiniani, he could appreciate the different styles of these artists; his main complaint against Baglione was not that he was a classicising artist, but that he did not 'do well', for he was clumsy and incompetent. Caravaggio enjoyed the friendship of an odd collection of people – booksellers, tailors, perfume makers, eccentric artists like Mastelletta and Cherubino Alberti, Sigismondo Laer and Orsi – but his art unites a revolutionary naturalism with a deep awareness of tradition. It remains, despite his respect for the skills of still life, based on the human figure, and is given resonance by a traditional language of gesture and expression, by figures and compositions underpinned by an aware-ness of the classical past and of Renaissance art.

Yet his definition of painting would surely have enraged high-minded theorists such as Zuccaro, and to some extent his list may be a smokescreen, an attempt, with an eye on future commissions, to placate the artistic establishment. Annibale Carracci showed no such reticence in criticising the works of d'Arpino and Roncalli. Caravaggio's relationship with d'Arpino had perhaps truly soured at this time, maybe partly due to rivalry over the commission at Santa Trinità dei Pellegrini, but his rejection of Gentileschi was politic. But as the questioner turns to Baglione, Caravaggio speaks out with blunt scorn. There is no painter, he claims, who praises Baglione, and the painting of the *Resurrection*, which he went to see with Prospero and Gio Andrea, had pleased no one: 'It didn't please me because it was clumsy and I think it was the worst thing that he has done and I have not heard any painter praise that painting.' Only Salini, Baglione's 'guardian angel', was present and ready, at the painting's unveiling, to praise it; and Salini, beneath contempt, is summarily dismissed with the lofty comment that he, too, might dabble in painting a little, but that Caravaggio had seen nothing by him.

In the rest of his evidence Caravaggio simply distanced himself from all of those involved. Longhi, safely absent from Rome, he says, is 'a great friend of mine' but the two have never discussed the *Resurrection*; he has not talked to Gentileschi for three years (this, surely, was quite untrue, and his closeness to Gentileschi was clearly his biggest danger); Ottavio Leoni was his friend, but, Caravaggio added in an odd aside, 'I have never spoken to him.' Mario, who lived on the Corso, and was

presumably Mario Minniti, had once lived with him, but had left three years ago, and he had not talked to him since; Bartolomeo was indeed his servant, but he had been away from Rome for two months. As for the *bardassa*, Giovanni Battista, Caravaggio is emphatic that he had never known him; 'I know no young man called Giovan Battista,' he says, 'and particularly not one who lives behind the Banchi and is young.' He ends with a ringing statement that he has heard no verses, neither in Latin nor in Italian, about Giovanni Baglione.

Having reached this impasse, on 14 September Gentileschi was called back, for Baglione presented new evidence against him, a letter,[37] allegedly from Gentileschi, in which the artist insultingly mentioned the golden chain which had been so ridiculed in the verses. Like Caravaggio, Gentileschi listed the principal painters in Rome, beginning, as Caravaggio had done, with the Cavaliere d'Arpino, and including Annibale, Giovanni and Durante dal Borgo, Roncalli, Caravaggio, and, diplomatically, Baglione, all of whom, he claimed, were his friends.[38] He then, however, admitted that there is rivalry between them, and described the sequence of paintings of *Earthly* and *Divine Love* that he, Baglione and Caravaggio had painted, and which, he says, brought to an end his friendship with Baglione. There then poured out, in a long stream-of-consciousness sentence, that perfectly conveys the touchy pride of these artists, Gentileschi's deep resentment against the pretensions of Baglione and of Caravaggio. Both, he claims, expect him to defer to them in the streets of Rome, even Caravaggio, he says crossly, who is my friend, waits for me to greet him, none the less both are friends of mine. It must be seven or eight months since he spoke to Caravaggio, but Caravaggio did send to his house to borrow a Capuchin robe and a pair of wings, which he had returned ten days ago. (Caravaggio used wings in the *Flight into Egypt* and the *Victorious Cupid*, and at this period he was painting St Francis in a Capuchin robe.) The poems had criticised Baglione for speaking ill of other artists, so Gentileschi makes light of this, for, he says, all painters are supported by their pupils, who describe them as the greatest men in the world, although perhaps Salini goes a little far, and Giovanni Baglione is not particularly foul-mouthed, but simply gives his views, as do all artists.

In the next piece of his evidence Gentileschi tied himself in knots over an attempt to identify his handwriting in the letter presented as evidence by Baglione. In the preceding year Baglione had journeyed to Loreto, and had brought from there an image of the Madonna of Loreto, which he had given to Gentileschi. But his gift had enraged its recipient, for it was a humble lead image, of the kind pilgrims wear in their hats, and — although of course he was pleased, because it was a holy image — Gentileschi would very much have preferred an image in silver. He put his views robustly in a letter to Baglione, and in this letter he referred to Baglione's golden chain, saying that he would do better to hang his balls around his neck, 'for such a chain would form a more fitting ornament'. These phrases were, of course, very similar to those in the poems, and Gentileschi, aware of his danger, and in considerable confusion (*involvens se in verbis*), refused to recognise the handwriting on the letter, which was produced as evidence: 'It seems to me and yet seems not, that this is my hand, but I am not aware of having written those things and done that damage which appears in this letter.'

The trial seems to have petered out, without reaching a conclusion. On 25 September 1603 Caravaggio was released from prison under house arrest.[39] The French ambassador, Philip de Béthune, went bail for him, and Conte Ainolfo di Bardi guaranteed that Caravaggio would not attack Baglione or Salini.[40] Caravaggio was ordered not to leave his home without written permission, on pain of being sent to the galleys.[41] De Béthune was an admirer of Caravaggio, and owned works by him, amongst them a *Danae* (untraced), which presumably showed a female nude; he was perhaps also encouraged to intercede by the pro-French Del Monte.[42] Sandart mentions that it was because of the fame of the *Victorious Cupid* that Caravaggio was freed, and perhaps his celebrity did help.

Longhi, who had been away, became angrily involved in the dispute on his return. He followed Baglione and Salini to the church of the Minerva, hurling insults and pulling faces at them as they attended Mass. As Baglione and Salini left church, Longhi threw a brick at Baglione, making him fall over, and as Baglione's cloak flew open, it revealed that he was armed with a dagger. Longhi withdrew, but went to lie in wait for

them in the doorway of Salini's house, his sword hidden under his jacket. A shopkeeper described how he had seen Longhi, 'a man with a red face', rushing furiously after the two painters, whom he accused of attacking him with stones and daggers. On 18 November Longhi was arrested and imprisoned, and released two days later, also under house arrest.[43]

There seems little doubt that Baglione and Salini had identified their attackers correctly, but, in the confusion of evidence where all had reason to lie, much remains unclear. Most tantalising is the *bardassa*,[44] Giovanni Battista, from whom, according to Salini, Trisegni had acquired the verses. Trisegni denied the existence of the *bardassa*, and he remains a shadowy figure, the only evidence for his existence being Salini, who claimed to know him from hearsay, and that denied.[45] Most probably, the *bardassa* represents Salini's attempt to smear Caravaggio and Longhi with the accusation of sodomy – Salini was notorious for spreading malicious gossip, and sodomitic insults were very common. Nowhere else is there the slightest hint that Longhi was homosexual, and indeed he enjoyed both a fruitful marriage, and an energetic night life in the brothels of Rome.

In the period immediately after the trial, Caravaggio was away from Rome. He may have accepted an invitation to paint an altarpiece for the Capuchin church, Santa Maria di Constantinopoli, at Tolentino in the Marches (a commission for which he was perhaps indebted to Del Monte, who came from the Marches), in order to defuse the situation in Rome, for Tolentino must have seemed, after Roman prominence, a provincial stage. It is likely that he took the opportunity to visit the celebrated centre of pilgrimages, Loreto, whose Madonna was to be the subject of one of his most celebrated works in the following year. A letter from Lancillotto Mauruzi to the Priors of Tolentino, on 2 January 1604, encourages them in their adventurous patronage; he describes Caravaggio as the leading painter in Rome, and stresses that he will create something extraordinary, which will bring glory to their city. A weak copy of an altarpiece of the *Blessed Isidoro Agricola* may give a shadowy glimpse of Caravaggio's picture, which was described with passion, in an eighteenth-century guidebook, as a most singular painting,

with figures so natural that they seemed to live, so lifelike were the flesh colours, and so natural the gestures, but which has since vanished.[46] Early in 1604 he was back in Rome, where, on 8 January he received a payment from Maffeo Barberini.[47]

Rome: 1603–1606

THE FERVOUR OF THE JUBILEE celebrations soon waned, and the last years of Clement's long reign were marked by increasing violence and civic unrest. The atmosphere was repressive, and when Camillo Borghese (the future Paul V) was made Cardinal Vicario in 1603, he hastened to renew the intimidating edict of Cardinal Rusticucci, which had set down rules for religious art. He inveighed against indecent altarpieces, and decreed that builders and painters who failed to obtain a licence for their works should be fined 25 scudi, or suffer imprisonment, exile, or yet greater punishments. Painters should submit preliminary cartoons or drawings for approval, before beginning their works.

The Aldobrandini family was becoming increasingly unpopular, for food was scarce, and the poor were suffering. In June 1603 Del Monte described the darkening mood to the Grand Duke. A friend of his, he wrote, had been stopped near the Bocca della Verità by an old man, who had, with great courage, railed against the Pope – 'There has never been a Pope more deceived than him, for God gives us abundance in all things, but we live in a harsh famine, justice has fled . . . taxes are infinite, and there are snares everywhere.'[1] Anger against the papal family exploded in the summer of 1604, when rioting spread through Rome, and the city was threatened with an armed uprising. On 23 August a sailor, imprisoned for debt, had escaped and taken refuge in the Palazzo Farnese, claiming the ancient right to asylum. The Governor of Rome came to arrest him, but Cardinal Odoardo Farnese refused to relinquish the prisoner. As tension mounted, the Piazza filled with an angry crowd of around 4000 armed men (prominent among the Farnese supporters, Alessandro and Giovan Francesco Tomassoni) and the great Palazzo Farnese seemed like a city under siege. The frail alliance between the Aldobrandini and Farnese families crumbled, for when Pietro Aldobrandini came to seek peace, Odoardo rejected his embassy with

insulting arrogance. The crowd clamoured for Pietro to be hurled from the window, and for his and Olimpia Aldobrandini's house to be sacked. The incident ended with the humiliation of the Aldobrandini, and thereafter the peace-loving Clement began to keep a private army in Rome, arranging for 700 Corsican soldiers to be stationed there the following month. Clement never recovered from this blow, and spasmodic violence, and rowdy conflicts between French and Spanish factions, continued to trouble Rome.[2]

Throughout these restless years, in which an atmosphere of armed aggression dominated the streets, Caravaggio's own life became increasingly stormy, and his troubles with the law more frequent. In April 1604 he was eating artichokes at the Tavern of the Blackamoor and asked the waiter, Pietro della Carnacia, from Lago Maggiore, which of them were done in oil, and which in butter. Pietro replied: 'Smell them, and you will easily know.' Pietro claimed that Caravaggio snatched the sword of one of his companions, intending to strike him. Another witness heard him yell, 'If I am not mistaken, you damned cuckold, you think you are serving some damned bum,'[3] as he hurled the plate of artichokes in Pietro's face, wounding his cheek. (But he did not see Caravaggio grasp his sword.) The painter was perhaps still smarting from the libel trial of 1603, and explosively touchy. He was sued by the terrified waiter, and tried along with a mixed bag of defendants accused of similar misdeeds – a launderer, a convert, a beardless youth, a furrier. He alone received no penalty, and it seems likely that a powerful protector, perhaps Del Monte, stepped in.[4]

But only a few months later, on 19 and 20 October, Caravaggio was again in the prison of the Tor di Nona, along with Pietro Paolo Martinelli, courier of the Pope, Ottaviano Gabrielli, the bookseller, and a perfume maker, Alessandro Tonti of Civitanova, all accused of throwing stones at the police in the Via dei Greci at 9.30 p.m. Martinelli said that he had eaten with Caravaggio and Gabrielli at the Tavern of the Tower, and they had then decided to take a walk through Rome.[5] Caravaggio claimed that he had been walking towards the Piazza del Popolo with Gabrielli, Onorio Longhi, and someone whose name he didn't know, when they had run into the others; he had been standing

chatting to a whore, Menicuccia, when he heard the stones being thrown Before he was jailed, Caravaggio sent for help, first to Cardinal Del Monte, then to the house of Olimpia Aldobrandini; Gabrielli testified that Caravaggio told him to 'go to the house of the lady Olimpia Aldobrandini, to a gentleman I can't remember whether he is called Settimio or what'. Gabrielli took the message, but was himself arrested. He pleaded that he had only been in prison once before. In his evidence Caravaggio denied swearing at the police, but he was constantly taunting the despised *sbirri*, the Roman police, with volleys of vulgar abuse, and the corporal, Malanno, was an old enemy; Caravaggio unconvincingly complained that Malanno was insolent and hostile whenever he ran into him. The perfume maker struggled to disassociate himself from the painter, claiming, hopefully, to have been a long way from Caravaggio, and pleading that he had never been in prison before; he had been simply taking a walk alone in the Via del Babuino. He added that Caravaggio, with arrogant confidence in the Cardinal's intervention, had boasted: 'At any rate tomorrow I shall get out.' Hardly a month later, on 18 November, he was back in prison, this time for coarse language. Arrested at the Chiavica del Bufalo, he had been asked for his licence to carry arms, and had produced it, but spoilt the moment by loud and gratuitous insults.

Caravaggio's violence was not unusual in Clement's Rome. But his paranoid response to imaginary slights, his touchy sense of honour, and his brutal tongue, suggest a deepening insecurity that reflects the ambiguities of his status. He was now in his early thirties, and, thrust centre stage by the *St Matthew* paintings, he was the most celebrated artist in Rome. *The Entombment of Christ* had been universally praised, Del Monte remained loyal, and the most eminent Roman collectors longed for a painting from his hand. But Caravaggio's path had not been easy; he had been driven to despair over the rejection of the *St Matthew* altarpiece, and was now troubled by the uncertain fate of the scandalous *Death of the Virgin*. Young painters continued to flock around him, but his charisma was resented by more traditional artists.

Bitterness colours the account of Filippo Baldinucci, the Florentine art historian: 'Novelty always pleases more than beauty, and in an instant,

among painters and particularly among young painters, there spread throughout Rome an immense renown . . .'[6] In the increasingly repressive atmosphere Caravaggio had begun to seem a dangerous artist whose works shocked and disturbed, and he was no longer the recipient of an overwhelming flood of demands for public works. Only two altarpieces for Roman churches were commissioned from him between 1603 and 1606. And he remained excluded from papal Rome, from that charmed circle of artists (among them Cesari d'Arpino, enviably made a knight in 1600, and Cherubino Alberti), on whom the Pope lavished favours

Caravaggio responded to this exclusion with intense anger and jealousy, ruthlessly bullying and sneering at other artists, particularly those close to his style, whose rivalry he feared. Orazio Borgianni had been away for some time in Spain, but had returned on the death of his wife; he was definitely back in Rome by 1606, when he was in trouble with the law. He was a violent man, involved in street brawls, and had beaten up a doctor after a row over a picture. He and his friend Saraceni were admirers of Caravaggio, and perhaps saw themselves as partisans, supporting Caravaggio's *colore* against Florentine and Roman *disegno*, and leaders of a circle of artists who protected their cause with blows as well as words. Neither yet painted in a Caravaggesque style, but even so Caravaggio was hostile to Borgianni, 'who spoke much ill of him, [and] if he had not actually engaged in some handling of weapons, nonetheless did have some untoward encounter with him'.[7] Borgianni was to become a powerful Caravaggesque painter and perhaps the jealous Caravaggio saw danger, despite Borgianni's adherence to his cause.[8]

Caravaggio's anger grew when he was allowed no part in Clement's second and last great public commission, for a series of altarpieces for St Peter's.[9] The Florentine artists Domenico Passignano and Ludovico Cigoli both won contracts, and with both of them Caravaggio had an uneasy relationship. Passignano had come to Rome in 1602, and, an easygoing, unpretentious painter, he enjoyed drinking in the taverns of Rome with Caravaggio. Cigoli was a very different character, melancholy, devout, and a universal Renaissance artist skilled in architecture and theory as well as painting, and believing in an art rooted in *disegno* and in careful preparation; he corresponded with Galileo, and won his

commission for St Peter's through the Grand Duke Ferdinando and through Del Monte.

In Rome Cigoli was given hospitality in the Villa Medici, and the Roman artists resented his privileged success. While he was away from the city they opened his enclosure in St Peter's and revealed the sketched-out painting, accusing Cigoli of plagiarism. Cigoli, shocked and enraged, at first refused to continue with his picture. But he was diplomatic, and he trod warily around the aggressive Caravaggio, in every way his opposite. Baldinucci tells us: 'He would accompany Passignano and Caravaggio to the taverns in order not to criticise the actions of the former or suffer the persecutions and very strange mind of the latter.'[10] But it was the peace-loving Passignano who was to fall foul of Caravaggio, this 'insolent and most strange man'. One day when Passignano had left an assistant working on his altarpiece, 'with no respect for place or person, [Caravaggio] drew his sword and slashed his curtained work pavilion', and, sticking his head through the hole, looked at the work and rudely pronounced: 'This is just as bad as I would have expected from a painter like him'.[11] The long-suffering Passignano refused to rise to the bait, and continued to seek out his and Cigoli's company.

Caravaggio's leadership was soon to receive a far more dangerous threat. Annibale Carracci had fallen victim to black melancholy, and was painting very little. Cardinal Odoardo Farnese had paid him the insultingly small fee of 500 scudi for the works he had done since coming to Rome, which included most of the decoration of the Farnese Gallery, and had moreover sent the fee to his room in a saucer. Annibale, already physically exhausted, and now utterly humiliated, fell into depression, and all his projects foundered. But Guido Reni, a young Bolognese painter on the threshold of a triumphant career, presented a far more serious rival. Reni had arrived in Rome late in 1601, under the patronage of Cardinal Sfondrato. He had lodged in the *forastiera* of Santa Prassede, where he and Francesco Albani had enraged Domenichino by playing cards late into the night: Albani and Domenichino were Bolognese painters in the studio of Annibale Carracci. In the vivid life of Reni by the Bolognese biographer Cesare Malvasia, he is made to incarnate

virtues that opposed those of Caravaggio. He was possessed of a melting, feminine beauty, and a sweet nature, being 'very fair with rosy cheeks, blue eyes and a finely modelled nose . . . he was very handsome and well made, with all parts and members in harmony';[12] he was patient, 'always affable and polite, tractable and courteous'; inclined to melancholy, he was none the less lively and amusing, generous with his money, and thought to be a virgin. He was devoted to the Virgin, and 'being no less a virgin' it was thought that she had appeared to him. He was not learned, wrote badly, and preferred the company of simpletons, gossips and gamblers. Reni was, moreover, deeply neurotic, anxious, morbidly afraid of women and witchcraft, and passionately addicted to gambling. Later in his career he would 'spend a month in the studios, then two months in the card rooms, which took away everything that he brought'. Reni could, however, be 'terrible and resolute' in the cause of art, and was always anxious to behave with fitting dignity before the rich and powerful. His art was graceful and idealising, and the official artists of Rome were quick to see his power. His 'marvellous qualities', Malvasia tells us, 'were discussed by Cavaliere d'Arpino, Gaspare Celio, Roncalli, and others associated with the papal court . . .'; they saw in him a leader who could oppose the supporters of Caravaggio, lead by Borgianni and Saraceni.

Reni made visits to Bologna in 1603 and 1604, and it may be at this point that d'Arpino, whose relationship with Caravaggio was deteriorating, wrote and encouraged him to hasten to Rome, 'to create opposition to Caravaggio, his declared enemy'.[13] In 1604 Guido made a puzzling visit to Loreto, in the Marches, where a much-coveted fresco commission for the New Sacristy of the basilica of Santa Maria di Loreto was being negotiated. Guido's young compatriot Lionello Spada was working there, and Reni was called in to give his opinion on the work. He condemned it, and Spada did not win the contract, which was awarded, the following year, to that far more established and experienced fresco painter, Cristofero Roncalli. Baglione later wrote that Caravaggio had himself coveted this commission, and had been so enraged by Roncalli's success that he had hired a Sicilian to beat him up;[14] Baglione had himself recently been in Loreto, where he had purchased the insulting

lead madonna, and perhaps he too was interested in the commission. In fact Caravaggio never worked in fresco, and it is unlikely that he wanted this contract, but the story remains puzzling. Spada was young and little-known, and Reni himself was only on the threshold of his illustrious career; it may well be that Caravaggio thought that Reni was angling for the contract for himself, and his rejection of Spada – who was so passionate an admirer of Caravaggio that he became known as the 'ape of Caravaggio' – was an insult to his leadership.[15] Back in Rome Reni was competing with Caravaggio, angling for work from his patrons, and, as he openly challenged his art, creating a lively sense of aesthetic debate.

In the autumn of 1604 the young Reni won a contract from the papal nephew, Cardinal Pietro Aldobrandini, for an altarpiece of the *Crucifixion of St Peter* for the church of the Tre Fontane. Caravaggio had had his eyes on this prestigious contract, and perhaps it had been destined for him. But the Cardinal had been egged on by d'Arpino, who promised him that 'Guido would transform himself into Caravaggio',[16] and this he did, while at the same time reproving Caravaggio's earthbound vision. His remarkable work was inspired by Caravaggio's Cerasi *Crucifixion of St Peter*, but the vividly naturalistic figures and surface realism are softened by a new elegance and abstract beauty. The darkness, too, is gentler, and conveys none of Caravaggio's anguished fear of death, while St Peter seems to reach upwards towards a divine light. The executioner holds out a nail to him, which seems to become a martyr's palm: death and salvation seem simultaneous.

At around the same time Caravaggio was exploring the theme of the full-length semi-nude youth, painting the *St John the Baptist* (1602) (Col. Plate 15) for Ciriaco Mattei, and a second *St John the Baptist* (Col. Plate 28) for Ottavio Costa,[17] both of which revive a Florentine tradition of paintings of the youthful St John. Costa's picture was intended as an altarpiece for the Oratory of the Confraternity della Misericordia at Conscente in Liguria, near Genoa, and a fief of the Costa family. The family was building a new church there, dedicated to St Alexander, and the Oratory had been the old parish church. Costa liked Caravaggio's painting so much that he kept it for his collection, sending a copy to Conscente, which remains in the Museo Diocesano, Albenga.

St John the Baptist, born without sin, a voice crying in the wilderness, brought a message of passionate hope to a darkened world. The precursor of Christ, he was a light shining in the darkness, a model of penitence and poverty. A vision of St John, dressed in rags and the skins of beasts, 'as he was usually shown in paintings,'[18] had moved Filippo Neri to live detached from earthly desires, and St John's life closely prefigured that of Christ. The Protestants had attacked this tradition, throwing doubt on John's childhood in the desert, and creating a new tradition, of a bourgeois family life; but the Catholics wished to revive his visionary splendour, and the sense that through him we approach the mystery of Christ and the Eucharist. Through the majestic red drapery, and the eerie play of moonlight, Caravaggio heightened a sense of prophetic mystery; but he retained the reality of the curly-headed youthful saint, building up psychological tension through the shadowed eyes and the play on taut, uncomfortable diagonals. The deep and brooding melancholy conveys penitence, while the reed cross holds out the promise of salvation. A contemporary wrote movingly: 'Before ascending to the above-mentioned church, in the narrow but fruitful valley, one comes upon a small, holy oratory . . . formerly the parish church, restored in the modern style in honour of that mysterious nightingale who announces the coming of Christ, Saint John the Baptist. The image of him in the desert, mourning human miseries, was painted by the famous Michelangelo da Caravaggio, and it moves not only the brothers but also visitors to Penitence.'[19]

Reni was in competition here too, for Ottavio Costa, as Tiberio Cerasi had done before him, seized the chance to juxtapose the two leading artists in Rome, and commissioned Reni to paint a *Martyrdom of St Catherine* for the new parish church of Sant' Alessandro at Conscente, where it remains.[20] An idealising work, it none the less suggests rivalry, for his executioner is handsome, and the setting dark, marked by only a few heavy-leafed plants. At the same time Reni painted his *David contemplating the Head of Goliath* (Plate 39). His David, elegant and nonchalant, leans against a classical column, his powerful gaze fixed on the severed head of the giant Goliath. The painting boldly lays claim to Caravaggio's style, in the dark background, and in the play of fur against flesh, while

39. Guido Reni, *David contemplating the Head of Goliath*
(Paris, Louvre)

the bright red hat, its single pink plume shockingly frivolous in so gory a scene, is almost a theft, a jolting reminder of the worldly youths in Caravaggio's *Calling of St Matthew*. Yet the sensual live model, so disdainful of Caravaggio's art in its insouciance, its utter lack of an intense inner life, is based on a celebrated antique sculpture, and the composition built up on a balance of horizontals and verticals, with forms arranged parallel to the picture plane, is classical. It is as if Reni is setting his belief in ideal beauty against Caravaggio's naturalism, and David, young and lovely, as was Guido himself, triumphs over the brutal Goliath, whose abundant black hair and beard recall Caravaggio. Marino, in a contemporary sonnet written to this, or a very similar picture, wrote:

> But if I look well at the victor and the vanquished
> More beautiful is the living one than horrible the dead
> one . . .[21]

and Reni's picture dramatises the contrast between his ideal art, which to his contemporaries seemed painted by an angel, and that of Caravaggio, trapped in cellar darkness.

Reni's arrival in Rome was deeply resented by both Annibale and Caravaggio. Annibale had developed an intense dislike of him in Bologna when the young Reni was studying at the Carracci academy, warning his cousin Lodovico to 'keep quiet when he is in difficulty', for Guido was always looking for 'something more delectable, more grace-ful, more exquisite'.[22] Caravaggio, however, who greatly 'feared this new manner',[23] was enraged at his presence, and threatened outright to break his skull.

> He also said that if Guido Reni claimed to be such a great man, why then did he spend the whole day searching for Caravaggio's paintings and buying any that came to hand? What a strange thing that was, and why did he do it? Why did he steal Caravaggio's style and his colour in the *Crucifixion of St Peter* at the Tre Fontane? He added that even if he had stolen

that job from him, he had not taken away his renown, that he was just the man to take the life of that evil man d'Arpino who, he well knew, had arranged this intrigue and had gotten for Reni, from Cardinal Borghese, the commission that should have been his . . .²⁴

Reni tried to placate him, avoiding his challenge to fight, saying, with great delicacy, that 'he was a servant and had come to court to paint and not to duel . . . that he did not want to compete with anyone, since he recognised and admitted that he was inferior to all'. In fact Caravaggio, to whom imitation was theft, was wrong: Reni became a far more dangerous threat when he moved away from Caravaggio's style and, drawing closer to d'Arpino, created a new classicism.

B UT BEFORE THIS, Caravaggio again won a commission for an important altarpiece, in the Roman church of Sant' Agostino. On 21 July 1602 the Bolognese Ermete Cavalletti had died, aged forty-six, leaving 500 scudi to provide for the acquisition and decoration of a chapel in the Roman church of Sant' Agostino.²⁵ Only a few months e arlier, Cavalletti had taken part in meetings of the Confraternity of Santa Trinità dei Pellegrini to discuss a pilgrimage to Loreto,²⁶ and his chapel was to be adorned with an altarpiece showing the Madonna of Loreto, or the Madonna of the Pilgrims. The chapel was acquired in September 1603, and it is likely that Caravaggio's work dates from 1604 to the first half of 1605. The church, its early Renaissance façade set back from the street, was in an extremely busy and lively area of Rome, constantly thronged with the traffic. It was close to the famous Albergo della Scrofa, on a busy pilgrim route, and many pilgrims paused to touch the feet of Jacopo Sansovino's cult *Virgin and Child* just across the nave from Cavalletti's chapel.

The cult of the Madonna of Loreto was particularly widespread in the later years of the sixteenth century. The small town of Loreto, in the hilly countryside of the Marches to the east of Rome, was celebrated for

the miraculous presence there of the holy house of the Virgin Mary. Legend said that this humble stone dwelling, once one of the three most famous places of the Holy Land, had flown there from Nazareth, in search of safety from the dangers of war. After various adventures, it had settled in Loreto in the night between 9 and 10 December 1294, and its cult flourished, along with the cult of the Virgin who had so desired its safety. This house, where the Virgin had been conceived, where the words of the Angel Annunciate had filled her heart, and where the Christ child had played, touched the popular imagination, and folktale and legend mingled with the Christian myth. It satisfied the need of a popular faith for something miraculous, removed from the everyday, that should lift the believer out of the here and now. At a time when devotional practices encouraged the devout to visualise the holy places in the greatest detail, the Holy House made a powerful appeal. The Jesuit Louis Richeôme, in the *Pilgrim of Loreto*, imagined the Holy Family there: 'For since our Sauiour, and his holy mother, and divers other saints dwelt there, how often in this their dwelling, did they sanctify it by their comming and going, by their breathing and looking, by their holy talke . . . How often hath the glorious Virgin his Mother made this place honourable by the offices, and seruices of Charity, of deuotion, of piety, of teares, and other signes and markes of sanctity?'[27]

In these fervent years the medieval passion for pilgrimage flourished. Luther had railed, 'Let every man stay in his own parish; there he will find more than all the shrines even if they were all rolled into one';[28] but in Catholic Europe Carlo Borromeo's arduous pilgrimages to Turin, when he braved the perils of the mountains, and performed many miracles, were legendary, as were his long nocturnal vigils at the Sacro Monte of Varallo. Caravaggio had himself been born in the shadow of the great pilgrimage church of the Madonna del Caravaggio. In the Jubilee year of 1600 the Trinità dei Pellegrini in Rome housed 210,000 pilgrims, and many journeyed to Loreto, where, in 1590, it had been decided to celebrate the arrival of the Holy House with a procession held on 10 December. Clement VIII himself made the pilgrimage in 1598. The immense popularity of the shrine at Loreto was a vigorous response to Protestant attacks on the cult of the Virgin, and so heightened was

the tension that during the conclave of 1605 rumours spread that English students from Padua were plotting to steal the treasures at Loreto.

Caravaggio's Madonna (Col. Plate 31) stands at the simple stone doorway of a house, its rough brick walls crumbling, and kneeling before her are dusty and travel-worn pilgrims, with cape and pilgrim's staff. She has no attributes, but the poverty and humility of the dwelling immediately suggests the Holy House, and she shows the child to the worshippers; Jesus is about five, for this is the home where his childhood was spent. Pilgrims at Loreto knelt as they approached the shrine, and many circled the house on their knees. Caravaggio's Madonna is warmly human, and brought close to the pilgrims, who are separated from her only by a step, while the low viewpoint, and the light, which seems to fall from the doorway of the church, include the viewer within the painted space, so that he too seems to kneel before her. And yet we are aware that she is a vision; she is lit from above, and towers over the pilgrims, her size, as in medieval art, conveying transcendence, and her strange, weightless pose suggesting that she has just alighted in the doorway. Two worlds meet, and the sturdy pilgrims gaze upwards at the Madonna and child. She is a deeply ambiguous figure, warm, fleshly (we feel the imprint of her fingers against the child's body), yet with an unreal grace, and encircled by mysterious light and shade. Caravaggio weaves together layers of reality and illusion; she is a housewife, welcoming the pilgrims in a dark Roman *vicolo*; she is a statue framed in a niche, suggesting the wooden statue within the shrine at Loreto, brought to warm life; she is truly the Madonna of Loreto, on the threshold of the Holy House, and born from the faith and in the imagination of the pilgrims.

Her closeness, and her welcoming pose, convey the Madonna's role as mediator, and the Madonna of Loreto was often invoked against illness and plague, and sometimes identified with the Madonna della Misericordia, whose cloak gave shelter to suffering humanity. Caravaggio had perhaps looked at early devotional images within the shrine which show the Madonna displaying her young son to the people,[29] or at woodcuts which told the story, and illustrated the rough stone house before it received its sumptuous marble revetment in the mid-sixteenth century. Or he may have known Antoine Lafréry's print of *The Pilgrimage to the Seven*

40. Antoine Lafréry, *The Seven Churches of Rome*
(print)

Churches (Plate 40), where kneeling pilgrims encircle a great statue of the Madonna, a personification of the church of Santa Maria Maggiore.[30]

The pilgrim powerfully symbolised the human condition. A stranger upon earth, he journeyed to the world to come, and Caravaggio's pilgrims, young and old, suggesting the journey of life, kneel before the gates of heaven. In Agostino Valier's *Dialogue on Christian Joy*, a re-creation of the spiritual dialogues held at the Oratory, Cusano spoke of the joy of pilgrimage: 'When we arrived at Loreto, at that holy house where the mother of God and Queen of the heavens is deeply venerated for the famous miracle, and when I saw the great number of miracles whose memories are preserved in that most noble church, my soul was pervaded by an indefinable lightness, while, as I knelt before the image of the most holy Mother, I exclaimed "How praiseworthy is God in the most holy Virgin . . ."'[31] To him it was a source of great joy that 'in pilgrimages

of this sort there is almost always a preparation for death; so it happens that the passing to God brings to an end these journeys and wanderings . . .'[32] And Richeôme spoke of 'the condition of mortall men, which is to be pilgrimes, and strangers upon earth', and of the Apostles walking as pilgrims into an unknown world.[33]

It was entirely new for the humble poor to appear centre stage in a public altarpiece, and the people 'made a great fuss over it'.[34] Cardinal Paleotti had written that the naturalism of religious art should not shock or disturb, and perhaps the people missed a more consoling and traditional splendour. The picture shows no hint of the squalor in which the Roman poor truly lived. Yet at a deep level it is in harmony with Oratorian spirituality, thrusting the poor, and their simple faith, before a courtly élite, insisting on a low style, and moving the viewer to that love and compassion through which he might win salvation. It marks the end of an era which had opened with Filippo Neri's foundation of the Confraternity of the Trinità dei Pellegrini in 1548, to assist poor pilgrims who had travelled to the Holy City from every part of Europe, and encouraging, throughout Clement's reign, an intense charitable activity and evocative rituals of mortification. Now the mood was changing, and the rhetoric of the Church grew increasingly triumphant. The *Madonna of Loreto* is the last great painting of Clementine Rome, and the last of Caravaggio's pictures which so movingly suggests a reawakening Catholic spirituality. Later its optimism would yield to a more desolate vision.

C LEMENT HAD NEVER RECOVERED from his humiliation at the hands of the proud Farnese. He fell ill in February 1605, and on 3 March the Pope died. France mourned his death, for he had absolved the King, and brought peace to France, but French supporters were delighted by the unexpected election of Alexander de' Medici as Pope Leo XI, the result of the tireless diplomacy of the French ambassador Philip de Béthune. Yet this satisfaction was to be short-lived. Taken ill at his coronation ceremony, Leo XI, already frail, died on 27 April. Rome was reduced to a state of almost total anarchy, for while the papal throne was empty normal government was suspended, and the lay officials of each

district, the *caporioni*, alone could administer justice.[35] As the bell on the Capitol tolled for the death of the Pope, the city's jails were emptied of their inmates, and the last of the prisoners, following the *caporioni*, carried away the *corda*, a rope used in torture, which the keeper of the prisons later had to buy back. Two swiftly successive Vacant Sees ensured the liberation of many long-restrained passions, and the second conclave of 1605 was a scandal. French and Spanish factions could not agree on a candidate, and, amid startling fracas and uproar, schism threatened. The day was saved by the leaders of the two parties, Cardinal Pietro Aldobrandini, and Cardinal Montalto, who produced a politically neutral surprise candidate, Camillo Borghese, who became Pope Paul V. His election marked the end of an era. The great cardinals of Clement's reign – Federico Borromeo, Cesare Baronio, Roberto Bellarmine (the two latter reluctant papal candidates), distinguished by their frugality and moral grandeur, began to seem the relics of an earlier, more austere and penitential age, and the new young cardinals, jockeying for position, were flushed with the ambitions of a new worldly triumphalism and confidence.

Paul V, from a Sienese family long settled in Rome, was, at fifty-three, a comparatively young man, and in good health. Not renowned for his intellectual brilliance, he was stern and authoritarian. His face was fleshy, with a short pointed beard, and small, sharp eyes. A true reforming Pope, in the spirit of the sixteenth century, he was pious and parsimonious in public life, but committed to charity and good works. His charity, however, vied with his other great passion, the prestige of his family and name, and to this end he lavished wealth and offices on his nephews. At his side stood the pleasure-loving Scipione Borghese, his nephew, whom he hastened to summon to Rome, and to propel to sudden fame. Scipione, who was only twenty-seven, was made a Cardinal, and his bright vivacity and joviality are wonderfully recorded in Bernini's later portrait bust (Plate 41). He was a very different character from his uncle, loved for his easy temper, and not at all keen on studies. The Venetian ambassador later commented on his 'mediocre learning and life dedicated to pleasure and entertainment'.[36] With Scipione the splendour of the great Cardinals' courts of the Renaissance was reborn, and his

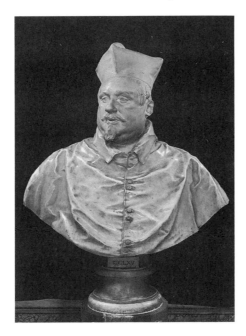

41. Gian Lorenzo Bernini, *Bust of Scipione Borghese*
(Rome, Galleria Borghese)

lavish banquets became the talk of Rome. A passionate collector, quick to encourage new talent, and ruthless in his methods, Scipione introduced Caravaggio to the Pope, whose portrait he painted.

But the future of public art in Rome lay with the older generation of official artists, from whom Paul V, continuing the traditions of Clement VIII, commissioned grandiose works that should convey the power of the papacy. The Cavaliere d'Arpino was quick to seize the new opportunities. He had begun to lose the favour of Clement, but with the election of Paul V his star revived, and he wielded immense influence over the Pope, who came frequently to watch him paint. Reni, too, was swift to see the path to fame. He abandoned Caravaggio's naturalism, creating more elegant works, closer in style to the Cavaliere d'Arpino, and charming the Pope with the gift of two small and exquisite paintings on copper. Soon Reni's graceful classicism was established as the official Borghese style. His paintings convey the radiance of Paradise,

and his is an art suited to a more triumphal age which was reasserting the old hierarchies, and moving away from the penitential fervour and sense of guilt and shame that had characterised Clement's reign. Caravaggio, himself dark and brutish, remained wrapped in darkness, while Guido, fair and beautiful, was, wrote Malvasia, 'like a noble eagle, so to speak, [who] took off in flight toward distant spheres, and drawing from on high concepts that were celestial, brought back to earth something of paradise'.[37] And Monsignor Agucchi, a prelate who wielded considerable influence at the papal court, was beginning to formulate a considered opposition to Caravaggio's naturalism. In his *Theory of Art*, written a little later (between 1607 and 1615), but inspired by conversations over these years with Annibale and Domenichino, he formulated a theory of ideal beauty, to which the enlightened should raise their thoughts; Caravaggio, he wrote, whilst most excellent as a colourist, had abandoned the Idea of beauty, and merely imitated nature. He compared Caravaggio to Demetrios, a celebrated naturalist of classical antiquity, creating an often repeated formula for hostile classicist critics.[38] Caravaggio became synonymous with dirty feet and clothes, and Federico Borromeo later jotted down: 'in his work there appear taverns and debauchery, nothing of beauty; Raphael is the opposite'.[39]

Caravaggio's tragic art, sombre and harsh, seems increasingly the product of a gloomier age, and his work began to lose the coherence and consistency of the years around 1600, when he had created, with such fresh and confident naturalism, a highly personal and tragic vision of Early Christianity. Solitary saints – the aged St Jerome (Plate 42), his flesh frail, deeply worn by time, pondering death; St Francis (Plate 43), in heavy, worn robe, a stark image of poverty and penitence; the young St John (Col. Plate 28), meditative, veiled in darkness – replace the lyrical youths of the 1590s, and the rustic yet grave Apostles that had peopled Caravaggio's works around the turn of the century. These were saints revered for their asceticism, and to St Jerome was attributed the famous dictum 'Follow naked the naked Christ'. His Corsini *St John the Baptist* (Plate 44), probably a little later than the picture for Ottavio Costa, is a rough Roman street boy with crabbed reddened hands, an uncomfortably stark image of humility, untouched by prophetic fire.

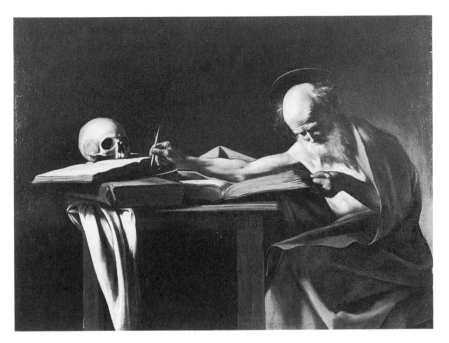

42. Caravaggio, *St Jerome in his Study*
(Rome, Galleria Borghese)

The paint is thinner, the naturalism less showy, less provocative, and often Caravaggio's figures seem dissolved in dark shadow; his compositions are sometimes strikingly archaic, and he no longer builds up complex pyramids of interwoven and weighty figures.

IN THE STORMY YEAR of the new Pope's election, and in the following year, Caravaggio's life was ever more disordered, and there is a sense that he was spiralling downwards, out of control, losing both status and equilibrium. He turned to Del Monte in moments of crisis, but, perhaps tired of the courtier's role, he was attempting to live by himself, and certainly by March 1605 he had rented a house in the Vicolo dei Santi Cecilia e Biagio (now the Vicolo del Divino Amore). He is recorded there, as a communicant, with one servant, Francesco, on 6 June 1605 (he may have been there earlier, for it is not clear where he was

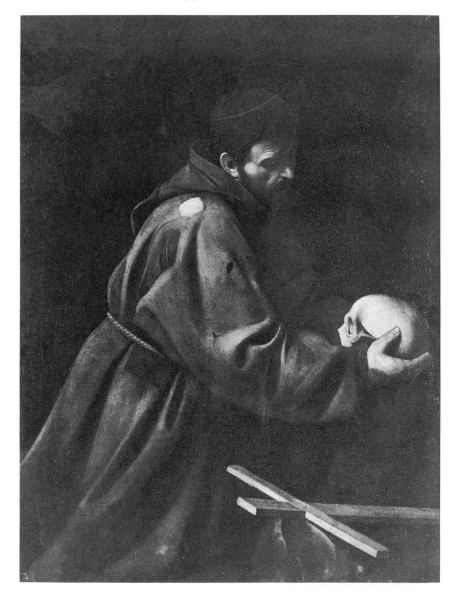

43. Caravaggio, *St Francis in Meditation*
(Rome, Galleria Nazionale d'Arte Antica, Palazzo Barberini)

living after his return from the Marches in January 1604).[40] Annibale, too, was living beyond the palace, and there is a sense that both artists were asserting a powerful individuality against the repressive hierarchies

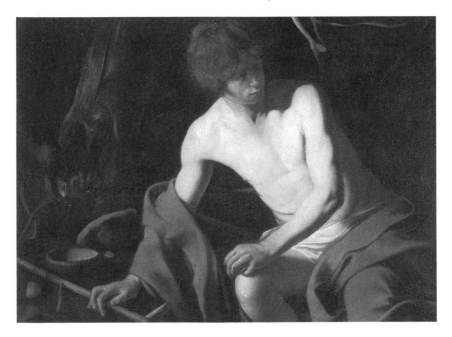

44. Caravaggio, *St John the Baptist*
(Rome, Galleria Nazionale d'Arte Antica, Palazzo Corsini)

of the court, and both had suffered, in different ways, from rejection. Early in 1605 Annibale, already depressed, had a complete breakdown, and as soon as he had recovered a little, he left the Farnese palace. He now preferred to be left to himself, and moved his house several times.

Caravaggio's house was in the district of Campo Marzio, between the Via dei Prefetti and the Via and Piazza della Torretta, where d'Arpino's studio had been. The Vicolo is a narrow street, flanked on one side by the vast walls of the Palazzo Firenze, where the ambassador to the Grand Duke of Tuscany lived, and opening out into the small Piazza Firenze. Here Caravaggio lived with very little comfort. He had almost nothing of any value, and an inventory of his possessions suggests a haphazard life, reduced to the bare essentials. There was an odd array of cutlery and crockery, with only two plates, but several glasses, a straw flask, and water jug – objects which call to mind the humble still lifes in the *Flight to Egypt* and the *Supper at Emmaus*. His furniture was old and worn – stools, an old chest, two old straw chairs and a small brush, although he also had a

more luxurious bed decorated with two columns, and a pull-out bed for a servant. There were few clothes, and these torn — 'a pair of trousers and an old coat in rags' — and may have been used in paintings (perhaps those worn by the pilgrims), and a random collection of items which may have been collected as props — 'a dagger, a pair of earrings, an old belt and a doorknocker'. Some of the objects are more personal, such as duelling weapons, and an ebony case holding a knife, and a guitar and violin. It seems likely that Caravaggio played the guitar, which does not, unlike the violin, appear in any of his paintings. There are also twelve books, tantalisingly without titles, and in the studio painting materials, mirrors, and several primed canvases.[41]

Caravaggio's rough bachelor existence was not unusual, and nearby, in the parish of San Lorenzo in Lucina, Annibale Carracci lived in a similar style, among an even sadder array of torn shirts, old and broken candlesticks, minimal furnishings and tableware.[42] Reni delighted in splendid houses, and in Rome he had rented a *palazzo* from the Mattei family for 160 scudi, even though he had a *palazzo* which he rented from the Borghese for only 50 scudi. But he was interested only in upholding the glory of painting by the external grandeur of his *palazzi*; he resisted furnishing, saying that it gave him greater pleasure to see every room crowded with primed canvases than adorned with fine furniture. Their ambitions were far removed from those of the Cavaliere d'Arpino, who in 1604 bought a *palazzo* on the Corso for 3000 scudi, which he proceeded to enrich architecturally, and to make a centre of literary and artistic life. His desire to rise to the splendour of the nobleman born was the more usual ambition of the seventeenth-century painter, and Tommaso d'Alessandri, in *Il Cavaliere Compito*, dedicated to d'Arpino, describes the luxury to which a *cavaliere*, or knight, might aspire in a grand Roman *palazzo*, well equipped with 'horses in the stables, with serving men and women, dressed in rich clothes of lovely and varied fabrics, his neck adorned with a magnificent gold chain, and on his muscular finger enamelled rings with finely pointed diamonds . . . with large buttons . . . with embroidered collars, and superb jewels . . . a table decked with all the bounteous gifts of God'.[43]

But for Annibale and Caravaggio the times were out of joint. The

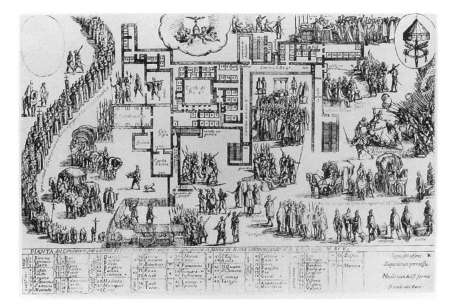

45. *The Conclave of 1605*
(Columbia University, New York)

streets and taverns in Caravaggio's neighbourhood, at the heart of the
densest part of Rome, became increasingly the theatre of a violent street
life. Just around the corner from Caravaggio's house, in the Piazza di San
Lorenzo in Lucina, there lived the rowdy Tomassoni family, whom
Longhi, and probably Caravaggio, had run up against a few years earlier.
At this time of two successive vacant sees Giovan Francesco Tomassoni
was *caporione* of Campo Marzio, and he and his brothers, Ranuccio and
Alessandro, led a disruptive neighbourhood police force. At the same
date, in the urban district of Castello, Baglione was *caporione*, and later
wrote that he had, while acting as *caporione* through two vacants sees,
preserved his neutrality; he probably knew the Tomassoni, and was later
to write favourably of Ranuccio. The spring of 1605 was particularly
turbulent, and culminated, on 1 May, in an alarming riot between French
and Spanish factions, in which several were wounded, and some perhaps
killed, in the Campo Marzio between the Piazza della Trinità and the
Strada delli Condotti. The Tomassoni were formidably present. As the

sheriff of Rome attempted to lead the rioters to the Tor di Nona, he was confronted, 'in the square of Cardinal Borghese', by the *caporione* and his brothers, heavily armed; Giuseppe Dionisi, in the service of the sheriff, later described how the three brothers appeared leading their bodyguard – 'which was a vast number of men, some armed with arquebuses, some with drawn swords and other sorts of arms. And Captain Francesco was armed with daggers, swords and forbidden pistol, his brothers with swords, and Alessandro bore his drawn sword in his hand.'[44] A violent dispute then ensued over who had authority over the prisoners.

At the end of the month, on 28 May, Paul V's coronation day, Captain Pino accused Caravaggio of carrying arms without a permit, and decorated his accusation with a quick sketch of Caravaggio's dagger and sword. On this occasion, Caravaggio had no permit, but claimed proudly that the Governor of Rome had told the sheriff and his corporals to leave him alone, and he was released without bail.[45] The lack of a permit suggests that Caravaggio, no longer able to claim, as he had in Piazza Navona in 1598, and again in 1601, that he was in the service of the Cardinal Del Monte, was losing status, and this perhaps aggravated his general hostility. He was busy professionally, for on 25 June he signed a contract with Massimo Massimi to paint a large picture, an *Ecce Homo*, to accompany a *Crowning with Thorns* that he had already painted for him (probably the painting now in Prato) and to deliver the picture by 1 August.[46] However, Caravaggio was in the thick of the raucous life of street battles with the Roman whores, where beating and kicking doors, throwing stones, yelling rude insults, was routine, and in July he was in trouble again, and back in the Tor di Nona, this time for attacking the house of two women, Laura della Vecchia and her daughter, Isabella.[47] Prospero Orsi, Cherubino Alberti, the bookseller Gabrielli, and a tailor from Narni stood bail for him. Then, only nine days later he made a far more serious assault on a notary over another woman, Lena.

Lena had entered his story with the *Madonna of Loreto*, for she was his model for the Virgin, and she posed for him in his house. Lena was not a whore, but came from a 'poor but honourable' family, and her mother allowed her, for a considerable fee, to model for Caravaggio. But her frequent visits to Caravaggio were jealously observed by a young notary,

Mariano da Pasqualone, who wished to marry her. His suit was rejected (for his job meant that he was sure to be damned), and he angrily rebuked Lena's mother for handing her daughter 'to an excommunicant and cursed man', Caravaggio.[48] Caravaggio, on hearing this, sought vengeance, looking for an opportunity to fight Pasqualone, and in late July he viciously attacked him in the Piazza Navona. Pasqualone was interviewed in the office of Paolo Spada by the Clerk of the Criminal Court, and stated:

> As Mr Galeazzo and I – it may have been about one hour after nightfall – were strolling in the Piazza Navona in front of the palace of the Spanish Ambassador, I suddenly felt a blow on the back of my head. I fell to the ground at once and realised that I had been wounded in the head by what I believe to have been the stroke of a sword . . . I didn't see who wounded me, but I never had disputes with anybody but the said Michelangelo. A few nights ago he and I had words on the Corso on account of a girl called Lena who is to be found at the Piazza Navona, past the palace, or rather the main door of Mr Sertorio Teofilo. She is Michelangelo's girl. Please, excuse me quickly that I may dress my wounds.

With Pasqualone was Galeazzo Roccasecca, writer of apostolic letters, who saw Mariano fall to the ground, and then saw 'a man with an unsheathed weapon in his hand. It looked like a sword or hunting knife. He turned round at once and made three jumps and turned towards the palace of Cardinal Del Monte . . . He wore a black cloak on one shoulder.' (As Caravaggio is doing in the *Martyrdom of St Matthew*.) He concluded, 'I only heard the wounded man say it could not be anyone but Michelangelo da Caravaggio.'[49]

After this shameful encounter Caravaggio fled to Genoa. Throughout this period Fabio Masetti, the Roman agent of Cesare d'Este, Duke of

Modena, had been trying in vain to get both Annibale Carracci and Caravaggio to deliver paintings to Modena. Early in the year, on 12 March, Cardinal Farnese had himself written to the Duke: 'When Annibale Carracci has recovered from a serious illness which he has had these past days and which still keeps him from painting, Your Highness's request will be attended to.'[50] In the summer Annibale began work on the picture, but was too ill to complete it. Masetti fared little better with Caravaggio, who constantly put him off, and on 17 August 1605 he wrote to the Duke: 'Caravaggio is in contempt of court, and is in Genoa.'[51]

C ARAVAGGIO'S CHOICE of Genoa was inspired by the possibility of finding powerful support there. Genoa was a major city, a financial centre which had made a grand recovery, earlier in the century, from a period of political and commercial decline. Its recovered prestige found expression in a lavish patronage of the arts, led by the powerful Doria, an old patrician family of soldiers and seamen who appreciated the power of art to celebrate their worldly status and display their wealth. The city had been lavishly embellished in recent years, by a series of aristocratic suburban villas, and by the splendid palaces that lined the Strada Nuova, whose Renaissance symmetry and elegance contrasted sharply with the narrow medieval streets of the old town. A brilliant and cultured ruling class, of immensely wealthy trading and banking families, displayed their riches in the sumptuous new *palazzi* and villas. Genoa attracted artists from the most sophisticated Italian cities and was unusually open to artists from northern Europe. Amongst Caravaggio's Roman patrons, some, such as Costa and the Giustiniani family, had strong links with Genoa, and Caravaggio may have counted on their support. He may, too, have again used his connections with the Colonna family, who were to prove so constant and so loyal — for Admiral Andrea Doria, an important political figure in the city, had married Giovanna Colonna, the daughter of Fabrizio Colonna and Anna Borromeo, and niece of the Marchesa Costanza of Caravaggio. Andrea Doria and his wife were influenced by Borromean spirituality, and Giovanna had been instructed by Giuseppe Calasanzio. Perhaps through them Caravaggio

attracted the attention of another branch of the Doria family, which had recently risen to economic power. Two of its members, Gian Carlo and Marcantonio Doria, the two sons of Agostino Doria (Doge in 1601–3), were important collectors and adventurous patrons, and in 1606 Rubens, who had visited the city earlier, painted for them the equestrian portrait of *Gian Carlo Doria with the Insignia of the Spanish Order of Santiago de Compostela.*[52] The family's spectacular art collection, of works by the most celebrated Italian painters, amongst them Titian and Tintoretto, was housed in the family *palazzo*.

Such patrons were well placed to appreciate Caravaggio's naturalism, and Marcantonio Doria was to become one of the most progressive and farsighted Genoese patrons, developing a particular taste for Neapolitan painting, and encouraging a lively artistic interchange between the two cities. In 1605, only twenty years old, he leapt at the opportunity to acquire a work by Caravaggio, and offered him the fabulous sum of 6000 scudi to decorate in fresco the loggia of his villa at Sampierdarena, outside Genoa. Caravaggio agreed to this project, but then, perhaps becoming uneasy at his lack of experience in fresco, withdrew. (Gentileschi and Caracciolo later decorated his loggia; since destroyed.) In Rome there was astonishment at his rejection of so princely a sum, but it does not seem to have damaged his relationship with Marcantonio, who later commissioned a painting from Caravaggio in Naples, and who remained attracted by Caravaggesque painting. Caravaggio is later referred to as Marcantonio's friend and he must have spent some time with him during this brief visit to Genoa; Marcantonio was a deeply religious man, a philanthropist, who made princely donations to very many hospitals, convents and churches, and he seems to have come from the same enlightened circles of the Church as the Mattei family. Later, as Girolamo Mattei had done, he requested a funeral 'with no pomp at all'.[53] But on 20 August, Fabio Masetti wrote to the Duke, 'Now peace is being negotiated for Caravaggio, and, once it is concluded, he will return.'[54] Almost immediately, on 24 August, he reported that 'Caravaggio has appeared in Rome in the hope of peace'.[55]

Throughout this trouble Caravaggio was perhaps helped by his powerful patrons, and perhaps by Del Monte, with whom Caravaggio

may well have again stayed for a while on his return to Rome. For it was to him that the tormented Este agent immediately turned for help on hearing of Caravaggio's return to Rome, begging him to order Caravaggio to despatch the promised and partly paid-for painting for the Duke of Modena. Del Monte, in reply, commented that 'one can give very few assurances about him . . . he is a very odd person [*stravagantissimo*]', and reported Caravaggio's rash rejection of the lavish sum of 6000 scudi to decorate a loggia for the Principe Doria.[56] Del Monte's remarks suggest an indulgence towards the vagaries of artistic genius, and the splendour of an artist who could turn down such princely sums. But Caravaggio had hitherto been extremely efficient, prompt to fulfil his contracts, and the superlative, *stravagantissimo*, seems also to carry the implication that Caravaggio was increasingly driven and difficult. Certainly that was Masetti's interpretation; he had been wondering whether Caravaggio might be persuaded to transfer to Mantua and work for the Duke of Modena, but on hearing of such instability he took fright and abandoned the idea.

On 26 August Caravaggio made what must have seemed a humiliating peace with Pasqualone, apologising for his action, and receiving a pardon from the Governor of Rome.

'I, Michelangelo Merisi, having been insulted by
Mr Mariano, clerk of the Vicar's Court, as he
would not wear a sword in the daytime, resolved to
strike him wherever I should meet him. One night,
having come upon him accompanied by another
man and having perfectly recognised his face,
I struck him. I am very sorry for what I did, and
if I had not done it yet, I would not do it. I beg
him for his forgiveness and peace, and I regard
the said Mr Mariano with a sword in his hand as
a man fit to stand his ground against me or
anybody else. I, Michelangelo Merisi, do affirm
all the above.[57]

It may be that Caravaggio was claiming that since Mariano did not carry a sword, even in daytime (wearing a sword at night was far more restricted), he could therefore not be challenged to a duel, and Caravaggio was therefore obliged to pursue an unarmed man. The peace was signed at the Palazzo del Quirinale, '*in anticamera illustrissimi et reverendissimi Domini cardinalis Borghesii*'. Here, for the first time, Scipione Borghese, who was later to play so powerful, if shadowy, a part in his fate, appears in Caravaggio's life. It may be that the Cardinal played an active role in this peacemaking, and that, in gratitude, Caravaggio gave him the *St Jerome* (Plate 42), a suitable gift for a new Cardinal.[58]

Caravaggio's troubles with the law were not over. On the very day he made peace with Pasqualone, his landlady, Prudenzia Bruna, to whom he had paid no rent for four months, sequestered his goods, drawing up an inventory of his possessions on 26 August, and barring him from his house. Caravaggio, in revenge, went to throw stones at her windows, and on 1 September she brought charges against him, in which Caravaggio is described as homeless, a painter '*non habentem locum permanentem*'.[59] The enraged Bruna reported that Caravaggio had damaged her blinds (and here she produced both blinds and stones as evidence), and then had returned with three friends, playing the guitar, and talking loudly in the street. This bringing in of rowdy reinforcements was characteristic of ritual attacks on property, and this behaviour was the last straw to Prudenzia Bruna, whose own house was next door to the one which she rented to Caravaggio. She also complained bitterly about his six months' unpaid rent, and a ceiling which Caravaggio had damaged. The witnesses whom she summoned to support her story, Francisca Bartholi and her servant, Lucretia, neighbours in the Vicolo of the ambassador to Florence, signally failed to do so, both claiming firmly that they were in bed 'continuously until daybreak'. They had heard nothing, and knew nothing of damaged blinds. They were, perhaps, afraid of Caravaggio's vengeance. The next month she rented the house to a more respectable lodger, the Bolognese cleric Giovanni Battista Trombini.

The autumn of this year, 1605, when, despite the continuing protection of Del Monte, Caravaggio was homeless, was a difficult and uneasy time. Throughout September and October Fabio Masetti

bewailed the problems that he was having with both Annibale and Caravaggio; Caravaggio pestered him with demands for money, and promises that the painting would be ready the next week, wheedling 32 scudi from him, and in November Masetti promised to send the Duke the views of intelligent connoisseurs on the picture's worth. But no picture was forthcoming, and in January 1606 Masetti, by now tired of false promises, and determined not to be strung along again, decided to seek help from superior powers, begging the Farnese to exert their authority over Carracci, and Del Monte over Caravaggio. The 32 scudi particularly annoyed him, and, he commented, Caravaggio blushed when he saw him.[60] Caravaggio's fortunes seemed to be sinking swiftly, and towards the end of October he was mysteriously wounded in the neck and ear, and recuperated in the house of a friend, Andrea Ruffetti, a lawyer who lived near the Piazza Colonna, and moved in literary circles. Here he was interviewed, on 24 October, by the notary of the criminal court, who commented that it was hard to see the wounds, because of their being covered with dressings, and reported Caravaggio's feeble excuse that he had fallen on his own sword and wounded himself: 'I wounded myself with my sword as I fell down these stairs, and I don't know where this took place and there was no one there.'[61] It was in this low state, homeless, inexplicably wounded, engaged in street fighting and stone throwing, yet still encircled by support, and fêted by literary men, that Caravaggio won a commission whose prestige surpassed anything he had obtained under Clement VIII: for an altarpiece in the most revered church in Christendom, St Peter's.

Clement VIII had dithered over the fate of the old basilica of Constantine, a hallowed relic of the early Christian era so venerated by Baronio, but which was nevertheless a somewhat uneasy and delapidated prelude to the massive splendour of Michelangelo's St Peter's. But on 17 September 1605, soon after the election of Paul V, the Congregazione della Reveranda Fabbrica di San Pietro advised that the old nave, now dangerous, should be destroyed, and Paul V ordered its demolition. The Congregazione had been appointed almost immediately on the election of Paul V, and had originally consisted of only three cardinals – Evangelista Pallotta, Benedetto Giustiniani, and Pompeo Arrigoni. Care

was taken to preserve relics and works of art, and the altars which had stood in the old church. Amongst these was the altar of the Palafrenieri, the Company of Grooms, which was removed from the old nave, to the right transept of Michelangelo's basilica, and as a result their altarpiece, which showed St Anne (the patron saint of the Company of the Grooms), the Virgin and the Christ Child, between Saints Peter and Paul, was no longer suitable. Anxious to retain their right to the altar, the company met on 31 October, and decided to make 'a beautiful and new painting' and appointed officials to discuss this with the painter.[62] No painter is named in the minutes of this meeting, but on 1 December Caravaggio received an advance of 25 scudi for the painting. On 8 April 1606 he signed a receipt for payment, declaring his satisfaction with the painting and referring to himself as Michel Angelo da Caravaggio. He received further payments in May, adding up to the rather modest sum of 75 scudi. It is not clear who recommended Caravaggio to the Palafrenieri. Although Caravaggio had himself been enraged by his exclusion from the altarpieces commissioned for the *nave piccole* of Clement VIII, the artists chosen – Passignano, Roncalli, Cigoli – had been responsive to Caravaggio's style, and the Cardinals associated with the commissions for St Peter's were far from hostile to him. His supporter, Giacomo Sannesio, had been connected with this project, probably after he was made a cardinal in 1604, and Benedetto Giustiniani was appointed to the new Congregazione. Del Monte was not made a member of the Congregazione until 1606, but he may none the less still have wielded some influence. He and Giustiniani are the most likely candidates for suggesting Caravaggio, and perhaps for having worked out the unusually abstract subject matter.

But Caravaggio's picture was not to stand for long on an altar in St Peter's. The carpenters were preparing its support in early March, and soon after this the painting was set on the altar in the right transept of St Peter's (where there is now a mosaic after Guido Reni's *St Michael the Archangel*). Yet within a month it was removed, for on 16 April porters were paid for carrying it to the church of the Palafrenieri, Sant'Anna dei Palafrenieri. In May the Palafrenieri made Caravaggio his final payment, so it is not entirely clear whether they, or other authorities, had rejected

the painting. For some reason the Palafrenieri had lost their right to the altar in the transept, and early in May they were negotiating for a new altar, finally acquiring one in the Old Sacristy. But the early sources do declare unambiguously that the picture was rejected. Baglione states: 'This work was painted for the Grooms of the Palace; but it was removed on the orders of the Cardinals in charge of St Peter's and subsequently given by the Palafrenieri to Cardinal Scipione Borghese.'[63]

Caravaggio's altarpiece (Col. Plate 29) was composed, like his *Madonna of Loreto*, of sculptural figures, isolated from one another, and the model is again Lena. It shows three figures of the Holy Family – the Virgin, the Christ Child, and the Virgin's mother, St Anne – staring intensely at a lashing snake at their feet. The Virgin tenderly supports her naked son, and, with her foot beneath that of Christ, both crush the serpent's head under their feet. The theme is taken from the book of Genesis (3: 15), when God says to the serpent which had tempted Eve: 'And I will put enmity between thee and the woman, and between thy seed and her seed; it shall bruise thy head, and thou shalt bruise his heel.' The serpent symbolises original sin, and the Virgin and her son stamp out the sin of Eve; it suggests too the crushing of heresy, and the importance of Mary, so belittled in the Protestant north, in the redemption of humankind. Caravaggio's composition, apparently based on Ambrogio Figino's painting for San Fedele in Milan, which Caravaggio may have seen as an apprentice, or perhaps knew through an engraving, reflects contemporary controversy over the translation of the passage. The Protestants held that it was Jesus, not Mary, who had stamped on the serpent's head, while the Catholics tended to favour Mary; but in a papal bull of 1569 it had been decreed that the Virgin, with the aid of her child, had bruised the serpent's head, and it is this doctrine that Caravaggio's placing of the feet so precisely interprets. With this somewhat recondite doctrine, Caravaggio interweaves another, suggesting, by the presence of St Anne, the doctrine of the Immaculate Conception, the belief that the Virgin had been born without sin, and thus pure, sinless, she plays a role in man's redemption.

St Anne, whose name means Grace, is an apocryphal, non-biblical figure, who had been immensely popular in the early sixteenth century,

when it was believed that she had been married three times, and these marriages gave to Christ a richly extended family, a Holy Kinship, that embroidered the stark biblical account. Such elaborations were rejected in the late sixteenth century, and both Baronio and Bellarmine believed in her monogamy; but at the same time the doctrine of the Immaculate Conception won increasing favour. It was believed that Anne, after years of barrenness, had conceived Mary in extreme old age, when she had kissed her husband, Joachim, at the Golden Gate. Thus Mary, like Jesus, her son, had been conceived without sin, and through divine intervention; her birth, too, was a kind of miracle.

In showing this scene Caravaggio separated the two faces of divine womanhood, breaking with the tradition, established by Leonardo, of weaving the holy figures together in an indissoluble pyramid. St Anne stands to one side; she is aged, with weather-beaten face and work-worn hands, just such a model as Caravaggio might have seen in a Roman market. And yet she has a grave and classic dignity; her drapery, the skirt falling in heavy, columnar folds, and the white wrap pulled tautly across her body, its startlingly white creases so crisp that they seem like deeply undercut marble, lying heavily against her body, suggest Roman sculpture, and the picture, so rooted in the present, seems to reach back to an ancient past. Her shadowy stillness and dark colours contrast sharply with the warm humanity with which the Virgin and child are painted, the light falling softly on richly coloured fabrics and flesh. The Virgin, her maternal aspect suggested by a deep décolleté, and by the tenderness of her expression, is dressed like a member of a prosperous artisan's family (this was traditional in sixteenth-century paintings of the Holy Kinship) and she has looped up her dress to reveal a darker underskirt. There is a hint of a domestic setting, for, unusually, Caravaggio has included a ceiling. Jesus is a curly-headed, entirely naked small boy, bathed in a golden light, and recoiling with an entirely natural horror, a figure that surely suggests a memory of a scene observed, of a child flinching with fear and distaste. His tense features and his whole body suggest a shrinking away, a fear that finds expression in the strangely fastidious gestures of the hands, one withdrawing within the protective embrace of his mother, and the other, silhouetted against the dark cavern that runs up

the centre of the painting, stretched bravely outwards, linking the two halves of the picture. The tension between the warm and domestic naturalism of the figures and their strange isolation in an overwhelming darkness encourages meditation on the ceaseless mystery of the incarnation and redemption, of Christ, 'incarnatus est ex Maria Virgine, et homo factus est'. And the emphatic nakedness of Christ, so human, so real, whose flesh is so vulnerable against the Virgin's hands, symbolises both primal guiltlessness, and, God made flesh, the mystery of his dual nature.[64]

This is a haunting and beautiful meditation on the Incarnation, but Bellori says that it was rejected because of the 'offensive portrayal of the Virgin with the nude Christ child'.[65] The rendering of mother and child are startlingly and, it must have seemed, shockingly naturalistic. They lack any hint of the regality associated with paintings of the mother of God and her son. Christ's nakedness may have seemed gratuitous and offensive, and treatise writers rebuked artists who showed Christ naked.

The painting increased Caravaggio's fame. Andrea Ruffetti, in whose house it was painted, asked his literary friend, Zaratini Castellini, who had advised Ripa over his Iconologia, to compose an epigram in its honour, and the faithful Marzio Milesi addressed a poem to the picture. Milesi addresses the painter still as 'angelico pittore', celebrating both his art and thought, and his poem suggests the complete orthodoxy of Caravaggio's painting, whose problems lay entirely in the style, rather than in the doctrine:

> Through Adam's sin was wretched man led astray,
> Arousing his maker's wrath
> When, God having been made man, he was reborn to a
> new life,
> For the way to heaven had been made plain.
> Whence that sharp serpent, the cause of sin,
> Was trodden underfoot
> By mother and son, and the great Vigil
> Kept by God's mother . . .[66]

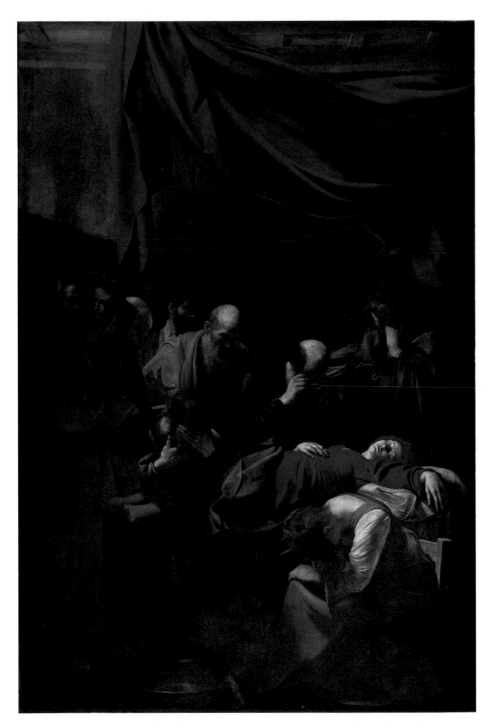

PLATE 27: *The Death of the Virgin*

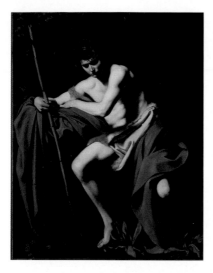

PLATE 28: *St John the Baptist*

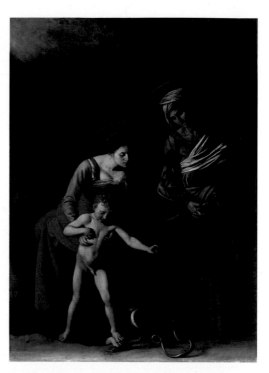

PLATE 29: *The Madonna and Child with Saint Anne*

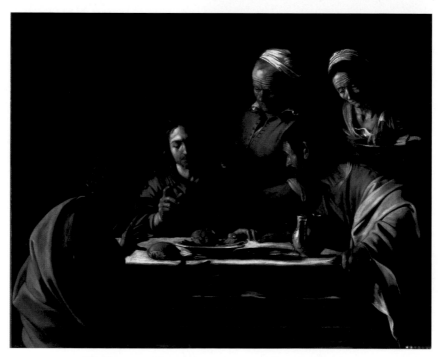

PLATE 30: *The Supper at Emmaus*

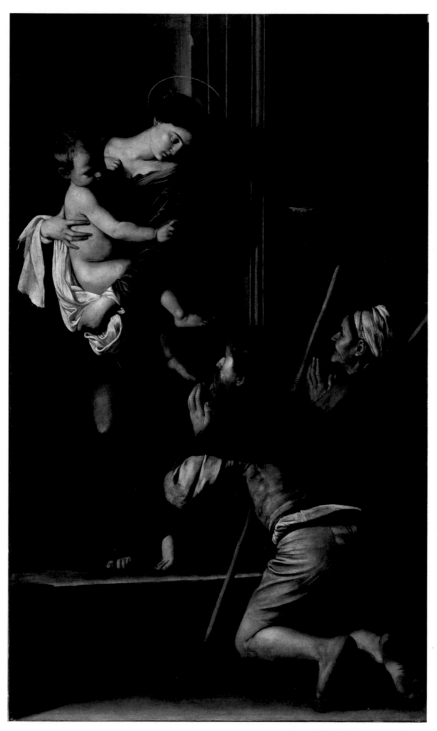

PLATE 31: *The Madonna of Loreto*

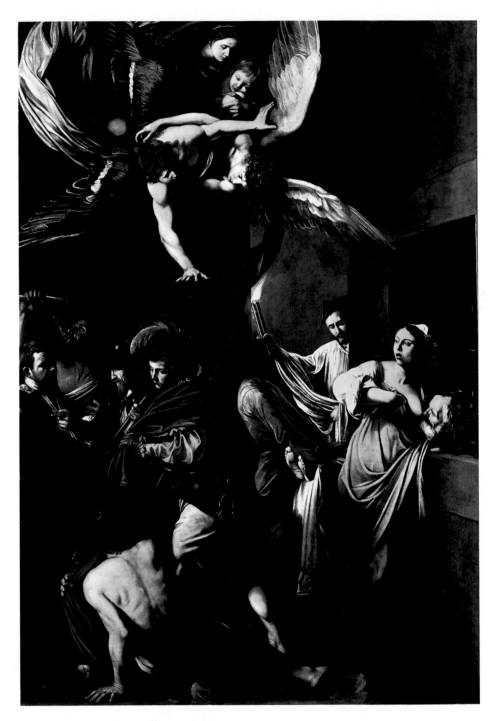

PLATE 32: *The Seven Acts of Mercy*

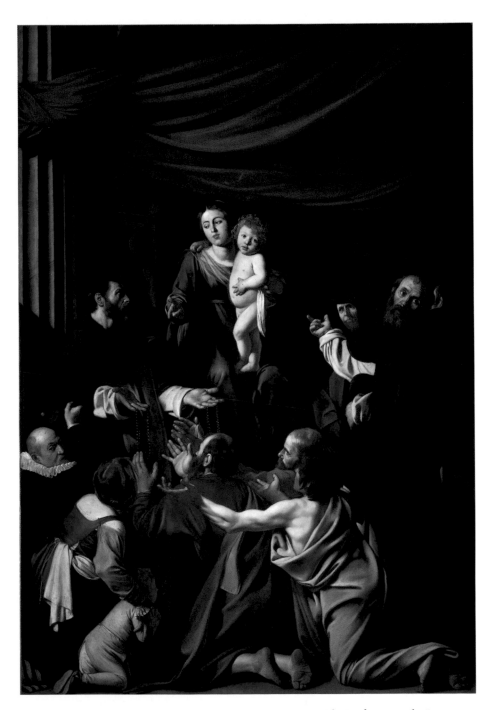

PLATE 33: *The Madonna of the Rosary*

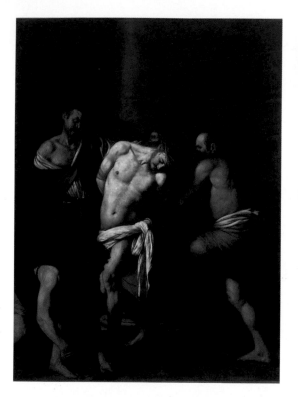

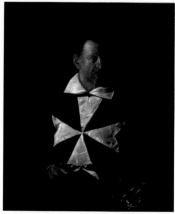

PLATE 35: *Portrait of a Knight of Malta; Fra Antonio Martelli*

PLATE 34: *The Flagellation of Christ*

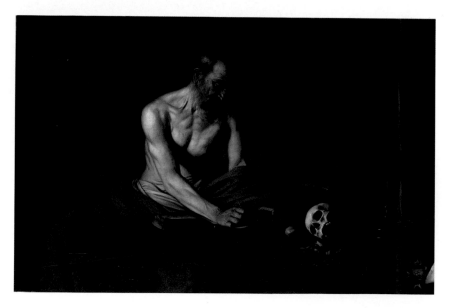

PLATE 36: *St Jerome Writing*

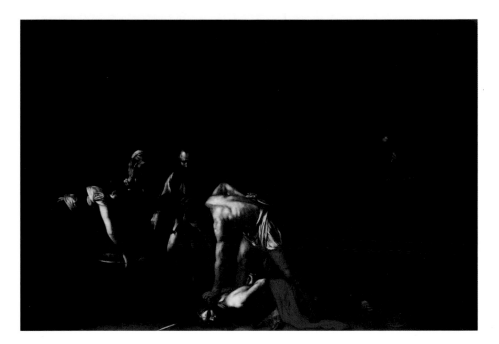

PLATE 37: *The Beheading of St John the Baptist*

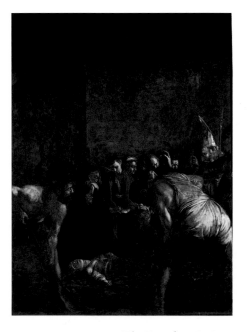

PLATE 38: *The Burial of St Lucy*

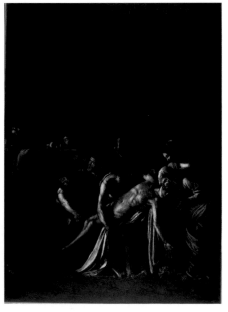

PLATE 39: *The Resurrection of Lazarus*

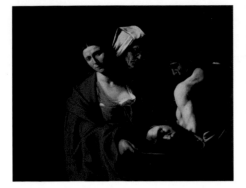

PLATE 40: *Salome with the Head of St John the Baptist*

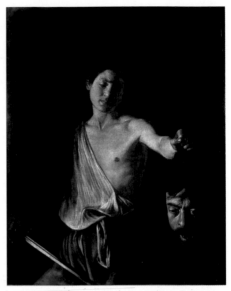

PLATE 41: *David with the Head of Goliath*

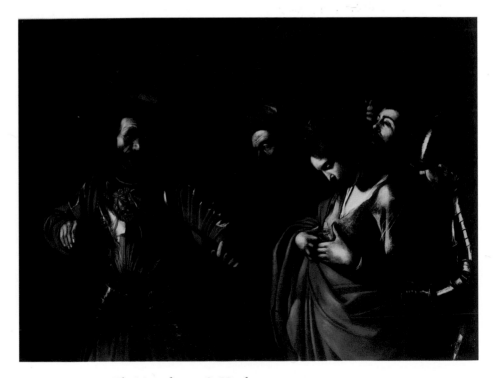

PLATE 42: *The Maryrdom of St Ursula*

Before the Madonna dei Palafrenieri had been acquired by Scipione Borghese, however, disaster overtook Caravaggio. The early months of 1606 had been very disturbed. Paul V, infuriated by Venetian attacks on the clergy, had clumsily issued an interdict against the city, causing tension throughout Europe. On 28 May the anniversary of the coronation of the Pope was celebrated, with processions designed to assert the power and glory of the papacy, and spectacular firework displays at the Castel Sant'Angelo. But the festivities were disrupted by outbreaks of violence, and at the Ripa Grande a fight broke out amongst the boats, when 'someone hit a man, who then with a blow deprived him of life'.[67] On the same evening, in the Via della Scrofa, near a tennis court close to the Palazzo Firenze, a group of armed men gathered. Petronio Toppa, a Bolognese captain who that winter had served at the papal fortress of the Castel Sant'Angelo, sat on stone near to the ball game, waiting to 'perform a service', with another soldier, a one-eyed Bolognese called Paolo (though Paolo then wandered off to visit a whore in the Campo Marzio), both of them wearing swords. A few days earlier Caravaggio had rowed with Ranuccio Tomassoni,[68] whose arrogant family dominated the neighbourhood. Caravaggio and his supporters were looking for trouble, and Toppa was hanging around to second the painter in a fight with Ranuccio. As Caravaggio and his friends walked past Tomassoni's house, just around the corner, in the Piazza di San Lorenzo in Lucina, Ranuccio, seeing them, armed himself to confront them. Violence flared up, and two sides formed. With Caravaggio were Onorio Longhi and Petronio Toppa, and an unnamed fourth man. With Ranuccio were his brother, Giovan Francesco, and his two brothers-in-law, Ignazio and Giovan Federico Giugoli.

It was Caravaggio's quarrel, and he and Ranuccio fought one-to-one for a long time; but then, as Ranuccio withdrew, he fell, and Caravaggio, who had aimed at his thigh or groin, caught him higher, and fatally, in the stomach. Ranuccio lay bleeding and his brother, Giovan Francesco, rushed to defend him. Petronio Toppa sprang to the aid of Caravaggio, preventing him from killing Giovan Francesco, but himself suffering severe wounds. Caravaggio, too, was badly wounded in the head, while Longhi, unusually, played only a minor part. Ranuccio was taken back to

his house, where, having confessed, he died, and was buried in the Pantheon on the following morning. Toppa, badly hacked and cut about, was taken to the shop of a barber-surgeon, near the Torre dei Conti, where he was treated for his wounds – his left arm had been so deeply cut that seven pieces of bone were removed from the wound, while he had received eight stabs in the thigh, a serious wound in the shin, and yet another in his left heel. His bloody state drew the attention of the police, and he alone ended in prison, in the Tor di Nona. It was known that Caravaggio too was wounded, and there was talk over where so famous a painter might have fled. He had perhaps hidden with Del Monte, who may have set about to organise his flight; or maybe he had gone to the Palazzo Giustiniani (Sandrart later wrote that 'he had to hide in the palace of Marchese Giustiniani, the protector of all virtuosi, who prized his works'),[69] or possibly to the Palazzo Colonna, here ending, as he had begun, his Roman years. Longhi took refuge in his native city, Milan, a destination perhaps dangerous to Caravaggio because of earlier crimes. The Tomassoni and Giugoli brothers went to Parma, a city ruled by their protectors, the Farnese. Caravaggio needed time to recover from his wounds, but by the following Wednesday he too had left Rome, for the safety of the Alban Hills. The long-persecuted Este agent thought that he had gone to Florence, and, on 31 May, wrote to the Duke, ever hopeful: 'Caravaggio has left Rome . . . I have heard that he has gone in the direction of Florence, and that perhaps he will come to Modena, where he will satisfy you with as many pictures as you want.'[70]

Nothing happened for a month. Then, on 28 June, the official in charge of the enquiries, Angelo Turco, put all those involved, Caravaggio, Onorio Longhi, Giovan Francesco Tomassoni, Ignazio and Giovan Federico Giugoli, in contempt of court. In the following month Petronio Toppa, from the Tor di Nona, sought to rally his friends around him, and two gave evidence on his behalf. The magistrate was looking for the fourth unnamed man, who had been on Caravaggio's side, and asked his first witness, Francesco Pioveni, who had served with Toppa in Lucca, Rome and Venice, if he knew another Bolognese corporal, Paolo Aldato – an acquaintance which Pioveni firmly denied. He added, equally firmly, that he had not been there when Toppa had been

wounded: 'I know absolutely nothing at all about this brawl except that Michelangelo Caravaggio the painter took part . . .'[71]

Francesco from Lucca next gave evidence. He described how, on the day of the murder, he had been passing the Palazzo Firenze, and had seen Toppa, with another Bolognese soldier, perhaps called Paolo, who had only one eye. Toppa asked his friend to wait for him a moment, as he had to 'perform a service'; Francesco, however, was in a hurry, and left with the one-eyed soldier. It is not clear whether this Bolognese soldier returned to play a role as the fourth man. Francesco seemed anxious to steer attention away from him, but he may well have been a friend, and perhaps Francesco wished to protect him, while at the same time was anxious to divert suspicion from himself. He concluded his evidence by stressing that he had not seen anyone with Toppa, whom he had always known as 'an honourable soldier, of unblemished reputation and repute, who would have done nothing unworthy of an honourable soldier...' It seems likely that Paolo, or Francesco himself, was the fourth man.[72]

The brawl caused a stir in Rome, and a flurry of newspaper reports circulated, while ambassadors hurried to write colourful accounts to the courts of Florence, Urbino and Modena. On the day of the brawl a newspaper gave a brief description: ' . . . on account of a game, and near to the palace of the Grand Duke, a row broke out between the son of the former Colonel, Lucantonio Tomassoni, and Michelangelo da Caravaggio, famous painter, and Tomassoni was killed by a blow delivered when, as he withdrew, he fell to the ground . . .'[73] Three days later a report added that 'Michelangelo da Caravaggio, a painter of some fame these days, is said to have been injured, but it is not known where he is . . . They claim that the cause of the fight was a bet of ten scudi on a game, which the dead man won from the painter . . .'[74] One of the representatives from Modena, Pellegrino Bertacchi, also thought that the row had flared up over a game of tennis, for a wrong call,[75] and Bellori, much later, wrote that the two young men had begun hitting each other with their tennis rackets. But Fabio Masetti made no mention of any game or bet, and believed that Caravaggio had been provoked. Writing some time after the event, Baglione presented the event harshly, with Ranuccio flatteringly presented as the distinguished victim of a

cowardly and vicious Caravaggio: 'And finally he confronted Ranuccio Tomassoni, a very polite young man, over some disagreement about a tennis match. They argued and ended up fighting.' His description of Caravaggio's fatal blow, unlike those given by the newspaper accounts, strongly suggests a guilty intent: 'Ranuccio fell to the ground after Michelangelo had wounded him in the thigh and then killed him.'[76] At the time of the fight Baglione was *caporione* of Castello, when Giovan Francesco Tomassoni was *caporione* of Campo Marzio, and he may well have been friends with the Tomassoni family. Mancini, who was more favourably disposed to Caravaggio, gave a less damaging account, and hints at some kind of feud; he makes no mention of any bet or tennis game, but, like Fabio Masetti, suggests that Caravaggio had been provoked: 'Finally, as a result of certain events he almost lost his life, and in defending himself Caravaggio killed his foe with the help of his friend Onorio Longhi and was forced to leave Rome.'[77]

The lives of Ranuccio, Onorio Longhi and Caravaggio had long been interwoven (in 1599 Longhi had been suspected of fighting with Tomassoni, and had sworn not to attack him), and later events hint that the fight was the climax of some long-running conflict. A chilling detail in one newspaper account suggests premeditation: 'It is said that Ranuccio was owed ten scudi by the painter, who, indignant with him, was delaying to pay him off and in order to protect himself from sudden injuries, [Caravaggio] had set aside six hundred scudi for himself just in case it was needed.'[78] Caravaggio had been constantly pestering the Este agent for money throughout the previous months, but none the less it is unlikely that he was planning to murder Tomassoni and then flee. It is far more probable that he was simply looking for a fight; clearly Toppa, who had asked his friend Francesco to wait a moment for him, expected shortly to be free to wander round the streets and brothels. He did not expect the 'service' to take long, or to be very serious. In the following month, on 11 July, Mario Tomassoni asked the court for time to bring his brother, Giovan Francesco, who had fled Rome, to testify on his own behalf 'on account of a peace or truce which was broken and a duel had with Michelangelo da Caravaggio . . .'[79] Later, in December of that year, Giovan Francesco, tried and condemned for '*contumacia*' (not turning up

at the trial), reappeared in Rome, and pleaded for grace from the Pope: 'And the speaker, having seen his brother thrown down criminally, and having seen that the truce had been broken, and since Caravaggio had hit him on the head and wounded him, and would have killed him, had Capt. Petronio not intervened, and then Capt. Petronio, defending Caravaggio, wounded him . . . on his knees he begs, since his brother is dead, to be freed of prosecutions and trials . . .' His plea was successful, and the magistrate decreed: 'Given what we have heard said, and having spoken with the pope, and the command given us by Farinacci, and since he did observe his exile from the city and papal state, we grant the grace in accord with the petition . . .'[80] The emphasis on a broken truce suggests that Caravaggio, like Longhi in 1599, had been ordered not to attack Ranuccio, and it is possible that the mysterious attack in October 1605, when Caravaggio claimed to have fallen on his own sword, was all part of this conflict, and that Caravaggio had not then wanted to involve the law, preferring to bide his time, waiting for vengeance.

Only nine days after Ranuccio's death arrangements were made to appoint a guardian, the respectable lawyer Cesare Pontono, for his daughter, Plautilla. Lavinia, the child's mother, was unwilling to undertake this, on account of her youth, and because she wished to get married again; Ranuccio's mother, on account of her age, was equally unwilling. Lavinia was left very little money and within a few months, in April 1607, her family were arranging a dowry for her second marriage to Fabbio Romanino de Sanctis. The rejection of Ranuccio's daughter (who was undoubtedly legitimate) and the haste of Lavinia's second marriage suggest a bad relationship between husband and wife. It is possible that, somehow, Lavinia had been insulted, or her honour impugned, and the presence of her two brothers at the side of Ranuccio may suggest that somehow their family honour was at stake. It seems likely that in some way disputes over women lay at the root of the fighting between Longhi, Caravaggio and Ranuccio, and perhaps Fillide Melandroni — Caravaggio's model and Tomassoni's whore — was involved as well.

At first it seemed as though the consequences of this brawl might not be too severe. On 16 June the Palafrenieri hastened to rid themselves of

their Madonna, painted by a homicide. It was bought by Cardinal Scipione Borghese (not given to him, as Baglione thought) and the Palafrenieri were pleased with their profit. None the less the Este agent wrote hopefully, on 23 September: 'Caravaggio having committed the homicide I told you about is at Pagliano with the intention of soon returning, and then I shall get back the 32 scudi . . .'[81] He continued to hope, well into the summer of the following year, that Caravaggio would be forgiven, because the homicide was not premeditated, and Caravaggio had been wounded. But his optimism is at odds with other evidence, for at the end of Caravaggio's life a newspaper referred to a *banda capitale* imposed on Caravaggio. This was a death sentence, and it has been suggested that this explains the suggestion of constant fear that haunted Caravaggio's final years;[82] it is possible that, whereas Longhi and the Giugoli were exiled for a few years, Caravaggio, the main perpetrator, suffered this much harsher, and, given that this was a brawl, unusually severe sentence. The harshness of the sentence may, too, reflect the elevated status of the Tomassoni, who themselves got off scot-free for similar offences. It was a truly terrible sentence, for it meant that anyone, in any place, could carry it out. But it is not entirely clear that this was so, and there remain deep ambiguities over Caravaggio's status. He did not try to hide for long, nor did the Pope later try to block his knighthood in Malta. The Este agent clearly did not think that anything very serious had happened, was irritated for the next year that the hunted man did not bother to answer his post, and seems to have been confident that Caravaggio would simply reappear in Rome, when he would recover his advance. It is striking, too, that all involved (apart from Giovan Francesco, who, as a relative of the victim, enjoyed a different status) tried to return to Rome at more or less the same time, suggesting that they had endured the mandatory time of exile

Caravaggio, Mancini tells us, on his desperate flight from Rome, 'first reached Zagarolo, where he was secretly housed by the Prince. There he painted a Magdalene and a Christ going to Emmaus, which was bought by Costa in Rome';[83] in another version he says that the picture was sent to Rome to sell. Bellori supplies the name of the prince — Don Marzio Colonna. Baglione, however, puts him in Palestrina, 'where he painted a

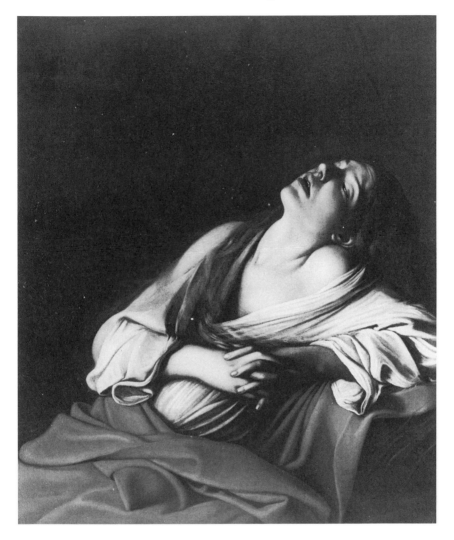

46. Caravaggio, *Mary Magdalene*
(Private collection)

Mary Magdalene',[84] and Fabio Masetti, as we have seen, in Paliano. All these were small towns in the Alban Hills, in Colonna territory: high Zagarolo, deep in wooded hills, and entirely dominated by the immense, fortress-like Palazzo Colonna, must have seemed a true and remote refuge, and it is likely that Caravaggio first stopped here. The son of Don Marzio, Don Francesco Colonna, was a close friend of Del Monte.

But it is possible that he also lingered at Paliano and Palestrina, both ruled over by another branch of the Colonna family, with whom Caravaggio had long been associated; Cardinal Ascanio Colonna was Bishop of Palestrina, while a nephew of Costanza Colonna, Filippo, was Prince of Paliano.[85] The two branches of the family were on good terms, and the Colonna continued to watch over Caravaggio.

These were desperate months for Caravaggio, sick and banished, and the paintings which Mancini describes are intensely personal. The *Mary Magdalene* is a stark image of exile, of anguish and guilt, the Milan *Supper at Emmaus* (Col. Plate 30) a tender portrayal of confidence in a redemptive Christ, who gently renews hope in the despairing disciples, and brings comfort to the poor.[86] Caravaggio had killed a man, and come close to death himself, and the first instinct of a Catholic was to make an act of contrition. His Magdalene is the sinner who spent many years in solitary penitence; she conveys the sense of desolation and abandonment that is part of the mystical experience, and the divine light creates a dazzling darkness. And in the *Supper at Emmaus* there is a truer humility, a touching sense of the meek in spirit for whom Christ came; it has none of the showy naturalism of the London *Supper at Emmaus* painted for Ciriaco Mattei, and the brilliant colours have yielded to very thinly painted browns and greys, so that the figures seem to emerge only tentatively and momentarily from the dark shadows. This is the true Emmaus, the slow revelation of the divine to the despairing disciples, sharing an early Christian meal of extreme simplicity. It is an elegiac painting, suggesting the end of a weary day: 'Abide with us, said the disciples, for it is toward evening, and the day is far spent' (Luke 24: 29). Night falls, but the risen Christ, with the power to forgive sins, brings hope in the dark journey through this world. The disciples recognise Christ in the breaking of the bread: 'And their eyes were opened, and they knew him: and he vanished out of their sight' (Luke 24: 31).

Caravaggio conveys the swiftness of their vision through light and dark. Where the London Christ shines in miraculous light, this frailer, bearded Christ seems to merge into the shadows, almost to vanish before our eyes. He is seen from a different viewpoint from the foreground disciple, heightening His unreality. A sacramental gravity touches the

peasant meal, with its broken bread, and single glass of wine, while the unlikely carpet transforms the inn's table into an altar. The rack of lamb, with overtones of the lamb of God, sets dead flesh against the promise of the Resurrection. The picture has some startlingly awkward passages, particularly the oddly drawn body and arm of the right-hand disciple, with his jutting-out ear, but none the less it represents a sudden deepening of mood, and at this moment Caravaggio felt the need for a forgiving Christ. The old woman, an emblem of the meek in spirit, evokes, for the first time, the sadness that hangs over many of his late tragic works.

As Caravaggio braved the dangerous road to Naples, perhaps with the money he had got from selling the *Supper at Emmaus* to Costa, his presence remained powerful in Rome. In the autumn the much-persecuted Baglione was shamefully attacked by a young painter, Carlo Bodello, who, protected by an armoured breastplate, had tried to kill him after Mass at the foot of the steps by the Trinità dei Monti; Baglione had refused to allow Carlo, who was a minor, and not yet a member of the Accademia, to vote for a new Principal. Now Baglione believed that Saraceni and Borgianni were encouraging Bodello to oppose him, hoping to replace him as Principal of the Accademia di San Luca with someone from their own party who would support their interests; 'They are my enemies,' complained Baglione, 'and partisans of Caravaggio, who is my enemy . . . and once they had killed me, they would have taken the news to Caravaggio, who would have rewarded them . . .'[87] It seems unlikely that Caravaggio was employing hit men in Rome to support the cause of naturalistic painting in Rome, but it is possible that his supporters were trying to remove those hostile to his return.

Laerzio Cherubini, anxious to recoup the large sum he had paid for the *Death of the Virgin*, took advantage of Caravaggio's celebrity to put the picture on the market in February of the following year. Mancini was anxious to buy it, and wrote to his brother saying that he had offered 200 scudi.[88] But Rubens, back in Rome to paint the high altar of the Chiesa Nuova, hastened to recommend it to the Duke of Mantua. The Duke's agent, Giovanni Magno, wrote to tell the Duke how greatly this picture appealed to connoisseurs of painting: '. . . for the painter is

the most famous modern artist in Rome, and this picture is believed to be the best that he has done . . .' Rejected by churchmen, the picture was secularised, acclaimed by the art world, and, Magno wrote modestly, he was impressed by the testimony of others, while not understanding 'certain artificialities which place this picture in such high esteem'. Once acquired, Magno exhibited the picture for a week, for, despite its fame, almost nobody had seen it, although it was in no way discredited for having been rejected by the church.[89]

Naples

AT THE END OF SEPTEMBER 1606, Caravaggio was in Colonna territory in the Alban Hills. By October, almost certainly still under Colonna protection, he was in Naples. Naples was a modern and vigorously cosmopolitan city, very different from Rome; it was the capital of the Kingdom of the Two Sicilies, part of the vast domains of the Spanish King Philip III, and ruled over by a series of Spanish viceroys. Tumultuous and grand, with an exploding population three times the size of Rome (by 1606 it numbered around 300,000), its port had links throughout the western Mediterranean, where trade and commerce flourished in seas made safer by the victory at Lepanto. The beauty of the bay, celebrated since antiquity, was proverbial, and from the shores there rose, as in a vast theatre, tiers of buildings, churches, palaces, monasteries, encircled by the city walls. Everything was subject to the very visible power of Spain. A strong military presence of powerful fortresses, a harbour teeming with Spanish galleys, and Spanish infantry garrisoned in its very centre ensured its security. The Castel Sant'Elmo, hewn out of the rock in the shape of a six-pointed star, dominated the hill overlooking the ancient centre. It was an emblem of Spanish power, and was visible from every quarter. By the shore, close to the new residence of the Viceroy, stood the vast Castel Nuovo. In 1606 the Viceroy was Juan Alonso Pimentel Herrera, Conde di Benevente, a sophisticated art collector, but arrogantly unconcerned for the people. Businessmen and merchants prospered in this flourishing trading centre, ensuring the city's greatness, and foreigners, soldiers, courtiers, diplomats, traders and merchants from all over Europe gathered there. Whole streets were occupied by French, Spaniards, Tuscans; Genoese and Florentine traders were prominent.

A wealth of *palazzi* and ecclesiastical buildings made the city one of the marvels of Europe. It retained its ancient Greek grid plan, and, within the ramparts, immensely long, straight avenues, most famous and

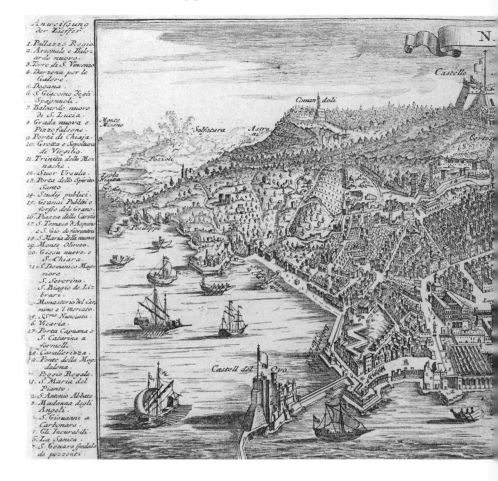

fashionable among them the new Via Toledo, thrust dramatically across its centre. It was forbidden to build outside the walls, and the chequer-board of streets was the site of a frenetic building boom. The feudal lords had been forced by the Viceroys to move to the city from their ancestral fiefs, and they vied with one another in the ostentation of their new palaces. Grandiose and massively rusticated portals, crowned by heraldic shields, and imposing façades, with heavily barred windows, proclaimed the mighty status of the ancient families, while the saturation of the city centre was intensified by the palaces of the new nobility, the high-ranking functionaries of the Spanish state, and the great Spanish families who had settled there. The area was small, and buildings rose vertiginously high, often four to six storeys. As Giulio Cesare Capaccio, for

47. View of Naples
(print)

many years secretary of the city's administration, commented, 'The city's buildings . . . are immensely high, in a way unknown in any other part of the world', creating a dark urban grandeur that was indeed unlike any other Italian city.[1] Adding to the hectic pressure on space and land were the religious orders, the Oratorians, Jesuits, Theatines, Dominicans and Benedictines, some of them immensely wealthy, and an astonishing number of churches, populous monasteries, and private oratories, as well as the grandiose cathedral, rose within its walls.

The palaces and the religious buildings took up so much space that the rest of the population were packed into crowded dwelling quarters, and a vital, noisy and violent life took place in the streets. The density, the cosmopolitan crowds, the noise, struck all observers. Capaccio wrote:

> I see in every street, every alley, at every corner, so many people who jostle me and tread on me and I have difficulty in getting away from them. I go into churches, of which there are so many, and I find them full of people; yet they are all there outside, not to mention all those who are at work, at home or in the offices and other buildings; one sees the streets, not just one or ten, but all of them, full of people on foot, on horseback, in carriages.[2]

The nobility, richly dressed in the Spanish fashion, led lives of extreme idleness, indulging a passion for luxury and display and a love of fine horses and carriages, duelling and music. But this wealth and idle luxury were brutally juxtaposed with extreme and degrading poverty. Around the enchanted seclusion of the stately rows of houses and palaces, with their scented gardens and loggias, filled with light and air and the sound of fountains, there pressed the dark mass of the people, bandits, soldiers, the landless. These continuously flooded in from the provinces, where, impoverished, and often starving, they sank to the bottom of society, to form a barefoot underclass, called the *lazzaroni*. Around the palaces and monasteries, whose heavy, excluding walls dominated the feverish activity of the streets, they lived out of doors, in dank grottoes, courtyards and foul-smelling porticoes. Ever in search of new space, they created a warren of poor dwellings, and a labyrinth of impenetrable alleys around the large marketplace, where executions took place, and the top of the Via Toledo where the Spanish infantry was quartered, and where vendettas and killings were common. The mob were feared, and Capaccio, at the beginning of the seventeenth century, wrote of them:

> Nowhere in the world is there anything so obtrusive
> and undisciplined, the result of the mixture and
> confusion of so many races . . . miserable, beggarly
> and mercenary folk of a kind such as to undermine
> the wisest constitution of the best of republics, the
> dregs of humanity, who have been at the bottom of
> all the tumult and uprisings in the city and cannot
> be restrained otherwise than by the gallows.[3]

In Naples, anarchy, which in Rome was just contained, threatened, and tumult and uprisings were feared with good cause. The 1580s and 1590s had been a period of great unrest; a revolt of 1585 had been put down with extreme and theatrical brutality, and its horrors lived on in popular myth; the Dominican Tommaso Campanella, whose popular insurrection of 1599 had been betrayed by the people themselves, languished in the darkness of prison, in the terrible Fossa di Sant'Elmo.

In courtly poetry, however, Naples remained an earthly Paradise, a land of richness and fertility, where Bacchus and Ceres seemed still to cast their radiance. In his *Portrait or Model of the Greatness, Delights and Marvels of the most noble city of Naples,*[4] the poet Giovanni Battista del Tufo, imprisoned in Milan, looked back with nostalgia to its pleasures, to its quays and markets piled high with fruits and fish, its welcoming inns, its splendid palaces and orderly hospitals. But in reality the years 1603–1606 witnessed the worst famine for forty years. The Conde de Benevente drained the people, first by rationing bread, then by a tax on fruit, and from prison Campanella harshly bewailed famine, as the greatest evil of the realm. Amid these afflictions hospices, hospitals and confraternities sprang up to assist the poor and there was an intense wave of popular devotion, a passion for relics, pilgrimages and miraculous images. Many new churches were built to the Madonna, who alone seemed to hold out hope to the suffering poor, and the cults of the Madonna of the Rosary, of the Madonna of Mercy, of the Madonna of Purgatory, all flourished.

In this turbulent city Caravaggio's path was almost certainly smoothed by the powerful patronage of the Colonna, who had always had close links with both Spain and Naples. When he finally left Naples in July

1610, he left from the residence at Chiaia of Costanza Colonna, the Marchesa di Caravaggio, and it is clear that the Colonna, on whose Latin estates Caravaggio had taken refuge, were still watching over him. The Colonna had a powerful Neapolitan presence. Don Maurizio Colonna had connections there; furthermore the fourth Prince of Stigliano, Luigi Carafa Colonna, was a nephew of Constanza's, and his immense and grandiose Palazzo Colonna, which still bears the Colonna arms (and where Caravaggio's *Martyrdom of St Ursula* now hangs), marks the beginning of the Via Toledo. Here Caravaggio was perhaps sheltered on his arrival in Naples. Luigi Carafa left family affairs to his able wife, Isabella Gonzaga, while he, a gentle and scholarly man, enjoyed the pleasures of literature and philosophy, holding a literary academy in his suburban villa, the Palazzo Cellamare, only a short walk, down the lovely Via Chiaia, from his town palace. Here Tasso had stayed, and the prince was himself an admirer of Marino, who addressed an epithalamium to his son.[5] It may have been through Marino, as well as the Marchesa, that he knew of Caravaggio, who had always acted as a magnet to literary men, and perhaps Caravaggio brought with him, as a gift to the Colonna, the *Magdalene* that he had painted in the Alban Hills and which so many artists were to copy in Naples.[6]

Shielded by such powerful support, Caravaggio was fêted by the Neapolitan art world. Naples was an artistic capital and very many painters and sculptors, and dealers in paintings and antiquities, flourished in the city, profiting from its links with other Italian cities and with northern Europe. Artists from Rome, amongst them the Cavaliere d'Arpino and his brother Bernardino, had already been attracted there, and in the busy workshop of Belisario Corenzio there flourished an elegant and pleasing decorative fresco style. The ships of Flemish merchants brought Dutch and Flemish pictures to Naples, which became extremely popular, and many Flemish painters settled there. Among them were Louis Finson and Abraham Vinck, who shared a studio in Naples from 1604, and were active dealers. An artistic colony similar to that around the Roman Trinità dei Monti and Via Margutta flourished in a parish called the Carità. At the top of the Via Toledo lay the Piazza Carità, and around it spread a web of narrow *vicoli*, or alleys,

where prostitutes and soldiers gathered and where there were many taverns. The most celebrated of these, at the top of the Via Sanfelice, was the Osteria del Cerriglio. In this parish lived the Sicilian Loise Rodriguez, from Messina, and Wensel Cobergher and Loise Croys, both Flemish artists. Near the Santo Spirito the sculptor Pietro Bernini, the father of Gian Lorenzo, had his studio, and close by lived Fabrizio Santafede, then the most celebrated of the Neapolitan painters, who was also a passionate collector and student of antiquities, and Teodoro d'Errico. Near the colony of Flemish artists were the two houses of Sebastiano Sellitto, painter and gilder, and his son, Carlo Sellitto, one close to the Palazzo Gravina, near the road that led to the monastery of Donnalbina, the other in the same area. In 1607 Sellitto opened his own workshop, and was soon successful, gaining a reputation not only as a religious artist, but also for genre, portrait and still life. The young Filippo Napoletano, later to win the protection of Cardinal Del Monte, was part of this workshop.

The most distinguished of the Neapolitan artists, Giovanni Battista Caracciolo, was on the threshold of his career. Unusually for a Neapolitan painter he was passionately interested in drawing, studying both the life model and ancient sculptures, and absorbing everything that he could from books and prints. He, too, with his large family of ten children, was to live for almost all his life in the parish of the Carità.

Amongst this group of artists Caravaggio's presence was eagerly awaited. He was already famous in Naples, and some had seen his Roman works. 'Caravaggio came to Naples,' wrote the eighteenth-century artists' biographer Bernardo de Dominici, 'where he was received with great acclaim by both painters and lovers of painting, and he paint-ed many works there.'[7] It may be that Caravaggio was welcomed by artists whom he knew; Caracciolo's art suggests that he had already studied Caravaggio's great public works in Rome, and he may have already met Caravaggio himself.[8] Louis Finson, too, on the road from Bruges to Naples, probably stopped at Rome, and looked at the works of Caravaggio which were causing so great a stir. Certainly he and Vinck later became his close friends. It was perhaps from the studio of Caracciolo or Sellitto, in the parish of the Carità, that Caravaggio

launched himself in Naples, and both painters were to fall under his powerful spell.

Wealthy Neapolitans, too, appreciated the glamour and prestige that a work by so celebrated an artist could bestow upon them. The Neapolitan nobility were uncultivated, possessing none of the sophisticated skills of Vincenzo Giustiniani or Ciriaco Mattei, but with the Neapolitan love of ostentation went a passion for the latest fashions and novelties from Rome. 'In that time the renown of Caravaggio had grown so great,' wrote De Dominici, 'and to such heights had his fame risen, that it not only echoed throughout Italy, but had also spread over the Alps. So dilettanti competed for his works, and there was no gallery in Rome, or elsewhere, of fine paintings which did not wish the adornment of a work by Caravaggio; to such a degree had he conquered the souls of connoisseurs, and of practitioners, with his new manner of darks with few lights, finishing in shadow, so that the contours are lost . . .'[9]

Bellori confirms this enthusiastic reception: 'Afterwards he went to Naples, where he immediately found employment, since his style and reputation were already known there.'[10] In a sense Caravaggio lived between two worlds; he was a bandit, condemned to death and in exile; but he was also a Spanish subject, and protected by some of the most powerful noble families in Italy. His arrival was triumphant, and to the revelatory power of his art was added the fascination of his notoriously difficult and extravagant temperament. His art responded immediately to the brutal city of Naples with a new, harsh darkness. New models appear, southern Italians, with browned, weather-beaten skins, goitrous throats, and inward-turned expressions of fatalistic suffering. There is a sense of the Neapolitan crowd, urgent and feverish, and evocative of the turbulence of Caravaggio's own life.

At once he was launched into a series of increasingly lucrative commissions, receiving a payment of 200 ducats on 6 October, when he had been in Naples for scarcely a month, for a large altarpiece showing the Madonna, with the child in her arms, surrounded by angels. Beneath, in the centre, were to be St Dominic and St Francis embracing, with to the right St Nicholas, and to the left St Vito. On the same day Caravaggio opened an account at the Banco di Sant'Eligio and deposited his

payment there. On 25 October he cashed in a money order from this
bank for 150 ducats at the Banco di Santa Maria del Popolo, presumably
to cover the expenses of the painting.[11] The patron was the wealthy
Ragusan grain merchant Niccolò Radolovich, and his altarpiece, of
which no trace remains, was to be delivered in December; Radolovich
aspired to rise into the nobility, and his patronage of so famous a painter
would have added considerable glory to the family name.

However, while Caravaggio was still working on this slightly old fash-
ioned altarpiece, he won a yet more prestigious commission, for a
Madonna della Misericordia or *The Seven Acts of Mercy* (Col. Plate 32), intended
as the high altar of the new church of the Pio Monte della Misericordia.
The Monte della Misericordia was a charitable institution which had
been founded in August 1601 by seven young noblemen, who met every
Friday at the Hospital for Incurables (the pox-ridden) and ministered to
the sick, providing them, at their own expense, with food and sweet-
meats. To the Catholic, faith without works was dead, and the Incurables
was the most famous charitable organisation in Naples, where the rich
sought sanctification through the salvation of others, and where true
charity lay in mortifying the senses, and stimulating compassion, by
mingling, as Christ had done, with dirt and disease. Del Tufo wrote in
praise of the gentleness and consideration with which charity was
administered, by those who 'serve those poor people, miserable and
afflicted, buried in great torments, full of ulcers, and perilous and fatal
illnesses, without feeling reluctance, and without giving any sign of dis-
taste'.[12] The project flourished, and in 1602 they decided to establish an
institution to practise all the seven acts of mercy, and to erect a church,
later known as the Pio Monte della Misericordia. A committee drew up
rules, and in 1605 they received an apostolic letter of recognition from
the Pope, Paul V, which accorded various privileges to the high altar. The
new church, built close to the Cathedral, was ready by 16 September 1606,
and, probably in October or November, the governors commissioned the
altarpiece from Caravaggio. On 9 January the following year, the altar-
piece having been completed with astonishing speed, Caravaggio received
370 ducats, to complete a payment of 400 ducats. The payment was
made through Tiberio del Pezzo, and the Banco di Santa Maria del

Popolo, in the Largo San Gaetano.[13] It was a considerably larger sum than that for the Radolovich altarpiece.

The Monte della Misericordia was characteristic of the very many charitable institutions that flourished in Counter-Reformation Naples: there were others to redeem Christian slaves and to bury the dead. Its founders were, however, distinguished both by their noble birth, and by their youth, for all were between twenty and thirty. In some, religious passion was dominant: Cesare Sersale, who played a central role in the Monte, having lived chastely with his wife, turned his back on the world and, in 1608, entered the Theatine Order. Andrea Astorgio, the Baron of Rocchetta, an important figure in the cultural life of Naples, was also deeply involved with the Theatines, and corresponded with Sant'Andrea Avellino. But Giovanno Battista Manso, the Marchese di Villa, another key figure, was a sophisticated gentleman amateur, skilled in arms, passionately interested in literature, and with some true understanding of the fine arts. He was a friend and patron of Tasso and Marino, and abreast of the latest developments in the Roman world of art and letters. In 1611, with Luigi Carafa Colonna, he was to found the most famous Neapolitan literary academy, the Accademia degli Oziosi. Tiberio del Pezzo, through whom the payment to Caravaggio was made, was not one of the original founders, but became a deputy in 1606, and later a member of Manso's Academy, and he too had Roman contacts.

The statutes of the Monte prescribed that there should be seven deputies, one responsible for management and patrimony, and six for separate charitable duties, listed as tending the sick, burying the dead, freeing those in prison, redeeming slaves, providing for the shamefaced poor (with food, drink, and clothes) and welcoming the pilgrim. These young men, ambitious, ardent, some highly cultivated, were looking for an artist who would bring lustre to their cause, and they seized upon the possibilities offered by Caravaggio's unexpected presence. He may have been supported by those most closely in touch with Rome — by Tiberio del Pezzo, or perhaps by Manso, aware of Marino's immense admiration for Caravaggio's art. Or perhaps the Carafa Colonna connection was again of value, and an Ascanio Carafa was one of the committee who drew up the institution's rules.

In his altarpiece Caravaggio united the theme of Our Lady of Mercy, with the Seven Acts of Mercy. His picture, however, does not show the acts carried out by the deputies (no prisoners are freed, nor slaves redeemed), nor does it suggest the young noblemen themselves; Caravaggio sets the scene in a rough Neapolitan street, excluding the world of the wealthy, and returning directly to the Gospel of St Matthew. Here Matthew describes six acts of mercy through which man, at the Last Judgement, may be saved. Christ in his glory proclaims that the blessed shall 'inherit the kingdom prepared for you from the foundation of the world: For I was an hungred, and ye gave me meat: I was thirsty, and ye gave me drink: I was a stranger, and ye took me in: Naked, and ye clothed me: I was sick, and ye visited me: I was in prison, and ye came unto me' (Matthew 25: 34–6). Matthew does not include burying the dead, but this had become part of the tradition in themedieval period.

At first sight, as the worshipper enters, Caravaggio's altarpiece seems to draw into the space of the church all the crowded confusion of the world outside, in the dark and narrow Via dei Tribunali, at the very centre of Naples and in the shadow of the cathedral. He shows the frenetic whirl of activity, and the brutal contrasts between extreme poverty and luxury, of a Neapolitan crossroads, with its tall buildings, deep shadows, its noise (both the woman giving suck, and the torch-bearing deacon, in crimson hat, seem to utter harsh and despairing cries) and overcrowding; there is a confusing tangle of gesticulating hands and legs, of movement and gesture. In the foreground crippled and naked beggars huddle together in the dark doorway of an inn, at the feet of the exotic young bravo, with feathered hat, elegant gloves, and dazzlingly colourful velvet cloak and sleeves. Behind them stands a bulky innkeeper, solid, with pudgy hands, and a fleshy, double-chinned face, strongly suggesting a model that Caravaggio had found in the taverns of Naples, whose innkeepers were legendary. He welcomes two pilgrims, one of whom is only glimpsed, his ear and baton just visible. To the right a pallbearer awkwardly struggles to carry a dead body, and an old man, through the bars of an iron grille, sucks at the breast of a young woman. This startling moment is at first absorbed into the naturalistic context, so harshly suffering yet strong is the woman's face, that of a Neapolitan

working woman, while her skirt, tucked like a bib under the old man's chin, evokes the sheets hung out to dry across Neapolitan alleys, moving gently in the breeze.

This is the dark side of Naples, where naked beggars huddled in doorways, whose prisons were feared and where the dead lay unburied in the streets. Woven into this evocation of Neapolitan life are the Seven Acts. The innkeeper welcomes the stranger; the bravo cuts his cloak in two, thus clothing the naked, and ministering to the sick. Behind him, the rough, bearded workman slakes his thirst in the heat and dust of the street, while on the right the dead are buried, and the woman visits prisoners and feeds the hungry. No one looks up in hope or joy, and the angel's hand, with its overtones of the Last Judgement, seems to weigh heavily upon the human world beneath.

Caravaggio gives this contemporary scene a universal meaning through a web of allusions to popular legends of the lives of the saints, to biblical heroes, and to the classical world. Most brightly lit, and most prominent, is the woman giving suck to an old man. This is an example of filial piety, known as Roman charity, and described by the Roman author, Valerius Maximus, in his *Of the Piety of a Daughter toward her Father* (5: 4). An old man, Cimon, in prison awaiting execution, was offered no food, but his daughter, Pero, kept him alive by suckling him with her own milk.[14] Caravaggio renders the Roman legend as an intensely human image of Christian charity, which was more often shown by a woman suckling two or more infants; it becomes an emblem of the entire painting, suggesting that celebrated passage in St Paul's Letter to the Corinthians, 'And now abideth faith, hope, charity, these three; but the greatest of these is charity' (1 Corinthians 13: 13). The old man becomes again an infant, and is reborn, and the scene suggests the metaphor of earthly life as a prison, where the soul is confined by the chains of the body. 'In our birth is our death' (*nascentes morimur*) is a cry that echoed desolately through much seventeenth-century poetry, and Campanella had written passionately of the soul's desire to soar above 'the dark prison of this world'. The bars of the prison establish the mood, and behind the central travellers the feet of the corpse follow swiftly, the candle flickering, suggesting a human life that is brutish and short.

In the centre, the young *bravo*, so boldly slashing his velvet cloak, has overtones of St Martin, a Roman soldier who shared his military cloak with a shivering beggar. His sad head is sharply juxtaposed with that of the pilgrim beside him, a haunting, strange figure, older, and more worn, his eyes heavily shaded by the wide pilgrim's hat. The pilgrim, too, is an emblematic figure, a poignant evocation of the quest for salvation, of the sense that man is a stranger in this world, journeying through darkness to the greater glories of the world beyond; Gaspare de Loarte, in his *Advice to Pilgrims* (1575), defined the pilgrimage as an exercise in faith, hope and charity, 'for our life itself is a perpetual pilgrimage of the spirit'. Christ himself was often described as a pilgrim, and he was too the recipient of the Acts of Mercy. In patristic literature the theme that through almsgiving the image of God is re-created recurs, and Caravaggio's shadowy pilgrim is surely Christ himself, suggesting the divine in the everyday world that will slowly, as in Matthew's parable, become known to us. To St Martin the presence of Christ in the poor was revealed in a dream, for, on the night after his act of charity, he dreamed that Christ appeared to him, clad in the piece of cloak that he had given to the beggar; he heard Christ say to the angels, 'Martin, while still a catechumen, gave me this to cover me.'[15] Behind the pilgrim, life-giving water gushes down the jawbone of an ass, to give life to the labourer, for this is Samson, who, after slaying a thousand Philistines with this jawbone as a weapon, suffered a terrible thirst in the desert, and called on God. 'But God clave an hollow place that was in the jaw, and there came water thereout; and when he had drunk, his spirit came again, and he revived . . .' (Judges 15: 19) Samson was a prefiguration of Christ, his thirst likened to the sufferings of Christ on the cross, and at this climactic moment he triumphs over death, and rises, as Christ was to do, to eternal life. The picture's extraordinary blend of the real and the mythical recalls the lavish decoration of the Neapolitan streets on the eve of the festival of St John, when they were richly adorned with written verses, sculptures, and paintings, of both classical and sacred subjects, of Hercules, Orpheus, Judith and Holofernes, and the deeds of Samson.[16]

In the upper half of Caravaggio's painting, the Madonna and Child

look down tenderly on the scene below. The divine and human meet, for the celestial group casts a shadow on the prison wall, and a wing thrusts against the bars; but in the street below there is no amazed recognition of the presence of the divine. The painting was originally known as the *Madonna della Misericordia* (Our Lady of Mercy), and the title suggests a type of medieval Madonna, who protected mankind beneath her ample cloak; she also suggests, as she looks down into the darkness, the Madonna del Purgatorio, who drew souls from Purgatory, and whose cult was strong in Naples. It seems that Caravaggio added the Madonna at a late stage, at the request of the patrons. She is central to their conception of charity, for the Catholic hoped for salvation through faith and good works, and through the Church and the intercession of the Madonna and saints. In Caravaggio's painting the hope of salvation remains distant, and he suggests fear, flight, the sudden threat of death itself, in scenes so furiously rendered that they evoke the recent dramas of his own life, and perhaps his own need for salvation. At the same time the picture's hectic clamour perfectly conveys contemporary spirituality, for the sense that good works were urgent, that salvation was pressing, was deeply part of Oratorian spirituality, as was the need for mortification, to come down low and touch the very centre of the suffering life of the street. This was Caravaggio's first major Neapolitan commission, and he undoubtedly intended it to launch him upon the Neapolitan stage. It is a declaration of his new naturalistic style, and young painters were to be converted to his cause, as they had been in Rome. It may be that he was given some advice by Manso, himself a poet, and the most literary of the deputies. It was perhaps Manso who suggested the episode of Cimon and Pero. The passage in Valerius Maximus is an *ekphrasis*, a description of a painting; Pero, he writes, 'filled with love, for Cimon, her father, who was very old, and whom destiny had thrown into a dungeon, nourished him by giving him her breast, as though to an infant. Our eyes are halted, stilled by wonder at the sight of this action in a painting; they are seized with admiration at this image, which renews and gives new life to an antique scene; in these mute and unfeeling figures, they seem to see bodies which act and breathe.'[17] Caravaggio was perhaps inspired to pit himself against this evocation of the naturalism

of ancient painting, and the drops of milk caught in Cimon's beard are a *tour de force*, like Zeuxis' grapes, of naturalistic art.

It seems likely that, at the same time as *The Seven Acts of Mercy*, Caravaggio was working on another large altarpiece, *The Madonna of the Rosary* (Col. Plate 33). This ambitious work was on the art market in Naples in the autumn of 1607, but it is not known who commissioned it, nor for whom it was painted, nor is it entirely certain that it was painted at this moment in Naples; it is a large painting, and was intended as an altarpiece. There are, however, strong arguments in favour of a Colonna commission, perhaps for an altarpiece for a Dominican church in Naples. The painting is a rosary altarpiece, and it shows the Madonna instructing St Dominic (his forehead emblazoned with a white star, for, at his baptism, his godmother saw a star descend on his brow) to distribute the Rosary to the faithful. The patron is sheltered by the saint's cloak, and invites the spectator to worship. The Rosary, of which each bead represented a mystery in the life of the Virgin or of Christ, was a form of meditative prayer, a way of deepening faith through pondering the vivid reality of the Gospel. Attacked by Luther, devotion to the Rosary had begun to revive in Italy in the second half of the sixteenth century, and it exploded as the century drew to a close. It gained new life through being associated with the Christian defeat of the Turks at the Battle of Lepanto in 1571, with the belief that the Virgin herself had caused favourable winds; Filippo Neri held that it was the prayers of the meek to the Madonna of the Rosary that had brought victory, and Don Juan hung his triumphant armour before a statue of the Virgin in Naples. Amid the fervour of these years, the Feast of the Rosary was established in 1573, and there was a spate of books and writings dedicated to the Rosary, two of the most influential, by Gaspare de Loarte and Luis de Granada, appearing in Rome in that year. Rosary altarpieces began to incorporate the heroes of Lepanto, and it seems likely that it was a Colonna, a member of the family of the great hero of Lepanto, Marcantonio Colonna, who appears in Caravaggio's altarpiece, before the column (*colonna*) that was his heraldic device.[18] One candidate is Don Marzio Colonna, who, Bellori believed, had protected Caravaggio in the Alban Hills, and whose mother, Donna Orinzia, had established a

confraternity of the Rosary at Zagorolo in 1575. Or it may be Antonio Colonna, father of Luigi Carafa Colonna, who perhaps welcomed Caravaggio to Naples. Antonio was a descendant of the great Marcantonio, and had himself fought at Lepanto, and was buried in the Chapel of the Most Holy Rosary in San Domenico, Naples, where Luigi too was to be buried. The portrait shows a man older than Luigi, but, with his slightly old-fashioned Spanish dress, this may be a commemorative portrait of Antonio. The picture may have been commissioned for this chapel in San Domenico, or possibly for another Dominican church in Naples.

Del Tufo celebrated the role of the glorious Colonna in the unceasing fight against heresy, and Caravaggio's picture suggests a parallel with Dominican valour. The Black Friars are an overwhelming presence in the painting, and they confront the viewer like a military unit. On the right stands St Peter Martyr, a thirteenth-century Dominican friar, with his attribute of a ghastly wound on his head. Killed by a heretic, he points to the Virgin, inviting the spectator to defend her cult against heresy. The cult was particularly associated with the Dominicans, and Capaccio describes the celebrations in honour of the Virgin of the Rosary at the church of San Domenico, which brought 'the odour of sanctity, consolation, and refuge to all the world'. Throughout the city, he continues, young and old, women and girls, artisans and gentlemen, sang the praises of Mary and of Jesus, and from the eyes of great nobles, and of the most lowly, fell ardent tears of devotion.[19] At the church of Santa Maria della Sanità, in an impoverished part of Naples, where misery was long and deeply rooted, a more popular cult flourished, and here a venerated image of the Virgin worked miracles.[20] The Dominican Luis de Granada wrote eloquently, 'The Rosary is medicine to the ill, happiness to the afflicted, strength to the weak, remedy to sinners, pleasure to the just, help to the living, prayer to the dead, and a universal comfort to all the church. She is the royal door, through which we enter, and go to the heart of God . . . she is the ladder, such as Jacob saw, through whom the earth is joined to the sky, and which angels ascend and descend, taking our prayers to God . . .'[21]

Caravaggio's work seems entirely orthodox, with the Virgin as media-

tor, uniting high and low. For Rosary confraternities were hierarchical organisations, intended to bind together rich and poor in the devotional activity of reciting the rosary, whose cult offered hope to the poor. Caravaggio included the aristocratic patron, and suggests a brotherhood which transcends social barriers. But the picture was not installed in a Neapolitan church, and in 1607 it was put on the art market. It is possible that it had been rejected by the church for which it was painted, and perhaps, although entirely orthodox, it lacked the celebratory quality of many Rosary altarpieces connected with Lepanto, and at the same time failed to create the reassuring sense of civic harmony that is so pronounced in many contemporary renderings. It includes an aristocratic patron, but none the less, where heaven and earth meet, there kneels a group of Neapolitan *lazzaroni*, their dusty feet thrust towards the spectator, whose fevered and urgent gestures had a disturbing quality. These poor are not devotionally idealised, as they are in the works of contemporary Neapolitan painters, and they perhaps seemed threatening in a brutal and despairing city where the mob was feared.

And this quality may have struck the congregation of San Domenico, for which the picture was perhaps intended, with particular force. For San Domenico was an aristocratic church, in the city's ancient centre, its sacristy lined with royal tombs, and frequented by a cultivated élite. Later, when a more popular form of reciting the Rosary was introduced, the aristocratic women who prayed at San Domenico complained that this was fitting only for the lower classes, for women of the people,[22] and such an élite congregation may also have disliked a picture that gave too great an urgency to the world of the poor. The new popular cult had its centre at the Dominican church of Santa Maria della Sanità, and it seems unlikely that this church was the intended destination of the altarpiece, for there seems no reason why they would have rejected it. The church was later to commission a vast altarpiece of the *Circumcision* from Caravaggio. It is possible that Don Maurizio, if he was the patron, put the picture on the market as soon as Caravaggio left Naples to solve some of his dire financial problems.

The events surrounding *The Madonna of the Rosary* remain mysterious, but *The Seven Acts of Mercy* was a success, treasured by the confraternity,

and with it Caravaggio's fame in Naples grew, and patrons of increasingly elevated stature, connected with the vice-regal court circles, began to seek the lustre of a work from his hand. Almost immediately he won the commission for a painting of *The Flagellation of Christ* (Col. Plate 34), for the chapel constructed within the courtyard of the monastery of San Domenico, which had been donated to the de Franchis family by Ferdinando Gonzaga, Prince of Molfetta, who had familial links with the Colonna Carafa. It is mentioned first by Bellori in his list of paintings done at Naples, and it is Bellori who gives the name of the patrons, de Franchis or di Franco. The de Franchis were an important family, from the upper bourgeoisie, and a street in the city, in the area around San Domenico, where their family *palazzo* was, was named after them. Their high standing had been established by Vincenzo de Franchis, who, before his death in 1601, had been Vice-Chancellor of the kingdom. Lorenzo, one of Vincenzo's three sons, became an official at the Confraternity of the Pio Monte della Misericordia in 1607, and, a witness to the success of Caravaggio's altarpiece there, he perhaps recommended Caravaggio to his brother, Tommaso de Franchis. Tommaso, court chancellor until 1642, was the most important family member of this generation and in May of 1607 he made a series of payments to Caravaggio. On 11 May Caravaggio was paid 100 ducats, to complete a payment of 250 ducats, for a painting which he had not yet delivered, and which was presumably *The Flagellation of Christ*, already nearing completion.[23] Later in the month, on 28 May, he received a further payment, of 40 ducats, probably also for *The Flagellation*, but just possibly for another painting.

The Flagellation of Christ was a prestigious commission, and for it Caravaggio created a dark and tragic work. Christ's scourging, ordered by Pontius Pilate, governor of Judaea, before he delivered him to be crucified, is starkly described in the four Gospels; John describes how, after Pilate has offered to release one of the prisoners, the crowd cries out, "'Not this man, but Barabbas.' Now Barabbas was a robber. Then Pilate therefore took Jesus, and scourged him' (John 18: 40 and 19: 1). The scene's most celebrated High Renaissance rendering, *The Flagellation of Christ* by Sebastiano del Piombo, in San Pietro in Montorio, Rome, inspired many later versions, in which the emphasis is on idealised

figures, in complex and difficult poses, caught in dramatic action, and twisting and turning through complex layers of space. Caravaggio rethought Sebastiano's composition, and his massive workmen no longer suggest an abstract idea of violence, but with awkward movements – one pulling Christ's hair, jerking him into place against the column, the other steadying a foot against his legs while tightening the bonds – concentrate on their job. Against their harsh brutality he sets a powerful Christ, painted with the heroic monumentality of classical sculpture, which emphasises the moving vulnerability of the intensely naturalistic flesh.

This naturalism, and the complex and tender beauty of Christ's expression, encouraged meditation on the mystery of the incarnation, of God made man, and yet condemned by man. Christ was brought lower than Barabbas, the robber, and in Caravaggio's picture Sebastiano's elegant Renaissance building, suggestive of Pilate's judgement hall, has yielded to a murky Neapolitan dungeon, where Christ, pitifully isolated, is tortured as a common criminal. St Paul had written: 'But [Christ] made himself of no reputation, and took upon him the form of a servant, and was made in the likeness of men: And being found in fashion as a man, he humbled himself, and became obedient unto death, even the death of the cross' (Philippians 2: 7–8). Contemporary devotional tracts emphasised this humility, and Luis de Granada, stressing the strength of Christ, 'the true Samson',[24] yet bound by man, wrote, 'For what is further from the majesty of God, than the baseness of these beatings? This is the punishment of slaves and robbers . . .'[25] In the early stages of this painting Caravaggio included, to the right of Christ, the portrait of a kneeling man, gazing upward with passionate devotion. Almost certainly Tommaso de Franchis, he was perhaps intended to be shown as contemplating the Flagellation, and participating in its sorrows. The picture may suggest the concerns of the flagellant communities which were prevalent in Naples. Carlo Borromeo had earlier tried to restore a deep meaning to the practice of flagellation, stressing that through the use of the scourge the worshipper may partake of the sufferings of Christ and atone for the sins of the world. Flagellation was practised in darkness, with a single light, which shone on an image of the crucified Christ. De Franchis probably asked Caravaggio to change the composition, but,

although the spectator is removed from within the picture, it retains a quality of passionate and intense meditation on the body of Christ. A shaft of light from the left floods across Christ's body, revealing it with a startling, visionary brightness. The picture has an ascetic, Borromean quality, and increased Caravaggio's fame, although de Dominici later complained that the body of Christ was ignoble.

With this series of great altarpieces Caravaggio transformed the Neapolitan art world. The response to his art was immediate, and the church of the Lombard nation, Sant'Anna dei Lombardi, became a centre of Caravaggesque painting, for which, later, Caravaggio was himself to paint three great works. Here, in 1608, Carlo Sellitto began a cycle of paintings already influenced by Caravaggio's use of light and dark, and Battistello Caracciolo was commissioned to paint frescoes (destroyed) for another chapel in the same church. To these artists Caravaggio's art, even though they may have known some of his Roman works, was truly a revelation, and he altered the course of Neapolitan painting. De Dominici suggests the excitement with which Caravaggio's works were greeted: 'In every way the new manner of that terrible style of shadowing, the truth of those nudes, the resounding lights without many reflections, stunned, not only the dilettantes, but most of the practitioners'. Caracciolo, he continues, abandoned his studies, and became a passionate convert, copying many of Caravaggio's works, amongst them *The Flagellation*.[26] Flemish artists, too, were enthralled, and Louis Finson began a series of copies of his work which helped to spread his fame throughout Europe; he shared a studio with Abraham Vinck, and they were particularly close to Caravaggio. The scholar Peiresc later wrote that Finson 'has all the style of Michel Angelo da Caravaggio and has learned from him', and Giacomo di Castro, a disciple of Caracciolo, wrote later that Vinck 'was a very close friend of Caravaggio'.[27]

Caravaggio was enjoying immense success in Naples, but suddenly, at its very height, he left for Malta, arriving there early in July 1607. This was an extraordinary and puzzling move; Malta, a small fortress island, offered none of the opportunities or pleasures of Naples, and no artist of Caravaggio's stature had ventured there. In the early months of this year Caravaggio's fame had continued to grow in Rome. In April the

Death of the Virgin had been exhibited to the Accademia di San Luca, and the most famous Roman painters had flocked to see it and to pay it homage. In May and June the Este agent was still expecting Caravaggio's return, writing, on 27 May, 'because that homicide was not premeditated, and he too was seriously wounded, there is talk of his forgiveness, and when he comes back I shall not fail to get the money', and, as late as 2 June he was complaining that Caravaggio had not answered any of his letters asking for a repayment of his advance, concluding – 'while he is exiled I doubt if I shall succeed, but as soon as he returns I will not let him off'.[28] Caravaggio was longed for in Rome, and maybe he was encouraged to go to Malta by his noble protectors, who saw a knighthood as a first step to redeeming him from exile and banditry. His *Madonna of the Rosary* was left in Naples, probably with Finson and Vinck, and on 15 September 1607 the Mantuan agent Ottavio Gentili wrote to the Duke Vincenzo I Gonzaga, who had bought the *Death of the Virgin*, 'I have also seen some good things by Michelangelo da Caravaggio that he has painted here and which are for sale.' (He does not mention the picture by name.) A little later in the month, on 25 September, Frans Pourbus, the court painter at Mantua, who was then in Naples to look at the collection of the Prince of Conca, wrote to the Duke that two further works by Caravaggio were available in Naples: 'I have seen two exceptionally beautiful paintings by Michelangelo da Caravaggio; one is of a Rosary and was made as an altarpiece: it is 18 palmi high and they want for it not less than 400 ducats; the other is a gallery painting, with half-length figures of Judith and Holofernes.'[29] Pourbus's letter undoubtedly refers to *The Madonna of the Rosary* and these letters strongly suggest that the picture was painted in Naples. No buyer was forthcoming, and Finson and Vinck finally took it back to Antwerp, where it was later presented by a group of art lovers, amongst them Rubens and Jan Breughel, to the Dominican church of St Paul.

Caravaggio in Malta

A T THE END OF MAY 1607 Caravaggio was working in Naples, but by 26 July, he was established on the small Mediterranean island of Malta, enjoying the hospitality of the Knights of the Order of St John. The traveller George Sandys describes Malta as lying 'in the Lybian sea, right betweene the Tripolis of Barbarie and the South-east angle of Sicilia: distant an hundred fourscore and ten miles from the one, and threescore from the other'.[1] It was famous as the home of an ancient Christianity, the island of Melita, whose barbarous people had shown no little kindness to the shipwrecked Apostle Paul (Acts 28: 1–2); now, through the lustrous presence of the Knights, who had moved there from Rhodes in 1530, it shone as the glorious shield of Christian Europe, enshrining the values of Christian chivalry. It was a bulwark against the Turks, for from Malta it was but a step to Sicily, and thence to Italy and southern Europe. The Knights, members of the most illustrious families of aristocratic Europe, were warriors who took the monastic vows of poverty, chastity and obedience, and dedicated themselves to the defence of the Catholic faith against the infidel and to the protection of the ill and weak. Francesco Sansovino, in his popular handbook on orders of knighthood, *Delle Origine de Cavalieri*, wrote: 'Every brother . . . fights for religion, for the Catholic faith, observes justice, defends the oppressed, and comforts them . . . Applies himself to moral and theological *virtùe*. Defends widows, and wards.'[2]

The late sixteenth century, when the Ottoman Empire threatened, and the religious militancy of Spain was at its height, was a glorious period in the Knights' history. In 1565, in the Great Siege of Malta, they had, against terrible odds, and suffering appalling losses, fought off a massive Turkish onslaught made by the most powerful Turkish sovereign, Suleiman the Magnificent. The Siege was marked by individual feats of heroism and macabre acts of cruelty. The Turks floated the bodies of decapitated knights on wooden crucifixes in the Grand Harbour, and

48. Matteo Perez d'Aleccio,
The Investment of Fort St Michael
(Valletta, Grand Master's Palace)

Jean de La Valette Parisot, the Grand Master, who became an almost legendary hero, responded by firing Turkish heads from the guns of Fort St Angelo. In the massacre at Fort St Elmo 120 knights were killed (the largest number from Italy) and their deaths were hailed as martyrdoms. Their heroic endurance made the Siege celebrated in the annals of warfare, and Sansovino wrote, 'worthy of being inscribed in the annals to the eternal glory of God, and of St John, and also of these illustrious knights'.

With these heroic feats the Order regained some of the lustre it had lost since the exile from Rhodes, and its glory was increased by the distinguished role the Maltese galleys played at the Battle of Lepanto in 1571, although its losses were heavy, and the general, Pietro Giustiniani, died in battle.

In the succeeding years the Knights were at the peak of their fame, acknowledged as the exemplars of Christian chivalry throughout Europe. The dream of becoming a Knight of Malta obsessed many young

noblemen, most vigorously around the turn of the century, when an unusual number – and the majority Italian – took the habit.[3] It was a dream that Caravaggio may have cherished for many years. His birth had taken place amid the dangers and triumphs of Lepanto, in the shadow of the family of the great hero of Lepanto, Marcantonio Colonna, and his very name, Michelangelo, had a victorious air. The ideals of Christian knighthood, of a glorious war against the powers of darkness, were a powerful call; and Caravaggio, so obsessed with status, so quick to feel slighted, aspired, as many painters did, to inclusion within the flower of European aristocracy. Bellori believed that Caravaggio went to Malta to receive the Cross; Caravaggio, he wrote, 'was eager to receive the Cross of Malta, which is usually given *per grazia* to honoured men for their merit and *virtùe*. He decided to go to that island . . .';[4] while Sandrart felt he was driven there by envy of the superior status of the Cavaliere d'Arpino.

After the Great Siege the Knights built the new capital of Valletta, named for the hero of the Siege, which was almost complete when Caravaggio arrived there. Valletta was an unassailable fortified stronghold, on the rocky promontory of Mount Sciberras; Sandys, on the island a year or two later than Caravaggio, described it as 'now almost absolutely finished . . . not great, but faire, exactly contrived, and strong above all others: mounted aloft, and no where assailable by land, but at the Southend. The walls of the rest do ioyne to the upright rocke, as if of one peece, and beaten upon by the sea.'[5] It was also elegant and beautiful, built like an ideal city of the Italian Renaissance on an ancient grid plan, and entirely symmetrical. Small gardens and fountains enriched the neat chequerboard of streets. The side streets descended by steep steps to the sea, while horses and mule-drawn chairs crowded the wider streets running lengthways. Within the ramparts was a city of churches and palaces, which rose from the shore, tier by tier, creating a play of light and shade against the soft and glowing stone buildings.

The young knights lived in the Auberges belonging to each nation, for the most part two-storey buildings, with flat roofs, on which they passed the summer evenings, and long, severe façades, where the trophies and escutcheons carved on their heavily rusticated porticoes proclaimed their national warrior pride. The Auberges and palaces were not separated

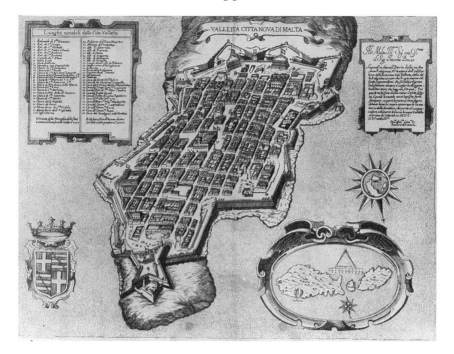

49. Francesco dell'Antella, *Valletta*
(from G. Bosio, *Dell'Istoria della Sacra religione et Ill ma Militia
di San Gio.Gierosol.no di Iacomo Bosio*, Rome, 1630)

from the population, as they had been in Rhodes, but rose, with a world-
ly air, in the narrow and crowded streets of Valletta, where traders in
luxury goods, from the East and from Italy, competed for the custom of
the five or six hundred noble warriors settled there. The atmosphere was
far from monastic and Sandys gives a lively description of the many
temptations that beset the sword-bearing youth of Europe:. 'The
Malteses', he writes:

> . . . are litle lesse tawnie than the Moores, especially
> those of the country, who go halfe clad, and are
> indeed a miserable people: but the Citizens are
> altogether Frenchified: the Great Maister, and maior
> part of Knights being French men. The women

weare long blacke stoles, wherewith they couer
their faces (for it is a great reproch to be seene
otherwise), who converse not with men, and are
guarded according to the manner of Italy. But the
jealous are better secured, by the number of allowed
curtizans (for the most part Grecians) who sit
playing in their doores on instruments; and with
the art of their eyes inueagle these continent by vow,
but contrary inpractise, as if chastitie were onely
violated by mariage . . .[6]

And violence was endemic, for as the Knights grew more numerous, and
danger lessened, their haughty arrogance and worldly aspirations
increased (Gibbon was to say, 'The knights neglected to live, but were
prepared to die in the service of Christ'), and the years around the turn
of the century were marred by brawling and by incidents such as a revolt
in 1581 against the Grand Master for attempting to clear Valletta of loose
and disorderly women.[7]

At the centre of this small, cosmopolitan, but confined and heavily male
city was the opulent court of the Grand Master, Alof de Wignacourt.
Wignacourt, a French noble from Picardy, had arrived in Malta immedi-
ately after the Great Siege, inflamed by a dream of glory created by the
already legendary events of 1565. The Order's historian, Giacomo Bosio,
tells us that he arrived on 2 June 1566, 'a most noble young Frenchman, in
the company of many other of the leading aristocrats of that nation' who,
inspired by rumours that the Turks might strike again, and zealous to fight
against the Infidel, had 'with most generous spirits left their homes' to shed
their blood in defence of the Holy Faith.[8] He took the habit in August of
that year, becoming Grand Hospitaller of France, and embarked on a glit-
tering military career. He was made Captain of the City of Valletta, and
played a dominant role in the ceremonial entry to that city; and, on his
election as Grand Master in 1601, flags bearing his arms adorned the
Palazzo Magistrale, and he pledged himself to 'bring back the Order to its
former splendour and greatness'.[9] On Caravaggio's arrival Wignacourt, a
stocky, balding man, with a rough warrior's face, and a large and pro-

nounced wart to the right of his nose, was sixty, at the height of his fame; Sandys wrote of him: 'This man is a Pickard borne, about the age of sixtie, and hath governed eight yeares . . . For albeit a Frier (as the rest of the Knights) yet is he an absolute Soueraigne, and is bravely attended by a number of gallant young gentlemen.'[10] In 1607 Wignacourt received the rank of Prince of the Holy Roman Empire, to which the style of Serene Highness was attached. The Palace of the Grand Master was a large, block-like building, built around courtyard gardens, and frescoed with crowded scenes of the legendary events of the Siege of Malta, by Matteo Perez d'Aleccio, an artist who had reached Malta after fleeing some obscure troubles in Rome.[11] Packed with the grisly details of slaughter and martyr-dom, these were propaganda works which kept the glory of the Order ever before the eye. Here Wignacourt held a splendid court, a display of rich-es and power, and surrounded himself with pages, over the years increas-ing their number from eight to sixteen. On his death he left 200 slaves, great wealth in ransom money, and a sumptuously furnished palace – a ll achieved while at the same time spending lavishly on the houses and furnishings of the Knights.

The flower of European aristocracy was so zealous to enter the Order that the Grand Master was courted by the most noble families, and was driven to lament the excessive pressure put on him by Cardinals and great princes for the granting of special favours.[12] Among his vast network of correspondents, which stretched throughout Europe, were men already closely linked to Caravaggio, who may well have played some role in supporting his quest for a knighthood and in encouraging his welcome by those closest to Wignacourt. The Giustiniani name recurs, for Marc'Aurelio Giustiniani, a cousin of Cardinal Benedetto, and brother of Orazio Giustiniani, a Knight of Malta, was on the island in July 1607, wishing to offer the Order property at Venosa, in the Kingdom of Naples, for the founding of a command by the Italian division. The Cardinal had himself written to Wignacourt to ensure a warm reception, and in August Wignacourt replied, assuring him that all had gone well.[13] And in an extraordinary way the name of the powerful Colonna family appears yet again, and Caravaggio's life became enmeshed with that of Fabrizio Sforza Colonna.[14]

One of the six sons of Costanza Colonna, Marchesa di Caravaggio, Fabrizio had led a dramatic life of unexplained crimes and extreme reversals of fortune, enjoying a strange status between prisoner and celebrity, and watched over and protected by the most powerful men in Italy – a life that has many parallels with that of Caravaggio. He had fallen foul of the law in 1602 but the Pope, who did not want to try one of so exalted a lineage in Rome, had sent him to Malta, entrusting him to the justice of the Order. The fate of Fabrizio became a *cause célèbre*; his arrival on the papal galleys at Civitavecchia in 1602, to be put in prison awaiting his trial, was reported in the Roman newspaper[15], and once exiled at Malta he was imprisoned, albeit with some freedom, for four years. Yet despite imprisonment and exile, in 1603 he was allowed to share the Priory of Venice with his uncle, Cardinal Ascanio Colonna, the Marchesa's brother. In 1605 Wignacourt wrote to Costanza Colonna, assuring her that that he was doing all he could to help her son, around whose cause had rallied the greatest and most prestigious names in Italy. In 1606 the Inquisition decided to release him, as his crimes remained unproven, and his imprisonment had been long. While welcoming this decision, the Pope demanded that he should stay three more years on the island, putting himself at the service of religion. Passing, as dal Pozzo remarked, 'in this way from prison to command',[16] he became General of the Hospitaller galleys until 1608, a post of great importance. Wignacourt hastened to write to the Marchesa di Caravaggio, on 30 June 1606, to express his great pleasure at Colonna's release, assuring her how deeply he esteemed her son's many qualities, and how passionately he desired to serve the Marchesa herself; he wrote in a similar vein to Cardinals Montalto and Arrigone and to Francesco Borghese, stressing how hard he had toiled in Colonna's cause. On his first voyage as general of the galleys, Colonna went first to Barcelona then spent the entire winter at Marseille, where a new galley was being fitted out, and finally left with five galleys, and, according to dal Pozzo, 'a good number of galley slaves, donated by the most Christian King'. He paused at Genoa, and again at Naples, where he embarked with 'another good number of galley slaves, donated by his most Catholic Majesty' and returned to Malta on 12 July 1607, disembarking on the following day.[17]

Almost certainly Caravaggio arrived with these galleys of the Order, commanded by Fabrizio Sforza Colonna, his path smoothed by the old feudal connection.[18] Immediately on his arrival, on 14 July, Caravaggio was made welcome at the highest level, and on the same day he began to mix with the Knights, to experience the aristocratic pleasures of Malta, yet also to witness the vigilance of the Inquisition. He was entertained, in the company of a Greek painter, at the house of a Sicilian Knight, Fra Giacomo Marchese, both of whom had also arrived on the galleys. A few days later, on 22 July, the Greek painter was accused of bigamy before a tribunal of the Inquisition; Paolo Cassar, a witness against him, described the gathering at Fra Giacomo Marchese's house – '. . . and while I was talking to the knight fra Gio Battista Mont'alto about his business the above-mentioned Fra Giacomo Marchese was talking to the painter Michel Angelo Caravaccio [sic]. At that time the same Fra Giacomo turned to us and said to us: There has come here on the galleys a painter who keeps two wives, one in Mussumeli, and one here in Malta: he did not mention his name . . .'[19] A few days later, on 26 July, Caravaggio (described as Roman) himself appeared before the Inquisitor, Leonetto Corbario, saying that he knew nothing about the matter, except that 'in the house of Fra Giacomo di Marchese is staying a Greek painter who came fifteen days ago on the galleys'. At the end of September Fra Giacomo Marchese brushed aside the whole episode as a misunderstanding. He had, he says, been jesting with a Sicilian, who had been invited to his house 'and as he was fond of saying jokes at times we laughed at him. I said to him that if he wanted to marry one of my slaves in the house, I would give her to him – this I said jokingly. He replied: Yes that I want to do like a man who keeps a wife in Sicily and another one here in Malta – without mentioning who he was, and all this in fun.' He denied any knowledge of a bigamous painter, and the trial was dropped, for the painter was said to have left the island. Caravaggio was clearly already well known, fêted in the most elevated society, attended by slaves (Sandys estimated that there were 1500 on the island), who formed a conspicuous feature of the life of the Christian Knights, carrying out menial tasks, or awaiting lavish ransom.

It seems that almost at once Caravaggio moved in the innermost court

circles, and the early biographies strongly imply that his first Maltese works were portraits of Wignacourt. Baglione tells us that Caravaggio went to Malta, 'where he was invited to pay his respects to the Grand Master and to make his portrait',[20] and Bellori that 'he was introduced to the Grand Master Wignacourt, a French gentleman. He painted him standing dressed in armour, and seated without armour, in the habit of Grand Master; the first is in the Armory of Malta.'[21] Only one of these works, the *Portrait of Alof de Wignacourt*, survives (Plate 50); perhaps at the same time Caravaggio painted, for Wignacourt's close friend and adviser, Ippolito Malaspina, the *St Jerome* in the Cathedral at Valletta (which bears the Malaspina arms), and, probably early in 1608, the *Portrait of Fra Antonio Martelli*. With these works Caravaggio, with extraordinary empathy, conveys the military and spiritual ideals of the Knights. They are deeply melancholy pictures, created for ageing men, whose lives had been dedicated to Christian knighthood. They seem to look back to past grandeur, to that 'former splendour and greatness' which Wignacourt had pledged himself to restore, and create the sense of a heroic age by echoes of the splendour of Renaissance art.

Ippolito Malaspina and Antonio Martelli were celebrated in the corridors of power in Malta; they belonged to the inner circle of Wignacourt's advisers and officials, and both were heroes of the Siege and of Lepanto. Malaspina, famed for his valour, had a long and illustrious military career, stretching back to the 1550s. A cousin of the Genoese Admiral, Gio Andrea Doria, in 1570 he had been elected Captain of the galley *Sant'Anna* and had fought with honour at Lepanto, arranging for the washing of the decks with vinegar and with perfumes when the Knights had been stricken with fever. In 1598 he became head of the Italian Langue, and played a key role in the election of Wignacourt in 1601. The two men were close, and Malaspina, who became Prior of Hungary, and Bailiff/Prior of Naples, continued to rise. In 1603 he was made commander of the papal fleet, and, temporarily setting aside the posts he held for the Order, he spent the next two years at the papal court in Rome, living in a palace in the Piazza Navona, where it is possible he knew Caravaggio, and certain that he would have known of his fame.[22] He was, moreover, related by marriage to one of

Caravaggio's Roman patrons, Ottavio Costa, who had a portrait of him in his Roman collection (in November 1606, Wignacourt had called one Alessandro Costa to Malta as a page), and by blood to Caravaggio's Genoese patrons, the Doria, a relationship of which he was intensely proud. In 1606 Malaspina was in north Italy, living at his ancestral estate Fosdinova in Lunigiana; but the Grand Master was growing increasingly anxious for his return to Malta, and on 21 November 1606 he wrote to Fabrizio Sforza Colonna, then in Marseille where a new galley was being built, exhorting him to bring Malaspina to Malta at the first possible opportunity, 'for we are greatly desirous of this'. At the beginning of February 1607, Wignacourt was growing increasingly impatient for Malaspina's arrival, again writing to Fabrizio Sforza, and expressing his great hope of once more seeing his friend in Malta. It is possible that Malaspina travelled with Caravaggio on one of the galleys commanded by Fabrizio Sforza Colonna, Malaspina embarking at Genoa, which was not far from Fosdinova, and Caravaggio at Naples. Certainly Wignacourt's letters suggest that he intended Colonna to facilitate his journey. Malaspina, who perhaps knew the artist in Rome, may well have facilitated his visit to Malta.

When Malaspina went to Rome, he left the Priory of Hungary to a distinguished Florentine Knight, Fra Antonio Martelli. Martelli, too, had had a long and brilliant military career. Born in 1534, he had played a prominent role in the Siege of 1565, when the Grand Master had praised him for his valour, rewarding him with the commandery of Città di Castello, 'for he is one of the people who in this siege has conducted himself with the greatest distinction'.[23] Having recovered from a severe wound at Messina, Martelli then returned to Tuscany, where, himself a member of a celebrated Florentine family, he spent many years in the service of the Grand Duke of Tuscany, Ferdinando I de' Medici. In the early years of the new century he was again in Malta, holding high office in the Order's governing council, as Prior of Hungary in 1603, and Prior of Messina in 1606.

With the portrait of the Grand Master, Caravaggio evoked the military splendour and power of the Order of St John. The Grand Master, holding the baton of office, is accompanied by one of his pages, perhaps

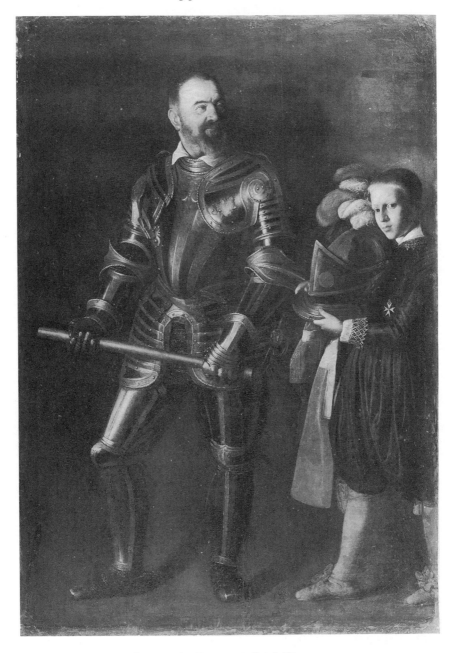

50. Caravaggio, *Portrait of Alof de Wignacourt*
(Paris, Louvre)

Nicholas de Paris Boissy, who became Grand Prior of France in 1657.[24] The portrait type itself suggests the heroic portraits of Renaissance warriors by Titian and Veronese, and the magnificent armour, probably made for Wignacourt, carried a symbolic weight. Sansovino, in his handbook to knighthood, described how the armour plating which covered all the body represented the Church, which had to be enclosed, and walled around, by the defence of the knight. And as the helmet is on the highest part of the body, so this defence has to be carried out by the most sublime souls – 'so the soul must be raised up, and on high, to defend and keep the people'. The spurs are to encourage the people to live well, while the hilt of the sword symbolises the world, for the knight is dedicated to the defence of the just and honest throughout the world.[25] Within this armour Wignacourt's pose is forthright, threatening, his features only slightly idealised (the wart is concealed), and his manly gaze fixed on the far distance, conveying the vision of the military commander. The crusading and chivalric ethos contrasts sharply with the atmosphere of pentitence and humility that fills Malaspina's *St Jerome*, but both were part of the Hospitaller ideal, for the knight, committed to military service, also served the poor and the sick, and in Malta the knights ministered in the large hospital built next to the harbour's edge in Valletta.

Malaspina's *St Jerome Writing* (Col. Plate 36), his Cardinal's hat restored to him, is a courtly penitent, brooding on death, with sunburned flesh and heavily veined hands. Perhaps Ippolito Malaspina, just returned from playing a powerful role in the Roman world of affairs, wished a devotional image that should suggest retreat and contemplation and a renewed dedication to the spiritual ideals of the knights; he had not only led a glittering military career (and it is tempting to believe that the scarred and rugged warrior's face may be a portrait), but had been commissioner for the poor, orphans, and widows, from the late 1590s until October 1609.[26] In contrast the portrait of Fra Antonio Martelli (Col. Plate 35) movingly conveys the intense sadness of a dying ethos and the frailty of the flesh: Martelli, ageing, with sagging neck and brooding eyes, is deeply melancholic. He is shown with extreme simplicity, in the habit of a *miles conventualis*, adorned only with the great

eight-pointed star, which shines with brilliance against the darkness of his dress, while through the twin might of the sword and the rosary he defends the world. This unadorned work suggests the humility that inspired the Hospitallers, and instilled in the most noble a desire to serve the weak. Formally it looks back to Titian, and the austere grandeur of the pose creates its symbolic and dramatic power. These three works together convey the spiritual ideals of the Knights, of Christian warfare, penitence, and humility, and share a deeply elegiac quality.

Wignacourt, Bellori tells us, was so well pleased with his portraits that he rewarded Caravaggio with the Cross of Malta, which was not easily won. In this period rules for entry into the Order were particularly complex and stringent, and for entry as a Knight of Justice, the most elevated rank, the Italians demanded two hundred years of nobility in all four lines; Knights of Grace, who had performed outstanding service to the Order, could be admitted without such proofs, but only four at a time. Each knight had, moreover, to pay a *passaggio* (a substantial sum of money) and, on nomination to the Order, to perform their 'Caravans', or military expeditions. And, writes Sansovino, 'whosoever has consummated a marriage, or committed homicide, or similar crimes'[27] was forbidden entry.

By the end of 1607, by which time his portrait had probably already been completed, Wignacourt began a strenuous campaign for the reception of Caravaggio. He must have been encouraged to receive, in 1606, a letter from Paul V expressing concern over the increasing worldliness of the knights, and emphasising that virtue was more important than ancestry.[28] On 29 December Wignacourt opened his campaign with two impassioned letters to his ambassadors to the Holy See in Rome, ardently pleading Caravaggio's cause. In a letter to Francesco Lomellini he recalled how, in the past, the privilege of conferring a knighthood 'without the necessity of proofs' had been repealed, but that he would now like, 'one single time', to avail himself of this lost privilege. For he passionately desires so to honour 'a most virtuous person, of most honoured qualities and habits and whom we keep as our particular servant and whom, in order not to lose him, we wish to console by giving him the habit of the Grand Master'. And he wishes 'that it will not prevent

him, that he has, in a brawl, committed a homicide' and to ensure that the knight should enjoy the privileges of food and lodging and of a salary.[29] He underlined the fervour of his wish, and added that the Commendatore, Francesco dell'Antella, will also write in his support. On the same day he wrote a very similar letter, in the same warm and enthusiastic vein, to Giacomo Bosio, Ambassador to the Holy See, and enrolling the support of his brother, Giovanno Ottone Bosio, Vice-chancellor of the Order in Malta, as well as that of dell'Antella.

Caravaggio is not mentioned by name, but the letters almost certainly refer to him, and subsequent events support this. Wignacourt's tone is ardent. The Grand Master clearly admired Caravaggio, and undoubtedly he saw at once how great a prestige Caravaggio could bestow upon him, and how rare an opportunity he now had to emulate the artistic splendour of European courts. He was, it is clear, passionately anxious not to lose him, and the quarrel with Tomassoni (referred to as a brawl, not a duel) seemed of little moment. By 7 February 1608, Wignacourt petitioned Pope Paul V himself, this time on behalf not only of Caravaggio, but of another unnamed knight. 'The Grand Master', he writes '. . . wishes to honour some persons who have shown virtue and merit and who have a desire and devotion to dedicate themselves to his service and that of the Hospital and does not have at the present moment any more suitable way of doing so . . .' He begs the Pope to give him, 'for one time only', the authority to adorn with the habit of a Magistral Knight 'two persons favoured by him and to be nominated by him; despite the fact that one of the two had once committed homicide in a brawl . . .'[30]

The petition was quickly granted, and on 15 February the Pope gave Wignacourt the power to receive the two men as brothers of the Grade of Magistral Knights, 'even if one of them committed murder during a brawl'.[31] Neither of the prospective knights is mentioned by name, but the second was almost certainly the Conte de Brie, who, as the illegitimate son of the Duc du Barry, had extreme difficulty in entering the Order.[32] Illegitimacy was a far more serious bar than homicide, and the Conte de Brie's aspirations, though supported by Cardinal Borghese and the Grand Duke of Tuscany, caused outrage; so enraged were the

Germans at the suggestion that he should enter their Auberge that, de Vertot tells us, they 'tear down the arms of the Grand Master and the order from off the gate of their inn, and leave only those of the emperor'.[33] But Caravaggio was supported not only by the Grand Master, but by the courtiers and men of letters who gathered around him. Among them were the Florentine Francesco dell'Antella, born in 1567, who had already been received into the Order by September 1595, and Giovanni Ottone Bosio, the brother of Giacomo Bosio, the Order's Ambassador to the papal court, and himself, while Caravaggio was in Malta, Vice-Chancellor of the Order.

Dell'Antella was particularly close to Wignacourt, acting as his secretary for many years, and in 1611 was rewarded with the commandery of San Giacomo in Campo Corbolini in Florence. Their relationship was to survive even the death of Wignacourt's nephew, Cavalier Henrico de Lancry de Bains, by the sword of dell'Antella; dell'Antella sent his friends to apologise, offering to withdraw from the Convent (i.e. the island), but Wignacourt insisted that he stay, 'knowing better than anyone else the wrong, that his nephew had done in provoking him, and satisfied with the respect, and the modesty of dell'Antella, he called him afresh to the Palace, and wished that he would continue in the office of Secretary'.[34] Dell'Antella was a friend of the brothers, Giovanni Ottone and Giacomo Bosio, who in 1581 had murdered the brother of the Viceroy of Calabria at the Vatican Palace, but so great was their diplomatic power that they had been pardoned by the Pope. Giovanni Ottone Bosio was the father of the antiquarian Antonio Bosio, scholar and archaeologist of Early Christianity, who had been in close contact with the Oratorians. He shared their interest in early Christianity and both he and Giacomo were poets, historians and men of letters, exchanging elegant madrigals with one another on Maltese topics, and mixing with scholars and antiquarians in Rome. Giacomo was commissioned to write a history of the Order by Wignacourt, and his *Historia della Sacra religione di S Giovanni Gerosolimitano* appeared in 1594. He illustrated this book with a drawing of Valletta drawn from nature by dell'Antella, which he describes as 'done by the hand of the most *virtùous*, valorous and courteous Cavalier Fra Francesco dell'Antella, now Secretary of the most

illustrious Grand Master, and courteously given to me; I keep it in my house, as a precious jewel, most dear to me' (Plate 49).[35]

These men were courtiers and *virtùosi*, skilled in the arts and in warfare, and perhaps in gratitude for his support Caravaggio was to paint for dell'Antella an unusual mythological subject, the *Sleeping Cupid*, which was in Florence by 1609 and remains in the Palazzo Pitti. Dell'Antella also took back to Florence an oval portrait of Wignacourt (untraced) by Caravaggio, which he kept in the manor of the grounds of the commandery of St Jacopo in Campo Corbolini in memory of the Grand Master to whom he was so deeply indebted.

Caravaggio was not admitted to the Order for some months after this, and it has been suggested that he was absent from the island. But more likely, as he was received into the Order on 14 July 1608 – that is, a year and a day after his probable arrival – he was fulfilling the requirement of a twelve-month novitiate. Wignacourt had specifically wished Caravaggio to enjoy all the privileges of the novitiate, and he presumably lived in the Italian Auberge, near the city gate, and close to the church of St Catherine of Italy. Here each knight had a set of austere rooms, but also enjoyed the greater opulence of the public rooms. Novitiates served in the hospital – hard though it is to imagine Caravaggio tenderly feeding the sick – and performed their devotions in the Oratory of St John.

And so, finally, in the summer of 1608, Caravaggio was received into the Order. The Bull of reception makes it very clear that this was done through a special papal authorisation, and that it was a reward for artistic genius and for the splendour that this brought to Malta. Thus Wignacourt declared:

> Whereas it behooves the leaders and rulers of
> commonweals to prove their benevolence by
> advancing men, not only on account of their noble
> birth but also on account of their art and science
> whatever it may be . . . And whereas the Honourable
> Michael Angelo, a native of the town Carraca in
> Lombardy called Caravaggio in the vernacular,
> having landed in this city and burning with zeal for

the Order, has recently communicated to us his fervent wish to be adorned with the habit and insignia of our Knightly Order . . . Therefore, we wish to gratify the desire of this excellent painter, so that our Island Malta, and our Order may at last glory in this adopted disciple and citizen with no less pride than the island of Kos (also within our jurisdiction) extols her Apelles; and that, should we compare him to more recent [artists] of our age, we may not afterwards be envious of the artistic excellence of some other man, outstanding in his art, whose name and brush are equally important.[36]

Caravaggio was admitted as a Knight of Ubidienza (obedience), suggesting that he had some claim to nobility, for this was a subdivision of the noble class of Knights of Giustizia (although the Grand Master had asked to make him a knight without the need for proofs). Such Knights did not take the vows of chastity, poverty and obedience, although they did swear to lead a life of Christian perfection, and to carry out social works. They were, however, free to follow a profession. At the investiture ceremony the novice dedicated himself to the Virgin and to St John the Baptist, kissed the white linen Cross, and received the habit to these words: 'Receive the yoke of the Lord, for it is sweet and light, under which you will find rest for your soul. We promise you no delicacies, but only bread and water, and a modest habit of no price.'[37]

Probably before he was admitted to the Order Caravaggio had begun to work on the largest and most celebrated of his Maltese works, *The Beheading of St John the Baptist* (Col. Plate 37), for the Oratory of the Co-Cathedral of St John in Valletta, which was almost certainly finished by 29 August, the feast day of the decollation of St John. It is extremely likely that this was painted as his *passaggio*,[38] in lieu of the large sum of money which was usually demanded from prospective knights; Bellori tells us that 'In the church of S Giovanni he was ordered to paint the beheading of St John'. Sandrart's account — 'He generously outfitted a man-of-war to fight against the Turks, and he painted the Beheading of

St John the Baptist in the church at Malta' – also suggests that the work may have been part payment of a *passaggio*.[39] The Oratory of St John, dedicated to the Order's patron saint, was built 'for administering the sacraments, instructing novices, and carrying out other religious ceremonies and good works' (Plate 52).[40] Criminal trials were also held here, and, a place highly charged with emotion, it was used as a place of private devotions by the Order's novices. Built between 1602 and 1605, it lies to the right of the cathedral, and in 1608 it was a plain rectangular construction, with a flat roof, and windows opening on to the cemetery where the victims of the Siege had been buried.[41] Caravaggio probably painted *The Beheading*, a vast work which fills the entire east end, *in situ*. The story of Herod's beheading of St John at the frivolous request of Salome is told with extreme simplicity in Matthew and Mark; Matthew wrote (14: 10–11): 'And he sent, and beheaded John in the prison. And his head was brought in a charger, and given to the damsel: and she brought it to her mother.' Caravaggio's painting has a biblical starkness; he sets the scene in a bleak prison yard, paring the cast down to its essentials, isolated in the vast darkness that surrounds them, and showing the execution of John, the first Christian martyr, the Order's patron saint and precursor of its many martyrs, so many of whom had lost their heads during the Siege, in an act of cruel butchery. In its original austere setting it would have been overwhelmingly illusionistic, for, as the novice entered the sacristy, there was nothing between him and this group of life-size figures, firmly set in a stage like architectural space, their action caught and frozen, and the bold geometric basis of the composition so clear and so strong. He must have felt himself a witness at a mesmeric moment of high drama, as the blood pours from St John's neck, and as the rope, swinging and twisting against the wall, suggests where, a moment before, he was bound. The executioner, as Bellori stressed, 'almost as if he had not killed him with his sword, takes his knife from his side, seizing the saint by his hair in order to cut off his head',[42] and the jailer instructs him to lift the head onto the waiting charger.

It is an ignoble scene. John does not kneel, as is customary in art, but is brought low, on the ground, and his body is trussed like that of a sacrificial lamb, his hands tied behind his back, his red cloak suggesting

blood, and a rope snaking across the floor. Action is arrested, and the group, earthbound, downward-looking, is utterly still, gesture and expression muted. Caravaggio emphasises the reality of John's death in a gloomy prison, unattended by angels; the threat of the prison, the terror of torture and punishment, are powerful – and this was a place where justice was meted out. Its ignobility must have startled young knights who received instruction before it and who aspired to the glorious feats of Christian chivalry, yet it is a meditation on the reality of martyrdom, and one profoundly rooted in Christianity, which stresses humility and mortification, and the poor and broken materials from which the Catholic hopes to re-create union with God. Each figure is utterly real, full of individual character, but seems also invested with a universal meaning, symbolising man's tragic fate, while the geometric clarity of the composition conveys a sense of preordained order. It is daringly asymmetric but also perfectly balanced, with a semicircle of figures set against the rectangles of window and gate, with its heavy Maltese quoins, and the figures themselves built up around a formal play of vertical and diagonal. John's imprisonment, and his silencing, marked the beginning of Christ's own mission; he was a forerunner of Christ and of the Eucharist, and his head a prefiguration of the Eucharistic sacrifice. Here blood pours from a head of extreme beauty, directly over the altar, and suggesting, to the participant in the Mass, the blood of Christ.

In a famous passage, Bellori commented on the bravura of the artist's technique: 'In this work Caravaggio put all the force of his brush to use, working with such intensity that he let the priming of the canvas show through the halftones.'[43] In the blood, still warm, which flows from John's neck, Caravaggio has written *f. michel.* which almost certainly stands for 'fra' (frater or brother) 'Michelangelo' (da Caravaggio). This signature, at the very centre of a painting before which young Knights received the sacrament, conveyed his pride in being received into the Order, in achieving the passionately desired knighthood. Wignacourt was full of admiration, and, Bellori tells us, 'As a reward, besides the honor of the Cross, the Grand Master put a gold chain around Caravaggio's neck and made him a gift of two slaves, along with other signs of esteem and appreciation for his work.' Caravaggio, given the

form of his signature, had presumably already received the Cross before the picture was completed, probably in time for the feast of the Beheading of the Baptist on 29 August 1608.

In these months Caravaggio enjoyed the pleasures and rich life-style of a cosmopolitan society, where he was ideally placed to receive commissions from the aristocracy of Europe, and where he was sought after and celebrated, and, perhaps because of his powerful supporters, he seems to have been released from performing his caravans, or periods of military service. Bellori touchingly describes Caravaggio's pleasure in his prosperity: 'Caravaggio was very happy to have been honored with the Cross and for the praise received for his painting. He lived in Malta in dignity and abundance.' He painted other works for the Grand Master, a St Jerome, and a Magdalene, for the Italian chapel in the cathedral of St John (both untraced).

He was well placed to make other contacts and, at the end of July, six galleys appeared in Malta, with their general, Filippo Gondi di Giogny, and bringing Francois, Prince of Lorraine, to the island, to make the acquaintance of the Grand Master and of the Convent. Their arrival was greeted with a display of opulence and ceremony, a cortège of nobles accompanied them to the palace, where they were lodged in splendour, and an exchange of gifts was made, the general bestowing on almost all the knights, and the entourage at the Palace, chains of gold and other rich gifts. They stayed for six days, and it may be that they saw Caravaggio's *Beheading of St John*, which was almost certainly well under way, and that through this contact Caravaggio was commissioned to paint the *Annunciation* (now in the museum at Nancy) which Henry II of Lorraine gave to the newly founded primatial church in Nancy, perhaps soon after his accession to the throne in 1608; Henry II was married to Margherita Gonzaga, sister of Cardinal Ferdinando Gonzaga, later so important in the campaign to win a papal pardon for Caravaggio.[44]

This period of stability and new contacts was to be all too short. Suddenly, Bellori continues, 'because of his tormented nature, he lost his prosperity and the support of the Grand Master. On account of an ill-considered quarrel with a noble knight, he was jailed and reduced to a state of misery and fear. In order to free himself he was exposed to grave

51. *Castel Sant'Angelo, Malta*
 (photo: Marquis Anthony Cassar de Sayn)

danger, but he managed to scale the prison walls at night and to flee unrecognised to Sicily, with such speed that no one could catch him.'[45] Bellori's account is doubtless modelled on that of Baglione, who wrote (inaccurately) that Caravaggio was made a Knight of Grace but, 'following some sort of disagreement with the Cavaliere di Giustizia, Michelangelo was put into prison'.[46] There seems little reason to doubt this story, though the details remain vague. It seems likely that the touchy Caravaggio, so quick to feel offence, in a violent city, where aristocratic rank was an all-consuming issue, and honour caused many deaths, had been provoked by the taunts of a haughty Knight of Justice to an upstart painter. Susinno, his Sicilian biographer, whose account may preserve local gossip, put it down to Caravaggio's arrogance: 'Michelangelo with the Cross on his chest did not abandon his natural belligerence but let

himself be blinded by the madness of thinking himself to be a noble-man born . . . he became so daring that one day he had the courage to compete with some other swordsmen and to affront the Cavaliere of Giustizia.'[47] If a knight came to blows with his brother, according to the statutes of the Order he was imprisoned and deprived of his habit. So, at the instance of the Fiscal Procurator, Caravaggio was cast into the underground cell at the Castel Sant'Angelo, a deep, bell-shaped hole, eleven feet deep, and hewn out of the solid rock, from which escape would seem impossible, and which bears the sad inscriptions of many knights who had been forgotten there, 'thrust into this well of Saint Angelo'. But somehow the painter made a dramatic, story-book escape, apparently scaling the awesome walls of the castle with a rope, and, what is yet more extraordinary, managed to sail out of the Grand Harbour, avoiding the sentries at St Elmo, and over the sea to Syracuse.

In this secret flight, Caravaggio breached a rule of the Order, Statute 13, which decreed that any Knight departing from Malta without written permission should be deprived of his habit. The authorities hastened to take action over this unlicensed flight, and, on 6 October 1608, a crimi-nal commission was set up, to search for Caravaggio, to summon him to appear, and to find out how he had pulled off this extraordinary feat. The commission presented its report a month and a half later, at a Council Meeting held on 27 November. Here it was decided that, as Caravaggio had contravened Statute 13, he should be deprived of his habit. Only a few days later, on 1 December, a solemn Public Assembly was held in the new Oratory to deprive Caravaggio of his habit. Here, as Edward Sammut has so evocatively written, 'rank upon rank of hoary old warriors, veterans of a hundred fights, some perhaps still with the sound and fury of the Dardanelles, possibly the Armada, perhaps even of Lepanto, still echoing in their ears', were ranged on either side, 'Bearers of proud and mighty names; the Grand Marshal, the Grand Hospitalier, the Priors of St Giles, of Champagne, of Rome and Venice, the Castellan of Emposta . . .' All, with awesome majesty, gathered to defrock Caravaggio. The Master of the Hospital and delegate for the Illustrious Grand Master, Fra Don Hieronymous de Guevara, solemnly repeated the charge, that Caravaggio had fled without licence, adding

52. C. von Osterhausen, *The Oratory of St John*
(Valletta, Malta)

that he had used a rope – a detail perhaps unearthed by the criminal commission. The Lord Shield Bearer himself described how he had looked for Caravaggio through the public places of the district, and then, with theatrical drama, Caravaggio was 'personally summoned once, twice, thrice and a fourth time' in a loud voice, but 'did not yet appear nor as yet doth he appear'. A unanimous vote to deprive him of his habit was passed, and Caravaggio, in the words of the Statute, was 'deprived of his habit, and expelled and thrust forth like a rotten and fetid limb from our Order and Community'.[48]

With truly tragic irony, Caravaggio's habit would have been ceremoniously removed from a stool before his own *Beheading of St John*, a gloomy accompaniment to the criminal trials held in the Oratory, where his

proud signature in blood, directly over the stool, took on a new menace; it was only four months since Caravaggio had won the right to sign himself 'fra'.

This highly coloured sequence of events leaves many problems. At no point is the crime which caused his imprisonment mentioned, and the commission's report has been lost; nor does Caravaggio's name appear in a list of crimes committed by Knights in that year.[49] It is, also, almost inconceivable that Caravaggio could have escaped, unaided, from Castel Sant'Angelo, or have so easily found a boat and safe conduct to take him to Sicily. It may be that Caravaggio had powerful support, perhaps of Fabrizio Sforza, perhaps of the Grand Master himself (who, a little later, was so quick to forgive dell'Antella for killing his nephew), and it is even possible that he was never in the prison. He perhaps left Malta in one of the Order's galleys, for the seas were stormy, although Sandys describes leaving Malta in a 'Phalucco of Naples, rowed by five, and not twice so big as a wherry, yet [it] will for a space keepe way with a gally', and arriving in Sicily the next morning.[50]

Caravaggio's status was to remain deeply ambiguous. His progress around Sicily was partly triumphal, and partly a flight, in fear both of Rome and of the Knights of Malta. He did not try to hide there, and as his trial in Malta took place, he was mixing with scholars in Syracuse. He never accepted his defrocking and later tried to win back the favour of the Grand Master, sending him a painting of *Judith and Holofernes*.

CHAPTER FOURTEEN

Sicily

H IS KNIGHTHOOD STRIPPED, Caravaggio made the short sea voyage to the nearest Sicilian port, the ancient Greek city of Syracuse. Like Naples, Sicily was ruled by a Spanish Viceroy; it, too, was truly a country of contrasts. An island of paradisial beauty, abundant in grain, fruit and wine, celebrated by the poets of classical Greece and Rome, it was intensely evocative of the beauties of an ancient civilisation. Yet in the late sixteenth century the reign of the Spanish King Philip III brought extreme economic difficulties, and the island was devastated by calamities, by plague, famine and poverty. At the centre of the Mediterranean, it was under constant threat from the Turks, and from the Barbary pirates who infested the dangerous seas of the North African coast. Its natural wealth was drained by the huge sums of money constantly spent on fortifications, and the people were pressed into military service.

Sicily had played a major role in Lepanto, when Spanish fleets had sailed from Sicilian ports, and the hero of Lepanto, Marcantonio Colonna, was welcomed as a saviour when he became the Viceroy of Sicily in 1577. And in this era began the enrichment of the intensely nationalistic Sicilian cities – Syracuse, Messina and Palermo – which vied with one another in wealth, power and autonomy, with splendid arrays of new monuments and grandiose civic buildings. Palermo, the Viceregal capital, was transformed by the grandeur of its new streets and the wealth of religious building, of churches, oratories, monasteries, created by the powerful religious Orders, into a triumphant propaganda statement of absolute Spanish power, fostered by an active ritual life, of lavish ceremonies and processions. But the splendid exteriors of these cities, where the nobles indulged in displays of ostentatious luxury, only masked the misery and slum conditions in which the people lived, creating anger that periodically erupted in hunger riots. The poor Orders ministered to such desolation, and there was a particularly strong

Capuchin presence here, while many confraternities and *compagnie* sprang up to serve the poor.

Caravaggio worked here for nine months, and in a sense his progress from Syracuse to Messina to Palermo was triumphant. Although he had fled as a criminal from Malta, he was welcomed by artists and men of letters, winning important and extremely well-paid commissions, fêted in a world where he towered over all other artists. His fame had again preceded him, and there was intense curiosity about this artist, whom people considered the best painter in Italy. He fascinated the Sicilians, and collectors were avid to win something from his hand; they saw a chance to participate in the most advanced art and were prepared to honour Caravaggio, to tolerate his worst excesses, and to allow, even to encourage, an unusual freedom. Caravaggio's style, always so sensitive to place, again changed. His great Sicilian altarpieces isolate their shadowy, pitifully poor figures in vast areas of darkness; they suggest the desperate fears and frailty of man, and at the same time convey, with a new yet desolate tenderness, the beauty of humility and of the meek, who shall inherit the earth. Despite his well-paid success, Caravaggio's behaviour became increasingly unbalanced; he was enraged by criticism, and swift to decry the gifts of local painters, giving vent to his envious and impatient nature; he was restless, unquiet, ever on the move, feared as a man deranged, described as mad. Caravaggio, a man with a very odd brain, as Del Monte had said, had long revealed such traits, but in Sicily there is a sense, clear in all the early accounts, that he lived in extreme fear, haunted by tumultuous anxieties. His exile, and the sudden reversal of his fortunes in Malta, may have disturbed his psychological balance; or it may be that Caravaggio, who went to bed fully dressed 'with his dagger (from which he was never separated) at his side'[1], feared the real dangers of pursuit, either from Malta, or from the long arm of the Roman law, which threatened death.

Yet at the very time that Caravaggio was ceremoniously deprived of his habit in Malta, he was warmly welcomed in Syracuse, where his old friend, Mario Minniti, was pursuing a highly successful career. Syracuse, the ancient Ortygia, and one of the most splendid Greek cities in Sicily, has a large, sheltered harbour, and an island, a narrow spit of land which

reaches out into the Ionian sea, on its furthermost point the massive fortress of Frederick II. It was the harbour closest to Sicily, and Caravaggio's most obvious destination. The Spanish presence was strong, and the city had recently increased its fortifications; Sandys, who journeyed there shortly after Caravaggio, reminds us of the constant threat of Turks and Pirates:

> The City itselfe is strongly walled (than which heretofore there was nothing more goodly), not farre removed on both sides from the sea: the point wheron it doth stand being but narrow towards the West, and so maketh by land a difficult approch: without which are the ruines of the old City . . . The garrison consists of two hundred Spaniards, and three hundred townes-men: besides certain horsemen of the countrey adioyning, who serve by turnes, and are nightly sent forth to scoure and guard the seacoasts. The buildings of the City are ancient, the inhabitants grave, and their women all hid under long blacke stoles, not unlike the Malteses.[2]

On the limestone plateau to the north of the city are the vast quarries from which the ancient city was built, hacked from the rock, creating a subterranean world of caves, canyons, and artificial grottoes intensely evocative of a remote past. The classical past blends with the early days of Christianity, and Syracuse was surrounded by catacombs, almost as extensive as those of Rome itself.

Here, on his return from Rome, where Caravaggio's excesses had driven him to take refuge in marriage and in a quiet life, had settled the friend of Caravaggio's youth, Mario Minniti. Minniti's life, since his departure from Rome probably around 1604, had continued to be full of drama, yet crowned with success. Attracted to his native country by a desire to display his 'happy, pleasurable and soft style of painting', he had immediately been forced, 'for a homicide casually committed', to

seek refuge in the Carmelite monastery, and there painted an *Assumption of the Virgin*.[3] He pleaded in vain for pardon from the relatives of the dead man, but finally his many virtues won over the city's authorities, who intervened on his behalf, and Minniti was freed. Leaving his wife with his family, the artist travelled to Messina, where, in the course of many visits, his career and fortune flourished, and his fame spread throughout Sicily. He ran a busy studio, instructing twelve students, keen to work with such a master, and he employed them to sketch in his compositions, and often to bring them to completion, while he added only the final touches. More conventionally successful than Caravaggio, he had become a respectable painter enjoying the pleasures of an elegant life and proud of his status. He wore close-fitting and showy clothes, and in summer he went to Messina to enjoy the fresh climate, spending the rest of the year in his native Syracuse. In sharp contrast Caravaggio lived with increasing indifference towards his way of life, dressing more like a swordsman than a painter, and eating his meals off a slab of wood or an old portrait canvas.

Minniti extended all possible kindness to Caravaggio, imploring the Senate of the city to employ him in some way, 'so that he could have the chance to enjoy his friend for some time and be able to evaluate the greatness of Michelangelo'.[4] Caravaggio's fame as a naturalistic painter had already reached Sicily, and he was also welcomed by Vincenzo Mirabella, a distinguished archaeologist, who wore a high Spanish ruff and elegant moustache, conveying the modish refinement of a dapper and confident courtier. In his *Dichiarazione della pianta dell'antiche Siracuse* (Naples, 1613), Mirabella recorded the catacombs and stone quarries around Syracuse. He describes going with the painter to visit a celebrated artificial grotto, then believed to be a prison constructed by the tyrant of Syracuse, Dionysius. The grotto was constructed in such a way that every sound echoed, and the whispered secrets of the prisoners could be heard from a hole above ground. 'I remember', wrote Mirabella, 'when I took Michelangelo da Caravaggio, that unique painter of our times, to see that prison. He, considering its strength, inspired by his unique genius as an imitator of natural things, said: Do you not see how the Tyrant, in order to make a horn to hear things, took no other model than

nature had herself made to achieve the same result. And so he made this prison like an ear. This had not been noticed before, and caused a great stir . . .'⁵ The quarry is still called the Ear of Dionysius. The incident vividly suggests Caravaggio's immense fame, and the wonder which his astonishing naturalism aroused; Mirabella presents Caravaggio as one imitator of nature commenting on another, and it seems likely that the painter intended this, and wittily and provocatively seized the opportunity to vaunt his declared dependence on nature alone.

Caravaggio's arrival was timely, for the church of Santa Lucia, the city's patron saint, which lay outside the city walls, was being restored, and the Senate, encouraged by Minniti, commissioned him to paint the altarpiece, probably with the intention of its being ready for the saint's feast day, only two months off, on 13 December.⁶ Through the cult of St Lucy, Syracuse expressed an intense national pride. Her statue adorned the ramparts, and for the cathedral the silversmith Pietro Rizzo had created a large silver reliquary statue of the saint, a display of glittering wealth and religious fervour which the Senate judged 'the most beautiful work in Italy'. St Lucy, martyred around 304, during the Emperor Diocletian's persecution of the Christians, had been buried in the catacomb (inaccessible at this time) under the church of Santa Lucia; but her miraculously preserved body had found its way to Venice, where a rival cult was set up, and the Syracusans were anxious to claim the authenticity of the local burial site.

It is for this reason that Caravaggio painted *The Burial of St Lucy* (Col. Plate 38), a subject rare in art, rather than her martyrdom. The best-known source for the story of St Lucy was *The Golden Legend*, which tells how St Lucy, in gratitude for the miraculous healing of her mother at the shrine of St Agatha (the patron saint of Catania), had bestowed her wealth, intended as her dowry, upon the poor. Her betrothed denounced her as a Christian, but Lucy refused to recant, offering her chastity to Christ. In fury the magistrate ordered her to be dragged off to a brothel, but nothing could move her, neither oxen nor witchcraft, nor a thousand men, and in the end she was pierced by a knife in the throat. Here, where she fell, she received the last rites, was buried, and the church of St Lucy was built. It is a story that sets virgin frailty and purity against brute

power, and a belief in salvation through Christ against imperial law, and it was on these contrasts that Caravaggio built his composition. The massive gravediggers frame the body of the saint, whose piteousness touches the heart, and whose hand seems to reach out, in a gesture of supplication, to the spectator; on the right stand the powers of State and Church, a military officer in Renaissance armour, and a sixteenth-century bishop, who blesses the body. Lucy's body forms the base of a triangle, with the head of the young man in red at its apex, a strong vertical at the picture's emotional centre. Around this group the anguish of the mourners is conveyed through the eloquence of hands and of expression, and the vast arches of the shadowy background recall the catacombs or the stone quarries around Syracuse. Caravaggio, whose imaginative response to place, and to the needs of his patrons, was so intense, created a work which movingly suggests, in this ancient setting, a small early Christian community, the poor and the meek to whom Christ brought hope and to whom Lucy had given her riches. The picture swiftly became popular, and was many times copied.

But despite this swift success, 'the unquiet nature of Michelangelo', Susinno relates, 'which loved to wander the earth, soon after led him to leave the home of his friend Minniti. He then went to Messina',[7] where he probably arrived in the winter of 1608–9. Messina, hemmed in by mountains, had a harbour that made it a key city in the Mediterranean; it boasted wide straight streets and elegant buildings. Sandys conveys the intense Spanish Presence: 'Upon the west side, and high mounted above it, stands a strong Citadell, which commandeth the whole Citie, manned by a garrison of Spaniards. South-west of it a fortresse on the top of a higher hill. And on the top of another towards the South, the Castle of Gonsage: both without the walls. The Citie is garnished with beautiful buildings, both publicke and private.'[8] Its ruling class was mercantile (there was a flourishing colony of Genoese merchants) and it was governed by a body of six annually elected magistrates, called the city Senate, which was responsible for important civic commissions. Messina, with a population of around 100,000 inhabitants, offered more opportunities than Syracuse, for it had a strong local school of painting and there were many connoisseurs and collectors eager to display their

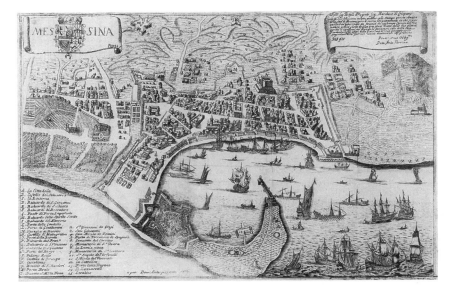

53. View of Messina
 (print)

knowledge. In the fifteenth century Antonello da Messina had estab-
lished a glorious tradition of painting, and Polidoro da Caravaggio had
been there in 1528, leaving behind an *Adoration of the Shepherds* deeply
admired by local artists. In this period, Susinno tells us 'such painters
flourished as Catalano l'Antico, Cumandeo, and others, very famous'.[9]
Catalano, who had painted in a sweet and graceful style reminiscent of
Federico Barocci, had died only recently, possibly in 1605. He perhaps
satisfied a lively demand for devotional art, for the writings of Paleotti
were well known, and the Messinese Placido Samperi, in his *Iconologia*,
had railed against lascivious art, pleading for images of the Virgin and
saints produced by artists 'of good conscience, which should compose
the soul, awakening virtue'.[10] An important Priory of Maltese Knights
was active there, but far from discouraging Caravaggio, this may have
attracted him, for he continued to call himself a Knight of Jerusalem,
and to work for patrons who had close ties with the Knights.

 Perhaps soon after his arrival in Messina Caravaggio won a commission
from a rich Geoese merchant, Giovanni Battista de' Lazzari, for a

Resurrection of Lazarus intended for a high-altar chapel in the church of the Padri Crociferi ('Cross-bearing Fathers'), hospitallers dedicated to the care of the sick. Lazzari had first ordered a conventional work, a Madonna with his name saint, St John; but by 10 June 1609 Caravaggio had delivered a *Resurrection of Lazarus* (Col. Plate 39), painted 'by Michelangelo Caravaggio militis Gerosolimitanus'.[11] Lazzari was in contact with a Knight of St John, fra' Orazio Torriglia, in Messina, and Caravaggio may have used such contacts, perhaps keeping his expulsion hidden, or in complicity with the highest echelons of the Knights themselves. It seems that the Lazzari family appreciated the extraordinary opportunity which Caravaggio's unexpected presence afforded, and Caravaggio himself may have thought of the new subject, again a play on the patron's name. He was treated as a great celebrity, respected as a Knight of St John, receiving the extremely lavish sum of 1000 scudi, and, unusually, given free rein 'to fulfil his creative fantasy'. Moreover, when Caravaggio asked for a room in the hospital to work in, they gave him the best room. Here he worked in secret, and, according to Susinno, forced the workmen whom he employed as models to hold a corpse already in an advanced state of decomposition, from which he painted the body of Lazarus. But when the picture was unveiled, Susinno continues, although it 'astonished', it also attracted some 'small observations' from Messinese critics, who wished to display their knowledge of art, and indulge in the pleasurable debates of the connoisseur. Caravaggio, enraged by such provincial pretentiousness, cut the painting to shreds with his dagger, but then offered to paint another, 'even more beautiful'. The story has the ring of truth, and the picture may be the second version of Caravaggio's *Resurrection of Lazarus*.

The Lazarus story is told only in the gospel of St John, and it is central to that gospel, which is so deeply pervaded by the great conflict between light and dark. Lazarus, the brother of Martha and Mary Magdalene, lay dying at Bethany. The sisters sent to Jesus, but when he arrived Lazarus had 'lain in the grave four days already'. They hastened there, with a crowd of the Jews, and Jesus, ordering the stone that lay upon it to be removed, cried, with a loud voice, 'Lazarus, come forth. And he that was dead came forth, bound hand and foot with grave clothes' (John 11: 43-44). In patristic literature Lazarus was a great

sinner, and the stone, raised by the gravediggers, was the weight of sin that prevented union with Christ. To St Ambrose Christ's great cry, echoed by many seventeenth-century preachers, was a call to penitence: 'Come forth. You who fester in spiritual darkness and in the filth of your sins, this passion of the guilty, come forth, confess . . .'[12] 'When a man is born,' wrote St Augustine, 'he is born already in a state of death . . . It is a great criminal that is signified by that four days' death and burial.' To him Jesus' groans and weeping suggested 'With what difficulty does one rise who lies crushed under the heavy burden of a habit of sinning! And yet he does rise: he is quickened by hidden grace within; and after that loud voice he riseth.' He quits 'the old refuges of darkness' with pain, 'confessing, yet guilty still'.[13] And it is with extreme difficulty that Caravaggio's Lazarus awakes; his body, the flesh frail, painted swiftly and transparently, is still stiff with death, and only the palm of his right hand opens to receive the light of Christ. His outflung arms suggest the Cross, and Lazarus' story looked forward to the Passion and Resurrection of Christ; but it also suggests the Last Judgement, and Caravaggio's Lazarus seems still in conflict, caught in terror, in a cosmic struggle between light and dark.

The picture has a hectic, apocalyptic quality, which accorded well with the religious fervour of Messina, a city of drought, famine, earthquake, of processions of penitents, where the poor were dependent on charity even for burial, and where, in 1607, a comet had terrified the people. In the church of the Cross-bearing Fathers, whose worship was directed to death on the Cross, Lazarus' story was a call to penitence and to rebirth in Christ, whose sacrifice was repeated in the Eucharist. At the same time, the desperate longing for grace, the terror of the dreams that may disturb the sleep of death, and the sense of dissolution that the flickering paint surface creates, seem intensely personal, conveying the tormented state which Susinno's biography suggests. Susinno records how, one day, Caravaggio, whose spirit 'was more disturbed than the sea of Messina with its raging currents that sometimes rise and sometimes fall', entered the church of the Madonna del Pilero. Here he was offered some holy water to wash away venial sin. 'I don't need it, he replied, since all my sins are mortal.'[14]

The *Resurrection of Lazarus* was a success, and the city Senate hastened to commission Caravaggio, again for the high price of 1000 scudi, to paint the high altar for the church of Capuchin monastery of Santa Maria La Concezione, a relatively modest building, with small turrets framing a plain façade, and which lay in the countryside outside the city, near the small hamlet of Borgo San Leone. The Capuchins had a strong presence in Messina, and their church was much loved by the people, drawn, as Placido Samperi wrote, to that holy place by the odour of virtue, to celebrate the great religious festivals of the year; Samperi describes the delights of the site and buildings, remarkable for the 'beauty of the gardens, and for the abundance of water, for the healthy air, and for the alms of many, and many thousands of scudi, given by Messinese citizens who loved that place'.[15]

Caravaggio's *Adoration of the Shepherds* (Plate 54), painted for its high altar, has none of the radiance and pastoral charm of so many early seventeenth-century nativities, in which music-playing shepherds bear gifts – doves, or a basket of eggs – and in which the Virgin tenderly draws back a veil to reveal Christ in a breathtaking blaze of supernatural light. His nativity is utterly bleak and desolate, with the ox and the ass huddled together in the cold shadows. The Virgin, piteously small and frail, sits, in deep melancholy, on the ground, and the shepherds, meagrely clad and worn, look with sad gentleness, touched with wonder, at the poor working family, the woman untended, and the old man who has laid down his carpenter's tools. Only the frailest of haloes, and the gentle fall of light, suggest the divinity of Mary and Joseph. It is a Capuchin Nativity, painted for the poorest of the poor Orders, and invites meditation on the humility of the Queen of Heaven, and on the virtue of poverty, the road to salvation. The Nativity was a scene especially dear to the Franciscans, with whom the traditional Christmas crib had originated, and the thirteenth-century Franciscan *Meditations on the Life of Christ* stresses the poverty of the Holy Family, 'the heavenly pearl' for which the worshipper must exchange everything. Jesus 'chose what was most tormenting, especially for a child, to be the son of a Mother who could not swaddle him but with the most wretched clothes, who hardly had any rags to wrap him in, and who had to place him in a manger ...

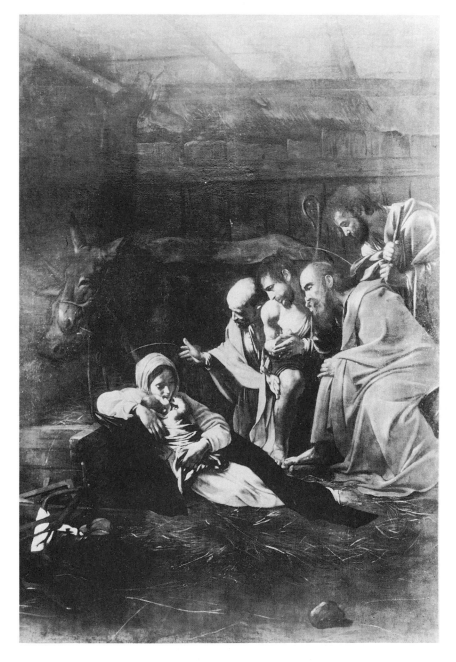

54. Caravaggio, *The Adoration of the Shepherds*
(Messina, Museo Regionale)

he had been born for the poor and for those who work hard.'[16] Capuchin preachers emphasised the grief of Jesus' life, and Mary's shadowed face looks forward to the harsh path of unrelieved suffering that leads to the Cross. In a sermon of the celebrated Capuchin preacher Mattia da Salo, who had visited Messina in 1583, Christ speaks of his bleak birth, at midnight, in midwinter, 'so that I should not lose time, but, as soon as born, I should begin to suffer for you . . . for see in how great a need of human help am I born, with no shelter, no bed, no fire, with no nurse to aid my mother . . .'[17]

The shepherds see God become man, a mystery repeated in the celebration of Mass before the altar; 'Let us enter into the mystery of the Eucharist with fervour and ardent Charity,' beseeched St John Chrysostom, who wrote so movingly of the poverty of Mary, the wife of a carpenter. 'The Kings adore this same body lying in the manger . . . but you do not look in the manger, but at the altar; you do not see a woman who holds him in her arms, but the standing priest . . .'[18] Caravaggio also painted a St Jerome writing (untraced) for the same church. *The Adoration of the Shepherds* was much admired, and Samperi wrote that it was 'considered by the connoisseurs as something extraordinary'.[19] Susinno was more at ease with this work, which lacks bold shadows, than with the darker, sketchier *Lazarus*; he believed that Caravaggio had been influenced by the 'sweet touch' of the much-loved local artist, Catalano l'Antico. But at odds with this, and more convincing, is his account of Caravaggio's anger when the people of Messina praised Catalano, who was probably recently dead, and who had been a very different kind of artist – a vivacious and happy man, who dressed nobly, studied the theory of art, and was pious and loving to everyone. Caravaggio was more at home with the stormier Filippo Paladino, a Florentine painter whose early adventures resemble his own.[20] Arraigned in Florence for armed assault and condemned to the galleys, Paladini had won his freedom in Malta, and ended up a wealthy and successful artist in Sicily, one of the first to respond to the art of Caravaggio; he painted a *St Francis receiving the Stigmata* for the Capuchin monastery of Santa Maria Concezione, to which Mario Minniti also contributed a large canvas, a *Raising of the Widow of Naim*. Paladino was very good at painting martyrdoms, and his fiery

nature delighted in painting executioners, fires and tortures. His art was admired by Caravaggio, who, in 'his usual satirical manner', preferred his works to those of Catalano, commenting sarcastically: 'This one is a true picture while the other canvases look like mere playing cards.'

Caravaggio was sought after in Messina, and Susinno mentions 'many other beautiful pictures by Caravaggio, which I must admit for the sake of brevity'. The noble collector Nicolò di Giacomo recorded how he had commissioned, probably in the spring of 1609, four scenes from the Passion of Christ, one of which, a Christ carrying the Cross (untraced), with the sorrowing Virgin, and two executioners, was certainly finished, and di Giacomo thought it succeeded wonderfully. It is not entirely clear whether the other three, which Caravaggio was to deliver in August, were ever painted. Nicolò di Giacomo was clearly a true enthusiast, prepared, like the Lazzari family, to give Caravaggio free reign, and willing to tolerate the vagaries of artistic genius. The subjects are to be treated 'according to the ideas of the painter' (*capriccio del pittore*) and he is to be paid 'as much as is fitting for this painter who has a crazy brain'.[21] His remarks suggest Caravaggio's frail psychological state. Well paid, sought after, famous, he was none the less, writes Susinno, the artist who squandered his wealth in adventures and revelries. Indeed, soon afterwards, at the height of this success, he inexplicably left for Palermo.

According to Susinno, Caravaggio left Messina after a quarrel with a school teacher. Caravaggio often followed the teacher to the arsenal, where galleys were built, to watch his pupils playing – 'Michele went to observe the positions of those playful boys and to form his inventions. But the teacher became suspicious and wanted to know why he was always around. That question so disturbed the painter, and he became so irate and furious, that he wounded the poor man on the head.'[22] His 'inventions' (*fantasie*) were probably artistic, and it is very unlikely that Susinno meant sexual fantasies, but the teacher seems to have been accusing him of homosexual interest, an accusation that was extremely perilous in Sicily, where, in 1608, the chief hangman, who had executed homosexuals, was executed for the same offence.

And so, probably travelling by sea, the 'fugitive arrived in Palermo, and in that city he also left excellent works of art'.[23] Palermo lay on a plain

spreading down to the sea, hemmed in by mountains, and its beauty had
been celebrated since antiquity; Fazello, in *De Rebus Siculis*, described it
thus: 'It seems not a real landscape but a painted form of outstanding
beauty.' It was the viceregal capital, its massive fortifications and harbour
a declaration of Spanish strength, and in these years of fevered building
activity, of spacious streets, palaces, and monasteries, it was becoming
one of the grandest and most modern cities in Europe, where both the
Spanish and local aristocracy delighted in lavish displays of wealth and
power. In the early years of the seventeenth century Vincenzo di
Giovanni wrote proudly how 'the riches of the people ennoble the city,
the abundance and nobility of so many knights, with so many richly
ornamented carriages and horses, and finally so many barons, counts,
marquesses, dukes and princes'.[24] There was a particularly strong
Genoese presence, and on 11 May 1609, Cardinal Giannettino Doria,
member of a family with whom Caravaggio had lasting connections,
made a triumphal entry into Palermo as Archbishop. Yet splendour
masked extreme poverty, for Palermo was a parasitical city, and the new
buildings, which ploughed through earlier houses, aggravated poverty,
creating startling contrasts between their beauty and the miserable huts
that sprang up behind them. The mendicant Orders ministered to
the poor, with the help of confraternities and the *compagnie*, associated
with the monasteries, which practised the spiritual exercises, and were
devoted to acts of charity.

In these years many *compagnie* were intent on the decoration of the
small buildings, known as Oratories, where they met, and it was for the
Oratory of St Lawrence, then in the possession of the Compagnia di
San Francesco d'Assisi, that Caravaggio painted the only work we now
know of in Palermo. The Oratory of St Lawrence was a simple rectan-
gular space whose walls were originally decorated with canvases showing
scenes from the lives of St Francis and St Lawrence. Both saints were
patterns of humility and charity – St Lawrence, a third-century deacon,
was roasted on a gridiron for giving the treasures of the church to the
poor – and these scenes culminated in Caravaggio's altarpiece, the
Adoration of the Shepherds with Saints Lawrence and Francis where the two saints
frame the nativity (Plate 55), and an angel bears a scroll with the words

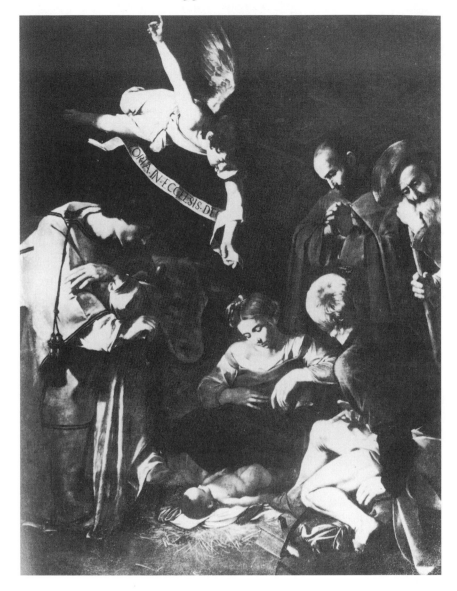

55. Caravaggio, *The Adoration of the Shepherds*
 with Saints Lawrence and Francis
 (formerly Palermo, Oratorio di San Lorenzo)

Gloria in excelsis Deo, words chanted in the Gloria Patri. Less austere than
the *Adoration* at Messina, and more conventionally symmetrical in com-

position, his painting conveys a more lyrical Franciscan spirituality. St Francis had re-created the crib at Greccio with a real ox and ass, and the painting recalls the tender description in the *Meditations on the Life of Christ* – 'The ox and the ass knelt with their mouths above the manger and breathed on the Infant as though they possessed reason and knew that the child was so poorly wrapped that He needed to be warmed . . . Thus the Lady of the World stayed, her face turned constantly toward the Manger, her eyes fixed affectionately on her sweet Son.'[25] In one version of St Francis's life the saint was said to have been born in a stable, and the writer concludes: 'The saint of God stood before the manger, full of sighs, overcome with tenderness and filled with wondrous joy.'[26] This *Nativity* is perhaps Caravaggio's most conventionally pious work, sweetly devout and unchallenging, looking back to the lyrical Lombard works of Moretto and Savoldo that he had known in his youth.

Caravaggio's stay in Palermo was short, and he was certainly once more in Naples by 24 October 1609. His wanderings in Sicily are full of contradiction, in part the triumphal progress of an international celebrity, admired and richly rewarded, and in part the anguished flight of a fugitive, fearing capture and possible death, sleeping with his dagger beside him; he was feared for his increasingly strange behaviour, and was constantly described – as he had not been in Rome – as mad and crazy. Nor is it clear whom he feared, whether the Roman law, or the Knights of Malta; he continued to call himself a Knight, and his months in Messina, where their presence was strong, does not suggest that he was hiding from the Knights. Mancini knew nothing of these years, and simply omits Sicily from his life of Caravaggio, but Baglione was clear that he left Palermo in fear – 'In Palermo he painted some works. But since his enemies were chasing him, he decided to return to Naples.'[27] This theme was later elaborated by Bellori, who wrote, 'misfortune did not abandon Michele, and fear hunted him from place to place . . . he no longer felt safe in Sicily, and so he departed the island and sailed back to Naples, where he thought he would stay until he got word of his pardon allowing him to return to Rome'.[28] It was now almost three years since Caravaggio had been exiled, and this was the customary term of exile, after which he might well expect a pardon. Great nobles had been

active on his behalf, and in Palermo he may have renewed contact with some of his noble patrons, such as the Doria (and perhaps the Archbishop, a Doria, who arrived in Palermo at almost the same moment as Caravaggio, had been instrumental in winning the commission for the Oratory of St Lawrence) and the Giustiniani family, who had close links with Palermo. This city may well have been the first stage of a journey back to Rome

And in 1608, just before he left, the Capuchin Vincenzo Donesana compared his life to that of his great compatriot Polidoro da Caravaggio. Polidoro, too, had languished in Sicily, having fled Rome when it was sacked by papal troops. But, Vasari tells us, having saved enough money to return, he was robbed by his serving boy and brutally murdered in his bed in Messina. Caravaggio, however, wrote Donesana, 'is on the contrary still alive, and has brought a very great deal to painting, inventing a path and a style that other painters will have to imitate, if they want to be perfect. For his divine ability in painting . . . he has been made a Knight by the Grand Master of the Order at Malta.'[29]

Naples and Death

ARAVAGGIO RETURNED TO NAPLES in the late summer of
1609, perhaps fleeing his enemies, or full of hope that he was
about to be pardoned, to be freed from the oppressive condi-
tion of banditry and exile. Those who had fled Rome with Caravaggio,
Onorio Longhi, and the brothers Giugoli, were also contemplating a
return. He was welcomed by both artists and patrons in Naples, where
he stayed in the Palazzo Cellamare at Chiaia, with his old protector, the
Marchesa di Caravaggio, now fifty-five, and briefly in Naples on family
business. The Spanish Viceregent, the Conde de Benavente, the Church,
noble Neapolitan families, great aristocrats from beyond Naples, among
them the Genoese Marcantonio Doria and the papal nephew, Scipione
Borghese, all hastened to acquire works from him, for he was the most
celebrated painter in Italy.

At the Riviera di Chiaia, to the west of Naples, Caravaggio had found
a refuge of paradisial beauty. Chiaia was an aritoscratic retreat, where
villas, set in spreading gardens, among cedars, figs and vines, had begun
to spread along the shore to Posillipo. Capaccio, in *Il Forastiero*, writes: 'I
can scarce believe that a more beautiful bay could ever greet mortal eyes.
The trees create gardens that in every season have flowers, and they are
green with orange trees, and with cedars of infinite grace . . . And all is
full of the habitations of great princes, an infinite number of gentlemen,
and of fishermen who come from that town.'[1] The Palazzo Cellamare,
where once Tasso had stayed, lay at the foot of the Via Chiaia only a
few minutes' walk from the Colonna town palace. It was a vast, block-
like, sixteenth-century palace, dominating its surroundings, and set in
immense terraced gardens, decorated with marble fountains, and fres-
coed walls, and offering views of both Naples and Posilippo. It was
opulent and lovely, offering those aristocratic pleasures of which del
Tufo had sung:

> Oh Chiaia, blessed shore: and oh, what gardens
> Are to be seen in those confines:
> And oh such strolls, and ah such glorious sports,
> As would restore the dead to life . . .[2]

But Caravaggio's enemies were in pursuit, and on 24 October 1609 he was so badly wounded in the Osteria del Cerriglio that a newspaper sent word of his death to Rome: 'There has come from Naples the news that Caravaggio the famous painter has been killed, while others say disfigured.'[3]

The Osteria del Cerriglio was the most famous tavern in Naples, and was indeed celebrated throughout Europe. It stood near the start of what is now the Via Sanfelice, and contained two large rooms, supported by arches, with two entrances, one to the Strada del Cerriglio, the other to the Vicolo di Santa Maria la Nova, and beyond this a courtyard with a fountain and terrace. The walls were adorned with proverbs celebrating the joys of wine and food, and women were on offer in the rooms above. The tavern was frequented by poets, artists and writers, and Cervantes says that it was very popular with the Spanish; Neapolitan poets sang of its joys, and it became synonymous with noble kitchens and the festive rites of Bacchus — the poet del Tufo wrote of

> . . . the Cerriglio,
> Where, on a balcony,
> Every type of tasty morsel is brought,
> Distinguished people come in through a secret
> entrance.
> And here, after distributing charity, the priest feasts . . .[4]

In this Rabelaisian setting Caravaggio came close to death.

Mancini, hearing the news, wrote in alarm to his brother: 'There is a rumour that Michelangelo da Caravaggio has been attacked by four men in Naples and there is fear that he has been scarred. If this is true it is a sin, and deeply disturbing . . . Let God grant that it is not true.'[5] Caravaggio was so badly wounded in the face during this incident that

he was almost unrecognisable.[6] On Christmas Day, two months later, Mancini wrote again: 'They say that Caravaggio may be near here, he wishes, soon to return to Rome . . .'[7]

Caravaggio's stay in Naples was to be short, and presumably some of it was taken up with convalescence. None the less, between October and July, when he left for Rome, he not only produced an astonishing number of works, but again created a new style. In his Sicilian works the figures are isolated in vast areas of darkness, set back in an architectural space, and the mood is often tender, conveying a profound sympathy with the poor and the meek who make up the Christian community. In Naples the mood harshens. Three-quarter-length figures, brought close to the spectator, are set against an abstract background of unrelieved, almost glittering blackness. These pictures are no longer tableaux vivants, as the Roman works had been, which startle with their immediacy, and with their new ways of telling a story and imagining the characters. They are starker, more concentrated works, built up around simple geometrical shapes, with very few colours, and with narrative pared down to the essentials. Their still figures, often strikingly pallid, are inward-turned and invite contemplation, and their theme is death and human evil. They show executioners and their victims, bound together in suffering, apparently without hope; there is a sense of the draining of faith, of submission to the tragic fate of man; they suggest an extreme casualness about human life that is deeply Neapolitan. In the *Crucifixion of St Andrew* (Plate 56) the saint longs for release from the prison of this world; the Risen Christ, rising with pain, one foot still in the tomb, flees 'like a sinner past his guards';[8] St Ursula, confronting her executioner, looks at her wound with appalled fascination, submitting to the bleak fact of death.

At the centre of this group of works, and intensely personal, are two pictures, *Salome with the Head of John the Baptist* (Col. Plate 40) and *David with the Head of Goliath* (Col. Plate 41). Similar in theme, they were both perhaps pleas for clemency, gifts from an artist who himself feared death by execution. Bellori tells us that Caravaggio sent a 'half-figure of Herodias with the head of St John the Baptist in a Basin'[9] from Naples to Malta to placate Alof de Wignacourt, and the Madrid painting may

well be that work. (The confusion between Salome and Herodias was common). It may have been painted in the late summer of 1609, before the attack at the Cerriglio, for it is close to the Sicilian works, and the executioner is a memory of the model for the shepherd in the Messina *Adoration*. Here Caravaggio transforms the story, of the dancing girl who so flippantly asked Herod for the head of John the Baptist, into a grave meditation on the vanity of human life. He ignores any erotic potential, rejecting the well-worn artistic contrast between a chic and seductive Salome, and a coarse and brutal executioner, and binds the three figures together in an arch of melancholy contemplation. There is no action, no sense of a moment caught and held, but stillness and grief, and the executioner, with bared shoulder, the flesh frailly painted, looks with sadness at his victim. The daring asymmetry, the figures so brightly lit in concentrated darkness, the subtle play of unstable curves, evoke transience, and the old woman, whose head seems joined to that of Salome, no longer offers a piquant contrast with her youth, but rather suggests the inevitability of death and age, implicit in the circular composition itself.

The *David with the Head of Goliath* may well have been a similar gift, aimed at Scipione Borghese, a desperate plea that the Cardinal should pardon him, and should free him from the fear of decapitation; it may perhaps have been sent to Rome to plead Caravaggio's cause.[10] David has killed the giant Goliath with a stone and sling, unsheathed his sword, and cut off his head. He is a shepherd boy, bare-headed and simply clad, 'a youth, and ruddy, and of a fair countenance' (1 Samuel 17:42), and Caravaggio sets his grace against the horror of Goliath's head, the forehead wounded, the neck streaming blood, and one eye, still living, gazing in anguish in the surrounding blackness. David's gaze is tender, and the two are bound together in a relationship with erotic resonance, underlined by the phallic sword. In the biblical story David's relationship with Goliath is homoerotic, and the word David means beloved. It is an arresting composition, of broad and simple shapes, in which the diagonals of sword and arm are halted by the strong vertical of David's hand and the giant's head, thrust so close to the spectator, and so heavy against the frailty of David's young arm.

In the head of Goliath, Bellori tells us, Caravaggio painted his own features. The picture is part of a long tradition of disguised self-portraits, which had its origin in the art of Giorgione. The first of these, and the first to create a relationship between the subject and the decapitated head, is Giorgione's *David meditating on the head of Goliath* which shows Giorgione as a melancholy David, in armour, brooding over Goliath's head and meditating on the power of the creative artist. A little later Titian dramatically painted himself as victim, subject to the cruelty of love, as the decapitated head of John the Baptist — borne on a charger held by a triumphantly seductive Salome.

Caravaggio played on this tradition and his rendering is in part rooted in his life. This is the head of the artist left for dead at the Cerriglio, wounded beyond recognition; it is an artist with reason to imagine his own execution, a darkly witty conceit reminiscent of the terrible clarity with which Walter Raleigh, waiting his own death, wrote:

> Just at the stroke, when my veins start and spread,
> Set on my soul an everlasting head . . ."

It also belongs to a culture in which condemned criminals were exhorted to penitence through pictures of cruelty and violence. The head still lives, and it suggests, in an age obsessed with salvation, a terrible fear of eternal damnation, of an everlasting consciousness

But perhaps most profoundly, and it is in this closer to Giorgione, it is about the power of the artistic imagination. It is an extraordinary image, a painting that startles and shocks the spectator. David has the pose and beauty of classical sculpture, brought to fresh artistic life, and caught between light and dark; Goliath, so real and yet so macabre, has the magical power of the Gorgon, placed before our eyes so that we are astonished and transfixed, turned to stone before it. It is truly a *meraviglia*, reminding us of the earlier Medusa, and its power to ensnare the spectator in a world of dark and tumultuous imaginings. It plays on the idea of life and death, on the power of the artist to make the dead live, and would have delighted such a collector as Marino, for whom Guido Reni's head of Goliath was a 'new Gorgon'[12] and whose imaginary

Galleria was hung with paintings of decapitations, of Salome, Judith, Jael and Sisera, David, and whose madrigals explore the theme of art's power to create wonder, to make the dead live, and to petrify the living. The severed head is a symbol of immortality, and Marino had written a sonnet to Orpheus, whose head continued to sing after he had been torn to pieces by frenzied Maenads.

These works were pleas for pardon, for the salvation of his marvellous talent, but Caravaggio was much sought after in Naples. He painted three important works, a *Resurrection*, a *St John* and *St Francis*, for Santa Anna dei Lombardi (all untraced), a church which was to be the centre of Caravaggesque painting in Naples, and he received a commission for a very large painting of the *Circumcision* from the Dominican church of Santa Maria della Sanità. The Conde de Benavente, Viceroy of Naples, left Naples in July 1610 and took with him a large *Crucifixion of St Andrew* (Plate 56) which may have been commissioned at this time. It shows an unusual moment in the story of St Andrew's crucifixion. The saint, having been tied rather than nailed to the cross, in order to prolong his suffering, preached to the crowds, who were moved to demand his freedom. The Proconsul of Patras ordered him to be freed, but Andrew longed to die like Christ on the cross, and his wish was miraculously granted, for the arms of the executioners were paralysed, and they could not loosen his bonds. Caravaggio's is an intense and still painting, moving in the extraordinarily free rendering of frail flesh, and in its deep sense of an exhausted longing for death.[13]

Another late work, *The Martyrdom of St Ursula* (Col. Plate 42), was commissioned by Marcantonio Doria, and Caravaggio worked on it in the spring of 1610. On 11 May 1610 Lanfranco Massa, correspondent and procurator of the Doria family, wrote to Marcantonio Doria about the painting and refers to Caravaggio as the 'friend' of Doria, a friendship that had presumably been formed during Caravaggio's visit to Genoa a few years earlier. Doria was also interested in paintings by Caracciolo, and as a patron was important in introducing Caravaggesque painting to Genoa. Massa had put Caravaggio's painting out in the sun to dry it more quickly, but this had softened the paint, 'because Caravaggio puts it on very thick', and was going to ask Caravaggio's help in preventing

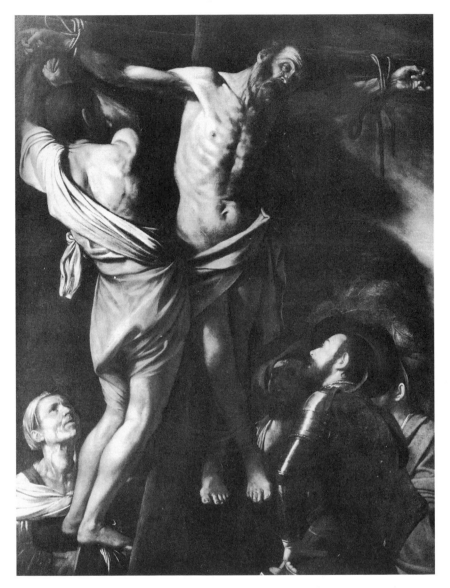

56. Caravaggio, *The Crucifixion of St Andrew*
(Cleveland Museum of Art)

damage to the work. The work had been greeted with the usual wonder, and, Massa reports, an unidentified Signor Damiano had seen it 'and was astounded, as also are all the others who have seen it'. The subject seems

to have been chosen in honour of Marcantonio's stepdaughter, who became a nun, Sister Ursula. The painting was finally despatched to Genoa on 27 May, in very good condition, in a felucca hopefully named *Santa Maria di Porto Salvo*, and arrived there 'in a long box' on 18 June.[14] But like the other late paintings, it is a tragic work, suggesting a personal despair. On the right the artist appears again, peering with appalled fascination at the executioner. This self-portrait is a quotation from the earlier *Taking of Christ*, where he had painted himself in a similar pose, but whereas that conveyed a flamboyant pride in creativity, this is a drained and desperate image. The artist is looking, not at the splendour of a world he has created, but at the horror of death.

In these months of the spring and early summer of 1610 Caravaggio was also painting, for Scipione Borghese, a melancholy *St John the Baptist*, perhaps his last picture, for which he used the same model as for the *David*; maybe Scipione had received the *David*, and was increasing the price of Caravaggio's return. Caravaggio was fêted, lavishly rewarded, and constantly in demand in Naples; but he was also in danger, perhaps from the Maltese, perhaps from the Spanish. But in Rome the art world longed for his return, and the noblest Italian families — the Colonna, the Doria, the Gonzaga, Scipione Borghese — were working to that end.

In the summer of 1610 Caravaggio, for so long an exile, left for Rome. He boarded the felucca at Chiaia, leaving from the Palazzo Cellamare, then the residence of the Marchesa Costanza, in whose household he had been born in Caravaggio; he took with him pictures intended for Cardinal Scipione Borghese, and others he left with the Marchesa. His pardon was assured, and he travelled with a safe conduct from Cardinal Ferdinando Gonzaga.[15] The felucca put in at Palo, a tiny port between Civitavecchia and the mouth of the Tiber, where there is very little but a fortress castle, and Caravaggio disembarked here, perhaps intending to go on to Rome. But disaster followed. The captain of the fortress put him in prison, maybe with the intention of checking his credentials, and ascertaining the validity of his pardon. Or maybe it was simply a mistake: Bellori says that the captain was waiting for another knight, and arrested Caravaggio in error. At this point the felucca, in high seas, could wait no longer, and went on to Port'Ercole, further up the coast; it

followed its usual itinerary, intending to disembark its cargo and take on a new one.

Caravaggio's situation was desperate. He bought his way out of prison, with a large amount of money, but then found himself, the most celebrated painter in Italy, alone, destitute, at a tiny frontier post, in a desolate, marshy terrain, infested with mosquitoes, where lawlessness and bandits threatened. His pictures had gone, and he must have set off to Port'Ercole, away from Rome, in pursuit of the felucca, desperate to recover his property, above all the paintings intended for Scipione Borghese, whose loss jeopardised his welcome in Rome. It was a harsh journey, of 100 kilometres, in the heat of midsummer, and Caravaggio travelled alone, perhaps by sea and land, and often on foot. Very little lay between Palo and Port'Ercole but a few fishing villages, and the frontier castles of San Severo and Santa Marinella.

Port'Ercole, then a small fortress town, under Spanish rule, lies on a spit of land that is almost an island, linked to the mainland only by a narrow causeway. A tiny square, with an elegant Renaissance palace, looks out over the sea. Here Caravaggio found that the felucca had gone, and with it most of his property, though maybe one picture had been left at Port'Ercole; he became very ill, from fever, and was perhaps comforted by the confraternity of San Sebastiano, whose role was to care for the sick and for travellers. Here, at this small outpost, once more within reach of Rome, he died, probably in the local infirmary. Baglione's account is romantic: 'In desperation he started out along the beach under the fierce heat of the July sun, trying to catch sight of the vessel that had his belongings. Finally, he came to a place where he was put to bed with a raging fever; and so, without the aid of God or man, in a few days he died, as miserably as he had lived',[16] but it does convey the real despair that Caravaggio must have felt on finding his paintings gone, and the sense of acute isolation that the place engendered, cut off from the world, with the great fortresses spreading up the hillside, and ringed by mountains, and, on all sides, the sea.

All Rome had been waiting for him, and news of his death spread fast. On 28 July the correspondent from Urbino wrote: 'News has arrived of the death of Michel Angelo Caravaggio, famous painter and

most excellent in colouring and imitation of nature, following his illness at Port'Ercole', and, three days later, another report ran: 'Michel Angel da Caravaggio, famous painter, is dead at Port'Ercole while travelling from Naples to Rome thanks to the grace of his Holiness in revoking the warrant for murder.'[17] Both reports were clear that Caravaggio had died at Port'Ercole, and that he had been pardoned by the Pope. His last days were a series of misadventures culminating in tragedy, and the early sources, and a series of letters from Deodato Gentile, the Bishop of Caserta, to Scipione Borghese, suggest their turbulence and despair.[18] On 24 July the correspondent of Scipione Borghese had been instructed by the Cardinal to write to Gentile and get an accurate account of what had happened. The Bishop hurried to reply on 29 July. The news of Caravaggio's death, he wrote, was entirely new to him, but he had swiftly made inquiries, and found that 'the poor Caravaggio did not die at Procida, but at Port'Hercole, because, having arrived at Palo with the felucca, in which he was travelling, he was there imprisoned by that Captain . . .' Gentile then began to look for the pictures which had returned to Naples on the felucca, and went to ask Costanza Colonna at Chiaia what had happened to them. Only three were still at Chiaia, two *St Johns*, and a *Magdalene*. Gentile told her to guard them well, and not to let anyone see them, for they were already spoken for by Scipione Borghese, and the problems of Caravaggio's heirs and creditors would have to be discussed. But a few days later the Bishop found out that the pictures had been sequestered by Fra Vincenzo Carafa, the Prior of Capua, on the grounds that they belonged to the Knights of Malta, of whom Caravaggio had been a member, and were now in the hands of the ministers of the Crown. The Prior seems unaware that Caravaggio had been defrocked, though Costanza Colonna knew it, and remarked that his claim was folly. It was only after many delays that Scipione finally received the *St John the Baptist* that is still in the Galleria Borghese in Rome, and the other two pictures disappear from the story. The Viceroy himself, Don Pedro Fernandez de Castro, who had succeeded the Conde de Benavente, had stepped in, asking for a copy of the picture, and, extremely puzzlingly, writing to the Judge of Military affairs at the Tuscan garrison, enclosing an inventory (perhaps made by

the confraternity of San Sebastiano) of Caravaggio's effects, and asking for the return of Caravaggio's belongings, particularly a *St John*. Two *St Johns* had returned to Chiaia, and it is extremely surprising, but not impossible, that there should be yet another; he may have been referring to the *Salome with the Head of John the Baptist* now in the National Gallery, London, and a very late work.

Caravaggio's epitaph was composed by Marzio Milesi, and Marino wrote a poem to him. His friends were more fortunate, for Onorio Longhi and Giovanni Franceso Tomassoni were both pardoned, and returned to Rome; Fillide Melandroni, briefly exiled from Rome in 1612 on the demand of the relatives of Giulio Strozzi, who wished to marry her, returned to amass considerable wealth. Only three days before his death a nephew was born in Caravaggio who bore the name Michelangelo. To his contemporaries he had been an odd, difficult character, both feared and admired, and the creator of a magical naturalism, that ravished human sight. A few years after his death Giulio Cesare Gigli described him as his contemporaries had viewed him:

> He was of a fantastic humour, indeed bizarre,
> Pallid of face, and his hair
> Thick and curly
> His eyes lively, yet deeply sunk . . .
> [he was]
> The great protopainter,
> Marvel of art,
> Wonder of nature,
> Though later a victim of misfortune.[24]

Notes

ABBREVIATIONS FOR FREQUENTLY CITED SOURCES

G. Baglione, *Le vite de' pittori, scultori, architetti, dal pontificato di Gregorio XIII del 1572, fino a tempi di Papa Urbano VIII nel 1642* (Rome, 1642)
Baglione/Hibbard, 1988

G. P. Bellori, *Le vite de' pittori, scultori ed architetti moderni* (Rome, 1672)
Bellori/Hibbard, 1988

G. Mancini, *Considerazioni sulla Pittura* (MS: Rome, c. 1617–30): ed. A. Marucchi and L. Salerno, 2 vols (Rome, 1956–7)
Mancini/Hibbard, 1988

M. Marini, *Caravaggio, Michelangelo Merisi da Caravaggio 'pictor Praestantissimus'* (Rome, 1989)
Marini, 1989

S. Corradini, *Caravaggio. Materiali per un processo* (Rome, 1993)
Corradini, 1993

INTRODUCTION

1 On Caravaggio and Mancini see M. Maccherini, 'Caravaggio nel Carteggio familiare di Giulio Mancini', *Prospettiva*, 86, 1997, pp. 71–92.
2 H. Hibbard, *Caravaggio* (London, 1983) (ed. con. 1988; pp. 343–387).
3 Bellori/Hibbard, 1988, p. 373.
4 S. Bann, *The True Vine: On Visual Representation and Western Tradition* (Cambridge and New York, 1989), p. 87.

CHAPTER ONE

1 Padre Guglielmotti, quoted in P. Colonna, *I Colonna dalle Origini all'Inizio del Secolo XIX* (Rome, 1927), p. 235.
2 N. Lemaître, *Saint Pie V* (Paris, 1994), p. 316.
3 P. Colonna, op. cit., p. 219. The long-lasting importance of the Colonna family to Caravaggio, which recent archival discoveries have confirmed, was first brilliantly inferred by M. Calvesi; see M. Calvesi, *Le Realtà del Caravaggio* (Turin, 1997), *passim*.
4 Mancini/Hibbard, 1988, p. 347. It has been suggested that Caravaggio was of noble birth; see M. Calvesi, 'La Nobiltà del Caravaggio', *Art e Dossier*, VII, 68, 1992, pp. 18–19.
5 Baglione/Hibbard, 1988, p. 352.
6 Most of the documentary research on Caravaggio's youth, to which this section is indebted, was done by M. Cinotti, and originally published in M. Cinotti, 'La Giovinezza del Caravaggio. Ricerche e Scoperte', in M. Cinotti ed., *Novità sul Caravaggio: Saggi e Contributi*

(Milan, 1975), pp183-214. A summary of these, and new material have been published by the same author, in *I Pittori Bergamaschi dal XIII al XIX Secolo*, vol. V, Il Seicento (Bergamo, 1991), vol. I, pp. 233–56. For the birth of the children, see p. 234.

7 The place and date of Caravaggio's birth have been the subject of considerable discussion. Michelangelo was certainly born before Giovan Battista, as other documents make clear, and the date of the wedding suggests a date either at the end of September or early in October. The inspired suggestion that he was born on 29 September 1571, on the feast day of the Archangel Michelangelo, was made by M. Calvesi, and for this see *Le Realtà del Caravaggio*, op. cit., p. 112. This is now usually accepted, and is supported by the epitaph written by Marzio Milesi, who says that Caravaggio died at the age of thirty-six years, nine months and twenty days. He got the year wrong, for Caravaggio was almost thirty-nine when he died, but the month and day suggest late September. M. Cinotti believed that Caravaggio was born in Milan (see M. Cinotti, 'La Giovinezza del Caravaggio. Ricerche e Scoperte', op. cit., pp. 200–214). More recently R. Zigliolo, in 'Il Caravaggio . . . a Caravaggio, in Roma' in S. Macioce (ed.), *Michelangelo Merisi da Caravaggio: La Vita e le Opere attraverso i Documenti* (Rome, 1995), p. 63, has argued that he was born in Caravaggio. Caravaggio later signed himself as 'Michelangelo da Caravaggio', and, when made a Knight of Malta, the official document, for which he himself presumably supplied the information, declared that he was 'born in the town called Caravaggio in Lombardy'. This seems conclusive.

8 P. Morigi, *La Nobiltà di Milano* (Milan, 1595), p. 332.

9 Ibid., p. 268.

10 *Il Seicento Lombardo*, exhibition catalogue, ed. G. Bora and others, 1973 (Milan, Palazzo Reale and Pinacoteca Ambrosiana), vol. I, p. 85. For the Lombard background see, in this catalogue, M. Gregori 'Note Storiche sulla Lombardia tra Cinque e Seicento', vol. I, pp. 19–46.

11 M. Rosci, *I Quadroni di San Carlo del Duomo di Milano* (Milan, 1965), p. 102.

12 Translated by J. Chorpening in 'Another Look at Caravaggio and Religion', in *Artibus et Historiae*, 16, 1987, p. 155.

13 As given in P. Brown, *Power and Persuasion in Late Antiquity: Towards a Christian Empire* (Madison, Wisconsin, 1988), p.153.

14 P. Phan, *Message of the Fathers of the Church* (Wilmington, Del., 1984), pp. 123, 7.

15 San Carlo Bascapé, as given in A. Guidetti, *San Carlo Borromeo: la vita nell'iconografia e nei documenti* (Milan, 1984), p. 108.

16 Ibid., p. 106.

17 San Carlo Bascapé, as given in E. Brivio, *The Life and Miracles of St Carlo Borromeo* (Milan, 1995), p. 15.

18 M. Cinotti, in *I Pittori Bergamaschi*, op. cit., p. 235, for the documents relating to this paragraph.

19 R. Zigliolo, op. cit., in S. Macioce (ed.), op. cit., p. 63.

20 On schooling see C. Dempsey, 'Some Observations on the Education of Artists in Florence and Bologna During the Later 16th Century', *Art Bulletin*, 52, 1980, pp. 552–69.

21 Quoted in *Il Seicento Lombardo*, op. cit., vol. I, p. 42.

22 R. Klein, H. Zerner (eds.), *Italian Art 1500–1600: Sources and Documents* (Englewood Cliffs, NJ, 1996), pp. 167–8.

23 This contract is published in M. Cinotti and G. A. Dell'Acqua, *Il Caravaggio e le sue Grande Opere di San Luigi dei Francesi* (Milan, 1971), p. 146, F2. S. Macioce, 'Considerazioni su documenti inediti relativi al soggiorno lombardo del Caravaggio', in *Storia dell'Arte*, 85, 1995, pp. 359–68, has suggested that Caravaggio was in Milan at a very much earlier date.

24 E. Bacceschi and M. Calvesi, 'Simone Peterzano', *I Pittori Bergamaschi*, op. cit., IV, *Il Cinquecento*, iv, p. 476.

25 E. C. Voelker, *Charles Borromeo's Instructiones Fabricae et Supellectilis Ecclesiasticae*, 1577 (Ann Arbor, Michigan, 1977), p. 228.

26 G. Alberigi, *Il Grande Borromeo: tra storia e Fede* (Milan, 1984), p. 112.

27 This contract is quoted, and discussed, in M. Gregori, ed., *Gli Affreschi della Certosa di Garegnano* (Turin, 1973), p. 10.

28 Bellori/Hibbard, 1988, p. 361.

29 M. Gregori, 'Riflessioni sulle origini della natura morta. Da Leonardo al Caravaggio' in *La natura morta al tempo di Caravaggio*, exhibition catalogue, 1996, (Rome, Musei Capitolini), p.19.

30 M. Kemp and M. Walker, eds; *Leonardo on Painting; an Anthology of Writings by Leonardo da Vinci, with a Selection of Documents Relating to his Career as an Artist* (Newhaven, Connecticut, and London, 1989), p. 42.

31 G. P. Lomazzo, *A Tracte Containing the Artes of Curious Paintinge Carvinge and Buildinge* (tr. R. Haydocke) (Oxford, 1598) (Farnborough, 1978), Book II, p. 3.

32 R. Klein and H. Zerner, op. cit., p. 112, from G. P. Lomazzo, *Idea del Tempio della Pittura* (Milan, 1590), chapter 29.

33 Translated in W. Kriegeskorte, *Giuseppe Arcimboldo* (Cologne, 1993), p. 45.

34 G. Comanini, *Il Figino overo del Fine della Pittura* (Mantua, 1591), in P. Barocchi (ed.), *Trattati d'Arte del Cinquecento fra Manierismo e Controriforma* (Bari, 1962), vol. III, p. 274.

35 Ibid., p. 286. For the importance of icastic art to Caravaggio see F. Quiviger, *Caravaggio* (London, 1992), p. 24.

36 G. P. Lomazzo, *A Tracte Containing the Artes . . .* , op. cit., Book III, p. 94.

37 P. Morigi, op. cit., p. 181.

38 For this possibility see G. Berra, 'Contribuzione per la datazione della natura morta di pesche di Ambrogio Figino', *Paragone*, 469, 1989, pp. 3–13. The painting is in a private collection.

39 For the documents concerning Caravaggio's sale of his property see M. Cinotti, in *I Pittori Bergamaschi*, op. cit., pp. 251-256. Mancini/Hibbard, 1988, p. 347.

40 W. Friedlaender, *Caravaggio Studies* (Princeton, NJ, 1955), p. 233.

41 This is the re-reading of this almost indecipherable document proposed by M. Calvesi, *Le Realtà del Caravaggio*, op. cit., p. 118.

42 Only Bellori, amongst the early sources, says that Caravaggio went to Venice; see H. Hibbard, *Caravaggio* (London, 1988) pp. 5–6.

43 C. Marcora (ed.), *I funebri per il Cardinale Carlo Borromeo* (Milan, 1984), p. 51.

44 Long extracts from the *Memoriale* have been published in F. M. Ferro, 'La Peste nella Cultura Lombarda', in *Il Seicento Lombardo*, op. cit., vol. I, pp. 85–124. For this quotation see p. 90.

45 Ibid., p. 88.

46 This is printed by G. Berra, op. cit., p. 5. It comes from a collection of poems entitled *Le Muse Toscane di diversi nobilissimi ingegni* (ed. G. Borgogni) (Bergamo, 1594).

CHAPTER TWO

1 *The Complete Works of Montaigne* (tr. D. Frame) (London, 1958), p. 954.

2 A. Zuccari, *I Pittori di Sisto V* (Rome, 1992), p. 58.

3 G. Martin, *Roma Sancta* (1581) (ed. G. B. Parks) (Rome, 1969), p. 54. On Rome, Civitas Sancta, see F. J. McGinness, *Right Thinking and Sacred Oratory in Counter-Reformation Rome* (Princeton, NJ, 1995), pp. 167–92.

4 J. Delumeau, *Rome au XVIe siècle* (Paris, 1975), p. 149.

5 Agostino, Cardinal Valier, *Il Dialogo della Gioia Cristiana* (tr. and ed. A. Cistellini) (Brescia, 1975), p. xiii.

6 G. Bentivoglio, *Memorie e Lettere* (ed. C. Panigada) (Bari, 1934), p. 36.

7 D. Beggiao, *La Visita pastorale di Clemente VIII (1592–1600)* (Rome, 1978), p. 36.

8 Ibid., p. 106.

9 G. Bentivoglio, op. cit., pp. 39 and 40.
10 On this see R. Zapperi, *Eros e Controriforma. Preistoria della Galleria Farnese* (Turin, 1994), p. 50.
11 J. Spon, *Voyage de l'Italie, de Dalmatie, de Grèce, et du Levant, fait aux années 1675 et 1676*, 4 vols. (Lyon, 1678), vol. I, p. 45.
12 On the cardinals' courts in sixteenth-century Rome, see G. Fragnito, 'Cardinals' Courts in Sixteenth-Century Rome', *Journal of Modern History*, 65, no. 1, 1993. This passage from Bentivoglio is quoted on p. 45.
13 F. Albergati, *Del Cardinale* (Rome, 1598), p. 191.
14 L. Spezzaferro, 'Il Recupero del Rinascimento', in F. Zeri, ed., *Storia dell'Arte Italiana*, Part 2, vol. II: *I Cinquecento e Seicento* (Turin, 1981), p. 186.
15 C. Fanucci, *Trattato di Tutte l'Opere Pie dell'Alma Città di Roma* (Rome, 1601), pp. 70–1.
16 B. Geremek, *Poverty: A History* (Oxford, 1994), p. 213.
17 C. Bacci, as quoted in D. Alaleona, *Storia dell'Oratorio Musicale in Italia* (Milan, 1945), p. 26.
18 L. Ponnelle and L. Bordet, *St Philip Neri and the Roman Society of his Times* (tr. R. F. Kerr) (London, 1937), p. 129.
19 Ibid., p. 492.
20 G. Bentivoglio, op. cit., p. 31.
21 C. K. Pullapilly, *Caesar Baronius, Counter-Reformation Historian* (Notre Dame, Indiana, and London, 1975), p. 54.
22 For the text of this see P. Barocchi, *Trattati d'Arte del Cinquecento, fra Manierismo e Controriforma* (Bari, 1961), vol. II, pp. 119–509.

CHAPTER THREE

1 Caravaggio is documented as being in Caravaggio in May 1592. His arrival in Rome in this year confirms Mancini's account; Mancini/Hibbard, 1988, p. 47, says that Caravaggio got to Rome when he was about twenty. M. Calvesi in 'La "caraffa di fiori" e i riflessi di luce nella pittura del Caravaggio', in S. Macioce, ed., *Michelangelo Merisi da Caravaggio: La Vita e le Opere attraverso i Documenti* (Rome, 1995), p. 237, n. 4 has published a letter which mentions the presence of Costanza Colonna in Rome at this date.
2 Baglione/Hibbard, 1988, p. 352.
3 The phrase is Malvasia's. For a discussion of the 'maniera statuina', and the reaction against it, see C. Dempsey, 'The Carracci Reform of Painting', in *The Age of Correggio and the Carracci: Emilian Painting of the Sixteenth and Seventeenth Centuries*, exhibition catalogue, National Gallery of Art (Washington, DC, 1986), pp. 237–54.
4 M. Roskill, *Dolce's 'Aretino' and Venetian Art Theory of the Cinquecento* (New York, 1968), p. 163.
5 Gilio da Fabriano, *Due Dialoghi . . . nel seconda si regiona de gli errori de Pittori circa l'historie* (Camerino, 1564), Folio 87v.
6 See letter from Baldo Falcucci, the court of Urbino's ambassador in Rome, in Z. Waźbiński, *Il Cardinale Francesco Maria Del Monte 1549–1626* (Florence, 1994), p. 61.
7 G. P. Bellori, *The Lives of Annibale and Agostino Carracci* (tr. C. Enggass) (University Park, Pennsylvania, and London, 1968), p. 6.
8 F. Haskell, *Patrons and Painters* (London, 1963), p. 121; as translated from M. Missirini, *Memorie per servire alla storia della Romana Accademia di San Luca* (1823), p. 126.
9 Bellori/Hibbard, 1988, p. 361.
10 The stay with Pandolfo Pucci is described in detail in Mancini's manuscript (Mancini/Hibbard, 1988), p. 347. Tarquinio is mentioned in one of the annotations to that manuscript, H. Hibbard, *Caravaggio* (London, 1988), p. 8.
11 For the quotations in this paragraph, see Mancini/Hibbard, 1988, p. 347.
12 The source for this is Mancini's additions to his manuscript; see, for the variant versions

of Mancini's manuscripts, and a discussion of these extremely confusing incidents, Marini, 1989, p. 15.

13 *The Boy Bitten by a Lizard* (London, National Gallery) cannot be the very early work mentioned by Mancini. For the problem of originals and copies of the *Boy Peeling a Fruit*, see S. Macioce, 'Una Nota per il Mondafrutto', in S. Macioce (ed.), op. cit. pp. 123–36.

14 Baglione/Hibbard, 1988, p. 352; Bellori/Hibbard, 1988, p. 356.

15 The stay with Antiveduto is only mentioned in Bellori's notes to Baglione, and he does not include it in his official biography; but it is in keeping with other events in Caravaggio's early career and probably true. Bellori/Hibbard, 1988, p. 356.

16 G. Baglione, *Le Vite de' Pittori, Scultori et Architetti* (Rome, 1642), p. 293.

17 G. Mancini, *Considerazioni sulla Pittura* (ed. A. Marucchi) (Rome, 1956), vol. I, p. 245.

18 M. Calvesi, *Le Realtà del Caravaggio* (Turin, 1990), p. 168, an attribution elaborated less cautiously by J. Spike in *La regola e la fama: San Filippo Neri e l'arte*, exhibition catalogue, 1995 (Rome, Museo Nazionale del Palazzo di Venezia), pp. 588–9.

19 F. Susinno, *Le Vite de' Pittori Messinesi* (1724) (ed. Martinelli) (Florence, 1960), p. 117. The date of Minniti and Caravaggio's stay in the studio of Lorenzo Siciliano is impossible to establish. M. Calvesi, op. cit., p. 169, argues for 1594–5; he argues that Minniti probably did not arrive in Rome until 1595 or '96, as Susinno tells us that he stayed there ten years, and left in 1606. However, he left Syracuse in 1592, and this would mean that he stayed in Malta for a considerable time; other authorities have suggested that it is more likely that he arrived in Rome in 1593.

20 Orlandi's account is published in S. Corradini, 'Nuove e false notizie sulla presenza del Caravaggio in Roma', in S. Macioce (ed.), op. cit., p. 74.

21 Letter of 21 July 1593; as translated in R. and M. Wittkower, *Born under Saturn* (London, 1963), p. 234.

22 Baglione, op. cit., p. 292.

23 Ibid., p. 357.

24 Ibid., p. 374.

25 Ibid., p. 102.

26 Ibid., p. 102.

27 For the life of Prospero Orsi, see Baglione, op. cit., pp. 299–300. His age is not entirely clear; he died in 1633 and Baglione says that he was then 75, which implies a birth date of 1558, and makes him considerably older than Caravaggio. This more or less tallies with Mancini's account. G. Mancini, op. cit., vol. I, p. 252, says that Orsi was between 50 and 60 in *c.* 1619–20. But the evidence of Costantino Spata, cited by S. Corradini and M. Marini in 'The Earliest Account of Caravaggio in Rome', *Burlington Magazine*, January 1998, p. 26, suggests that Orsi was 25–28 years old in 1597.

28 The early sources disagree on the date of this episode; Baglione puts it before Caravaggio's period in Cesari's studio; Mancini, with detail that suggests accuracy, places it later, and says that it concluded his stay there. Mancini also says that Caravaggio did many paintings for the Prior of the hospital, who took them home to Seville (but in his notes he says Sicily). It is not clear who the Prior was during Caravaggio's stay.

29 Bellori/Hibbard, 1988, p. 361.

30 The *Sick Bacchus* was in Cesari's stock in 1607, when it was confiscated by Scipione Borghese. That implies that it was painted while Caravaggio was still in Cesari's studio. Baglione, however, says that 'a Bacchus with different bunches of grapes' (Hibbard/Baglione, 1988, p. 352) – almost certainly the *Sick Bacchus* – was amongst a number of 'portraits of himself in the mirror' that Caravaggio painted while he was trying to live by himself, immediately after leaving Cesari. It is possible that Cesari could have bought the painting at some later date before 1607. *The Boy with a Basket of Fruit* was also confiscated from Cesari.

31 G. Marino, *La Galeria* (Venice, 1620), ed. M. Pieri (Padua, 1979), p. 199.

32 Horace, Odes, Book 1, 1; *Complete Odes and Epodes* (London, 1983), pp. 69–70.

33 Philostratus the Elder, *Imagines* (tr. A. Fairbanks) (London, 1931), p. 125.

34 Horace, Ode XVII, Book 1, op. cit., p. 86.

35 G. B. del Tufo, *Ritratto o Modello delle Grandezze, delitie e meraviglie della nobilissima Città di Napoli* (ed. C. Tagliareni) (Naples, 1956), pp. 32–2.

36 As translated by W. Friedlaender, in 'The Academician and the Bohemian; Zuccari and Caravaggio', in *Gazette des Beaux Arts*, XXXIII, 1948, p. 30.

37 D. Heikamp (ed.), *Scritti d'Arte di Federico Zuccaro* (Florence, 1961), pp. 65–8.

38 A Michele Milanese is listed in the Libro degli Introiti of the Accademia di San Luca, but the date is not clear; it has been suggested that this artist, who then disappears from history, may have been Caravaggio. For Caravaggio's participation in the Forty Hours see H. Waga, *Vita Nota e Ignota dei Virtuosi al Pantheon* (1992), 'Appendice 1', 'Lista delli fratelli che hanno a stare assistenti alle S. Me Ora. ni di Quarta Hore', pp. 219–220ff; and S. Rossi, 'Peccato e Redenzione negli Autorittratti del Caravaggio' in S. Macioce, ed., op. cit., pp. 316–27.

39 From V. Giustiniani, 'Letter on Painting to Theodor Ameyden' in G. Bottari (ed.), *Raccolta di Lettere sulla Pittura* (Rome, 1768), vol. VI, pp. 247–53. As translated in R. Enggass and J. Brown, *Italy and Spain 1600–1759: Sources and Documents* (Englewood Cliffs, NJ, 1970), p. 17.

40 C. Van Mander, Het Schilder-Boeck (Haarlem, 1604) as translated in H. Hibbard, 1988, p. 344.

CHAPTER FOUR

1 Bellori/Hibbard 1988, p. 362.

2 G. Baglione, *Le vite de'pittori, scultori et architetti* (Rome, 1642), p. 300.

3 G. Mancini, *Considerazioni sulla Pittura* (ed. A. Marucchi) (Rome, 1956), vol. I, pp. 251–2.

4 Ibid., notes, Vol. I, p. 227.

5 Mancini/Hibbard, 1988, p. 347.

6 A. Proia and P. Romano, *Roma nel Rinascimento* (Rome, 1933), p. 140. The census is from 1566.

7 Marini, 1989, p. 26, says that it is just possible that Caravaggio was at the Palazzo Petrignani in 1594, as he may have followed the painter Anton Maria Panico, who left Petrignani's service in January 1594. C. Gilbert, *Caravaggio and His Two Cardinals* (University Park, Pennsylvania, 1995), pp. 132–3, argues for the date of 1595.

8 B. Castiglione, *The Book of the Courtier* (1561) (tr. T. Hoby) (London, 1974), p. 18.

9 L. Spezzaferro, 'La Cultura del Cardinal Del Monte e il primo tempo di Caravaggio', *Storia dell'Arte*, 9–10, 1971, p. 68; as translated by C. Gilbert, op. cit., p. 203.

10 L. Spezzaferro, op. cit., p. 67, n. 51.

11 G. Pieraccini, *Le Stirpe dei Medici di Cafaggiolo* (Florence, 1925), vol. II, p. 289.

12 Z. Waźbiński, *Il Cardinale Francesco Maria Del Monte 1549–1626* (Florence, 1994), p. 77.

13 Ibid., p. 113.

14 First published and translated by F. T. Camiz, 'Music and Painting in Cardinal del Monte's Household', *Metropolitan Museum Journal*, 26, 1991, p. 213. For the original see Z. Waźbiński, op. cit., pp. 376–7.

15 L. Spezzaferro, op. cit., p. 21.

16 Z. Waźbiński, op. cit., p. 377.

17 Ibid., p. 379.

18 Ibid., pp. 381–2.

19 See Marini, 1989, p. 26, and C. Frommel, 'Caravaggios frühwerk und der Kardinal Francesco Maria del Monte', *Storia dell'Arte*, 9/10, 1971, pp. 7–8, n. 20 for Petrignani's inventory of 18 March 1600, which contains no mention of Caravaggio.

20 G. Mancini, op. cit., p. 216.

21 Baglione/Hibbard, 1988, p. 352, tells us that Caravaggio suffered from dire poverty after leaving Cesari's studio, until he was rescued by a French dealer, Maestro Valentino, who lived near S Luigi dei Francesi. As S. Corradini and M. Marini, in 'The Earliest Account of Caravaggio in Rome', *Burlington* Magazine, CXL, January 1998, pp. 25–8, have demonstrated this dealer was the Italian, Costantino Spata.

22 The early sources on the *Gypsy Fortune Teller* are extremely confusing, a confusion exacerbated by the fact that there are two versions of this painting, the work in the Capitoline, and another work, subtler in mood, in the Louvre in Paris. Scholarly opinion is divided both over attribution and over the sequence in which they were painted. Mancini tells us that 'During that period he painted many pictures, and in particular a Gypsy who tells a young man his fortune, the Flight into Egypt, the Penitent Magdalene, a St John the Evangelist' (Mancini/Hibbard, 1988, p. 347), but it is not clear whether 'that period' means when he was in d'Arpino's studio or with Fantin Petrigani. Elsewhere he describes a *Gypsy Fortune Teller* that belonged to Alessandro Vittrice, but this does not mean that all his remarks on the painting refer to this version. This picture was left to Alessandro by Gerolamo Vittrice, the patron of the *Entombment of Christ* (Vatican, Pinacoteca); Corradini, 1993, p. 96. Mancini mentions a painting of a gypsy sold for 8 scudi and this was probably the Capitoline picture, bought by del Monte for this low price. For a summary of the arguments over dating and attribution see K. Christiansen, *A Caravaggio Rediscovered: the Lute Player*, exhibition catalogue, Metropolitan Museum of Art, New York, 1990, pp. 54–5, and *Michelangelo Merisi da Caravaggio. Come nascono i Capolovari* (ed. M. Gregori), exhibition catalogue, 1991 (Florence, Palazzo Pitti; Rome, Palazzo Ruspoli), pp. 86–95.

23 Bellori, as translated in Hibbard, p. 362.

24 Anton Maria Cospi, *Il Giudice Criminalista* (Florence, 1643), p. 551.

25 Ibid., p. 553.

26 A. Bragaglia, *Storia del Teatro Popolare Romano* (Rome, 1958), p. 91.

27 Ibid., p. 98.

28 On Del Monte's connection with the Gelosi, see Z. Waźbiński, op. cit., p. 86. For the quote see A. Bragaglia, op. cit., p. 92; it is taken from the *Diario di G. Pavoni* for the Medici-Lorrain wedding.

29 These engravings are part of the *Receuil de Froissard*, Stockholm, National Museum.

30 On gypsy dress, see Paul Holberton, 'Giorgione's "Tempest" or "little landscape with the storm with the gypsy": more on the gypsy and a reassessment', *Art History* vol. XVIII, no. 3, 1995, pp. 383–403. For the quotation, see p. 386.

31 On this, see Barry Wind, '"Pitture Ridicole": Some Late Cinquecento Comic Genre Paintings', *Storia dell'Arte* 20, 1974, pp. 25–35.

32 See D. J. Gordon, 'Gypsies as Emblems of Comedy and Poverty', *Journal of the Gypsy Lore Society*, 3rd series, XXIII, 1944, pp. 39–42. Gordon cites Ripa's *Iconologia* (Padua, 1625), pp. 104–5. The Ariosto frontispiece is illustrated opposite p. 40.

33 G. Murtola (ed.), 1603, *Rime del Signor Gasparo Murtola* (Venice, 1604), Madrigal 472; as given in K. Christiansen, op. cit., p. 17.

34 O. Tronsarelli, *L'Appollo* (Rome, 1634), pp. 212–3.

35 F. Berni, *Rime* (ed. D. Romei) (Milan, 1985), p. 62.

36 A. Rocca, 'Trattato di Fr. Angelo Rocca Vescovo e Prefetto della Sacrestia apostolica per la salute dell'anima e per la Conservazione della Robba' (Rome, 1617), in *Costume e Società nei giochi a Stampa di Giuseppe Maria Mitelli*, exhibition catalogue, 1988 (Foligno, Palazzo Alleori Ubaldi) p. 78.

37 R. Zapperi, *Eros e Controriforma. Preistoria della Galleria Farnese* (Turin, 1994), p. 87.

38 Archivio di Stato di Roma, Tribunale Criminale del Governatore Processi Busto 291, Anno 1595, pp. 445ff.

39 Z. Waźbiński, op. cit., p. 142n.

40 Bellori/Hibbard, 1988, p. 363.

41 Fondazione Treccani degli Alfieri, *Storia di Milano: L'Età della Riforma*, vol. X (Milan, n.d.), p. 408.

42 See D. Boughner, *The Braggart in Renaissance Comedy* (Minneapolis, 1954), p. 80.

43 I am grateful to Lynda Stephens for suggesting that the gloves, which so prominently reveal the polished finger, might be cheats' gloves. See also A. M. Cospi, op. cit., pp. 560–61.

44 A. M. Cospi, op. cit., p. 561.

45 P. Aretino, *Le Carte Parlanti* (Palermo, 1992), p. 229.

46 A. Bragaglia, op. cit., p. 108.

47 Amayden, as translated by C. Gilbert, op. cit., p. 205. This chapter, 'Reports on Sexuality', contains a fascinating discussion of the sexual orientation of Del Monte and Caravaggio.

48 Amayden's report is published in Latin in the seminal article by L. Spezzaferro, op. cit., p. 61.

49 This letter is dated 9 July 1593. Archivio di Stato di Firenze (Fondo Mediceo del Principato 3759, ff.600–01). I am grateful to Franca Trinchieri Camiz for telling me of this letter.

CHAPTER FIVE

1 Z. Waźbiński, *Il Cardinale Francesco Maria Del Monte 1549–1626* (Florence, 1994), p. 115.

2 Ibid., p. 518. On Leoni's relationship with Del Monte, see pp. 198–9.

3 R. Toste, *Discourse to the Bishop of London* (1589) (ed. R. C. Melzi), p. 59. I am grateful to Emma Lauze for this reference. The suggestion that Gerolama was the model for the Judith was made by R. B. Amidei, 'Della committenza Massimo', *Caravaggio: Nuove Riflessioni, Quaderni di Palazzo Venezia*, 6 (Rome, 1989), p. 50.

4 Z. Waźbiński, op. cit., p. 240.

5 Ibid., p. 455.

6 Ibid., p. 380; A. Banti (ed.), *Europa Milleseicentosei Diario di Viaggio di Bernardo Bizoni* (Milan–Rome, 1942), pp. 76–7.

7 Baglione/Hibbard, 1988, p. 352.

8 G. Martin, *Roma Sancta* (1581) (ed. G. B. Parks) (Rome, 1969), p. 96.

9 Z. Waźbiński, 'Uno Schizzo di P. P. Rubens per il ritratto di un cardinale: Montalto o Del Monte?', in *Rubens: dall'Italia all'Europa*, Atti del Convegno, 1990, p. 73.

10 B. Castiglione, *The Book of the Courtier* (1561) (tr. T. Hoby) (London, 1974), p. 101.

11 L. Spezzaferro, 'La Cultura del Cardinal del Monte e il primo tempo del Caravaggio', *Storia dell'Arte*, 9–10, 1971, p. 59.

12 V. Galilei, *Il primo libro della prattica del contrapunto intorno all'uso delle consonanze* (MS 1588–91), as given in T. Carter, *Music in Late Renaissance and Early Baroque Italy* (London, 1992), p. 185.

13 G. Caccini, *Le Nuove Musiche*, as given in T. Carter, op. cit., p. 190.

14 Z. Waźbiński, *Il Cardinale Francesco Maria del Monte*, op. cit., pp. 137–8.

15 Z. Waźbiński, ibid., pp. 138–9.

16 K. Christiansen, *A Caravaggio Rediscovered: The Lute Player*, exhibition catalogue, 1990 (New York Metropolitan Museum of Art), p. 45.

17 Archivio di Stato di Firenze, Fondo Mediceo del Principato 3762, unpaginated.

18 V. Giustiniani, *Discorso sopra la Musica* (tr. Carol MacClintock), in *Musicological Studies and Documents* 9, American Institute of Musicology, 1962, pp. 67 and 80. All the quotations in this paragraph are from this source: see pp. 69, 71 and 76.

19 C. L. Frommel, 'Caravaggios Frühwerk und der Kardinal Francesco Maria Del Monte', *Storia dell'Arte*, 9–10, 1971, pp. 44–5.

20 As given in K. Christiansen, op. cit. p. 46.

21 Archivio di Stato di Firenze, Fondo Mediceo del Principato, Folio 3760, f.937.

22 Ibid., f.947; letter of 29 May 1599.

23 In recent years a great deal of work has been done on Caravaggio and music, and this section is indebted to the following articles: F. Trinchieri Camiz and A. Ziino, 'Caravaggio:

Aspetti musicali e committenza', in *Studi Musicali*, 12, 1983, pp. 67–90; F. T. Camiz, 'The Castrato Singer: From Informal to Formal Portraiture', *Artibus et Historiae*, ix, 18, 1988, pp. 171–186; 'La Musica nei quadri di Caravaggio', *Caravaggio: Nuove Riflessioni Quaderni di Palazzo Venezia*, 6, 1989, pp. 198–221; 'Music and Painting in Cardinal del Monte's Household', *Metropolitan Museum Journal*, 26, 1991, pp. 213–26; H. Colin Slim, 'Musical Inscriptions in Paintings by Caravaggio and his Followers', in *Music and Context: Essays in Honor of John Milton Ward* (ed. A. Shapiro) (Cambridge, Massachusetts, 1985), pp. 241–63; Barbara Russo Hanning, 'Images of Monody', in *The Age of Marino: Literature, Fine Arts and Music* (ed. F. Guardiani) (Toronto, 1994), pp. 465–85.

24 Baglione/Hibbard, 1988, p. 352.

25 E. Grillo (ed.), *Torquato Tasso: Aminta, a Pastoral Drama* (London, 1924), pp. 72–3.

26 V. Giustiniani, op. cit., p. 78.

27 G. Mancini, *Considerazione sulla Pittura* (Rome, 1956–7), ed. V. Marucchi, vol. I, 1956, pp. 129–30.

28 G. Murtola (ed., 1603), *Rime del Signor Gasparo Murtola* (Venice, 1604).

29 The two versions of this picture, *The Lute Player* (St. Petersburg, Hermitage) and *The Lute Player* (New York, Wildenstein), have been the subject of much dispute. The present author has followed K. Christiansen's views of their relationship and dating: see K. Christiansen, op. cit., pp. 58–60.

30 S. Sadie (ed.), *The New Grove Dictionary of Music and Musicians* (London, 1980), vol. 7, p. 96.

31 The identification of the lutanist as Montoya was suggested by F. T. Camiz, *Music and Painting in Cardinal Del Monte's Household*, op. cit., p. 221. Camiz has also suggested that Caravaggio knew Philostratus's description of the Greek musician Amphion, and that he deepened the significance of his portrayal of a contemporary musician by an allusion to the classical past. See F. T. Camiz, 'Per prima cosa guarda la lira, per vedere se è dipinta correttamente': quadri a soggetto musicale all'epoca di Caravaggio', in *La Natura Morta al Tempo di Caravaggio*, 1995 (Rome, Musei Capitolini), pp. 75–9.

32 Z. Waźbiński, op. cit., p. 570.

33 Ibid. p. 89.

34 G. Baglione, *Le Vite de' Pittori, Scultori e Architetti* (Rome, 1642), p. 365.

35 G. Paleotti, in B. Barocchi, *Trattati d'Arte del Cinquecento, fra Manierismo e Controriforma* (Bari, 1961), vol. 2, p. 299.

36 See P. M. Jones, *Federico Borromeo and the Ambrosiana: Art Patronage and Reform in Seventeenth-Century Milan* (Cambridge, 1993), p. 83.

37 C. L. Frommel, op. cit., p. 31.

38 Baglione/Hibbard, 1988, p. 352.

39 Both the date and attribution of this small painting on copper by Jan Breughel are uncertain. For a discussion of this problem see *La Natura Morta al Tempo di Caravaggio*, exhibition catalogue, op. cit., p. 108.

40 As given in A. Martini, *I Tre Libri delle Laudi Divine di Federico Borromeo* (Padua, 1975), p. 193.

41 This picture has recently inspired some very brilliant writing, by S. Bann, *The True Vine: On Visual Representation and Western Tradition* (Cambridge and New York, 1989), pp. 68–101, and by N. Bryson, *Looking at the Overlooked: Four Essays on Still Life Painting* (London, 1990), pp. 77–83.

42 A. Quint, *Cardinal Federico Borromeo* (New York, 1986), p. 252.

43 Ibid., pp. 24–5.

44 G. Murtola, op. cit., Madrigal 473; reprinted in M. Marini, 1989, p. 404.

45 Quoted by J. Shearman, *Only Connect: art and the spectator in the Italian Renaissance* (Princeton, NJ, 1992), p. 50.

46 G. Vasari, *Le Vite de' più eccellenti pittori, et scultori italiani, da Cimabue insino a' tempi nostri*, ed. G. Milanesi (Florence, 1959) vol. iv, p. 24. See Z. Waźbiński, op. cit., p. 96. For a summary of recent scholarship on the Medusa see M. Gregori, in *La Magnificenza alla Corte dei Medici*, exhibition catalogue (Florence, Museo degli Argenti), 1997, no. 59, pp. 101–2.

47 Baglione/Hibbard, 1988, p. 352.
48 G. Getto, *Barocco in Prosa e Poesia* (Milan, 1969), p. 115.
49 *Meditations on the Life of Christ* (tr. I. Ragusa and ed. I. Ragusa and R. B. Green) (Princeton, NJ, 1961), p. 67.
50 The picture's provenance is uncertain and controversial. The will of Ottavio Costa, drawn up in 1606, mentions a picture of St Francis by Caravaggio (L. Spezzaferro, 'Ottavio Costa e Caravaggio: Certezze e Probleme' in M. Cinotti (ed.), *Novità sul Caravaggio: Saggi e Contributi* [Milan, 1975], p. 113); but a *St Francis in Ecstasy* is also mentioned in the inventory of the possessions of Cardinal Del Monte made in 1627 (C. Frommel, *Caravaggios Frühwerk und der Kardinal Francesco Maria Del Monte, Storia dell'Arte*, nos. 9–10, 1971, p. 34.).
51 *I Fioretti* (1477), as given in P. Askew, 'The Angelic Consolation of St Francis of Assisi in Post-Tridentine Painting', *Journal of the Warburg and Courtauld Institutes*, XXXII, 1969, p. 285.
52 F. Mattesini, 'San Francesco in Tasso', in *San Francesco e il Francescanesimo nella Letteratura Italiana del Rinascimento al Romanticismo* (ed. S. Pasquazi), Atti del Convegno Nazionale (Rome, 1990), pp. 170–2.
53 E. Cecchi and N. Sapegno (eds.), *Storia della Letteratura Italiana* (Milan, 1967), vol.V, p. 794.
54 A. Cacciotti, 'The Cross: Where, according to Jacopone da Todi, God and Humanity are Defined', *Studies in Spirituality*, 2, 1992, p. 66.
55 Luis de Granada, *Counsels on Holiness of Life* (tr. O. Shipley) (London, Oxford and Cambridge, 1869), p. 142.
56 See F. T. Camiz, 'Luogo molto vago et delitioso . . . il casino del Cardinale del Monte ed un suo soffitto dipinto da Caravaggio', in *Ricerche di Storia dell'Arte*, 1992, pp. 81–8 for this work. Cavalieri's letter is on p. 82.

CHAPTER SIX

1 For a transcript of this inquiry, from which all these quotations are taken, see S. Corradini and M. Marini, 'The Earliest Account of Caravaggio in Rome', *Burlington Magazine* CXL, January 1998, pp. 25–8.
2 J. von Sandrart, *Joachim von Sandrarts Academie der Bau-, Bild- und Mahlerey-Künste von 1675* (ed. A. R. Pelzer) (Munich, 1925), as translated in H. Hibbard, *Caravaggio* (London, 1988).
3 This perfect simile is from T. V. Cohen, 'The Lay Liturgy of Affront in Sixteenth-Century Italy', *Journal of Social History*, 25, no. 4 (1992), p. 866.
4 G. Baglione, *Le Vite de Pittori, Scultori et Architetti* (Rome, 1642), p. 156.
5 Archivio di Stato di Roma, Tribunale Criminale del Senatore, reg. 1438, Costituto di Onorio Longhi del 4 maggio 1595 p. 20v, cited in R. Bassani and F. Bellini, *Caravaggio Assasssino* (Rome, 1994), p. 13.
6 S. Corradini, 'Nuove e false notizie sulla presenza del Caravaggio in Roma', in S. Macioce (ed.), *Michelangelo Merisi da Caravaggio: La Vita attraverso i Documenti* (Rome, 1995), p. 73. Obscene lyrics were part of the usual weaponry of scorned young men; E. Cohen, in 'Honor and Gender in the Streets of Early Modern Rome', *Journal of Interdisciplinary History*, xxii, 4, 1992, p. 613, tells the story of a young prostitute, Aurelia, woken by the delicate harmonies of lute and guitar, accompanied by the lyric 'Oh little whore, now comes the summer/Prepare your ass for your lover'.
7 R. and M. Wittkower, *Born Under Saturn* (London, 1963), p. 196.
8 Corradini, 1993, pp. 8–9.
9 L. Pascoli, *Vite de Pittori, Scultori ed Architetti moderni* (Rome, 1736), vol. II, pp. 512–3.
10 G. Baglione, op. cit., p. 156.
11 Ibid., p. 157.
12 Ibid., p. 360.
13 R. and M. Wittkower, op. cit., p. 198. ·

14 Baglione, op. cit., pp. 132–3; as translated in R. and M. Wittkower, op. cit., p. 89.

15 R. Zapperi, *Eros e Controriforma: Preistoria della Galleria Farnese* (Turin, 1994), p.49.

16 Bellori/Hibbard, 1988, p. 373.

17 C. van Mander, *Het Schilder-Boeck* (Haarlem, 1604), p. 191r, as translated in Hibbard, 1988, p. 344.

18 Baglione/Hibbard, 1988, p. 355.

19 The Italian word *cortigiana* does not quite translate as the English 'courtesan', and *cortigiane*, prostitutes and whores, are often hard to differentiate. Fillide was immensely successful and became wealthy, but none the less she participated in the violent behaviour and insult wars of common prostitutes.

20 Corradini, 1993, p. 10.

21 F. Angeloni, *Historia di Terni* (Rome, 1666), p. 199; quoted in R. Bassani and F. Bellini, op. cit., p. 65.

22 F. Bellini, 'Tre documenti inediti per Michelangelo da Caravaggio', *Prospettiva*, 63, 1992, p. 70.

23 Corradini, 1993, pp. 11–17. The quotations in this paragraph are from this document, dated 25 October 1600. It is extremely difficult, and runs together many incidents, including Longhi and Caravaggio's brawl with Marco Tullio and Flavio Canonici, for which see p. 16. The magistrates seem to have been fishing for information with questions that seem unrelated and to have little bearing on the matter in hand, but perhaps underlying them is the beginning of an enmity on Longhi's part towards Ranuccio Tomassoni. Caravaggio does not appear in these preliminary skirmishes with Ranuccio, but he was side by side with Longhi in other violent episodes.

24 Corradini, 1993, p. 26.

25 G. Martin, *Roma Sancta* (1581) (ed. G. B. Parks) (Rome, 1969), p. 145.

26 *The Complete Works of Montaigne* (tr. D. Frame) (London, 1958), *Travel Journal*, p. 957.

27 R. Bassani and F. Bellini, op. cit., p. 74.

28 R. Bassani and F. Bellini, op. cit., p. 68.

29 Idem.

30 This episode, and Prudenzia Zacchia's complaint against Fillide and her friend Prudenzia Brunori are both described in Corradini, 1993, pp. 21–5, a document full of lively insults and colourful syphilitic imagery that vividly evokes such neighbourhood warfare. I am greatly indebted to Tom and Elizabeth Cohen for help in reading these documents. Roman street life is discussed in several of their publications; see Thomas V. Cohen, 'The Lay Liturgy of Affront', op. cit., pp. 857–77, and for material on whores and courtesans especially, E. Cohen, 'Honor and Gender in the Streets of Early Modern Rome', *Journal of Interdisciplinary History*, XXII, 4, 1992, pp. 597–625; E. Cohen, '"Courtesans" and "Whores": Words and Behaviour in Roman Streets', *Women's Studies*, vol. 19, no. 2, 1991, pp. 201–8.

31 B. Castiglione, *The Book of the Courtier* (1561) (tr. T. Hoby) (London, 1974), pp. 35 and 40.

32 On this see F. R. Bryson, *The Point of Honor in 16th century Italy: An Aspect of the Life of the Gentleman* (New York, 1935). The quotation from Aristotle is as given on p. 28.

33 T. d'Alessandri, *Il Cavaliere Compito* (Viterbo, 1609), pp. 65–7.

34 E. Cohen, *Journal of Interdisciplinary History*, has coined the term 'house scorning' for this ritual.

35 L. Lawner, *I Modi: The Sixteen Pleasures, an Erotic Album of the Italian Renaissance* (London, 1988), p. 38, who cites F. Pona, *La Lucerna* (ed. G. Fulco) (Rome, n.d.), p. 109.

36 G. Martin, op. cit., p. 143.

37 On this see R. Zapperi, op. cit., p. 50.

38 See C. L. Frommel, 'Caravaggio, Minniti e il Cardinal Francesco Maria Del Monte', in S. Macioce (ed.), *Michelangelo Merisi da Caravaggio: La Vita e le Opere attraverso i documenti* (Rome, 1995), pp. 18–42. The idea is attractive, and it is very likely that Caravaggio would have used his room mate as a model, but the portrait engraving, although certainly similar to

Caravaggio's youth, is not absolutely unimpeachable evidence. For the portrait engraving see G. Grosso Caccopardo, *Memorie de Pittori Messinese e degli Esteri* (Messina, 1821), ill. 83.

39 For Fillide's will see Corradini, 1993, pp. 111–12. The will is dated 8 October 1614.

40 Marini, 1989, p. 402.

41 This was first suggested by R. Barbiellini Amidei, in 'Della Committenza Massimo', in *Caravaggio: Nuove Riflessioni, Quaderni di Palazzo Venezia*, 6, 1989, p. 51.

42 J. de Voragine, *The Golden Legend* (tr. W. G. Ryan) (Princeton, NJ, 1993), vol. I, p. 375.

43 The hidden symbolism of the ointment jar was first pointed out by P. Askew, 'Caravaggio: Outward Action, Inward Vision', in S. Macioce (ed.), op. cit., p. 249.

44 Bellori/Hibbard, 1988, p. 362.

45 See R. Bassani and F. Bellini, op. cit., pp. 53–8. Not all the documents concerning Anna Bianchini are reliable. On the difficulties of using these documents see S. Corradini, 'Nuove e false documenti sulla presenza del Caravaggio in Roma', in S. Macioce (ed.), op. cit., pp. 71–8.

46 Corradini, 1993, pp. 117–20, publishes an inventory of Fillide's property which includes this work.

47 Quoted by B. Aikema, 'Titian's *Mary Magdalene* in the Palazzo Pitti: An Ambiguous Painting and its Critics', *Journal of the Warburg and Courtauld Institutes*, 57, 1994, p. 51.

48 G. Martin, op. cit., pp. 143, 144.

49 J. de Voragine, op. cit., vol. I, p. 375.

50 The history of the *Bacchus* is unclear. M. Marini, 1989, p. 399, has made the interesting suggestion that it may have hung in Del Monte's musical camerino with *The Lute Player* and *The Musicians*. Z. Waźbiński, *Il Cardinale Francesco Maria del Monte 1549–1626* (Florence, 1994), p. 99, says that the *Bacchus* was acquired by Francesco Guicciardini in 1618 for the Grand Ducal collections.

51 Horace, Odes, Book 1, 18; *The Odes of Horace* (tr. J. Michie) (Harmondsworth, 1967).

52 On artists and Bacchus see K. Hermann Fiore, 'Il *Bacchino Malato* autoritratto del Caravaggio ed altre figure bacchiche degli artisti', in *Caravaggio: Nuove Riflessioni, Quaderni di Palazzo Venezia*, op. cit., pp. 95–132.

53 It is impossible to see this self-portrait in a reproduction of the painting, but it does exist.

54 G. B. Marino, *L'Adone*, I, 43; translated in J. V. Mirollo, *The Poet of the Marvellous: Giambattista Marino* (New York and London, 1963), p. 78.

55 Sandrart/Hibbard, 1988, p. 379.

56 Mancini/Hibbard, 1988, p. 349. The dates of Giovan Battista Merisi's stay in Rome are given by R. Zigliolo, 'Il Caravaggio . . . a Caravaggio, in Rome', in S. Macioce (ed.), op. cit., p. 63.

57 F. Susinno, *Le Vite de Pittori Messinesi e di altri che fiorirono in Messina* (ed. V. Martinelli) (Florence, 1960), p. 117.

CHAPTER SEVEN

1 O. Panciroli, *I Tesori Nascosti dell'Alma Città di Roma* (Rome, 2nd ed., 1625), p. 2.

2 Archivio di Stato di Firenze, Fondo Mediceo del Principato, vol. 3759, f. 531.

3 Ibid., f. 12.

4 Ibid., f. 10.

5 Ibid., f. 34v–35r.

6 Idem.

7 Z. Waźbiński, *Il Cardinal Francesco Maria Del Monte 1549–1626* (Florence, 1994), p. 147.

8 Archivio di Stato di Firenze, Mediceo del Principato, vol. 3760, f. 945.

9 R. Krautheimer, 'A Christian Triumph in 1597', in *Essays in the History of Art Presented to Rudolph Wittkower* (London, 1967), p. 174.

10 T. Buser, 'Jerome Nadal and Early Jesuit Art in Rome', *Art Bulletin*, LVIII, 1976, p. 432.

11 H. Barnabeus, *Purpura sancta seu vita Cardinalis Baronii* (Rome, 1651), p. 62; as given in R. Krautheimer, op. cit., loc. cit.

12 On Counter-Reformation patterns of conversion see A. Mali, 'Patterns of Conversion in Christianity', *Studies in Spirituality*, 2, 1992, pp. 209–22.

13 P. Barocchi (ed.), *Trattati d'Arte del Cinquecento fra Manierismo e Controriforma* (Bari, 1961), vol. 2, p. 215.

14 Ibid., p. 228.

15 See I. Fosi, *La Società Violenta: Il Banditismo nello Stato Pontificio nella Seconda Metà del Cinquecento* (Rome, 1985).

16 As given in M. Gregori, *The Age of Caravaggio*, exhibition catalogue, 1985 (New York, Met: Naples, Capodimonte), p. 256.

17 See C. Ricci, *Beatrice Cenci* (tr. M. Bishop and H. L. Stuart) (London, 1926), for the quotations in this and the following paragraph: p. 211n, 211, 206, and 213.

18 O. Panciroli, op. cit., p. 264. M. S. O'Neil, 'Stefano Maderno's *Saint Cecilia*: A seventeenth-century Roman sculpture remeasured', in *Antologia di Belle Arti*, 25–26, 1985, p. 13.

19 C. Baronius, *I Annales Ecclesiastici* vol. 9, as quoted in M. S. O'Neil, op. cit., p. 16.

20 Archivio di Stato di Firenze, Fondo mediceo del Principato, no. 3760, f. 76.

21 M. Calvesi, *Le Realtà del Caravaggio* (Turin, 1990), pp. 123–6.

22 Z. Waźbiński, op. cit., p. 635.

23 Marini, 1989, p. 418.

24 S. Tuccio, *Giudetta*, printed in B. Soldati, *Il Collegio Mamertino* (Turin, 1908), p. 170. On Tuccio, see G. Calogero, *Stefano Tuccio* (Pisa, 1919).

25 This was pointed out by Elena Ciletti, 'Patriarchal ideology in the Renaissance Iconography of Judith', in M. Miguel and J. Schiesari (eds.), *Refiguring Women. Perspectives on Gender and the Italian Renaissance* (Ithaca, NY, and London, 1991), pp. 110–36. For an overview of the iconography see also M. Garrard, *Artemisa Gentileschi: the image of the female hero in Italian Baroque Art* (Princeton, NJ, 1989), which is particularly interesting on Abra and her likeness to a procuress.

26 On Caravaggio's method of working directly from nature, and for an analysis of this picture, see K. Christiansen, 'Caravaggio and "L'Esempio davanti del naturale"', Art Bulletin, LXVIII/3, 1986, pp. 421–5.

27 Jaynie Anderson, *Judith* (Paris, 1997), pp. 58–9.

28 E. Safarik, in I. Faldi and E. Safarik, *Acquisti 1970–2: XV Settimana dei Musei Italiani*, exhibition catalogue, 1972 (Rome, Palazzo Barberini), p. 32, placed the picture in this context.

29 F. della Valle, 'La Reina di Scozia', in G. Getto, *Barocco in Prosa e in Poesia* (Milan, 1969), p. 254.

30 G. B. della Porta, *La Turca* (1606), in F. Vazzoler (ed.), *La Maschera del Boia* (Geneva, 1982), p. 72.

31 The documents for this commission are published in Marini, 1989, pp. 426–36.

32 L. von Pastor, *The History of the Popes*, ed. R. F. Kerr (London, 1933), vol. xxiii, p. 139. The connection between Caravaggio's paintings and the conversion of Henry IV was first argued by M. Calvesi, op. cit. pp. 279–84.

33 Pastor, op. cit., pp. 192–3.

34 Marini, 1989, p. 430. For the translation, see W. F. Friedlaender, *Caravaggio Studies* (Princeton, NJ, 1955), p. 297.

35 Baglione/Hibbard, 1988, p. 353.

36 For a discussion of the history of the commission for the Contarelli chapel, see, in addition to the documents in Marini, 1989, C. Gilbert, *Caravaggio and His Two Cardinals* (University Park, Pennsylvania, 1995), pp. 159–89, and, for the role of the Crescenzi family, M. Pupillo, 'I Crescenzi, Francesco Contarelli e Michelangelo da Caravaggio: contesti e documenti per la commissione in San Luigi dei Francesi', in S. Macioce (ed.), *Michelangelo Merisi da Caravaggio; La Vita e Le Opere attraverso i Documenti* (Rome, 1996), pp. 148–66.

37 J. de Voragine, *The Golden Legend* (tr. W. G. Ryan) (Princeton, NJ, 1993), vol. II, p. 185.

38 For the development of the composition see D. Mahon, 'Egregius in Urbe Pictor: Caravaggio Revised', *Burlington Magazine*, XCIII, 1951, pp. 223–34.

39 J. von Sandrart, *Joachim von Sandrarts Academie der Bau-, Bild-, und Mahlerey-Künste von 1675* (ed. A. R. Pelzer) (Munich, 1925), as translated in Hibbard, 1988, p. 378.

40 There is a great deal of very brilliant writing on the Contarelli chapel. I am particularly indebted to M. Calvesi, op. cit., and F. T. Camiz, 'Death and Rebirth in Caravaggio's Martyrdom of St Matthew', *Artibus et Historiae*, XI, 1990, pp. 89–105. There is also a particularly illuminating short paragraph in M. Fumaroli, *L'Age de l'Eloquence* (Geneva, 1980), p. 149. Bellori identified the figure with the coin in his hat as St Matthew but recently this has become controversial. Several scholars believe that St Matthew is the young man at the end of the table, who has not yet responded to the call, and that Bellori's St Matthew is pointing, not at himself, but at this young man. This view was first put forward in N. Demarco, 'Caravaggio's Calling of Matthew', *Iris: Notes on the History of Art*, 1, 1982, pp. 5–7. It was rejected by H. Hibbard, *Caravaggio* (London, 1983) and by other scholars. H. Röttgen, 'Da ist Matthäus', *Pantheon*, 49, 1991, pp. 97–9, provides an interesting analysis of gesture to support the identification of Matthew as the bearded man.

41 St John Chrysostom, *Homilies on the Epistles of Paul to the Corinthians*, as given in T. Thomas, 'Caravaggio's First Inspiration of St Matthew', *Art Bulletin*, LXVII, (1985), p. 644.

42 The idea that the dark space in the foreground of the picture represents a baptismal pool was suggested by Marini. It was developed by F. T. Camiz, op. cit., who suggests that it is probably that such a pool was visible in San Lorenzo in Lucina in the sixteenth century, and makes an interesting comparison with Cristofero Roncalli's *Baptism of Constantine* in St John Lateran, Rome.

43 L. Puppi, *Lo Splendore dei Supplizi Liturgia delle esecuzione capitali e iconografia del martirio nell'arte europeo dal XII al XIX secolo* (Milan, 1990), p. 55.

44 For this possibility see F. T. Camiz, op. cit., p. 101.

45 Marini, 1989, p. 446, and for all documents associated with this commission pp. 446–7.

46 F. J. McGinness, *Right Thinking and Sacred Oratory in Counter-Reformation Rome* (Princeton, NJ, 1995), p. 170.

47 M. Marini, 1989, p. 447, published an inventory of Francesco Sannesio (the heir to Cardinal Giacomo) dated 19 February 1644, which records 'Doi quadri grandi in tavola che rappresentano un San Pietro crocifisso e l'altro la convers[ion]e di San Paolo corniciati e filetatti d'oro'.

48 Baglione/Hibbard, 1988, p. 354.

49 Bellori/Hibbard, 1988, p. 364.

50 Mancini/Hibbard, 1988, p. 350.

51 *The Spiritual Exercises of St Ignatius* (Dublin, 1864), pp. 97 and 105.

52 John Webster, *The Duchess of Malfi*, V, v, 99–101.

53 F. Huerner, *Rubens and the Roman Circle* (New York and London, 1996), p. 15.

CHAPTER EIGHT

1 G. Marino, tr. J. Mirollo, in *The Poet of the Marvelous: Giambattista Marino* (New York and London, 1963), p. 25.

2 V. Giustiniani, 'Discorso sopra il Giuoco del Pallamaglio', in C. Bascetta (ed.), *Sport e Giuochi: Trattati dal XV al XVIII Secolo* (Milan, 1978), vol. 2, p. 329. On Giustiniani see the essay in E. Cropper and C. Dempsey, *Nicolas Poussin* (Princeton, NJ, 1966), pp. 64–105.

3 G. Mancini, *Considerazioni sulla Pittura* (ed. A. Marucchi) (Rome, 1956), vol. 1, p. 143.

4 G. B. Marino, *Lettere familiari* (Turin, 1966), p. 62: letter from Ravenna, 1607.

5 Anon. Epigram 593 in *The Greek Anthology* (tr. W. R. Paton) (New York and London, 1917), vol. III, p. 331.

6 F. Scannelli, *Il microcosmo della pittura* . . . (Cesana, 1657), as translated in Hibbard, 1988, p. 357.

7 Bellori/Hibbard, 1988, p. 364.

8 G. Fulco, 'Ammirate l'Altissimo Pittore: Caravaggio nelle Rime inedite di Marzio Milesi', *Ricerche di Storia dell'Arte*, 10, 1980, pp. 65–89.

9 On this see S. Macioce, 'Una nota per il "Mondafrutto"', and C. Belloni, 'Cesare Crispolti Perugino: documenti per una biografia', both in S. Macioce (ed.), *Michelangelo Merisi da Caravaggio: La Vita e Le Opere attraverso i Documenti* (Rome, 1995), pp. 123–36; pp. 136–48. For the quotation, see p. 138.

10 Biography of Maffeo Barberini by Andrea Nicoletto, the Canon of San Lorenzo in Damaso, quoted by C. d'Onofrio in *Roma Vista da Roma* (Rome, 1967), pp. 56–8.

11 J. N. Eritreo, alias Gian Vittorio Rossi, *Pinacotheca imaginum illustrium, doctrinae vel ingenii laude, virorum* (1st edn, Cologne 1645; Leipzig 1729), p. 379. Translated Esther Langdon.

12 G. Baglione, *Le Vite de' Pittori, Scultori et Architetti* (Rome, 1642), p. 315.

13 C. Malvasia, *Felsina Pittrice: Vite de' Pittori Bolognesi* (ed. M. Brascaglia) (Bologna, 1971), p. 425.

14 This letter is extremely difficult to understand; it was published by G. Cozzi, 'Intorno al Cardinale Ottaviano Parravicino, a monsignor Paolo Gualdo e a Michelangelo da Caravaggio', *Rivista Storica Italiana*, LXXIII, 1, 1961, pp. 36–58. For a commentary see M. Calvesi, *Le Realtà del Caravaggio* (Turin, 1990), pp. 196–200.

15 G. B. Marino, *Poesie Varie* (ed. B. Croce) (Bari, 1913), p. 299.

16 G. B. Marino, *Rime* (Venice, 1602), dedication.

17 See E. Cropper, 'The Petrifying Art: Marino's Poetry and Caravaggio', *Metropolitan Museum Journal*, 26, 1991, pp. 193–212, a seminal article on the relationship between Marino and Caravaggio, to which I am indebted.

18 G. B. Marino, *La Galeria* (ed. M. Pieri) (Padua, 1979), 'La Madre Infelice', p. 38.

19 Marini, 1989, p. 373: translated Esther Langdon.

20 Ovid, *Metamorphoses* (Harmondsworth, 1955), Book III, p. 85.

21 For an illuminating discussion of Narcissus in painting, which includes a discussion of Caravaggio's *Narcissus*, see S. Bann, *The True Vine: On Visual Representation and Western Tradition* (Cambridge and New York, 1989), pp. 127–56.

22 Philostratus the Elder, *Imagines* (Cambridge, Massachusetts and London, 1969), Book I, 23, pp. 89–91.

23 G. B. Marino, *La Galeria*, op. cit., p. 13: Sonnet 7, 'Narciso di Bernardo Castello'.

24 *Idem.*

25 L. B. Alberti, *On Painting* (tr. C. Grayson) (Harmondsworth, 1991), p. 61.

26 G. B. Marino, *La Galeria*, op. cit., p. 14: 'Narciso di Francesco Maria Vanni'.

27 For an interesting description of the web of contacts that link the Giustiniani, Marino, Castello and Caravaggio, see S. Danesi Squarzina, 'Caravaggio e i Giustiniani', in S. Macioce (ed.), op. cit., pp. 94–123.

28 G. B. Marino, *Lettere Familiari*, op. cit., p. 276: Letter 148, 1620.

29 This *avviso* was first published in R. Zapperi, 'Per la datazione degli affreschi della galeria Farnese' in *Mélanges de l'Ecole Française de Rome, Moyen Age Temps Modernes*, 93, 1981, pp. 821ff. and in R. Bassani and F. Bellini, Caravaggio Assassino (Rome, 1994), p. 119.

30 C. Malvasia, op. cit., p. 282.

31 C. Malvasia, op. cit., as translated in J. R. Martin, *The Farnese Gallery* (Princeton, NJ, 1965), p. 14.

32 C. Malvasia, *Felsina Pittrice*, op. cit., p. 295. All the quotations from Malvasia in this paragraph are from this source.

33 G. P. Bellori, *The Lives of Annibale and Agostino Carracci* (tr. C. Enggass) (University Park, Pennsylvania, and London, 1969), p. 16.

34 G. P. Bellori, op. cit., p. 60.

35 C. Malvasia, op. cit., p. 296.

36 G. P. Bellori, op. cit., p. 17.
37 D. Mahon, 'Egregius in Urbe Pictor: Caravaggio revised', *Burlington Magazine*, XCIII, 1951, p. 230, n. 72.
38 G. P. Bellori, op. cit., p. 34.
39 M. Maccherini, 'Caravaggio nel carteggio familiare di Giulio Mancini', *Prospettiva*, 86, April 1997, pp. 71, 84.
40 This is recorded in a poem by G. Murtola, *Rime del Signor Gasparo Murtola* (1603 ed., Venice 1604), no. 471, 'Per lo medesimo (Amore Pittura del Caravaggio)'.
41 M. Marini, *Caravaggio: Michelangelo Merisi da Caravaggio pictor praestantissimus* (2nd edn, Rome, 1989), p. 564.
42 M. Maccherini, op. cit., p. 74.
43 Scannelli, op. cit., as translated in Hibbard, 1988, p. 359.
44 See on this A. W. G. Posèq, 'Caravaggio and the Antique', *Artibus et Historiae*, xi, 21, 1990, pp. 147–67.
45 G. P. Bellori, op. cit., p. 31.
46 Marini, 1989, p. 461.
47 G. B. Marino, *L'Adone* (Milan, 1988), pp. 347, 348 and 356.
48 T. Amayden, *Famiglie Romane* (*c.* 1640), Biblioteca Casanatense, Rome MS 1335, f. 438r and v.
49 J. von Sandrart, *Joachim von Sandrarts Academie der Bau-, Bild-, und Mahlerey-Künste von 1675* (ed. A. R. Pelzer) (Munich, 1925), as translated Hibbard, 1988, p. 378.
50 For a translation of this letter, see R. Enggass and J. Brown, *Italy and Spain 1600–1758: sources and documents* (Englewood Cliffs, NJ, 1970), pp. 16ff.
51 Ovid, *Amores* (tr. G. Lee) (London, 1968), p. 3, lines 1–6, 14–17. I am grateful to Esther Langdon for pointing out this passage.
52 Murtola, op. cit., madrigal 471. See Marini, 1989, p. 564.
53 M. Wiemers, 'Caravaggio's Amore Vincitore im Urteil eines Romfahres um 1650', *Pantheon*, XLIV, 1986, pp. 59–61, argues that the passage is evidence of Caravaggio's homosexuality. This transcription of the manuscript is from J. Gash, review article, M. Gregori, ed., 'Come dipingeva il Caravaggio: Atti della Giornata di Studio', *Burlington Magazine*, CXL, 1997, p. 41. I have changed his raie to rare. I am grateful to Ann Brookes for discussing this with me. For a convincing demolition of Symonds as a reliable source, see C. Gilbert, op. cit., p. 200.
54 G. Fulco, 'Ammirate l'Altissimo Pittore: Caravaggio nelle Rime inedite di Marzio Milesi', *Ricerche di Storia dell'Arte*, 10, 1980, p. 88.

CHAPTER NINE

1 *Catechismus, Ex Decreto Concilii Tridentini, Ad Parachos*, as translated in M. W. Gibbons, *Giambologna: Narrator of the Catholic Reformation* (Berkeley, California, and London, 1995), p. 57.
2 G. Martin, *Roma Sancta* (1581) (ed. G. B. Parks) (Rome, 1969), p. 71.
3 *Meditations on the Life of Christ* (tr. I. Ragusa and ed. I. Ragusa and R. Green) (Princeton, NJ, 1961), p. 320.
4 Ibid., p. 4.
5 On meditative literature see L. Martz, *The Poetry of Meditation: a study in English Religious Literature of the Seventeenth Century* (Newhaven, 1954), pp. 16–170.
6 M. Vanti, *San Camillo de Lellis e i suoi Ministri degli Infermi* (2nd edn., Rome, 1958), p. 440.
7 L. Ponnelle and L. Bordet, *St Philip Neri* (tr. R. F. Kerr) (London, 1937), p. 209.
8 G. M. Ellero, *Esegesi e Teologia dell Incarnazione secondo Giovanni Crisostomo* (Vicenza, 1967), p. 149. On poverty, see B. Geremek, *Poverty: A History* (Oxford, 1994).
9 L. Scupoli, *The Spiritual Combat* (London, 1950), pp. 156–7.
10 For the contract, see N. R. Parks, 'On Caravaggio's *Dormition of the Virgin* and its Setting',

Burlington Magazine, CXVII, pp. 438–48, and P. Askew, *Caravaggio's Death of the Virgin* (Princeton, NJ, 1990), p. 133.

11 On the Mattei family, see F. Cappelletti and L. Testa, *Il Trattenimento di Virtuosi: Le collezioni seicentesche di quadri nei Palazzo Mattei di Roma* (Rome, 1994), and idem, in *Caravaggio e la collezione Mattei*, exhibition catalogue, 1995 (Rome, Galleria Nazionale d'Arte Antica di Palazzo Barberini, Salone da Pietro da Cortona), pp. 29–55

12 F. Bellini, 'Tre documenti inediti per Michangelo da Caravaggio', *Prospettiva*, 63, 1992, p. 70.

13 C. Malvasia, *The Life of Guido Reni* (tr. C. and R. Enggass) (University Park, Pennsylvania and London, 1980), p. 43.

14 For these dates see F. Cappelletti and L. Testa, 'I Quadri di Caravaggio nella collezione Mattei: I nuovi documenti e i riscontri con le fonti', *Storia dell'Arte*, LXIX, 1990, pp. 234–244. On Caravaggio and the Mattei see also S. Benedetti, *Caravaggio: The Master Revealed*, exhibition catalogue, 1993 (Dublin, National Gallery of Ireland).

15 Baglione/Hibbard, 1988, p. 353.

16 L. Richeôme, *The Pilgrime of Loreto* (1629) (London and Ilkley, 1976), p. 174.

17 Luis de Granada, *Book of Prayer and Meditation* (tr. R. Hopkins), as quoted in L. Martz, *The Poetry of Meditation*, op. cit., p. 77.

18 Antonio de Molina, *A Treatise of Mental Prayer* (tr. J. Sweetman) (Saint-Omer, 1617), pp. 60–1.

19 Baglione tells us that the picture was painted for Ciriaco Mattei; it is already recorded in the inventory of the Giustiniani collection by 1606. Several scholars, amongst them S. Benedetti, op. cit., pp. 15–16, and L. Testa, in 'La Quadreria di Ciriaco', in F. Cappelletti and L. Testa, *Il Trattenimento di Virtuosi*, op. cit., p. 41, believe that Baglione was simply mistaken in saying that Ciriaco ordered the picture, although if so this would be Baglione's only mistake of this kind. Silvia Danesi Squarzina, in 'I Giustiniani e l'Oratorio dei Filippini', *Storia dell'Arte*, 85, 1995, pp. 369–94, and in 'Caravaggio e i Giustiniani' in S. Macioce (ed.), *Michelangelo Merisi da Caravaggio: La Vita e le Opere attraverso i Documenti* (Rome, 1995), pp. 94–123, has argued convincingly that Benedetto was as important as Vicenzo as a patron of Caravaggio, and that there is a contrast between the religious works which he, a Jesuit Cardinal, ordered, and those ordered by his brother, a virtuoso and connoisseur. See also S. Danesi Squarzina, 'Documents for the History of Collecting: 24. The collections of Benedetto Giustiniani', Part I, *Burlington Magazine*, CXXXIX, 1997, pp. 766–92.

20 Baglione/Hibbard, 1988, p. 146n.

21 G. Baglione, *Le Vite de pittori, scultori et architetti* (Rome, 1642), p. 100.

22 On the relationship of Francesco Contarelli with the Crescenzi family, and the role of the Crescenzi in the Contarelli chapel, see M. Pupillo, 'I Crescenzi, Francesco Contarelli e Michelangelo da Caravaggio: contesti e documenti per la commissione in S. Luigi dei Francesi', in S. Macioce (ed.), op. cit., pp. 148–67.

23 For all these documents see Marini, 1989, pp. 435–7, who summarises the complex arguments over dating.

24 This is quoted in T. Thomas, 'Caravaggio's First Inspiration of St. Matthew', *Art Bulletin*, LXVII (1985), p. 640. For interesting iconographical discussions see also I. Lavin, 'Divine Inspiration in Caravaggio's Two *St Matthews*', *Art Bulletin* LVI, 1974, pp. 59–81; I. Lavin, 'Addenda to "Divine Inspiration"', *idem*, pp. 590–1.

25 Bellori/Hibbard, 1988, p. 365.

26 R. Cannatà and H. Röttgen, 'Un Quadro per la SS Trinità dei Pellegrini affidato al Caravaggio, ma eseguito dal Cavalier d'Arpino', in S. Macioce (ed.), op. cit., p. 82. For the original document see A. Lemoine, 'Caravage, Cavalier d'Arpin, Guido Reni et la confrérie romaine de la SS Trinità dei Pellegrini', *Storia dell'Arte*, 85, 1992, pp. 416–29. The document is p. 428.

27 *The Letters of Peter Paul Rubens* (tr. R. S. Magurn) (Cambridge, Massachusetts, 1955), p. 39.

28 The dating and patronage of *The Entombment of Christ* have been the subject of bitter controversy. C. Barbieri, S. Barchiesi, D. Ferrara, *Santa Maria in Vallicella* (Rome, 1995), pp. 61 and 181, publish documents relating to this commission. On 1 September 1604, by which time

Caravaggio's altarpiece was installed, the church authorities agreed to give Gerolamo the altarpiece from the original chapel 'avendo di sua cortesia fatto fare il quadro nuovo del Caravaggio'. This suggests very strongly that Gerolamo had commissioned the altarpiece. M. Calvesi, in 'Michelangelo da Caravaggio: il suo Rapporto con i Mattei e con altri collezionisti a Roma', in *Caravaggio e la collezione Mattei*, op. cit., pp. 19–20, offers a different reading of these documents, arguing for a date of 1600 and the patronage of Pietro Vittrice. For the documents see also Marini, 1989, p. 462.

29 Mancini mentions Alessandro Vittrice as the owner of *The Gypsy Fortune Teller*. A document of 3 May 1607 mentions four pictures left by Gerolamo to Alessandro, amongst them a *Gypsy*. It does not mention Caravaggio's name. See Corradini, 1993, p. 96.

30 This section on Caravaggio and the Oratorians at the Chiesa Nuova is indebted to the researches of Alessandro Zuccari, presented in a series of articles. See A. Zuccari, 'La capella della "Pieta" alla Chiesa Nuova e i committenti del Caravaggio', *Storia dell'Arte*, 47 (1983), pp. 53–6, and 'Cultura e predicazione nelle immagini dell'Oratorio', *idem*, 85, 1995, pp. 340–54. For this quotation see *idem*, p. 342.

31 Ibid., p. 343.

32 Bellori/Hibbard, 1988, p. 366.

33 Luis de Granada, *A Spiritual Doctrine conteining a rule to liue wel, with divers Praiers and Meditations* (Louvain, 1599), p. 101.

34 For an extremely interesting account of *The Entombment of Christ*, with particular reference to the role of Alfonso Paleotti and the importance of the Holy Shroud of Turin to the iconography of the chapel, see S. Grossman, *Caravaggio: The Deposition from the Vatican Collections*, exhibition catalogue, 1984 (Washington DC, National Gallery of Art).

35 G. Marino, *Dicerie sacre del Cavaliere Marino* (Rome, 1618), p. 70.

36 Baglione/Hibbard, 1988, p. 354.

37 See P. Askew, op. cit., p. 133–46, to which this chapter is much indebted, for documents relating to this commission.

38 Cherubini's will of 1602 is printed in P. Askew, op. cit., pp. 134–5.

39 As translated in Askew, op. cit., p. 22.

40 G. M. Ellero, op. cit., p. 149.

41 I. Lavin, 'Caravaggio's Roman Madonnas', paper presented at 'The Age of Caravaggio' Symposium, New York, Metropolitan Museum of Art, 1985, quoted by P. Askew, op. cit., p. 105.

42 The source for these events is Mancini/Hibbard, 1988, p. 349, and as given in Marini, 1989, p. 479. Baglione too says that the picture was removed because of the Virgin's lack of decorum, her swollen belly and bare legs.

43 M. Maccherini, 'Caravaggio nel carteggio familiare di Giulio Mancini', *Prospettiva*, 86, April 1997, p. 82.

44 The picture's date is controversial. P. Askew, op. cit., has argued for an early date, suggesting a possible gap in Caravaggio's activities from mid-November 1601 through the winter of 1602. This, however, depends on a later dating for the Vatican *Entombment*, of 1604–6. The present writer finds her stylistic arguments for an early dating convincing, the Apostle with his hands to his eyes is reminiscent of the first *St Matthew*, and the figure behind him of the second *St Matthew*, both of 1602. Moreover, the poetic feeling for these heavy and rustic figures has much in common with the ethos of the works from 1600–2.

CHAPTER TEN

1 G. Fulco, 'Ammirate l'Altissimo Pittore: Caravaggio nelle rime inedite di Marzio Milesi', *Ricerche di Storia dell'Arte*, 10, 1980, p. 88.

2 Bellori/Hibbard, 1988, p. 365.

3 C. G. Malvasia, *The Life of Guido Reni* (tr. C. and R. Enggass) (University Park, Pennsylvania, and London, 1980), p. 43.

4 F. Scanelli, *Il microcosmo della pittura, overo trattato diviso in due libri* (Cesena, 1657), as in Hibbard, 1988, p. 358.

5 C. van Mander, Het Schilder-Boeck (Haarlem, 1604), as translated in Hibbard, 1988, p. 344.

6 J. von Sandrart, *Joachim von Sandrart's Academie der Bau-, Bild-, und Mahlerey-Künste von 1675* (ed. A. R. Pelzer) (Munich, 1925), as translated in H. Hibbard, *Caravaggio* (London, 1988), p. 378.

7 Van Mander, as translated in *idem*, p. 344.

8 Bellori/Hibbard, 1988, p. 364.

9 Baglione/Hibbard, 1988, p. 353.

10 G. Vasari, *Le Vite de' piu eccellenti pittori, et scultori italiani, da Cimabue insino a' tempi nostri* (ed. G. Milanesi) (Florence, 1959), vol. 4, p. 92.

11 This was convincingly suggested by R. Bassani and F. Bellini, *Caravaggio Assassino* (Rome, 1994), p. 117.

12 Corradini, 1993, p. 15.

13 For this episode see Corradini, 1993, op. cit., pp. 15–17. For the identification of Marco Tullio's companion as Flavio Canonici see R. Bassani and F. Bellini, op. cit., p. 114. This identification is plausible, but not proven; Flavio Canonici makes a shadowy appearance in other incidents in which Longhi was involved (see Corradini, 1993, p. 26), and it is possible that Caravaggio wounded him on a separate occasion. For the judicial peace, see Corradini, 1993, pp. 26–7. The documents are extremely difficult to interpret.

14 See W. Friedlaender, *Caravaggio Studies* (1955), pp. 269–70. For Caravaggio's appeal see Corradini, 1993, p. 26.

15 M. Marini, 1989, p. 437.

16 On Caravaggio and Marzio Milesi, see G. Fulco, op. cit., pp. 65–89, in which these poems are printed, and L. Spezzaferro, 'Il Testamento di Marzio Milesi: tracce per un perduto Caravaggio', *idem*, pp. 90–9.

17 Baglione/Hibbard, 1988, p. 353.

18 G. Mancini, *Considerazioni sulla pittura* (ed. A. Marucchi) (Rome, 1956–7), vol. I, p. 246.

19 Archivio di Stato di Roma, Tribunale del Governatore, Investigazioni, reg. 328. Querela di Adriano Monteleone del 12 gennaio 1601, cc.174r–175v.

20 C. Malvasia, *Scritti originali del conte Carlo Cesare Malvasia spettanti alla sua Felsina Pittrice* (ed. L. Marzocchi) (Bologna, 1982), p. 388. On this see L. Spezzaferro, 'Il Caravaggio, i collezionisti Romani, le nature morte', in *La Natura Morta al Tempo di Caravaggio*, exhibition catalogue, 1995–6 (Rome, Musei Capitolini), p. 49.

21 G. Baglione, *Le Vite de' Pittori, Scultori et Architetti* (Rome, 1642), p. 188.

22 For this rivalry between Baglione, Gentileschi and Caravaggio see H. Röttgen, *Caravaggio: Der irdische Amor oder der Sieg der fleischlichen Liebe* (Frankfurt, 1992), pp. 16–22.

23 G. A. Dell'Acqua and M. Cinotti, *Il Caravaggio e le sue Grande Opere da San Luigi dei Francesi* (Milan, 1971), p. 156, F54.

24 G. Baglione, op. cit., p. 403.

25 For the identification of the face of the Devil as a portrait of Caravaggio see H. Röttgen, 'Quel diavolo è Caravaggio. Giovanni Baglione e la sua denuncia satirica dell'Amore terreno', *Storia dell'Arte*, 79, 1993, pp. 326–40.

26 G. Baglione, op. cit., p. 402.

27 For these poems see W. Friedlaender, op. cit., pp. 271–3: I have used Friedlaender's translation of the second poem. These poems were published in their unexpurgated versions by H. Röttgen, 'Quel diavolo è Caravaggio', op. cit., pp. 332–3.

28 The trial evidence was published in English by W. Friedlaender, op. cit., pp. 270–9. Improved versions of the documents are in G. A. Dell'Acqua and M. Cinotti, op. cit., pp. 155–6.

29 G. A. Dell'Acqua and M. Cinotti, op. cit., p. 153, F46. Translated in W. Friedlaender, op. cit., p. 273.

30 For Salini's testimony see ibid., pp. 153–4, F47.

31 Ibid., p. 154, F49.

32 Ibid., p. 154, F50.

33 For Caravaggio's evidence see ibid., p. 155, F52. Much of the evidence is translated in W. Friedlaender, op. cit., pp. 277–8.

34 As given in K. Christiansen, 'Caravaggio and "L'esempio davanti del naturale"', *Art Bulletin*, LXVIII, 1986, p. 421.

35 This was first suggested by W. Friedlaender, op. cit., p.277, followed by A. Coliva, *Il Mastelletta* (Rome, 1980), p. 12.

36 C. Malvasia, *Felsina Pittrice: Vite de' Pittori Bolognese* (Bologna, 1841), vol. II, p. 96, as translated in R. and M. Wittkower, *Born under Saturn* (London, 1963), p. 116.

37 G. A. Dell'Acqua and M. Cinotti, op. cit., p. 155, F53.

38 Gentileschi's testimony is in ibid., p. 156, F55.

39 *Idem.*

40 Corradini, 1993, p. 29.

41 G. A. Dell'Acqua and M. Cinotti, op. cit., p. 156, F55.

42 J. P. Babelon, 'Les Caravages de Philippe de Béthune', *Gazette des Beaux Arts*, s. VI, CXI, 1988, pp. 33–8.

43 The documents concerning Longhi's release are published in R. Bassani and F. Bellini, op. cit., p. 164. For the challenge to a duel see G. A. Dell'Acqua and M. Cinotti, op cit., pp. 156–7, F56.

44 William Lithgow, in Italy in 1632, wrote of 'the monstrous filthiness' of their 'bardassi, or buggered boys'. See D. Posner, 'Caravaggio's Homo-erotic Early Works', *Art Quarterly*, 34, 1971, pp. 301–24.

45 For a convincing argument that the *bardassa* did not exist see C. Gilbert, *Caravaggio and His Two Cardinals* (University Park, Pennsylvania, 1995), pp. 194–9.

46 The document is published by Marini, 1989, p. 472, who also publishes a reproduction of the copy at Ascoli Piceno (Marini, cat. no. 56).

47 M. Aronberg Lavin, 'Caravaggio Documents from the Barberini Archives', *Burlington Magazine*, CIX, 1967, pp. 470–3.

CHAPTER ELEVEN

1 Letter of 23 June 1603; Archivio di Stato di Firenze, Mediceo del Principato, vol. 3761, unpaginated.

2 On this episode see R. Couzard, *Une ambassade à Rome sous Henri IV* (Paris, 1900), p. 307ff., and R. Zapperi, *Eros e Controriforma: Preistoria della Galleria Farnese* (Turin, 1994), pp. 37–45.

3 See W. Friedlaender, *Caravaggio Studies* (Princeton, NJ, 1955), pp. 279–80. See also S. Macioce, 'Attorno a Caravaggio: Notizie d'Archivio', *Storia dell'Arte*, 55, 1985, pp. 289–93, and Corradini, 1993, pp. 30–2.

4 S. Macioce, op. cit., p. 292.

5 G. A. Dell'Acqua and M. Cinotti, *Il Caravaggio e le Sue Grande Opere da San Luigi dei Francesi* (Milan, 1971). The documents relating to this episode are pp. 157–8.

6 F. Baldinucci, *Notizie de' Professori del Disegno da Cimabue in qua* (6 vols.), (Florence 1681–1728; 1846 edn.), vol. III, pp. 683–84.

7 G. Baglione, *Le Vite de' Pittori, Scultori et Architetti* (Rome, 1642), p. 142. This encounter could have been when Borgianni was young, before he left for Spain at the end of the sixteenth century.

8 On the partisanship of Borgianni and Saraceni, see L. Spezzaferro, 'Una testimonianza per gli inizi del caravaggismo', *Storia dell'Arte*, 23, 1975, pp. 53–60.

9 M. Chapell and W. C. Kirwin, 'A Petrine Triumph: The Decoration of the Navi Piccole in San Pietro under Clement VIII', *Storia dell'Arte*, 21, 1974, pp. 119–70.

10 F. Baldinucci, op. cit., vol. III, p. 277.

11 Ibid., pp. 227, 447.

12 C. Malvasia (tr. C. and R. Enggass), *The Life of Guido Reni* (University Park, Pennsylvania and London, 1980), p. 107. The quotations in this paragraph are from the same source, pp. 121, 126, 93, 115, and 40.

13 Ibid., p. 49.

14 G. Baglione, op. cit., p. 291.

15 On this sequence of events, around which many myths were spun in the early sources, see, for a lucid summary of recent scholarship, Ilaria Chiappini di Sorio, 'Cristofero Roncalli detto Il Pomerancio', in *I Pittori Bergamaschi dal XIII al XIX secolo: Il Seicento*, i (Bergamo, 1983), pp. 3–201.

16 Malvasia, op. cit., p. 50.

17 The picture was commissioned after November 1603. See R. P. Townsend and R. Ward, 'Caravaggio and Tanzio: The Theme of St John the Baptist', exhibition catalogue, 1995 (Philbrook Museum of Art, Tulsa), 1996 (Nelson-Atkins Museum of Art, Kansas City). This chapter is also indebted to M. Fumaroli, *L'Ecole du Silence* (Geneva, 1994), pp. 294ff.

18 L. Ponnelle and L. Bordet, *St Philip Neri and the Roman Society of his Time*s (London, 1937), p. 123. This is how Filippo Neri described his vision to Federico Borromeo.

19 For this quotation, and its source, see M. Gregori in *The Age of Caravaggio*, exhibition catalogue, 1984 (New York, Met: Naples, Capodimonte), p. 303.

20 See P. Matthiesen and S. Pepper, 'Guido Reni: an early masterpiece discovered in Liguria', *Apollo*, XCI, 1970, pp. 452–62, and S. Pepper, 'Caravaggio and Guido Reni: Contrasts in Attitudes', *Art Quaterly*, 34, 1971, pp. 325–44.

21 The relevance of this poem was pointed out by S. Pepper, 'Guido Reni's *Davids*: The Triumph of Illumination', *Artibus et Historiae*, 25, 1992, p. 134. The poem is from G. Marino, *La Galeria* (ed. M. Pieri) (Padua, 1979), vol. I, p. 51, no. 4.

22 Malvasia, op. cit., p. 42.

23 Ibid., p. 50.

24 Ibid., p. 51.

25 The documents have been published in L. Lopresti, 'Un Appunto per la Storia di Michelangelo da Caravaggio', *L'Arte*, 1922, p. 116, and in his 'Sul Tempo più probabile della *Madonna dei Pellegrini* a San Agostino', *L'Arte*, 1922, p. 176. For Cavalletti's will see Corradini, 1993, p. 27.

26 R. Cannatà and H. Röttgen, 'Un Quadro per la Santa Trinità dei Pellegrini affidato al Caravaggio, ma eseguito dal Cavalier d'Arpino', in S. Macioce (ed.), op. cit., p. 82.

27 L. Richeôme, *The Pilgrime of Loreto* (1629 edn., Ilkley and London, 1976), p. 31.

28 As given in B. Pullan, 'Catholics and the Poor in Early Modern Europe', in *Poverty and Charity: Europe, Italy, Venice 1400–1700* (Aldershot, 1994), p. 18.

29 See F. Grimaldi and K. Sordi (eds), *L'Iconografia della Vergine di Loreto nell'arte* (Loreto, 1995), p. 17.

30 M. Fagiolo and M. L. Madonna (eds), *Rome, 1300–1875: L'Arte degli Anni Santi*, exhibition catalogue, 1985 (Rome, Palazzo Venezia), p. 27–28.

31 Cardinal Agostino Valier, *Il Dialogo della Gioa Cristiana* (tr. and ed. A. Cistellini) (Brescia, 1975), p. 87.

32 Ibid., pp. 92–3.

33 L. Richeôme, op. cit., p. 64.

34 Baglione, Hibbard, 1988, p. 354. Baglione's word, *schiamazzo*, is difficult to translate, but on balance it seems that it is derogatory. For an alternative view see F. Bologna, *L'Incredulità del Caravaggio* (Turin, 1992), pp. 230–2.

35 L. Nüssdorfer, 'The Vacant See: Ritual and Protest in Early Modern Rome', *Sixteenth-Century Journal*, XVIII, 1987, pp. 173–89.

36 C. D'Onofrio, *Roma Vista da Roma* (Rome, 1967), p. 200.

37 C. Malvasia, op. cit., p. 36.
38 For this comparison see D. Mahon, *Studies in Seicento Art and Theory* (London, 1947), p. 257.
39 F. Borromeo, *Della Pittura Sacra* (ed. B. Agosti) (Pisa, 1994), p. 97.
40 Marini, 1989, p. 53.
41 For the inventory of Caravaggio's goods see M. Marini and S. Corradini, 'Inventarium omnium et singulorum bonorum mobilium di Michelangelo da Caravaggio: "pittore"', *Artibus et Historiae*, 28, 1993, pp. 161–71.
42 See R. Zapperi, 'L'Inventario di Annibale Carracci', *Antologia di Belle Arti*, 3–4, 1979, pp. 62–8.
43 T. d'Alesandri, *Il Cavaliere Compito* (Viterbo, 1609), p. 70.
44 These documents were first published by S. Macioce, op. cit., 'Attorno a Caravaggio: Notizie d'archivio', pp. 289–92. See also S. Corradini, 1993, pp. 55–7.
45 Corradini, 1993, p. 58. G. A. Dell'Acqua and M. Cinotti, op. cit., p. 158.
46 This contract was discovered and published by R. B. Amidei, 'Della Committenza Massimi' in *Caravaggio: Nuove Riflessioni, Quaderni di Palazzo Venezia*, 6, 1989, p. 47. The picture is usually identified with an *Ecce Homo* which is now in the Palazzo Bianco, Genoa.
47 Corradini, 1993, p. 58.
48 J. Hess, *Die Künstlerbiographien von Giovanni Battista Passeri* (Leipzig and Vienna, 1934), pp. 347–8. Passeri tells how a young notary, who wished to marry Caravaggio's model, spoke ill of Caravaggio to her mother; in revenge Caravaggio attacked him with a hatchet and then took refuge in the church of San Luigi dei Francesi. He does not mention either Mariano Pasqualone or Lena by name, but his account finds confirmation in the criminal archives, which prove that Caravaggio did attack a notary over a woman. The church of San Luigi dei Francesi is close to the Palazzo Madama, where Caravaggio perhaps sought refuge with del Monte. The identification of Lena with a whore, Maddalena di Paolo Antognetti, made by R. Bassano and F. Bellini, *Caravaggio Assassino* (Rome, 1994), p. 207, is incorrect.
49 For these translations see W. Friedlaender, op. cit., p. 284, with additions from the better version in G. A. Dell'Acqua and M. Cinotti, op. cit., p. 158.
50 Documents as translated in J. R. Martin, *The Farnese Gallery* (Princeton, NJ, 1965), p. 18.
51 Corradini, 1993, p. 61.
52 M. Sica in *The Dictionary of Art* (ed. J. Turner) (New York and London, 1990), vol. IX, p. 174.
53 Ibid.
54 Corradini, 1993, p. 62.
55 *Idem.*
56 *Idem.*
57 W. Friedlaender, op. cit., p. 285.
58 This was suggested by M. Calvesi, 'Michelangelo da Caravaggio: il suo rapporto con i Mattei e con altri collezionisti a Roma', in *Caravaggio e la Collezione Mattei*, exhibition catalogue, 1995 (Rome, Galleria Nazionale d'Arte Antica di Palazzo Barberini), p. 21.
59 Corradini, 1993. The documents concerning Prudenzia Bruna are pp. 64–7.
60 Ibid., p. 69.
61 Ibid., p. 67.
62 For the documents concerning the altarpiece commissioned by the Company of the Grooms, see Marini, 1989, pp. 484–8.
63 Baglione/Hibbard, 1988, p. 354.
64 On the nakedness of Christ see L. Steinberg, *The Sexuality of Christ in Renaissance Art and in Modern Oblivion* (Chicago, 1983). For a discussion of the pose of St Anne, and its relationship to Roman art, see S. Settis, 'Immagini della meditazione, dell'incertezza, e del pentimento nell'arte antica', Prospettiva, 2, 1975, pp. 4–18.
65 Bellori/Hibbard, 1988, p. 372.
66 Marini, 1989, p. 485.

67 Corradini, 1993, p. 70. The documents relating to the homicide are pp. 70–3.

68 A newspaper of 3 June 1606 claims that 'segùi una questione da buono a buona tra un certo Michelangelo da Caravaggio, pittore famoso, et un tal Ranutio . . . tra quali doi giorni prima erano passate alcune querele'. See R. Fuda, 'Note Caravaggesche', *Paragone*, 43, 509–511, 1992, p. 74.

69 Sandrart, as translated in H. Hibbard, op. cit., p. 377.

70 Corradini, 1993, p. 71.

71 Ibid., pp. 80–1.

72 M. Calvesi believes that the fourth man was Mario Minniti, which is possible; certainly Minniti committed a homicide, but this may have been in Sicily. See M. Calvesi, 'Michelangelo da Caravaggio: il suo rapporto con i Mattei ...', op. cit., in *Caravaggio e la Collezione Mattei*, op. cit.

73 Corradini, 1993, p. 70.

74 Ibid., p. 71; translated in H. Hibbard, *Caravaggio* (London, 1988), p. 206.

75 Corradini, 1993, p. 71.

76 Baglione/Hibbard, 1988, p. 355.

77 Mancini/Hibbard, 1988, p. 348.

78 As translated in Hibbard, op. cit, p. 206.

79 Corradini, 1993, p. 76.

80 For the aftermath of the homicide, see Corradini, 1993, pp. 90–5. I am indebted to Sandro Corradini for discussing these documents with me, and suggesting that family honour may have been at the root of the brawl.

81 Corradini, 1993, p. 84.

82 M. Calvesi, *Le Realtà del Caravaggio* (Turin, 1990), pp. 138–45.

83 Mancini/Hibbard, 1988, p. 348.

84 Hibbard, op. cit., 1988, p. 355.

85 On this fascinating web of relationships see M. Calvesi, *Le Realtà del Caravaggio* (Turin, 1994), *passim*, and the remarks by R. Fuda, op. cit., pp. 75–8.

86 The picture now in the Brera, Milan, is usually identified with the picture bought by Costa in Rome, which he then gave or sold to the Marchese Patrizi before 1624, when it is recorded in Patrizi's inventory. For a summary of the arguments see M. Marini, 1989, p. 490.

87 Corradini, 1993, pp. 87–9. This trial was first discussed by L. Spezzaferro, 'Una testimonianza per gli inizi del Caravaggismo', op. cit.

88 M. Maccherini, 'Caravaggio nel Carteggio familiare di Giulio Mancini', *Prospettiva*, 86, April 1997, p. 82.

89 For these letters, see Corradini, 1993, pp. 93–6.

CHAPTER TWELVE

1 G. C. Capaccio, *Il Forastiero: Dialoghi con G. C. Capaccio, Accademico Otioso* (Naples, 1634), vol. II, p. 850.

2 As translated in G. Galasso, 'Society in Naples in the Seicento', *Painting in Naples 1606–1705 from Caravaggio to Giordano*, exhibition catalogue, 1982 (London, Royal Academy of Arts), p. 25.

3 G. C. Capaccio, op. cit., as quoted in B. Croce, *History of the Kingdom of Naples* (tr. Frenaye) (Chicago and London, 1970), p. 120.

4 G. B. del Tufo, *Ritratto o Modello delle Grandezze: Delitie e meraviglie della Nobilissima Città di Napoli* (ed. C. Tagliareni) (Naples, 1959).

5 On Luigi Carafa, see M. Calvesi, *Le Realtà del Caravaggio* (Turin, 1990), p. 129.

6 In the nineteenth century this painting was in the collection of the Principessa Carafa Colonna.

7 B. de Dominici, *Vite dei Pittori, Scultori ed Architetti Napoletani*, vol. III (1844 edn, Naples), p. 40.

8 In *Battistello Caracciollo e il Primo Naturalismo a Napoli* (ed. F. Bologna), exhibition catalogue, 1991 (Naples, Castel Sant'Angelo and Certosa di San Martino), Stefano Causa argues (p. 186) that, although we cannot know whether Caracciolo knew Caravaggio or not, he must have known the great public works in Roman churches at first hand.

9 B. de Dominici, op. cit., p. 40.

10 Bellori/Hibbard, 1988, p. 368.

11 For the contract see V. Pacelli, 'New Documents concerning Caravaggio in Naples', *Burlington Magazine*, CXIX, 1977, pp. 819–29. For Caravaggio's banking activities in connection with this painting see V. Pacelli, *Le Sette Opere di Misericordia* (Salerno, 1984), p. 102. The documents are also published and discussed in Marini, 1989, p. 501.

12 G. B. del Tufo, op. cit., pp. 272–3.

13 The documents connected with the payment are published and discussed in V. Pacelli, op. cit., 1984, pp. 102–3, and in Marini, 1989, p. 494. The information on patrons and on the Statutes of the Monte are also from Pacelli.

14 A. Tuck-Scala, 'Caravaggio's "Roman Charity" in *The Seven Acts of Mercy*', in J. Chenault Porter and S. Scott Munshower (eds), *Parthenope's Splendor: Art of the Golden Age in Naples* (University Park, Pennsylvania, 1993), pp. 126–63; Tuck-Scala made the interesting observation that Caravaggio's source for Cimon and Pero, in Valerius Maximus, is an ekphrasis. This scene was not common in Italian art before Caravaggio, nor had it been associated with the Seven Acts.

15 This was pointed out by M. Calvesi, op. cit., p. 359. See also J. de Voragine, *The Golden Legend* (tr. W. G. Ryan) (Princeton, NJ), vol. II, p. 292.

16 G. B. del Tufo, op. cit., p. 214, writes how the pilgrims 'put up monuments and statues' and describes a series of paintings of the deeds of Samson.

17 Valerius Maximus, *Memorabilia*, V4, 'Of Filial Piety', (ed. M. Nisard) *Oeuvres Complètes de Valère Maxime* (Paris, n.d.), vol. I, p. 363.

18 One school of thought, led by Friedlaender, has argued that the picture was the one ordered by the Duke of Modena but never delivered; see W. Friedlaender, *Caravaggio Studies* (Princeton, NJ, 1955), p. 199. The suggestion that the patron was Don Marzio Colonna was put forward by J. Hess in an article, 'Modelle e Modelli del Caravaggio', *Commentari*, V, 1954, pp. 277–9. On the iconography of the picture, and the evidence presented by radiography, see W. Prohaska, 'Untersuchungen zur *Rosenkratz Madonna* Caravaggios', *Jahrbuch der Kunsthistorischen Sammlungen in Wien*, 76, 1981, pp. 111–32.

19 G. C. Capaccio, op. cit., pp. 877–8.

20 On this see M. Rosa, 'L'Onda che Ritorna: Interno ed estero Sacro nella Napoli del 600', in S. B. Gajano and L. Scaraffia (eds), *Luoghi sacri e spazi della santità* (Turin, 1990), pp. 397–417.

21 Luigi di Granata, *Rosario della Sacratissima Vergine Maria* (Rome, 1573), p. 3.

22 M. Rosa, op. cit., p. 409.

23 For the documents see V. Pacelli, 'New Documents concerning Caravaggio in Naples', *Burlington Magazine*, CXIX, 1977, pp. 819–29, and the same author's 'Nuovi documenti sull'attività del Caravaggio a Napoli', *Napoli Nobilissima*, XVII, 1978, pp. 57–67. The documents are also published and analysed in M. Marini, 1989, pp. 517–19. For information on the de Franchis family see V. Pacelli and A. Bréjon de Lavergnée, 'L'Eclisse del Committente? Congetture su un ritratto nella *Flagellazione* di Caravaggio rivelato dalla radiografia', *Paragone*, XXXVI, 419, 421 and 423, 1985, pp. 209–18.

24 Luigi di Granata, op. cit., p. 120.

25 Ibid., p. 117.

26 B. de Dominici, op. cit., p. 41.

27 D. Bodart, *Louis Finson* (Brussels, 1970), p. 11.

28 Corradini, 1993, p. 96.

29 These documents are published in Marini, 1989, p. 497. See also Corradini, 1993, p. 97.

CHAPTER THIRTEEN

1 George Sandys, *A Relation of a Journey begun An:Dom: 1610* (London, 1615), p. 228.

2 F. Sansovino, *Della Origine de Cavalieri di M. Francesco Sansovino* (Venice, 1570), p. 33.

3 On the Knights of Malta generally see H. J. A. Sire, *The Knights of Malta* (New Haven, Connecticut, and London, 1994), and for the Order's increased popularity at the end of the sixteenth century, p. 74.

4 Bellori/Hibbard, 1988, p. 368.

5 Sandys, op. cit., p. 232.

6 Sandys, op. cit., p. 234.

7 R. A. de Vertot, *The History of the Knights of Malta* (London, 1728), Book XIII, p. 55.

8 G. Bosio, *Dell'Istoria della Sacra religione et Ill.ma Militia di San Gio: Gierosol.no di Iacomo Bosio. Di nuovo ristampata, e dal medesimo autore ampliata et illustrata* (Rome and Naples, 1621–84), vol. III, p. 768.

9 B. Dal Pozzo, *Historia della Sacra Religione di Malta* (Verona and Venice, 1703–5), pp. 442–3.

10 Sandys, op. cit., p. 230.

11 M. Buhagiar, *The Iconography of the Maltese Islands, 1400–1900: Painting* (Malta, 1987), p. 49.

12 S. Macioce, 'Caravaggio a Malta e i suoi referenti: notizie d'archivio', Storia dell'Arte, 81, 1994, publishes the letters from Wignacourt cited in this chapter, pp. 207–29.

13 F. Ashford, in 'Caravaggio's Stay in Malta', *Burlington Magazine*, LXVII, 1935, pp. 168–74, suggested that the Giustiniani cousins facilitated Caravaggio's move to Malta. She suggested that Caravaggio went in the company of Marc'Aurelio Giustiniani, and the dates fit, for the petition about Venosa is dated 24 July 1607. It is possible that the Giustiniani helped Caravaggio in Malta, and that he arrived with them; but on balance the more likely explanation (which does not, however, entirely exclude the interest of the Guistiniani) is that he sailed with Fabrizio Sforza Colonna.

14 The story of Fabrizio Sforza Colonna, and his connection with Caravaggio, was first pieced together, from the account in Dal Pozzo, op. cit., pp. 41, 459 and 521, by M. Calvesi, *Le Realtà di Caravaggio* (Turin, 1990), pp. 131–3.

15 Archivio di Stato di Firenze, Fondo Mediceo de Principato, file 4028, Avvisi da Roma, 1600–2, p. 47 (13 July 1602).

16 B. dal Pozzo, op. cit., p. 521.

17 B. dal Pozzo, op. cit., p. 522.

18 On the date of arrival of the galleys in Malta see D. Cutajar, 'Caravaggio in Malta. His Works and His Influence', in P. Farrugia Randon (ed.), *Caravaggio in Malta* (Malta, 1989), pp. 1–18. See also M. Buhagiar, op. cit., p. 62. There is strong circumstantial evidence that Caravaggio came with these galleys, but it is not proved and he may have been on the island even earlier. Calvesi, op. cit., p. 160, n. 120, quotes dal Pozzo, who gives the date of the arrival of the galleys as 12 July 1609.

19 The documents relating to this hearing are reproduced in facsimile and with an English translation in J. Azzopardi, 'Documentary Sources on Caravaggio's Stay in Malta', in P. F. Randon (ed.), op. cit., pp. 30–31.

20 Baglione/Hibbard, 1988, p. 355.

21 Bellori/Hibbard, 1988, p. 368. It is possible that a seated portrait of Grand Master Wignacourt (Wignacourt Collegiate Museum, Rabat), attributed to Cassarino, is a copy after a lost work by Caravaggio.

22 See J. Gash, 'The Identity of Caravaggio's "Knight of Malta"', *Burlington Magazine*, CXXXIX, 1997, pp. 156–60, n. 29.

23 G. Bosio, op. cit., p. 677.

24 J. Toffolo, *Image of a Knight* (London, 1988), p. 27.

25 F. Sansovino, op. cit., pp. 4–5.

26 S. Macioce, *Caravaggio a Malta e i suoi referenti: notizie d'archivio*, op. cit., pp. 217, 221 and 228. Malaspina left a 'quadro grande' and 'quattro piccoli' to the chapel of the Italian Langue

in the Cathedral of St John. She suggests that the 'quadro grande' alludes to the *St Jerome*, which hangs there now. John Gash (op. cit.) inferred from this that the painting was originally commissioned for Malaspina's personal devotions rather than as a public work.

27 F. Sansovino, op. cit., p. 33r.

28 B. dal Pozzo, op. cit., p. 523.

29 S. Macioce, *Caravaggio a Malta e i suoi referenti: notizie d'archivio*, op. cit., pp. 207–8.

30 Corradini, 1993, p. 97. This document is transcribed and translated in J. Azzopardi, 'Caravaggio's Admission into the Order' in P. F. Randon (ed.) op. cit., p. 55.

31 J. Azzopardi, ibid, p. 56. Corradini, 1993, p. 98.

32 This identification was suggested by S. Macioce, *Caravaggio a Malta e i suoi referenti: notizie d'archivio*, op. cit., p. 210.

33 R. A. de Vertot, op cit., Book XIII, p. 60.

34 B. dal Pozzo, op. cit., p. 568.

35 G. Bosio, op. cit., p. 872.

36 J. Azzopardi, 'Documentary Sources on Caravaggio's Stay in Malta' in P. F. Randon (ed.) op. cit., p. 33, gives a transcription and a translation of this document.

37 Quoted from H. J. A. Sire, op. cit., p. 213.

38 D. Cutajar, 'Caravaggio in Malta: His Works and His Influence', in P. F. Randon (ed.), op. cit., pp. 11–13.

39 J. von Sandrart, Joachim von Sandrart's Academie der Bau –, Bild –, und Mahlerey – Künste von 1675 (ed. A. R. Pelzer) (Munich 1925), as translated in H. Hibbard, *Caravaggio* (London, 1988), p. 482.

40 B. dal Pozzo, op. cit., p. 482.

41 On the original architectural context of the picture, and its socio–religious context, see the very fascinating article by D. M. Stone, 'The Context of Caravaggio's "Beheading of St John" in Malta', *Burlington Magazine*, CXXXIX, 1997, pp. 161–70, to which this section is indebted.

42 Bellori/Hibbard, 1988, p. 369.

43 *Idem*. The quotations in this and the following paragraph are from this source.

44 On the Lorrain family and the commission for *The Annunciation*, see M. Calvesi, *Le Realtà di Caravaggio*, op. cit., pp. 375–9, and S. Macioce, op. cit., p. 209.

45 Bellori/Hibbard, 1988, p. 369.

46 Baglione/Hibbard, 1988, p. 355.

47 F. Susinno, *Le Vite de' Pittori Messinesi* (1724: ed. V. Martinelli, Florence, 1960) as translated in Hibbard, op. cit., 1988, p. 381.

48 These documents are published in J. Azzopardi, op. cit., p. 39; see also Corradini, 1993, pp. 100–1. The quotations from Sammut are from E. Sammut, 'The Trial of Caravaggio', in P. F. Randon, (ed.), op. cit., p. 61. For a clear summary of the primary sources on Caravaggio in Malta see also J. Azzopardi, 'Un *San Francesco* di Caravaggio a Malta nel Secolo XVIII: commenti sul periodo maltese del Merisi', in S. Macioce (ed.), *Michelangelo Merisi di Caravaggio*, op. cit., pp. 195–212.

49 J. Azzopardi, 'Un *San Francesco* di Caravaggio . . .', op. cit., p. 197. The list is in a private collection in Malta.

50 G. Sandys, op. cit., p. 234.

CHAPTER FOURTEEN

1 F. Susinno, *Le Vite de' Pittori Messinesi* (1724; ed. V. Martinelli, Florence, 1960), as translated in Hibbard, 1988, p. 386.

2 G. Sandys, *A Relation of a Journey begun in Anno Domini 1610* (London, 1615), p. 241.

3 F. Susinno, op. cit., p. 117.

4 F. Susinno, as translated in Hibbard, p. 381.

5 V. Mirabella, *Dichiarazione della pianta dell'antiche Siracuse* (Naples, 1613), p. 89. This passage is quoted in Marini, 1989, p. 100.

6 For a summary of the scholarship on this painting, and the controversy over the patron, see Marini, 1989, p. 535.

7 Susinno, as translated in Hibbard, 1988, p. 382.

8 G. Sandys, op. cit., p. 245.

9 Susinno, as translated in Hibbard, 1988, p. 382.

10 P. Samperi, *Iconologia della Gloriosa Vergine Madre di Dio Maria, Prottetrice di Messina* (Messina, 1644), p. 4. See also V. Abbate, 'I Tempi del Caravaggio: Situazioni della Pittura in Sicilia (1580–1625)', in *Caravaggio in Sicilia: Il suo Tempo, il suo Influsso*, exhibition catalogue, 1984 (Palermo, Museo Regionale di Palazzo Bellomo), p. 45.

11 For the documents concerning this picture see Marini, 1989, pp. 536–7. The story of the commission is told by Susinno, as translated in Hibbard, 1988, p. 382, from which the quotations in this section are taken.

12 Ambroise de Milan, *La Pénitence*, Book II, chapter vii (Paris, 1971), p. 171.

13 St Augustine, *Lectures or Tractates on the Gospel according to St John* (tr. Rev. J. Innes) (Edinburgh, 1874), vol. II, pp. 132, 136, 139.

14 Susinno, as translated in Hibbard, 1988, p. 386.

15 P. Samperi, op. cit., p. 145.

16 *Meditations on the Life of Christ* (tr. I. Ragusa and R. B. Green) (Princeton, NJ, 1961), p. 37.

17 C. Cargnoni (ed.), *I Frati Cappucini* (Perugia, 1988), vol. III, i, p. 725.

18 G. M. Ellero, *Esegesi e Teologia dell'incarnazione secondo Giovanni Crisostomo* (Vicenza, 1967), p. 150.

19 P. Samperi, op. cit., p. 143.

20 For the lives of Catalano l'Antico and of Filippo Paladini, see F. Susinno, op. cit., pp. 96–193 and 103–6.

21 See Marini, 1989, p. 568.

22 Susinno, as translated in Hibbard, 1988, p. 386.

23 *Idem.*

24 G. Bellafiore, *Palermo: Dalle Origine alla maniera in Metamorfosi della Città* (ed. L. Benevolo) (Milan, 1995), p. 151.

25 *Meditations on the Life of Christ*, op. cit., pp. 33–5.

26 As given in E. A. Armstrong, *Saint Francis: Nature Mystic* (Berkeley, California, and London, 1973), p. 142.

27 Baglione/Hibbard, 1988, p. 355.

28 Belllori/Hibbard, 1988, p. 370.

29 R Ziglioli, 'Il Caravaggio . . . a Caravaggio, in Roma', in S. Macioce (ed.), *Michelangelo Merisi da Caravaggio: La Vita e le Opere attraverso i Documenti* (Rome, 1995), p. 65.

CHAPTER FIFTEEN

1 G. C. Capaccio, *Il Forastiero: Dialoghi con G. C. Capaccio, Accademico Otioso* (Naples, 1634), p. 821.

2 G. B. del Tufo, *Ritratto o Modello delle Grandezze: Delitie e meraviglie della Nobilissima Città di Napoli* (ed. C. Tagliareni) (Naples, 1959), p. 29.

3 J. F. Orbaan, *Documenti sul Barocco in Roma* (Rome, 1920), p. 157.

4 G. B. del Tufo, op. cit., p. 149.

5 M. Maccherini, 'Caravaggio nel Carteggio familiare di Giulio Mancini', *Prospettiva*, 86, April 1997, p. 83.

6 M. Calvesi, *Le Realtà del Caravaggio*, (Turin, 1990), p. 147, has suggested that Caravaggio was attacked by Spanish soldiers and that he remained a prisoner of the Spanish throughout his Neapolitan stay, although allowed to work and given a considerable degree of freedom. Baglione and Bellori both believed that his attackers were Maltese.

7 M. Maccherini, op. cit., loc. cit.

8 C. N. Cochin, *Voyage d'Italie* (Paris, 1758), vol. I, pp. 171–2; for this source, and other early descriptions of this lost picture, see Marini, 1989, p. 568.

9 Bellori/Hibbard, 1988, p. 370.

10 This is the view expressed cautiously by M. Calvesi in 'Michelangelo da Caravaggio: il suo rapporto con i Mattei e con altri collezionisti Romani', *Caravaggio e la Collezione Mattei*, exhibition catalogue (Rome, Galleria Nazionale d'Arte Antica di Palazzo Barberini), p. 24.

11 N. Ault (ed.), *Elizabethan Lyrics* (New York, 1960), p. 362.

12 G. Marino, *La Galeria* (ed. M. Pieri) (Padua, 1979), p. 51, no. 4.

13 On this picture see A. Tzeutschler Lurie and D. Mahon, 'Caravaggio's *Crucifixion of Saint Andrew* from Valladolid', *Bulletin of the Cleveland Museum of Art*, 1977, pp. 3–24. The late dating was suggested by M. Gregori, *The Age of Caravaggio*, exhibition catalogue (New York Metropolitan, and Naples, Capodimonte), p. 349.

14 V. Pacelli and F. Bologna, 'Caravaggio, 1610: la *Saint'Orsola confitta dal tiranno* per Marcantonio Doria', in *Prospettiva*, 23, 1980, pp. 24–45.

15 Bellori tells us that Caravaggio was protected by Cardinal Gonzaga; see Bellori/Hibbard, 1988, p. 370.

16 Baglione/Hibbard, 1988, p. 356.

17 As translated in ibid., p. 255.

18 For the texts of these letters see V. Pacelli, 'La Morte del Caravaggio e alcuni suoi dipinti da documenti inediti', *Studi di Storia dell'Arte*, 2, 1991, pp. 167–88, and V. Pacelli, *L'Ultimo Caravaggio: Dalla Maddalena a mezza figura ai due San Giovanni (1601–1610)* (Todi, 1994).

19 The letters from Deodato Gentile, recently discovered by Vincenzo Pacelli, which seemed at first sight to elucidate what had happened at Caravaggio's death, have proved very difficult to interpret. It is not at all clear what pictures went on the felucca (the *David*, for instance, may have been sent to Scipione earlier, or it may have been left at Chiaia, with Caravaggio intending to send for it; nor is it clear that the three pictures that were at Chiaia had necessarily been returned from Port'Ercole). Very different interpretations of this material have been given by M. Marini, 'L'Ultima Spiaggia', *Art e Dossier*, 66, 1992, pp. 8–11; M. Calvesi, 'Michelangelo da Caravaggio', op. cit., in *Caravaggio e la Collezione Mattei*, op. cit., pp. 17–29; V. Pacelli, 'Un Nuova Ipotesi sulla Morte di Michelangelo Merisi di Caravaggio' in S. Macioce (ed.), op. cit., pp. 184–95. There is also a puzzling notice from 1630, from the church and monastery of SS Apostoli at Naples, which suggests that Caravaggio was murdered; it claims that he had received 100 scudi to do a painting but because he was murdered the church lost the money and the picture. It also seems likely that Caravaggio intended to return to Naples, for he left the large picture for Santa Maria della Sanità unfinished.

20 G. C. Gigli, *La Pittura Trionfante* (1615), as translated in M. Kitson, *The Complete Paintings of Caravaggio* (London, 1969), p. 10.

Location of paintings

Dimensions are in centimetres, height preceding width. Medium is oil on canvas unless otherwise stated.

The Adoration of the Shepherds; 314 x 211; Messina, Museo Regionale
The Adoration of the Shepherds with Saints Lawrence and Francis; 268 x 197; stolen, formerly Palermo,
 Oratorio di S Lorenzo
The Annunciation; 285 x 205; Nancy; Musée des Beaux-Arts
Basket of Fruit; 31 x 47; Milan, Pinacoteca Ambrosiana
Bacchus; 98 x 85; Florence, Uffizi
The Beheading of St John the Baptist; 361 x 520; Valletta, Oratory of the Co-Cathedral of St John
The Blessed Isidoro Agricola (copy); 220 x 150; Ascoli Piceno, Pinacoteca Communale
Boy with a Basket of Fruit; 70 x 67; Rome, Galleria Borghese
Boy Bitten by a Lizard; 66 x 49.5; London, National Gallery
Boy Peeling a Fruit; 64.2 x 51.4; London, Phillips
The Burial of St Lucy; 408 x 300; Syracuse, Museo Regionale di Palazzo Bellomo
The Calling of St Matthew; Rome, S. Luigi dei Francesi
The Cardsharps; 91.5 x 128.2; Fort Worth, Kimbell Art Museum
St Catherine of Alexandria; 173 x 133; Madrid, Museo Thyssen-Bornemisza
Christ on the Mount of Olives; 154 x 222; destroyed, formerly Berlin, Kaiser-Friedrich Museum
The Conversion of the Magdalene; 100 x 134.5; Detroit, Detroit Institute of Arts
The Conversion of St Paul (first version) (oil on panel); 237 x 189; Rome, Odescalchi Collection
The Conversion of St Paul (second version); 230 x 175; Rome, S. Maria del Popolo
The Crowning with Thorns; 178 x 125; Prato, Palazzo degli Alberti (Cassa Risparmio e Depositi)
The Crowning with Thorns; 127 x 165.5; Vienna, Kunsthistorisches Museum
The Crucifixion of St Andrew; 202.5 x 152.7; Cleveland, Cleveland Museum of Art
The Crucifixion of St Peter; 230 x 175; Rome, S. Maria del Popolo;
David and Goliath; 110 x 91; Madrid, Prado
David with the Head of Goliath; 125 x 101; Rome, Galleria Borghese
The Death of the Virgin; 369 x 245; Paris, Louvre
Doubting Thomas; 107 x 146; Potsdam, Sanssouci Bildergalerie
Ecce Homo; 128 x 103; Genoa, Palazzo Rosso
The Ecstasy of St Francis; 92.5 x 107.8; Hartford, Wadsworth Atheneum
The Entombment of Christ; 300 x 203; Rome, Vatican Palace, Pinacoteca
The Flagellation of Christ; 286 x 213; Naples, Capodimonte
St Francis in Meditation; 124 x 93; Rome, Galleria Nazionale d'Arte Antica, Palazzo Barberini
St Francis in Meditation; 130 x 98; Rome, S. Maria della Concezione
The Gypsy Fortune Teller; 116 x 152; Rome, Pinacoteca Capitolina
The Gypsy Fortune Teller; 99 x 131; Paris, Louvre
St Jerome in his Study; 112 x 157; Rome, Galleria Borghese
St Jerome Writing; 117 x 157; Valletta, Co-Cathedral of St John
St John the Baptist; 129 x 94; Rome, Pinacoteca Capitolina
St John the Baptist; 170.6 x 130; Kansas City, Nelson-Atkins Museum of Art

St John the Baptist; 94 x 131; Rome, Galleria Nazionale d'Arte Antica, Palazzo Corsini

St John the Baptist; 159 x 124.5; Rome, Galleria Borghese

Judith and Holofernes; 145 x 195; Rome, Galleria Nazionale d'Arte Antica, Palazzo Barberini

Jupiter, Neptune and Pluto (oil on plaster); 500 x 285; Rome, Casino Ludovisi

The Lute Player; 94 x 119; St Petersburg, State Hermitage

The Lute Player; 100 x 126.5; New York, Wildenstein

The Madonna of Loreto; 260 x 150; Rome, S. Agostino

The Madonna and Child with St Anne (Madonna dei Palafrenieri); 292 x 211; Rome, Galleria Borghese

The Madonna of the Rosary; 364.5 x 249.5; Vienna, Kunsthistorisches Museum

Mary Magdalene; 123 x 98.3; Rome, Galleria Doria Pamphilj

Mary Magdalene; 106.5 x 91; Rome, private collection

The Martyrdom of St Matthew; 323 x 343; Rome, S. Luigi dei Francesi

The Martyrdom of St Ursula; 140.5 x 170.5; Naples, Banca Commerciale Italiana

St Matthew and the Angel (first version); 223 x 183; destroyed, formely Berlin, Kaiser-Friedrich Museum

St Matthew and the Angel (second version); 296.5 x 195; Rome, S. Luigi dei Francesi

Medusa (oil on canvas mounted on convex poplar shield); diameter 55.5; Florence, Uffizi

The Musicians; 92 x 118.5; New York, Metropolitan Museum of Art

Narcissus; 110 x 92; Rome, Galleria Nazionale d'Arte Antica, Palazzo Barberini

Portrait of Fillide; 66 x 53; destroyed, formerly Berlin, Kaiser-Friedrich Museum

Portrait of Maffeo Barberini 124 x 90; Florence, private collection

Portrait of Cardinal Baronio (attribution); 60 x 48; Florence, Uffizi

Portrait of a Knight of Malta; Fra Antonio Martelli; 118.5 x 95.5; Florence, Palazzo Pitti

Portrait of Giovan Battista Marino (?) (attribution); 73 x 60; Switzerland, private collection

Portrait of Alof de Wignacourt; 195 x 134; Paris, Louvre

The Rest on the Flight into Egypt; 135.5 x 166.5; Rome, Galleria Doria Pamphilj

The Resurrection of Lazarus; 380 x 275; Messina, Museo Regionale

The Sacrifice of Isaac; 104 x 135; Florence, Uffizi

Salome with the Head of St John the Baptist; 116 x 140; Madrid, Palacio Real

Salome with the head of St John the Baptist; 91.5 x 107; London, National Gallery

The Seven Acts of Mercy (Madonna della Misericordia); 390 x 260; Naples, Pio Monte della Misericordia

The Sick Bacchus; 67 x 53; Rome, Galleria Borghese

Sleeping Cupid; 72 x 105; Florence, Palazzo Pitti

The Supper at Emmaus; 141 x 196.2; London, National Gallery

The Supper at Emmaus; 141 x 175; Milan, Brera

The Taking of Christ; 133.5 x 169.5; Dublin, National Gallery of Ireland

Victorious Cupid; 156 x 113; Berlin, Gemaldegalerie, Staatliche Museen zu Berlin, Preussischer Kulturbesitz

LOCATION OF WORKS BY OTHER ARTISTS MENTIONED IN THE TEXT

NB: Murals, and other works whose location is clear from the text, are omitted.

Alberti, Durante
 The Nativity; Rome, Chiesa Nuova
Allori, Cristofano
 Judith with the Head of Holofernes; Florence, Palazzo Pitti

Baglione, Giovanni
 Divine Love Overcoming the World, the Flesh and the Devil; Rome, Galleria Nazionale d'Arte Antica,
 Palazzo Barberini;
 Divine Love Overcoming the World, the Flesh and the Devil; Berlin, Gemaldegalerie Staatliche Museen
 zu Berlin, Preussischer Kulturbesitz
 The Resurrection (modello); Paris, Louvre
Barocci, Federico
 The Visitation; Rome, Chiesa Nuova
Bernini, Gian Lorenzo
 Portrait Bust of Scipione Borghese; Rome, Galleria Borghese
Breughel, Jan (ascribed)
 Carafe of Flowers; Rome, Galleria Borghese
Breughel, Jan
 Vase of Flowers; Milan, Pinacoteca Ambrosiana
Campi, Antonio
 The Agony in the Garden; Milan, Pinacoteca Ambrosiana
Carracci, Annibale
 The Assumption of the Virgin; Rome; S. Maria del Popolo
 Domine Quo Vadis; London, National Gallery
 A Hanging (drawing); Windsor, Royal Collection
 St Margaret; Rome; Museo Nazionale d'Arte Antica, Palazzo Barberini, on deposit from
 S. Caterina della Rota
 Self Portrait, Parma, Galleria Nazionale
Caravaggio, Polidoro da
 The Adoration of the Shepherds; Messina, Museo Regionale
Figino, Ambrogio
 The Madonna of the Serpent; Milan, S. Antonio Abate
 Still Life with Peaches; Private Collection
Giorgione (previously ascribed to)
 Soldier and Woman Carrying a Flute; Hampton Court, Royal Collection
Giorgione
 David Meditating on the Head of Goliath; Vienna, Kunsthistorisches Museum
Laureti, Tommaso,
 The Triumph of Religion; Rome, Vatican Palace, Sala di Costantino
Leonardo da Vinci
 The Madonna of the Rocks; London, National Gallery
Leoni, Ottavio
 Portrait of Caravaggio (drawing); Florence, Biblioteca Marucelliana
Ligozzi, Jacopo
 Two African Vipers (drawing); Florence, Uffizi
Manfredi, Bartolomeo
 Mars Chastising Cupid; Chicago, Art Institute of Chicago
The Master of Hartford
 Fruits and Flowers in Two Carafes; Hartford, Wadsworth Atheneum
 Still Life with Fruit, Flowers and Vegetables; Rome, Galleria Borghese
 Still Life with Game Birds; Rome, Galleria Borghese
Minniti, Mario
 The Raising of the Widow of Naim; Messina, Museo Regionale
Paladino, Filippo
 St Francis Receiving the Stigmata; Messina, Chiesa dei Capuccini
Parmigianino
 Amor (Cupid Carving his Bow); Vienna, Kunsthistorisches Museum

Peterzano, Simone
The Deposition, Milan; S. Fedele
Pulzone, Scipione
The Crucifixion; Rome, Chiesa Nuova
The Holy Family; Rome, Galleria Borghese
Raphael
The Conversion of St Paul (tapestry); Rome, Vatican Palace, Pinacoteca
The Transfiguration; Rome, Vatican Palace, Pinacoteca
Reni, Guido
The Crucifixion of St Peter; Rome, Vatican Palace, Pinacoteca
The Martyrdom of St Catherine; Conscente, S. Alessandro
David Contemplating the Head of Goliath; Paris, Louvre
Rubens, Sir Peter Paul
Gian Carlo Doria; Genoa, Palazzo Spinola
Sebastiano del Piombo
The Flagellation; Rome, S. Pietro in Montorio
Titian
Death of St Peter Martyr; destroyed, formerly Venice, SS Giovanni e Paolo
Mary Magdalene; Florence, Pitti Palace
The Resurrection (from the Averoldi Altarpiece); Brescia, SS Nazzaro e Celso
Salome with the Head of St John the Baptist; Rome, Galleria Doria Pamphilj
The Venus of Urbino; Florence, Uffizi
Vasari, Giorgio
The Beheading of St John the Baptist; Rome; S. Giovanni Decollato

Acknowledgments

I SHOULD LIKE TO THANK many friends for help and information, especially Sergio Benedetti, Tom and Elizabeth Cohen, Kate Gallagher, John Gash, John Keats, Emma Lauze, Judith Landry, Francesca Piovano, Jonathan Rolls, Erich Schleier, Christopher Mendez and my fellow members of the Independent Scholars' Group, Elizabeth Allen and Lynda Stephens. I am, of course, also deeply indebted to previous Caravaggio scholars, for ideas and for factual information. The footnotes are not meant to be exhaustive, but to assist the reader in locating relevant materials and areas of controversy, and, hopefully, to acknowledge at least some of these debts to the vast body of Caravaggio scholarship. In Rome, Tuscany and Naples many scholars were generous with their time and knowledge, and I should like to thank Silvia Danesi Squarzina, Maria Bernardini, Francesca Cappelletti, Michele Maccherini, Vincenzo Pacelli, Mario Rosa and Karen Wolfe for help and hospitality. My debt to Sandro Corradini and to Maurizio Marini is great, and I much appreciated their generosity in discussing their archival discoveries with me and helping me to procure photographs. I am particularly grateful to Maurizio Marini for lending me the photograph of the painting which he believes to be Caravaggio's lost portrait of Giovan Battista Marino, and which he intends to publish shortly. The staff of the British School at Rome provided practical help, particularly Maria Pia and Valerie Scott. I am also grateful to the Maltese, particularly Canon John Azzopardi, Mario Buhagiar, Keith Sciberras and Marquis Anthony Cassar de Sayn, who provided me with hospitality, ideas and photographs. At Chatto & Windus I should like to thank Jonathan Burnham for his initial encouragement, and Jenny Uglow for help with my manuscript. My son and daughter, John and Esther Langdon, have both provided practical help, and I am indebted to my daughter for various classical literary allusions and translations. I should also like to mention my class of students at the Australia National University, who

provided some last minute ideas. But perhaps my greatest debts of all are to Franca Trinchieri Camiz, for much encouragement and help of many kinds, to Father Dermot Fenlon, for many wonderful conversations about Roman Catholicism; and Anthony Langdon, for a great deal of practical help, but, even more, for many long discussions of Caravaggio's art.

I WOULD ALSO LIKE TO THANK the following individuals and institutions for their kind permission to reproduce paintings and other material in their possession, as acknowledged in the List of Illustrations: The Art Institute of Chicago; Avery Architectural and Fine Arts Library, Columbia University in the City of New York; Banca Commerciale Italiana, Naples; Sergio Benedetti; Biblioteca-Pinacoteca Ambrosiana, Milan; The Bridgeman Art Library, London; © The British Museum, London; The British Library, London; The Marquis Cassar de Sayn; © The Cleveland Museum of Art; © 1998 The Detroit Institute of Arts; Galleria Borghese, Rome; Galleria Doria Pamphilj, Rome; Gemäldegalerie, Staatliche Museen zu Berlin, Preussischer Kulturbesitz; Galleria Nazionale d'Arte Antica, Rome; Galleria Nazionale, Parma; Kimbell Art Museum, Fort Worth; Künsthistorisches Museum, Vienna; Logart Press; Maurizio Marini; Christopher Mendez; The Metropolitan Museum of Art, New York; Musee du Louvre, Paris; Museo Nacional del Prado, Madrid; Museo Regionale, Messina; Museo Thyssen-Bornemisza, Madrid; Naples, Banca Commerciale Italiana; The National Gallery of Ireland, Dublin; The National Gallery, London; The Nelson-Atkins Museum of Art, Kansas City, Missouri; Palacio Real, Madrid; Palazzo Pitti, Florence; Pinacoteca Capitolina, Rome; Pinacoteca Vaticana; Scala Istituto Fotografico Editoriale, S.p.A., Soprintendenza per I Beni Artistici e Storici di Firenze; Soprintendenza per I Beni Artistici e Storici di Roma; State Hermitage; Stiftung Preussische Schlösser und Gärten Berlin-Brandenburg/Bild Archiv; Vatican Museum; Wadsworth Atheneum, Hartford; Warburg Institute, London.

Index

Figures in *italics* refer to captions within the text; those in **bold** indicate colour plate numbers.

Accademia degli Insensati (Non-Sensual Academy), Rome, 65, 195, 201
Accademia degli Oziosi, Naples, 328
Accademia degli Umoristi, Rome, 195-6
Accademia dei Crescenzi, Rome, 229
Accademia dei Lincei, Rome, 115
Accademia della Valle di Blenio, Milan, 26
Accademia di San Luca, Rome, 49, 50, 54, 56, 74-5, 78, 96, 103, 228, 256, 317, 339
Accolti, Marcello, 82
Acquaviva, Cardinal Claudio, 128, 130, 262
Aeneas, 12
Agnolo [Velli], Padre, 243
Agostini, 79
Agucchi, Monsignor: *Theory of Art*, 292
Alban Hills, Rome, 42, 105, 109, 310, 315, 319, 324, 333
Albani, Francesco, 210, 279
Albenga, near Genoa, 102
Albergati, Fabio, 79; *Il Cardinale*, 43
Albergo della Scrofa, Rome, 285
Alberti, Cherubino, 59-60, 74, 76, 135-6, 194, 270, 278
Alberti, Durante, 74; *The Nativity*, 242
Alberti, Leon Battista: *On Painting*, 203-4
Alberti, Romano, 74
Albertini, Gaspare, 140-41
Aldato, Paolo, 310
Aldobrandini, Cinzio Passeri, Cardinal of St George, 96, 137
Aldobrandini, Giovan Francesco, 137
Aldobrandini, Olimpia, 150, 276, 277
Aldobrandini, Cardinal Pietro, 40, 41, 90, 99, 105, 107, 109, 128, 156, 160, 199, 205, 275, 276, 281, 290
Aldobrandini family, 43, 199, 207, 211, 275, 276
Aldrovandi, Ulisse, 82, 113
Aleccio, Mattheo Perez d', 345; *The Investment of Fort St Michael*, 341
Alessandri, Tommaso d': *Il Cavaliere Compito (A Knight's Duties)*, 143, 296

Allori, Cristofano: *Judith with the Head of Holofernes*, 200, 205
Altemps, Duke of, 134
Altieri, Cardinal, 128
Altieri family, 48
Amayden (Flemish writer), 93-5
Amayden, Theodore, 217
Ambrose, St, 372
Ambrosiana, Milan, 119
Amphion, 112
Andrea, Gio, 267, 269, 270
Andreini, Francesco: *Le Bravure del Capitano Spavento (The Brags of Captain Frightall of Hell Valley)*, 91
Andreini, Isabella, 87, 91
Anne, St, 306-7
Anno Santo, 154, 156
Antonine column, Rome, 34
Antwerp, 339
Apocrypha, 166
Apollo Belvedere, 51
Aquila, 163
Aquila and Prisca, house of, 181
Aragona, Tullio d', 211
Aratori, Giovan Giacomo (C's maternal grandfather), 19, 29
Aratori family, 12-13
Arcadelt, Jacques, 105, 111, 112; *Primo Libro*, 112
Arch of Constantine, Rome, 9, 33-4
Arch of Septimus Severus, Rome, 33
Arch of Titus, Rome, 9
Archconfraternity of St John the Beheaded, 159
Archconfraternity of Santa Maria dell' Orazione e Morte, 247
Archconfraternity of Santa Trinità dei Pellegrini, 240-41
Archilei, Vittoria, 128, 130
Arcimboldo, Giuseppe, 26, 27, 66
Aretino, Pietro, 79, 85; *Le Carte Parlanti*, 92
Argentini, Lorenzo, 134
Arion, 106, 107
Ariosto, Ludovico, 209; *Comedies*, 88
Aristotle, 143
Armenini, Giovanni Battista, 22
Arpino, Cavaliere d' *see* Cesari, Giuseppe
Arrigone, Cardinal, 346
Arrigoni, Pompeo, 304
Astorgio, Andrea, Baron of Rocchetta, 328
Augustine, St, 372
Augustinians, 180
Avellino, Sant'Andrea, 328

Bacchus, 26, 69, 70
Baglione, Giovanni, 57, 62, 65, 66, 76, 77, 78, 104, 109, 114, 115-16, 122-3, 135-6, 172, 182, 186, 197, 213, 214, 217, 230, 237, 240, 246, 252, 255, 257, 258, 262-73, 280-81, 297, 306, 311-12, 314-15, 317, 348, 360, 379; *Divine Love Overcoming the World, the Flesh and the Devil*, 258, 259, 260, 261, 271; *Lives of the Artists*, 4-5; *The Resurrection*, 259, 262, 265, 270
Bagnaia, 109
Baldinucci, Filippo, 277-8, 279
Banco di Santa Maria del Popolo, 327
Banco di Sant'Eligio, 326-7
Bande Nere, Giovanni delle, 20
Bann, Stephen: *The True Vine*, 6
Barbari, Jacopo de', 113
Barbary pirates, 364, 366
Barberini, Monsignor Maffeo *see* Urban VIII, Pope
Bardi, Conte Ainolfo di, 272
Bardi, Giovanni de, 106
Barefoot Carmelites, 224
Barnabites, 16
Barocci, Federico, 23, 54, 192, 370; *The Visitation*, 243
Baroncelli, Valerio, 90
Baronio, Cardinal Cesare, 48, 50, 109, 155, 156, 158, 162, 163, 181, 197, 242, 248, 290, 304, 307; *Annales Ecclesiastici*, 48-9, 107, 189, 224
Barry, Duc du, 353
Bartholi, Francisca, 303
Bartolomeo (C's servant), 266, 271
Bartolommeo (card player), 90
Bascapé, San Carlo, 18, 19
Bassano, Jacopo, 97
Bassano da Sutri, 205, 217
Bassano family, 23, 25, 192
Baths of Caracalla, Rome, 9
Baulduin, Noel, 125
Bellarmine, Roberto, 290, 307
Bellori, Giovan Pietro, 5, 14, 25, 29, 57, 68, 85, 87, 91, 93, 112, 148, 188, 193-4, 210, 211, 215, 232, 234, 240, 243-4, 252, 254-5, 308, 311, 314, 326, 333, 336, 342, 348, 352, 356-60, 379, 383, 388
Belvedere, Vatican, 195
Belvedere Torso, 211
Bembo, Pietro, 211
Benavente, Juan Alonso Pimentel Herrera, Conde de, 319, 323, 381, 386, 390
Benedictines, 321
Bentivoglio, Guido, 42, 48; *Memorie*, 40

Bergamo, 28
Berni, Francesco: *Capitolo del Gioco*, 89; *Commento alla Primiera*, 89
Bernini, Gian Lorenzo, 325; *Portrait Bust of Scipione Borghese*, 290, 291
Bernini, Pietro, 325
Bertacchi, Pellegrino, 311
Berti, Paolo, 205
Béthune, Philip de, 272, 289
Bianchini, Anna, 140, 149
Bizoni, Bernardo, 104
Black Friars, 334
Bloemart, Abraham, 125
Bodello, Carlo, 317
Boissy, Nicholas de Paris, 351
Bologna/Bolognese, 30, 228, 235, 269, 280
Bonino, Cesare: *Carlo helps and brings aid to the poor*, 17
Borghese, Camillo *see* Vicario, Cardinal
Borghese, Francesco, 346
Borghese, Cardinal Scipione, 209, 290-91, 291, 303, 306, 309, 314, 353, 381, 384, 388, 389, 390
Borghese family, 4, 42, 296
Borghese Gallery, Rome, 72, 116, 390
Borghese inventory (1634), 241
Borgianni, Orazio, 192, 252, 278, 280, 317
Borgo, Durante dal, 271
Borgo, Giovanni dal, 271
Borromeo, Anna, 48, 300
Borromeo, Cardinal Carlo, Archbishop of Milan, 11, 15-16, 18, 19, 20, 23, 29, 30, 48, 56, 126, 237, 247, 286, 337; *Instructiones fabricae et Supellectilis Ecclesiasticae*, 23; *Memoriale*, 31-2
Borromeo, Federico (d 1562), 15
Borromeo, Cardinal Federico, 48, 126, 290, 292; and the Accademia di San Luca, 49, 56, 96; and Breughel, 115; created Archbishop, 96; friendship with Del Monte, 102-3; on medieval traditions, 124; *De Pictura Sacra*, 250-51; *Le Laudi*, 116-17; *Musaeum*, 119; *Le Piaceri*, 116-18, 125
Borromeo family, 30, 55-6
Bosio, Antonio, 354
Bosio, Giacomo, 344, 353, 354; *Historia della Sacra religione di S Giovanni Gerosolimitano*, 354-5
Bosio, Giovanni Ottone, 353, 354
bravi, 91, 133
Brescia, 28, 185
Bresciano, Ludovico, 265
Breughel, Jan, 103, 115, 116, 119, 339; *Carafe of Flowers* (ascribed), 116; *Vase of Flowers*, 117, 119
Brie, Conte de, 353-4
Brill, Paul, 103, 115, 228
British Museum, London, 80
Brothers of Mercy, 161
Brothers of St John the Baptist, 161
Bruegel, Pieter, 103
Bruna, Prudenzia, 303

Bruno, Giordano, 41, 162, 163
Brunori, Prudenzia, 141
Butio, Hippolito, 139

Caccini, Giulio, 106-7, 108; *Le Nuove Musiche*, 106
Cagliari, Paolo *see* Veronese
Calabria, Viceroy of, 354
Calasanzio, Giuseppe, 300
Calvesi, Maurizio, 6
Calvetti, Olimpio, 160
Calvin, John, 155, 189
Calvin, Stephen, 163
Cambiaso, Luca, 192
Camillo de Lellis, St, 46
Campanella, Tommaso, 323, 330
Campani, Caterina (later Longhi), 213
Campi, Antonio: *The Agony in the Garden*, 23-4
Campi, Bernardino, 20
Campi family, 26
Campidoglio, Rome, 159
Campo Corbolini, Florence, 354, 355
Campo de' Fiori, Rome, 38, 159, 162
Campo Marzio, Rome, 38, 44, 54, 55, 61, 63, 138, 295, 297, 309, 312
Campo Vaccino (previously the Forum), Rome, 33
Canonici, Flavio, 139, 256
Cantalice, Fra Felice da, 46
Capaccio, Giulio Cesare, 320-21, 322-3, 334; *Il Forasterio*, 381
Capellario, Lorenzo, 139
Capello, Bianca, 81
Capitol, Rome, 9, 38, 41, 74
Capitoline Hill, Rome, 96
Capopardo, G. Grosso, ed.: *Memorie de' Pittori Messinesi*, 60
Capuchins, 3, 16, 46, 47, 224, 271, 364-5, 373, 375, 380
Caracciolo, Battistello, 338
Caracciolo, Giovanni Battista, 301, 325, 386
Carafa, Fra Vincenzo, Prior of Capua, 390
Caravaggio (town), 10, 11, 12, 13, 14, 19, 20, 28, 29, 30, 388, 391
Caravaggio, Giovan Battista, 153
Caravaggio, Michelangelo Merisi da: appearance, 5, 69, 131, 391; apprenticed to Peterzano, 21, 22, 24-5, 28, 268; arrested for carrying weapons, 138, 156, 229; arrives in Rome (1592), 33, 51; attack on Pasqualone, 299; attacked in Naples (1609), 382-3, 384, 385; attacks on fellow artists, 256-7; behaviour becomes more unbalanced, 365; birth (1571), 1, 10, 12, 388; in Cesari's studio, 65-8; creates a new Catholic art, 1, 6-7, 226; death (1610), 389-90; death sentence, 314, 326; defines a good artist, 268, 269; defrocked, 361-3, 364, 365, 390; Del Monte's role, 78; education, 20-21; epitaph, 391; escapes from a Maltese prison,

359-62, 365; the failure of the *Death of the Virgin* commission, 246-51, 277; fame spreads (1599), 179; feared by other painters, 254; flees from Rome (1606), 251, 310, 312, 314-16, 381; homosexuality allegation, 5, 6, 93, 220-21, 376; illness, 67-8, 77, 188, 196, 211, 256; imprisoned and loses paintings in Palo (1610), 388-9, 390; influences, 76; his inheritance, 29, 30, 55; isolation, 152, 153; kills Ranuccio Tomassoni (1606), 1, 309-12, 314, 316, 339, 353; knighthood in Malta, 314, 339, 342, 345, 352-6, 358-9, 380; libel trial (1603), 241, 264-73, 276; meets Orsi, 67; pardoned by the Governor of Rome, 302; pardoned by the Pope, 390; patronage, 4, 6, 7, 54, 95, 137, 191, 194, 229, 237, 300, 349, 380, 386; personality, 1, 136, 152, 326, 391; response to sudden stardom, 253, 277; street-fighting, 138, 152, 304; the Tribunal (1597), 131-2; and violence, 6, 29, 77, 209, 253, 277
style, 365; dark colouring, 5, 383; illusionism, 6, 118, 151, 188, 202, 204, 213, 232; imitations of, 258, 338; naturalism, 1, 5, 25, 77, 85, 146, 165, 173, 180, 193, 207, 209, 215, 228, 232, 234, 235, 243, 262, 265, 284, 291, 292, 293, 301, 332-3, 367, 391; union of naturalism with a deep awareness of tradition, 270; union of naturalism with idealism, 234
subjects, card players, 1; gypsies, 1; love and death, 216; martyrdom, 165; musicians, 1; the poor, 224-5; self-portraits, 7, 151, 178-9, 234, 235, 388; violent death, 165
techniques, bravura of C's technique, 358; chiaroscuro, 188; use of light and dark, 188-90; method of painting from posed models, 167-8; use of mirrors, 115, 122-3; refraction and reflection, 115-16
works, *The Adoration of the Shepherds*, 373, 374, 375, 378, 384; *The Adoration of the Shepherds with Saints Lawrence and Francis*, 377-9, 378; *The Annunciation*, 359; *Bacchus*, 10, 116, 145, 150-52, 232; *Basket of Fruit*, 12, 116-19, 232; *The Beheading of St John the Baptist*, 37, 356-9, 359, 362-3; *The Blessed Isidoro Agricola*, 273-4; *Boy with a Basket of Fruit*, 2, 68, 70-72; *Boy Bitten by a Lizard*, 11, 116, 201, 204; *Boy Peeling a Fruit*, 57, 58, 145, 195; *The Burial of St Lucy*, 38, 368-9; *The Calling of St Matthew*, 18, 145, 170, 174-6, 177, 240, 252, 253, 284; *The Cardsharps*, 5, 84, 85, 89-93, 104, 145, 174, 199; *Christ on the Mount of Olives*, 235, 236; *Circumcision*, 335, 386; *The Conversion of the Magdalene*, 122, 123,

146, 150; *The Conversion of St Paul*, **21**, 182, 183, 184-7; *The Conversion of Saul*, 5, 219; *The Crowning with Thorns*, 228, 235, 298; *The Crucifixion of St Andrew*, 383, 386, 387; *The Crucifixion of St Peter*, ii, **20**, 182, 187-8, 222, 281; *Danae*, 272; *David and Goliath*, 169-70, 169; *David with the Head of Goliath*, **41**, 383, 384-6, 388; *Death of St Joseph*, 67; *The Death of the Virgin*, **27**, 226-7, 229, 246, 248-51, 277, 317-18, 339; *Divine Love triumphing over Earthly Love*, 211, 213, 217, 271; *Doubting Thomas*, **23**, 230, 235-7; *Ecce Homo*, 228, 298; *The Ecstasy of St Francis*, 9, 123, 126-7, 145; *The Entombment of Christ*, **26**, 241-5, 246, 277; *The Flagellation of Christ*, **34**, 336-8; *The Gypsy Fortune Teller*, 3, 84-9, 93, 144-5, 174, 175, 242; *The Inspiration of St Matthew*, 238; *Judith and Holofernes*, **13**, 146, 166-8, 170, 200, 209, 363; *Jupiter, Neptune and Pluto*, 128, *128*; *The Lute Player*, **6**, 111-12, 113, 115-16, 201, 204, 218; *Madonna and Child with Saint Anne*, **29**, 304-9, 314; *Madonna della Misericordia*, 327-8; *The Madonna of Loreto*, **31**, 287, 289, 298, 306; *Madonna of the Rosary*, **33**, 333-5, 339; *The Martyrdom of St Matthew*, **19**, 170-71, 173-4, 176-9, 184, 200, 234, 257, 262, 299; *The Martyrdom of St Ursula*, **42**, 324, 383, 386-8; *Mary Magdalene*, **7** , 146-50, 359; *Mary Magdalene* (untraced), 235, 390; *Medusa*, **14**, 119-22, 199, 200, 201; *The Musicians*, **4**, 109-11, 113, 144, 145; *Narcissus*, **17**, 202-3, 204; *Portrait of Alof de Wignacourt*, 348, 349, 350, 351; *Portrait of Fillide*, 145, 147; *Portrait of Giovan Battista Marino* (attrib.), 193, 194, 198, 205; *Portrait of a Knight of Malta; Fra Antonio Martelli*, **35**, 348, 351-2; *Portrait of Maffeo Barberini*, 205; *The Rest on the Flight into Egypt*, **8**, 123-6, 146, 271, 295; *The Resurrection of Lazarus*, **39**, 370-73, 375; *Resurrection* (untraced), 386; *The Sacrifice of Isaac*, 219; *St Augustine* (untraced), 235; *St Catherine of Alexandria*, 145, 146, 164, 165-6, 170; *St Francis in Meditation*, 292, 294; *St Francis* (untraced), 386; *St Jerome*, 348, 351, 359; *St Jerome* (untraced), 235; *St Jerome in his Study*, 292, 293, 303; *St Jerome Writing*, **36**, 375; *St John the Baptist*, **15**, 213, 214, 219, 225, 230, 281-2, 292-3, 295, 388, 390; *St John* (untraced), 386, 390, 391; *St Mary Magdalene*, 315, *315*, 316, 324; *St Matthew and the Angel*, **25**, 219, 237-40, 277; *Salome with the Head of St John the Baptist*, **40**, 383-4, 391; *The Seven Acts of Mercy*, **32**, 327-33, 333, 335-6; *The Sick Bacchus*, **1**, 68, 69-70; *Sleeping Cupid*, 213, 355; *The Supper at Emmaus*, **22**, **30**, 72-3, 219, 225, 230-33, 234, 295, 316-17; *Susanna*, 205; *The Taking of Christ*, **24**, 230, 233-5, 257, 388; *Victorious Cupid*, **16**, 213-20, 218, 230, 237, 258, 271

Caravaggio, Polidoro da, 14, 39, 51, 194, 259, 380; *The Adoration of the Shepherds*, 370

Cardinalate, 42

Carità, Naples, 324, 325

Carmelites, 250, 367

Carracci, Agostino, 207, 209

Carracci, Annibale, 75, 84, 180, 186, 207-11, 213, 214, 215, 217, 218, 227, 253, 255, 267-70, 279, 284, 292, 294-5, 296, 300, 304; *The Assumption of the Virgin*, 180, 185; *A Hanging*, 161; *Picture Seller*, 54; *St Margaret*, ?10; *Samson and Delilah*, 200; *Self Portrait*, 208, *208*

Carracci, Ludovico, 192, 284

Carracci family, 30, 205

Casa Borromeo, Milan, 89

Casa Grande, via dei Giubonnari, Rome, 195

Casa Milesi, Rome, 194

Casa Pia, 149, 247, 248, 249

Cassar, Paolo, 347

Castel Nuovo, Naples, 319

Castel Sant' Angelo, Malta, 137, 256, 309, 360, 361, 363

Castel Sant'Elmo, Naples, 319

Castellini, Giovanni Zaratini, 196, 308

Castello, Bernardo: *Narcissus*, 203, 204

Castello Sforzesco, Milan, 14

Castiglione, Baldassare, 105, 142; *The Book of the Courtier*, 79, 217

Castro, Giacomo di, 338

Catacomb of Priscilla, Rome, 157

Catalano l'Antico, 370, 375, 376

Catholic Reformation, 224, 245

Catholicism: and C's religious art, 1; and the dissent of northern Europe, 15; dreams of crusade, 2; revived, 2-3, 34; Rome as the centre of, 34, 50

Cavalieri, Emilio de', 81, 82-3, 97, 107, 109, 128; *Blind Man's Buff (Il Gioco della Cieca*, 107; *Rappresentazione di Anima e di Corpo*, 176

Cavalieri, Tommaso de', 65, 81

Cavalletti, Ermete, 285

Cecilia, St, 157, 162

Celio, Gaspare, 280

Cellini, Benvenuto: *Perseus with the head of Medusa*, 121

Cenci, Beatrice, 160, 161-2, 205

Cenci, Francesco, 160, 161

Cenci, Giacomo, 160, 161

Cenci, Lucrezia, 160, 161

Cenci affair, 159-62, 168

Cerasi, Tiberio, 179, 180, 182, 185, 186, 213

Cerasi chapel, Santa Maria del Popolo church, 179, 180, 185, 186, 188, 207, 213, 222, 229, 230, 232, 246, 281

Cervantes Saavedra, Miguel de, 382

Cervini, Gregorio, 239

Cesari, Bernardino, 65, 67, 68, 324

Cesari, Giuseppe (Cavaliere d'Arpino), 61, 63-8, *64*, 74, 76, 77, 85, 115, 122-3, 132, 136, 143, 156, 158, 172, 173, 195, 196, 207, 209, 241, 267, 268, 270, 271, 278, 280, 281, 291, 295, 296, 324, 342; *David Killing Goliath*, 200; *Jael and Sisera*, 200; *Triumph of Constantine*, 209

Cesari, Muzio, 63

Cesi, Federico, 97, 115

Cesi, Guidobaldo, 97

Chapel of the Most Holy Rosary, San Domenico, Naples, 334

Charles V, Holy Roman Emperor and King of Spain, 1, 2

Cherubini, Laerzio, 226, 229, 246-8, 251, 317

Chiaia, Naples, 324, 381, 388, 390, 391

Chiesa Nuova, Rome, 105, 176, 241, 317

Chios island, 99

Christianity: martyrdom, 157, 158, 159, 358, 368; medieval, 3; renewed, 34; St Peter and, 181; *see also* Church, the

Christine of Lorraine, 81, 87, 107

Chrysostom, St John, 117, 176, 225, 239, 250, 375

Church, the, 16, 35, 39, 48, 49, 125, 156-9, 166, 167, 181, 189, 223, 225-6, 248, 289, 351, 381

Ciamberlano, Ludovico: 'He saw the faces of St Carlo and St Ignatius glow', 45

Cigoli, Ludovico, 278-9, 305

classicism, 50, 285, 291

Clement VII, Pope, 1

Clement VIII, Pope, 2, 40, 41, 43, 47-8, 49, 64, 98, 106, 134, 135, 143, 144, 154, 156, 159-63, 172, 179, 180, 198, 211, 247, 275, 276, 278, 286, 289-92, 304, 305

Co-Cathedral of St John, Valletta: Italian chapel, 359; Oratory, 348, 356, 357, 362-3, *362*

Cobaert, Jacques, 171-2; *St Matthew and the Angel*, 237

Cobergher, Wensel, 325

Cointrel, Matthieu *see* Contarelli, Matteo

Collegio Romano, Rome, 21

Colleoni, Bartolomeo, 20

Colonna, Anna (née Borromeo), 11

Colonna, Antonio, 334

Colonna, Cardinal Ascanio, Bishop of Palestrina, 55, 163, 316, 346

Colonna, Contestabile, 90

Colonna, Costanza, Marchesa di Caravaggio, 10, 12, 28, 51, 55, 163-4, 300, 316, 324, 346, 381, 388, 390

Colonna, Fabio, 113

Colonna, Fabrizio Sforza, 11, 300, 345, 346, 347, 349

Colonna, Filippo, Prince of Paliano, 316

Colonna, Don Francesco, 315
Colonna, Isabella (née Gonzaga), 324
Colonna, Luigi Carafa, Prince of Stigliano, 324, 328, 334, 336
Colonna, Marcantonio, 9, 10-11, 223, 333, 334, 342, 364
Colonna, Don Marzio, 314, 315, 333
Colonna, Don Maurizio, 324, 335
Colonna, Donna Orinzia, 333-4
Colonna, Orsina Peretti Damasceni, Principessa, 163
Colonna, Vittoria, 56
Colonna family, 4, 28, 30, 48, 56, 300, 316, 323, 324, 333, 345, 388
Colosseum, Rome, 105
Comanini, Gregorio, 27, 28; *Il Figino* , 27; 'On the Painting of Certain Very Naturalistic Peaches', 32, 72
Commedia dell'Arte, 86-7, 88
Compagnia di San Francesco d'Assisi, 377
Conca, Matteo di Capua, Prince of, 197, 198, 339
Conclave of 1605, The, 297
confraternities of the Rosary, 10
Confraternity della Misericordia Oratory, Conscente, 281
Confraternity of the Pio Monte della Misericordia, 336
Confraternity of San Sebastiano, 389, 391
Confraternity of Santa Trinità dei Pellegrini, 285, 289
Congregation of Lombardy, 180
Congregation of the Oratory/ Oratorians, 3, 46, 47, 48, 49, 62, 102, 104, 114, 126, 127, 176, 224, 225, 242, 243, 321, 332, 354
Congregazione della Reveranda Fabbrica di San Pietro, 304, 305
Constantine basilica, Rome, 304
Contarelli, Francesco, 237, 241
Contarelli, Matteo (Matthieu Cointrel), 170, 172, 173, 174, 177, 178, 237
Contarelli chapel, San Luigi dei Francesi church, Rome, 68, 170, 171, 172, 178, 188, 193, 202, 232, 237, 252, 254-7
Contarini, Tommaso, 81
Convertite, Rome, 141, 149
Corbario, Leonetto, 347
Cordier, Nicolas, 98
Corenzio, Belisario, 324
Corfu, 12
Cornetto, Cavaliere Luigi del, 110
Correggio, Antonio de, 23
Corso dei Servi (now Corso Vittorio Emanuele), Milan, 13
Cosimo II of Tuscany, 135
Cospi: *Il Giudice Criminalista*, 92
Costa, Alessandro, 349
Costa, Ottavio, 102, 166, 232, 281, 282, 292, 314, 317, 349
Costa family, 281, 300
Council of Trent (1545), 3, 15, 23, 142, 189

Counter-Reformation, 1, 7, 20, 21, 23, 26, 52, 126, 328
courtly love, 142
Cremona, 28
Crescenzi, Abate Giacomo, 172, 237
Crescenzi, Crescenzio, 194, 201
Crescenzi, Francesco, 194
Crescenzi, Giovanni Battista, 102, 114
Crescenzi, Melchiorre, 137, 193-4, 199
Crescenzi, Virgilio, 134, 172
Crescenzi family, 63, 105, 134, 172, 194, 199, 229, 237
Crispolti, Cesare, 194
Croatia, 136
Croys, Loise, 325
Cumandeo, 370
Cupid, 214
Cupid with a Bow, 97, 215
Curbiello (a bandit), 137
Cusano, Cardinal, 48, 288-9

Damiano, Signor, 387
Del Monte, Cardinal Francesco Maria, 104, 105, 123, 154, 162, 230, 253, 272, 273, 275, 279, 298, 302, 304, 305, 315, 365; accompanies the Pope, 156; acquires Villa Ludovisi, 127-8; and alchemy, 113, 121-2, 128; Amayden and, 93-5; association with the Works of St Peter's, 172; Cardinal Ferdinando de' Medici's adviser, 80, 81; circle of friends, 97-8, 126, 130; collections, 82, 96-7, 103, 108, 112-13, 232, 258; C's patron, 54, 95, 132, 229, 293, 303; director of the Accademia di San Luca, 96; early life, 78-80; and Federico Morromeo, 102-3; on Henry IV, 155; importance to C, 78; life in the Palazzo Madama, 82-3; love of music, 106-9, 110; loyalty to C, 277; and the Mattei, 228; Napoletano and, 325; owns paintings by C, 211, 213, 217; personality, 83-4; rise to eminence, 80, 81-2; and St Catherine of Alexandria, 165; and science, 82, 97, 102, 113-14, 119
Del Monte, Guidobaldo, 79, 82; *Perspectivae*, 113-14
Del Monte, Ranieri, 79
Della Carnacia, Pietro, 276
Della Porta, Giovanni Battista: *Natural Magic*, 123; *La Turca*, 170
della Valle, Federico: *Judith*, 168; *The Queen of Scotland*, 168
della Vecchia, Isabella, 298
della Vecchia, Laura, 298
Della Rovere family, 79
dell'Antella, Francesco, 353, 354-5, 363; *Valletta*, 343 354-5
Demetrios, 292
Deti, Cardinal, 107
Diocletian, Emperor, 368

Dionisi, Giuseppe, 298
Dionysio (card player), 90
Discalced Carmelites, 247-8, 250
Dolce, Lodovico, 52
Domenichino, 253, 279, 292
Dominicans, 321, 334
Dominici, Bernardo de, 325, 326, 338
Donesana, Vincenzo, 380
Donnalbina monastery, Naples, 325
Doria, Agostino, 301
Doria, Gian Carlo, 301
Doria, Cardinal Giannettino, 377, 380
Doria, Admiral Gio Andrea, 300, 348
Doria, Giovanna (née Colonna), 300
Doria, Marcantonio, 301, 381, 386, 388
Doria, Principe, 302
Doria family, 4, 102, 300, 301, 349, 377, 380, 386, 388
Dürer, Albrecht, 235

Ear of Dionysius, Syracuse, 367-8
eastern Europe, 2, 136
Edict of Cardinal Rusticucci, 40, 275
Elsheimer, Adam, 114, 252-3, 269
Emilia Romagna, 207
Equicola, Mario, 211
Eritreo, Giano Nicio: *Pinacotheca imaginum illustrium*, 196
Errico, Teodoro d', 325
Esquiline Hill, Rome, 34
Este family, 2, 4

Faber, Johann, 41, 97, 114
Fabriano, Gilio da, 52
Fanucci, Camillo, 44
Farinacci, Prospero, 161, 205, 313
Farnese, Cardinal Alessandro, 42, 103, 163, 205, 209, 300
Farnese, Octavio, Duke of Parma, 137
Farnese, Cardinal Odoardo, 43, 207, 275-6, 279
Farnese, Ottavio, 90
Farnese Dukes, 2
Farnese family, 43, 48, 98, 137, 275, 304, 310
Farnese Gallery, Rome, 207, 208, 210, 213, 279
Farnese Hercules, 211
Fathers of the Madonna della Consolazione, 185, 186
Fazello: *De Rebus Siculis*, 377
Felicità, St, 157
Fermo, Saint, 14
Fernandez de Castro, Don Pedro, 390-91
Ferrara, 2, 156, 255
Ferrara, Duke of, 108
Ficino, Marsilio, 211
Figino, Ambrogio, 27; *The Madonna of the Serpent*, 24, 306; *Still Life with Peaches*, 28, 32, 72
Finson, Louis, 324, 325, 338, 339
Flanders, 80, 136, 137

Index

Flemish art, 103, 338
Flemish, in Rome, 55
Florence, 62, 199; Carnival, 107; and Medusa, 121
Florentine Camerata, 106
Foligno, 163
Fontana, Lavinia: *Herodias with the Head of John the Baptist* , 200
Fort St Angelo, Malta, 341
Fort St Elmo, Malta, 341
Fosdinova, Lunigiana, 349
Fossa di Sant'Elmo, Naples, 323
France: civil war, 2; 'devastation' in, 154; fights for dominance in Italy, 1; peace with Spain (1598), 136, 171; riot between French and Spanish factions (Rome, 1605), 297; settlement with Spain (1559), 2; struggle for political domination over the Papacy, 39
Francesco (C's pupil or servant), 220, 293
Franchis, Lorenzo de, 336
Franchis, Tommaso de, 336, 337
Franchis, Vincenzo de, 336
Franchis, de family, 336
Francis, St, 16, 126, 127, 271, 377, 379
Francis Xavier, St, 158
Franciscans, 47, 124, 158, 373
Franco-Spanish war, 156
François, Prince of Lorraine, 359
Frascati, 109, 185, 199
Frederick II, Emperor, 366
Friedlaender, Walter: *Caravaggio Studies*, 5

Gabrielli, Ottaviano, 276
Galilei, Vincenzo: *Dialogue on Ancient and Modern Music*, 106, 112
Galileo Galilei, 82, 97, 106, 113, 278
Galiti, Nunzio: *Milan in the Plague*, 31, *31*
Galleria Borghese, Rome *see* Borghese Gallery, Rome
Gallio, Cardinal Tolomeo, 247
Garegnano, 24
Genoa, 2, 104, 163, 164, 299, 301, 346, 349, 386, 388
Gentile, Deodato, Bishop of Caserta, 390
Gentileschi, Artemisia, 161, 168
Gentileschi, Orazio, 76, 135, 152, 161, 252, 259, 301; Baglione's libel suit, 264-8, 270, 271-2; *St Michael the Archangel*, 258
Gentili, Ottavio, 339
Germany, 154
Gesù church, Rome, 259, 265
Giacomo, Nicolò di, 376
Giancarli, Giglio Artemio: *The Gypsy*, 87
Gibbon, Edward, 344
Gigli, Giulio Cesare, 391
Gilbert, Creighton: *Caravaggio and His Two Cardinals*, 6
Giogoli brothers, 310
Giorgione, 23, 30, 71, 73, 97, 109,

165, 173, 255; *David Meditating on the Head of Goliath*, 385; *Soldier and Woman Carrying a Flute* (previously ascribed to), 97
Giovanni, Vincenzo di, 377
'Giovanni Battista', 265-6, 271, 273
Gismondo, 267
Giugoli, Giovan Federico, 310, 314, 381
Giugoli, Ignazio, 137, 310, 314, 381
Giustiniani, Cardinal Benedetto, 99-102, *100*, 104, 140, 156, 181, 205, 226, 235, 247, 259, 304, 305, 345
Giustiniani, Gerolama, 99, 101, *101*
Giustiniani, Geronima, 146, 167
Giustiniani, Giorgio, 99, 102
Giustiniani, Giuseppe, 99, 100, 101, 102
Giustiniani, Marc'Aurelio, 345
Giustiniani, Orazio, 345
Giustiniani, Pietro, 341
Giustiniani, Vincenzo, 61, 62-3, 76, 99-104, *99*, 107, 110, 111, 116, 145, 180, 191-2, 204, 213, 216-17, 218, 221, 228, 229, 230, 232, 234, 237, 240, 246, 251, 253, 269, 310, 326; *Discorso sopra la Musica*, 108; *La Galleria Giustiniani*, 100; *Letter on Painting*, 192, 217-18
Giustiniani, Cardinal Vincenzo, 99, 100, 102
Giustiniani family, 99-102, 131, 204, 205, 228, 229, 246, 300, 380
Giustizia, Cavaliere of, 360, 361
Gli Inquieta Academy, Milan, 28
Golden Age, 105, 107, 112
Golden Legend, The, 3, 49, 147, 149, 165, 174, 248, 368
Gondi di Giogny, Filippo, 359
Gonzaga, Cardinal Ferdinando, Prince of Molfetta, 336, 359, 388
Gonzaga, Margherita, 359
Gonzaga, Vincenzo, 253
Gonzaga, Duke Vincenzo I, 339
Gonzaga court, Mantua, 253
Gonzaga family, 2, 4, 388
Grammatica, Antiveduto, 58-62, 113, 197, 252, 258
Granada, Luis de, 127, 233, 245, 333, 334, 337; *Brief Memorial and Guide to the Duties of a Christian*, 16
Graziano, Antonio Maria, 34
Great Siege of Malta, 340, 341, 342, 344, 345, 348, 349, 357
Greco-Roman reliefs, 245
Gregory, St, 158
Gregory XIII, Pope, 44, 64, 98, 242
Gregory of Nyssa, 43
Griettano, Antonio, 65
Gualdo, Francesco, 194, 196, 197
Gualdo, Paolo, 197
Gualfreducci, Onofrio, 108, 109
Guarini, Battista, 97, 105; *Il Pastor Fido*, 107
Guevara, Fra Don Hieronymous de, 361-2
Gunn, Thom: 'In Santa Maria del Popol', 5-6

gypsies, 86-8

Henry II of Lorraine, 359
Henry IV of Navarre, 2, 39, 40, 154-5, 171, 289
Hermes Trismegistus, 113
Hermitage, St Petersburg, 115
Hibbard, Howard: *Caravaggio*, 5, 6
High Renaissance, 180, 336
history painting, 173, 254, 269
Holbein, Hans: *The Dance of Death* series, 89; *The Gamblers*, 89
Holy League, 9, 10
Holy Shroud of Turin, 245-6
Honthorst, Gerrit van, 113, 192
Horace, 70, 150
Hospital for the Incurables, Naples, 327
Hungary, 2, 136, 137

icastic art, 27
Ignatius, St, 158
illusionism, 6, 27, 32, 69, 118, 151, 188, 193, 202, 203, 204, 213, 232
Imitation of Christ, 3, 47, 158
Immaculate Conception, 306
Imperia, 146
Inn at Velletri, The (a comedy), 93
Inquisition, 347
Isabella d'Este, 133
Isola dei Mattei, Rome, 227
Italy: France and Spain fight for dominance in, 1; northern, 4, 25, 80, 103, 111; rises to new eminence, 1

Jerome, St, 16, 48, 150, 167, 225
Jesuits, 3, 16, 21, 46, 104, 153, 157, 158, 321
Jews, 163
John of Austria, Don,, 18
Juan, Don, 333
Julius II, Pope, 3

Kingdom of the Two Sicilies, 319
Knights of the Order of St John, 340-49, 351-5, 357, 361, 362, 363, 370, 371, 379, 390
Künsthistorisches Museum, Vienna, 385

Laer, Sigismondo, 192, 205, 269, 270
Lafréry, Antoine: *The Seven Churches of Rome*, 287-8, *288*
Lancry de Bains, Cavalier Henrico de, 354
Landini, Tommaso: *Fountain of the Tortoises*, 227
landscape, as a novel form of art, 66
Lanfranco, Giovanni, 102
Laokoön, 51, 209
Late Mannerism, 20
Laureti, Tommaso: *The Triumph of Religion*, 33, 35
Lauri, Giovanni Battista: 'Of the Boy and the Scorpion', 201-2
Lawrence, St, 40, 377

Lazzari, Giovanni Battista de', 370-71

Lazzari family, 376

Le Blanc, Horace, 256

Lellis, Camillo de, 90, 223

Lena, 298-9

Leo I, Pope, 246

Leo X, Pope, 3

Leo XI, Pope, 289, 290

Leonardo da Vinci, 25-6, 121-2, 161, 307; followers of, 21, 97; *The Last Supper*, 26; *Medusa*, 121; *The Virgin of the Rocks*, 26

Leone, Ludovico, 80, 98

Leone, Ottavio, 80, 98, 265, 270; *Group Portrait of Artists, including Sigismondo Laer and Ottavio Leone*, 268; *Portrait of Caravaggio*, xii, 98; *Portrait of the Cavaliere d'Arpino*, 64; *Portrait of Giovanni Baglione*, 262

Lepanto, 9, 10, 18, 319, 333, 334, 335, 341, 342, 348, 361, 364

Licinio, Bernardino, 97

Ligozzi, Jacopo, 82, 113; *Two African Vipers*, 122

Loarte, Gaspare de, 333; *Advice to Pilgrims*, 331

Lodi, 28

Lomazzo, Gian Paolo, 23, 26, 27, 151, 161; *Rabisch*, 21-2; *Trattato*, 26

Lombards: Lombard artists type-cast, 67; in Rome, 55, 134, 194

Lombardy, 4, 14, 20, 23, 25, 28, 71

Lomellini, Francesco, 352

London, Bishop of, 100

Longhi, Antonio, 134

Longhi, Decio, 133, 134, 196

Longhi, Martino, 133

Longhi, Onorio, 179, 188, 196, 201, 220, 257, 276, 297, 381; accused of breaches of the peace, 138-9; as an architect, 133, 134; the attack on Tullio, 256; Baglione's libel suit, 264, 265, 266, 270, 272-3; commissions portraits of himself, 213; C's close association with, 133; death, 135; exiled, 314; house arrest for attacking Baglione and Salini, 272-3; marries, 213; pardoned, 391; personality, 134-5; and Ranuccio Tomassoni, 138, 139, 309, 312, 313; street-fighting with C, 138, 152, 309; takes refuge in Milan, 310; as a troublemaker, 133, 254

Longhi, Roberto, 5, 74

Loreto, 272, 273, 280-81, 285-8

Lotto, Lorenzo, 124

Loyola, Saint Ignatius, 189; *Spiritual Exercises*, 189

Luca (Roman barber), 131, 132

Lucia, St (St Lucy), 157, 368

Ludovisi family, 42

Luke, St, 75

Luther, Martin, 2, 3, 189, 223, 286, 333

Maderno, Stefano, 162

Madonna of Caravaggio sanctuary, 20, 286

Madonna del Pilero church, Messina, 372

Madonna della Misericordia, 287, 332

Madonna of Loreto, 272, 273, 285-8

Madonna of Mercy, 323

Madonna of the Pilgrims, 285

Madonna of Purgatory, 323, 332

Madonna of the Rosary, 10, 323, 333

madrigals, 105, 106, 111, 194, 201, 216, 219, 354

Magdeburg Centuries, 48-9

Maggi, Giovanni, 266

Magno, Giovanni, 317-18

Malanno, Corporal, 277

Malaspina, Ippolito, 348-9, 351

Malta, 7, 314, 338, 339, 340-63, 365, 375, 383

Malvasia, Cesare, 175, 197, 208-9, 229, 253, 269, 279-80, 292

Mamertine prison, Rome, 181

Mancini, Giulio, 4, 5, 29-30, 41, 57, 67, 68, 77, 78, 97, 111, 123, 153, 182, 188, 192, 196, 197, 211, 213, 220, 250, 251, 258, 312, 314, 317, 379, 382, 383

Manfredi, Bartolomeo, 253; *Mars Chastising Cupid*, 212, 213

'maniera statuina', 51, 85

Mannerism, 51, 52, 62, 64, 76

Manso, Giovanni Battista, Marchese di Villa, 328, 332

Mantua, 302, 339

Mantua, Duke of, 108, 317

Manzoni, Alessandro: *I Promessi Sposi*, 29

Marchese, Fra Giacomo di, 347

Marchese, Signor, 104

Marcus Aurelius column, Rome, 181

Marino, Giambattista, 70, 105, 192, 193-4, 197-205, 233, 257, 284, 324, 328, 385-6, 391; *Adone*, 216; 'La Bella Bocca', 201; *La Galeria*, 200, 203, 205; 'Murtoleide', 191; 'Painting, or the Holy Shroud', 246; *Rime*, 199; *Salamacis and Hermaphrodite*, 217

Martelli, Fra Antonio, 348, 349

Martin, Gregory, 104, 140, 144, 149, 223; *Roma Sancta*, 35

Martin, St, 331

Martinelli, Pietro Paolo, 276

Mary Magdalene, St, 40

Masetti, Fabio, 299-304, 311, 312, 315

Masetti, Ulisse, 140

Massa, Lanfranco, 386, 387

Massimi, Fabrizio de', 242

Massimi, Massimo, 228-9, 298

Massimi family, 48, 226

Mastelletta, Il (Giovanni Andrea Donducci), 269, 270

Master of Hartford, The: *Fruits and Flowers in Two Carafes*, 72-3, 73; *Still Life with Fruit, Flowers and Vegetables*, 72; *Still Life with Game Birds*, 72

Matham, Theodor Dirck: *Portrait of Gerolama Giustiniani*, 101, 101

Mattei, Antonio, 141

Mattei, Asdrubale, 74, 78, 226, 228, 229, 230

Mattei, Ciriaco, 191, 213, 226, 228, 229, 230, 234, 235, 241, 253, 281, 316, 326

Mattei, Giovanni Battista, 230

Mattei, Cardinal Girolamo, 226, 227, 228, 301

Mattei family, 42, 226, 228, 237, 296, 301

Matthew, St, 170

Mauruzi, Lancillotto, 273

Mausoleum of Augustus, Rome, 132, 139

Maxentius, Emperor, 165

Maximus, Valerius, 332; *Of the Piety of a Daughter towards her father*, 330

Medici, Cardinal Alessandro de, 181

Medici, Duke Cosimo, 121

Medici, Grand Duke Cosimo I, 80

Medici, Grand Duke Ferdinando I de', 87, 93, 96, 122, 135, 191, 275, 279; arrives in Rome (1569), 42; buys the Villa Medici, 80; C declares his loyalty, 94; collections, 57, 82, 88, 97; as a gamester, 90; marriage, 81; Martelli serves, 349; and music, 106-9; patronage of Del Monte, 80, 81-2; personality, 80-81; on Rome, 48; and science, 113, 119

Medici, Francesco de', 113

Medici, Grand Duke Francesco I, 81

Medici ambassadors, 38

Medici court, 81, 82

Medici family, 4, 20, 96, 104

Medici Grand Dukes, 2

Meditations on the Life of Christ, 47, 124, 223, 373, 379

Medusa, 120-22

Mei, Girolamo, 97

Melandroni, Cinzia, 140

Melandroni, Enea de', 140

Melandroni, Fillide, 136, 140-46, 149, 152, 166, 167, 196, 313, 391

Melandroni, Silvio, 140, 142

Mellan, Claude: *Portrait of Vincenzo Giustiniani*, 99, 101

Merisi, Bernardino (C's paternal grandfather), 12, 19, 30

Merisi, Caterina (C's aunt), 12

Merisi, Caterina (C's half-sister), 12, 14

Merisi, Caterina (C's sister), 14, 29

Merisi, Fermo (C's father), 10, 12, 19, 30

Merisi, Francesco (C's uncle), 12, 19, 29

Merisi, Giacomo (C's uncle), 12

Merisi, Giovan Battista (C's brother), 14, 19, 21, 29, 153

Merisi, Giovanni Pietro (C's brother), 19

Merisi, Lucia (née Aratori; Fermo's

second wife and C's mother),
12-13, 19, 29, 30
Merisi, Ludovico (C's uncle), 12,
28, 29, 55, 56
Merisi, Maddalena (née Vacchi;
Fermo's first wife), 12
Merisi, Margarita (C's half-sister),
12, 19
Merisi, Pietro (C's uncle), 12, 19, 30
Merisio, Bartolomeo (C's uncle),
20
Messina, Antonello da, 370
Messina, Sicily, 364, 365, 367, 369-
73, 370, 375, 376, 379, 380
Michelangelo Buonarroti, 3-4, 51,
56, 67, 74, 76, 81, 97, 175, 184,
187, 207, 210, 211, 214, 215, 226,
258; The Last Judgement, 3, 51-2, 179
Middle Ages, 44, 19, 223, 226
Milan: Carlo Borromeo on, 31-2;
cathedral, 14, 19, 23; Jubilee
(1576), 18; lively literary culture,
28; Longhi takes refuge, 310; lux-
ury v poverty, 14-15; 'Mostra del
Caravaggio e dei Caravaggeschi'
exhibition (1951), 5; plague, 18-19,
31; as a Spanish dominion, 14; as
a violent city, 29
Milesi, Giovanni, 196
Milesi, Marzio, 146, 194, 215, 252,
257-8, 308, 391; 'La Pittura', 194,
257
Minerva, church of the, Rome, 272
Minniti, Mario, 98, 145, 151, 175,
219, 220, 265, 271, 365; deserts C,
153; engraving of the artist, 60,
145; friendship with C, 60-61, 145;
involved in brawls, 136; in Sicily,
366-7, 369; as a successful artist,
366, 367; Assumption of the Virgin,
367; The Raising of the Widow of
Naim, 375
Mirabella, Vincenzo, 367-8;
Dichiarazione della pianta dell'antiche
Siracuse, 367
Modena, 2, 300, 311
Modena, Cesare d'Este, Duke of,
299-300, 302, 310
Molina, Antonio de, 235
Montaigne, Michel Eyquem de, 33,
38, 136, 140
Montalto, Cardinal Alessandro, 64,
90, 98-9, 105, 107, 108, 112, 113,
191, 253, 290, 346
Mont'alto, Gio Battista, 347
Montalto family, 42
Monte, Cardinal del, 4
Monte Caprino, Rome, 33
Monte della Misericordia, 327, 328
Montefeltro, Guidobaldo da, 79
Monteleone, Adriano, 258
Montoya, Pedro de, 108-9, 112
Mora, Domenico: Il Cavaliere, 143
Moretto da Brescia, 28, 379
Morigi, Paolo, 14, 28
Mount La Verna, Tuscany, 126
Murtola, Gaspare, 88, 120, 194, 195,
201, 216, 219; Rime, 111
Museo Diocesano, Albenga, 281

music, 104-13
Musso, Cornelio, 149
Muziano, Girolamo, 171; Ascension,
242

Nancy museum, 359
Naples, 2, 7, 301, 319-39, 321, 340,
346, 379, 381-3, 386, 388, 390
Napoletano, Filippo, 325
Natalis, Michael: Portrait of Cardinal
Benedetto Giustiniani, 100, 100
National Gallery, London, 391
Navagero, Andrea, 120-21
Nazianus, Gregory of: On the Love
for the Poor, 16
Neapolitan painting, 301
Negrone, Padre, 16
Neri, Filippo, 46-7, 48, 80, 86, 96,
105, 127, 150, 163, 181, 224, 225,
239, 240, 242, 282, 289, 355
Neri, Nero, 106
Nero, Emperor, 56
Nicoletto, Andrea, 195
northern Europe, 4, 15, 38, 51, 57,
63, 124, 176, 252
Nuremberg, 104

Odescalchi collection, Rome, 182
Olgiati chapel, Santa Prassede,
Rome, 68
Oratorians see Congregation of the
Oratory
Oratory of St Lawrence, Palermo,
377, 380
Oratory of San Bernardino,
Caravaggio, 14
Orlandi, Cristofero, 61, 62
Orpheus, 106, 112
Orsi, Aurelio, 77, 195
Orsi, Carlotta, 78
Orsi, Prospero, 75, 78, 93, 195, 230,
267, 270; C meets, 67; as C's
agent, 226, 229, 258; encourages
C to risk independence, 77; and
the Tribunal (1597), 131-2; turns
against Cesari, 77
Orsini, Fulvio, 98
Orsini, Don Verginio, 90
Ortaccio, Rome, 139-40
Ospedale della Consolazione,
Rome, 180, 186
Ospizio Sistina, Rome, 39
Ostaria dell' Orso, Rome, 38
Osterhausen, C. von: The Oratory of
St John, 362
Osteria del Cerriglio, Naples, 325,
382, 384, 385
Ottoman Empire, 340
Ovid, 216; Amores, 218-19;
Metamorphoses, 202, 203, 215

Padri Crociferi church, Messina,
371, 372
Padua, 79, 80
Paladino, Filippo, 375-6; St Francis
Receiving the Stigmata, 375
Palafrenieri, 305-6, 313-14
Palatine Anthology, 193
Palazzo Avogardo, Rome, 113

Palazzo Cellamare, Chiaia, Naples,
324, 381, 388
Palazzo Cenci, Rome, 160
Palazzo Colonna, Naples, 315, 324
Palazzo Colonna, Rome, 56, 164
Palazzo Crescenzi, Rome, 102, 199
Palazzo del Campidoglio, Rome,
205
Palazzo del Comune, Caravaggio,
20
Palazzo del Quirinale, Rome, 303
Palazzo della Cancelleria, Rome, 98
Palazzo Farnese, Rome, 207, 209,
210-11, 215, 275, 295
Palazzo Firenze, Rome, 38, 295,
309, 311
Palazzo Giustiani, Rome, 99, 101-2,
170, 205, 217, 220, 310
Palazzo Giustiniani alle Coppelle,
Rome, 99, 102
Palazzo Gravina, Naples, 325
Palazzo Madama, Rome, 82, 83, 95,
96, 98, 99, 103, 104, 107, 109, 113,
170, 179, 196, 211, 226, 229
Palazzo Magistrale, Valletta, 344
Palazzo Mancini, Corso, Rome, 195
Palazzo Massimo alle Colonne,
Rome, 229
Palazzo Mattei (now Caetani),
Rome, 226-30, 227, 235, 246
Palazzo Pitti, Florence, 148, 355
Palazzo Vecchio, Florence, 113, 128
Palazzo Vercelli, Rome, 103
Palazzo Zuccaro, Pincian hill,
Rome, 62, 263
Palelli, Leonora, 134
Paleotti, Cardinal Gabriele, Bishop
of Bologna, 49-50, 96, 251, 289,
370; Discorso intorno alle immagini
sacre e profane, 49, 115, 159, 223
Palermo, Sicily, 364, 365, 376-7, 379,
380
Palestrina, 314-15, 316
Paliano, 314, 315, 316
Pallotta, Evangelista, 304
Palma, Jacopo (Il Giovane), 23, 192
Palma, Jacopo (Vecchio), 23, 97
Palo, 388, 389, 390
Pamfili family, 42
Panciroli, Ottavio, 154
Panico, Anton Maria, 84
Panigarola, Francesco, Bishop of
Asti, 30, 49
Pantheon, Rome, 102, 114, 310
Paolucci, 161
Papal States, 2, 156
Paracelsus, 113
Paravicino, Cardinal, 128, 155, 197
Parione, Rome, 39, 54
Paris, 2
Parisot, Jean de La Valette, 341, 342
Parma, 2, 310
Parmigianino, Ludovico, 266; Amor
(Cupid Carving his Bow), 215-16
Parrhasius, 27
Paruta, Paolo, 43-4
Pascoli, Lione, 134-5
Pasqualone, Mariano da, 160, 299,
302-3

Passeri, Cinzio, Cardinal di San Giorgio, 40-41
Passignano, Domenico, 278, 305
Patrizi, Francesco, 41
Paul, St, 180-81, 182, 340
Paul III, Pope (previously Cardinal Vicario), 275, 290, 291, 293, 298, 304, 309, 327, 352, 353
Paul III, Pope, 2-3
Pauline chapel, Vatican, 184, 187
Peace of Cateau Cambrésis (1559), 2
Peiresc (scholar), 338
Peretti, Camilla, 56
Peretti, Orsina Damasceni, Marchesa di Caravaggio, 56
Peretti family, 56
Pesaro, 79
Pesaro, Venturino: La Farsa satyra Moral, 91; Il Parto Supposito, 91
Peter, St, 35, 180-81, 182, 223, 225
Peter Martyr, St, 334
Peterzano, Angelica, 22
Peterzano, Simone, 21-5, 28, 268; Adoration of the Shepherds, 24; The Deposition, 24; Resurrection, 24
Petrarch, 216
Petrella Salto fortress, 160
Petrignani, Monsignor Fantin, 78, 84
Petronio, Capt., 313
Philip II, King of Spain, 2, 14, 18, 40, 133
Philip III, King of Spain, 319, 364
Philostratus, 71; Imagines, 200, 202-3
Piacenza, 2
Piatto, Cardinal Flaminio, 61
Piazza Borghese, Rome, 90
Piazza Carità, Naples, 324
Piazza dei Santissimi Apostoli, Rome, 134
Piazza del Duca, Rome, 90
Piazza del Popolo, Rome, 36, 38, 98, 159
Piazza della Signoria, Florence, 121
Piazza di Ponte Sant'Angelo, Rome, 161
Piazza di San Lorenzo, Rome, 138, 297, 309
Piazza di San Salvatore, Rome, 78
Piazza Firenze, Rome, 295
Piazza Missori, Milan, 13
Piazza Navona, Rome, 38, 54, 72, 139, 156, 229, 266, 298, 299, 348
Piazza Salviati, Rome, 159
Piazza Sant'Angelo, Romne, 38
Pico della Mirandola, Giovanni, Comte, 211
Pietra Santa, Gregorio Cervina da, 179
Pietropaolo (barber's apprentice), 131, 132
Piisimi, Vittoria, 87
Pincio, Rome, 34, 38
Pinelli family, 131
Pino, Captain, 298
Pio Monte della Misericordia church, Naples, 327
Pioveni, Francesco, 310, 311

Pisani, Baldassare, 123
Pius IV, Pope, 15
Pius V, Pope, 9, 10
Platea Trinitatis (later Piazza di Spagna), Rome, 38
Plato: Symposium , 211
Pliny, 27, 71
Poland, 154
Pona, Francesco: La Lucerna, 144
Ponte, Rome, 39
Ponte di Santa Maria (later Ponte Rotto), Rome, 160
Ponte Sant'Angelo, Rome, 9, 38
Pontono, Cesare, 313
Pontono, Lavinia, 313
Pontono, Plautilla, 313
Popolano, Giovan Ambrogio, 15
Pordenone, Il (Giovanni Licinio de Sacchis), 23
Porta del Popolo, Rome, 36
Porta Folceria, Caravaggio, 19, 28
Porta Orientale, Santa Babila parish, Milan, 22
Porta Seriola, Caravaggio, 12, 13, 19
Port'Ercole, 388, 389, 390
Portland Vase, 97
Posilippo, 381
Pourbus, Frans, 339
Poussin, Nicolas, 5
Pozzo, B. dal, 346
Prato, 228, 298
Priory of Maltese Knights, Messina, 370
Propertius, Sextus, 151
Protestantism, 2, 10, 15, 39, 40, 48, 154, 165, 166, 177, 181, 222, 236, 248, 282, 286, 306
Pucci, Monsignor Pandolfo, 56, 57
Pudens, Praxedis, 181
Pudens, Pudenziana, 181
Pudens, senator, 181
Pudenziana, St, 157
Pulzone, Scipione, 54, 80, 103, 224, 226; The Crucifixion, 243, 244; The Holy Family, 52, 53
Pyramid of Cestius, Rome, 105

Quamvis Infirma (papal bull of 1587), 45
Quirinal, Rome, 56

Radolovich, Niccolò, 327, 328
Rados, Giuseppe: View of the Corso dei Servi, Milan, 13
Raleigh, Sir Walter, 385
Raphael, 51, 52, 59, 66, 67, 74, 76, 77, 85, 97, 146, 158, 173, 174, 184, 186, 208, 209, 226, 240, 245, 292; Disputa, 35; School of Athens, 35; The Tranfiguration, 178
Rappresentazione di Judith Hebrea, La, 167
Reggi, Raffaellino da, 39
religious art: Carlo Borromeo and, 24; in Lombardy, 23; naturalistic, 52; Paleotti on, 49-50, 96, 115
Rembrandt van Rijn, 263
Renaissance, 225; architecture, 174, 342; art, 3, 21, 23, 25, 76, 89, 109,

120-21, 173, 178, 193, 215, 218, 245, 270, 348; cardinals, 15, 42, 290; courtesans, 145-6; courty love, 142; literature, 85, 89, 109, 215; and melancholy, 70; nec spe, nec metu motto, 133; princely popes, 10; rhetoric, 176; Rome, 1, 3, 38, 138, 207
Reni, Guido, 90, 102, 218, 252, 253, 279-85, 291-2, 296; The Crucifixion of St Peter, 281, 284; David Contemplating the Head of Goliath, 282, 284, 285, 385; The Martyrdom of St Catherine, 282; St Michael the Archangel, 305
Rhodes, 341, 343
Ribera, Jusepe de, 218
Richeôme, Louis, 231-2, 289; Pilgrim of Loreto, 286
Ripa, Cesare, 88; Iconologia, 67, 86, 97, 192-3, 194, 228, 257, 308
Rizzo, Pietro, 368
Rocca, A.: Treatise for the health of the soul and for the preservation of property and goods against card and dice players, 89-90
Roccasecca, Galeazzo, 299
Rodriguez, Loise, 325
Roman Empire, 157
Roman Martyrology, 48
Romanino de Sanctis, Fabbio, 313
Rome: ancient decorative art, 67; apocalyptic fears, 50; C arrives in (1592), 33, 51; C attempts to return (1610), 388-9, 390; C flees from (1606), 251, 310, 312, 314-16, 381; the centre of Christian power, 34; the centre of the Counter-Reformation, 52; the city of the Popes, 1, 39; creation of a modern city, 34; C's first work, 57-8; C's poverty, 57, 78; culture of honour, 142-3; described, 36, 38-9; Early Christian churches, 156, 157; flooding (1599), 160, 198; Forty Hours, 75-6; French population, 170; gaming, 90; history painting, 67; homosexuality, 144; immigrants, 55; itinerant population, 44-6, 133, 223; Jubilee Year (1600), 23-4, 154, 158, 163, 167, 168, 170, 171, 179, 180, 181, 198, 275, 286; luxury, 43-4, 50; medieval, 138; music in, 104-9; palaces, 42, 43; pilgrimage to the seven basilicas, 105; poverty, 44, 45, 46, 50, 289; private academies for the practice of virtù, 102, 114; prostitution, 6, 41, 139-44, 145-6; Renaissance, 1, 3, 38, 138, 207; renews her power, 2; sacked (1527), 1-2, 33; studios, 53, 57; urbanisation, 35; villas, 42; violence, 50, 122-3
Roncalli, Cristofero, 62-3, 104, 114, 218, 229, 253, 267, 268, 270, 271, 280, 305
Rosary, 333-5
Rossi, Giacomo, 13, 19

Rossi, Giovanni Vittorio *see* Eritreo, Giano Nicio
Rotolanti, Gregorio, 266, 267
Röttgen, Herwarth: *Il Caravaggio: Ricerche e Interpretazione*, 6
Rubens, Peter Paul, 54, 114, 218, 241, 253, 263, 317, 339; *Gian Carlo Doria*, 301
Rudolf II, Emperor of Austria, 26
Ruffetti, Andrea, 196, 304, 308
Rusticucci, Cardinal, 143, 158

Sacra Rappresentazione, 167
Sacri Monti, Lombardy, 245
St John Lateran cathedral, Rome, 35, 52, 66, 67, 158, 173, 181, 209
St Paul, Dominican church of, 339
St Paul, monks of, 266
St Peter's, Rome, 9, 34, 155, 163, 177, 181, 278, 279, 304-8
St Peter's Square, Rome, 155
SS Fermo e Ristico church, Caravaggio, 20
Salini, Tommaso ('Mao'), 252, 258, 262-7, 270-73
Salo, Mattia da, 375
Salviati, Anton Maria, 42-3
Salviati family, 48
Sammut, Edward, 361
Samperi, Placido, 373, 375; *Iconologia*, 370
Sampierdarena, near Genoa, 301
San Andrea delle Fratte parish, Rome, 55
San Carlo church, Milan, 13
San Domenico church, Naples, 334, 335
San Domenico monastery, Naples, 336
San Fedele church, Milan, 24
San Francesco Grande, 26
San Giacomo degli Spagnoli church, Rome, 38
San Giovanni Battista church, Caravaggio, 20
San Giovanni dei Fiorentini church, Rome, 39
San Giovanni in Conca church, Piazza Missori, Milan, 13
San Gottardo church, Milan, 14
San Lorenzo church, Damaso, 149
San Lorenzo church, Rome, 138
San Lorenzo in Lucina parish, Rome, 55
San Luigi dei Francesi church, Rome, 38, 68, 102, 145, 170, 171-2, 179, 246, 256
San Pietro in Montorio church, Rome, 162
San Sebastiano church, Rome, 9, 227
San Severo castle, 389
San Stefano Rotondo church, Rome, 157, 159
Sandrart, 152-3, 175, 217, 254, 272, 310, 342, 356-7
Sandys, George, 340, 342-5, 347, 363, 366, 369

Sannesio, Cardinal Giacomo, 182, 305
Sansovino, Francesco: *Origine de cavalieri . . . con la descrittione dell'isole di Malta e dell'Elba*, 143, 340, 351, 352
Sansovino, Jacopo, 79; *Virgin and Child*, 285
Sant' Agostino church, Rome, 285
Sant' Alessandro church, Conscente, 281, 282
Sant' Eustachio, Rome, 229
Sant' Onofrio monastery, 96
Santa Anna dei Lombardi church, Naples, 386
Santa Caterina dei Funari church, Rome, 210, 227
Santa Cecilia in Trastevere church, Rome, 162
Santa Croce, Gerusalemme, 34
Santa Lucia church, Syracuse, 368
Santa Maria Concezione monastery, Sicily, 375
Santa Maria del Popolo church, Rome, 36, 180, 182
Santa Maria della Consolazione church, Rome, 55
Santa Maria della Consolazione, Hospital of, Rome, 67-8
Santa Maria della Sanità church, Naples, 334, 335, 386
Santa Maria della Scala church, Trastevere, 227, 246, 247, 249
Santa Maria della Vittoria, 10
Santa Maria dell'Anima church, Rome, 38
Santa Maria di Constantinopoli church, Tolentino, 273
Santa Maria di Loreto basilica, 280
Santa Maria in Vallicella church, Rome, 39, 241
Santa Maria La Concezione monastery church, Borgo San Leone, 373
Santa Maria Maggiore basilica, Rome, 34, 288
Santa Maria monastery, Aracoeli, Rome, 9
Santa Marinella castle, 389
Santa Prassede, Rome, 68, 279
Santa Prisca church, Rome, 181
Santa Pudenziana church, Rome, 181
Santa Susanna church, Rome, 158
Santa Trinità dei Monti, Rome, 38
Santa Trinità dei Pellegrini church, Rome, 270
Santafede, Fabrizio, 325
Sant'Angelo district, Rome, 227
Sant'Anna dei Lombardi church, 338
Sant'Anna dei Palafrenieri church, Rome, 305
Santi Apostoli church, Rome, 56
Santi Nereo ed Achilleo church, Rome, 158, 163
Santi Pietro e Paolo church, Caravaggio, 13
Santori, Cardinal Giulio, 64

Sapienza, University of Rome, 21, 41, 133
Saraceni, Carlo, 156, 250, 252, 278, 280, 317
Sartis, Fabio de', 179
Sarto, Andrea del, 97
Saul, conversion of, 183-4
Savoldo, Giovanni Girolamo, 28, 124, 185, 379
sbirri (police), 137-8, 277
Scala Santa, St John Lateran, Rome, 35, 52, 67
Scanelli, Francesco, 193, 214; *Il Microcosmo della Pittura*, 253
Scarpellino, Francesco, 266
Schiavone, Andrea, 192
Scuola di Leggere e Scrivere, Caravaggio, 21
Scupoli, Lorenzo: *A Spiritual Conflict*, 46, 226
Sebastiano del Piombo: *The Flagellation of Christ*, 336-7
Sellitto, Carlo, 325, 338
Sellitto, Sebastiano, 325
Sersale, Cesare, 328
Servite monastery, Milan, 13
servitù particolare, 54
Sfondrato, Cardinal Paolo Emilio, 64, 65, 162, 279
Sforza, Fabrizio, 12, 363
Sforza Colonna, Muzio, 11, 12, 28, 56, 163
Sforza da Caravaggio, Francesco I, 10, 12, 13
Sforza da Caravaggio family, 10, 13
Shakespeare, William: *Julius Caesar*, 131
Sicca, Marsilia, 205
Siciliano, Lorenzo, 57, 60
Sicily, 2, 7, 162, 340, 360, 363, 364-80, 383
Sillani, Felice, 134, 139
Sistine Chapel, Vatican, 52, 69, 108-9, 175, 179, 210, 211, 214
Sixto-Clementine Bible, 166
Sixtus V, Pope, 34, 35, 44-6, 52, 56, 78, 89, 98, 144, 154, 159, 181, 246
Slovenia, 136
Song of Songs, 125, 127
Spada, Lionello, 175, 197, 280, 281
Spada, Paolo, 299
Spain: fights for dominance in Italy, 1; Henry IV declares war on (1595), 39; peace with France (1598), 136, 171; riot between French and Spanish factions (Rome, 1605), 297; settlement with France (1559), 2; struggle for political domination over the Papacy, 39
Spampa, Girolamo, 256-7
Spata, Caterina (née Gori), 78
Spata, Costantino, 78, 84, 131-2
Spinola family, 102
Spon, Jacob, 42
Stadium of Domitian, Rome, 38
Stella, Jacques, 192
Stelluti, Francesco, 41
still life, as a novel form of art, 66

Stock, St Simon, 250
Strozzi, Giulio, 142, 145, 196, 391
Studio Padovano, Padua, 79, 80
Suetonius, 56
Suleiman the Magnificent, 340
Susinno, F., 145, 360-61, 369-72, 375, 376
Swiss Guards, 162
Symonds, Richard, 220
Syracuse, Sicily, 361, 363-7, 369

Tarquinio (of Rome), 56, 57
Tasso, Torquato, 41, 79, 96, 105, 107, 127, 197, 199, 209, 324, 328, 381; *Aminta*, 107, 110; *Gerusalemme Liberata*, 204
Tavern of the Blackamoor, Strada delli Greci, Rome, 90, 93, 132, 276
Tavern of the Tower, Rome, 132, 276
Tavern of the Turk, Rome, 93, 132
Tavern of the Wolf, Rome, 132
Tempesta, Antonio, 42, 197, 267-8; *Map of Rome*, 37, 42, 98; *Scene of Martyrdom*, 155
Teofilo, Sertorio, 299
Tertullian, 225
Testa, Antonella, 198
Theatines, 3, 16, 46, 47, 321, 328
Theresa, St, 158
Tibaldi, Pellegrino, 20
Tiber river, 9, 126, 139, 160, 198
Tiberio del Pezzo, 327, 328
Tibullus, Albius, 151
Tintoretto, Jacopo, 23, 25, 301
Titian, 22, 23, 25, 79, 97, 109, 146, 245, 301, 351, 352; *Death of St Peter Martyr*, 178; *Mary Magdalene*, 97, 110-11, 148; *The Resurrection*, 185; *Salome with the Head of St John the Baptist* , 385; *The Venus of Urbino*, 79
Tivoli, 109
Todesco, Giorgio, 267, 268, 269
Todi, Jacopone da, 127; *Laudi*, 224; *Pianto della Madonna*, 224
Tolentino, the Marches, 273
Tomassoni, Alessandro, 137, 275, 297, 298
Tomassoni, Giovan Francesco, 137, 138, 275, 297, 298, 309, 310, 312-13, 314, 391
Tomassoni, Lodovico, 137
Tomassoni, Lucantonio, 137, 311
Tomassoni, Mario, 137, 312
Tomassoni, Ottavio, 137
Tomassoni, Ranuccio, 136-42, 194, 297, 309-10, 311-12, 353
Tomassoni family, 136-7, 138, 142, 152, 297, 309, 310, 312, 314
Tonti, Alessandro, 276
Toppa, Petronio, 309, 310-11, 312
Tor di Nona, Rome, 38-9, 159, 162, 276, 298, 310

Tor Savella, Rome, 159
Torriglia, fra' Orazio, 371
Toste, Robert, 100-101
Trajan column, Rome, 34, 181
Trastevere, Rome, 54, 162, 227, 249
Travagni, Vittorio, 179
Tre Fontane, church of the, Rome, 281, 284
Treaty of Vervins (1598), 2
Tribunal of the Governor of Rome (1597), 131
Trinchieri Camiz, Franca, 6
Trinità de' Pellegrini, Rome, 47, 78, 80, 163, 230, 286
Trinità dei Monti, Rome, 55, 132, 317, 324
Trisegni, Filippo, 264, 265, 266-7, 273
Trombini, Giovanni Battista, 303
Tronserelli, Ottavio: *L'Apollo*, 88-9
Tuccio, Stefano: *Crispus*, 163; *Flavia*, 163; *Judith*, 167
Tufo, Giovanni Battista del, 71-2, 327, 334, 381-2; *Portrait or Model of the Greatness, and marvels of the most noble city of Naples*, 323
Tullio, Marco, 255-6
Turco, Angelo, 310
Turin, 245, 246, 286
Turks, 2, 9, 10, 39, 99, 154, 163, 333, 340-41, 344, 356, 364, 366
Tuscany, 2
Tuscany, Grand Duke of, 353

Uffizi, Florence, 116, 122, 145, 201, 232
University of Pisa, 82
Urban VIII, Pope (Maffeo Barberini), 94, 127, 132, 195, 201, 219, 274
Urbino, 54, 79, 80, 97
Ursula, Sister, 388
Usimbardi (Cardinal Ferdinando de' Medici's secretary), 80-81

Vaga, Perin del, 229
Valier, Cardinal Agostino, 39, 44, 222; *Dialogue on Christian Joy*, 288-9
Valletta, Malta, 342-3, 343, 344, 351, 354
Vallicella, Rome, 47, 48
Valois Kings, 2
Van Dyck, Anthony, 263
Van Dyck, Floris, 66, 76
Van Mander, Carel, 76, 136; *Lives of the Painters*, 253-4
Varallo, Sacro Monte of, 286
Varola, Gabriele, 13
Vasari, Giorgio, 62, 121, 255, 380; *The Beheading of St John the Baptist*, 159
Vatican, Rome, 38, 52, 155, 211

Vatican Library, 35
Vatican Logge, 63
Vatican Palace, Rome, 9, 52, 354
Vatican Pinacoteca, 184
Vecellio, Cesare, 87-8
Vendenghini, Luigi, 161
Venetian art, 79-80, 93, 97, 103, 109, 156, 210, 255
Venice, 2, 4, 22, 23, 28, 30, 80, 156, 199
Venosa, Kingdom of Naples, 345
Veronese (Paolo Cagliari), 23, 351
Via dei Tribunali, Naples, 329
Via della Pilotta, Rome, 56
Via Frattina, Rome, 138
Via Giulia, Rome, 39
Via Margutta, Rome, 324
Vialardi, Francesco Maria, 160-61, 162
Vicario, Cardinal (Camillo Borghese; later Paul V), 275
Vicenza, 197
Vicolo del Divino Amore, Rome, 38, 138, 220, 293, 295
Villa Aldobrandini, Frascati, 41, 109
Villa Celimontana, Rome, 42
Villa Ludovisi, Porta Pinciana, Rome, 127-8, 128, 130
Villa Mattei, Rome, 105
Villa Medici, Pincio, Rome, 42, 57, 80, 97, 109, 132, 201, 279
Vinck, Abraham, 324, 325, 338, 339
Vinta, Belisario, 94, 113
Virgil: *Eclogues*, 211
virtù, 102, 114
Vittorio, 61
Vittrice, Alessandro, 88, 242
Vittrice, Gerolamo, 242
Vittrice, Pietro, 242
Volpato, Giovanni: *The Farnese Gallery, Rome*, 206

Webster, John: *The Duchess of Malfi*, 190
Wignacourt, Alof de, 344-5, 346, 348, 349, 351-6, 358, 383
Willaert, Adrian, 79, 105
Works of St Peter's (Fabbrica di San Pietro), 172

Zacchia, Caterina, 141
Zacchia, Prudenzia, 141-2
Zagarolo, 314, 315, 334
Zeuxis, 27, 71, 246, 333
zingaresche, 86
Zuccaro, Federico, 39, 51, 62, 74, 192, 228, 235, 255-8, 263, 267, 268, 270; *Idea*, 75; *Self Portrait*, 62, 63
Zuccaro, Taddeo, 51, 63, 93, 227
Zucchi, Francesco, 66
Zucchi, Jacopo, 66